THE ESSENTIAL MARILYN MONROE
MILTON H. GREENE
50 SESSIONS

ACC EDITIONS

"

This is a truly authentic look into Monroe's life, and the best collection of photographs of the world's most glamorous star by someone who really knew her

PAT NEWCOMB, MARILYN'S ASSISTANT

"

COLOR PHOTOGRAPHY'S WONDER BOY

BY DOUGLAS KIRKLAND, PHOTOGRAPHER

Milton Greene was born in 1922 and although only 12 years my senior, he was a giant in the world of photography. At 23, Milton was already recognized as "Color Photography's Wonder Boy!" I started following his work while growing up in my small town of Fort Erie, Ontario in Canada; population 7,000. I was dazzled by his first Marilyn Monroe story in *Look* magazine, and read about his friendship with the goddess who no-one could ever imagine meeting in the flesh. All I had to dream with were her films, which played at the local Parkway Theater on weekends. I was obsessed with photography and could not get enough of Milton's glamorous fashion and celebrity portraits in *Vogue, Harper's Bazaar, Look* and *Life* magazine, which my mother subscribed to. As an aspiring photographer, I think I secretly hoped to become Milton Greene someday. Little did I know, at the time, I would later get a job with *Look* and would be sent to Hollywood in 1961 to photograph Marilyn Monroe for the 25th anniversary of the magazine.

I will never forget the first time I met my hero, Milton. It was 1962.

Huntington Hartford had purchased Hog Island, a very small island off Nassau and renamed it Paradise Island. Millions of dollars were spent on the building of the resort and the Ocean Club. The opening was covered by the press worldwide. Melvin Sokolsky was there shooting for *Harper's Bazaar*, Arnold Newman was working for *Life* magazine, Milton was photographing a fashion spread for *Vogue* and there I was photographing top model Kecia Nyman for *Look* magazine. It was all very fancy, the fireworks were imported from France. Journalists and photographers kept bumping into each other on this small, 685-acre island. Milton was exceptionally friendly and open with me. Although I was unquestionably the junior there, he never failed to ask me how my work was going and was always very encouraging. One morning at breakfast, I noticed how tired he looked and I asked him if he was feeling okay.

"Oh I never sleep when I am on a shoot!" he replied. This was how dedicated Milton was to his art. His intensity was something I could relate to. I wanted to ask him about Marilyn and his experience with her, but didn't dare! He was the true professional expert, who had spent close to five years of his career working with her.

I met Milton met again in 1972 when Norman Mailer was working on his controversial book on Marilyn. I admired the magnificent large black-and-white prints from the 1956 Black Sitting that Milton brought to show us at our house. I didn't think of fine art prints being collectible at the time and once again I was learning from Milton.

In 1984, my wife Francoise and I met Milton on a plane to Los Angeles. We all had moved there by then. He was his usual charming self, never competitive. We were both working for different film companies and we made plans to get together. We had a wonderful, memorable dinner at Spago. He was the most entertaining storyteller; Milton's anecdotes about the Hollywood he had been exposed to were brilliant, biting and right to the point. He was already ill then but held high hopes of recovery. We were deeply saddened by his death in 1985.

In 2016, I was invited to exhibit my photographs of Marilyn, along with Milton's, in Shanghai, a very intimidating thought. With the wonderful work his son Josh had done nursing his father's archives, I again had the opportunity to see the monumental body of work that Milton had created of Marilyn.

The Essential Marilyn Monroe shows previously unpublished images, saved by the miracle of modern technology and is a timeless tribute to a truly unique beauty. Marilyn loved the camera and the camera loved her back. She gave it all – happiness, sadness, vulnerability – and the images reflect this. A lot of people have tried to copy Marilyn over the years and none has ever gotten close.

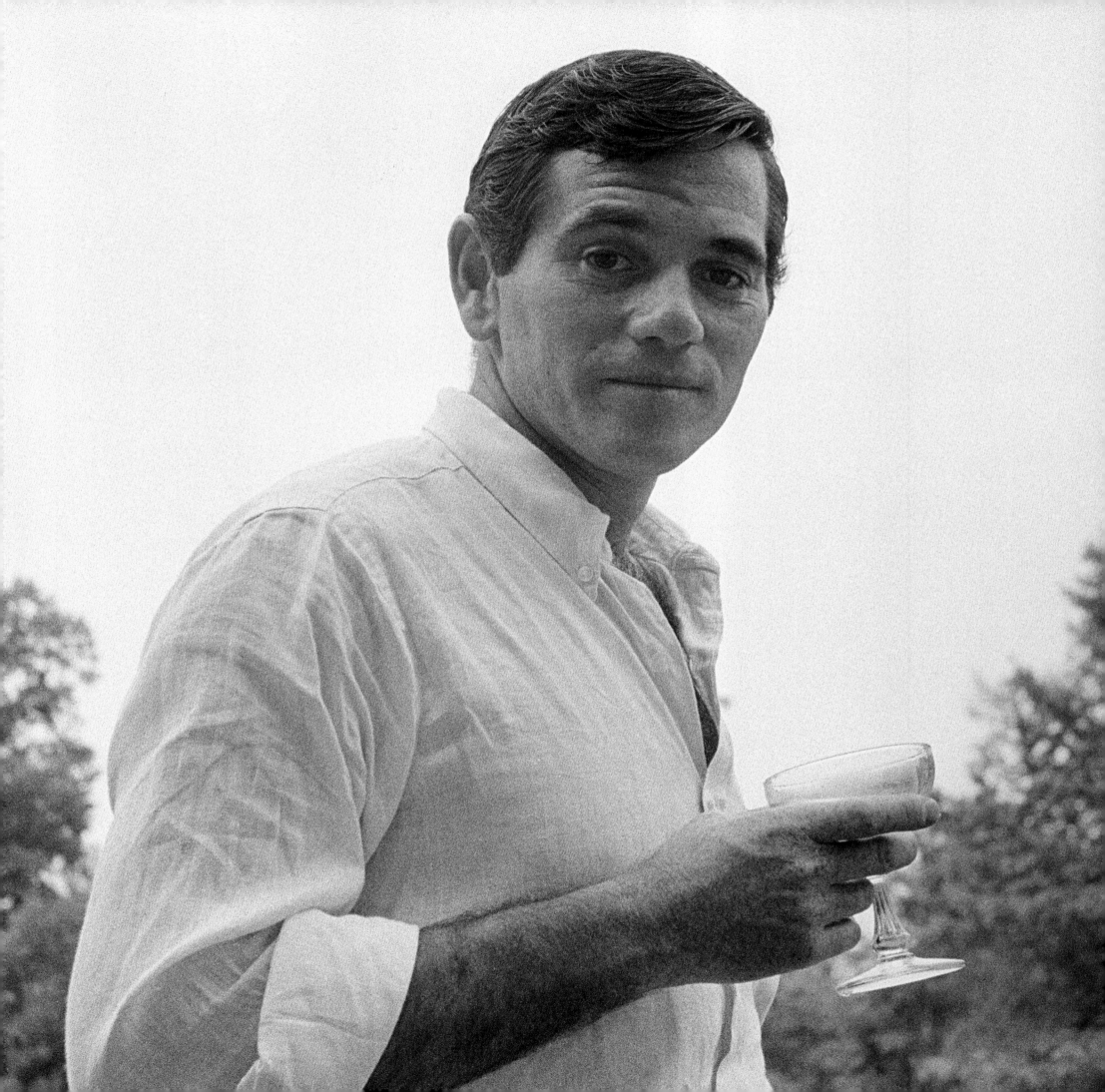

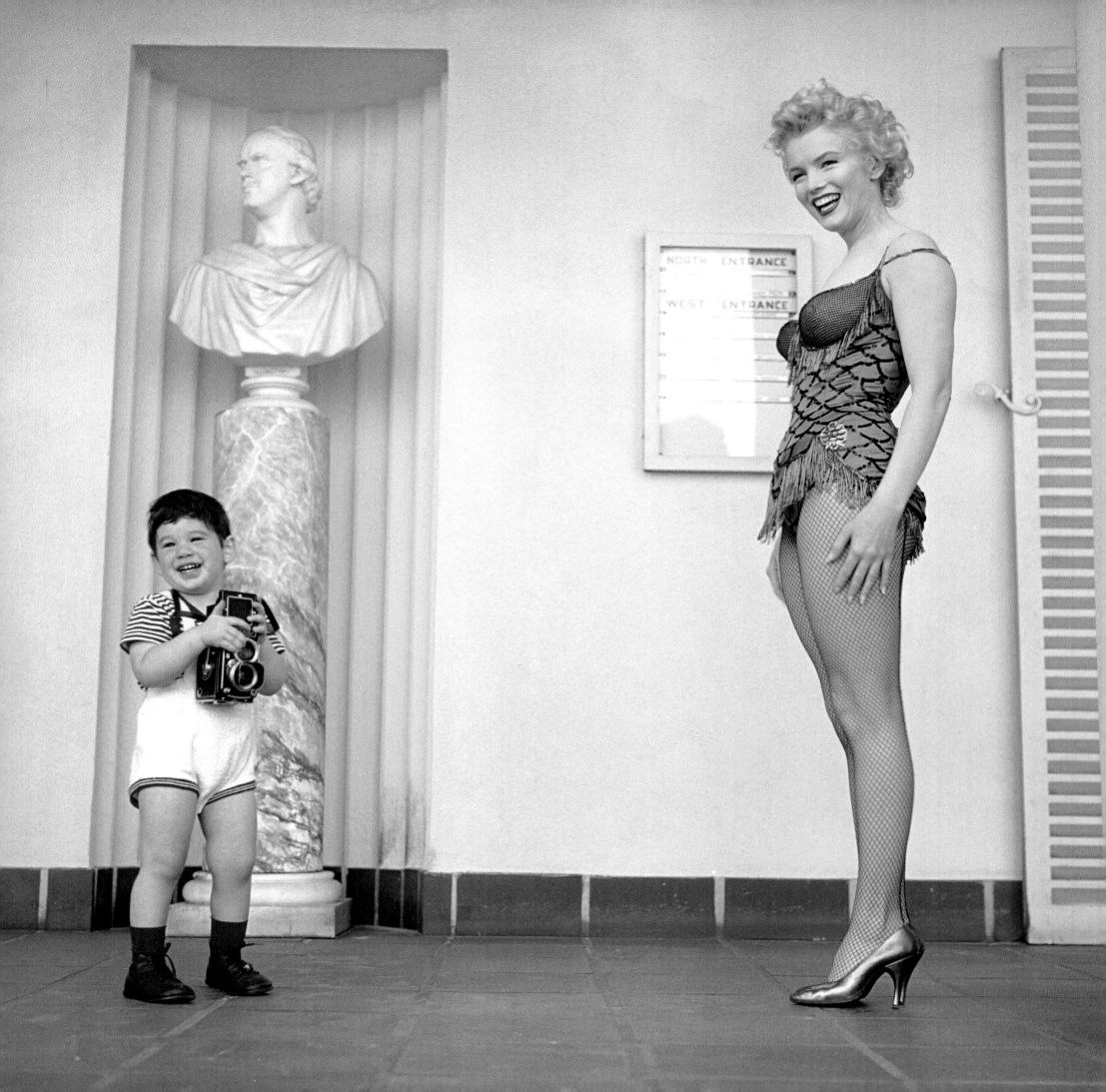

MILTON'S VISION

BY JOSHUA GREENE

In the early 1990s, Douglas Kirkland showed me 16"x20" prints from one of my favorite Monroe sittings, his extraordinary 1961 session of Marilyn dancing under sheets and hugging pillows. These exquisite prints were on 500lb matte rag paper and the inks had a vibrancy and subtlety of color that was clearly not photographic. I asked him about their backstory and Douglas introduced me to Mac Holbert, who ran Nash Editions, a pioneer in fine art digital printmaking. At the time, Nash Editions operated out of the garage of one of Graham Nash's homes in Long Beach, California where Mac lived. Having no understanding of computers, software or of digital technology, I went to visit their makeshift studio bringing with me three 88mb SyQuest disks, each containing one of my father's images.

Let me set the scene: it was a modest house up on the street level with a cobblestone driveway that went down towards the beach. The studio was housed in a two-story garage with a living space above. The lower floor had 14-foot ceilings and below were five or six people at various workstations. Walking in, the first thing I saw were large prints crisscrossed on lines and hanging by clothespins: William Coupon's series documenting indigenous tribes from South America. Again, I was taken by the intense color and the matte paper. These early Iris ink jet prints on 500lb Arches watercolor paper started a revolution in fine art printing. Mac introduced himself and said, "Let me see what you got?" Popping one of the disks into the reader, he studied the image, looked back at me and exclaimed, "These are terrible!" When an artist is bold enough to tell you the truth, it's a test of your confidence to accept a negative response and not take it personally. It was training I had received all my life from my father, the illustrator Joe Eula, Gene Moore, who was a visual genius, and other mentors, too many to mention. At that point I looked at Mac and said, "I respect you for being direct. I will be honest with you, this work was done with my supervision but I don't know how to use a computer let alone Photoshop." Standing behind an operator drove me crazy because I knew it was 70% right but I did not know how to get the color I wanted. I asked Mac if he would be willing to do some work for us, as well as mentor me, informing him that these were three images

in a collection of more than 3,000! Mac was very generous, allowing me to come and observe his techniques.

Working for many photographers, my focus was not just on Milton's restoration. I was also guided by my history in traditional photographic printmaking, which was much more real to me than the art of manipulating images through software. Even today's photographers and artists have not been taught how to SEE as a printmaker, unaware of their responsibility to take an image from its source, be it film or digital, and see it through to making a print that captivates the viewer. We are always limited by the technology, although less today than ever before.

I had been pitching this project to Robin Morgan of Iconic Images in London over the last three years. The pitch included the making of this book in addition to finding partners to create a public exhibition that could travel the world. With the support of a network of galleries, I hoped to create enough interest to make available a very small quantity of limited edition prints, approved and authenticated by us.

In March of 2017, Robin called me with exciting news; he had found partners who wanted to do a public exhibition and the book. We still needed to complete the thousands of hours required to finalize 400 images; my original pitch date was spring of 2018. The genuine excitement over the project came with a caveat: release date for the book would need to be moved up to Fall 2017! I produced my first book, *Milton's Marilyn*, in 1994. It was the first opportunity for people to learn about the experiences of my family and friends during 1953 to 1957, when Milton and Marilyn reached for the stars and changed each other's lives. In the years since the release, those in the know kept asking me when we were going to do another book sharing the last of the never-before-seen images. For the past 20 years, I've been waiting for a time to curate and plan how to introduce the last hurrah: a book honoring the Monroe/Greene collaboration.

My role in this project was driven by my desire to serve my father, my interest in illustrating his gifts as a photographer and selecting images that the world would be excited to see. My focus was on fulfilling those emotional needs, more so than editing out images that are technically imperfect, which you will

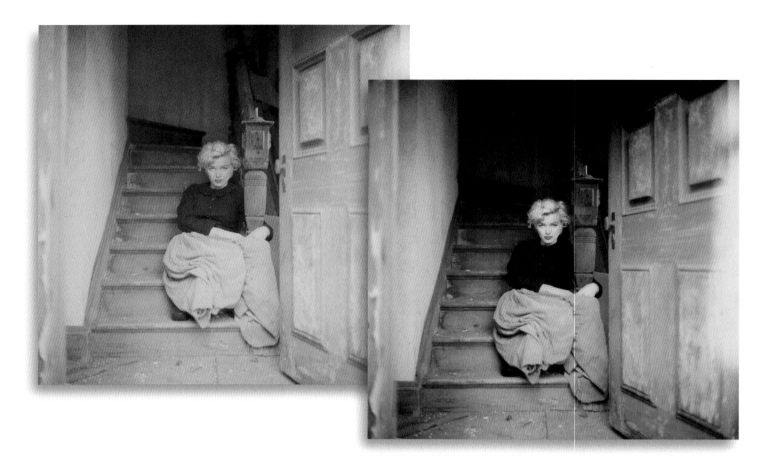

see in the Negligee, Nude Sweater, Rock, Ballerina and Joseph Schenk sittings. Those images are far worse than what you see in the book. They are limited in their quality due to the condition of the original film being strongly affected by bad processing which altered the exposure. The 35mm black-and-whites are questionable because Milton, in his excitement, would process the film in a hotel room and the development time and water temperature were inconsistent. I felt it was more important to always represent the emotion.

From the initial selection of 400, there are 284 images in the book, of which 154 have been unseen until now. There are 22 that have been introduced over the last few years only as limited edition fine art prints. There are 108 previously published images, which we consider favorites that must be included. Of those, there are four that were only printed once in *Look* magazine in the 1950s and have never been seen since. Those images are on pages 41, 42 and 80. The fourth image, which appears on page 16, was a *Look* cover from November 17, 1953. For your interest, on the opening page to each sitting we have indicated which pages have previously unpublished pictures.

It's so important for the viewer to understand that the original condition of the film is completely unprintable and has been since the 1970s. So what you see in this book is a monumental effort by many people. When I first embarked on digital restoration, my perspective was to bring the images back as they may have looked on the original film. Over the years, my point of view has shifted to: "What did Milton do with the original film? What would he do if he were alive today working with the digital darkroom?" Milton was a maverick in the darkroom, using the technology of his day, which included dodging and burning, and moving a silk stocking up and down while exposing the negative to the paper, which creates a varied type of diffusion; as a result, no two prints were ever the same. He used three different strengths of developers, to slam the blacks, to make the grays more silver and to control the whites so they remained soft like porcelain.

It's a look that has become a standard in the fashion industry and you see it in the work of Richard Avedon, Bert Stern, Irving Penn and other photographers of his generation. Milton would also create a textured screen on acetate, and by gently moving it across the print, it changed the grain structure. Over time, he started printing black-and-whites as sepia, a combination of manipulating warm tone developers with Portriga paper. With color work, he made masks to separate the subject from the background and control the luminosity of a print. All these techniques allow the printmaker to control how the viewer sees the image. That final result was never in the original film, it was created in the darkroom. It's back to printmaking. My approach to how Milton would treat his images with today's technology is what you see in this book. I have taken liberties that some may consider unorthodox. I see this, however, as an opportunity to introduce what he would've done, like it or not.

Milton used the following equipment during the Marilyn sessions: an 8"x10" Deardorff and a 4"x5" Linhof, both with Schneider lenses; a 2.25"x2.25" 2,8 C Rolleiflex; and Canon and Nikon 35mm Rangefinder cameras. As good as this equipment was for its time, all of these lenses were uncoated, meaning they did not refract light and they lacked contrast and saturation. Worst of all was the Rolleiflex, which was the camera he used for over 70% of the library they created. The condition of the images we worked on was compounded by the fact that film was organic and subject to storage conditions. Over time, all of these films aged differently when kept in the same hostile environment. The 8"x10" and 4"x5" emulsions were less affected than the 2.25. The color 35mm Kodachrome was, and remains, the most stable film Kodak ever produced.

Milton was a natural light photographer. He preferred a controlled environment with daylight outside, under trees, in a forest, against natural backdrops. His preference was open, diffused light, rarely direct sunlight, which he found to be offensive and unattractive. In the 1950s there were no strobe light

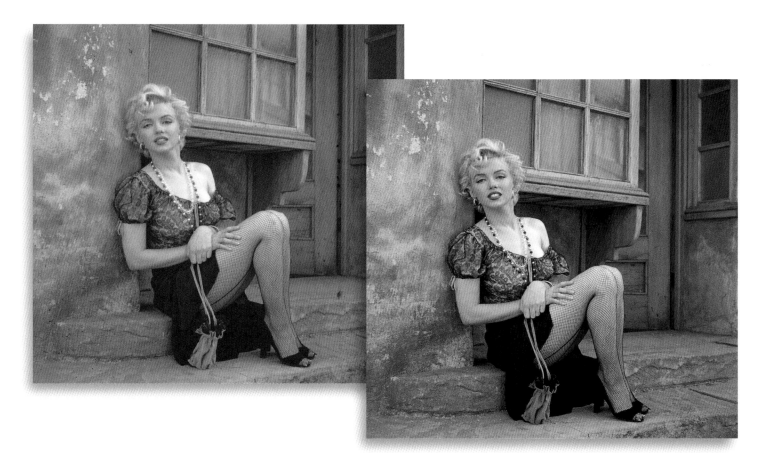

boxes. At best, strobe heads were a direct light source with or without a reflector. Nothing could recreate the source of a soft skylight effect except bouncing off a wall or ceiling. Milton worked with the Schwartz strobe company, which was downstairs in his 480 Lexington studio in New York. They took an 8"x10" Saltzman camera stand on wheels and modified it to handle the weight of a metal grid that had 25 200watt strobe heads attached to it. By adding heavy layers of spun glass diffusion and a white back panel, he perfected a movable bank light with 25 bulbs and only one shadow. Hence the skylight effect. This light source was used in all the photographs of Marilyn in the NYC studio except one: the Red sitting, their last photographic collaboration together. In addition to using his bank light, Milton added a 10K watt, 3200 Kelvin light source, thereby mixing the warm yellow glow of the tungsten light with a strobe exposure. It was a radical approach because what you get on film cannot be changed. People have asked me to correct the yellow cast but that was Milton's intent.

Milton's studio in Connecticut had three, 5x10-ft glass panels on the north wall and two more in the ceiling as skylights; he would diffuse the direct light using fabric shades. The Trestle, Red Sweater and V-Neck Sweater sittings were done in this daylight studio. Notice the soft, shadowless glow.

One of Marilyn's rare gifts was that her eyes changed color based on her surroundings. Though they appeared blue most of the time, the shades of blue would change. At times her eyes would appear hazel, other times green. As you go through the book, you will notice her eyes subtly changing color. It's not an accident.

In September 2016, Iconic Images coordinated a Marilyn Monroe exhibition featuring Kirkland and Greene's images in Shanghai. Our hosts gave us first-class treatment and Douglas, his lovely wife Francoise, and I got a chance to re-connect. In our many conversations, I shared with Douglas my vision for this book. I told him I was thinking of three different titles: *Marilyn Seen*, *Marilyn Unseen*, or

The Essential Marilyn. He insisted it be called *The Essential Marilyn by Milton H. Greene*. Fast forward to the intense 12 weeks the Archives team spent preparing images; it occurred to me that Douglas has been an inspiration throughout my digital evolution and that we share this common love for photography, printing and Marilyn Monroe. With Douglas's inspiration in mind, I asked him to write a few words which have become the foreword of this book.

I still consider Mac Holbert the greatest at digital imaging and printmaking. Looking at the daunting reality of having to tweak the color and tonal values for 284 images, I knew I needed help in order to complete this book. My team prepared the images first by scanning, then spending 30 hours to remove all surface marks, scratches and oil residue from fingerprints. Then came ten hours of masking, isolating the eyes, face, hair, lips, mouth, extremities, clothes and background. Having independent control of these elements allowed me the ability to blend, mix, and match the colors, no different to a chef using ingredients to affect the taste of food.

I will admit that my Photoshop skills are limited in that I blend my colors by eye; I don't do color "by the numbers." Given that the condition of the film of any one sitting can vary, no two scans are ever the same. Therefore, whatever adjustment you make to one layer is not the same as the others; each layer requires individual attention. Five weeks into our 12-week marathon, I called Mac and asked him if he would work on some of our images. Although he had his own substantial workload, Mac agreed to help. In five days he returned to me amazing results. More importantly, his approach to the images taught me alternative ways to use the software that opened my eyes yet again. Truly an example of an artist confident to share his work. Embracing those new lessons, it recharged and reignited my passion for the project. Now four weeks out, with 140 images to go, there was no choice but to double-down: seven days a week, 12 hours a day, whatever it took...

MARILYN AND MILTON

BY JAY KANTER, FILM PRODUCER

While living in New York, I became a friend of Amy and Milton Greene. I knew Marilyn during my agent days working in Los Angeles, but I was not her agent at that time.

Marilyn was a young star at Fox, and had the right to choose her photographer. She knew how to pick the best talents, and she picked Milton, one of the best in the business. The two of them made magic together and the photos show it.

Marilyn was having problems at Fox. She was one of the hottest stars in the business, and was tied to an exclusive, low-paying contract. She wanted the right to do independent films and, at the same time, the right to study and work at The Actors Studio in New York.

Marilyn and Milton formed Marilyn Monroe Productions, and Milton took Marilyn to New York where she lived with Amy, Milton and their son, Joshua.

While Marilyn was working at The Actors Studio, the renegotiations of her Fox contract were not going well, so Milton asked me if my agency, MCA, would represent Marilyn and their new production company. Of course, I jumped at the chance. After a while, the Fox deal was worked out and she was able to make outside pictures.

I soon found out from our London office that Laurence Olivier was going to do a movie of a Terence Rattigan play that he had done in London, called *The Prince and the Showgirl*. When I told Milton about this, he and Marilyn jumped at the chance to work with Olivier and Rattigan. Marilyn Monroe Productions had bought its first movie.

Olivier called me to say that he and Rattigan were coming to New York to attend the premiere of his new film, *Richard III*, which NBC bought, and Olivier suggested it would be a good chance to meet Marilyn and Milton. A meeting was arranged. I picked up Olivier and Rattigan at the airport. It was pissing with rain, so he suggested we go to her apartment rather than asking her to come out in such poor weather.

We arrived at the apartment, and Milton greeted us and served us some food and drinks. One, then two, then three drinks later, I said to Milton that they had to leave for the premiere soon. I knocked on Marilyn's bedroom door and entered. There she sat, looking in the big mirror, like a scared little girl almost afraid to meet the great actor. I explained to her that they had to leave soon for the premiere.

She came out, and the charming Olivier gave her a big hug and a kiss, and all's well that ends well. I'll remember that long, long afternoon. Marilyn and Milton continued on.

They are both up there in that star-lit sky, shining as bright as ever.

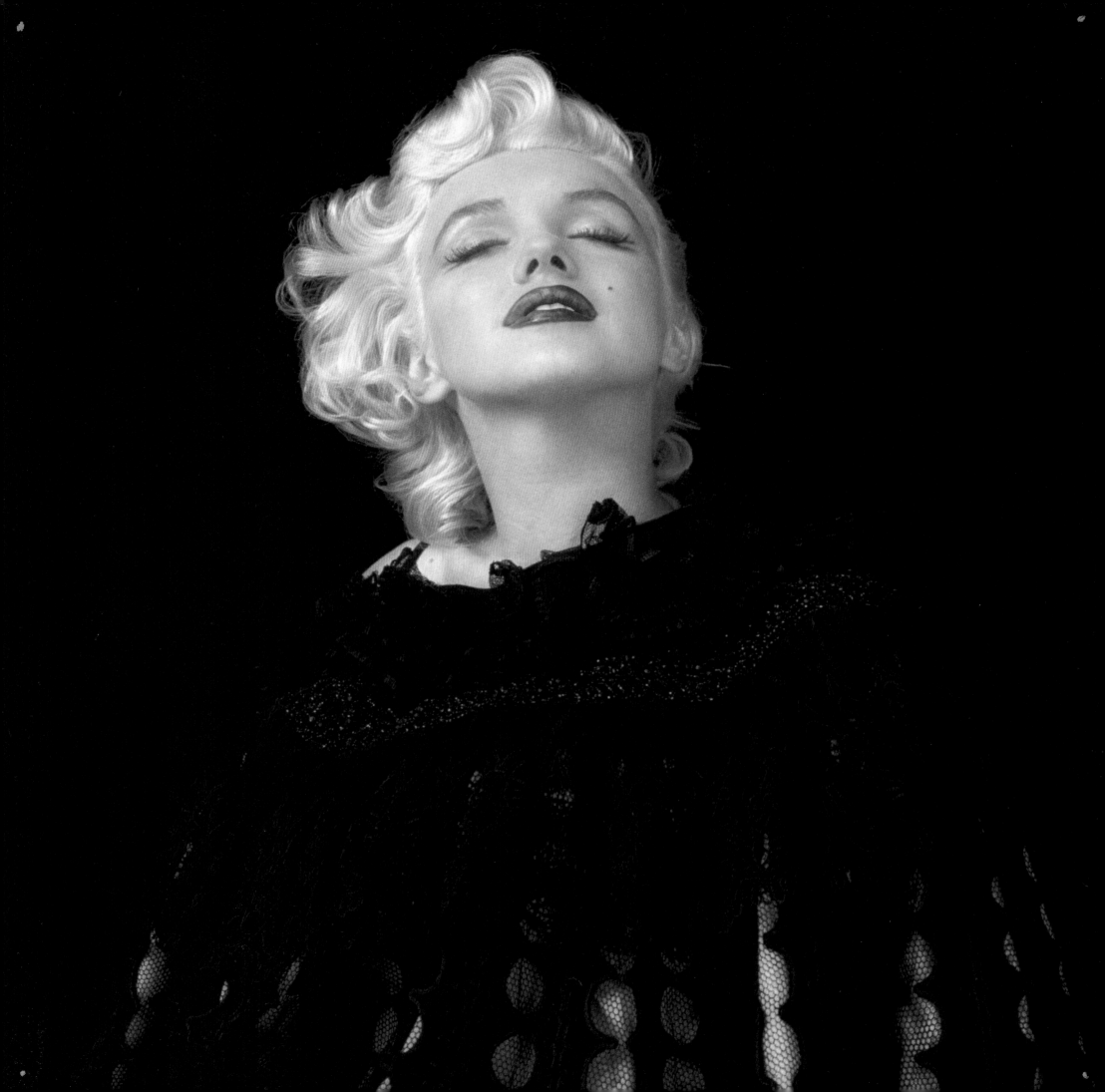

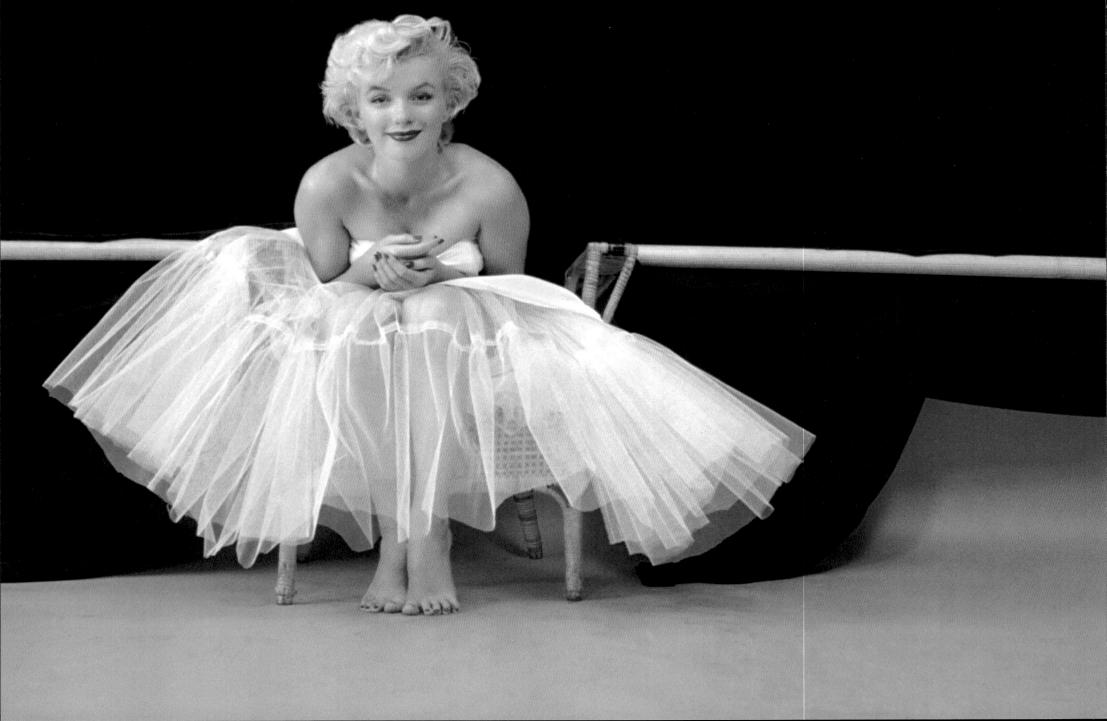

CONTENTS

50 SESSIONS

MANDOLIN

September, 1953 – Fleur Cowles, editor-in-chief of *Look* magazine, brought Milton to Los Angeles to meet Marilyn. Mandolin was the first photographic collaboration between the two. Over the next three days they created memorable work that won her over. Marilyn had sprained her left ankle while filming *River of No Return*, which was the only reason she was even available for this assignment.

Unpublished images:
Pages 15, 17, 18, 19, 20, 21

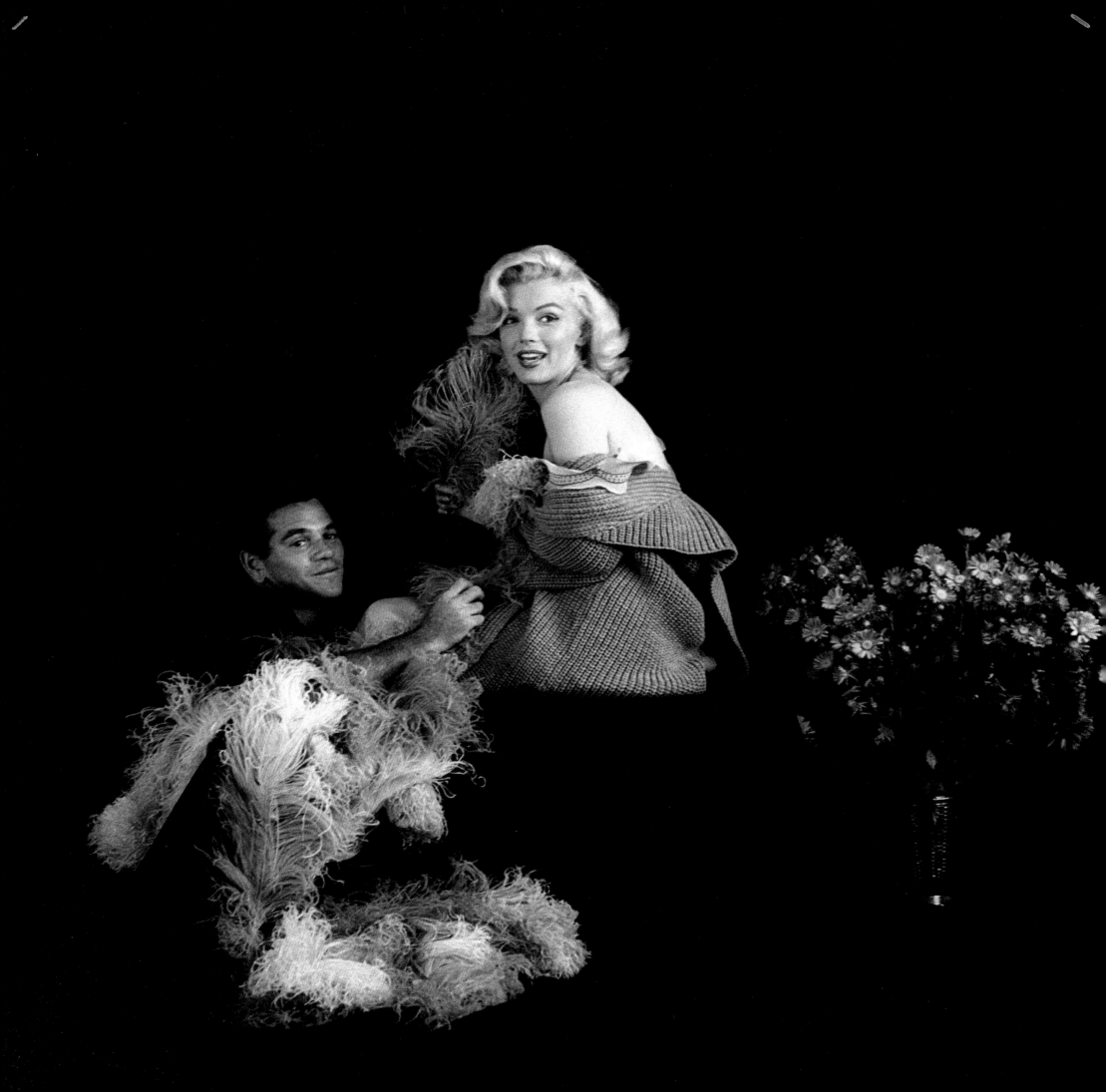

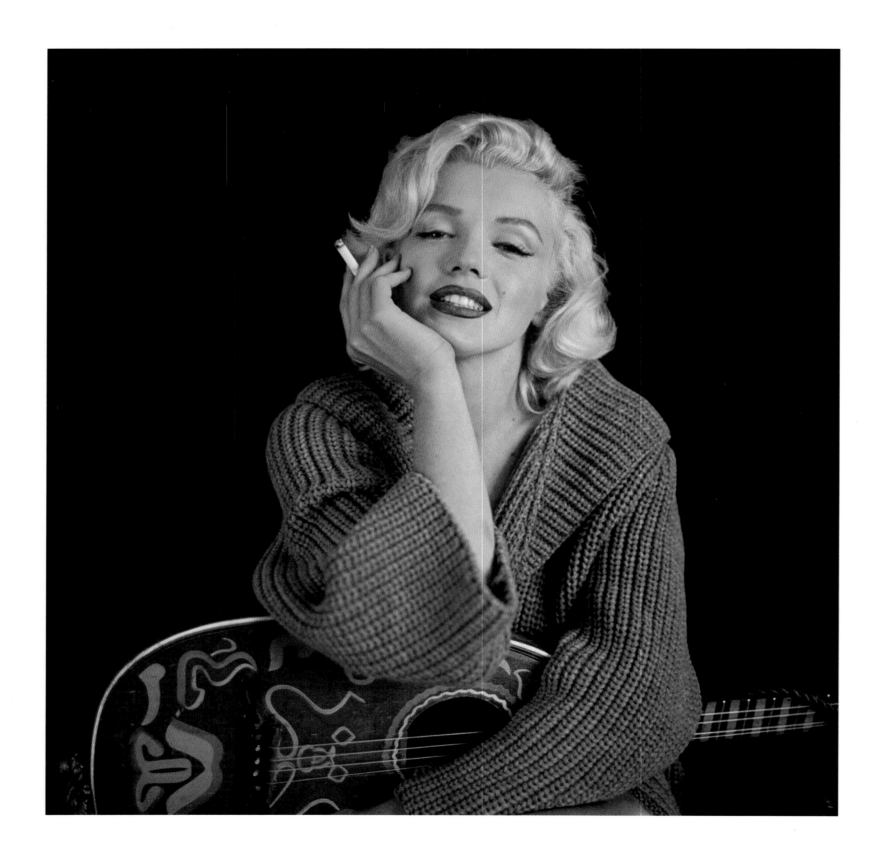

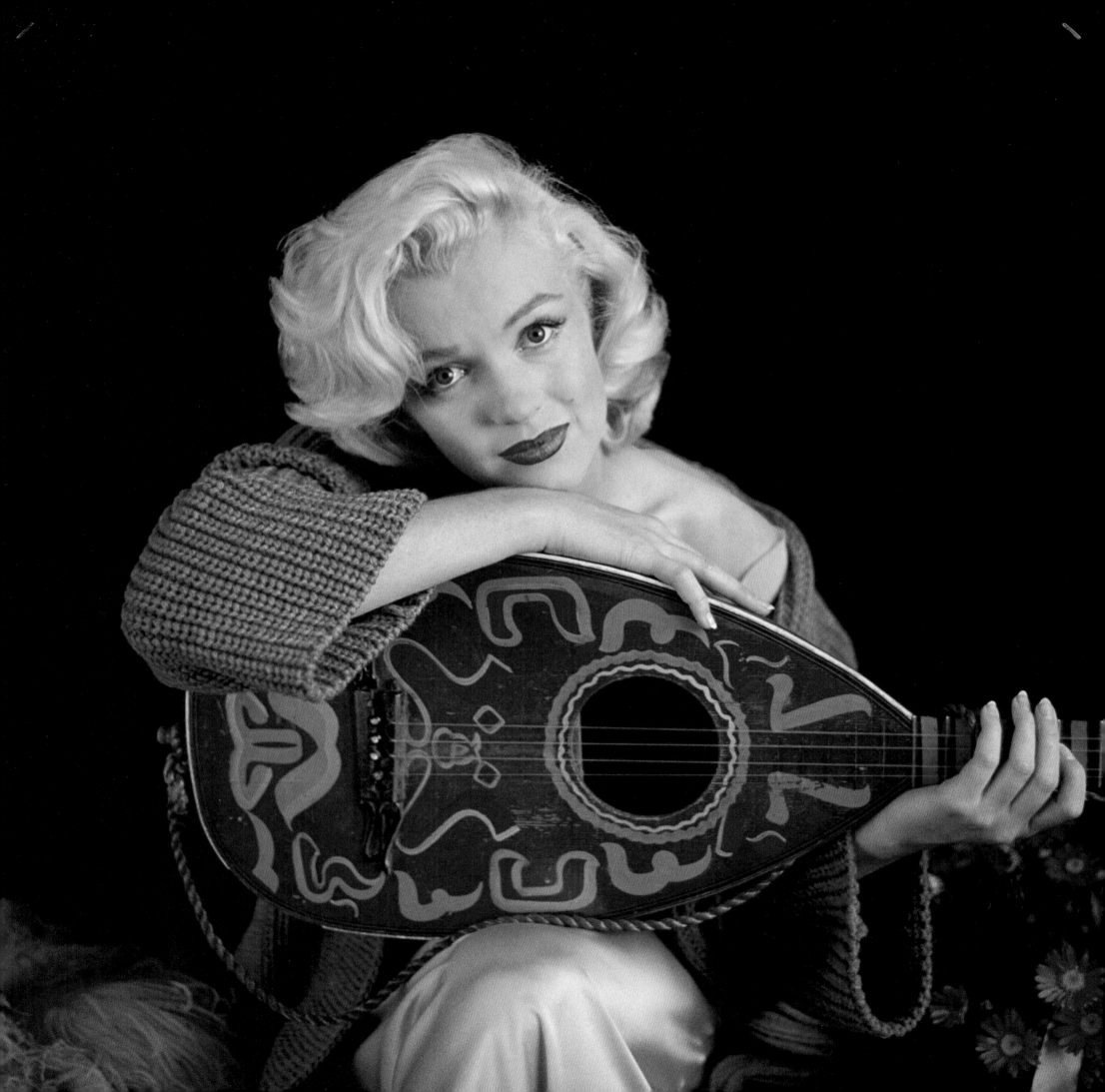

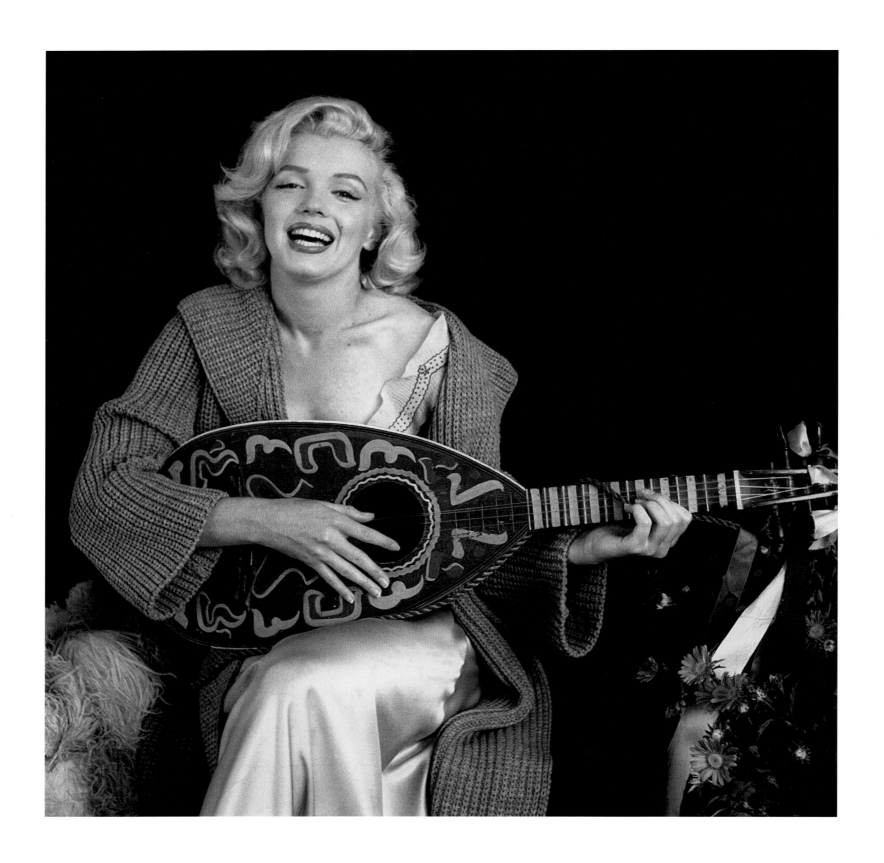

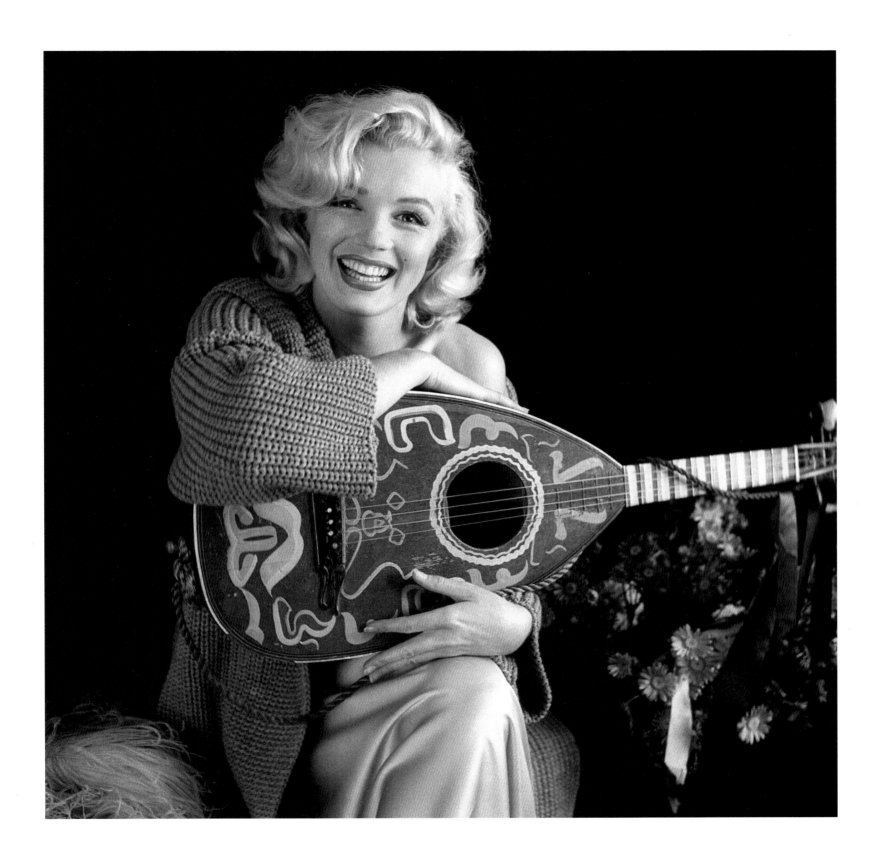

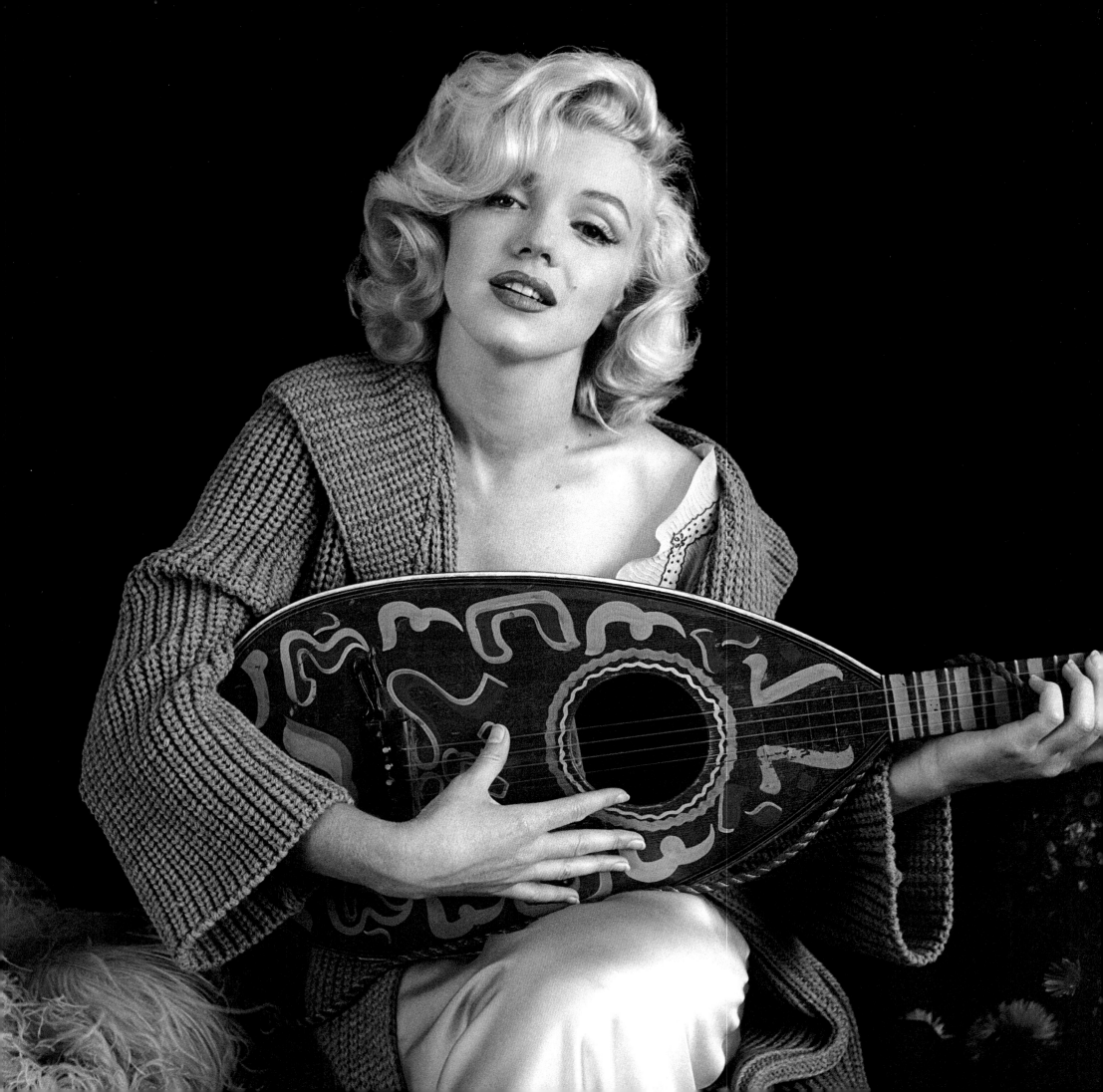

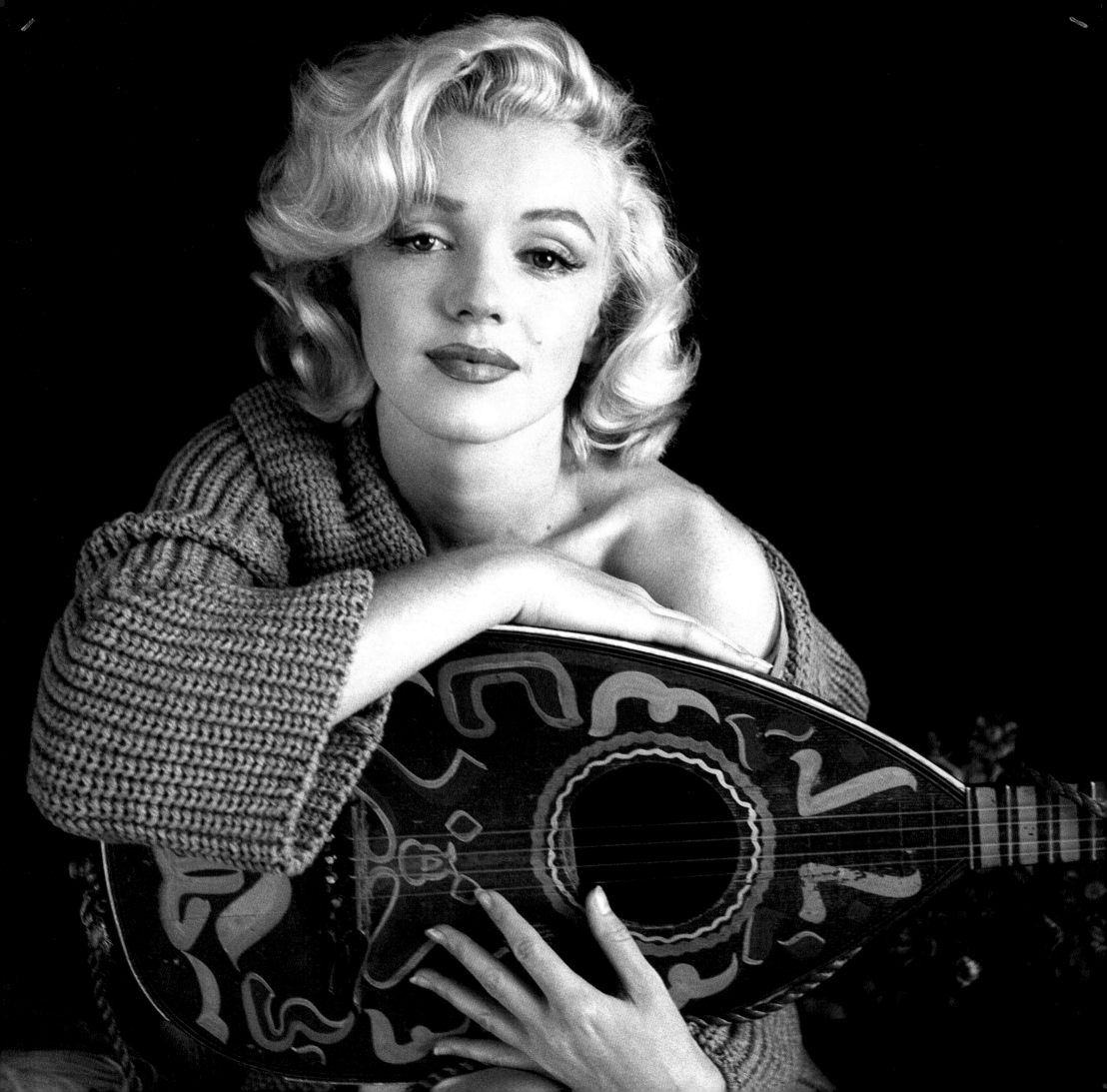

NEGLIGEE

September, 1953 – In the second ensemble from their first collaboration, Marilyn is wearing a negligee adorned with fur and a diamond bracelet. Because of her sprained ankle, most of the pictures that they did together over those three days had Marilyn sitting, kneeling or lying on the floor.

In the 1950s, when sending color and black-and-white film to be processed, it could take 24 hours to get the film back. At times, Milton would use his 35mm Nikon to capture impromptu candids for a more personal feel. Being impatient, Milton would process the 35mm film himself in the bathroom. However, in this case, he made a mistake with the temperature and underdeveloped the film. The four images on pages 26-29 and 34-35 were from that underdeveloped roll; they are more personal and natural, even though the quality has been compromised.

Unpublished images:
Pages 24L, 24R, 25L, 25R, 30, 31, 32

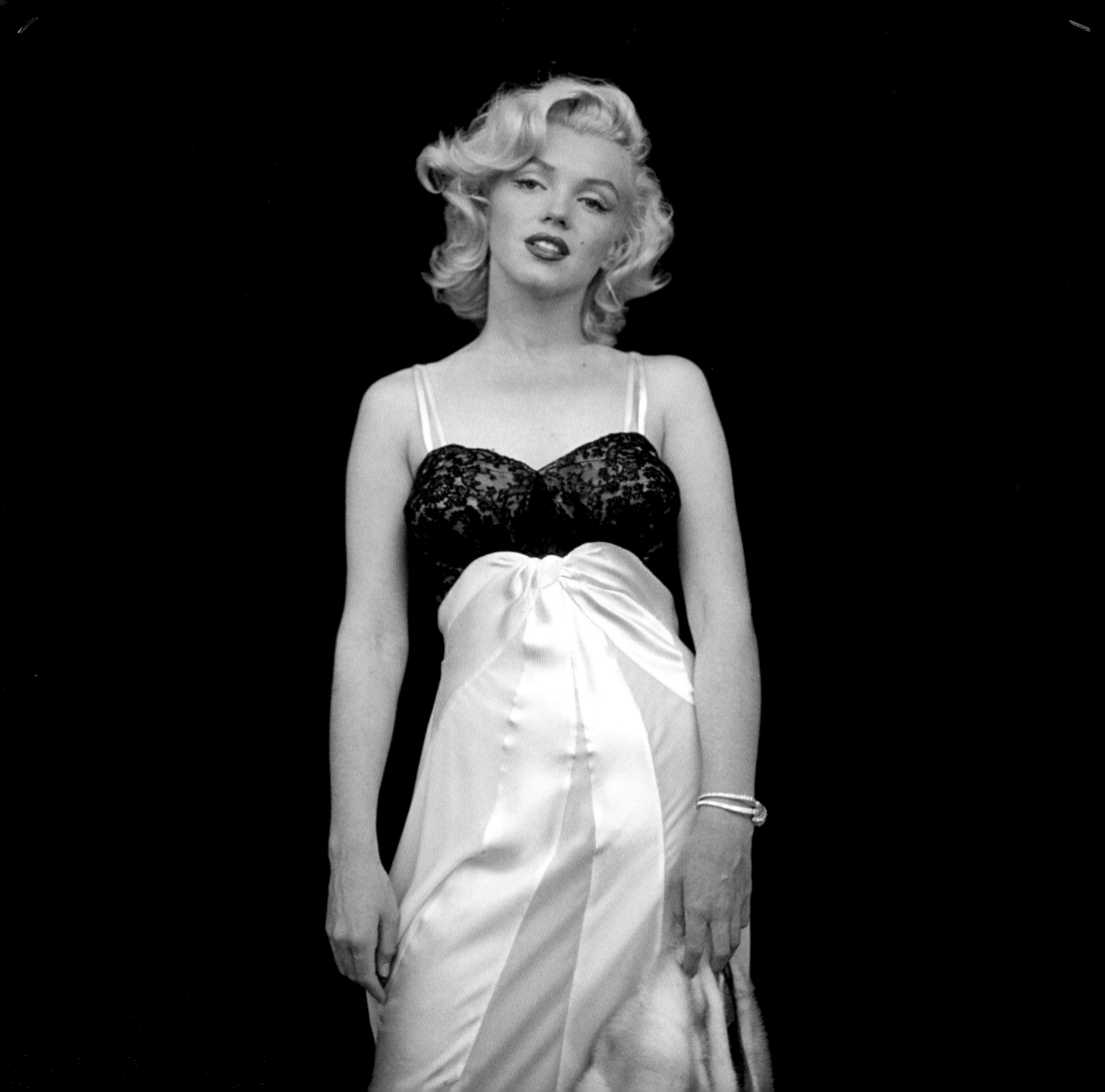

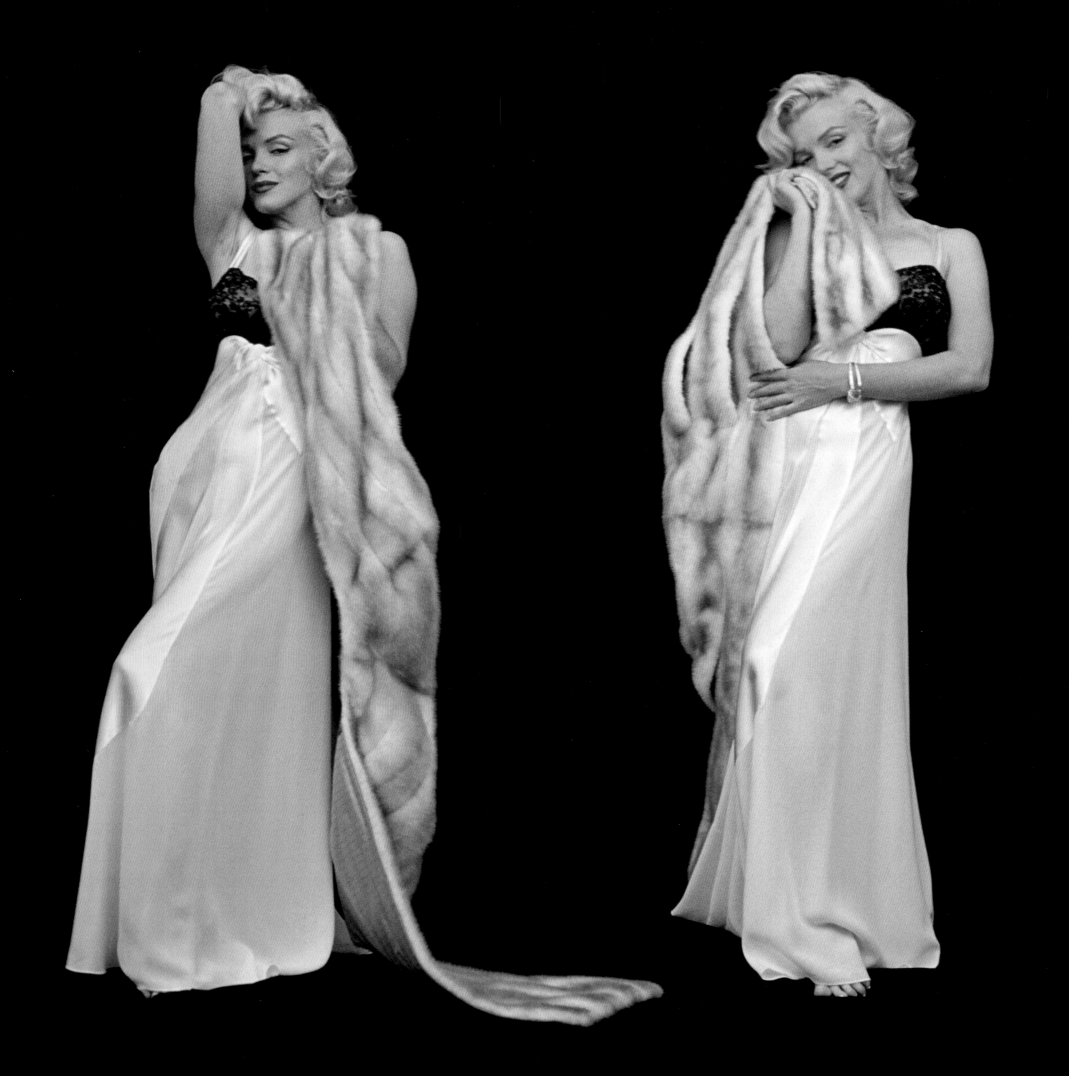

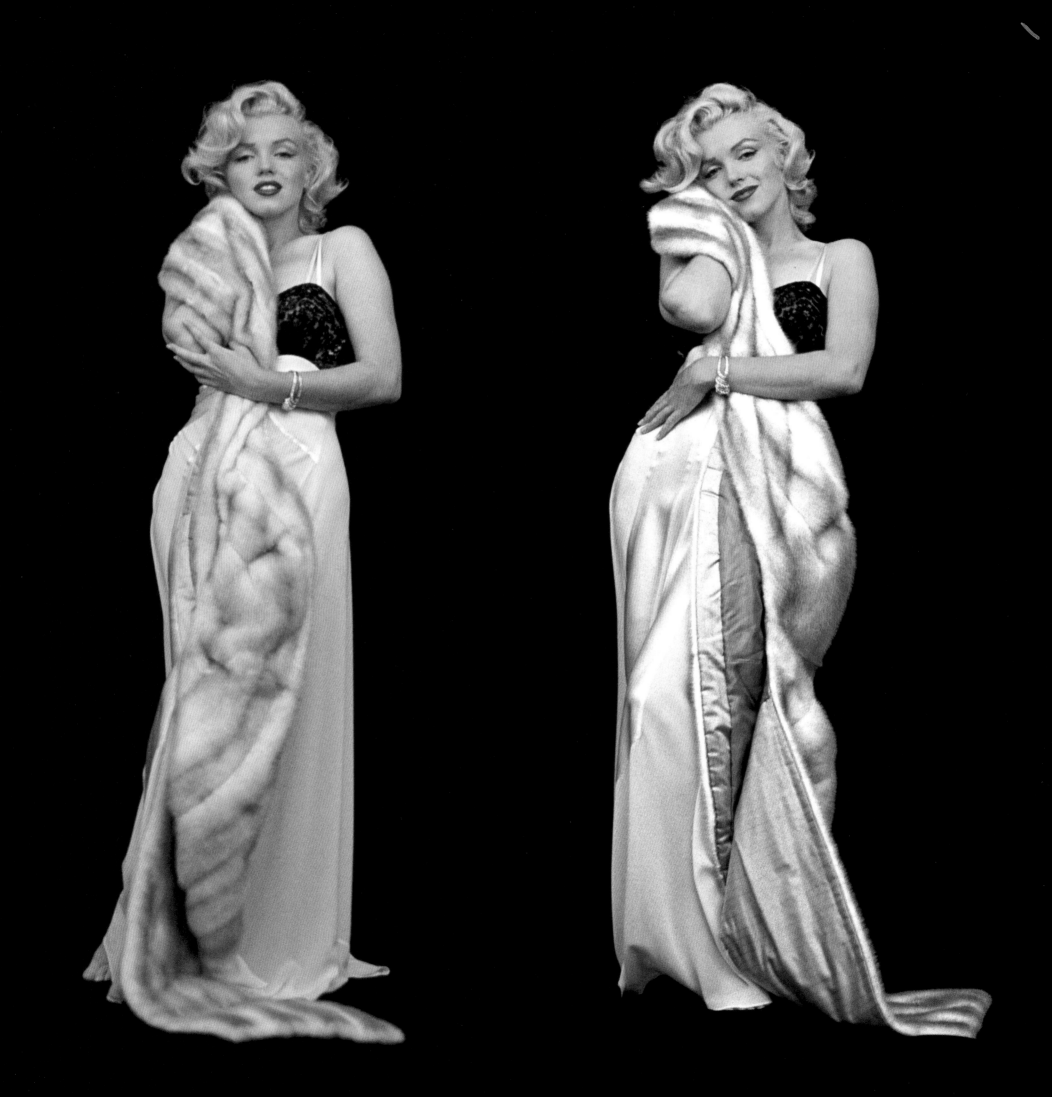

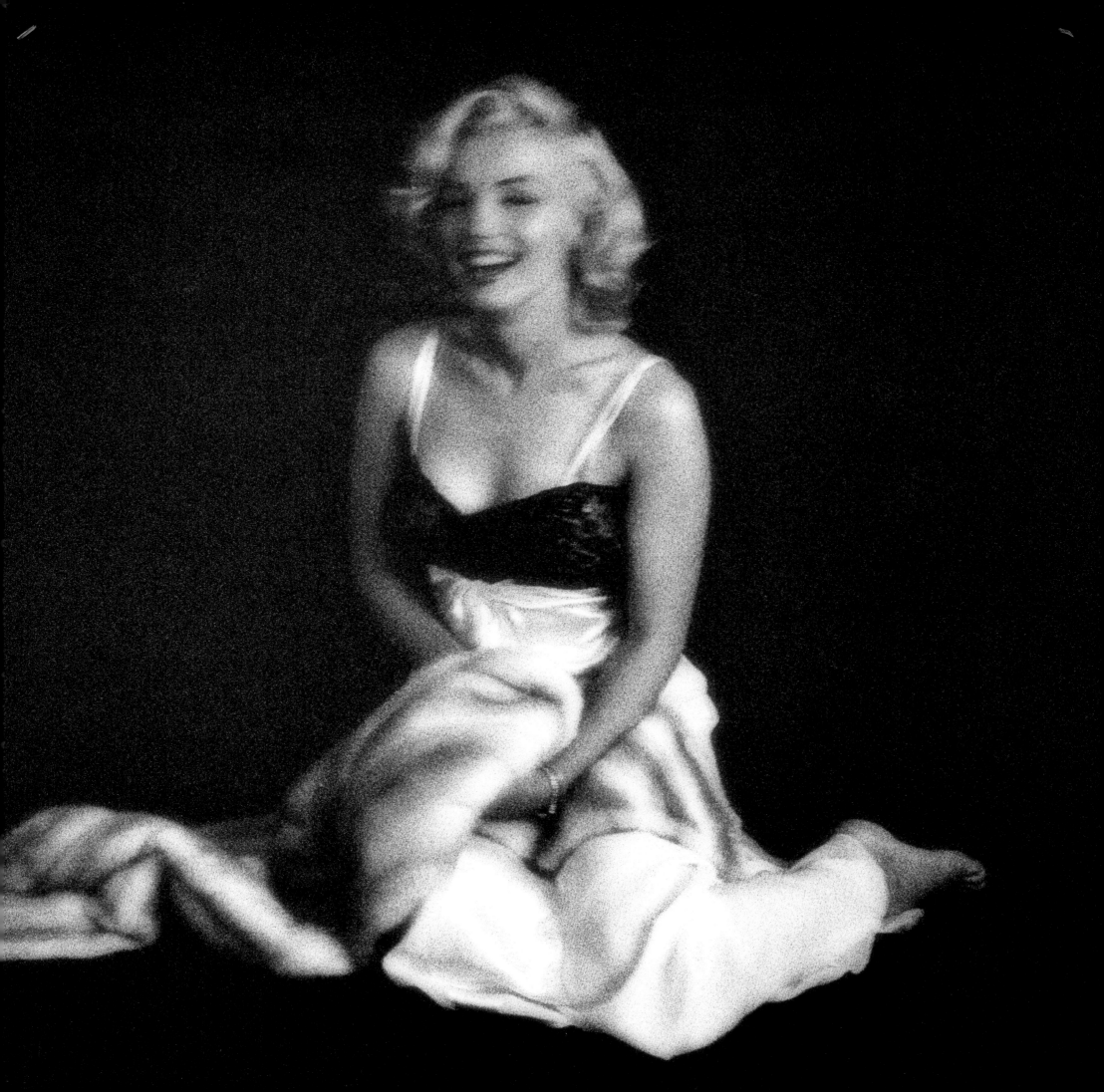

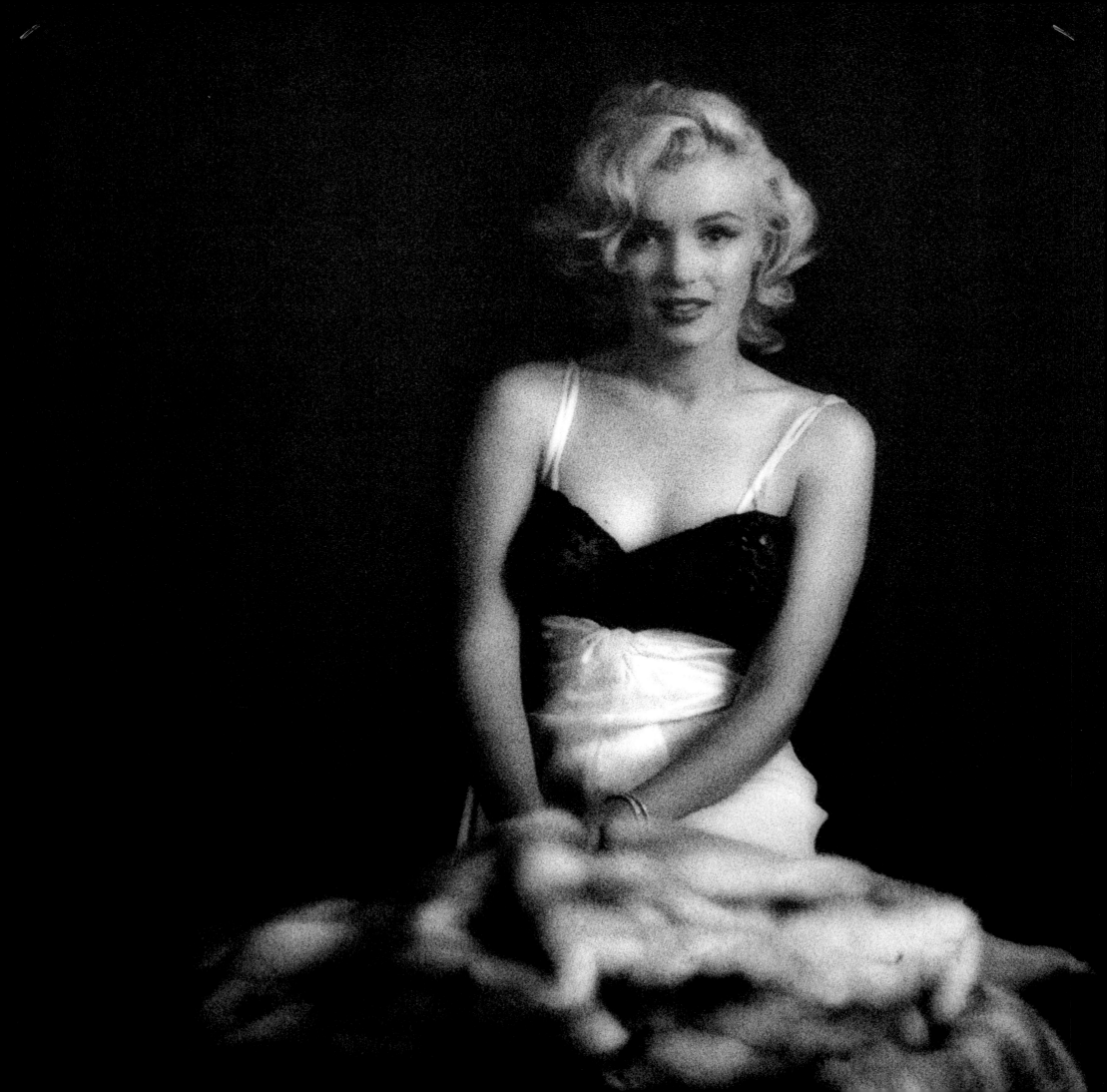

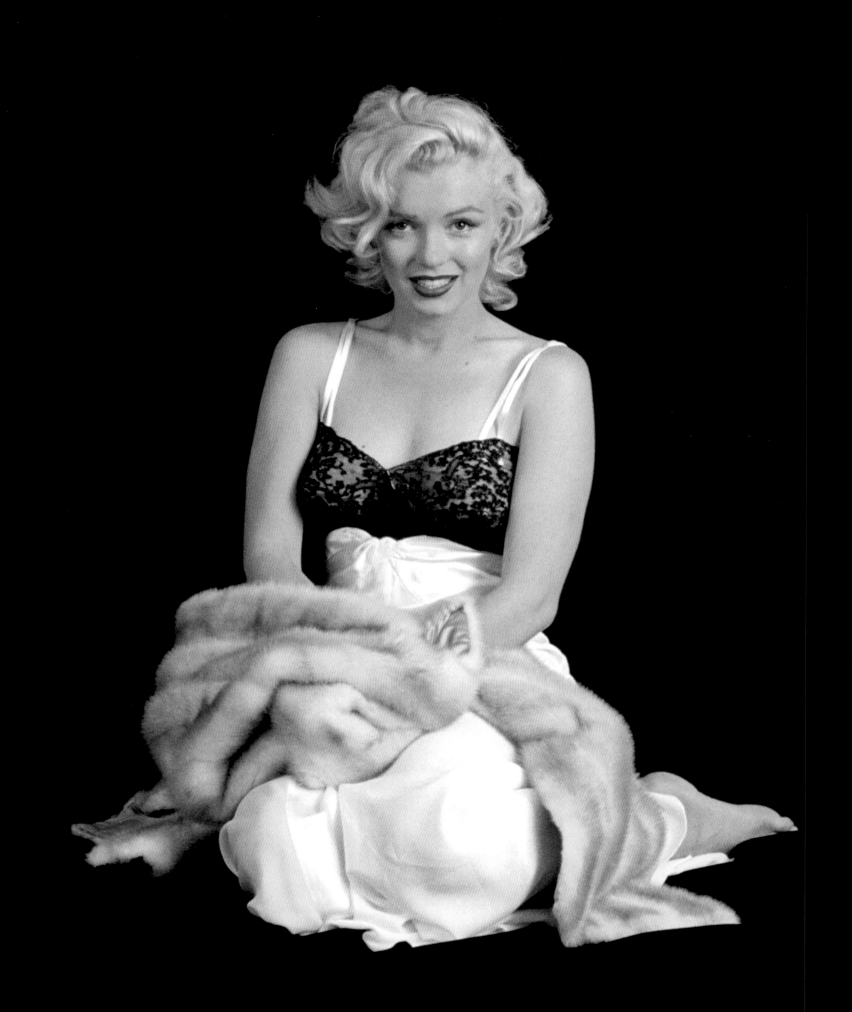

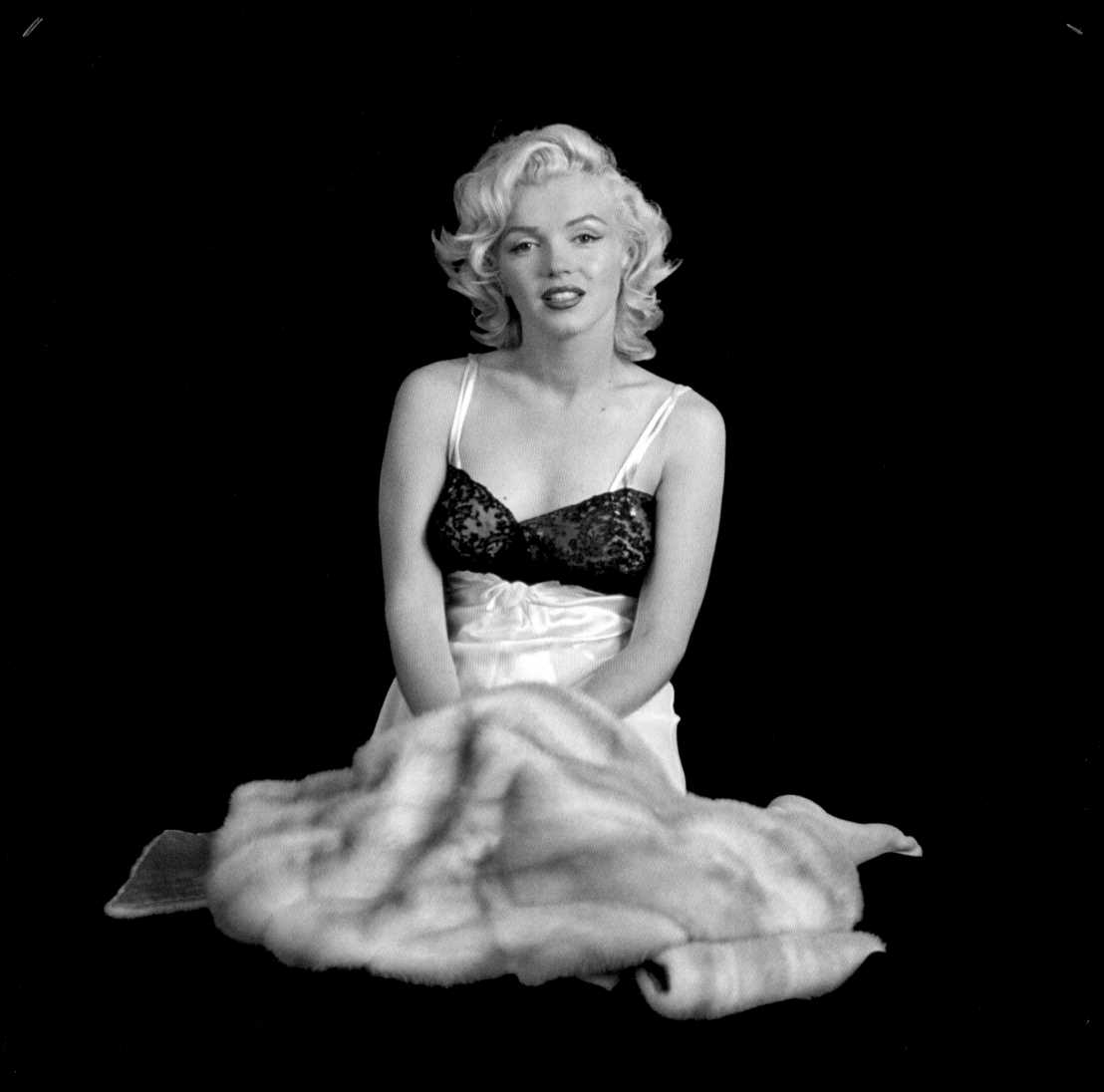

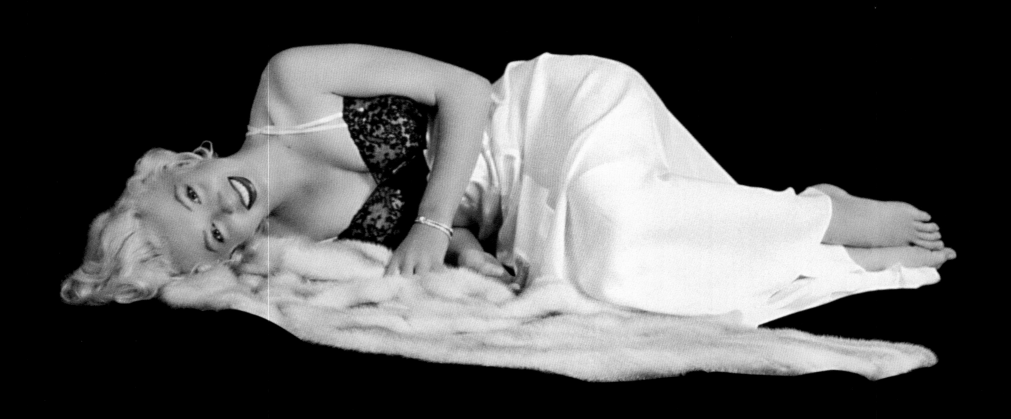

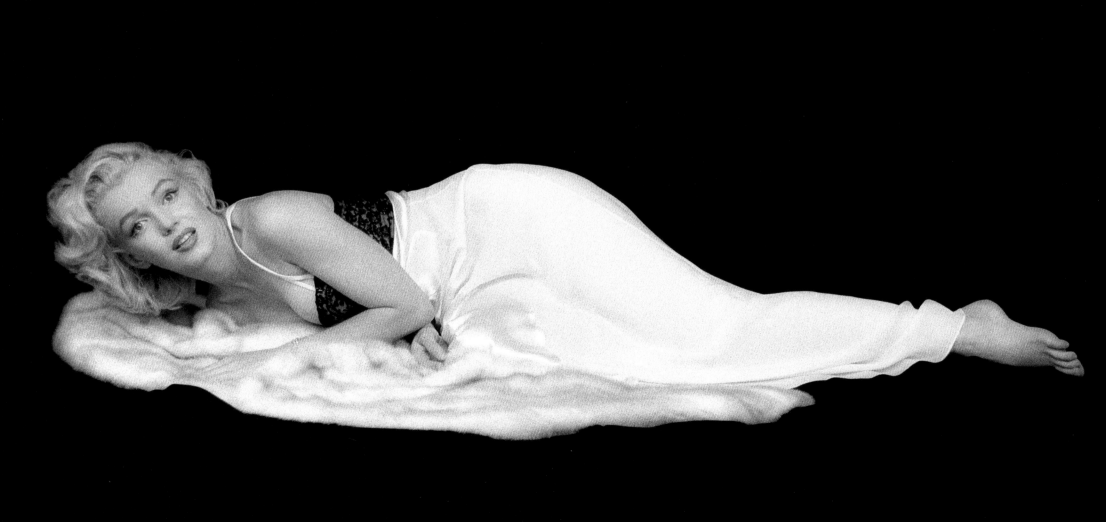

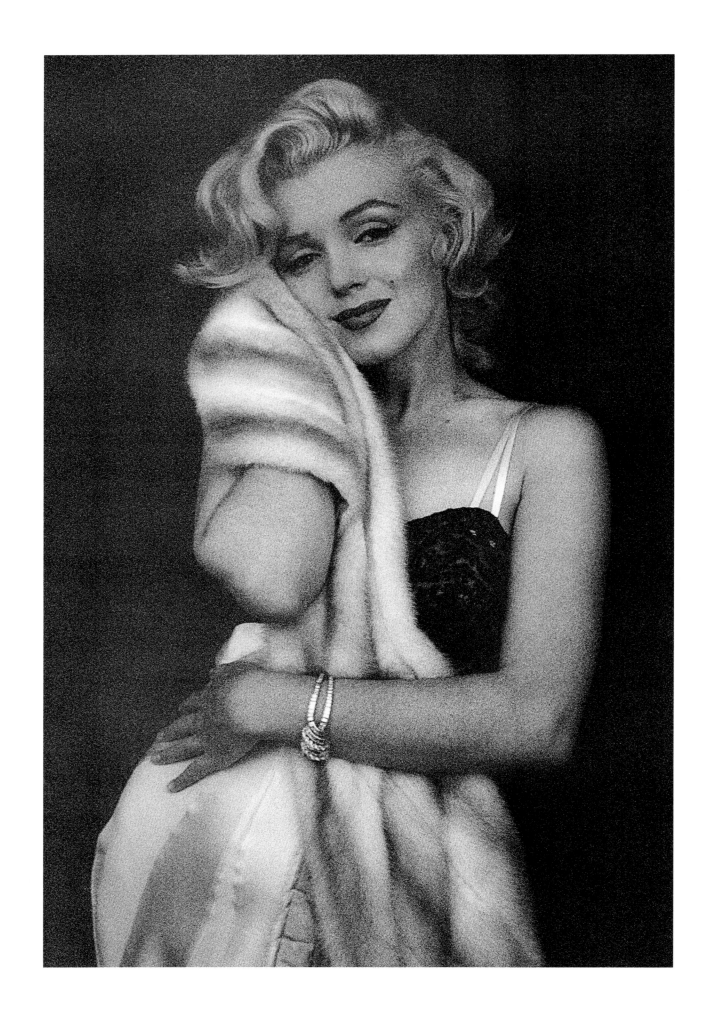

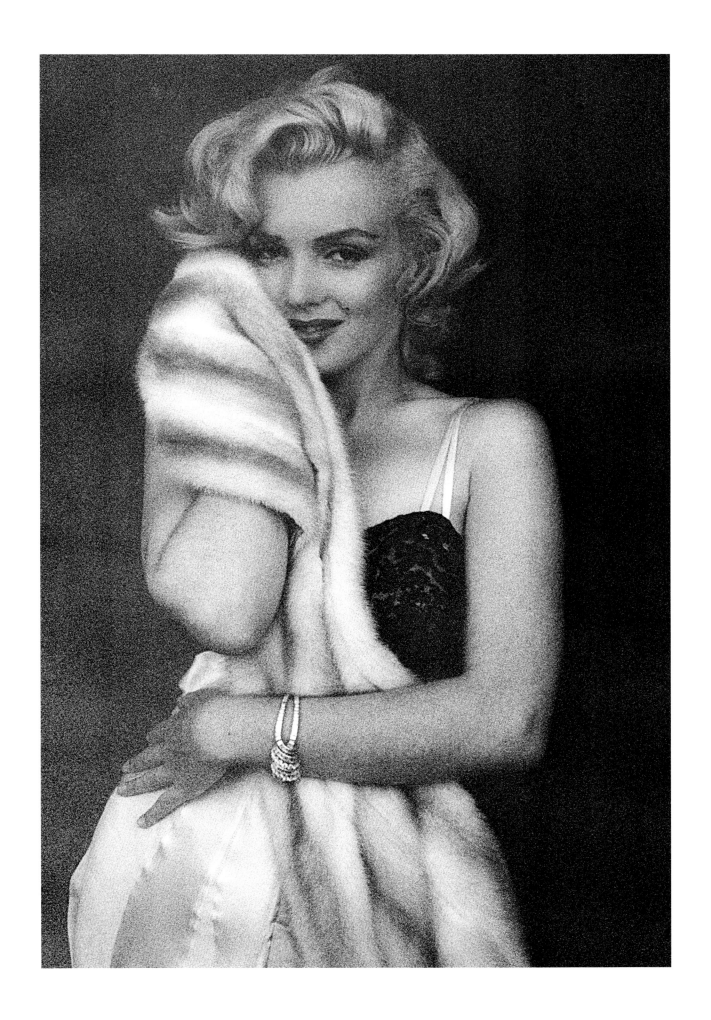

NUDE

September 1953 – Taken during their first sitting for *Look* magazine, this series was shot after the entourage from *Look* had left. Milton loved to use props in his photography. Here Marilyn is wearing one of Amy's sweater coats, a favorite of Milton's. At the time, many of these photos were considered too risqué for *Look* magazine, which ended up only publishing a few of the pictures of her sitting on the floor. Here again, notice Marilyn is sitting on the floor or kneeling, a result of the sprained ankle. On pages 39, 40 and 41, the indentation from wearing an Ace bandage is visible above her left ankle.

Unpublished images:
Pages 38, 39, 40, 43

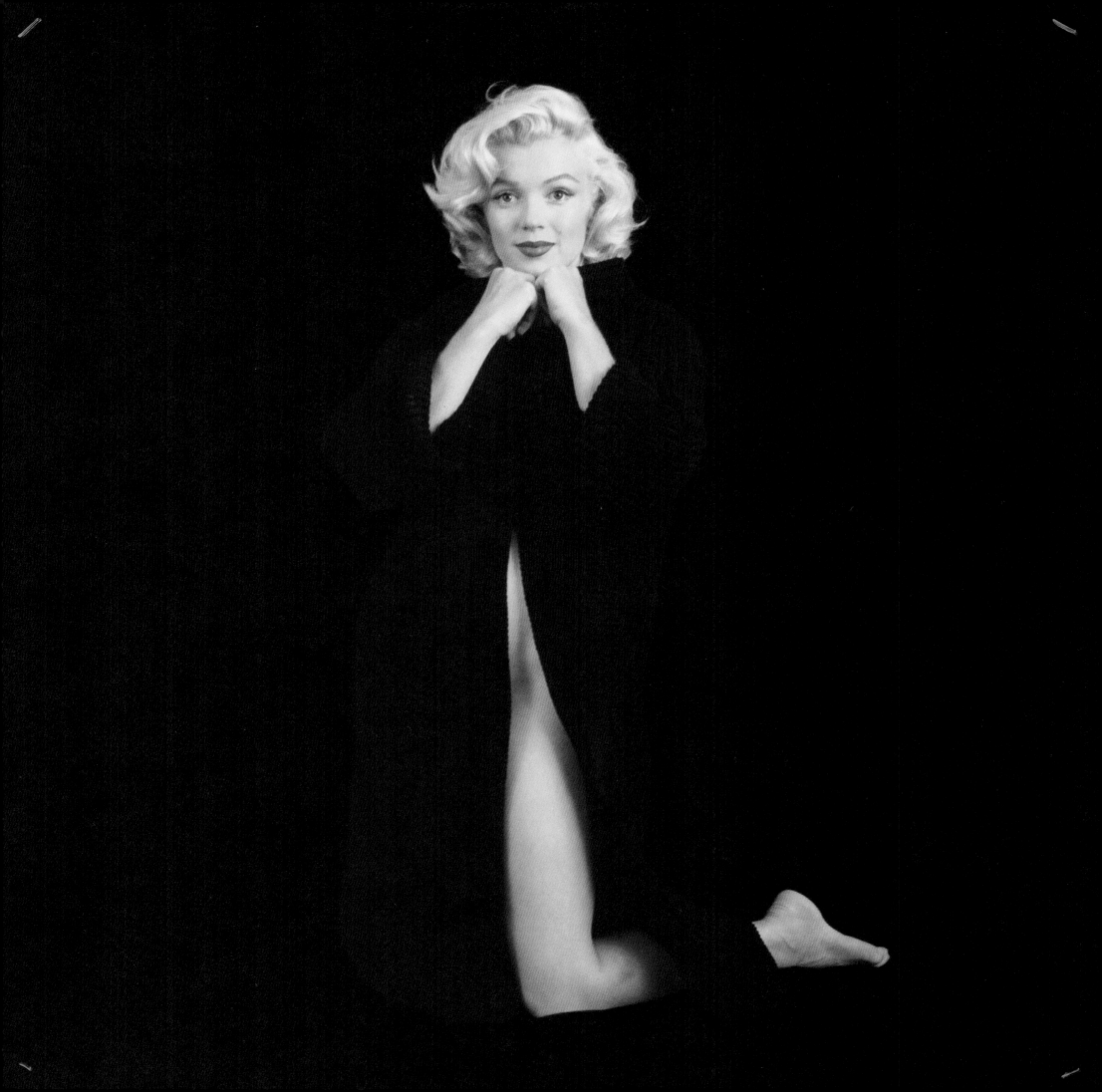

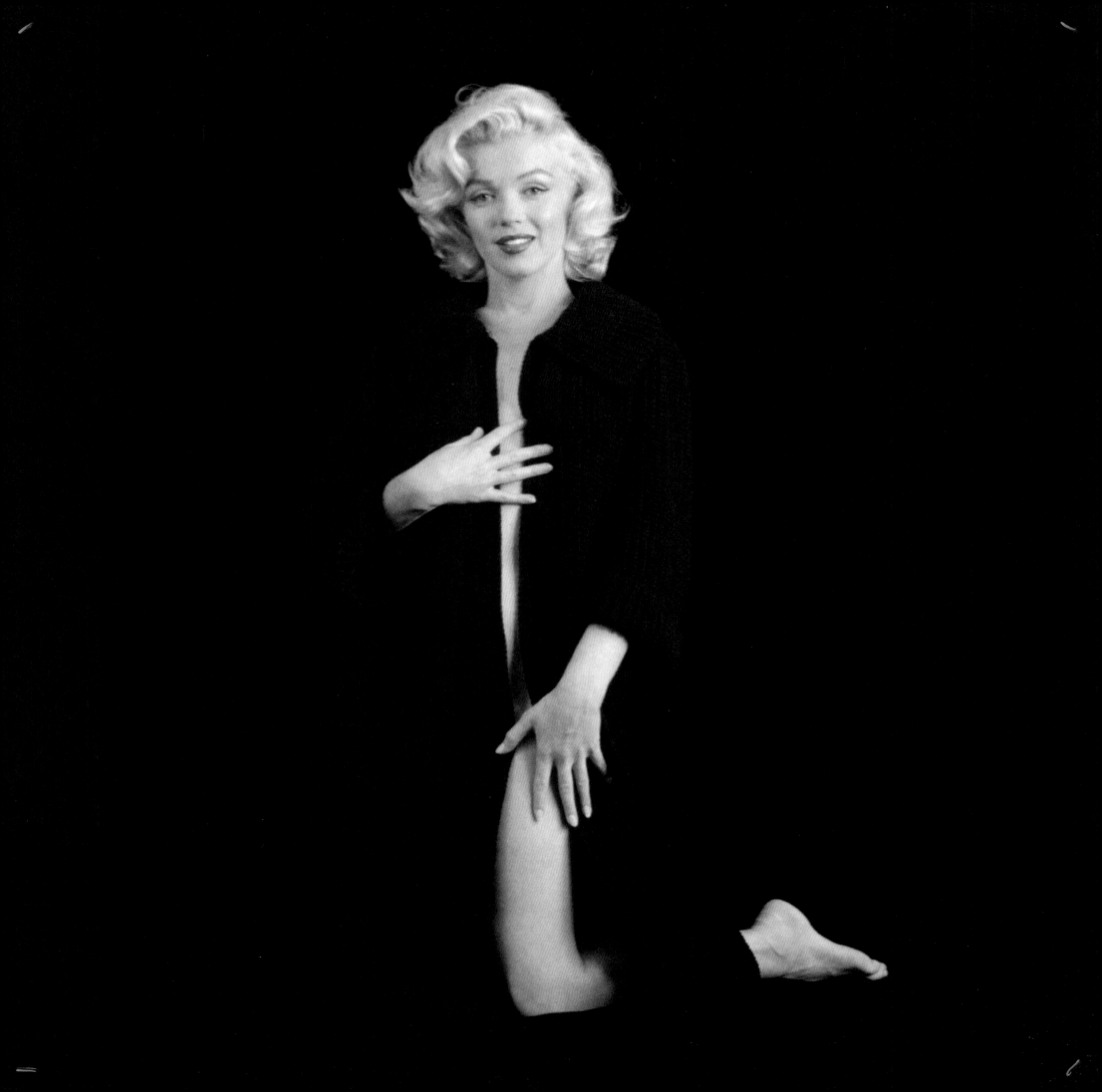

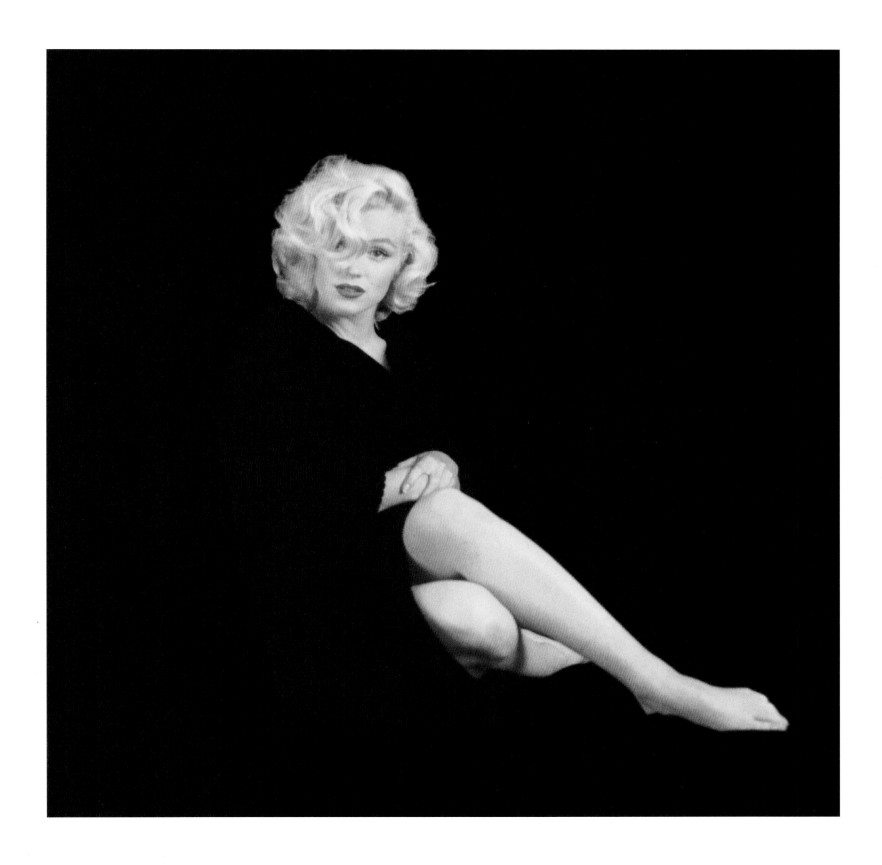

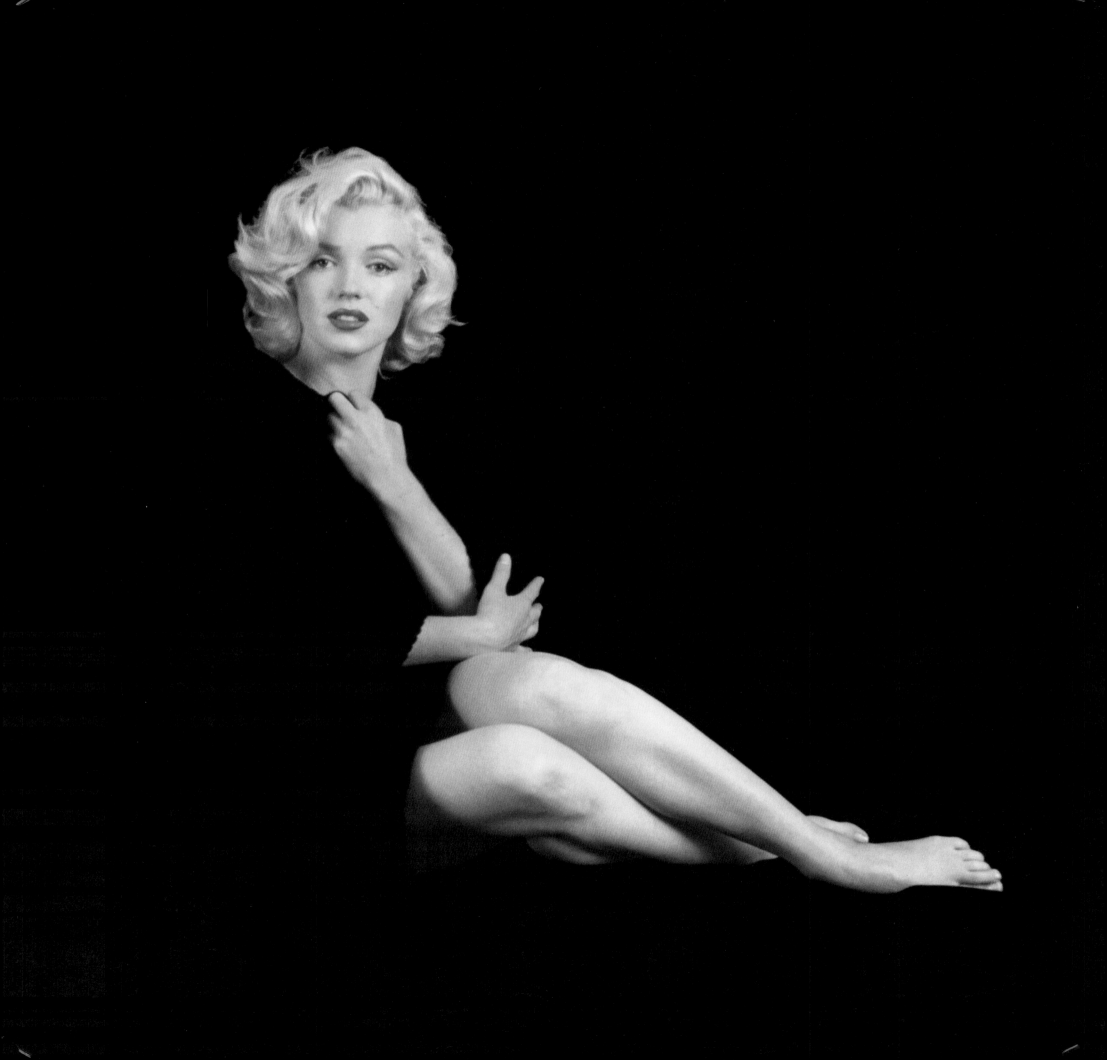

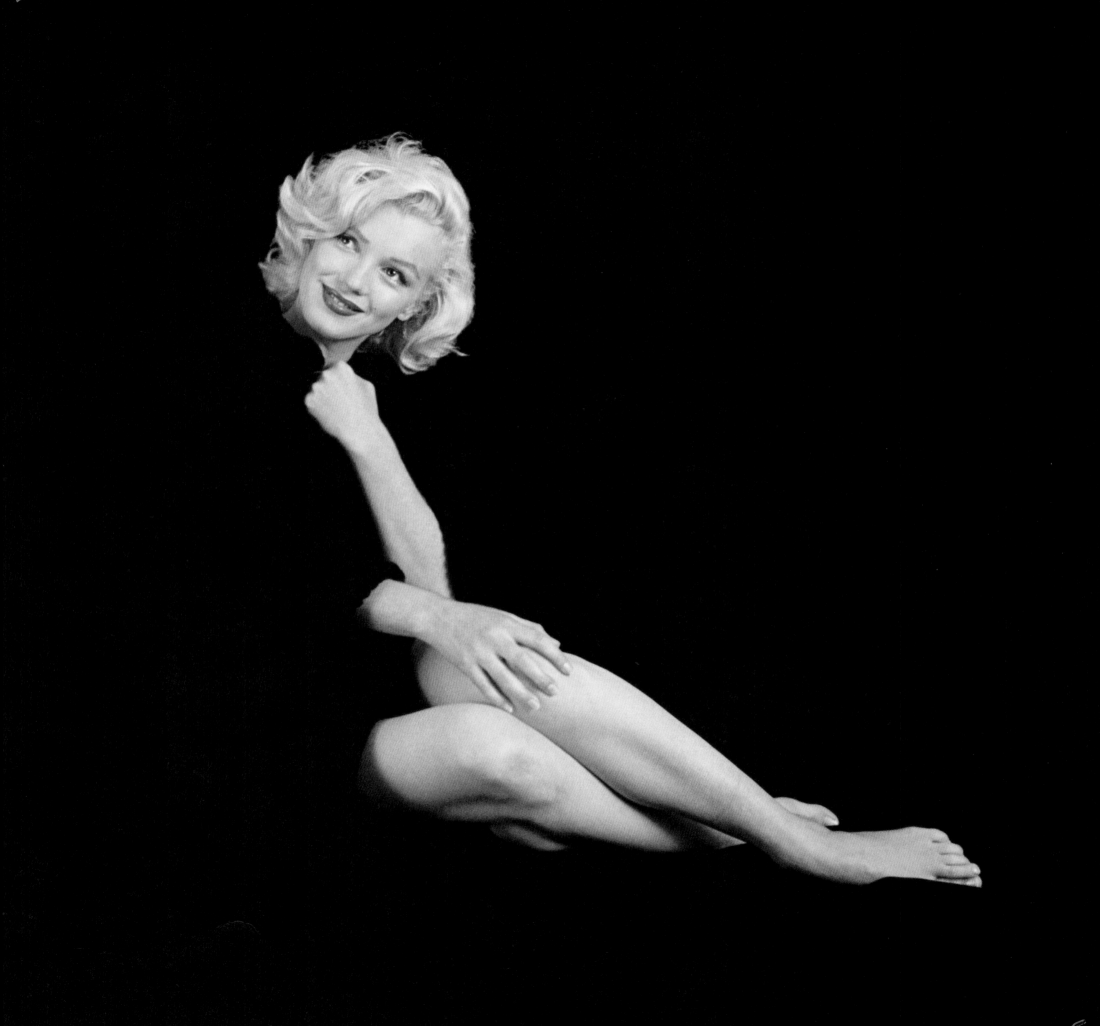

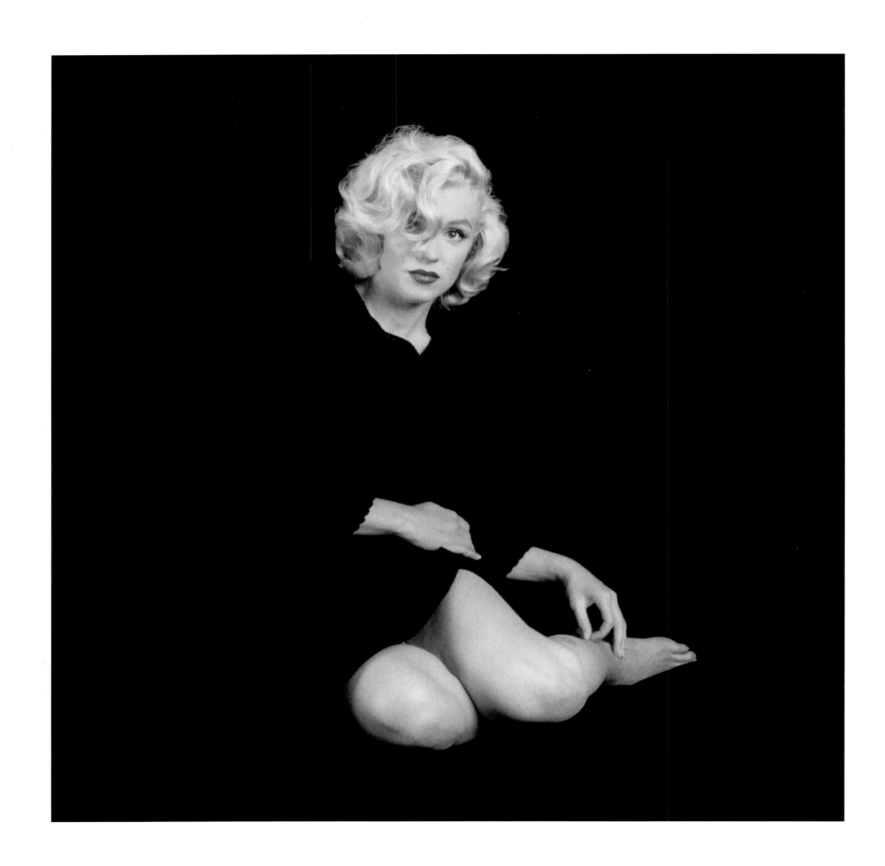

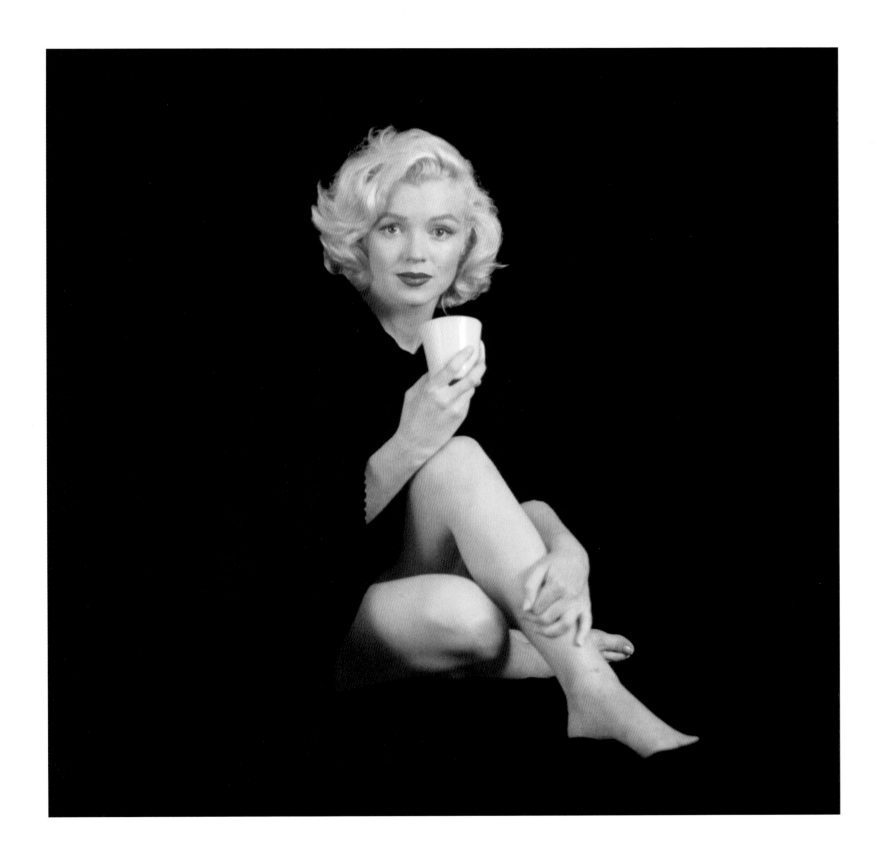

TREE

September, 1953 – The next day, Milton picked up Marilyn
to have lunch and later, to review the pictures afterwards.
On the way to lunch, Milton, who loved trees, spotted the
perfect setting. This series of pictures was taken with Marilyn
wearing her own clothing. Their friendship blossoming,
Marilyn confided in Milton about her dissatisfaction with
her studio "slave" contract.

Unpublished image:
Page 46

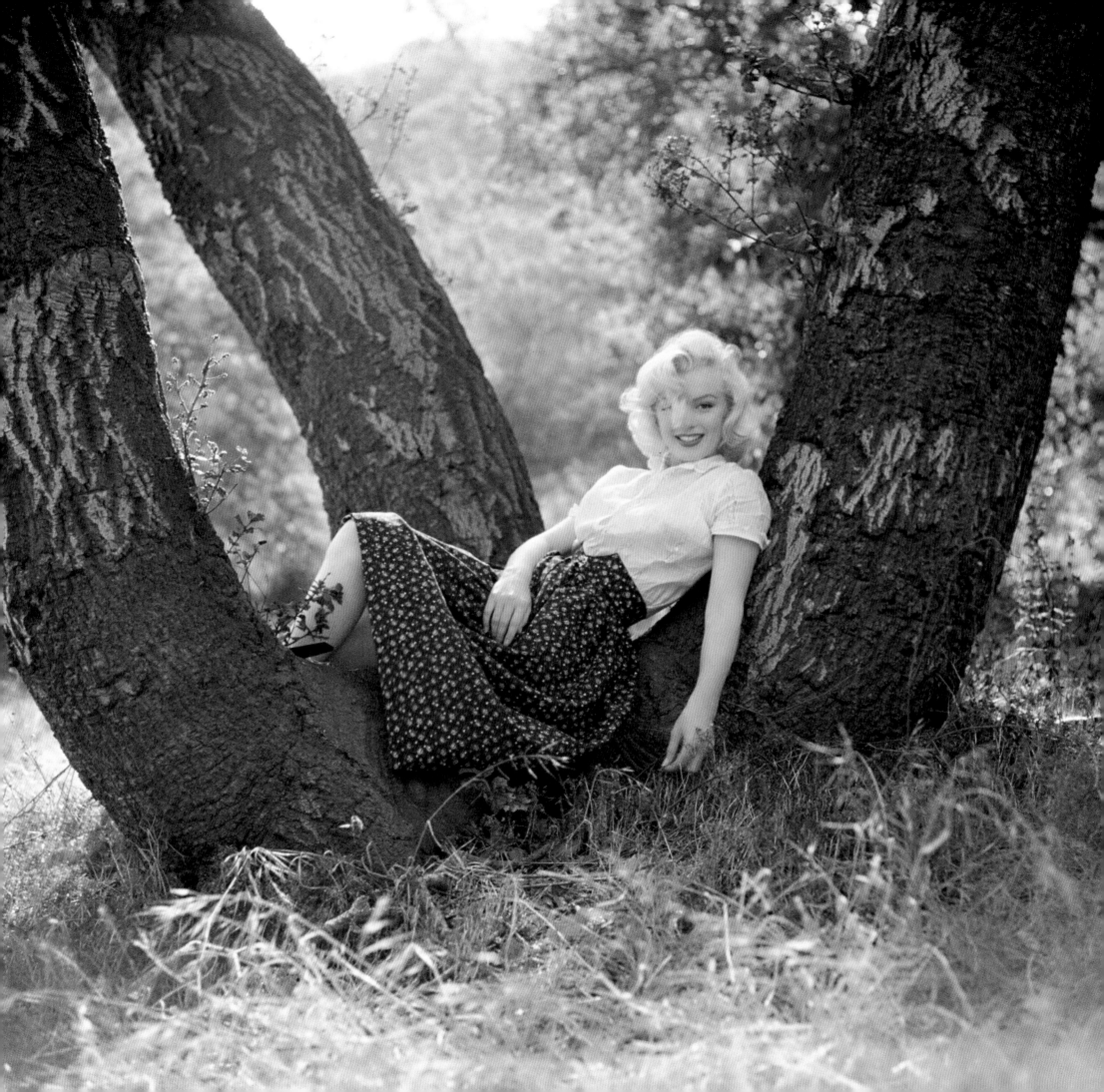

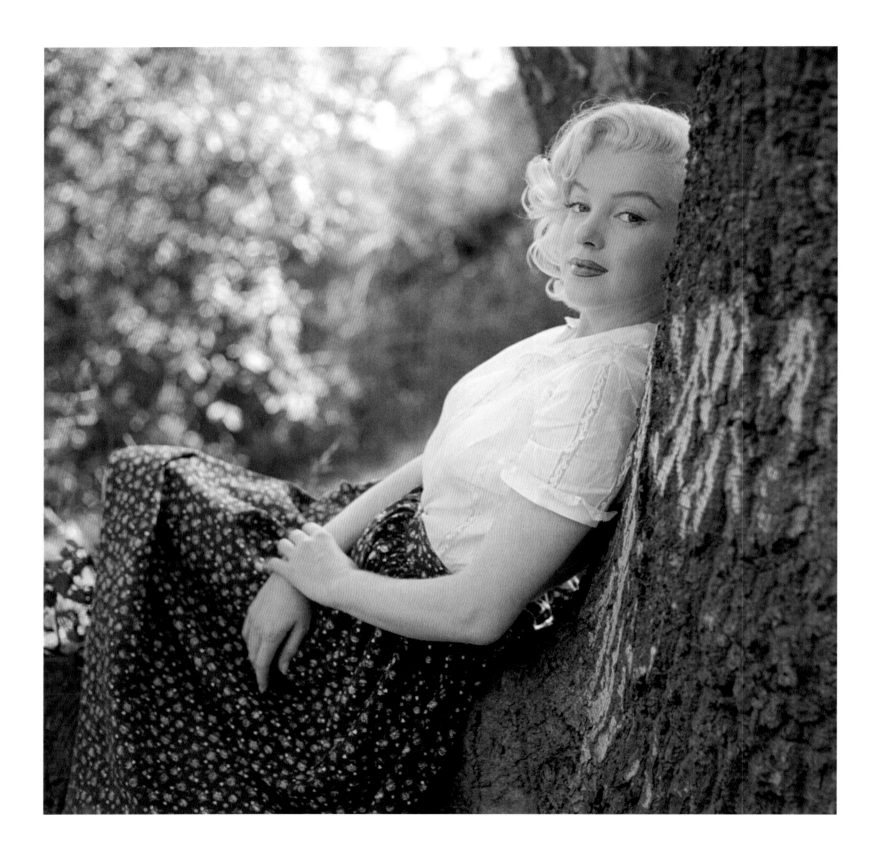

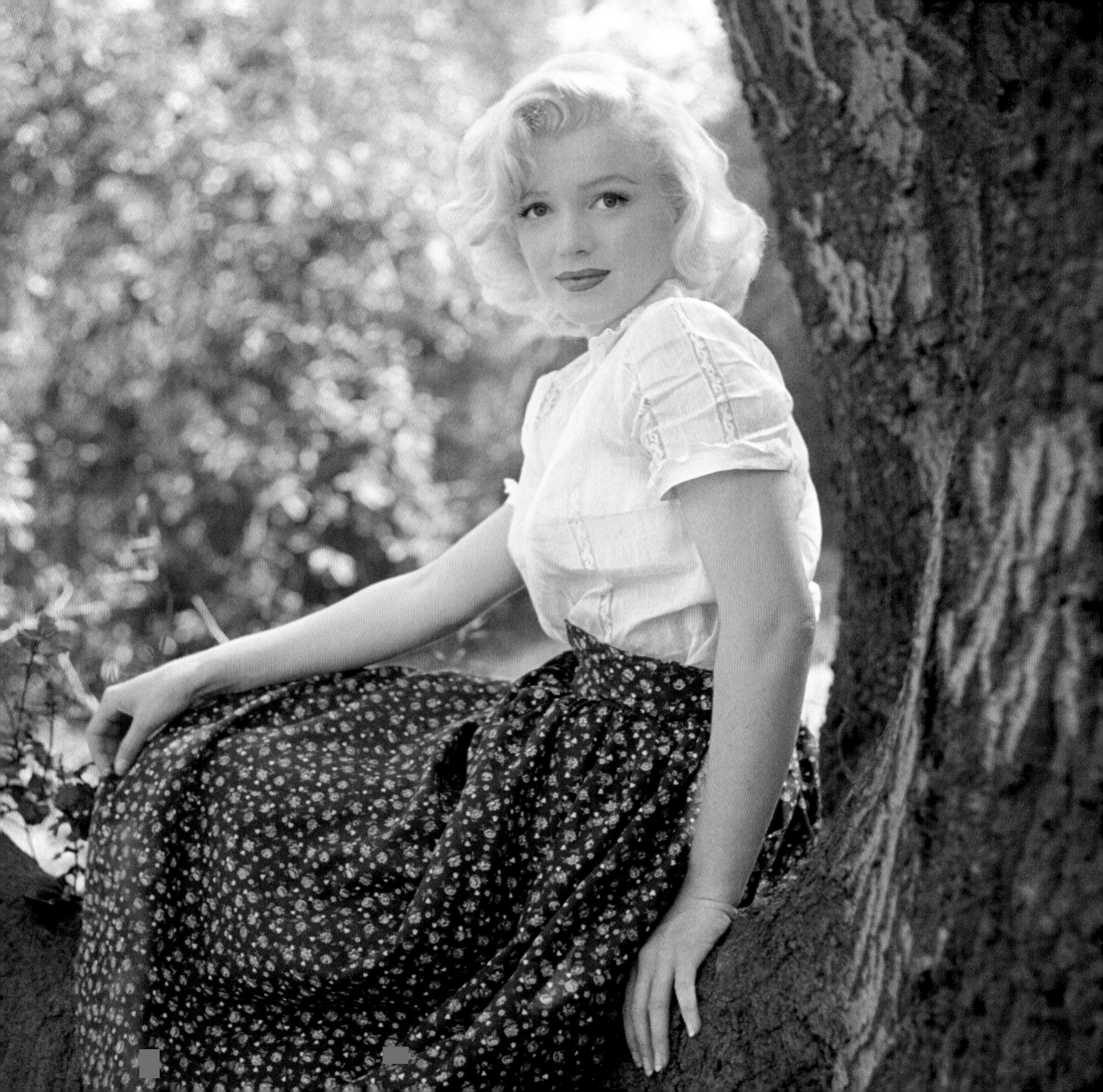

CANDIDS

September, 1953 – This series of candid photos was taken during that first collaboration. Notice the bandage around her left ankle from the *River of No Return* injury. Marilyn loved this cashmere coat by Dior and kept it for the rest of her life, making it a staple of her personal wardrobe.

Unpublished images:
Pages 49, 50, 51, 52

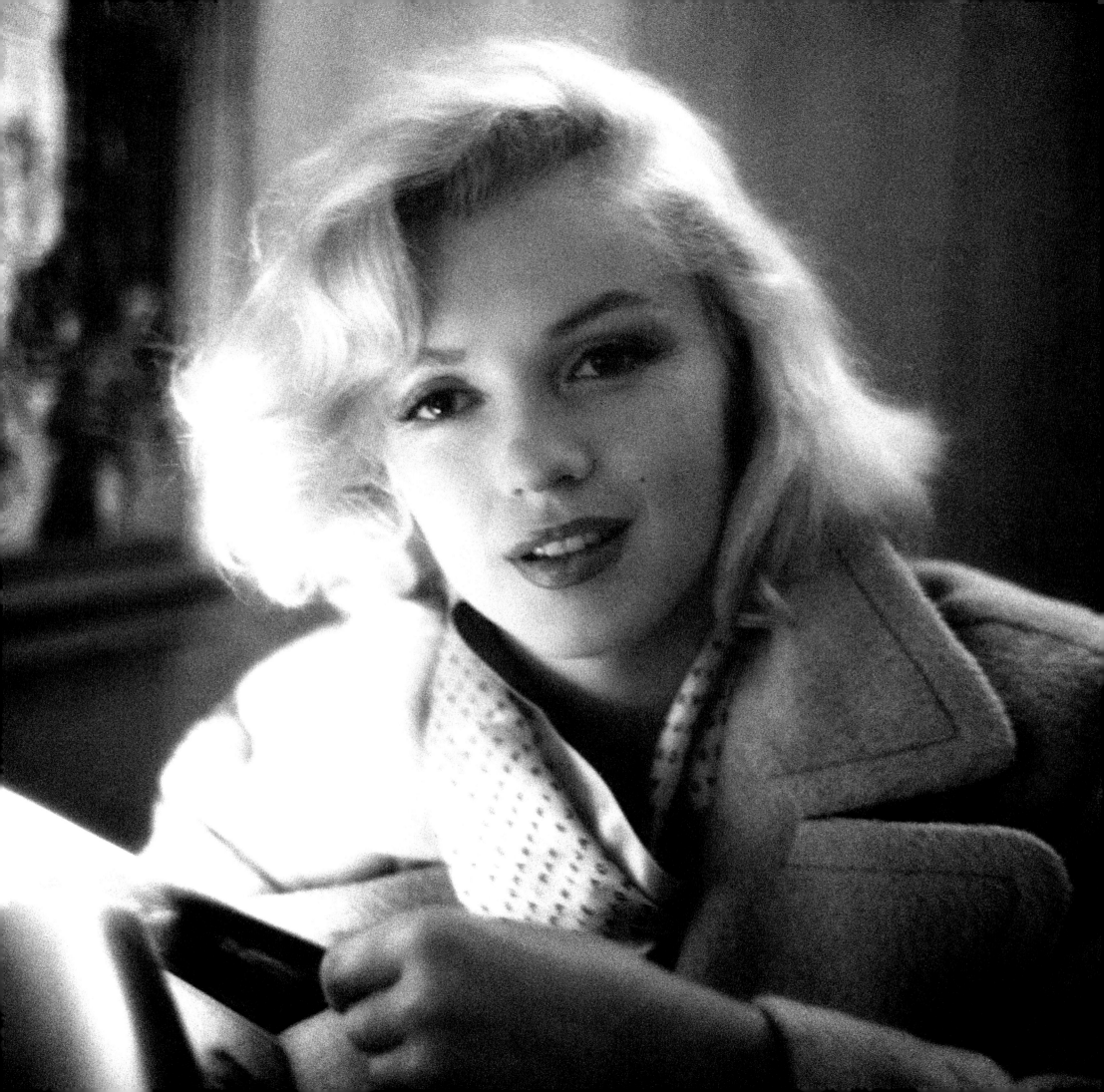

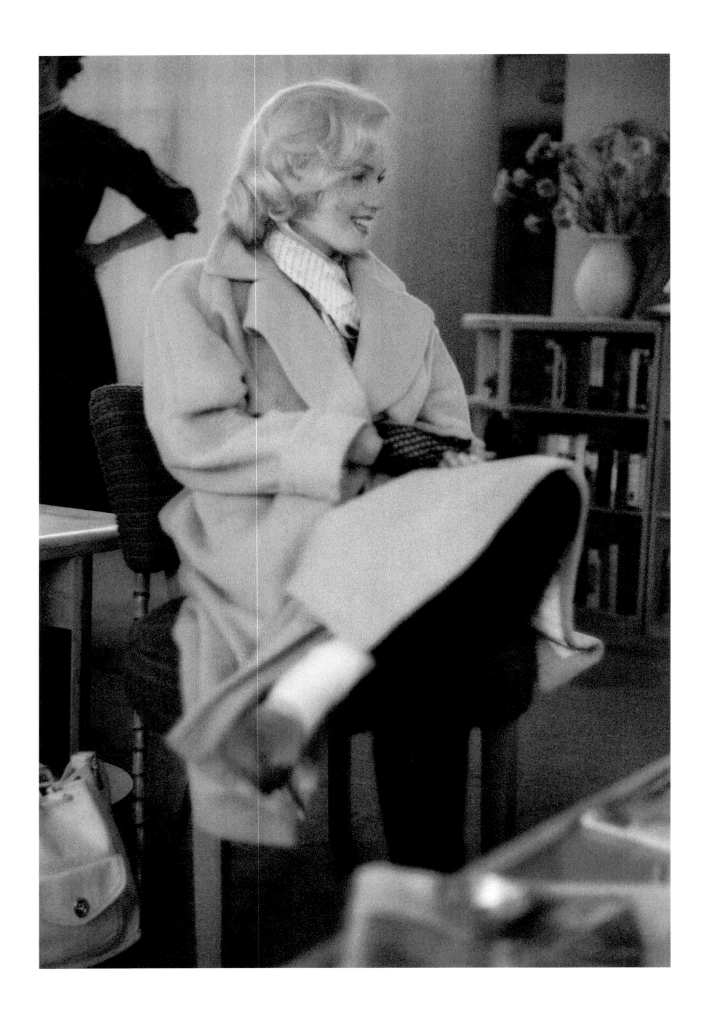

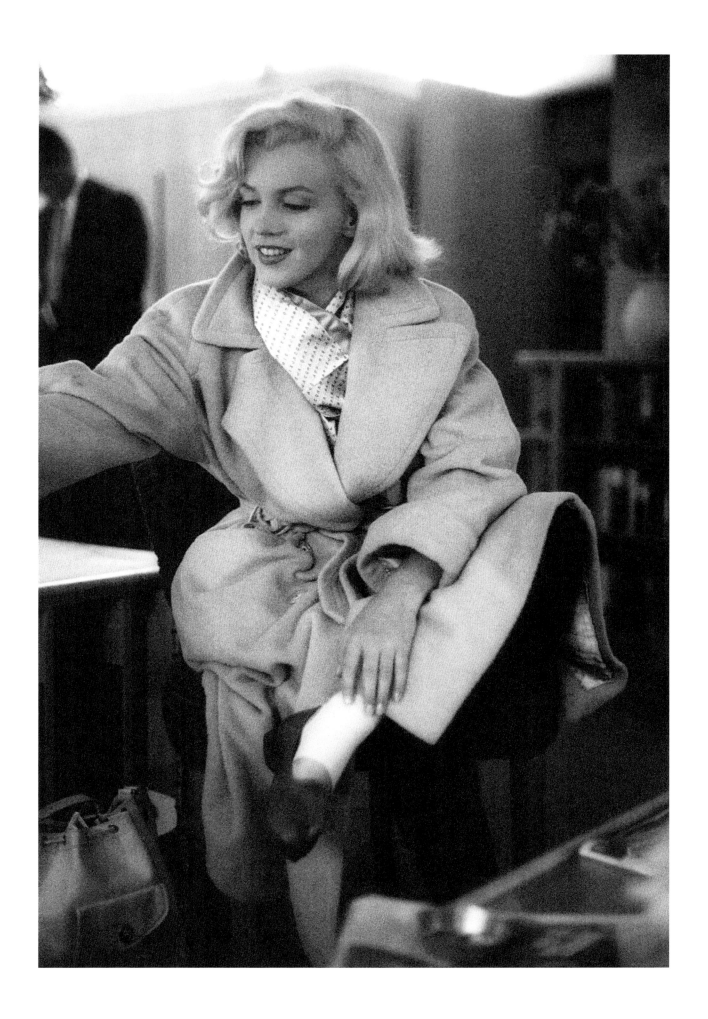

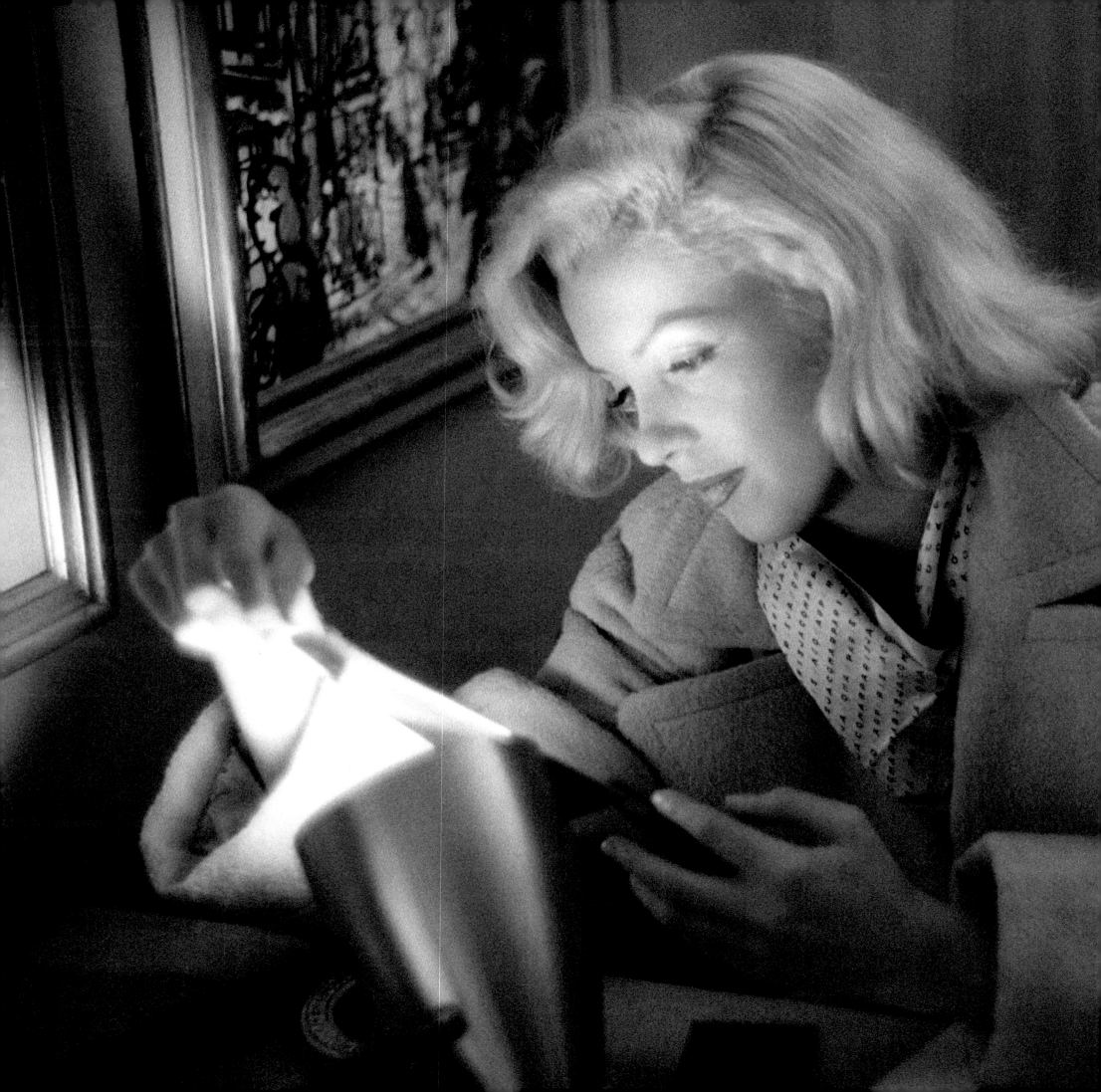

SCHENK HOUSE

October 1953 – Joseph Schenk was partners with
Darryl F. Zanuck, together creating 20th Century Fox.
After being convicted and serving time for tax evasion,
Schenk returned to 20th Century Fox and mentored a young,
up-and-coming Marilyn Monroe. Schenk remained
Marilyn's benefactor, but was unable to convince Zanuck
to give her more roles of substance. This reality only fueled
Marilyn's desire to be free of Fox. During one Fall
weekend, Schenk allowed Milton and Marilyn to stay at the
guest villa of his Beverly Hills estate.

Unpublished images:
Pages 55, 56, 57, 58, 60, 61, 62

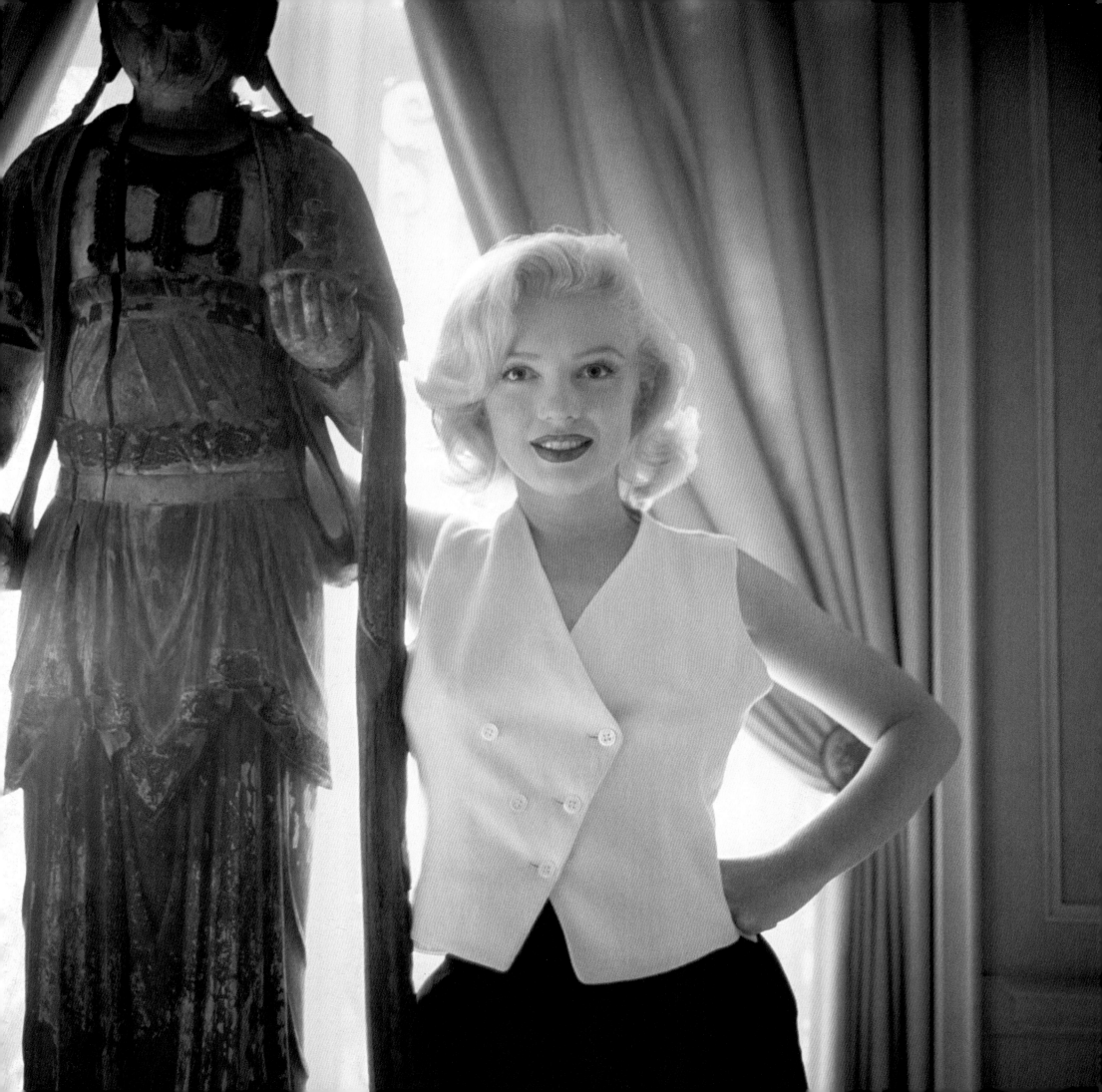

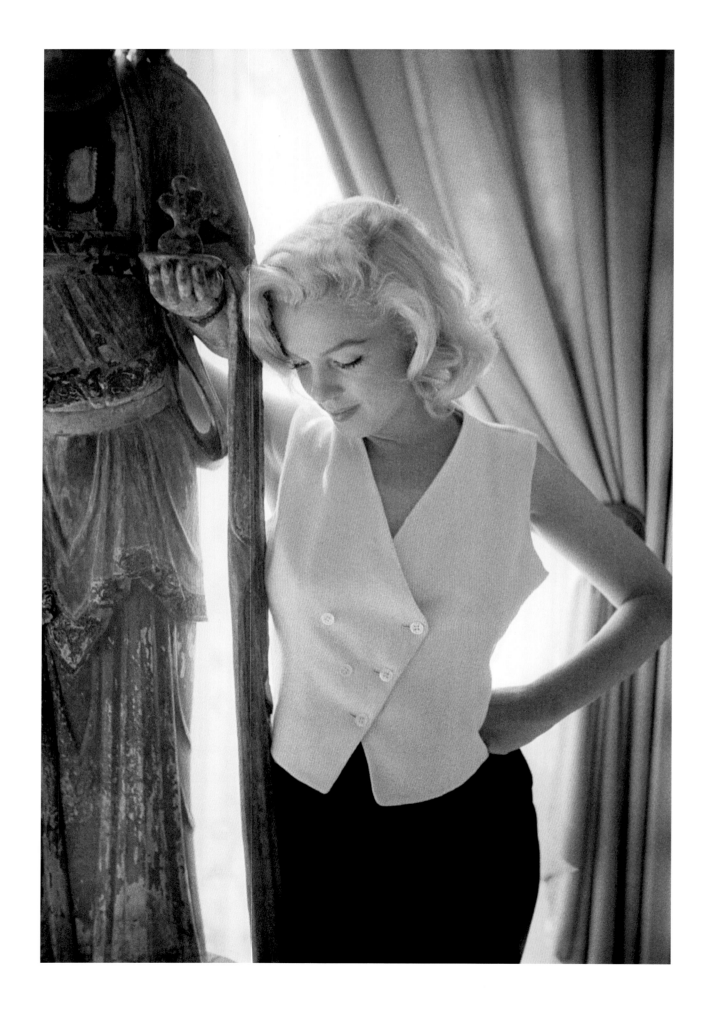

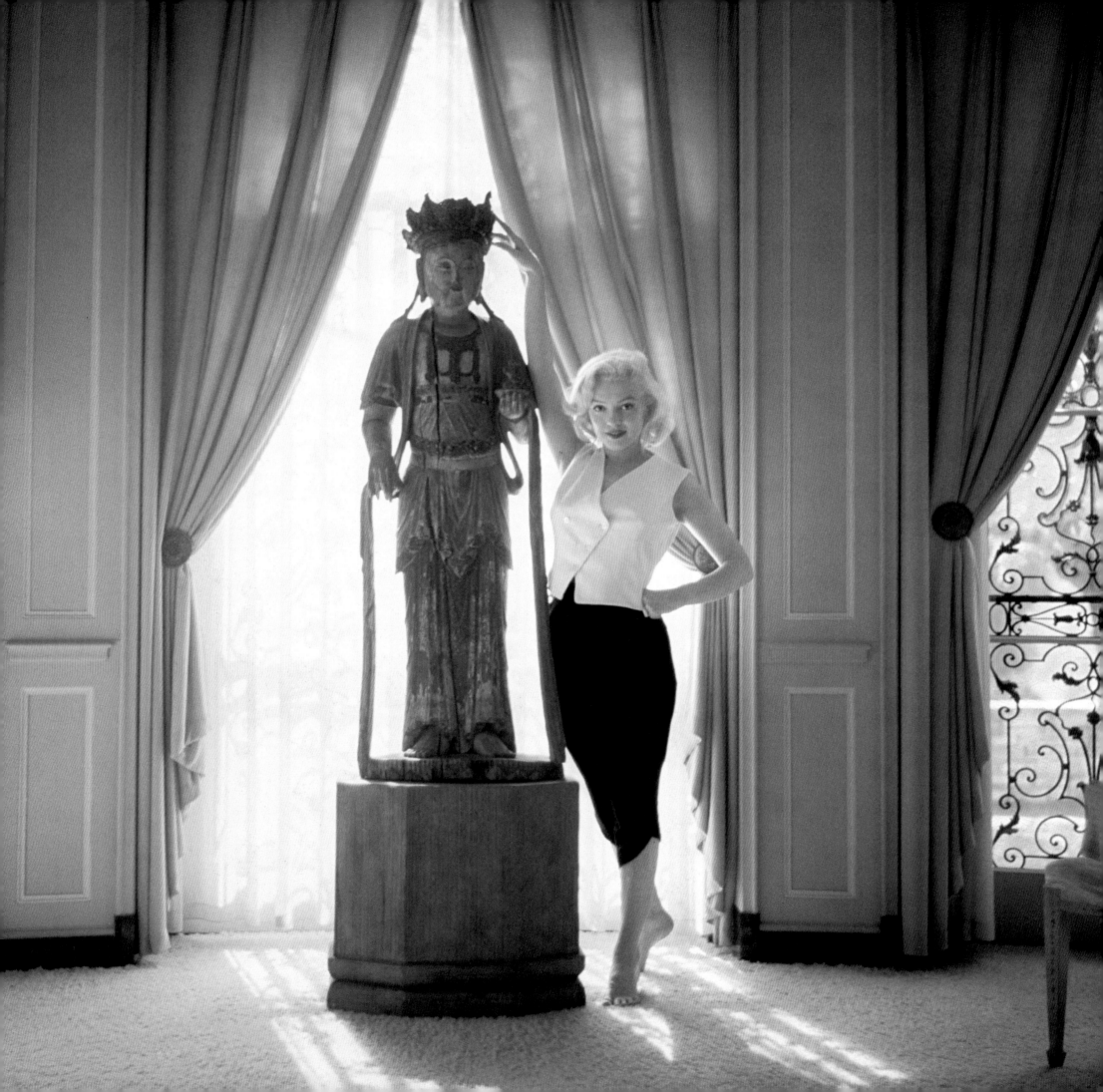

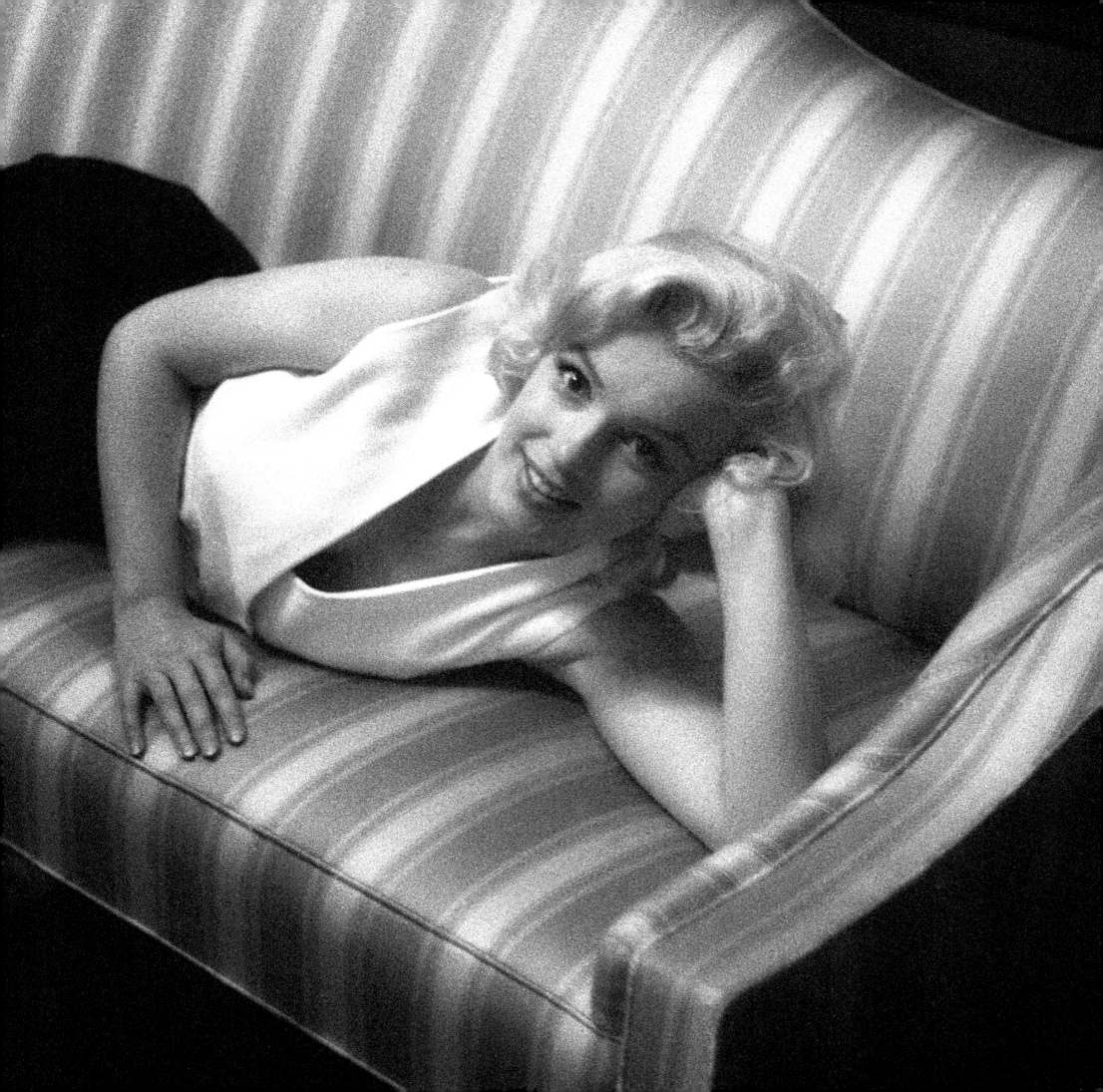

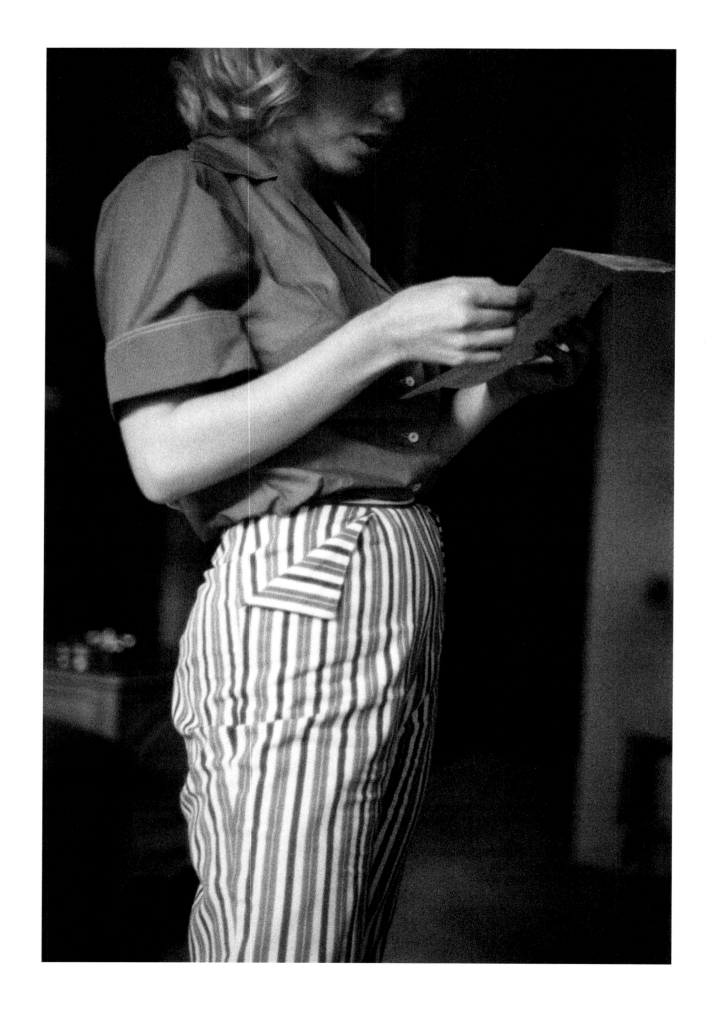

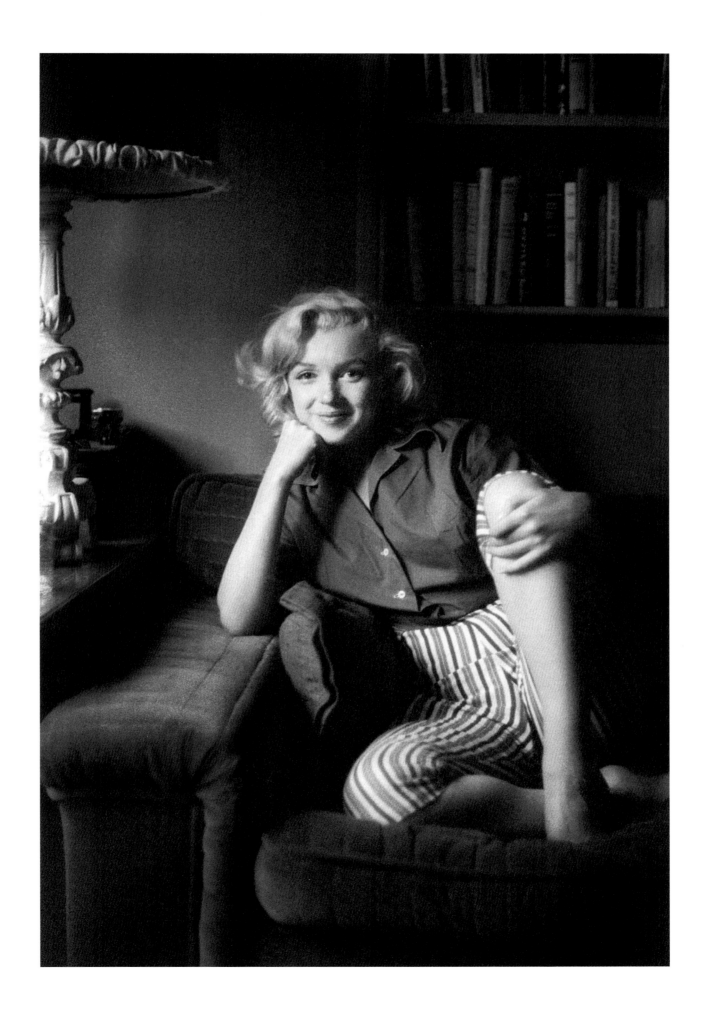

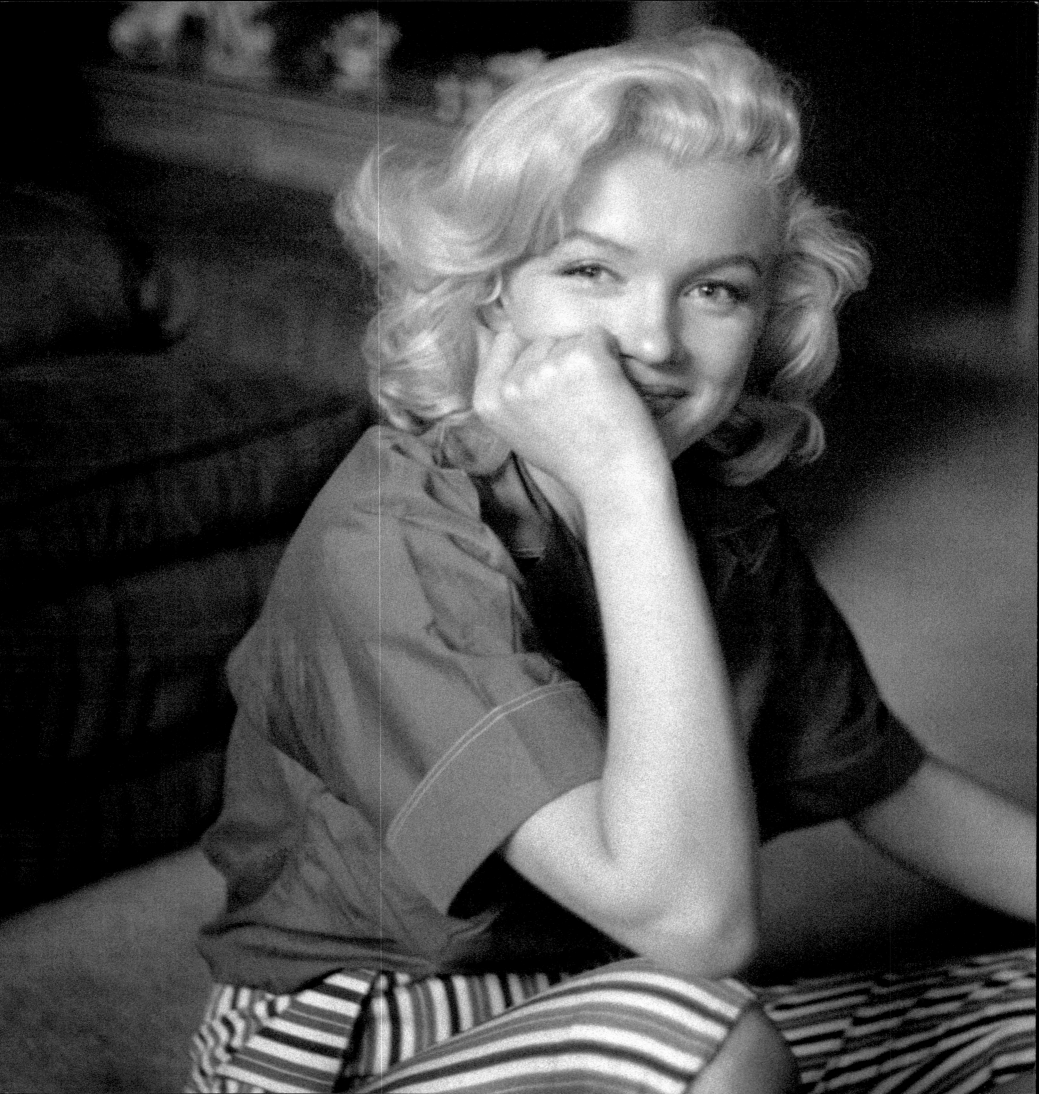

BED SITTING

October 1953 – This rare and previously unpublished series of photos was taken at the guest villa of Joseph Schenk's estate. The simple environment of only pillows, sheets, a robe and copper cup (very 1950s) showed Marilyn's adaptability; a chameleon showing a different personality. It is extraordinary to see how many different looks she could produce and how comfortable she was with Milton behind the camera. Milton's talent for simplicity is captured in these images.

Unpublished images:
Pages 65, 66, 67, 68, 69, 70, 71

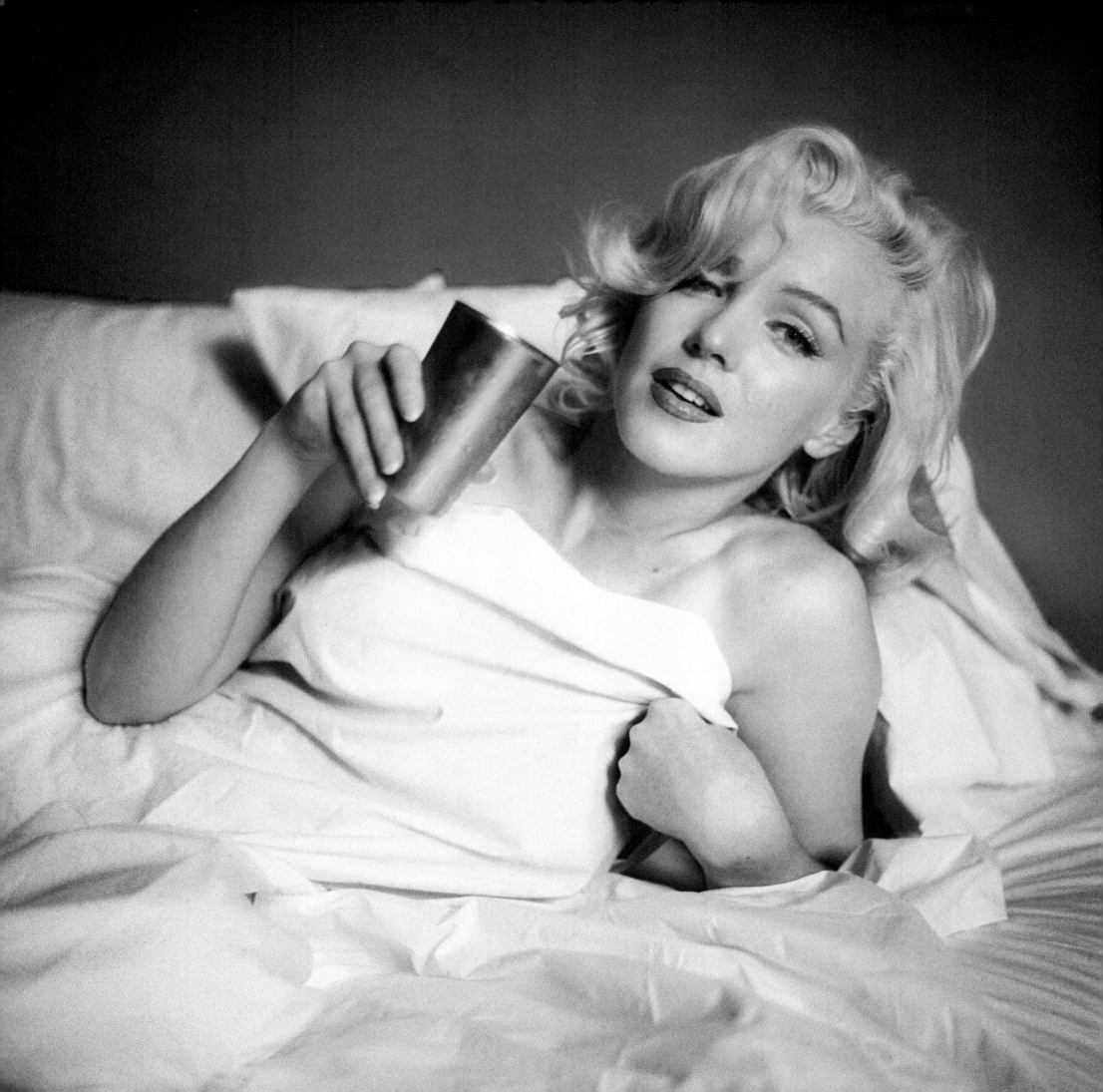

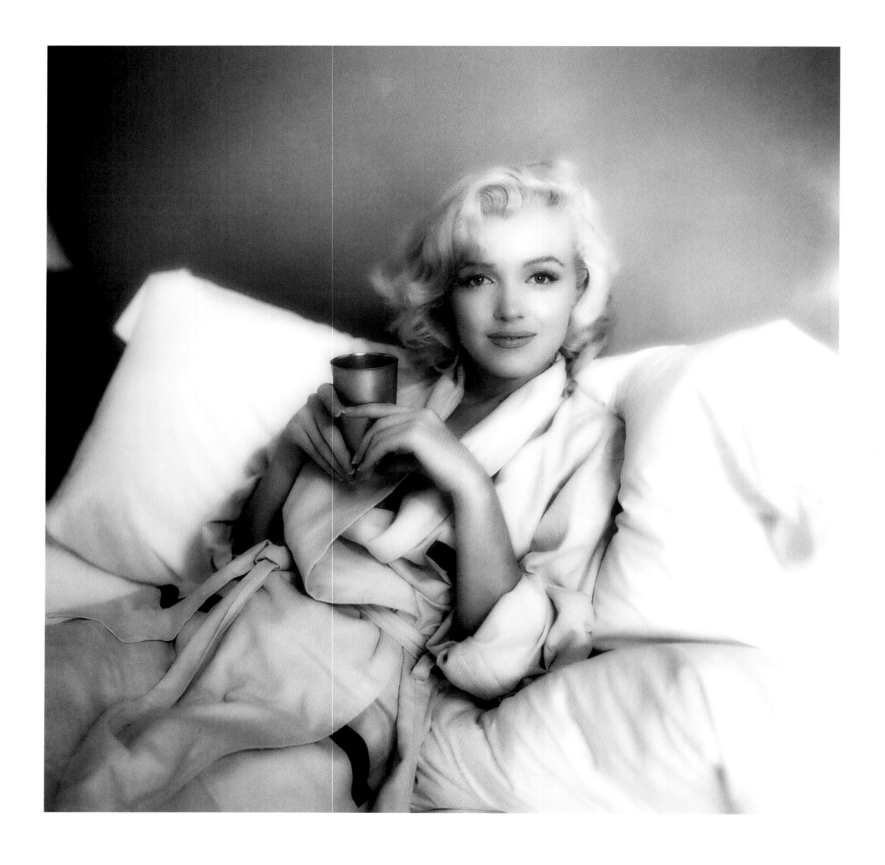

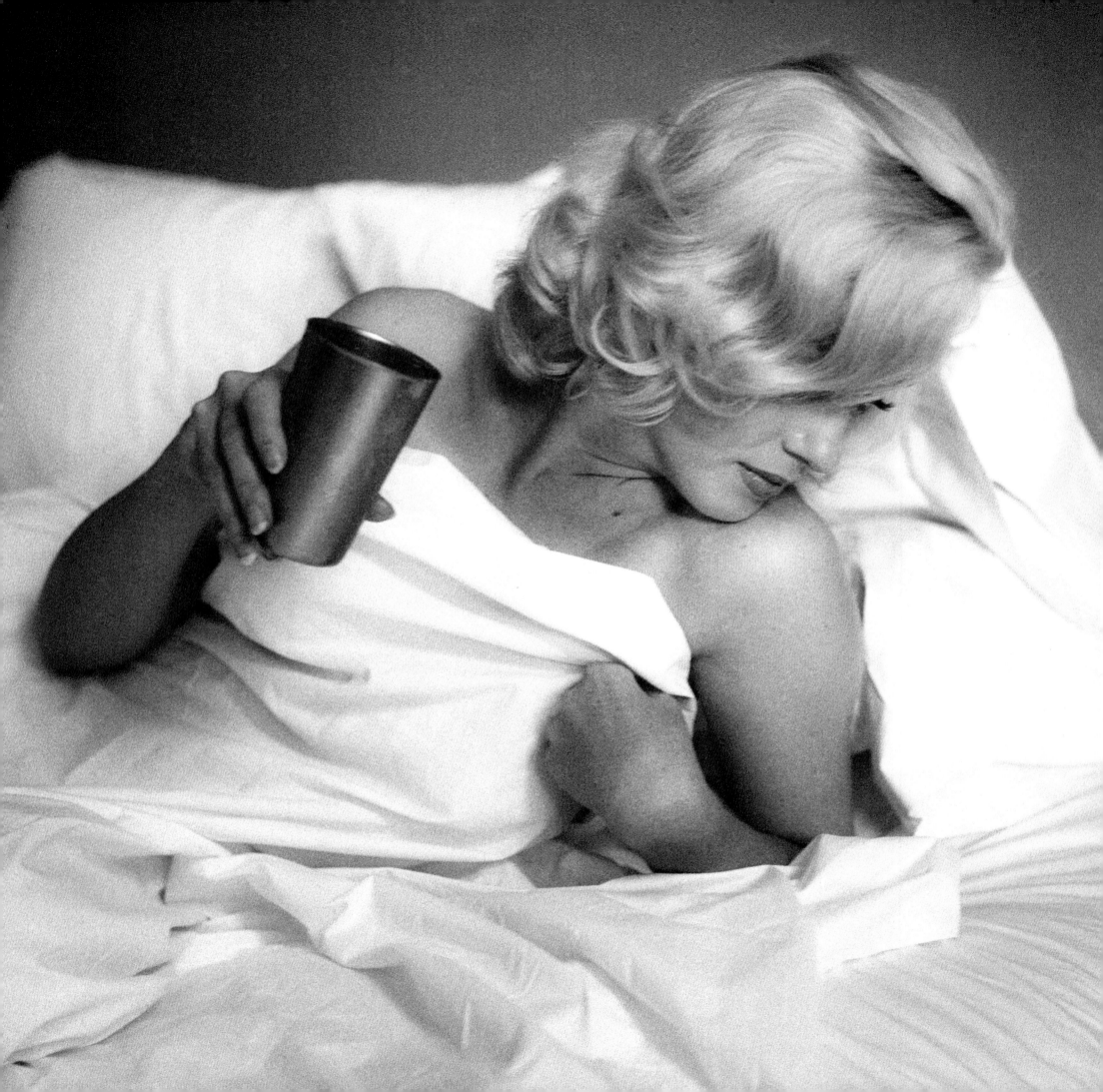

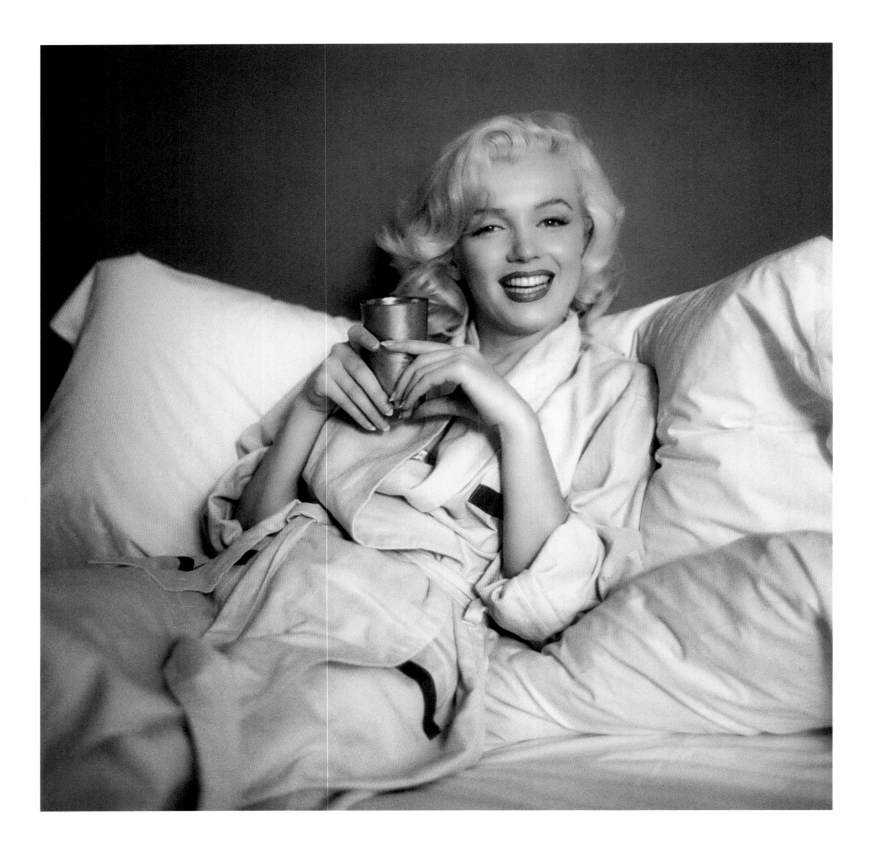

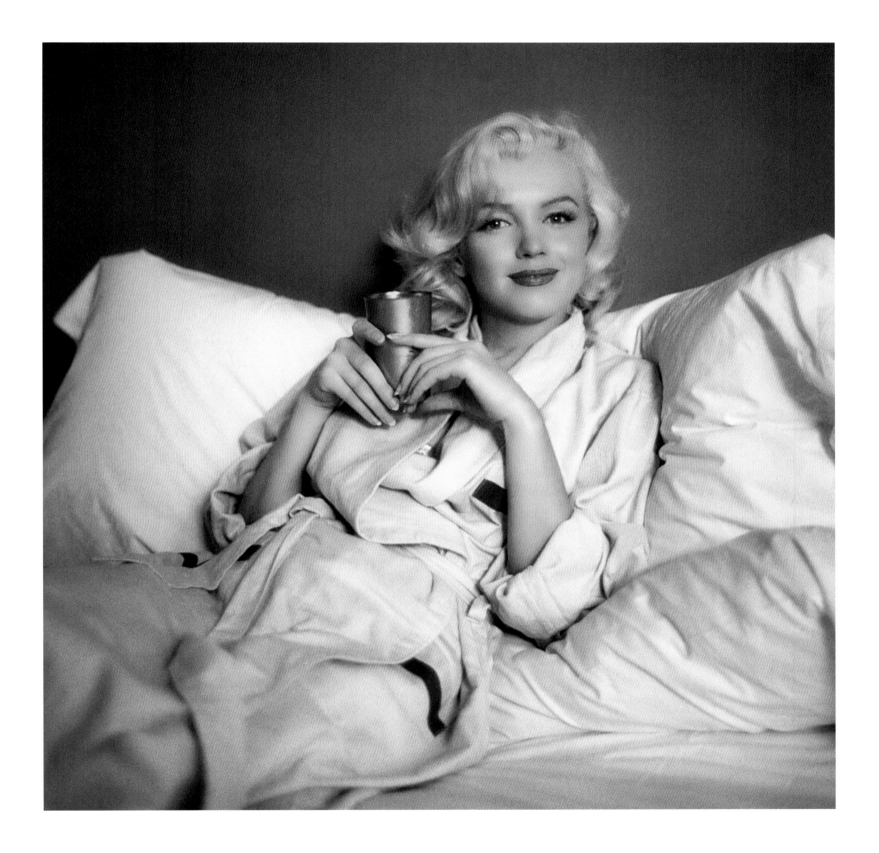

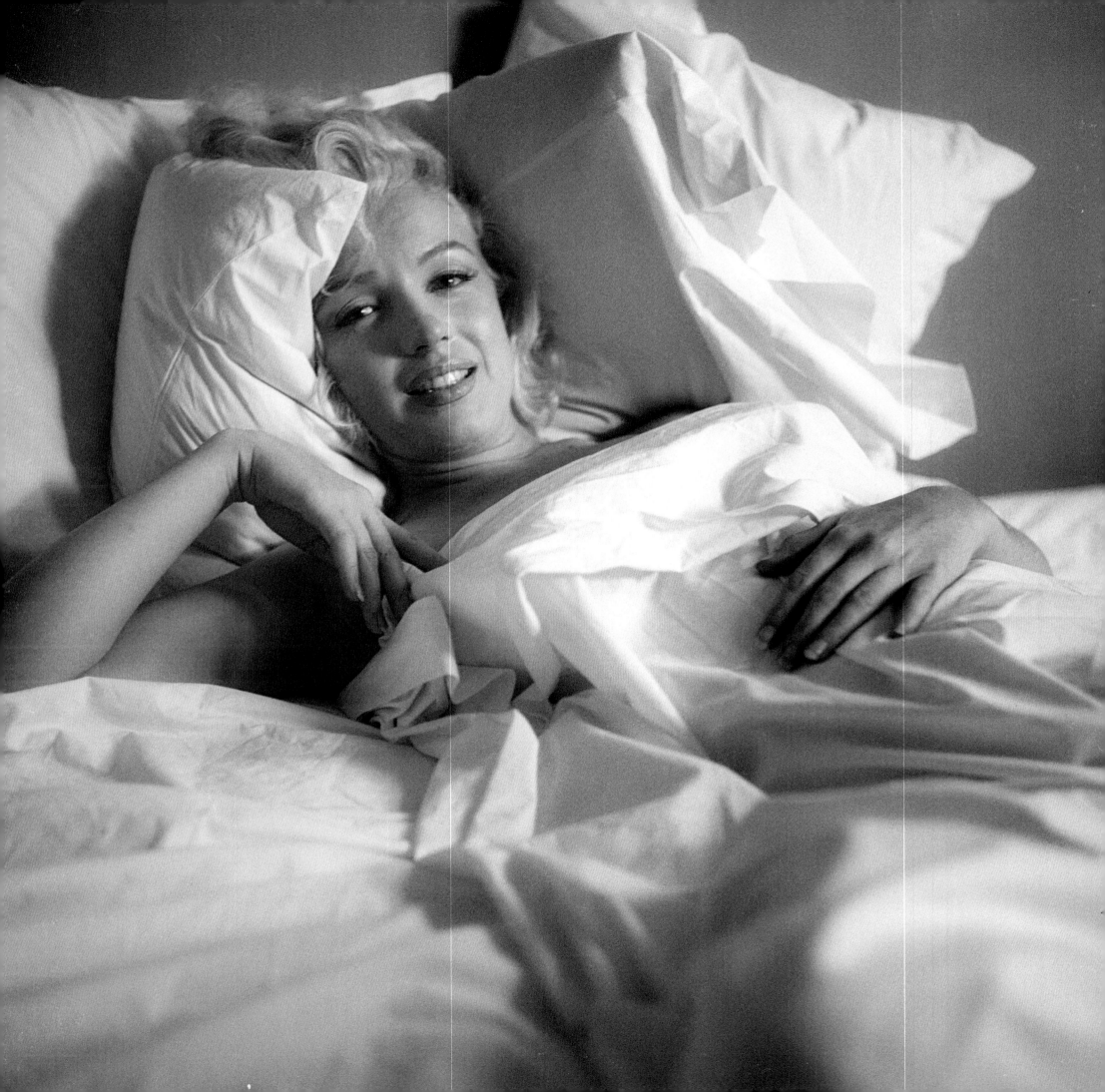

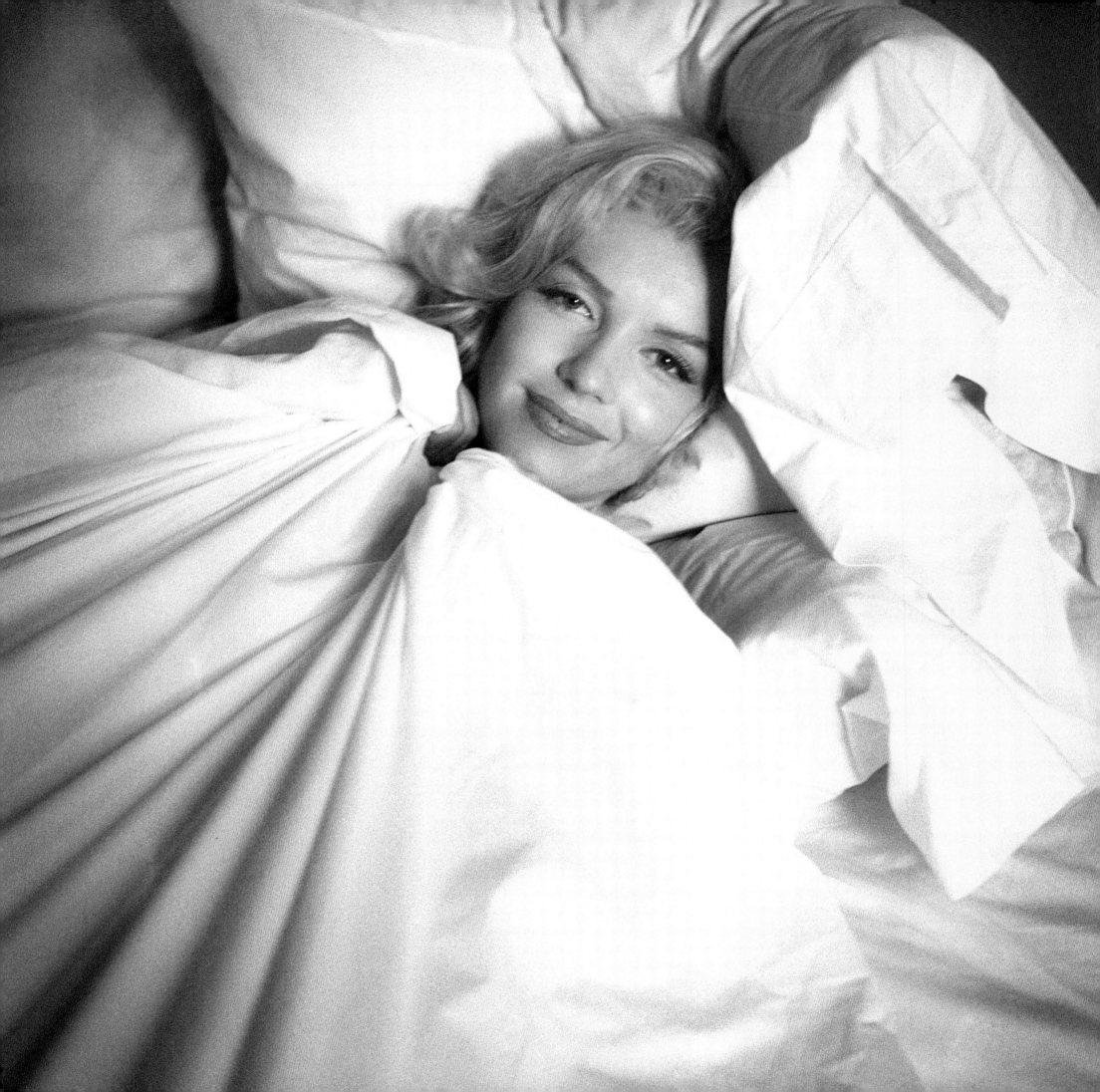

ROCK

May 1954 – Milton loved using textured backgrounds, such as draped fabrics or natural landscapes. Taken at Laurel Canyon, Marilyn is nestled into a crevasse and posed for this charming series of photos for *Look* magazine. Of these images, only the photo on page 80 appeared in the magazine. All the others have remained unpublished until now.

Unpublished images:
Pages 73, 74, 75, 76, 77, 78, 81

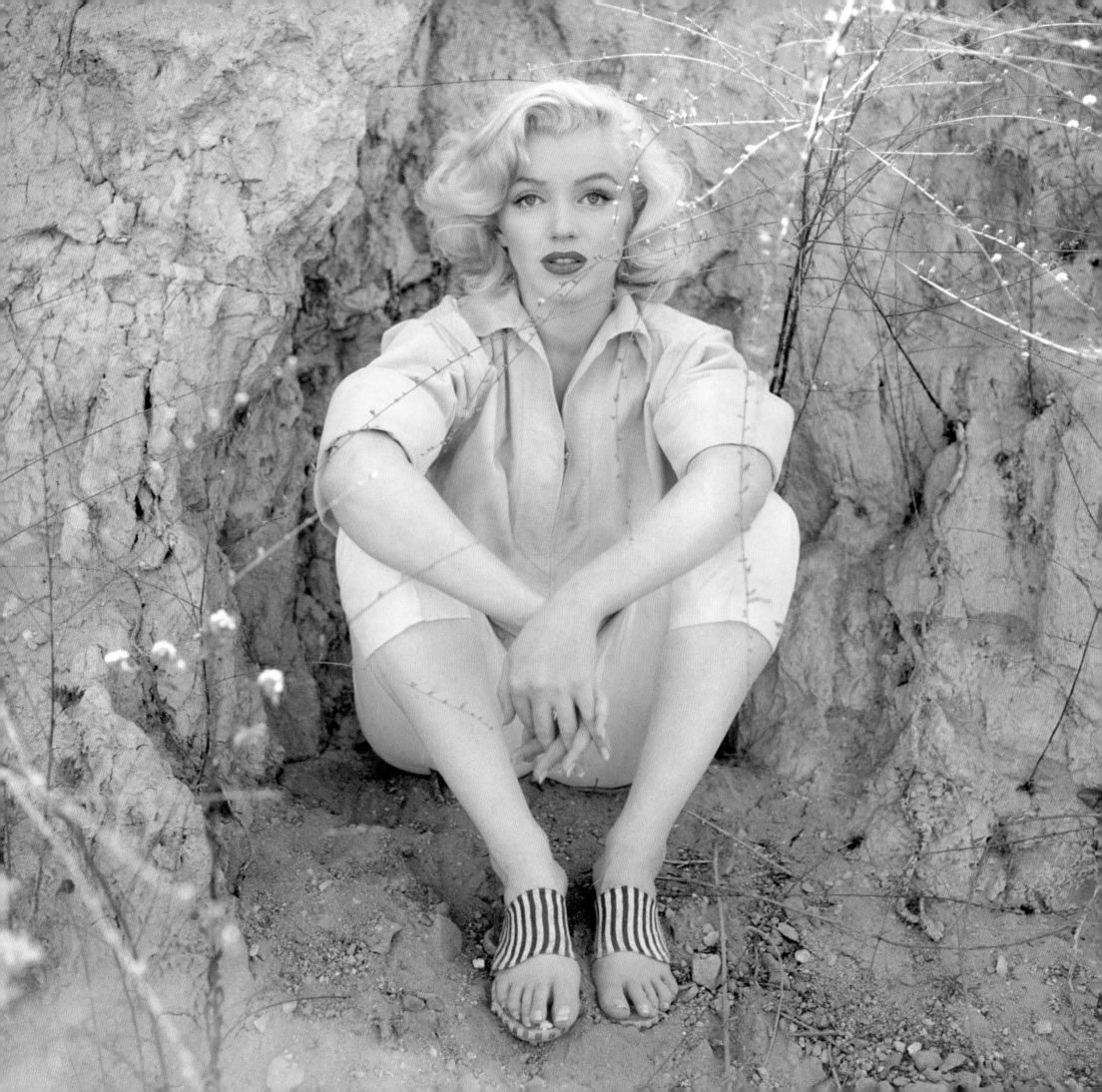

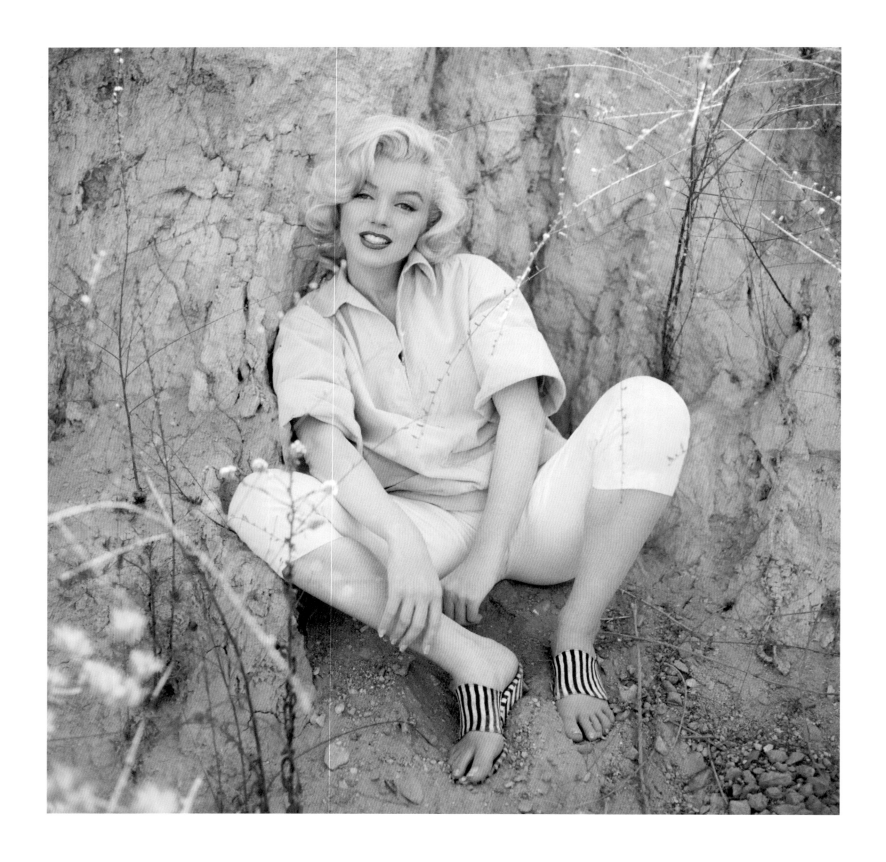

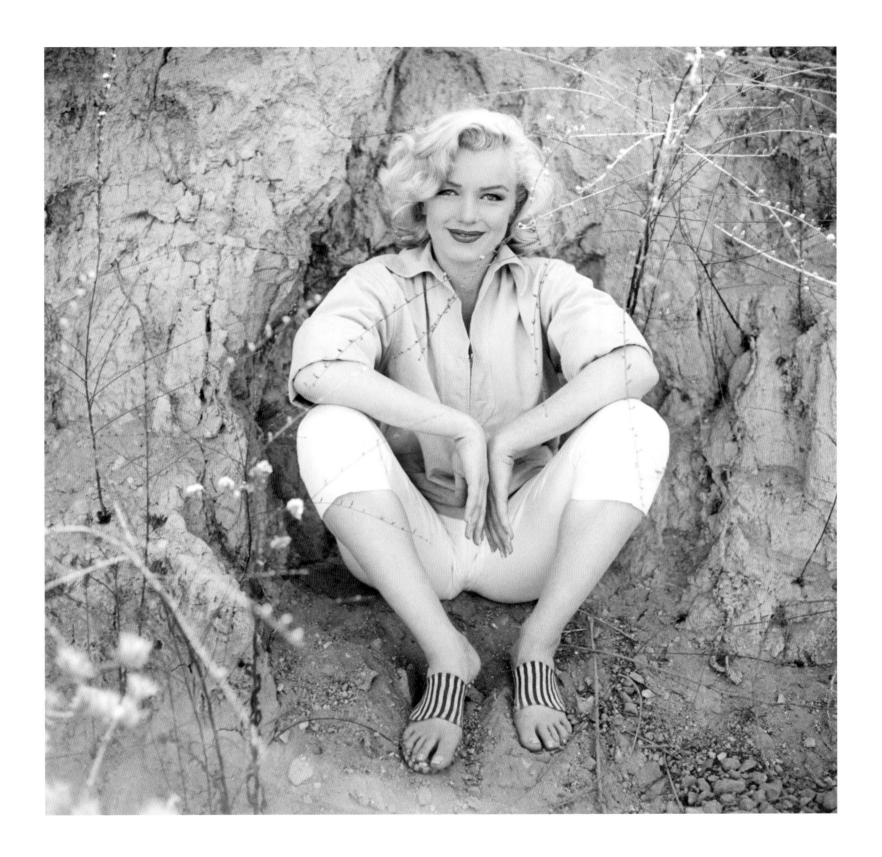

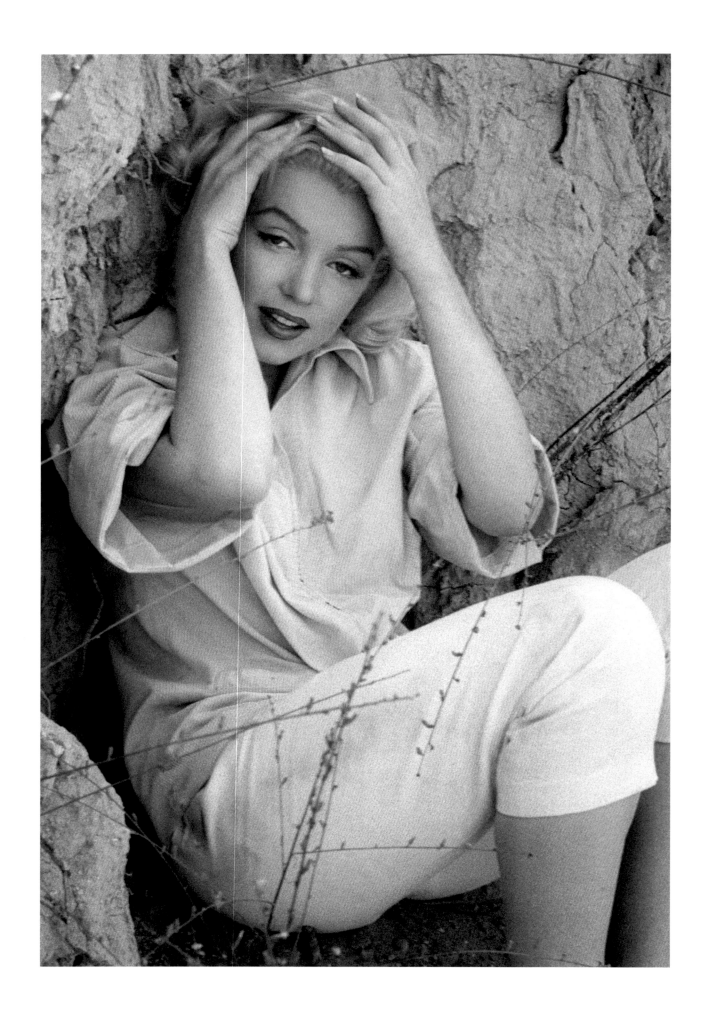

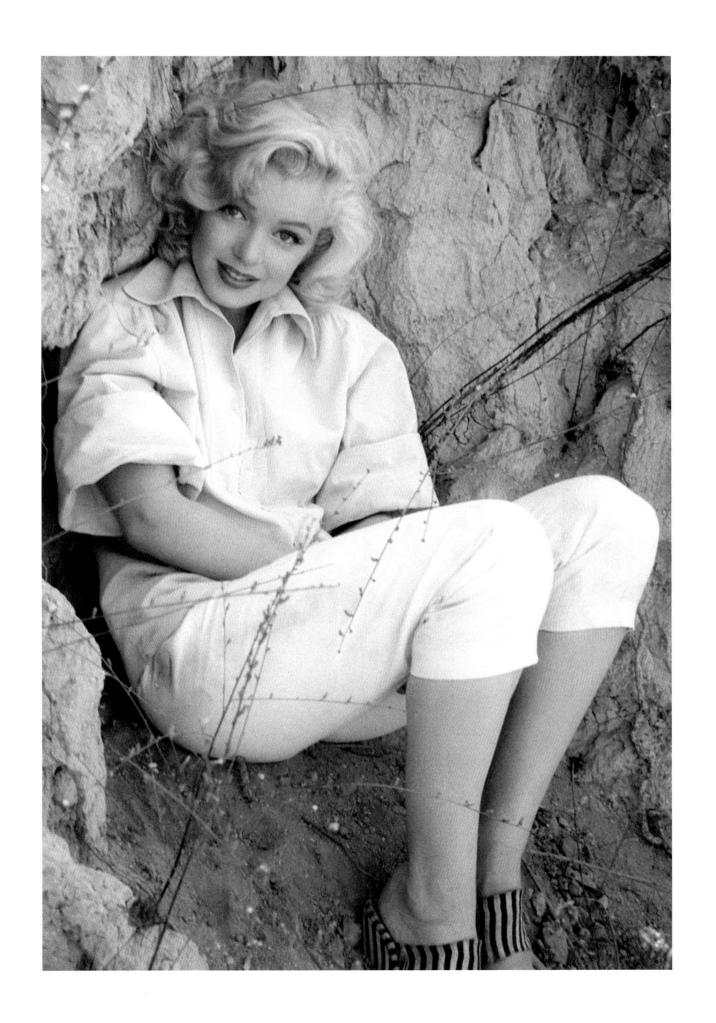

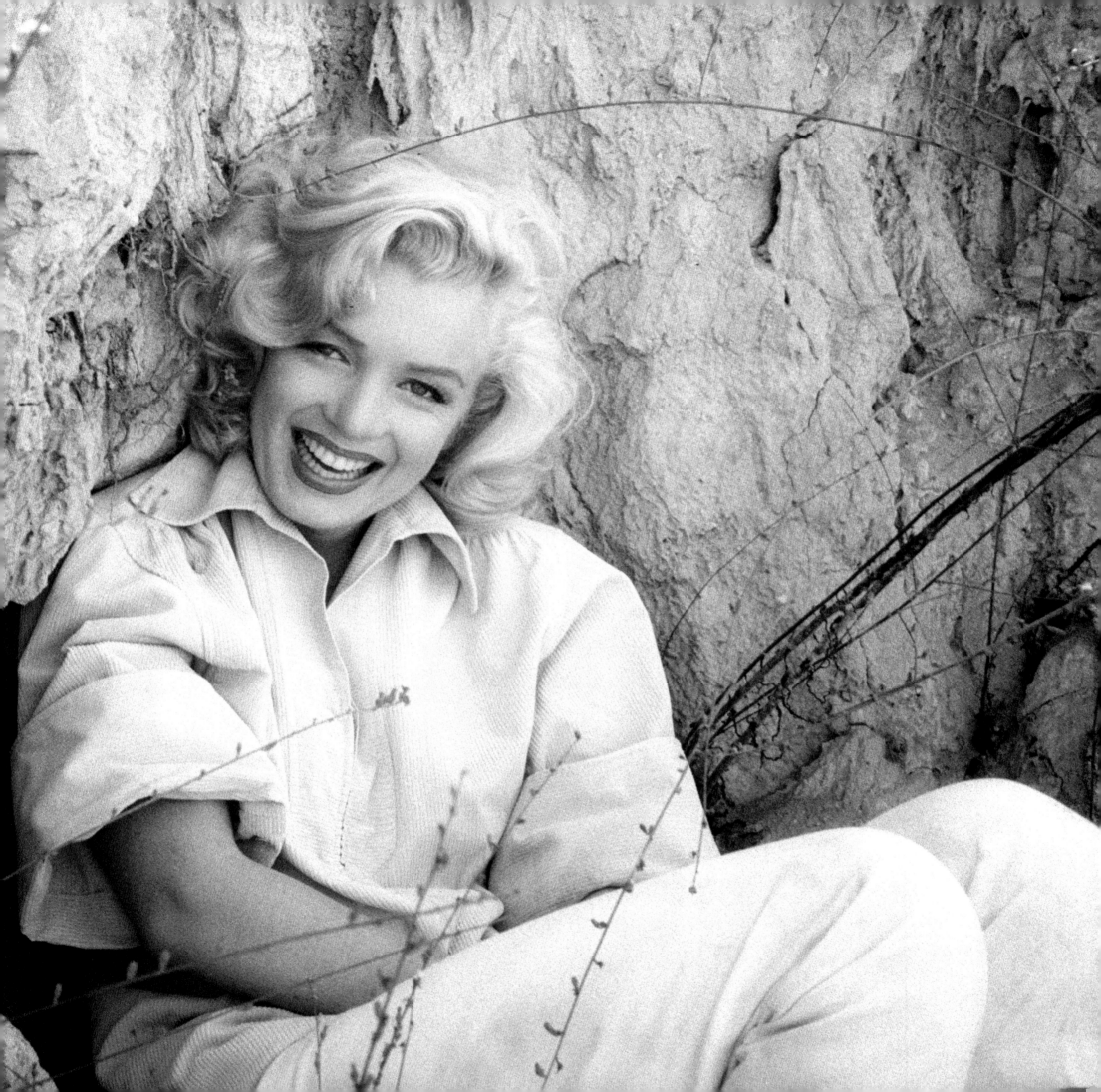

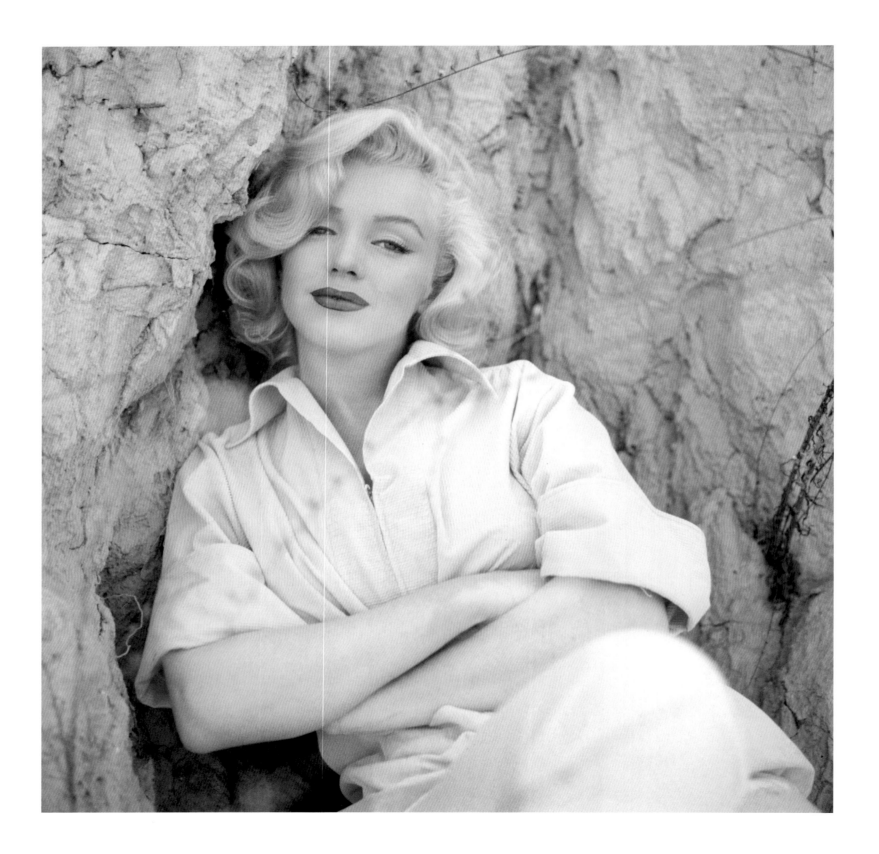

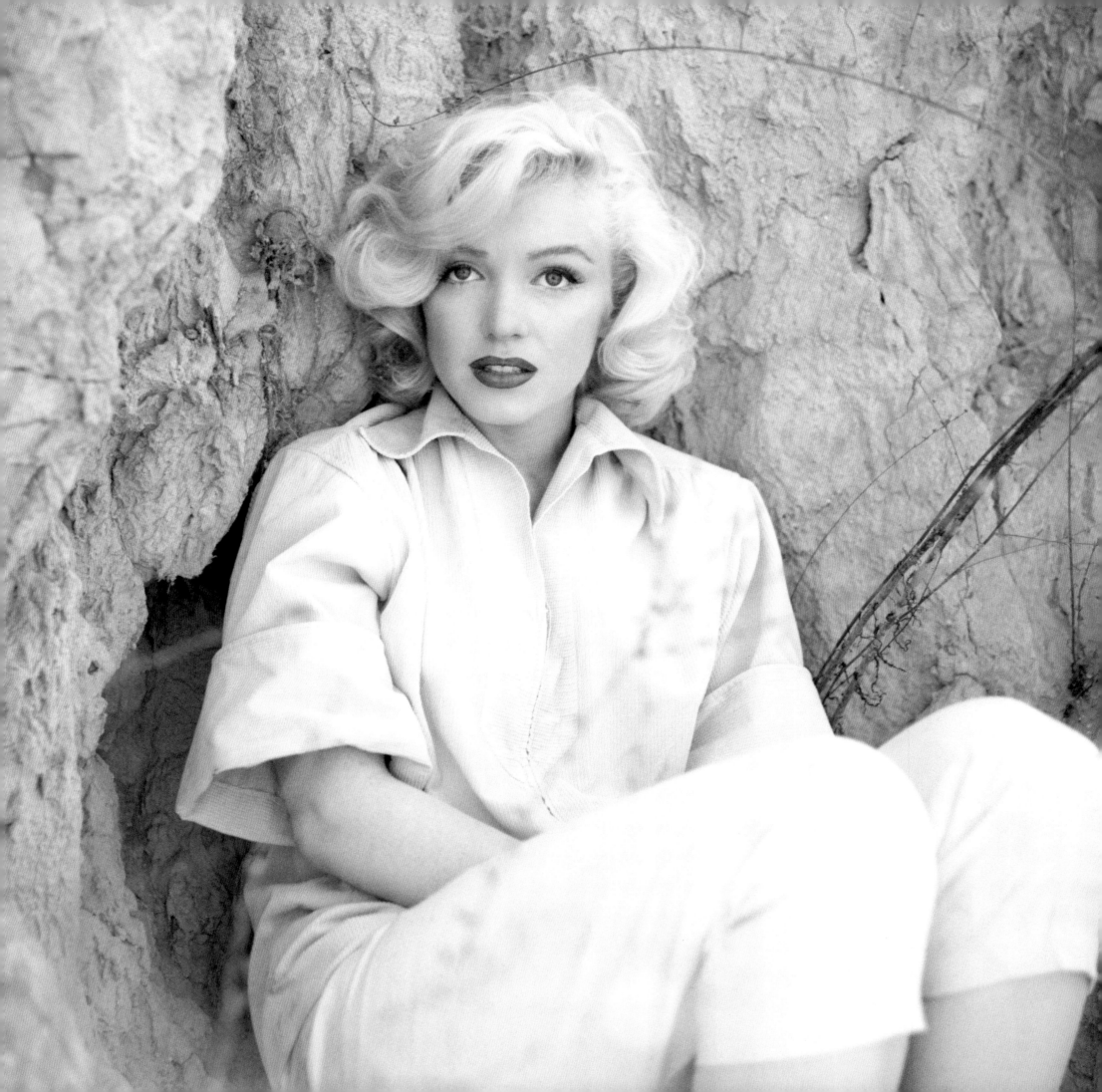

LAUREL
CANYON

May 1954 – Milton and Marilyn visited a horse ranch in
Laurel Canyon. This series of fun and impromptu pictures
shows a casual Marilyn relaxing, riding horses and having
fun. Having to ride and snap photos at the same time was not
easy – Milton, being the city boy from Brooklyn was no
cowboy! The camaraderie between Milton and Marilyn is
evident in their photos together.

Unpublished images:
Pages 84, 86, 88, 89

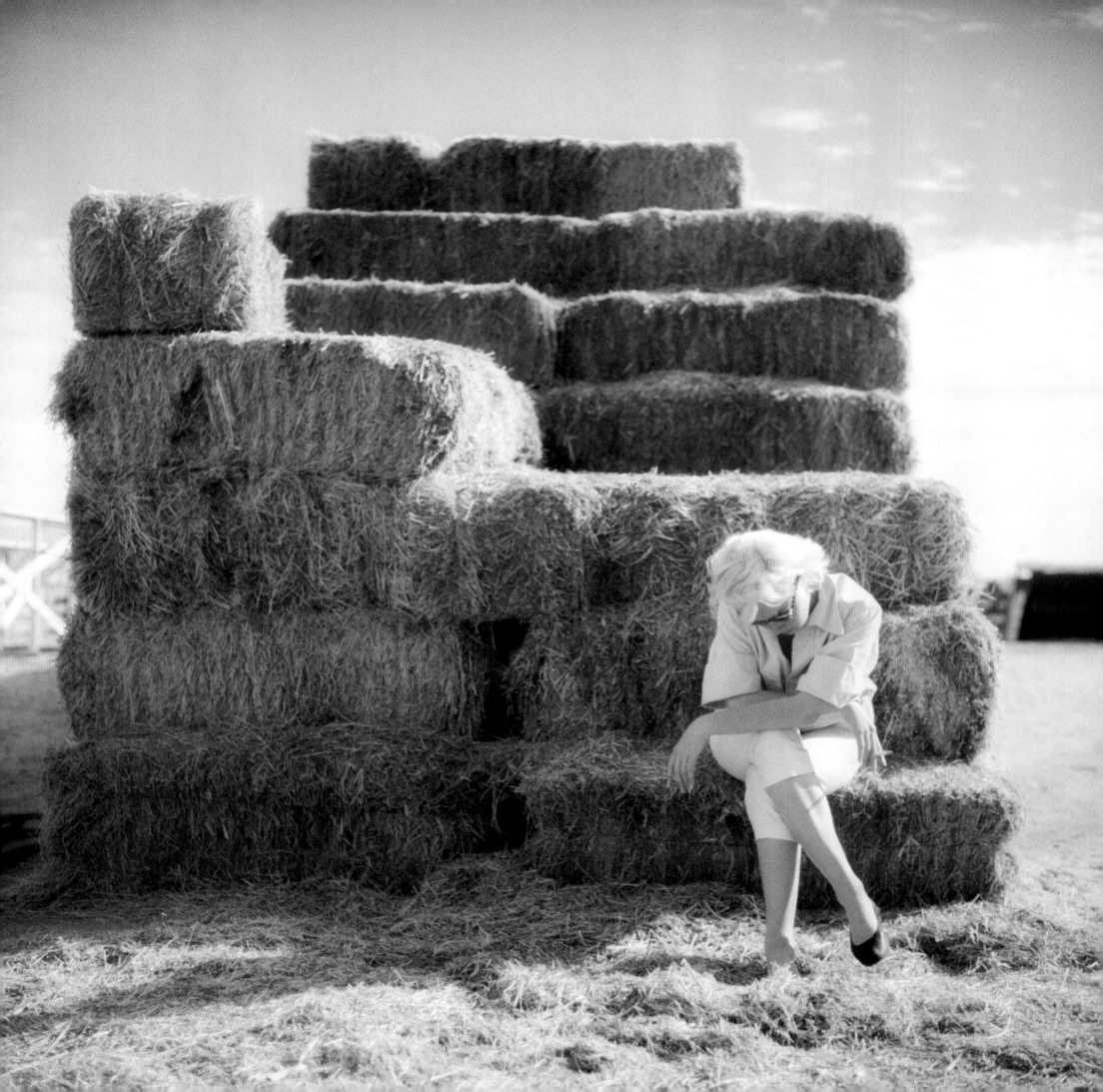

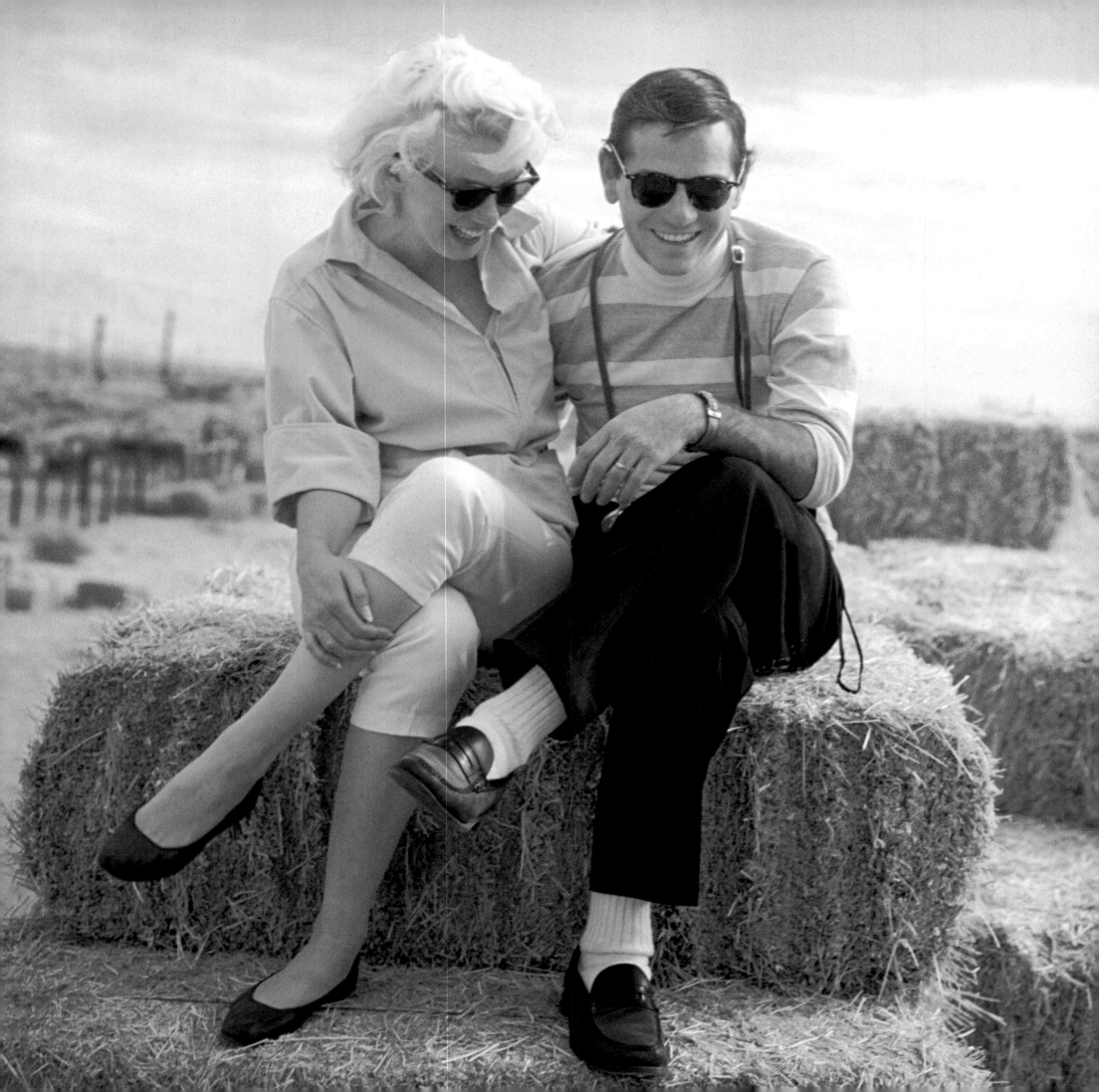

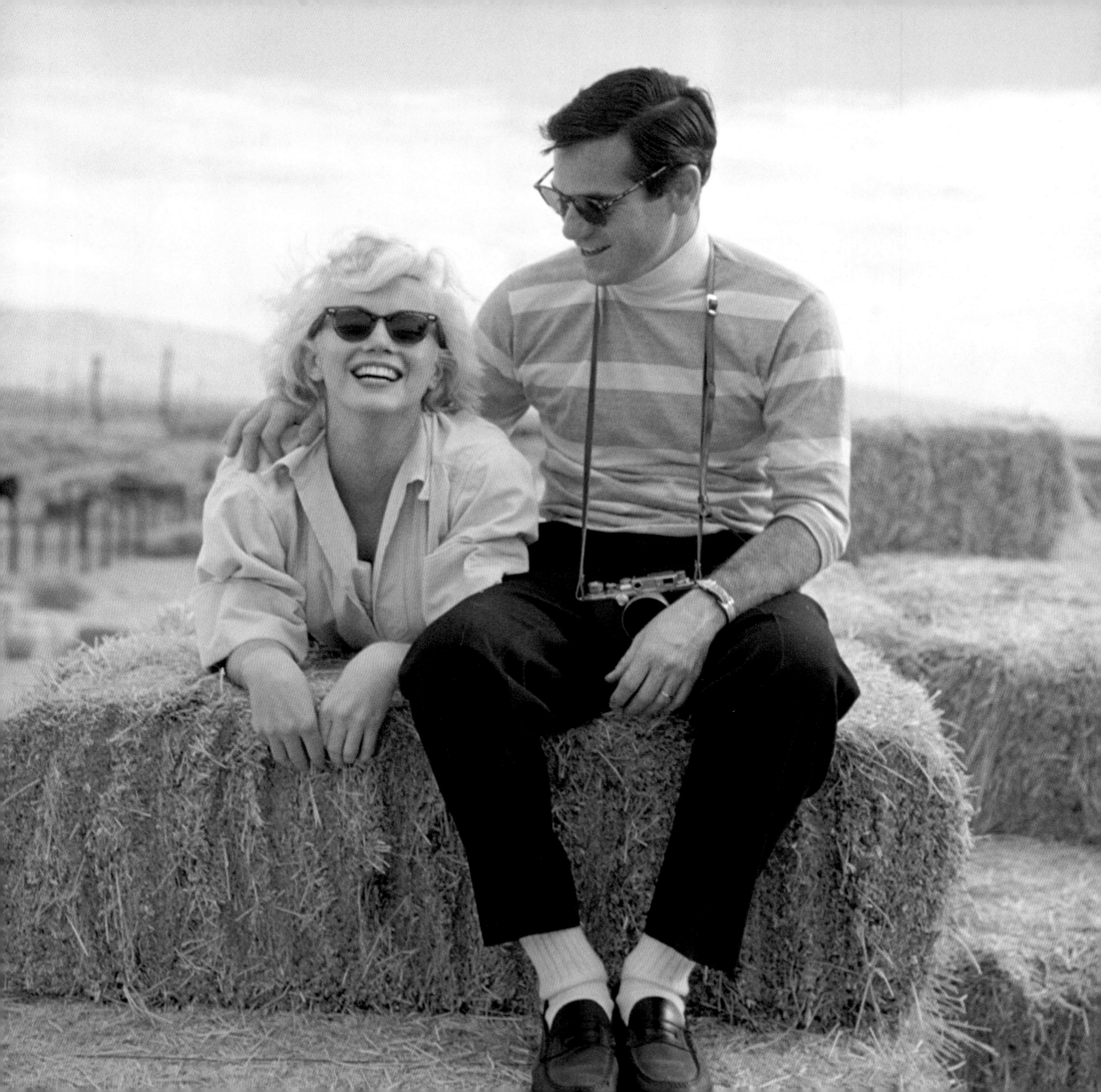

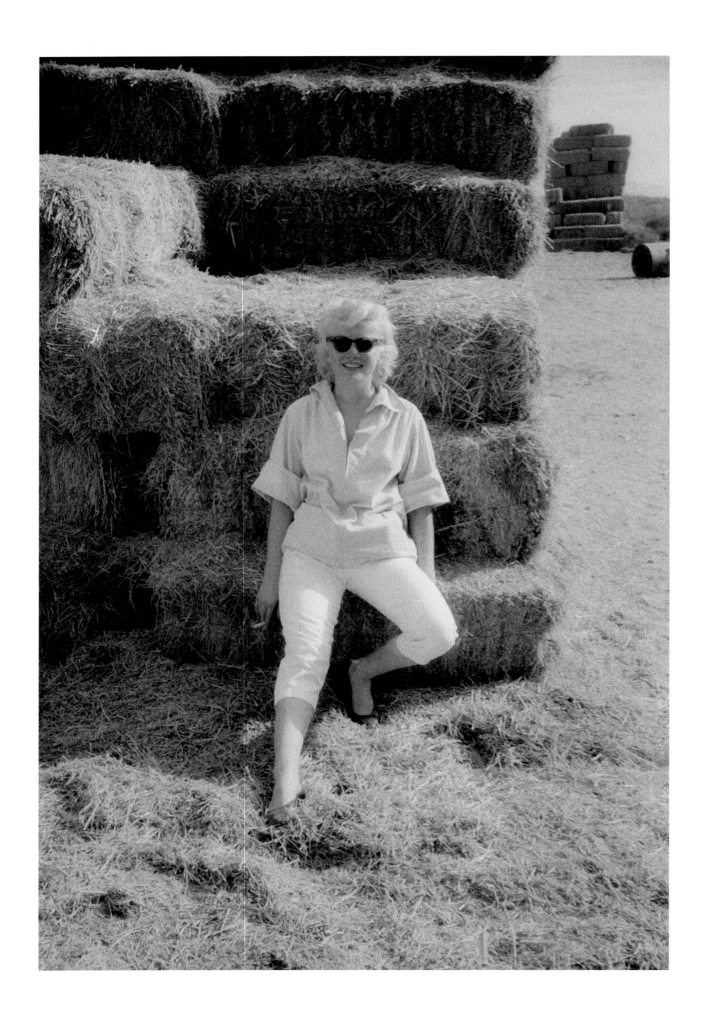

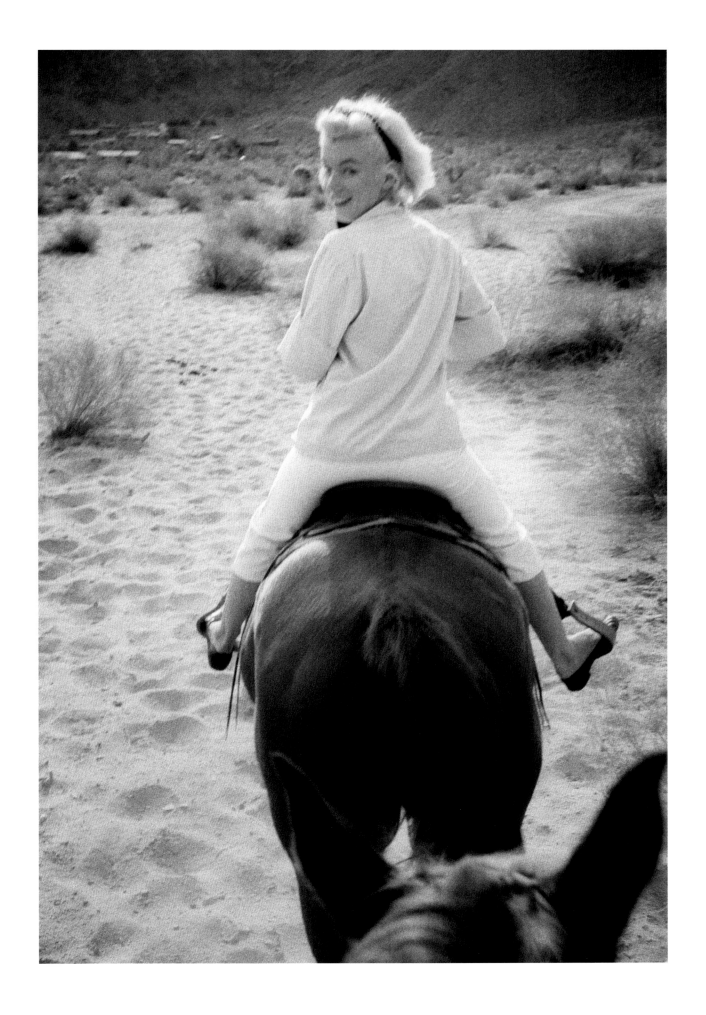

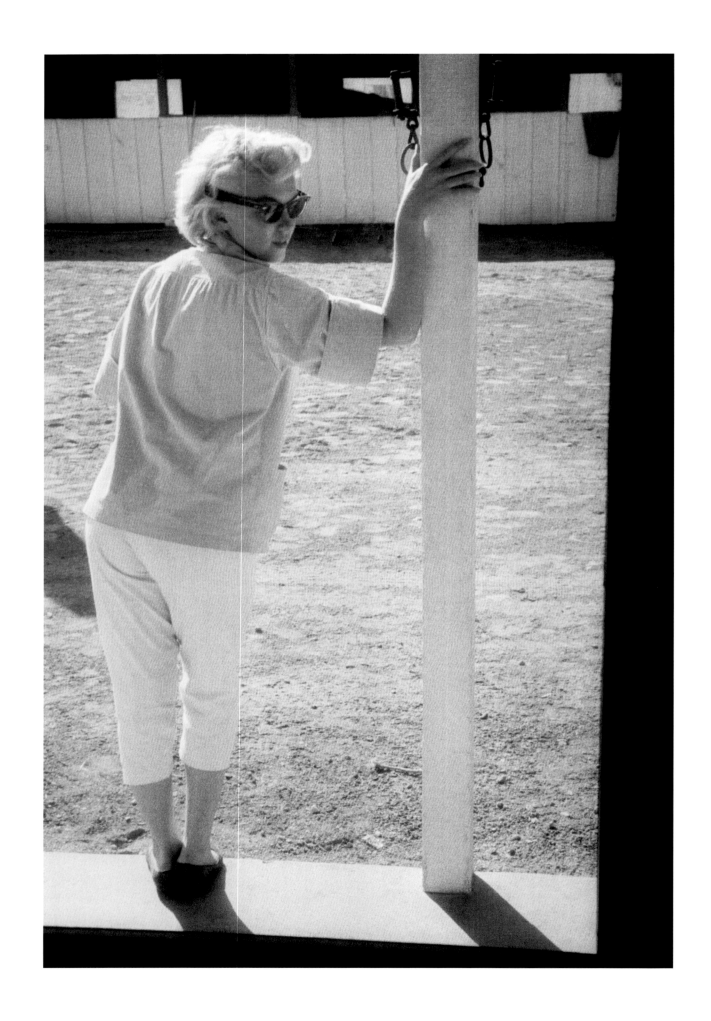

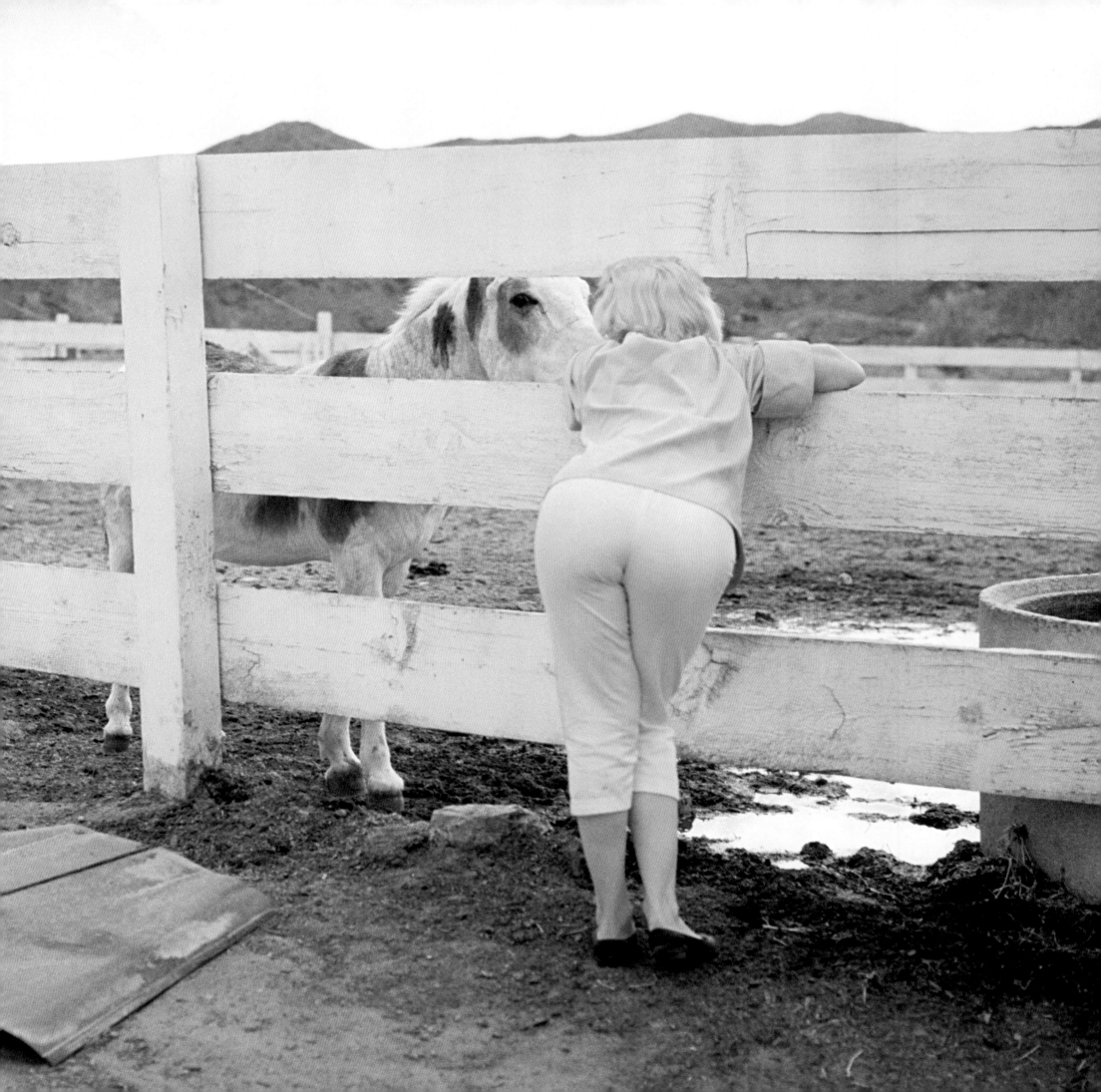

PEASANT

May 1954 – Rifling through the 20th Century Fox prop
closet during one of those glorious Sunday afternoons on the
studio backlots, Milton and Marilyn photographed the
Peasant Sitting. Taken on May 24, 1954, this series was created
on the French village set used for *What Price Glory*. Milton
believed in Marilyn's ability to be a dramatic actress and to
prove it to her, photographed her in the costume that
Jennifer Jones wore in her Oscar-winning performance in
The Song of Bernadette.

Over time, he began portraying Marilyn as different characters.
They loved the fact she played a saint, an inside joke that
Marilyn and Milton found humorous. Later photos in this
series show Marilyn prepping her makeup along with her
long-time makeup artist Allan "Whitey" Snyder.

Unpublished images:
Pages 92, 93, 94, 95, 96, 97, 98, 99, 100, 102

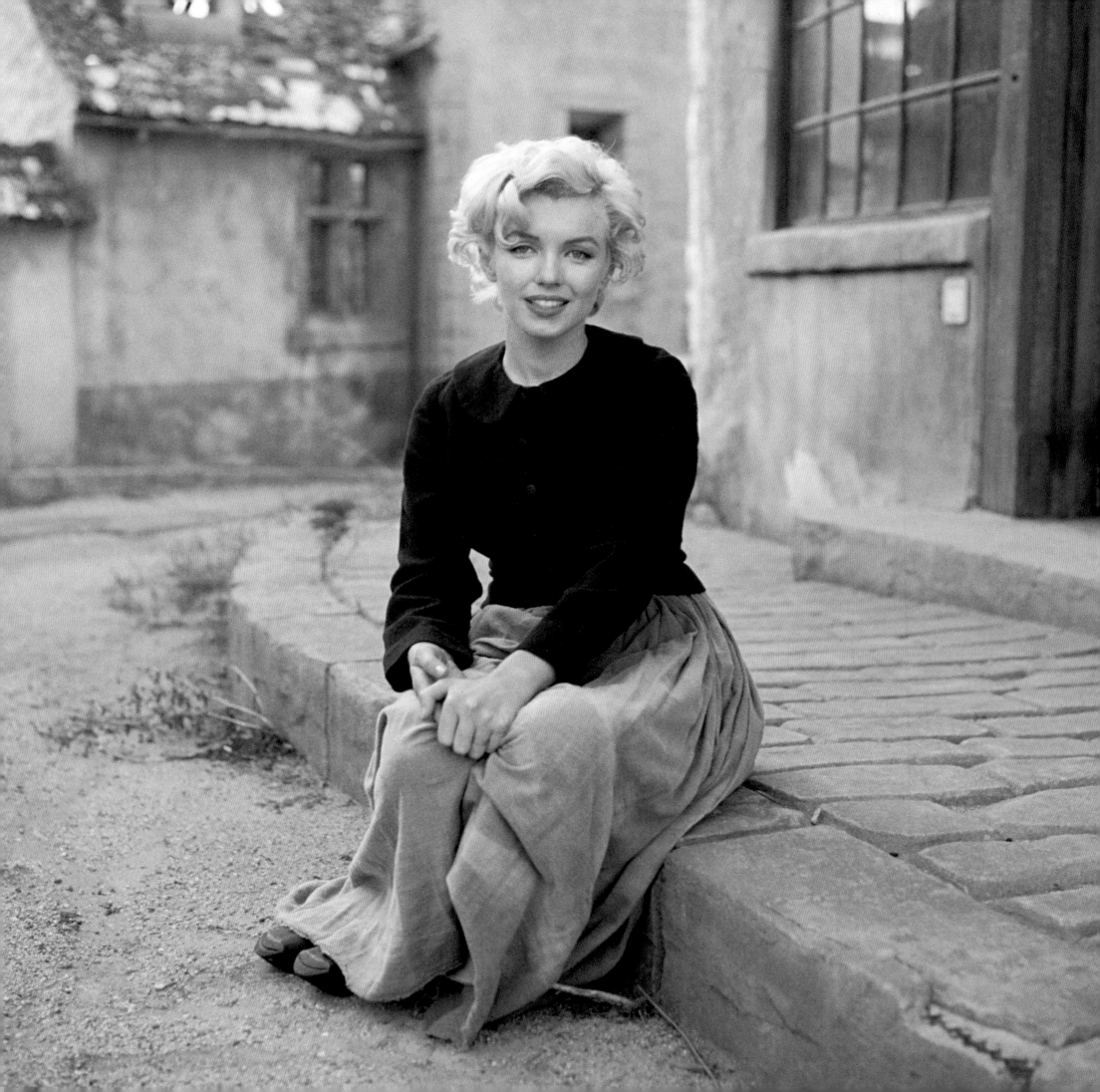

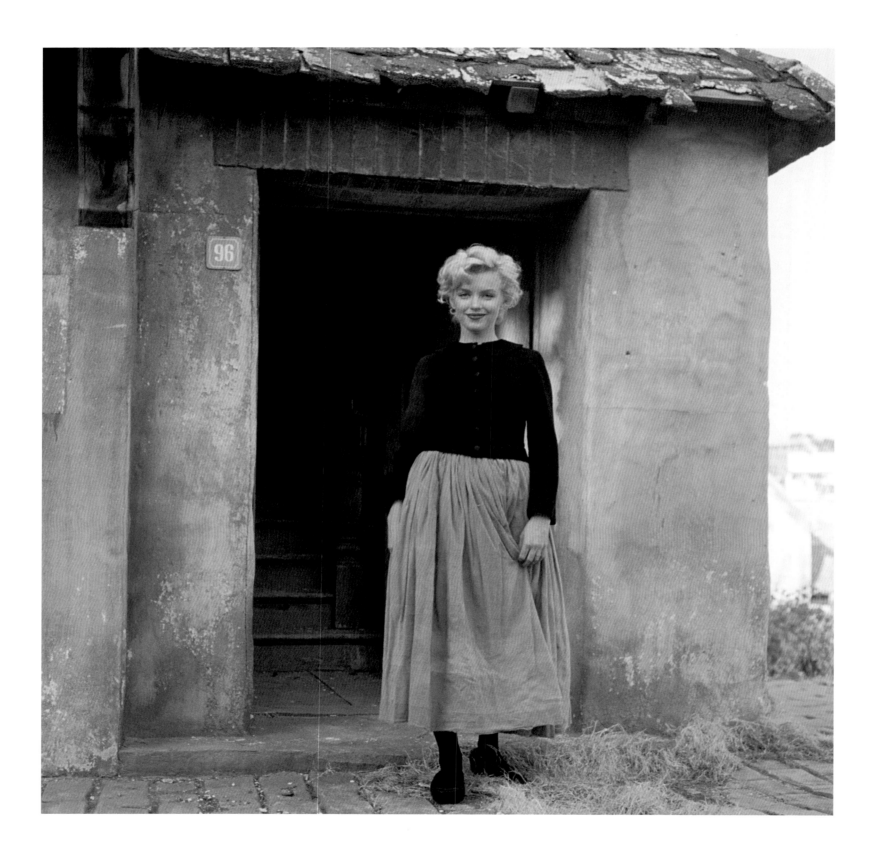

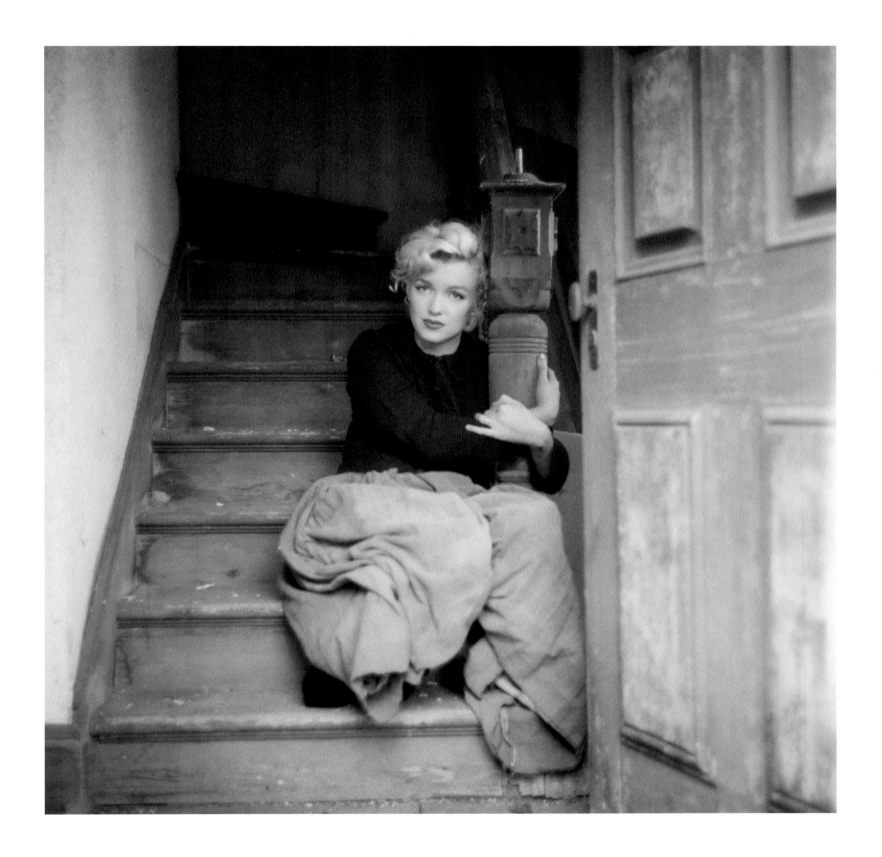

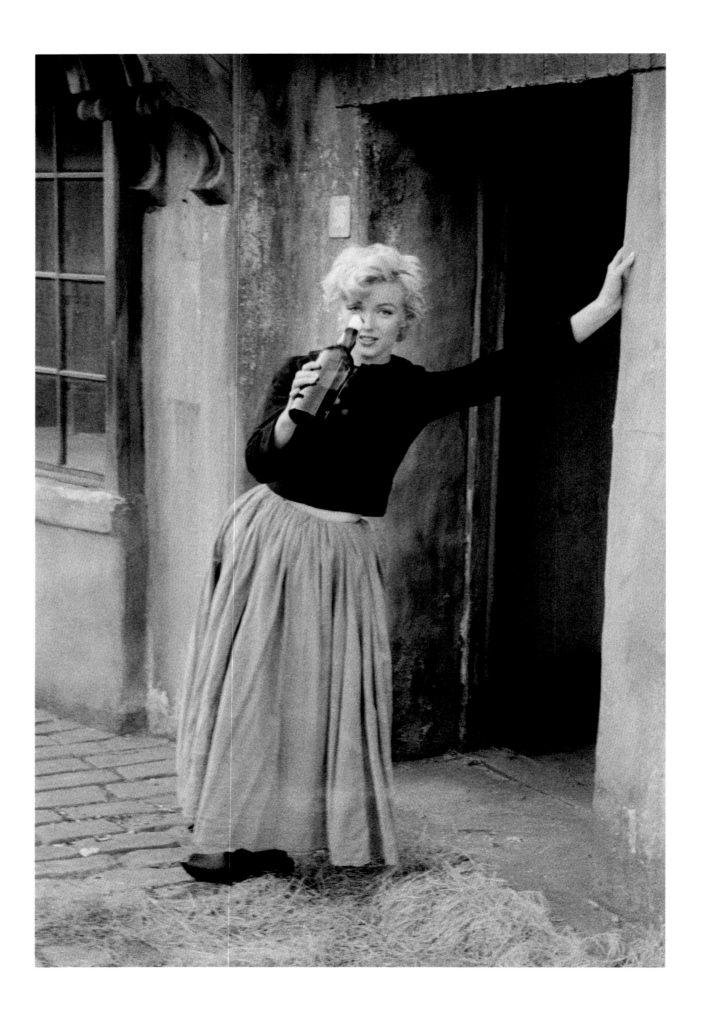

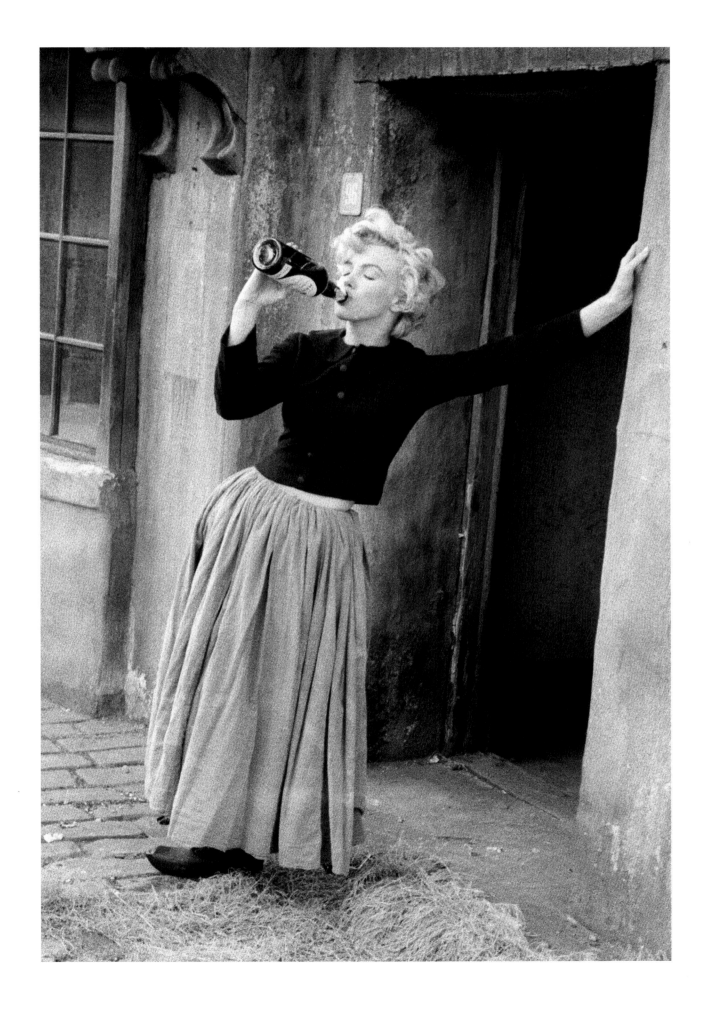

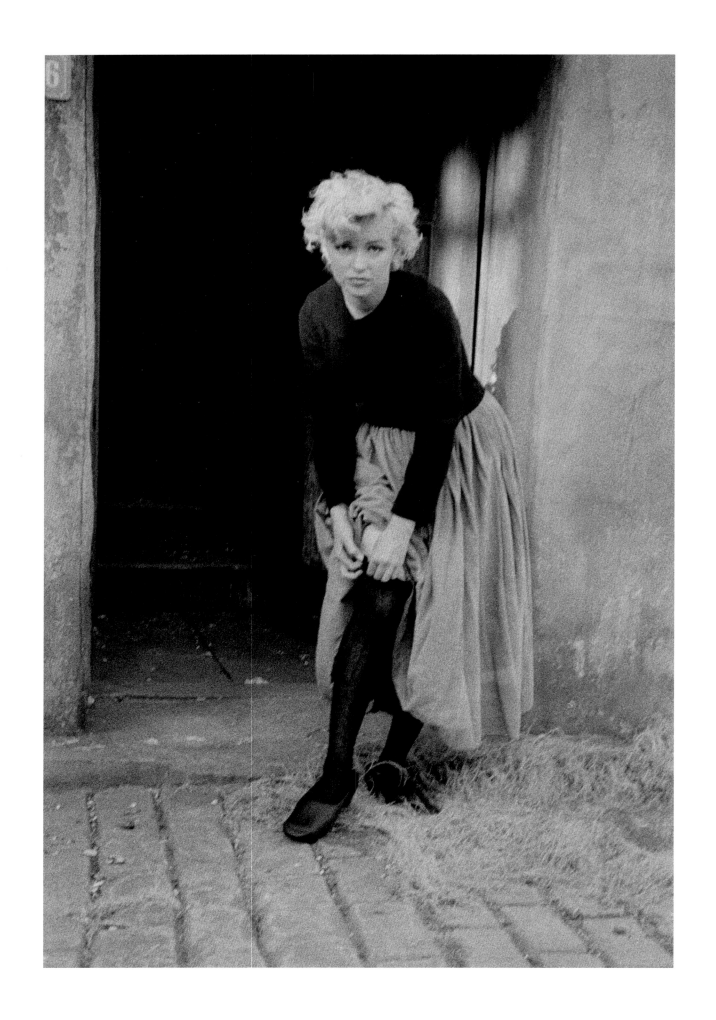

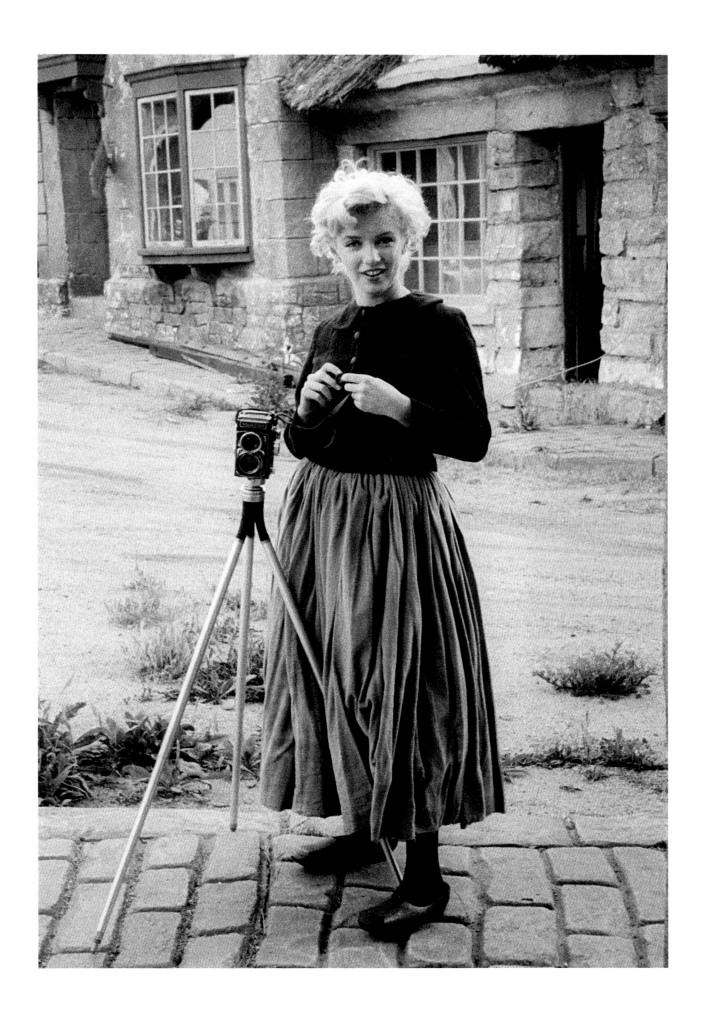

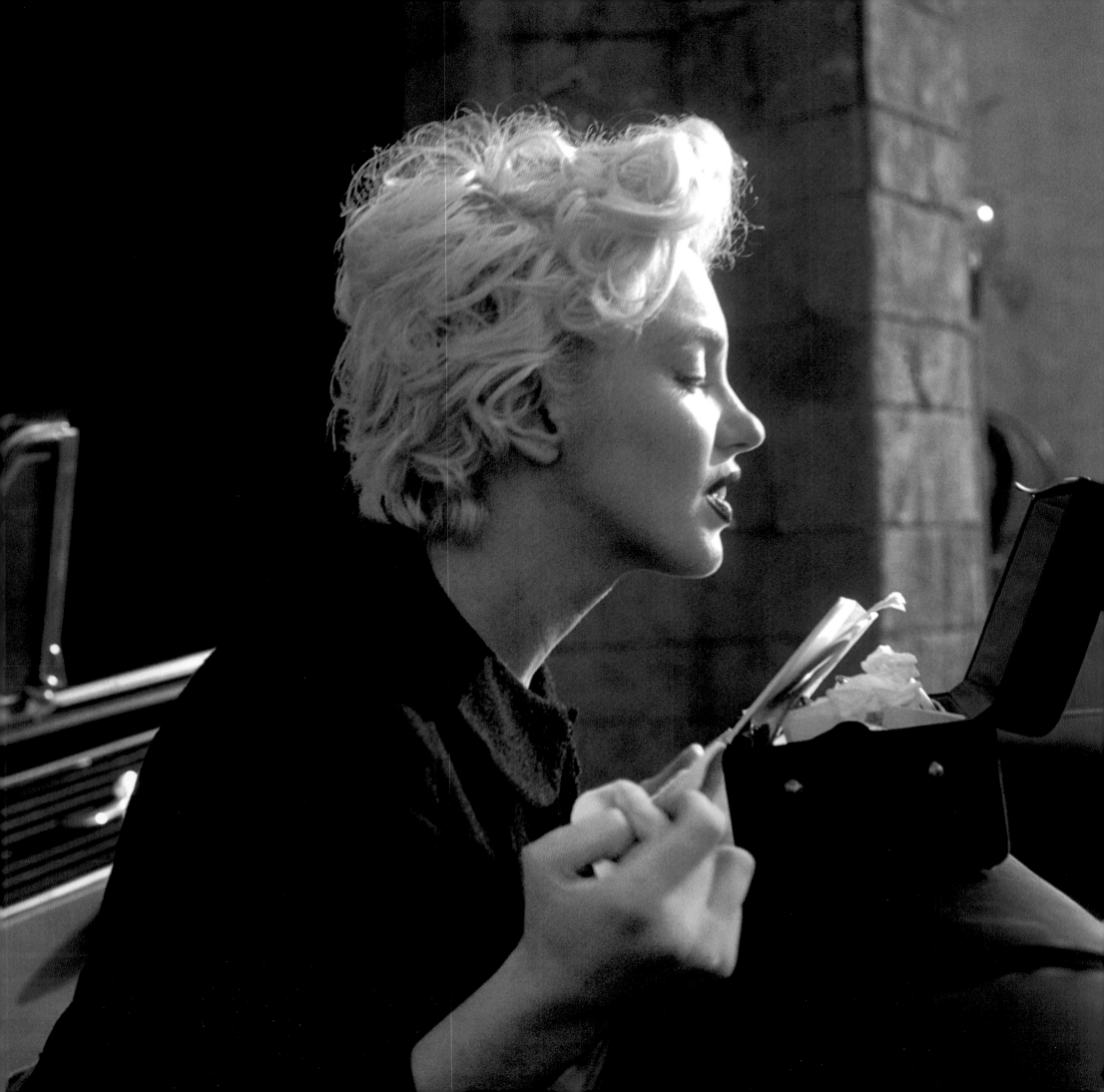

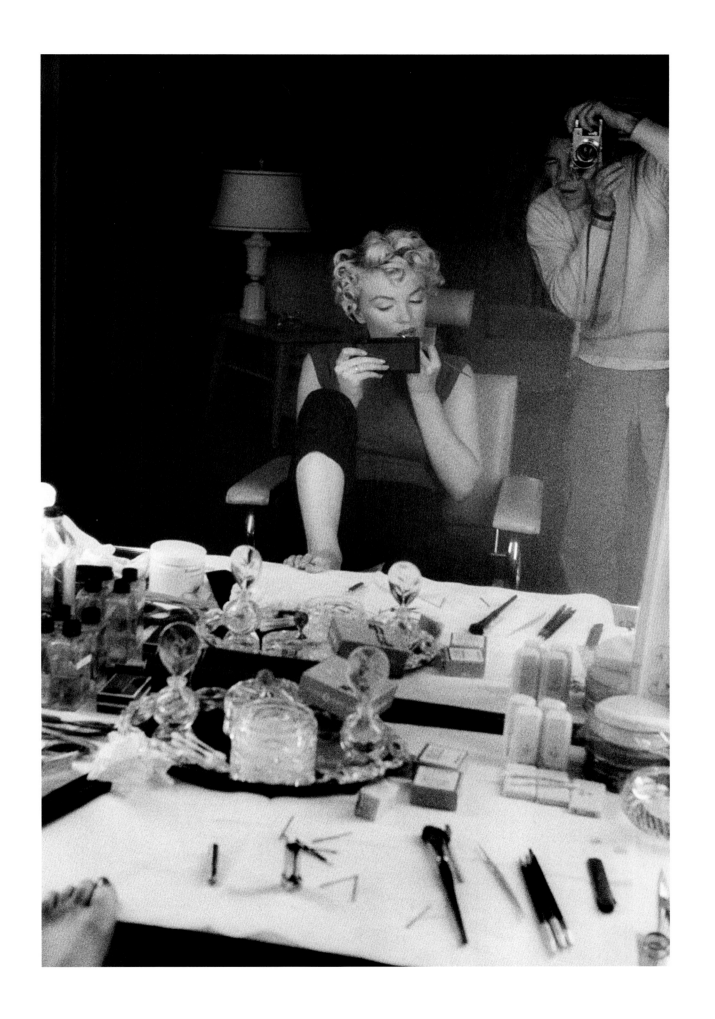

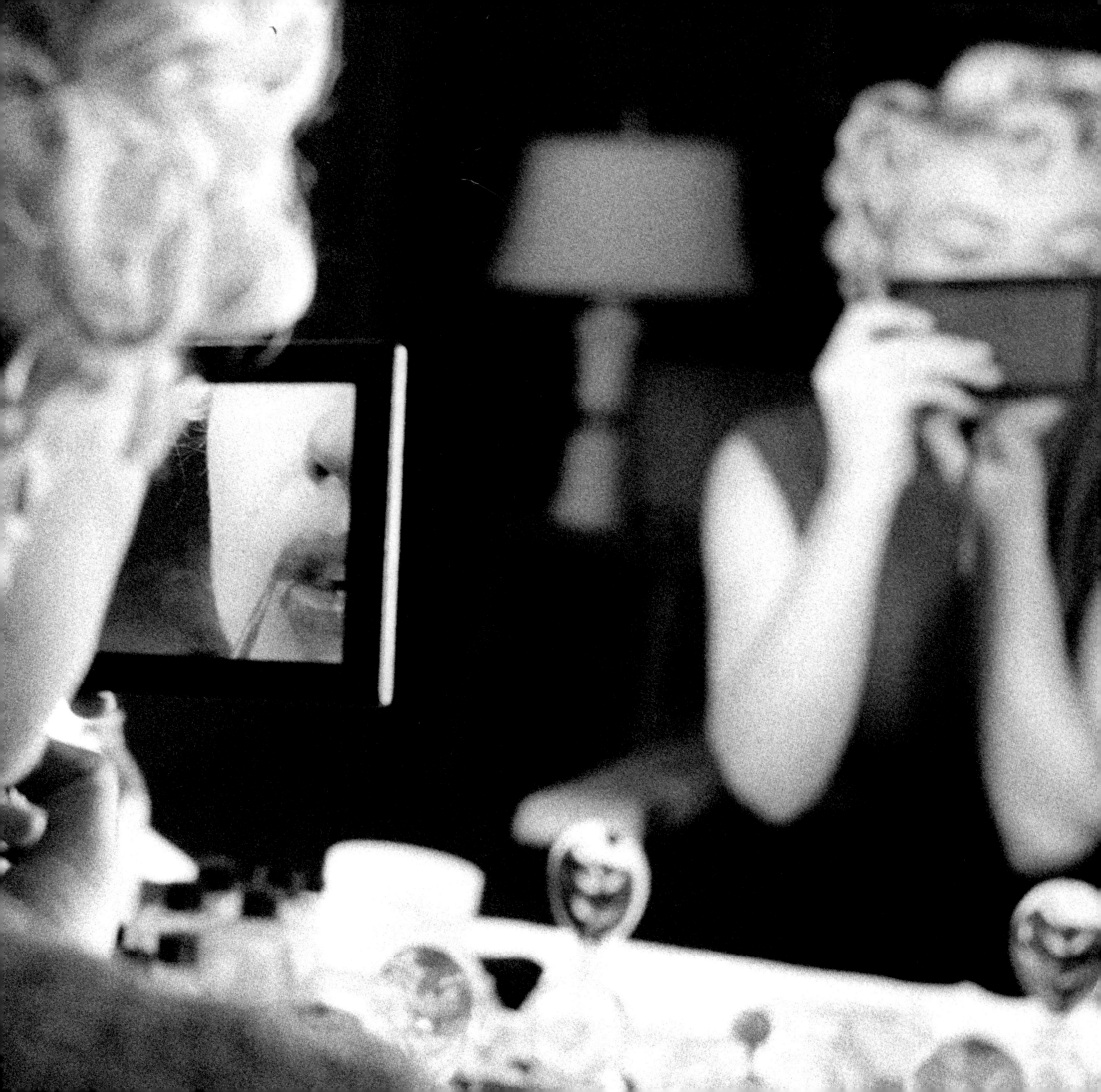

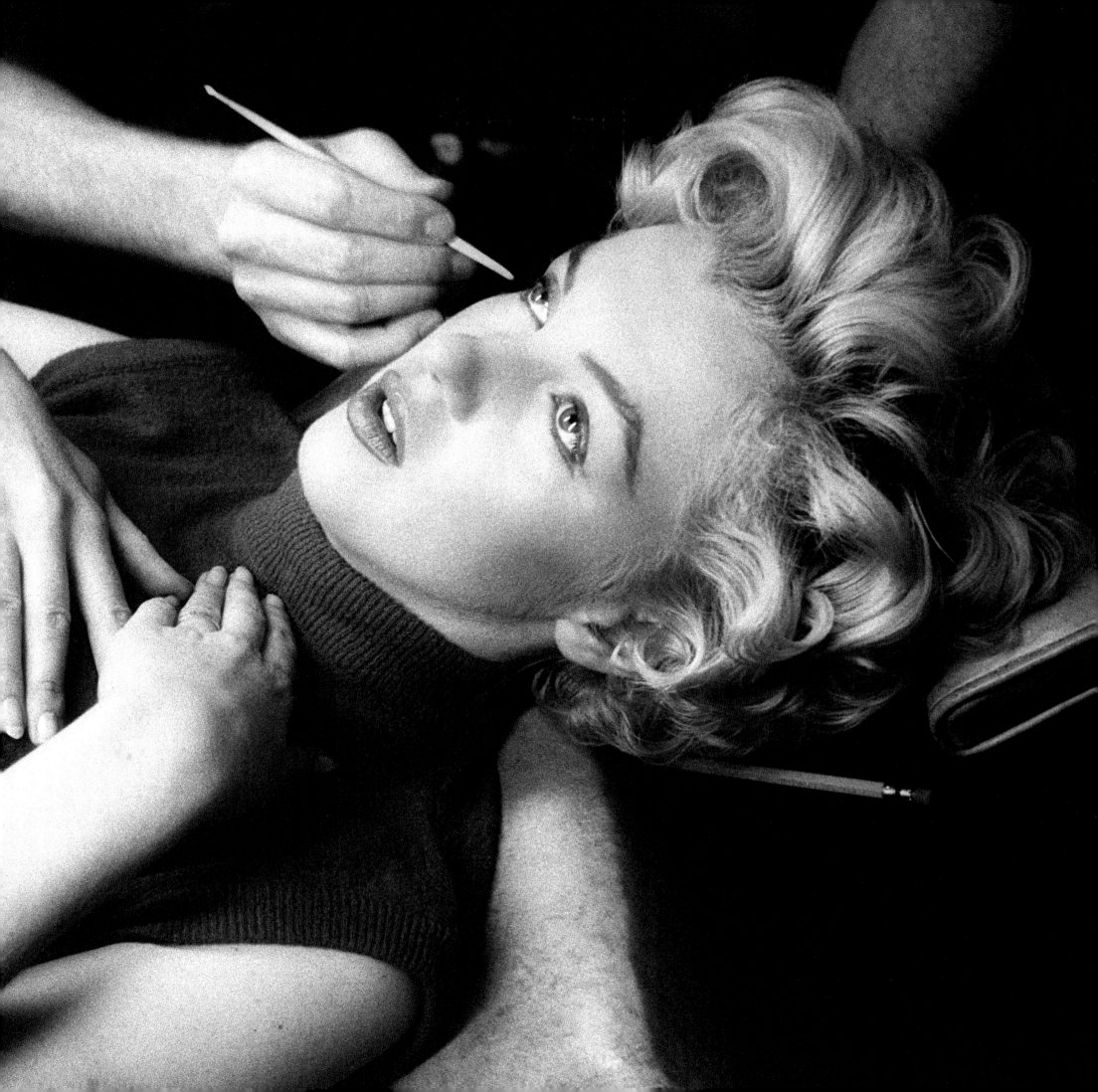

THE SEVEN
YEAR ITCH SET

September, 1954 – One of Marilyn's most iconic images is of
the scene from *The Seven Year Itch* when her dress, designed
by William Travilla, blows up while standing over the
subway grate. Milton was on the set when photographer
Sam Shaw captured that legendary moment. Off to the side
was her husband Joe DiMaggio, who became enraged
witnessing her free-spirited show of expression. Here,
Marilyn takes a break and talks with her acting coach at the
time, Natasha Lytess.

Unpublished image:
Page 105

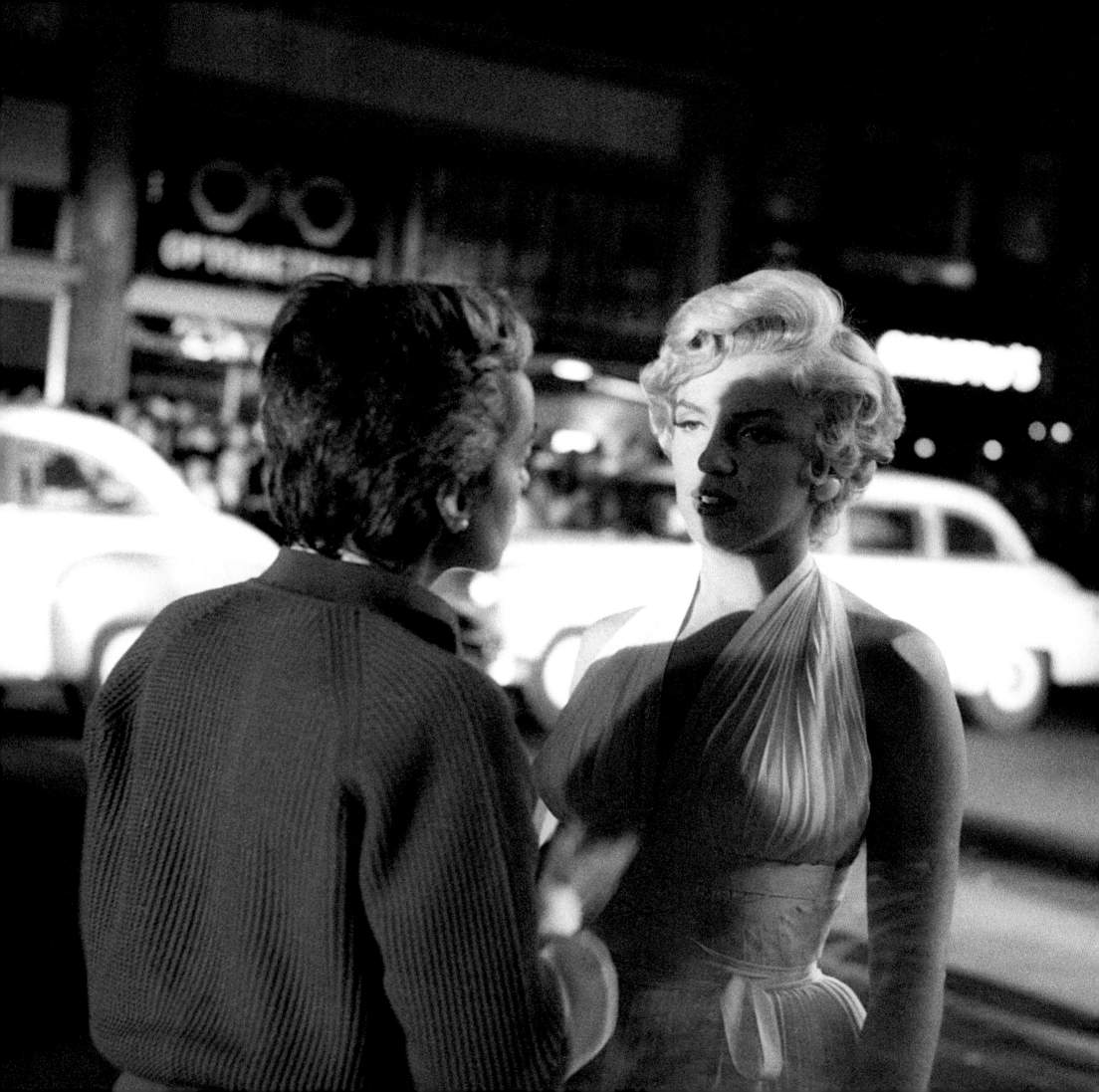

HOTEL ROOM

September, 1954 – Another series of candid photos taken by Milton. Knowing her unhappiness with her 20th Century Fox contract, Milton, with advice from his attorney Irving Stein, convinced Marilyn to come to New York and let Milton and Irving file a lawsuit against the studio. Milton assured her that he would cover her costs of living, room and board, massages once a week, as well as acting classes. This was Marilyn's introduction to living with the Greene family in New York and Connecticut.

Unpublished images:
Pages 108, 110

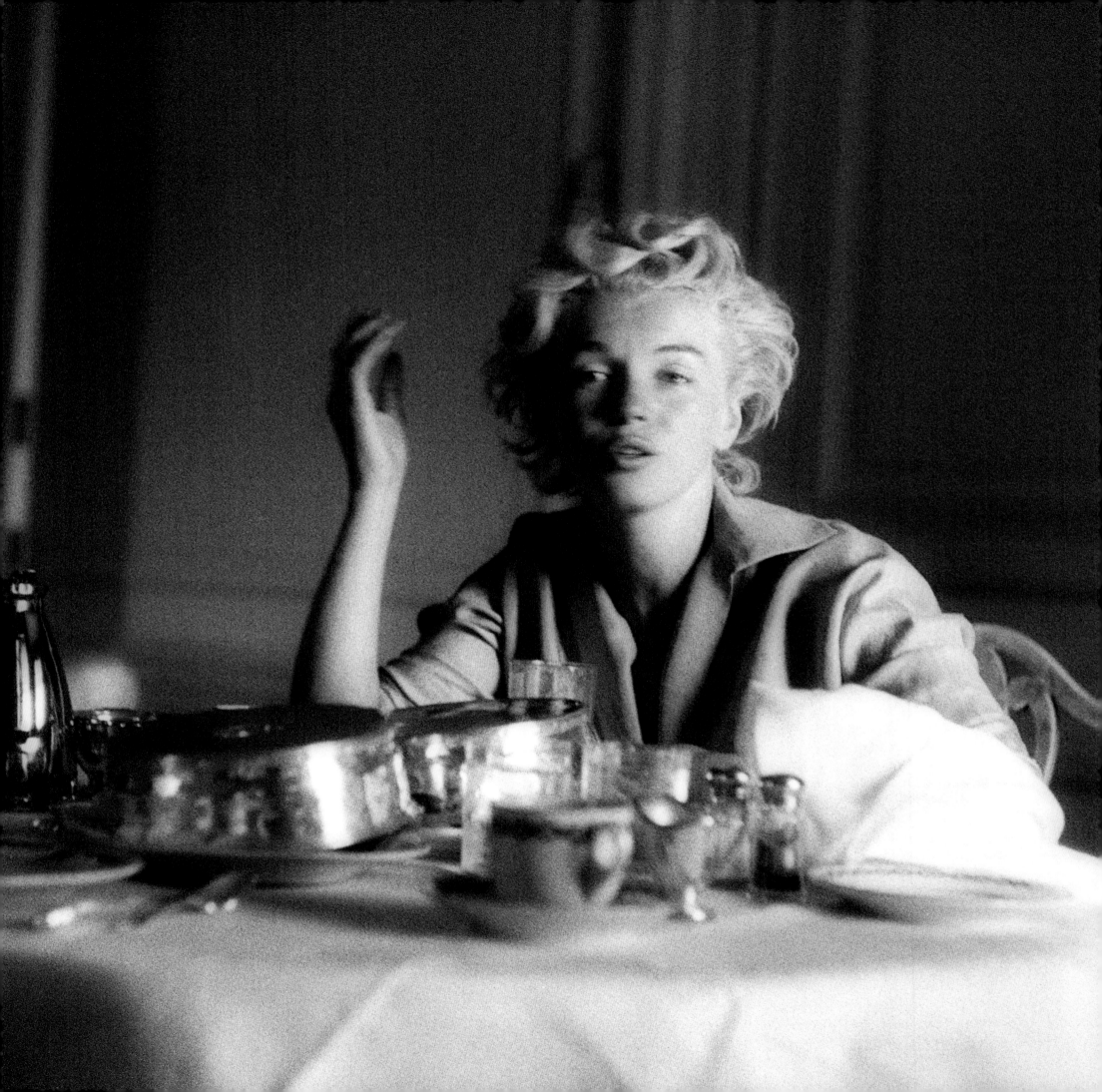

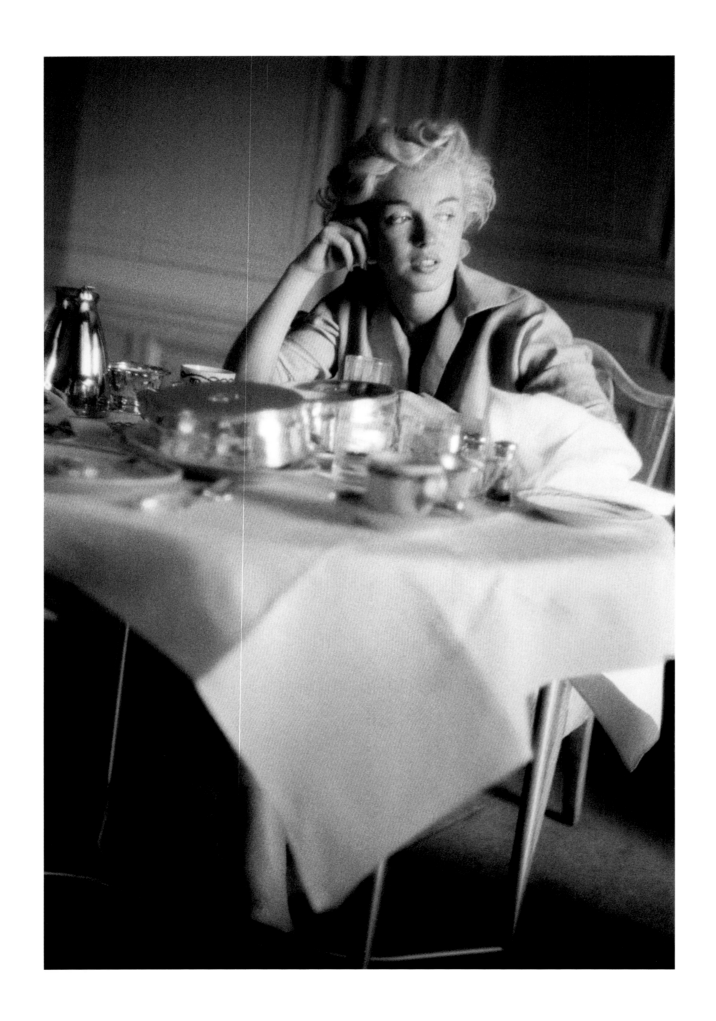

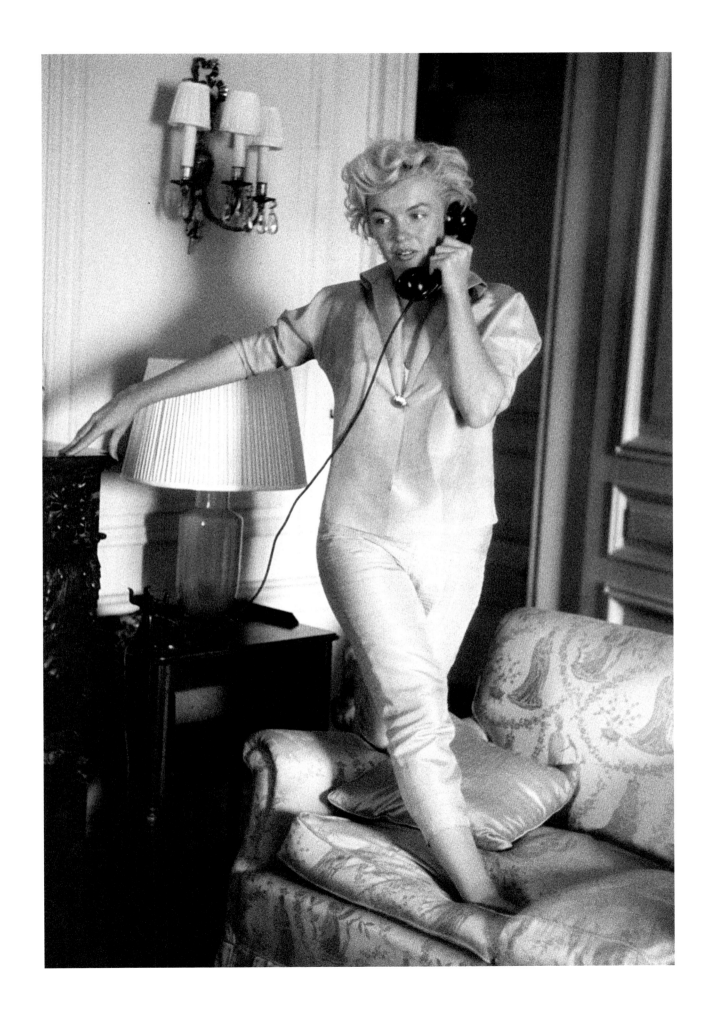

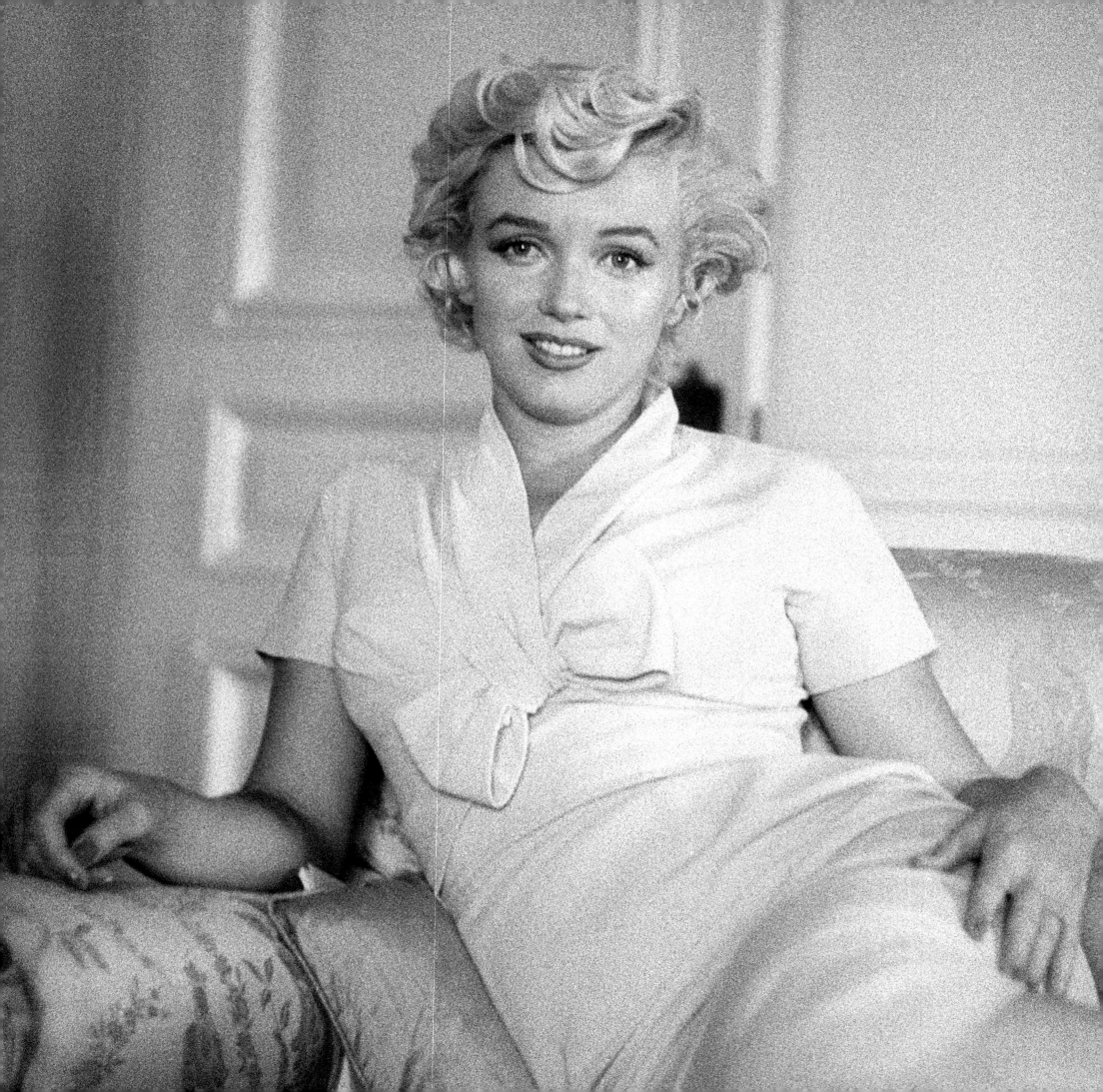

BALLERINA

October 1954 – Perhaps Milton and Marilyn's most recognizable series of images, the Ballerina Sitting was named by *Time* magazine in 1999 as one of the top three photographs of the 20th century, alongside Philippe Halsman's photo of Albert Einstein and Yousuf Karsh's Winston Churchill. Taken in Milton's New York studio, Marilyn is wearing an ill-fitting tulle and satin dress. The design of the dress has been commonly attributed to Anne Klein, a close personal friend of the Greenes whose clothes Milton frequently borrowed. However, it was actually created by another New York designer, Herbert Kasper, while working for 7th Avenue fashion manufacturer Arnold-Fox. Milton also used Kasper's designs at various times during the 1950s. The fitting error was because Milton's wife, Amy, did not know Marilyn's actual dress size, as they had yet to shop together. Apparently, the dress was two sizes too small, requiring Marilyn to hold up the front bodice. What we love is Marilyn's ability to take it all in her stride. It was her sense of humor and deep trust in Milton that made this such an iconic series.

Unpublished images:
Pages 116, 118L, 120

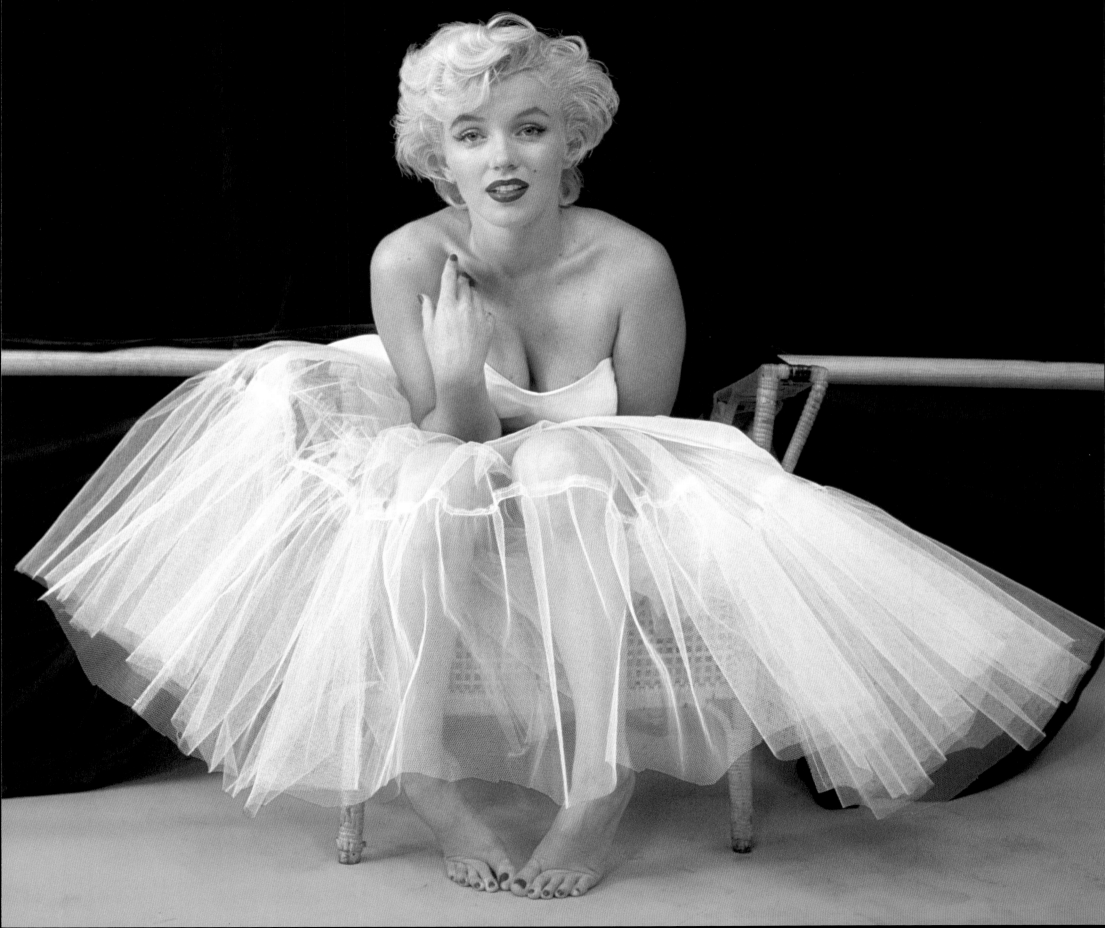

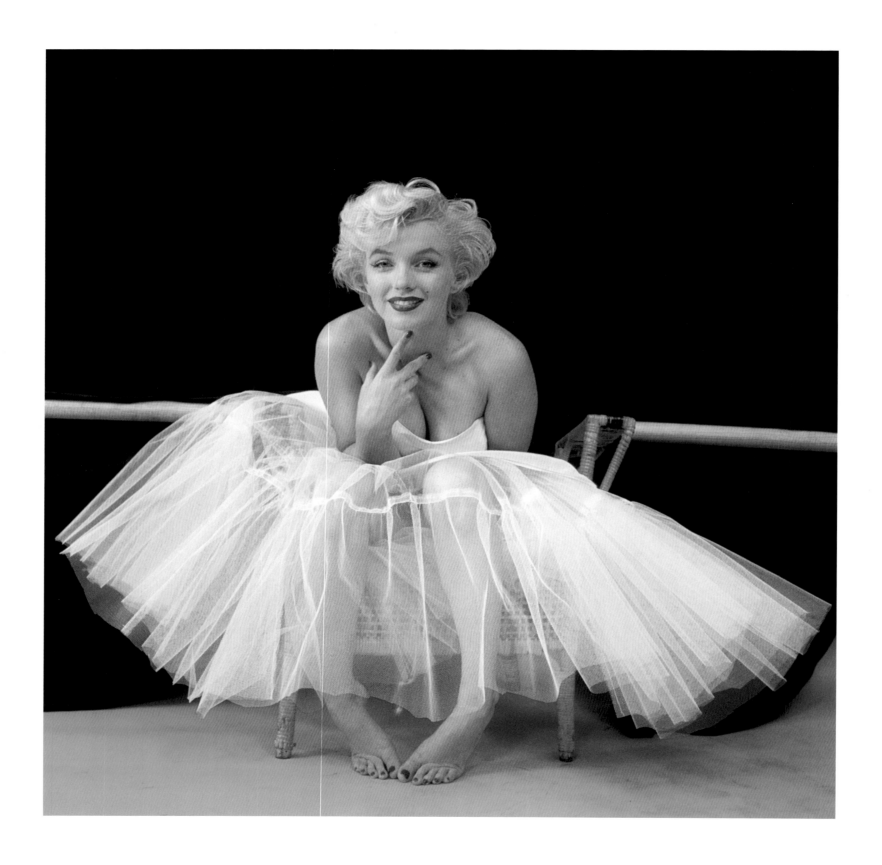

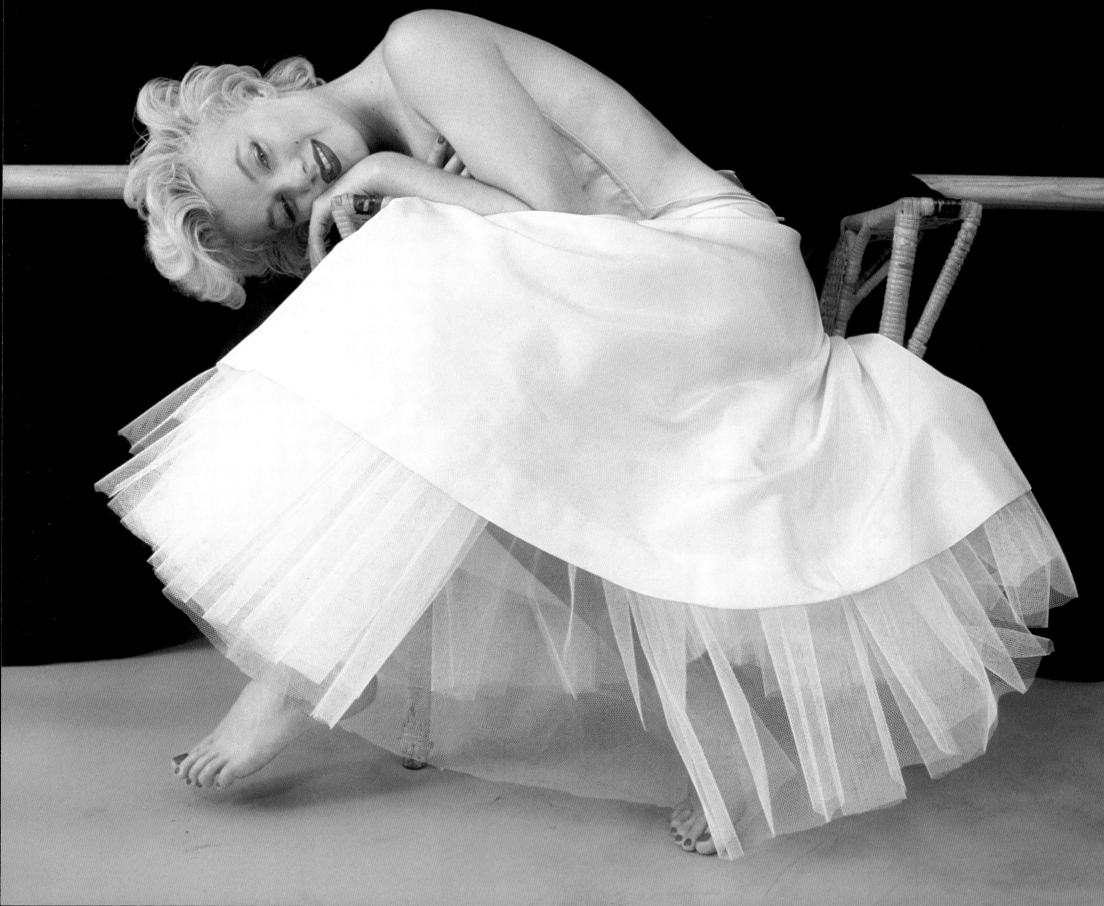

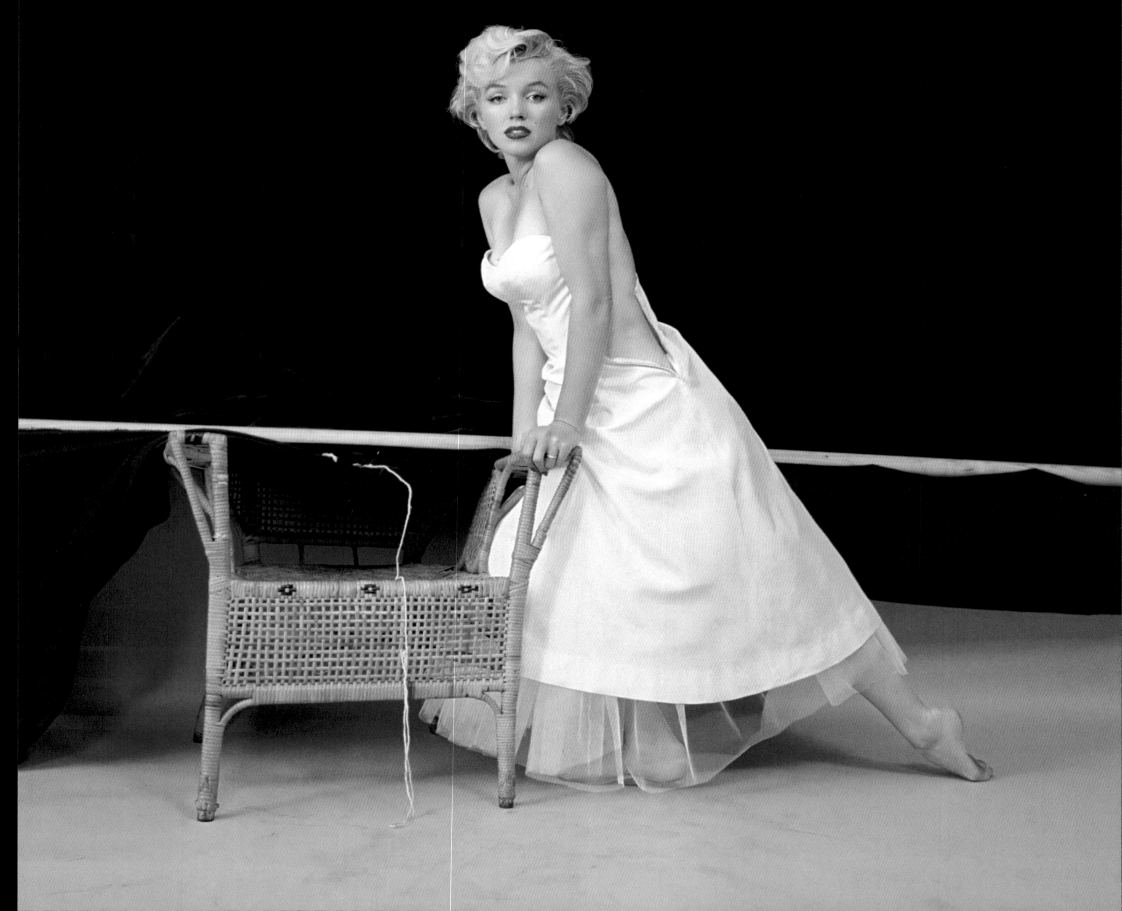

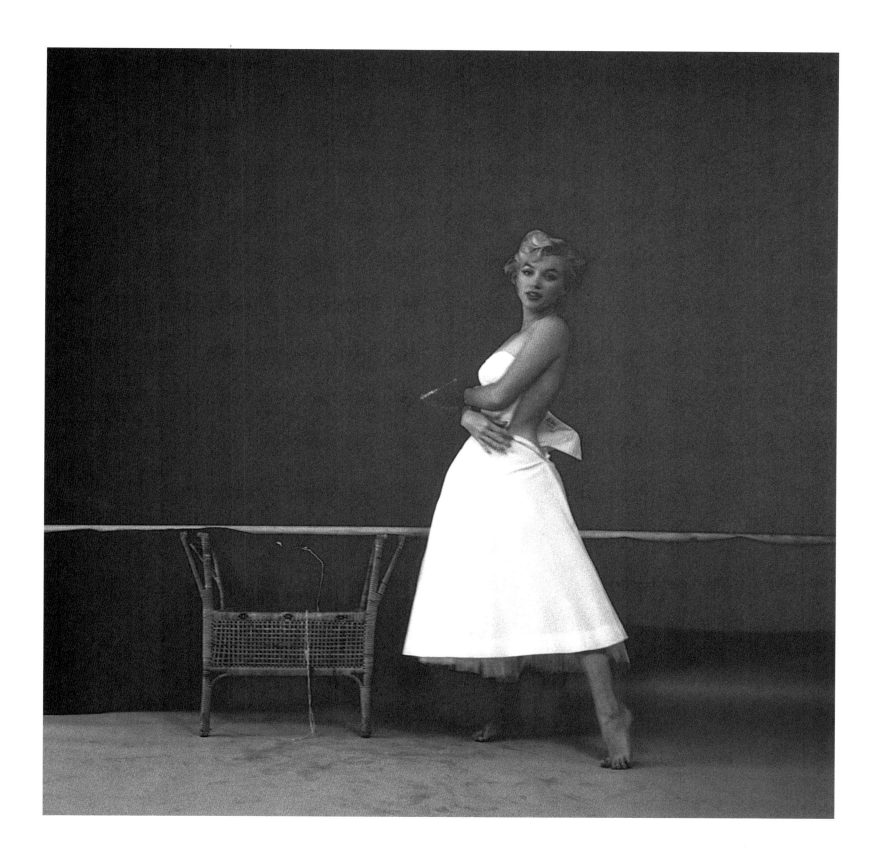

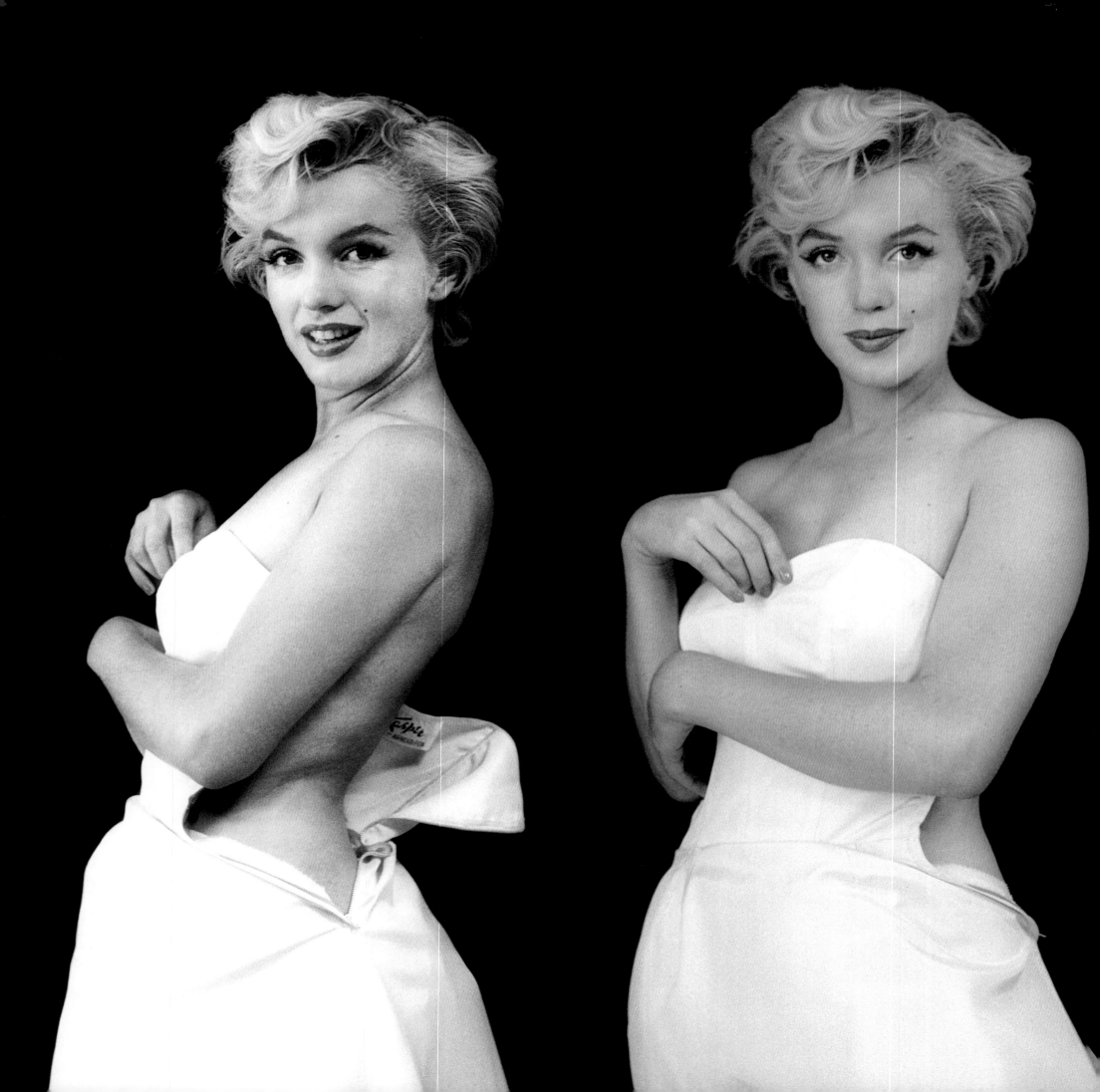

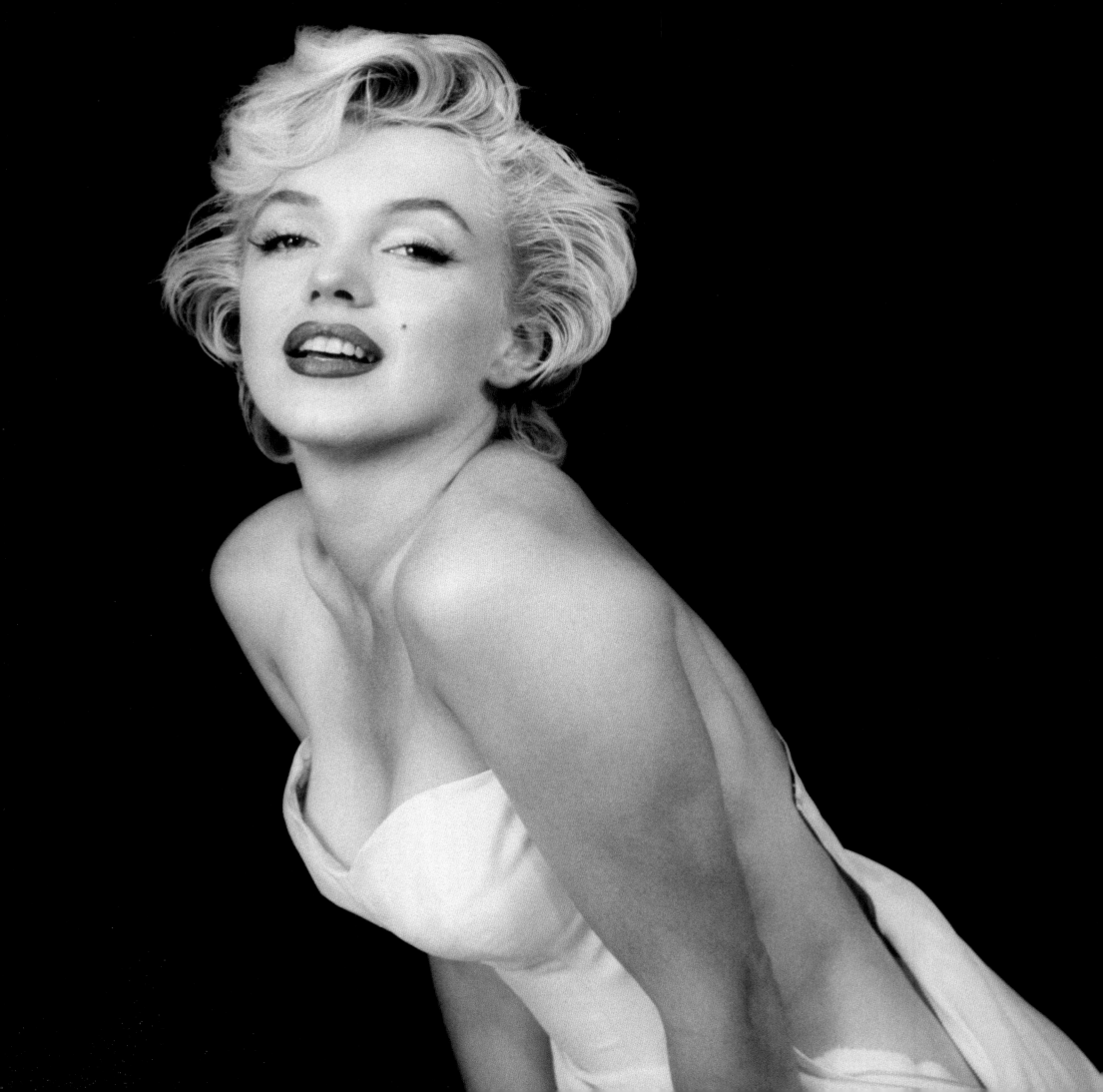

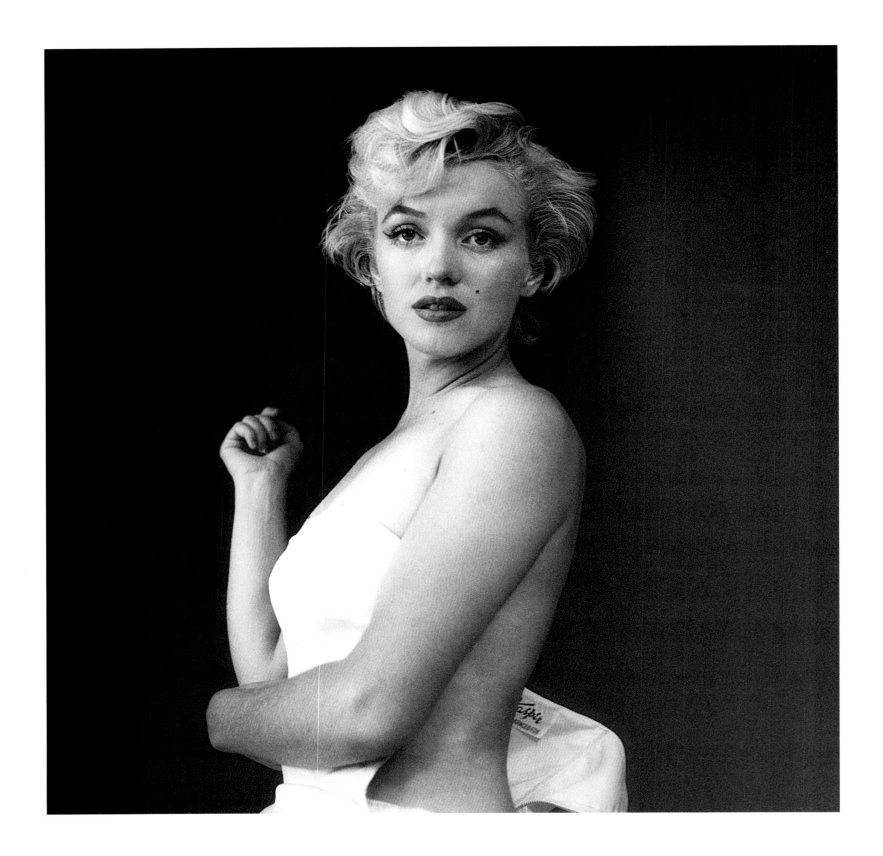

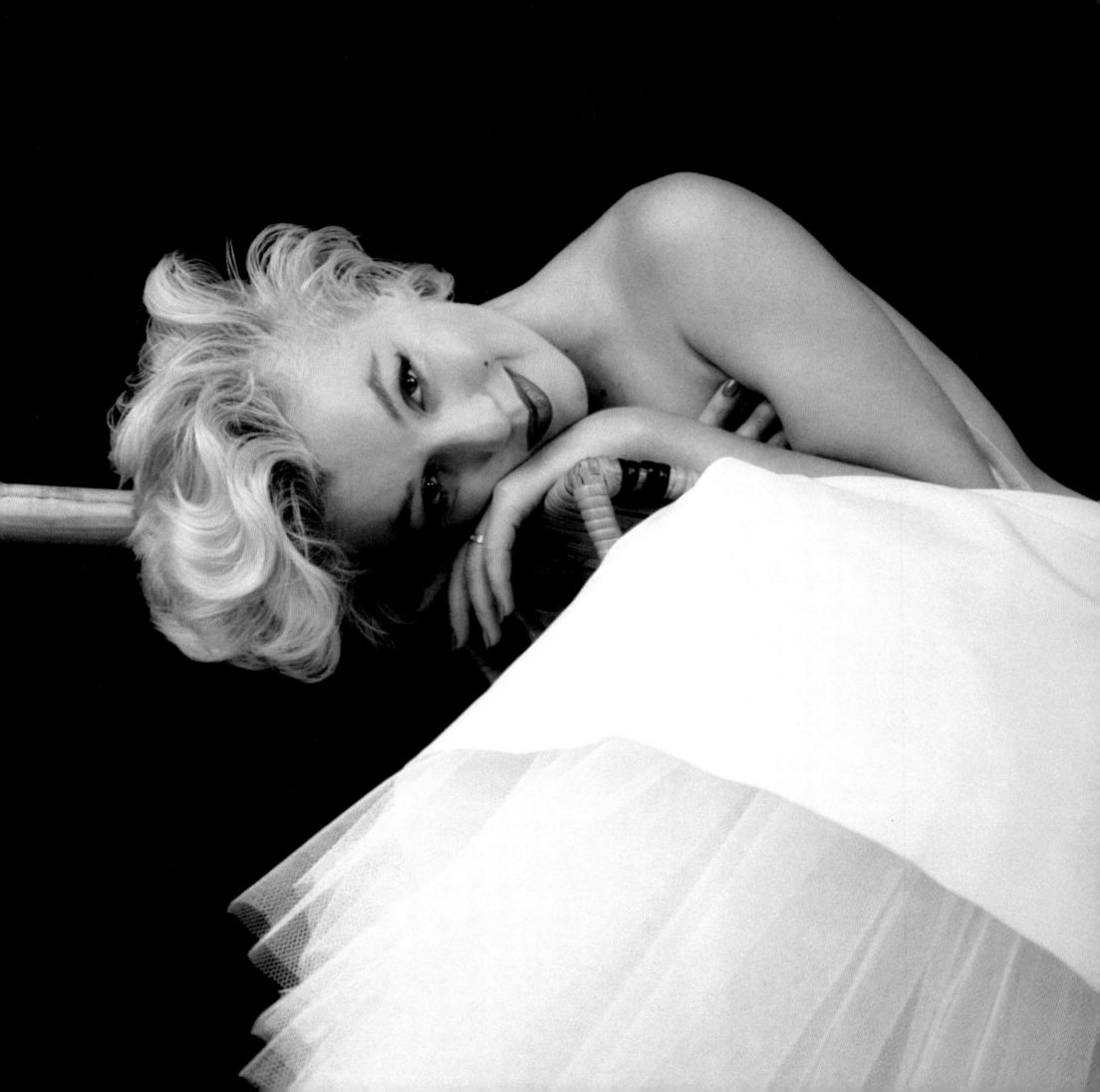

GOLD DRESS

October, 1954 – Taken the day after the Ballerina images,
Milton made an effort to keep Marilyn focused and occupied.
Now living full-time in New York, Marilyn was living life
like she should: going to jazz clubs, enjoying great theater
and studying her craft.

Unpublished image:
Page 125

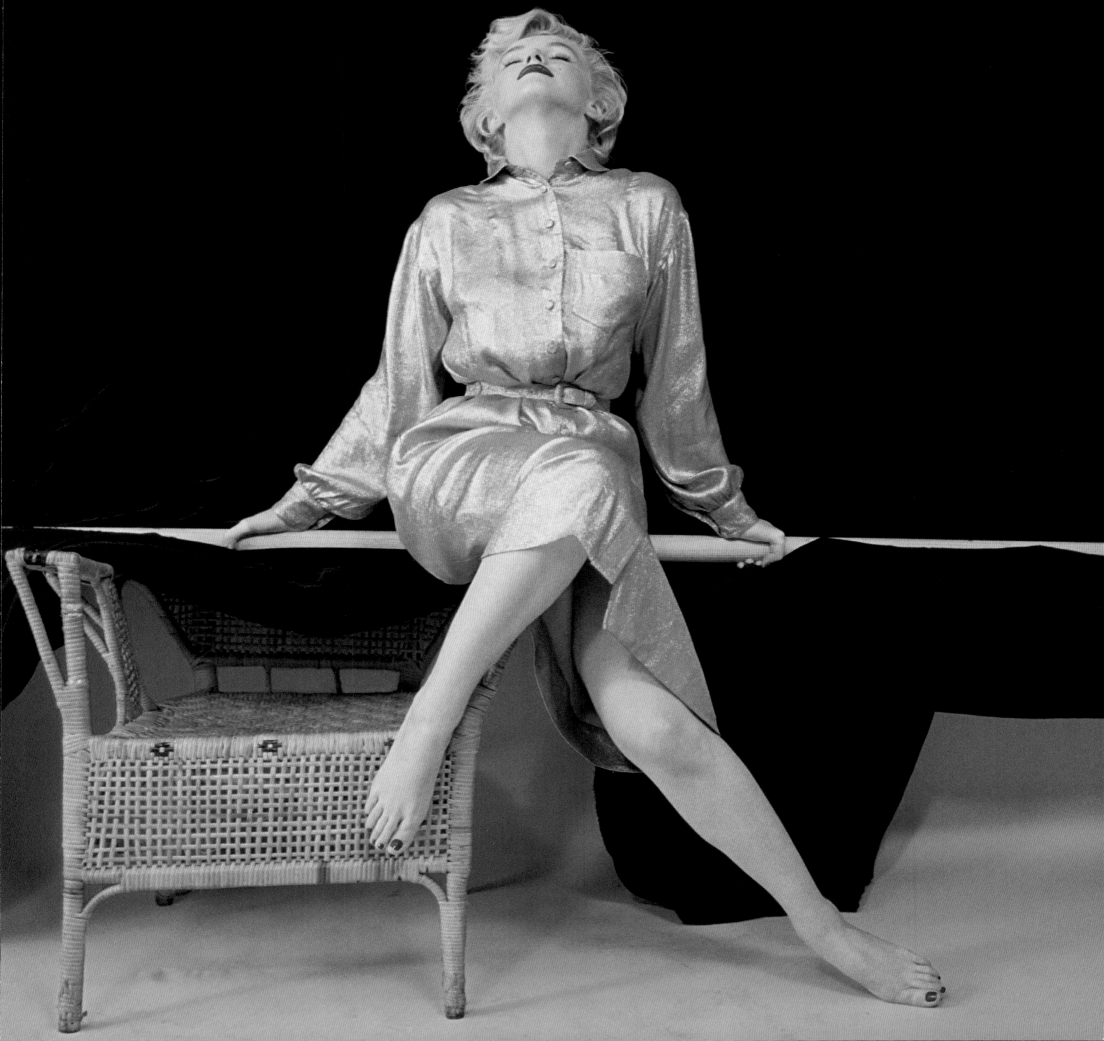

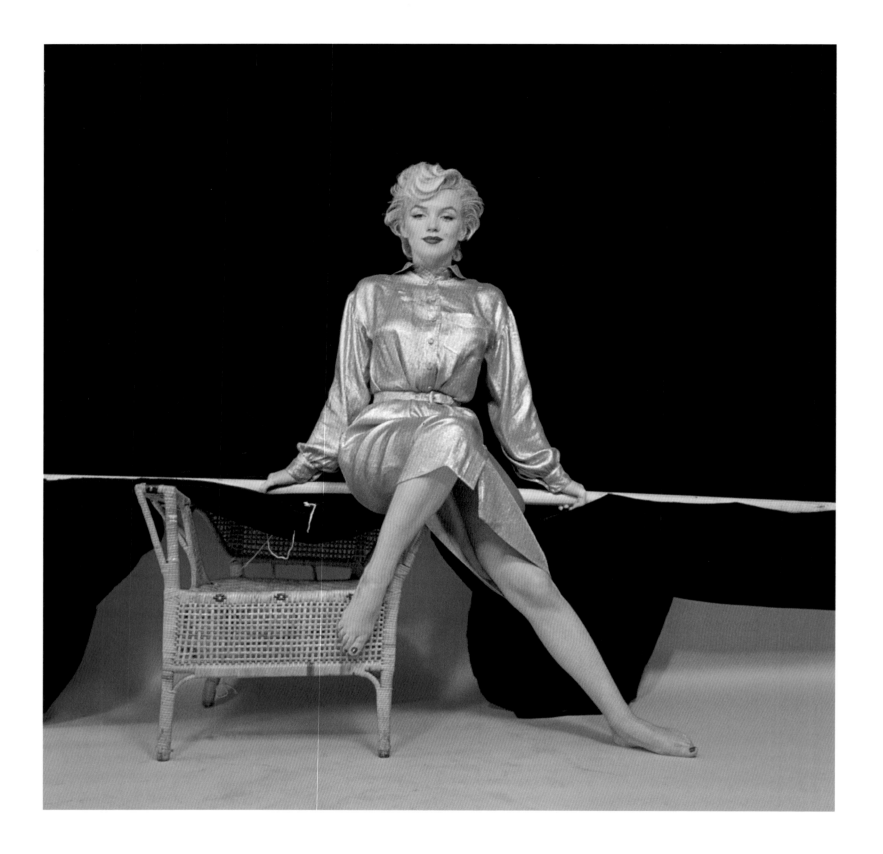

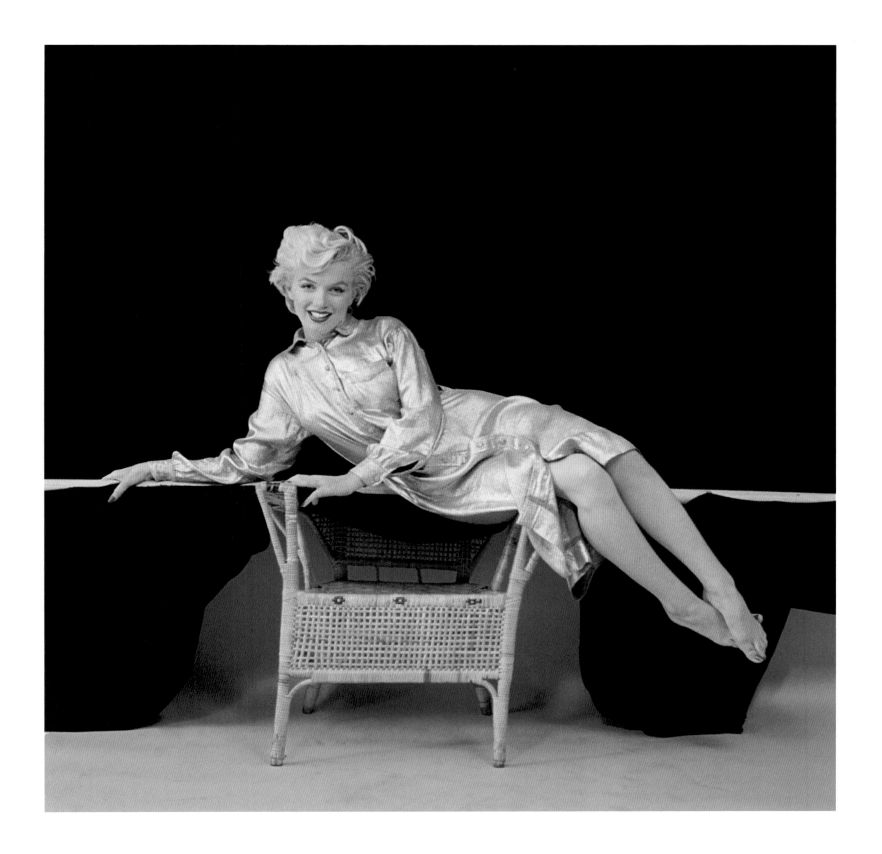

COCKTAIL PARTY

January 1955 – After a year in self-imposed exile from her public, and living with the Greene family in New York while battling Fox, Marilyn and Milton were able to announce the formation of Marilyn Monroe Productions (MMP).
On January 7, 1955 they held a press conference to announce the new company and had a reception that evening. Among the celebrities on Milton's guest list was another Hollywood sex goddess from a bygone era, Marlene Dietrich.

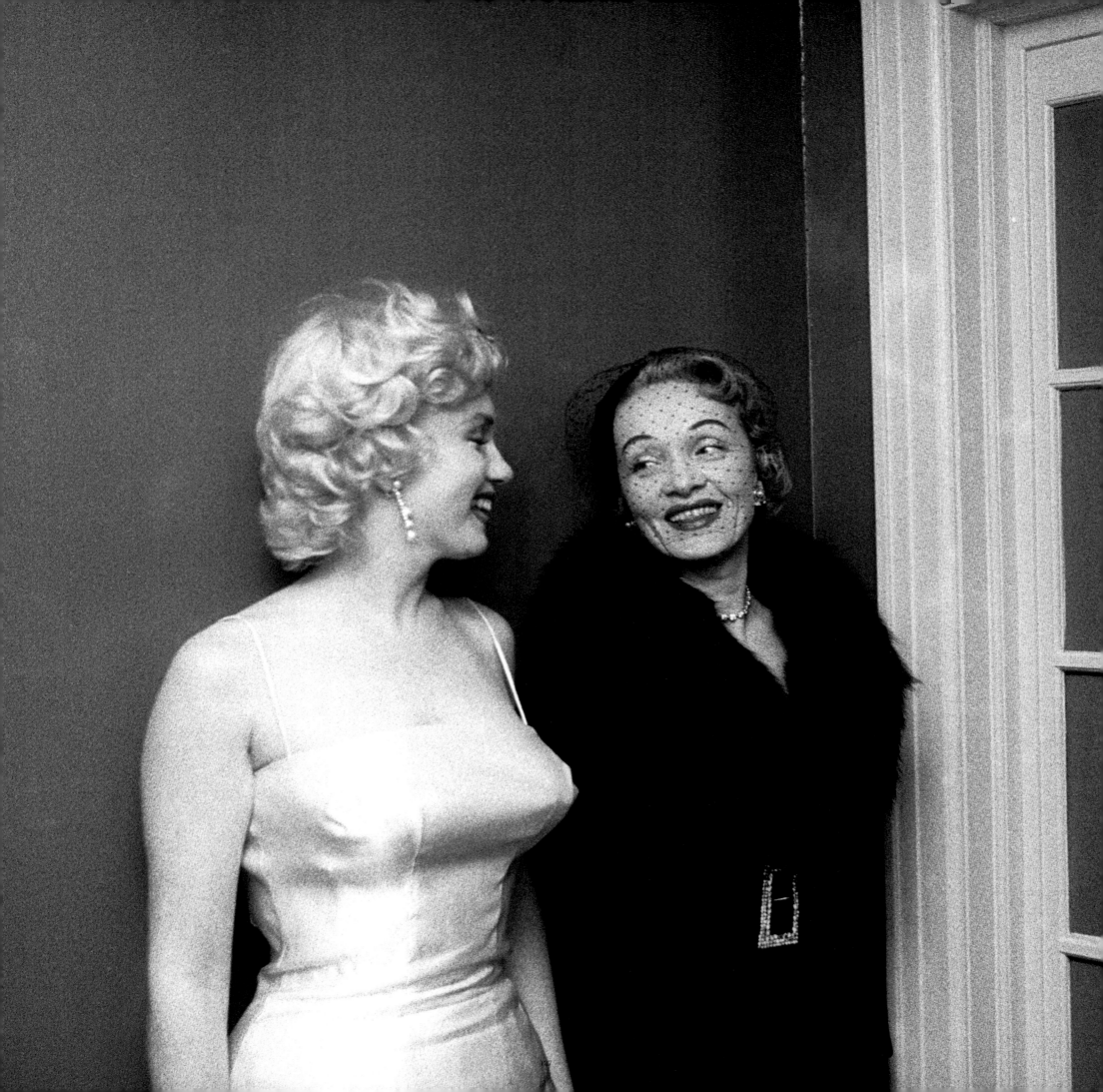

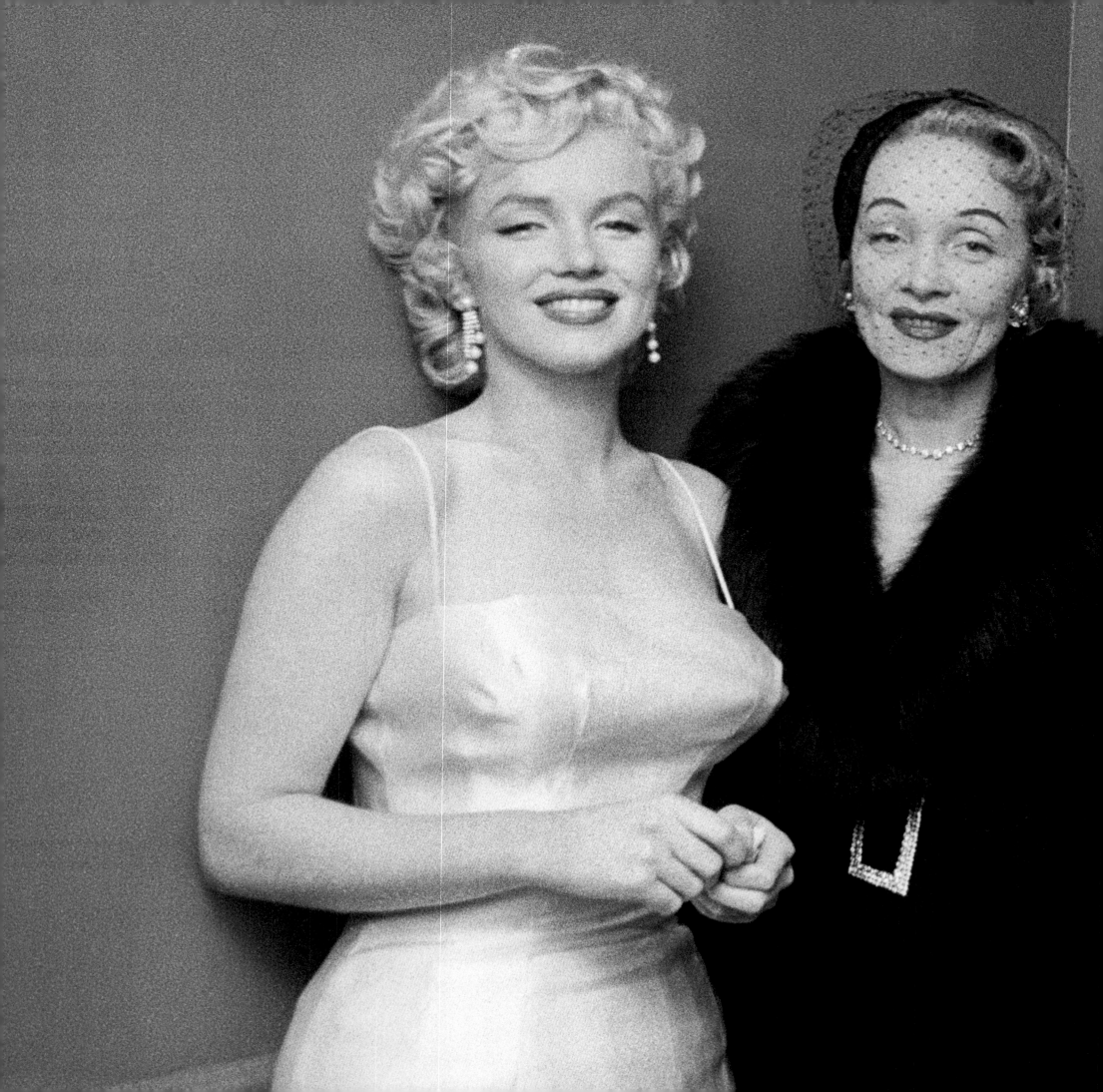

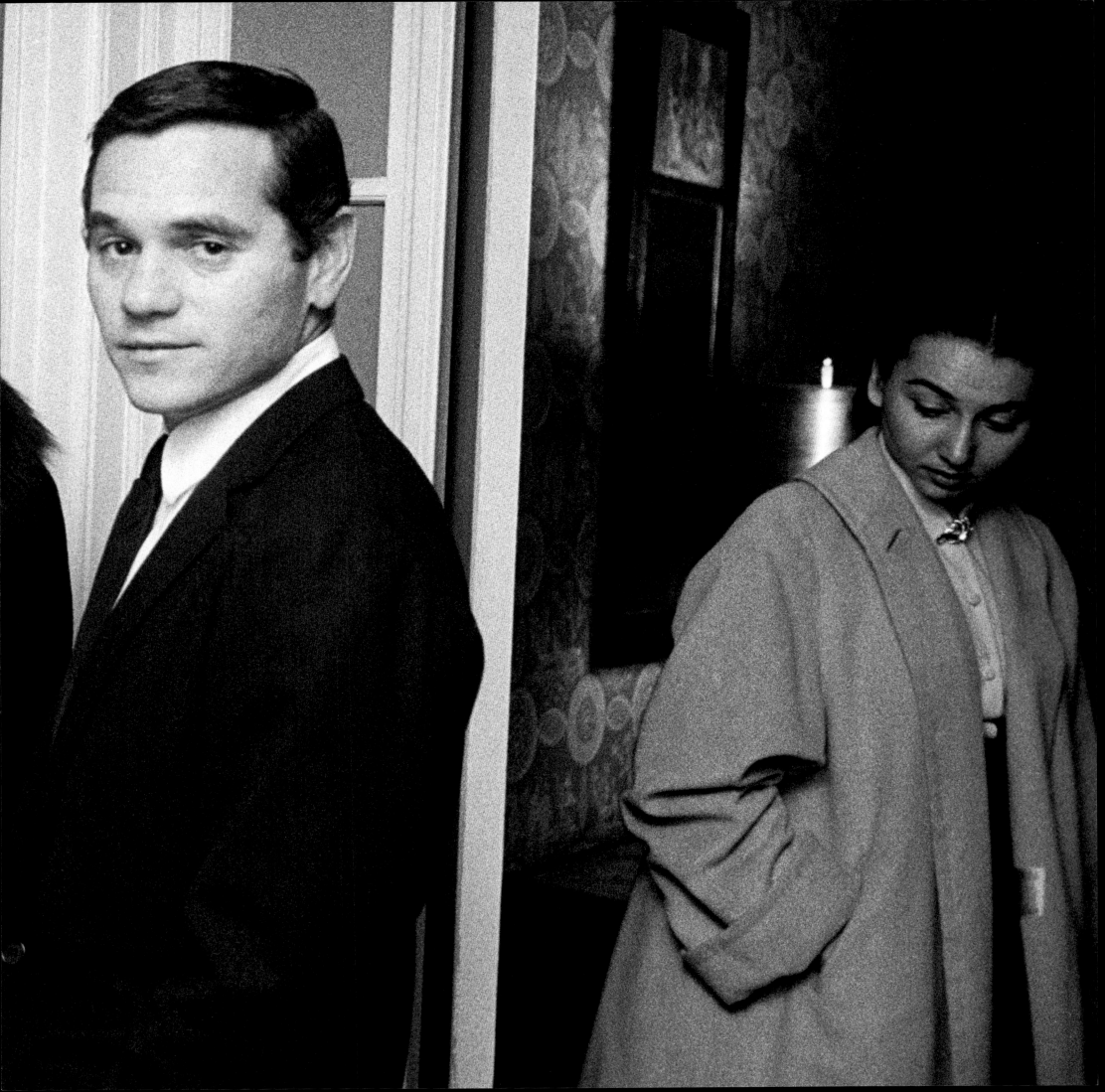

480
LEXINGTON

February 1955 – 480 Lexington was the address of Milton's famed New York studio. The tenants in this building were primarily photographers, architects, designers and engineers who were on the cutting edge of designing lighting equipment and camera accessories. Milton's studio on the 14th floor had the higher ceilings and 10-foot French doors that opened onto a loggia, which was a balcony that wrapped around the entire exterior of the 14th floor. Milton used this as a location for many photos during his career.

Unpublished images:
Pages 132, 133

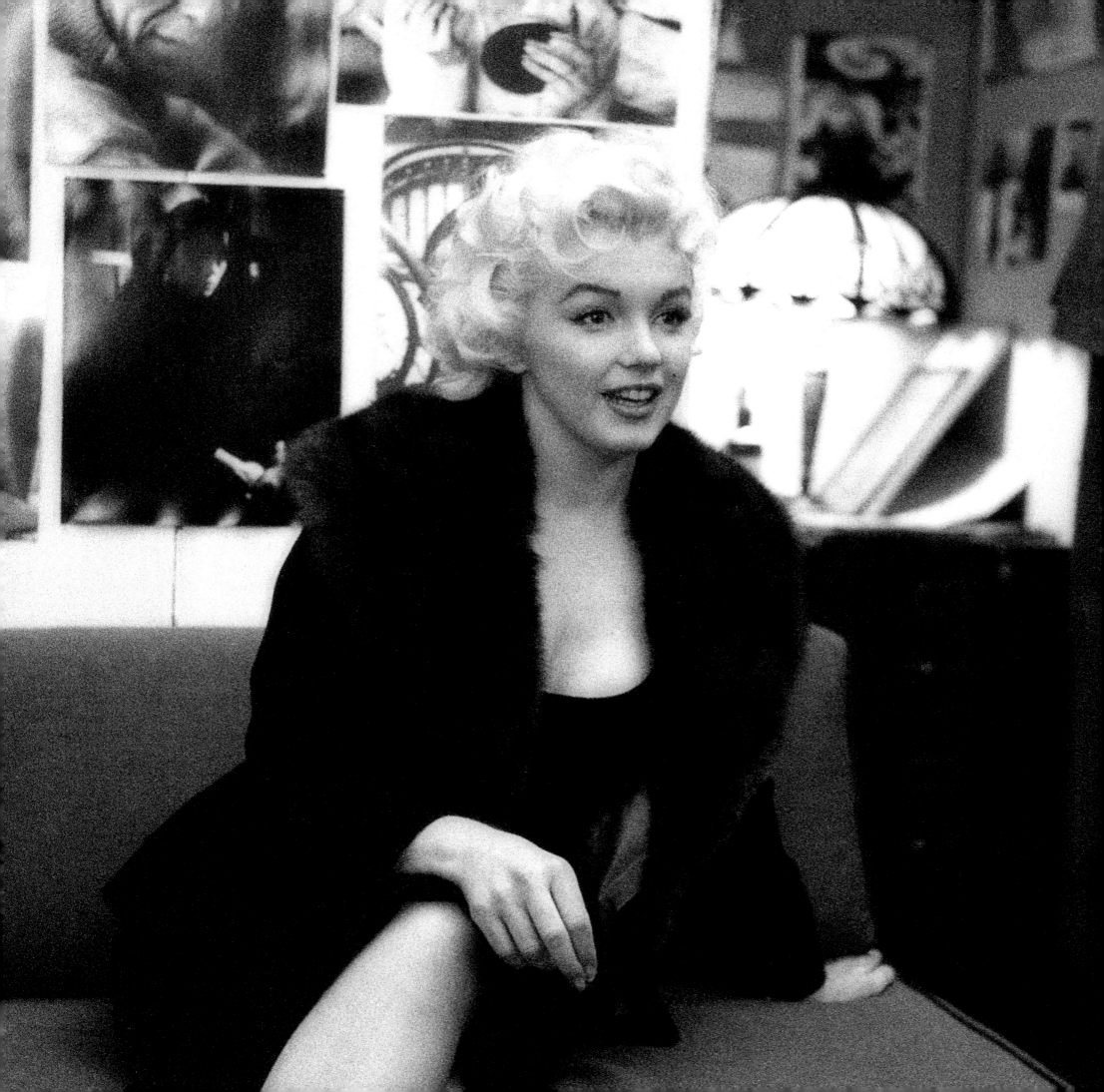

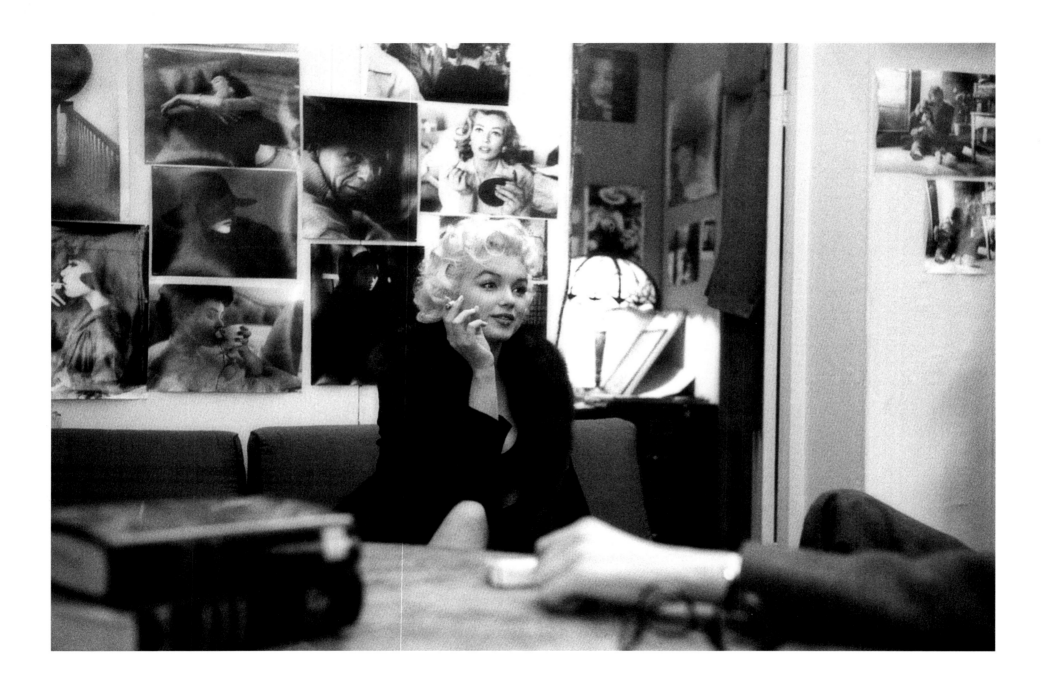

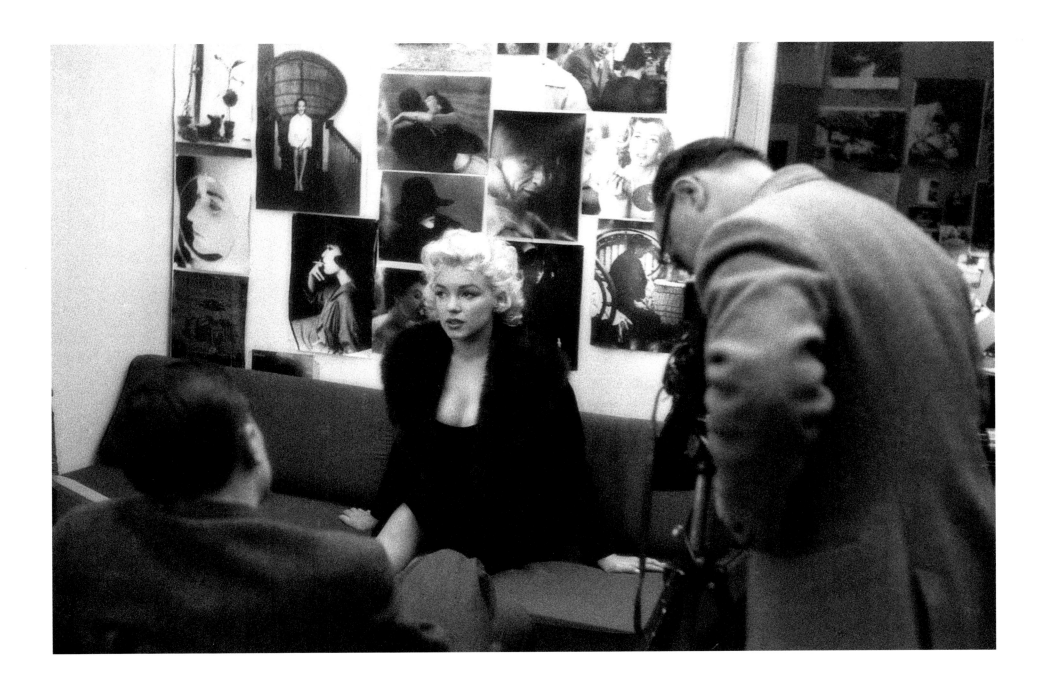

ORIENTAL

February 1955 – Look magazine gave Milton an assignment to shoot oriental gowns. Marilyn posed as the model. Close family friend, artist Joe Eula was the stylist. They created the right setting with Asian-style furnishings: a screen, a table and large pillows with tassels. Milton and Joe's wicked sense of humor led them to include Pekingese dogs as an Asian accessory. One of the images from this sitting appeared in *Look's* June 14, 1955 edition.

Unpublished images:
Pages 136, 137

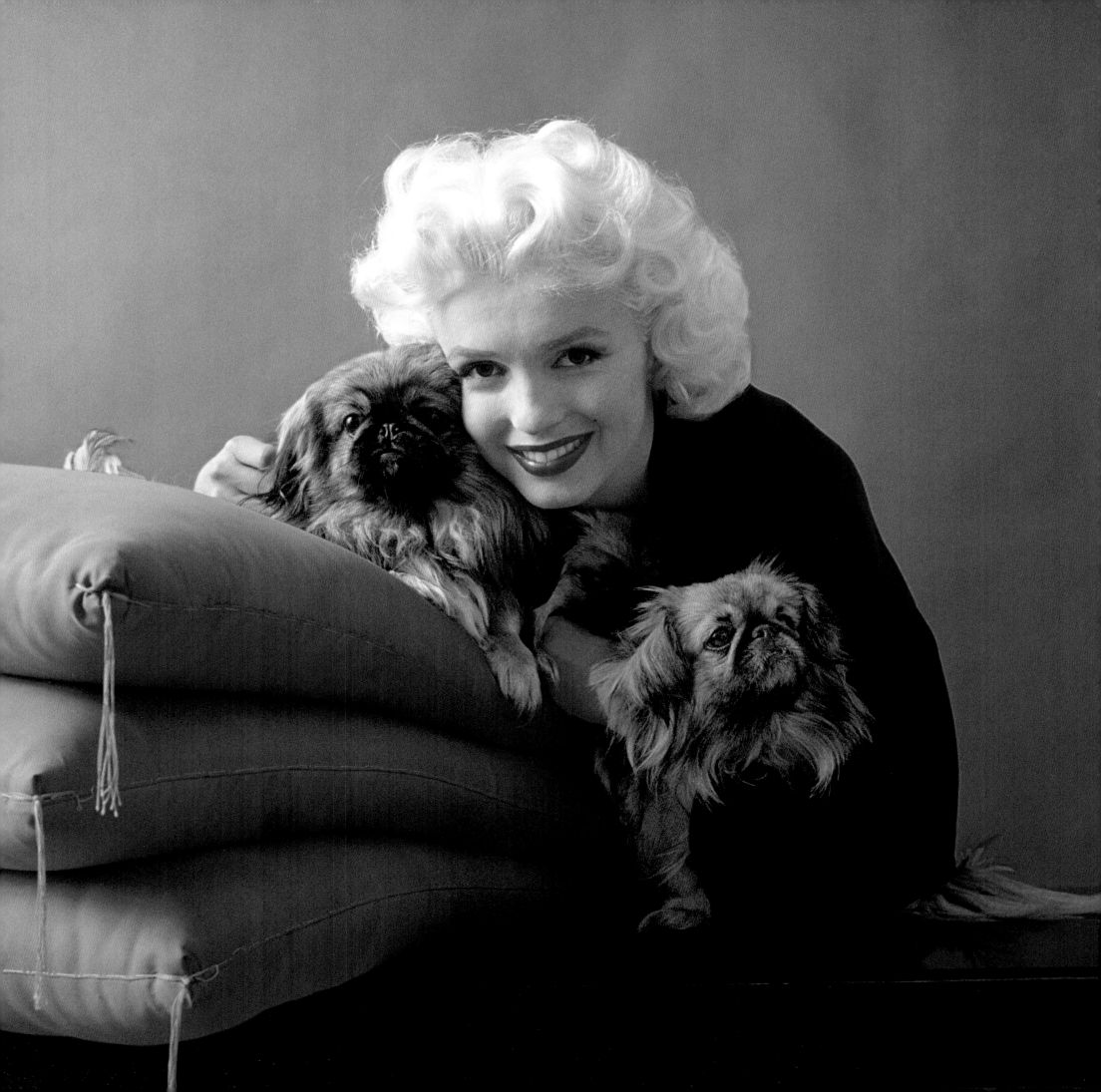

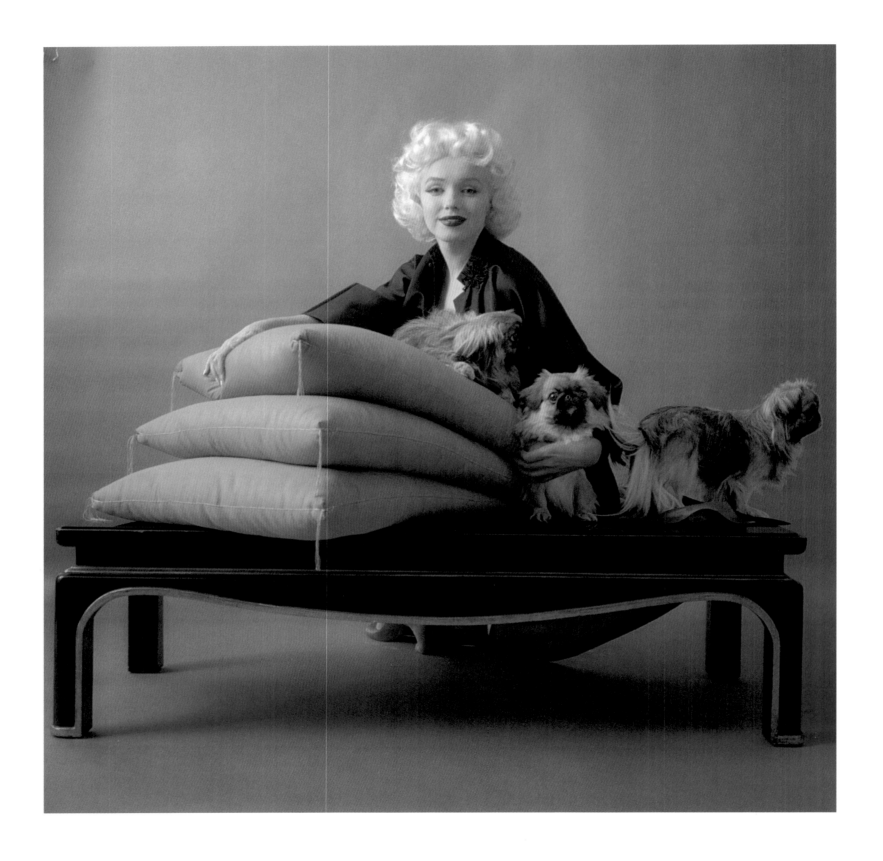

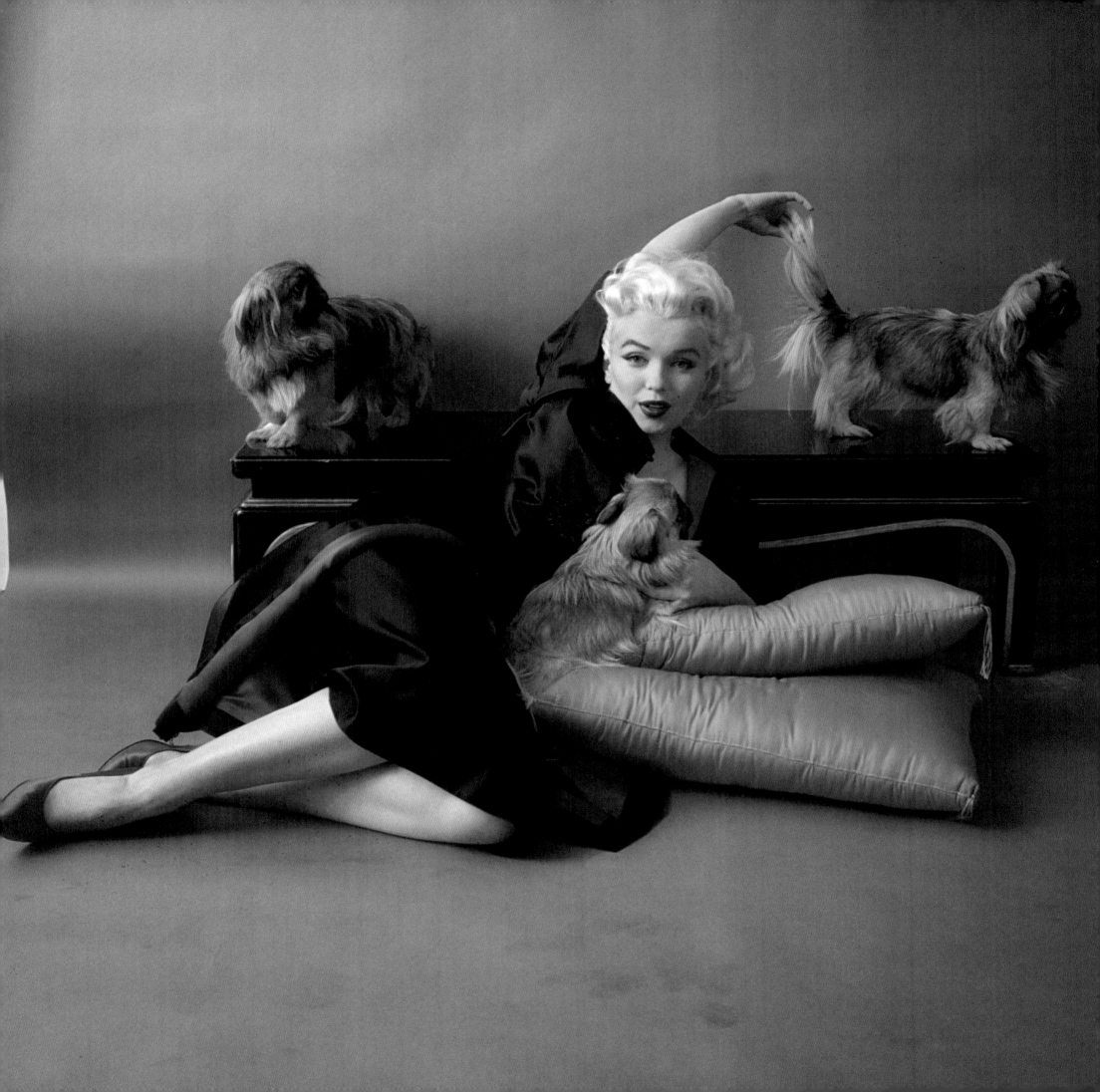

WHITE ROBE

March 1955 – Here Marilyn has just finished doing her
makeup, and is wearing her favorite outfit, a white
terrycloth robe. As she came out of the studio, Milton said,
"Let's shoot this." And, unprompted, he began shooting
her in the robe.

Unpublished images:
Pages 142, 143, 144

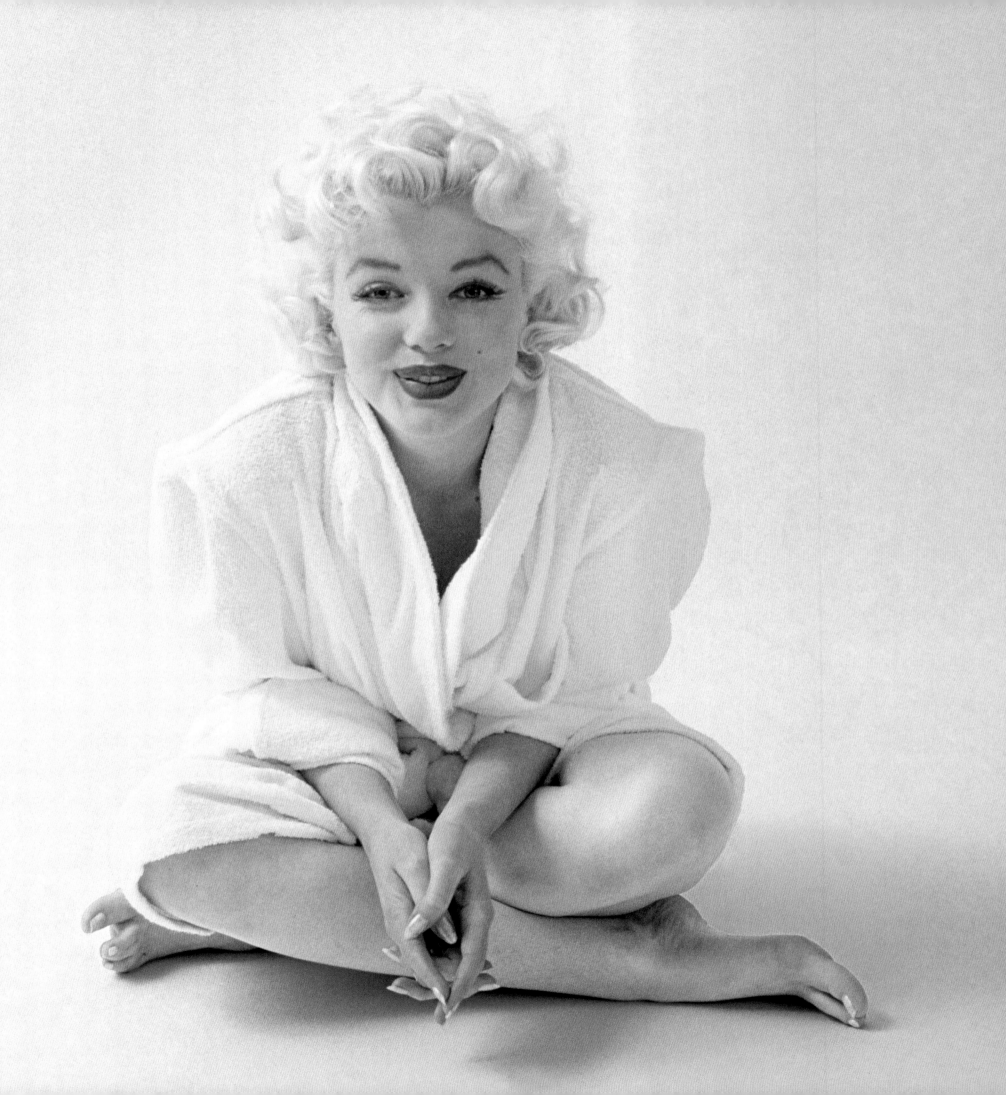

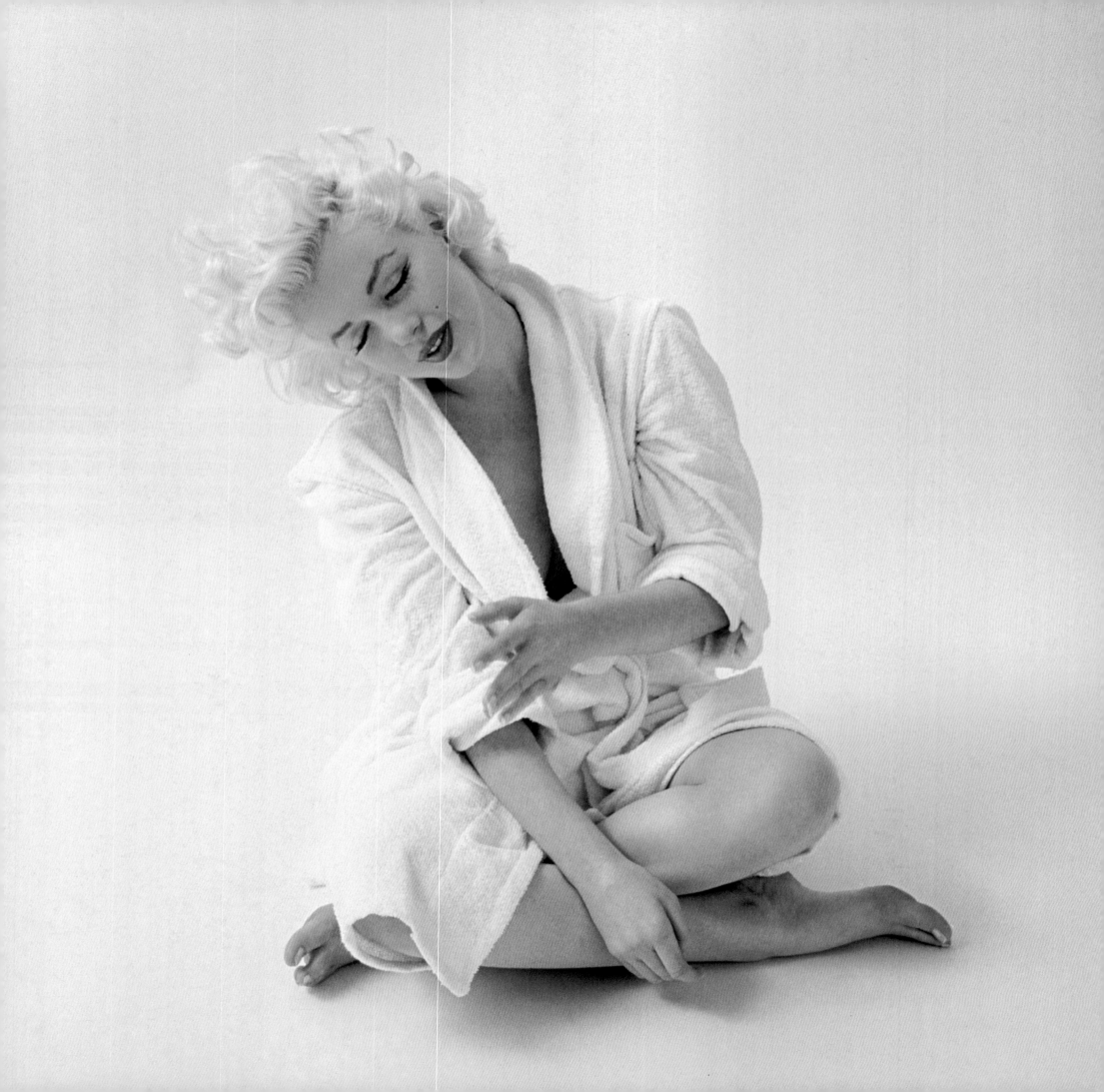

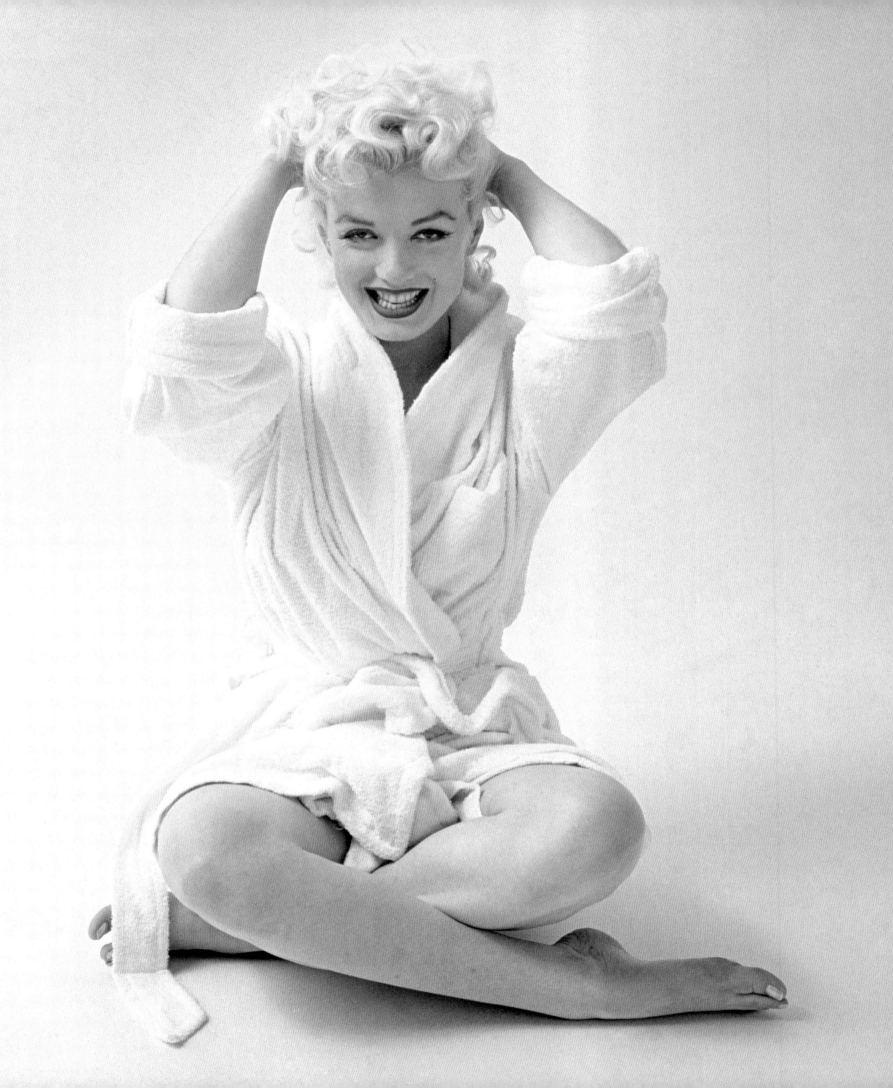

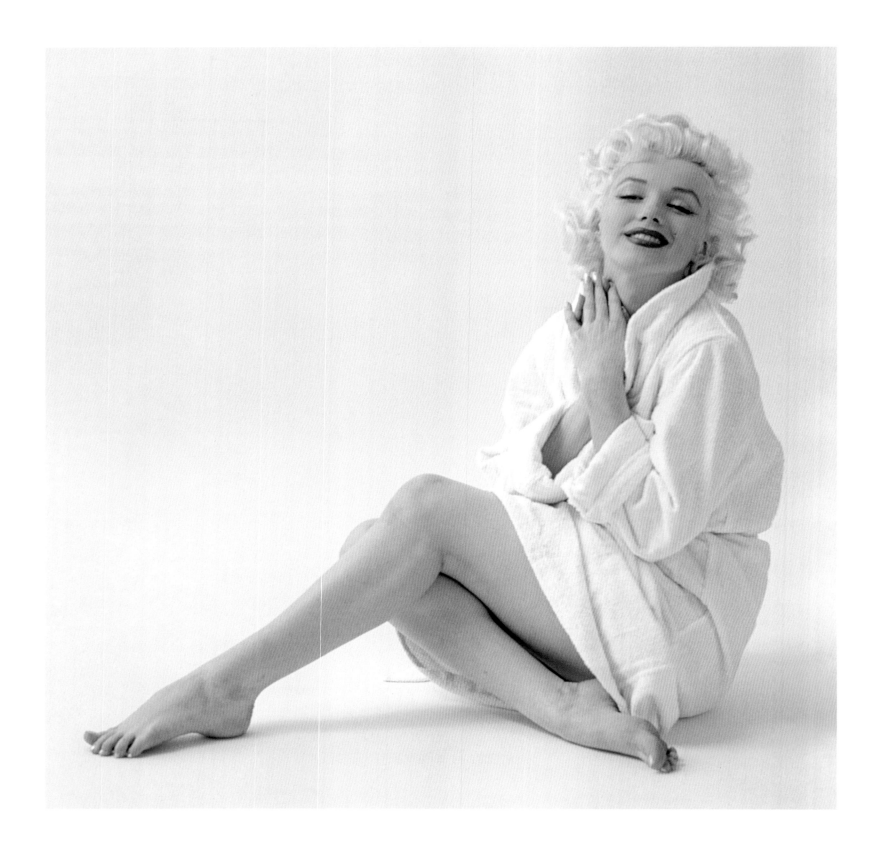

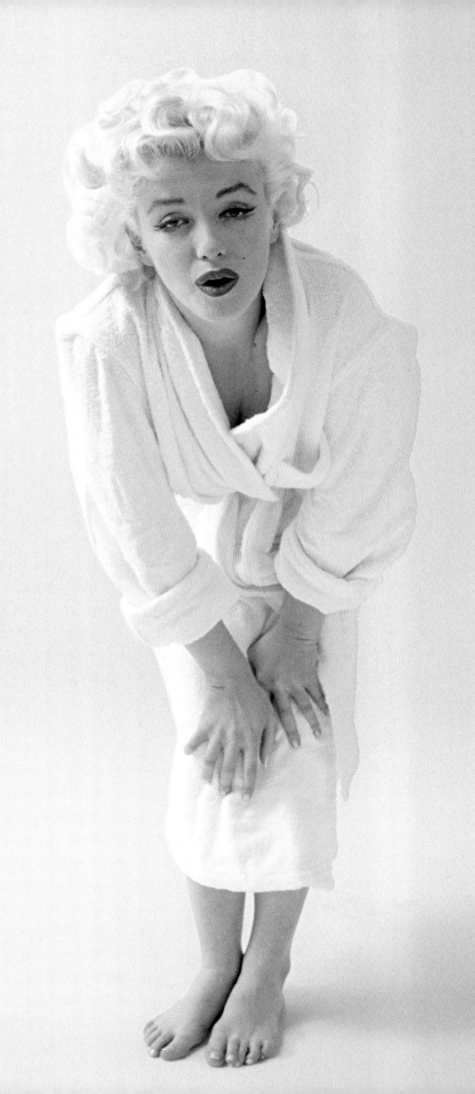

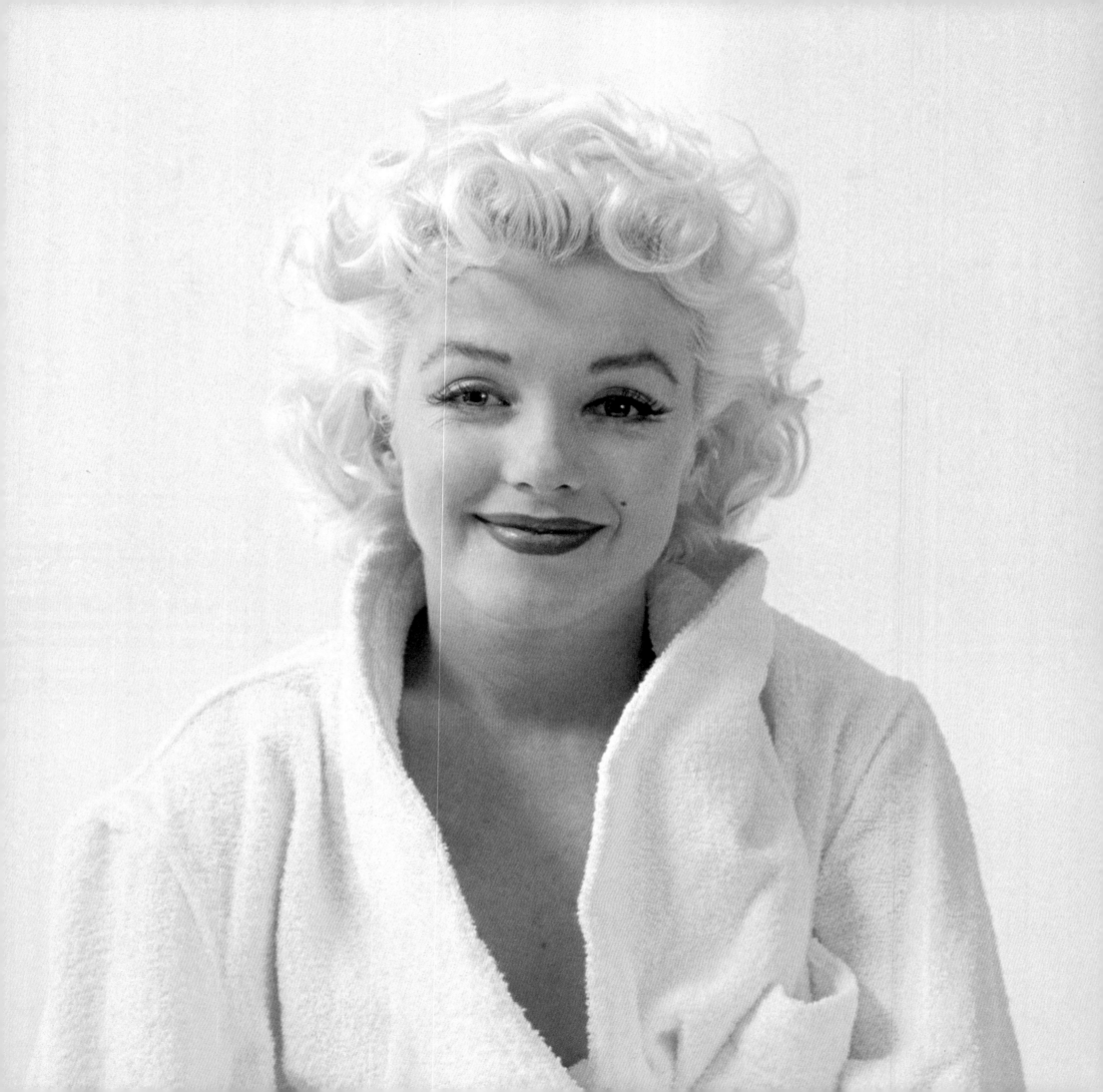

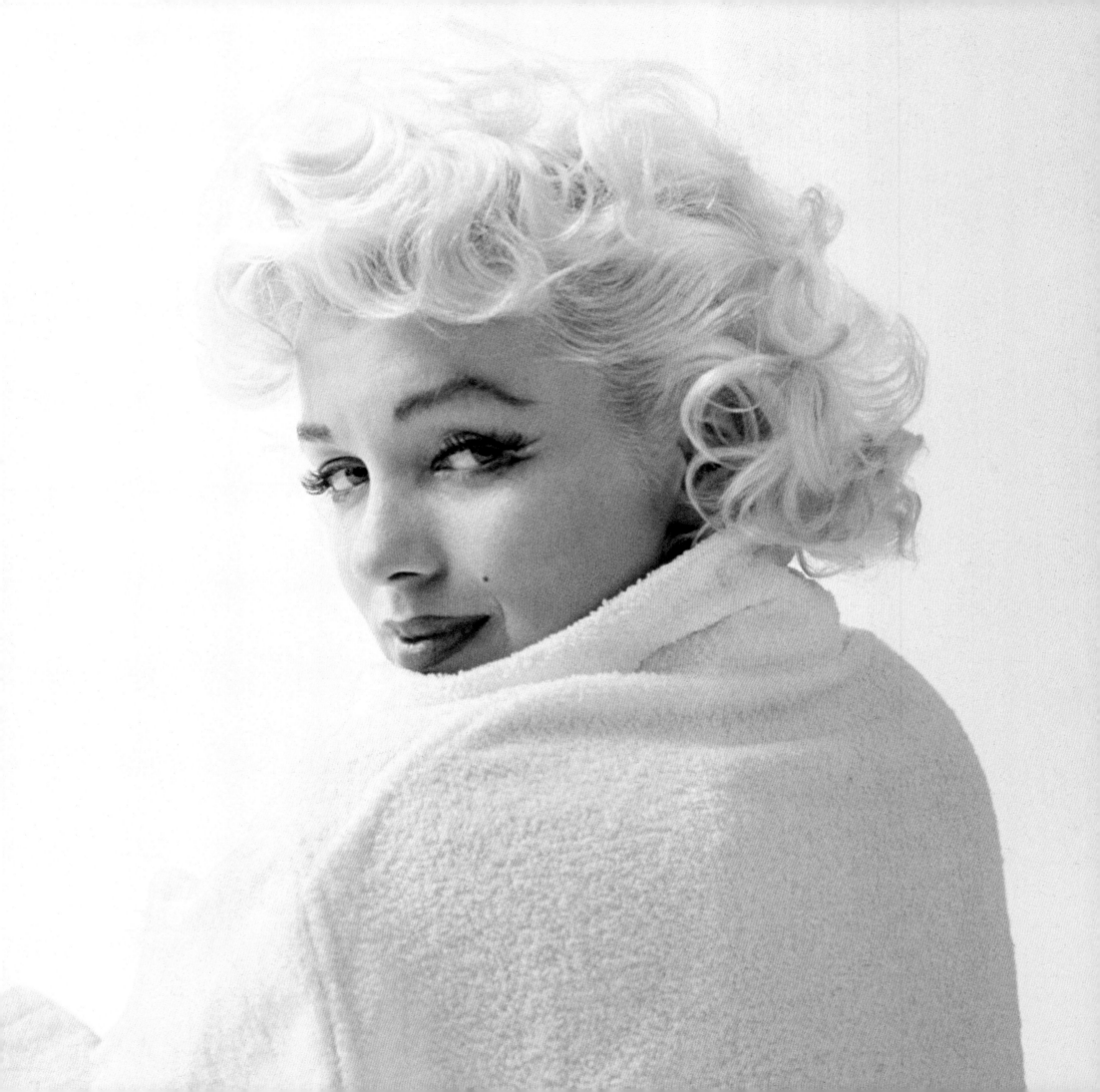

EMERALD

March 1955 – In light of the new partnership, Milton set up a series of sittings to explore angles, lighting and hair and neck lines, to become more familiar with how the camera and lights captured Marilyn. These were not necessarily for any particular assignment; simply a learning tool for both of them to study.

Unpublished images:
Pages 148, 150

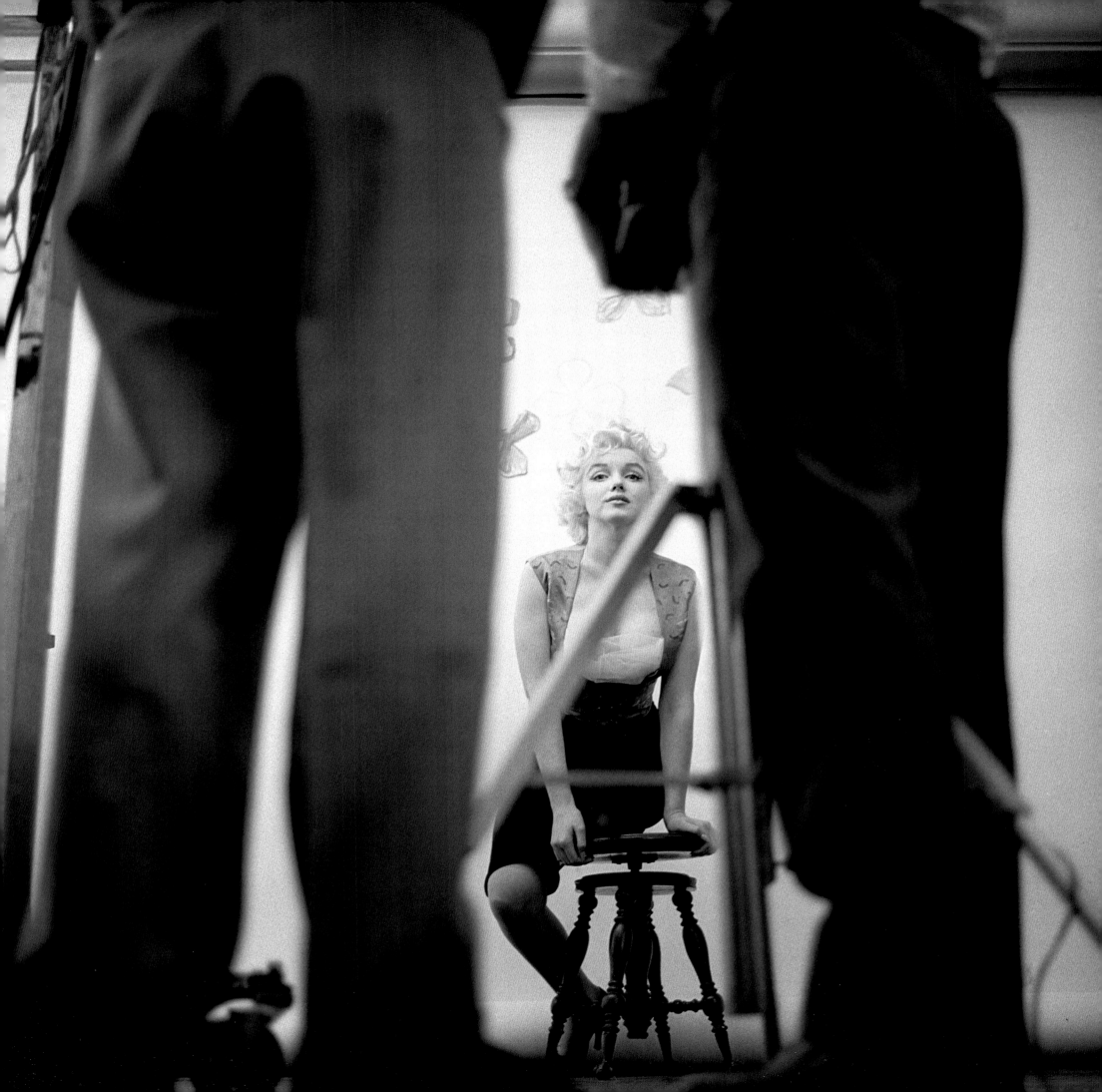

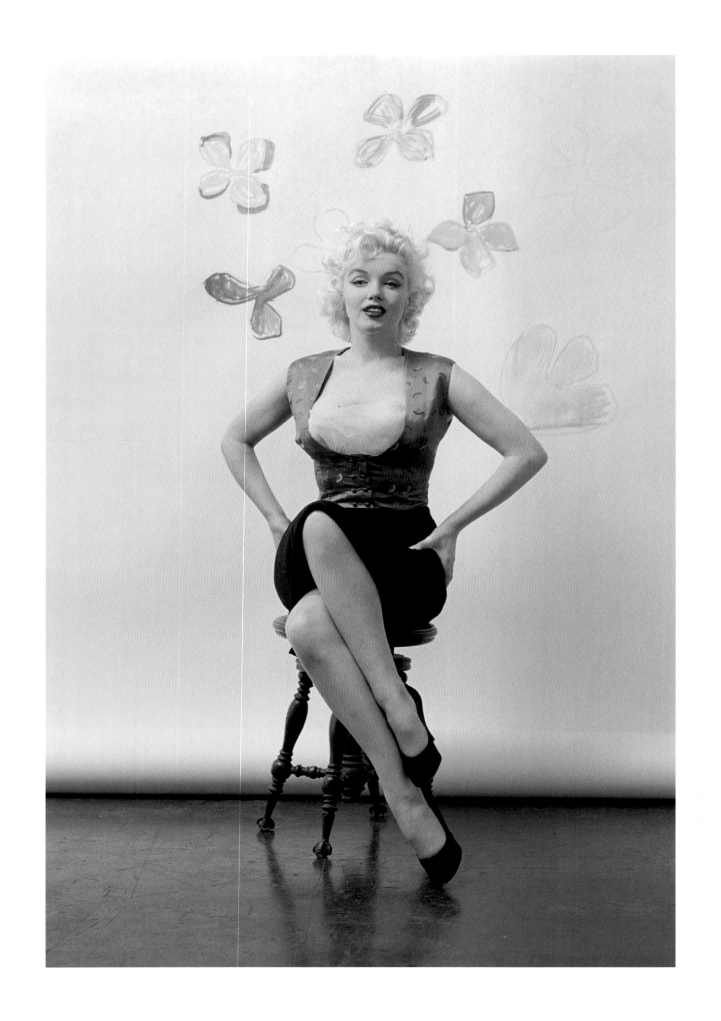

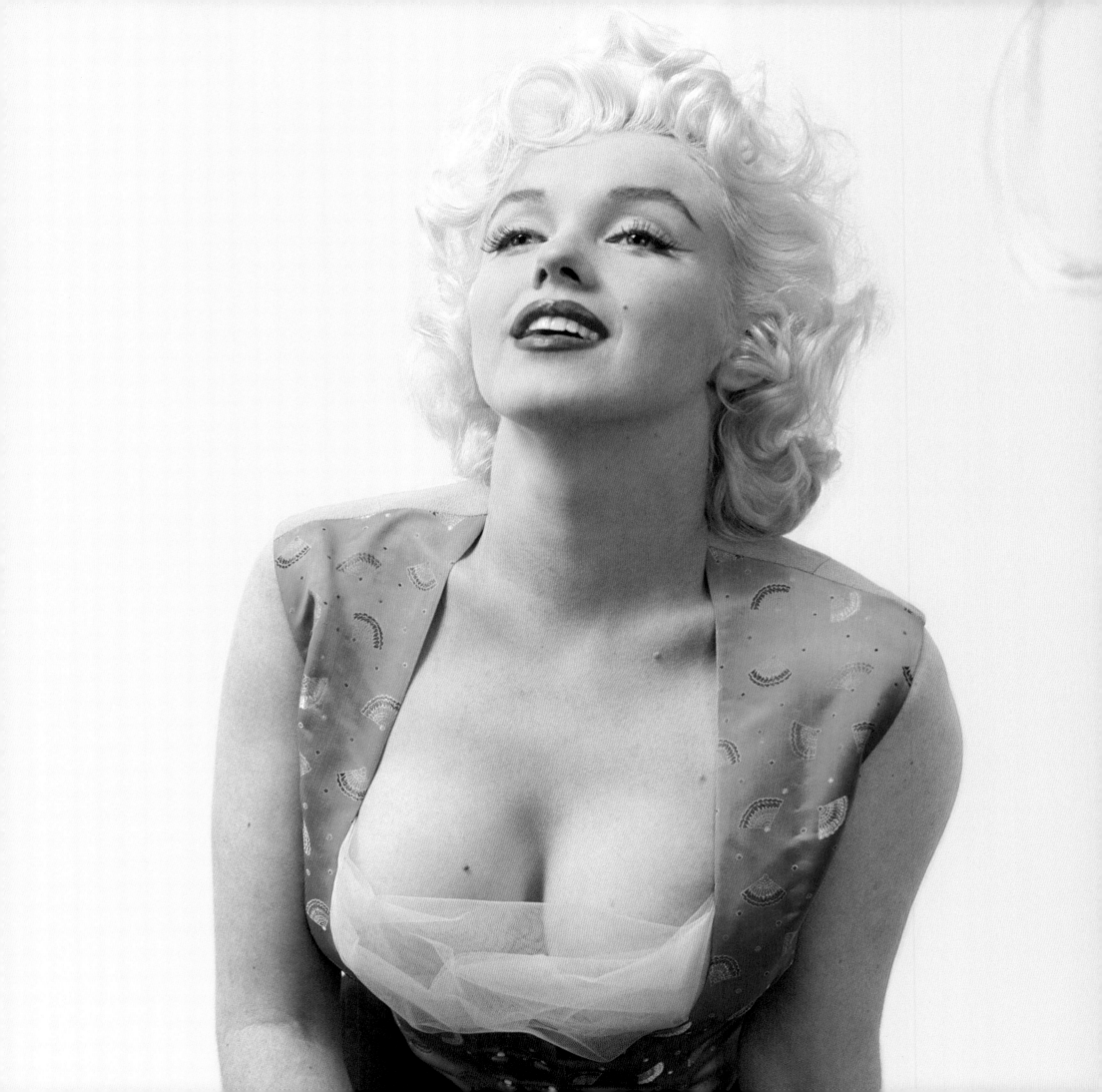

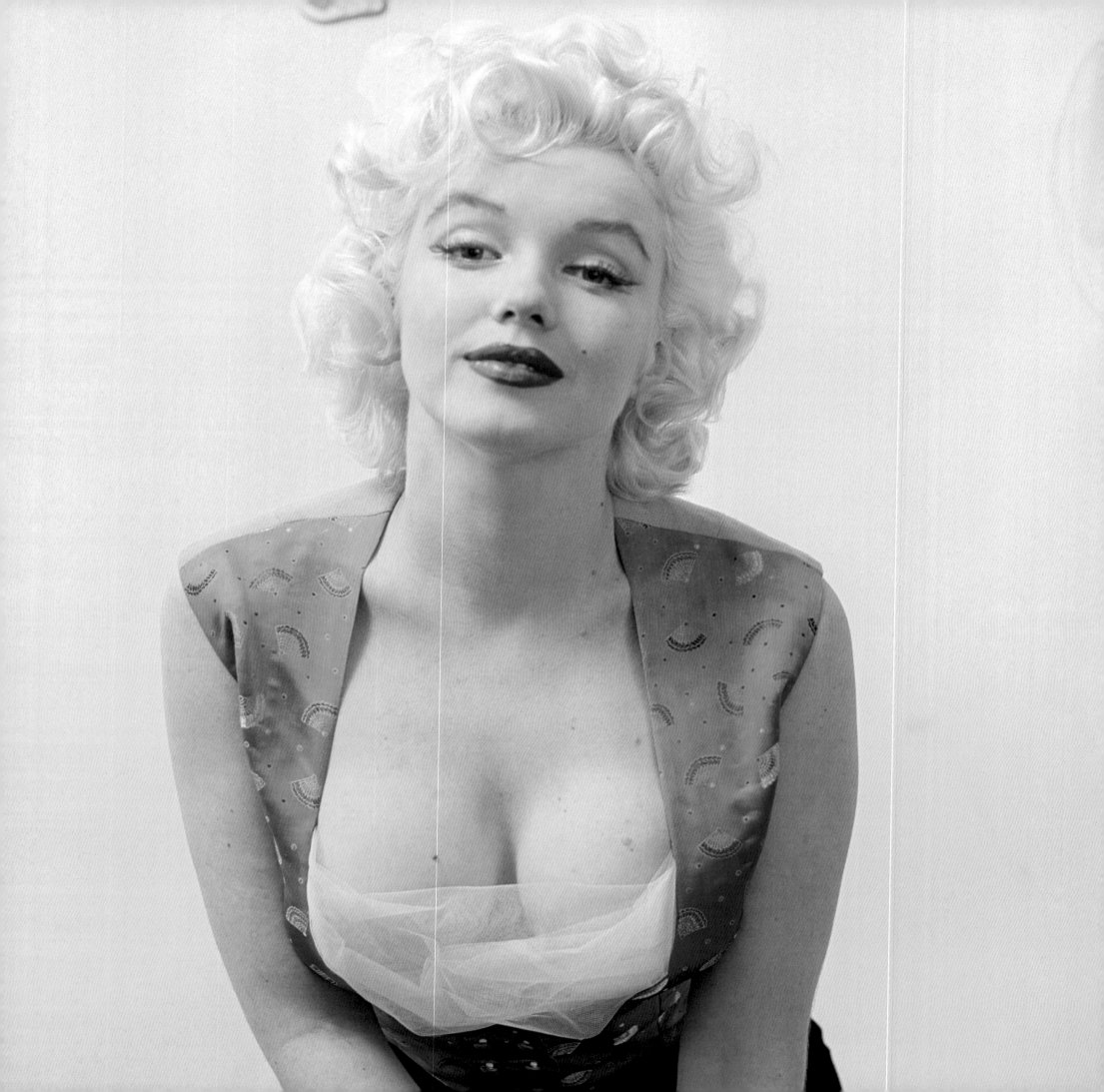

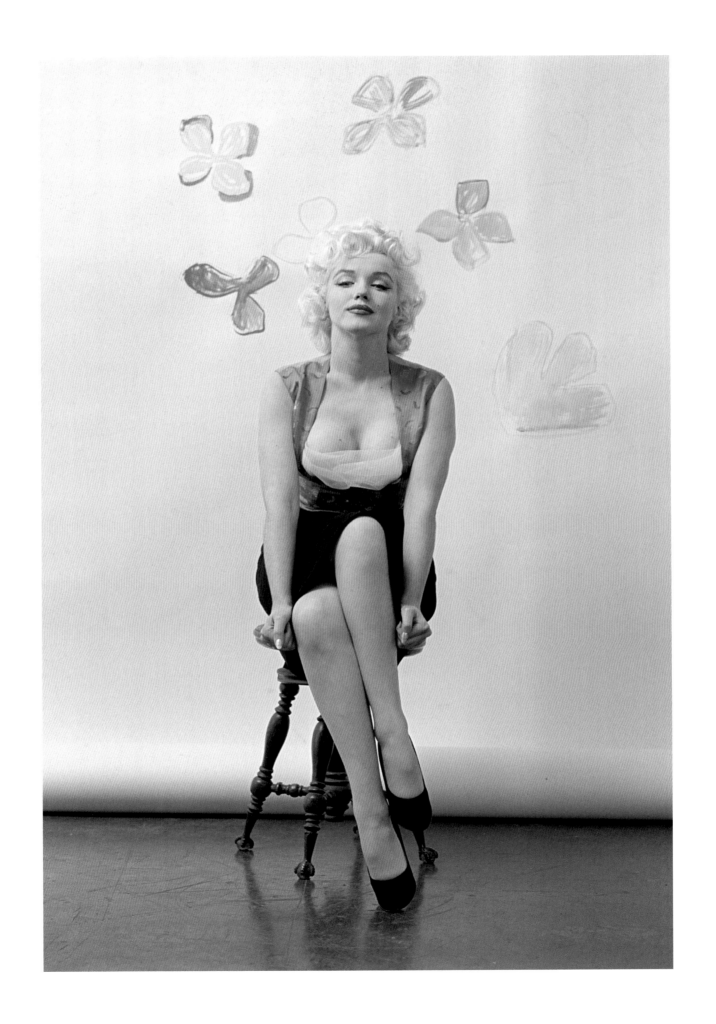

SAMMY

March 1955 – Sammy Davis Jr., who had just recuperated from a car accident that had cost him his left eye, was about to release his first album on Decca Records. Decca hired a photographer and when Sammy saw the photos, he rejected them all. He turned to his manager and friend, Jess Rand, who recommended he seek out Milton. Three days later, Sammy turned up at the studio while Milton was photographing Marilyn. After finishing with Marilyn, Milton reshot his album cover, with Marilyn in attendance. This image (opposite page) ended up as the lead image for *Starring Sammy Davis Jr.* The charming candids on the following pages were taken by Milton's in-house assistant Hal Berg and show the two superstars meeting for the first time. Marilyn and Sammy's friendship blossomed. The following week, Jess arranged for Milton and Amy to see Sammy at the Riviera and it was instant fusion. Sammy would become like family and was godfather to their son Joshua.

Unpublished images:
Pages 153, 154, 155, 157

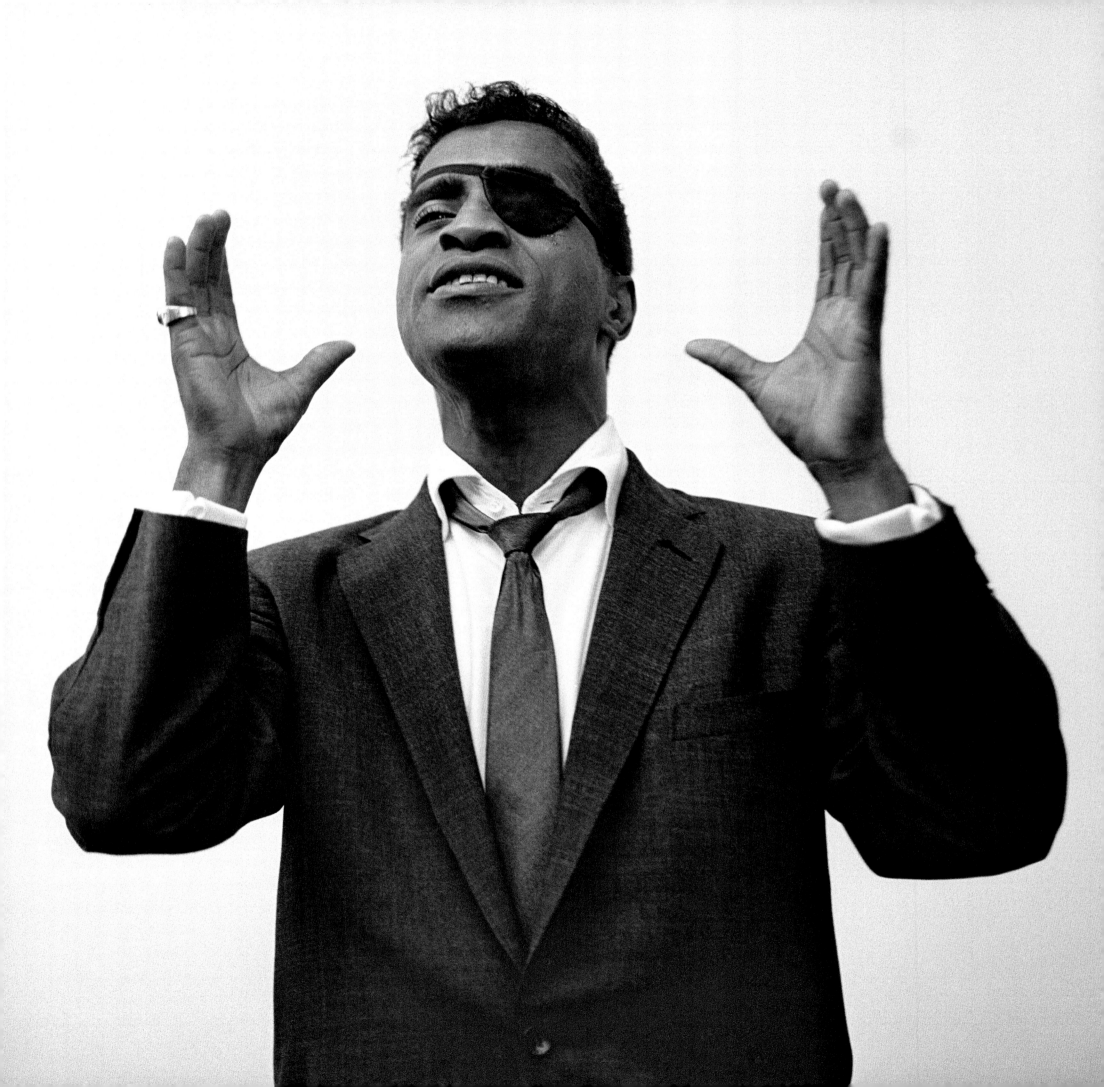

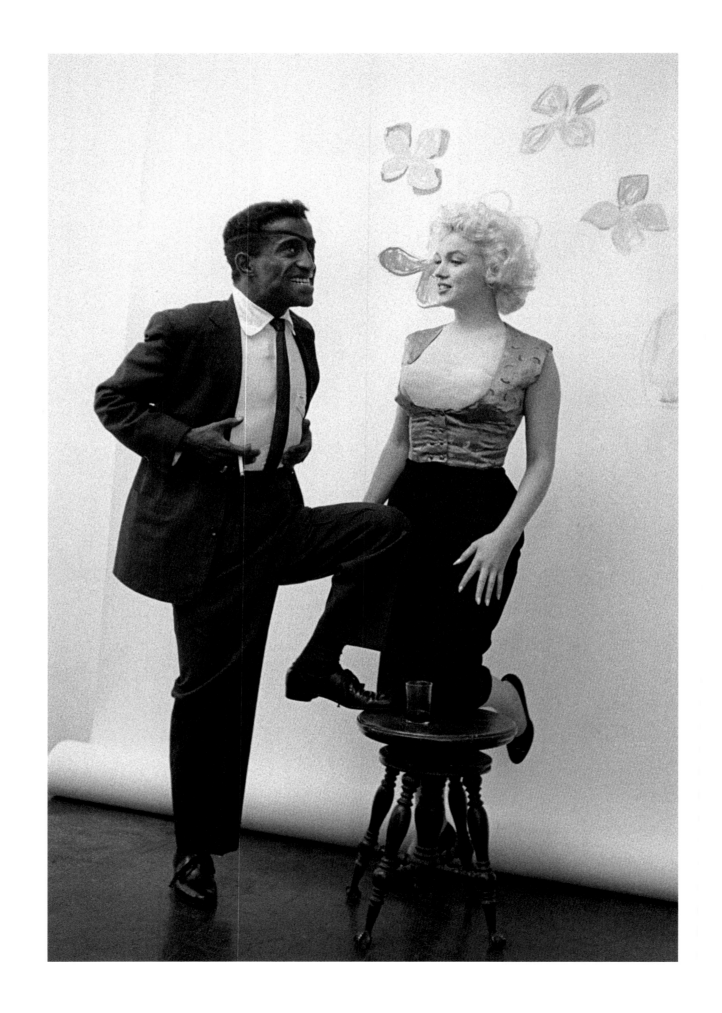

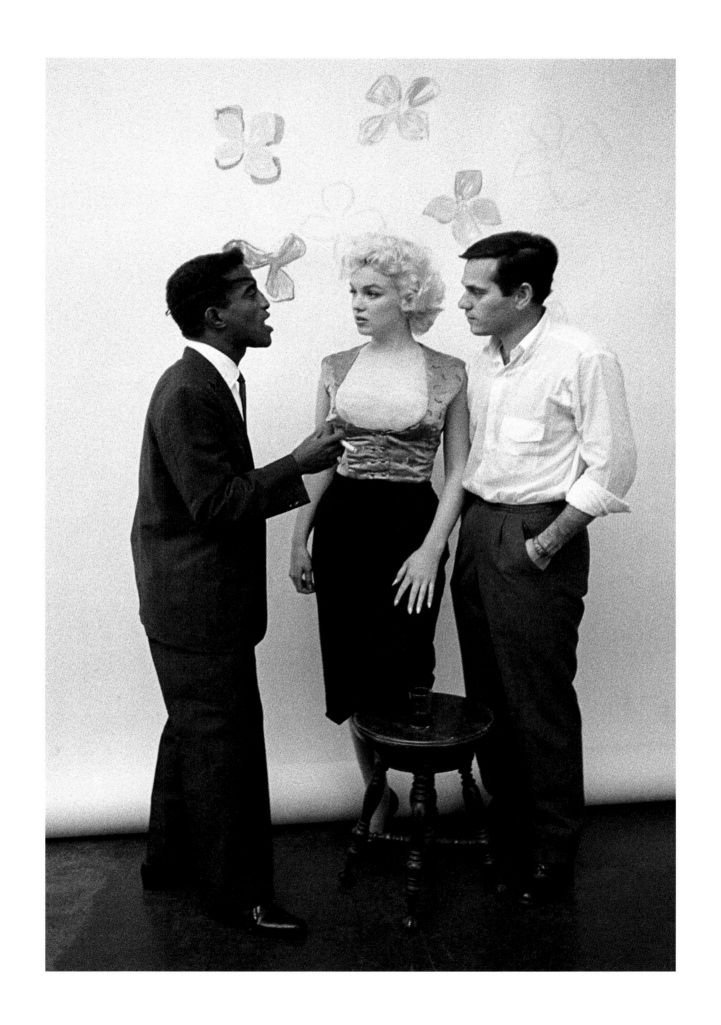

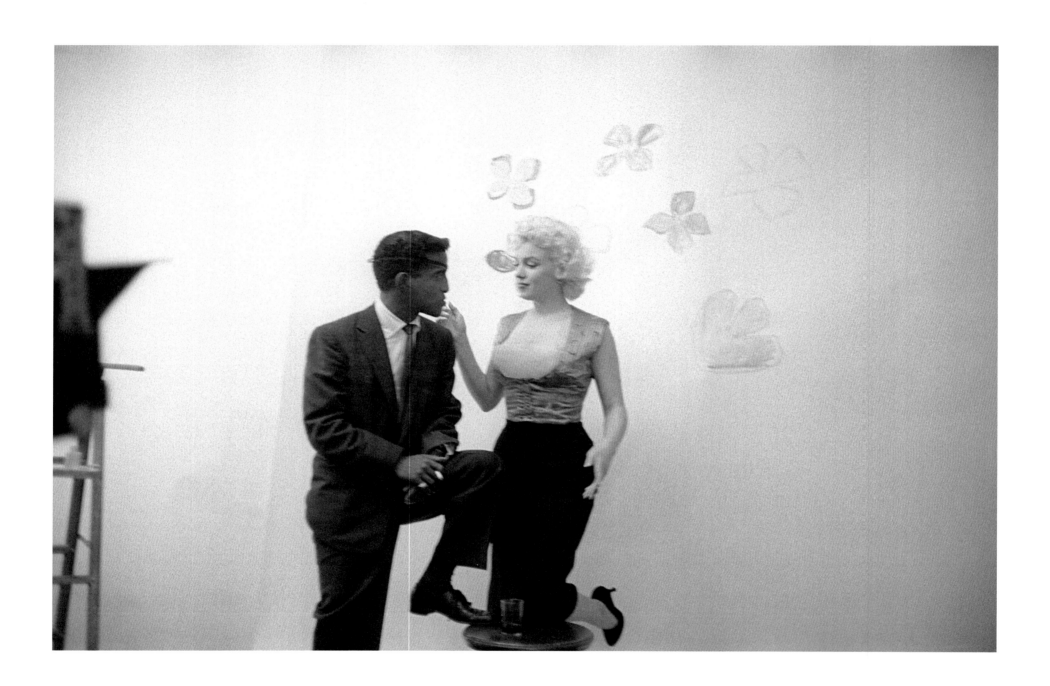

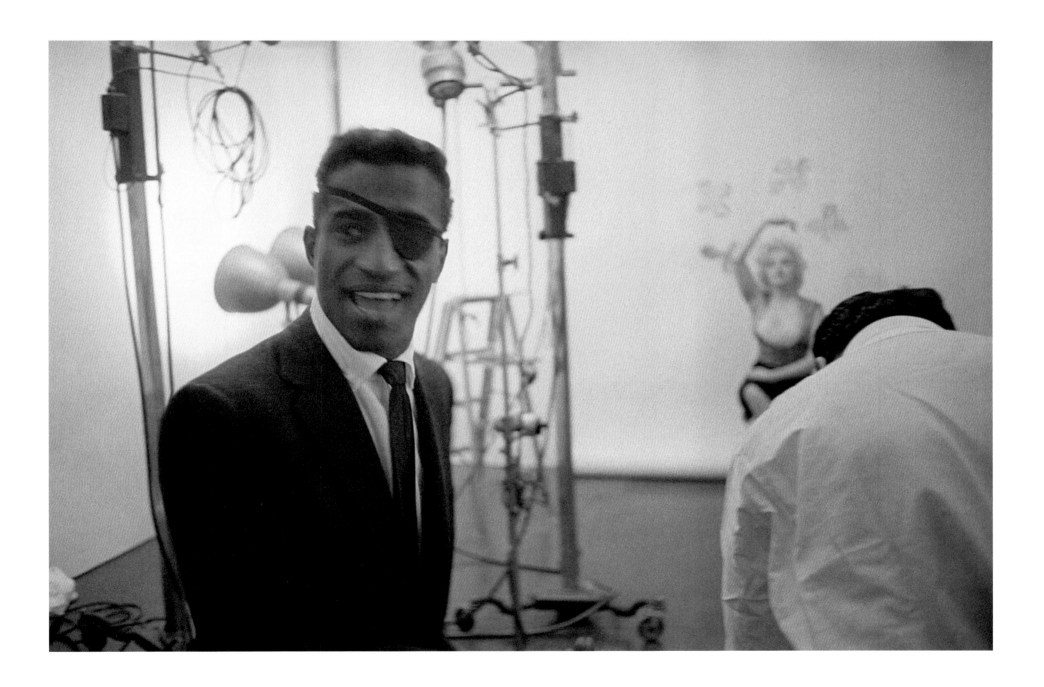

WICKER

March 1955 – Imbibing spirits, Milton and Marilyn holed
up in his New York studio to create this loose and relaxed series
of images. Marilyn is wearing matching trousers and jacket
designed by Jax of Hollywood. This retro style for a 1950s
modern woman became a signature look for Marilyn.
Marilyn hated wearing high heels. Her personal preference
was to go barefoot or to wear a simple pair of flats.

Unpublished images:
Pages 162, 163, 164

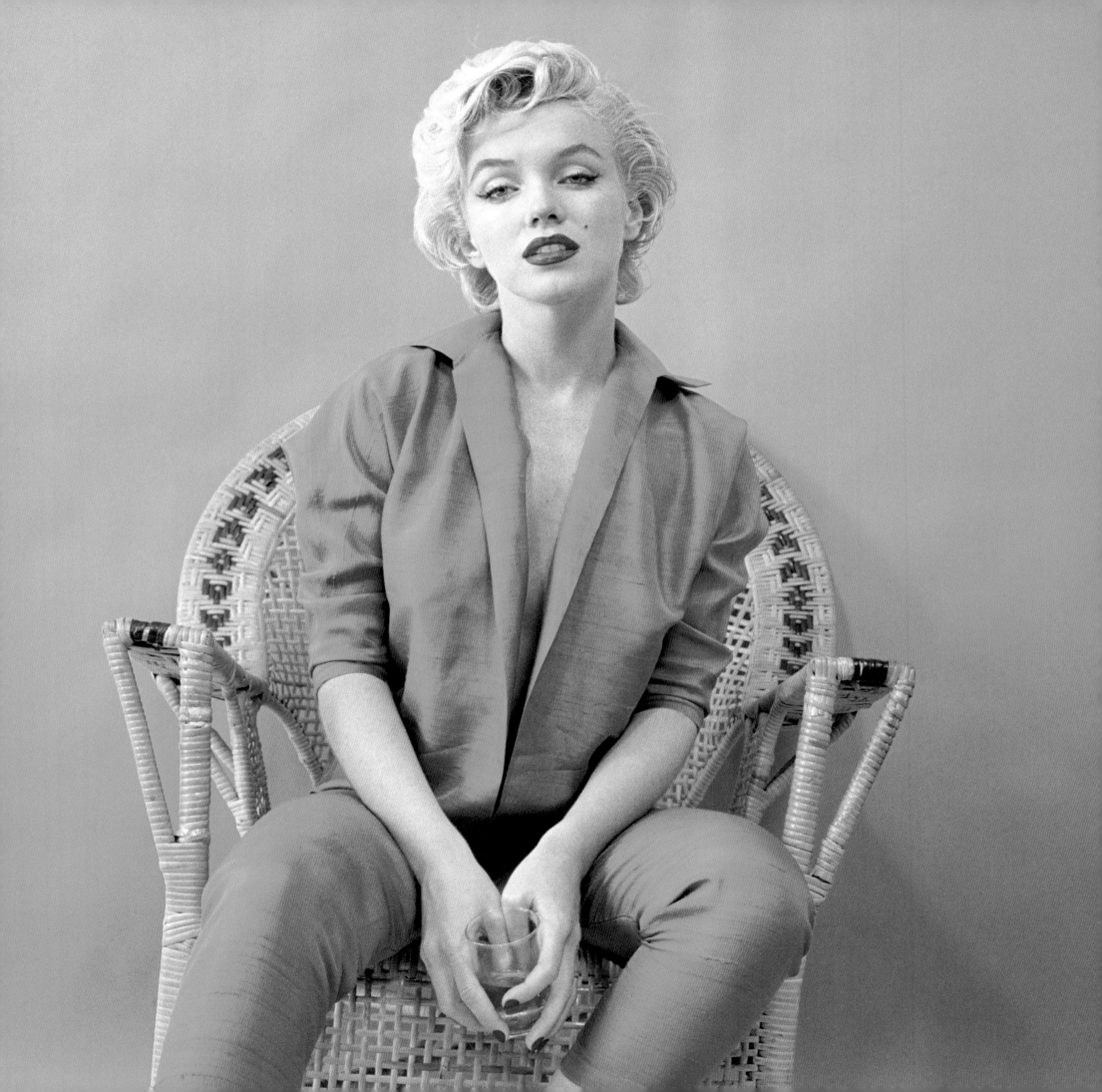

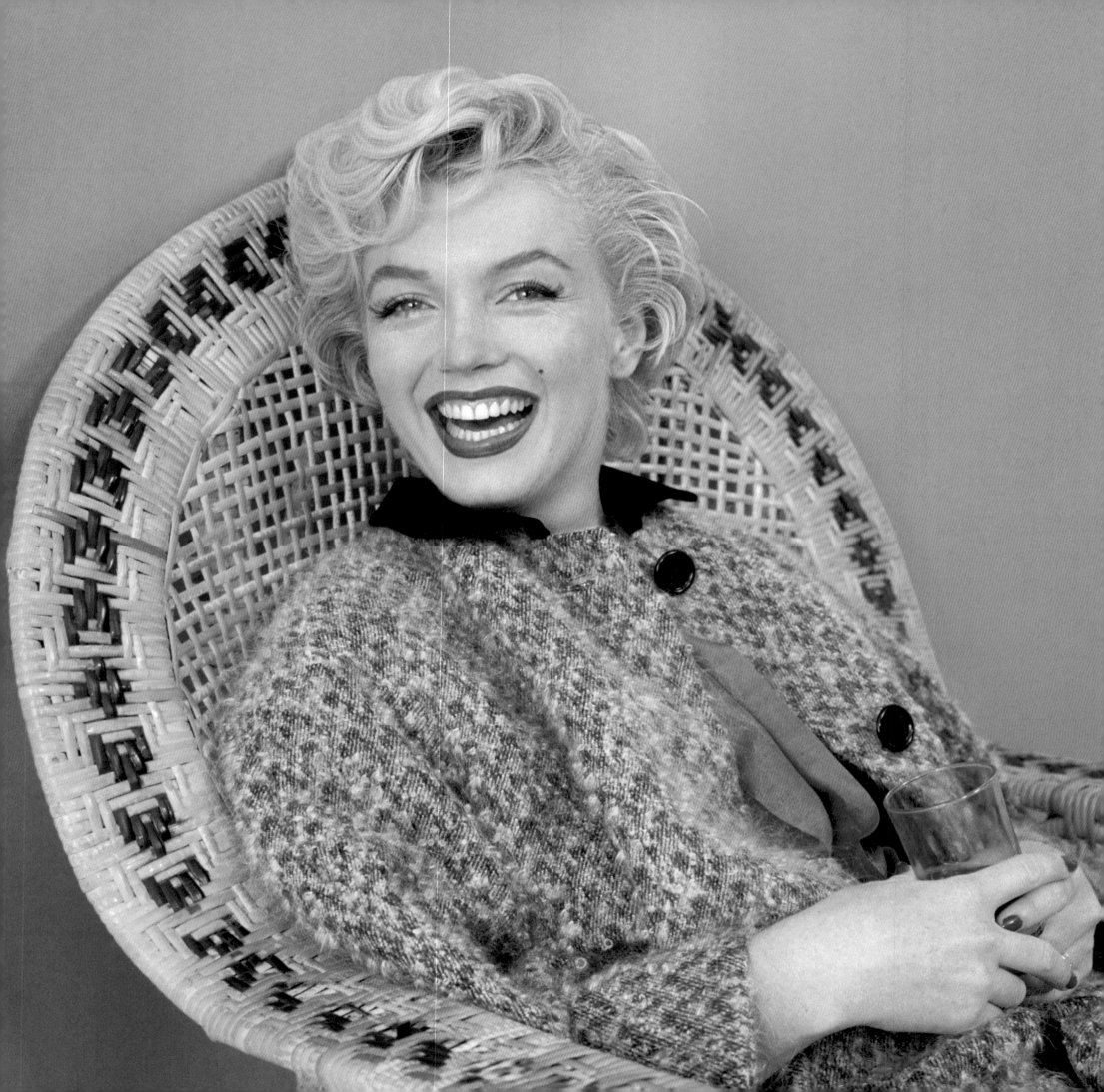

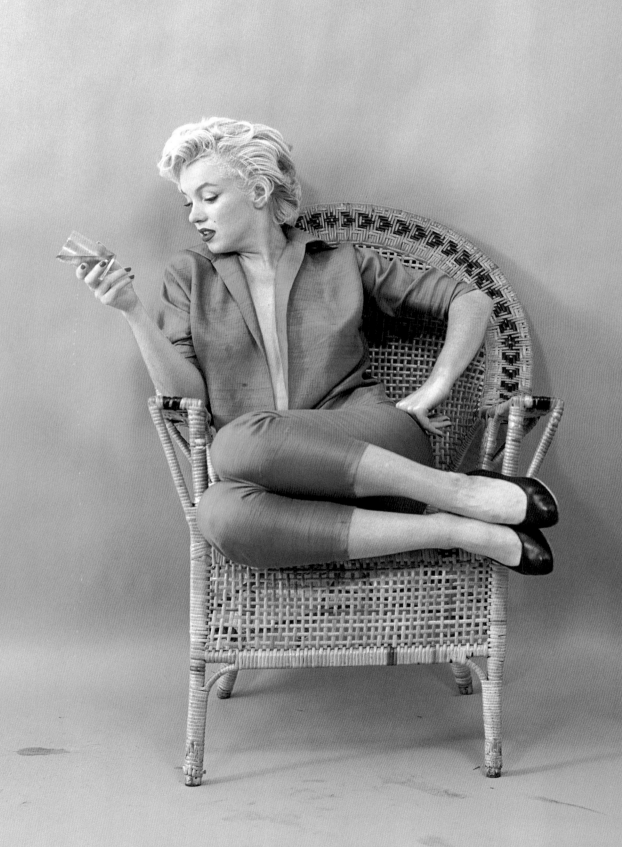

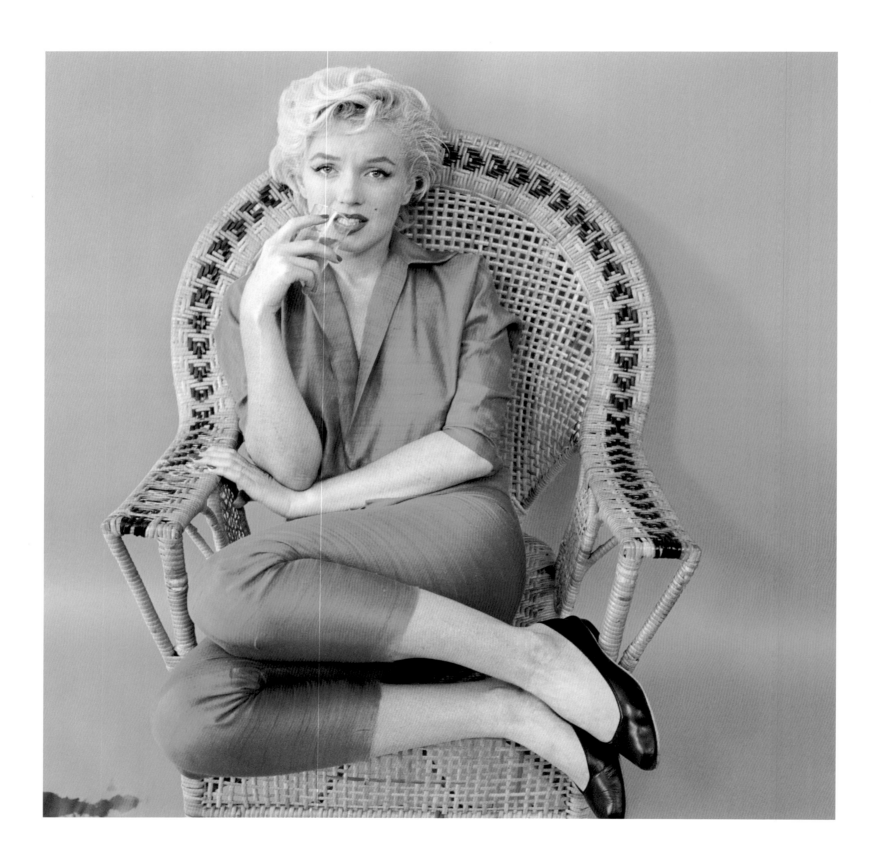

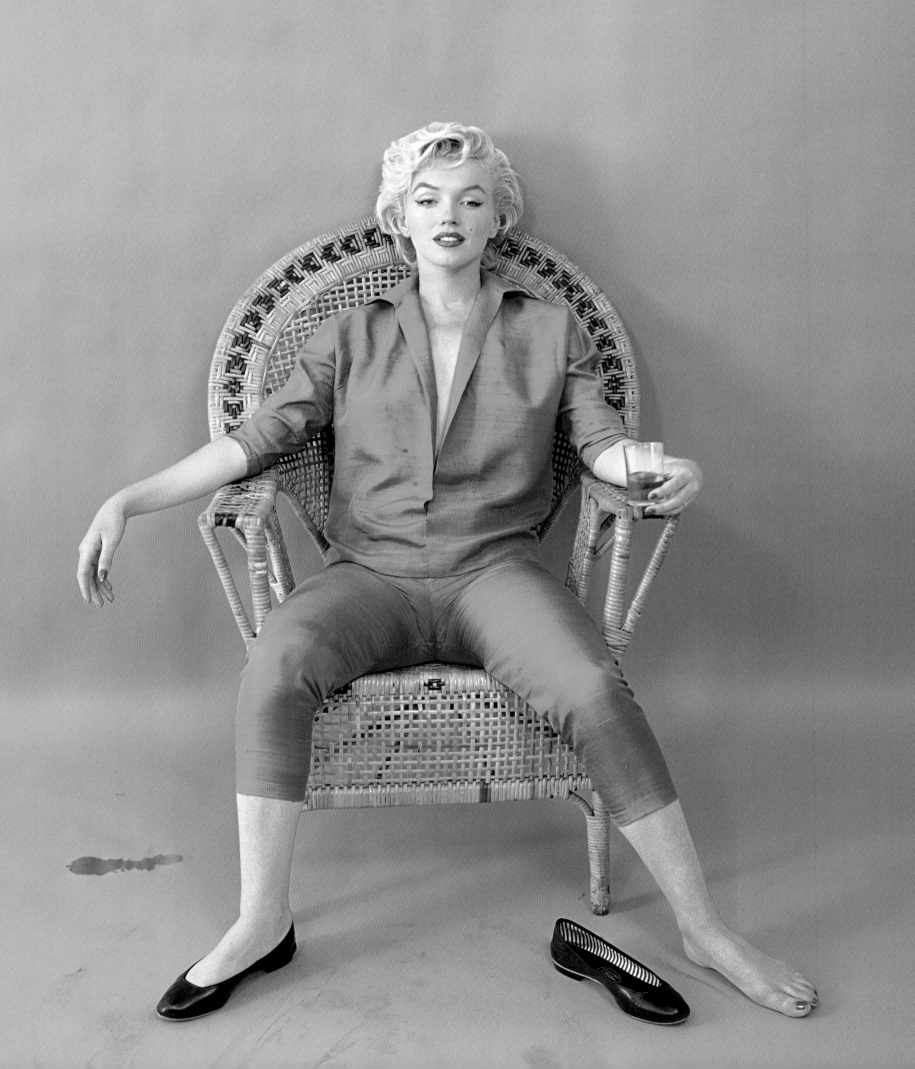

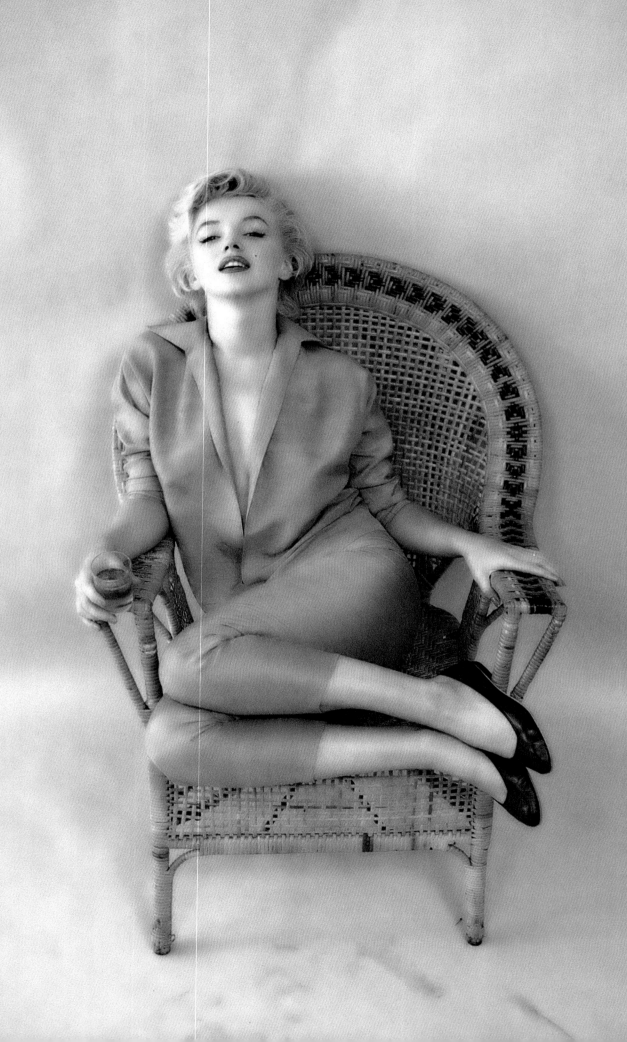

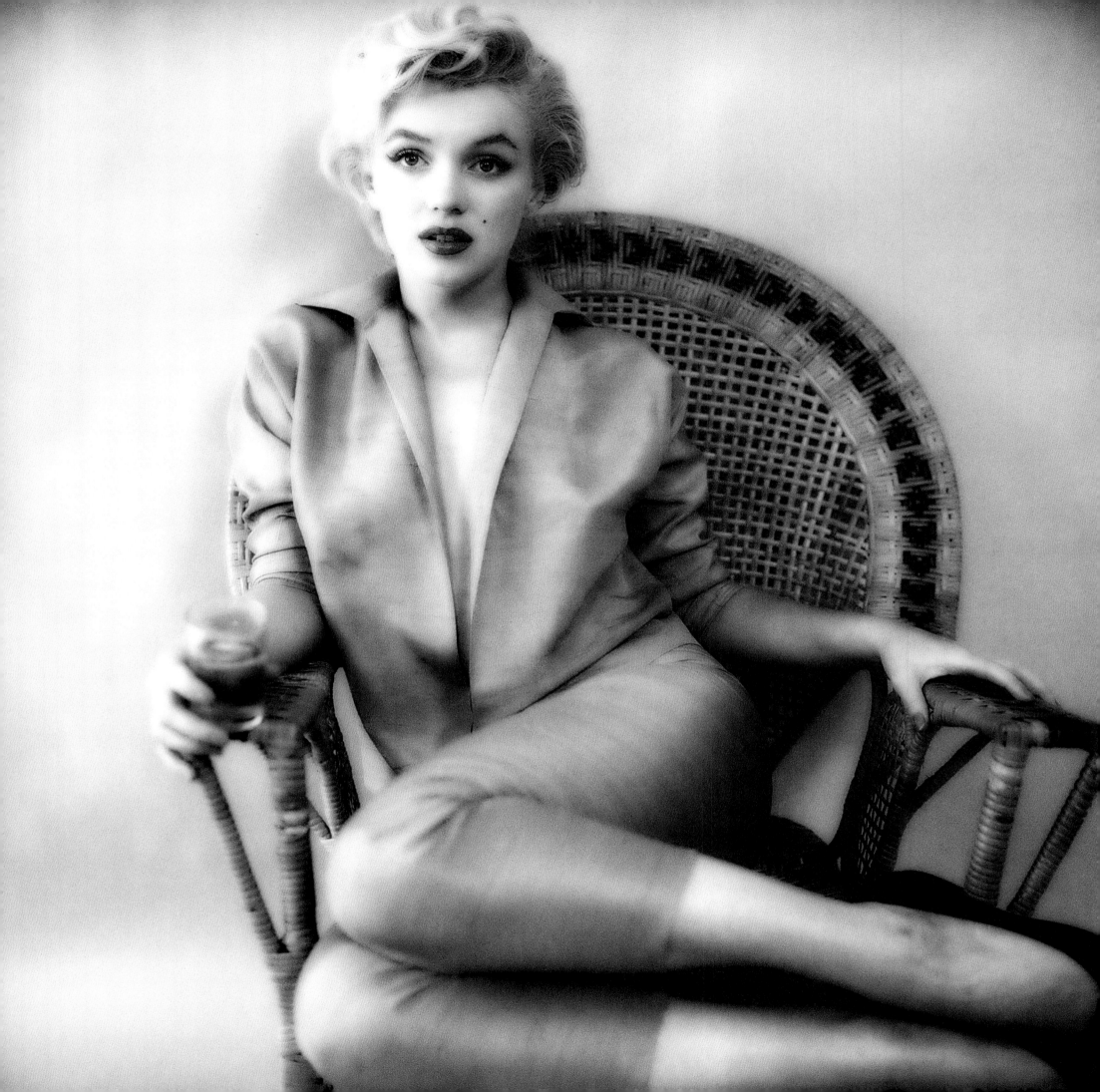

FRIARS CLUB

March 11, 1955 – Held at the Waldorf Astoria, Marilyn attended The Friars Club Testimonial Dinner for Dean Martin and Jerry Lewis, who were being honored for their charity work on behalf of the Muscular Dystrophy Association (MDA). Milton Berle was Master of Ceremonies and Marilyn was seated next to Eddie Fisher. Sammy Davis Jr. and Phil Silvers were also in attendance to honor their friends. In the audience were Milton and Amy Greene, who were sitting at a table with Ruth Berle. It was a fun night of raucous entertainment, honoring the classic comedy duo. Lewis would continue to do work for the MDA with his annual telethons.

Unpublished images:
Pages 167, 168

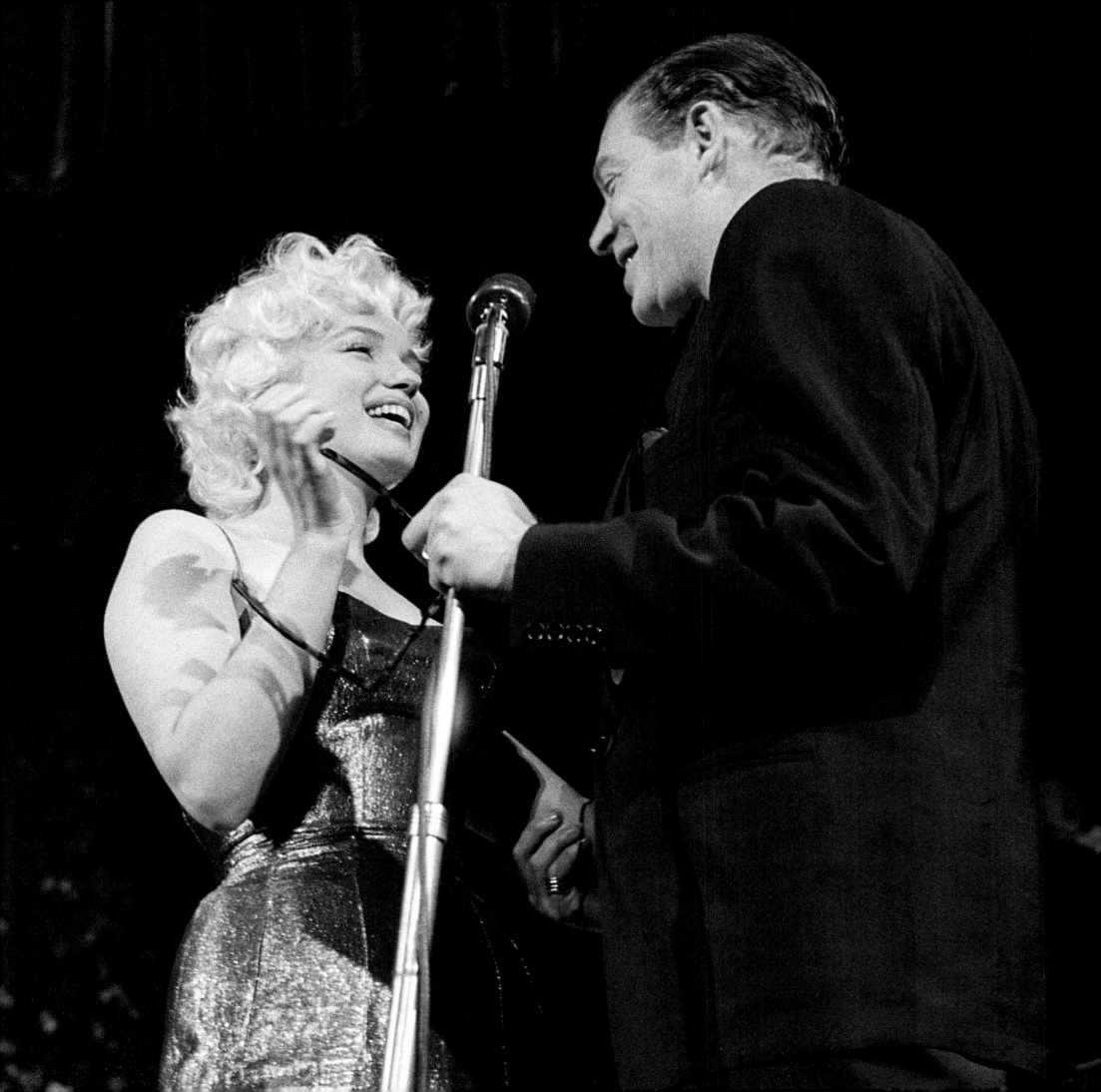

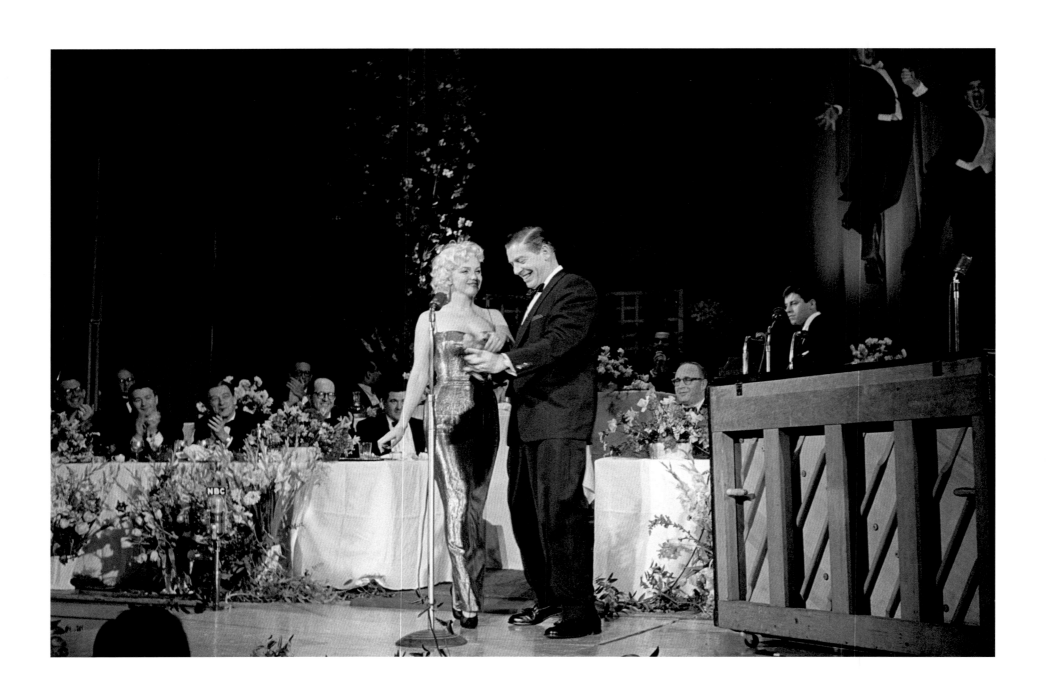

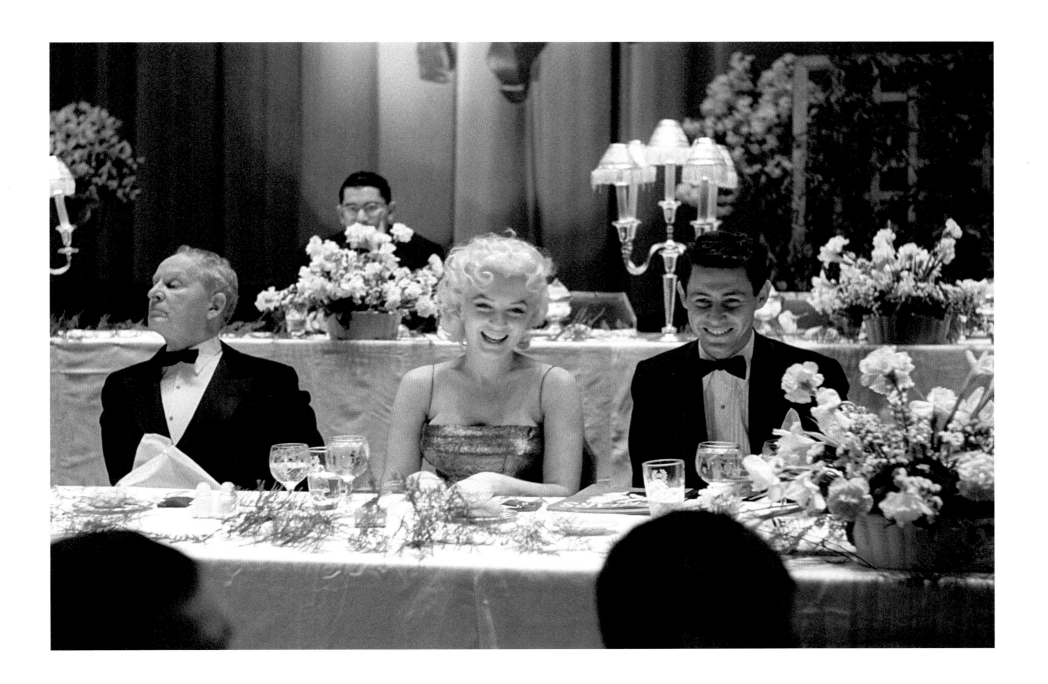

CIRCUS

March 30, 1955 – A fund-raiser held for the Arthritis & Rheumatism Foundation at the old Madison Square Garden was the event that re-introduced Marilyn to the world after a year in hiding. It was the 'Show Of Shows', a circus with Milton Berle (Uncle Miltie) as the ringmaster.

Milton and Marilyn, inspired and excited by the whole idea, decided to use the evening's festivities to make the formal announcement of Marilyn Monroe Productions to the world. It was Marilyn's idea to ride a pink female elephant, complete with a pink bow on the tail, as well as a matching rhinestone harness and saddle. Her entrance and reappearance to the world on March 30 was pandemonium and caused a media frenzy, and the rest is history.

Unpublished images:
Pages 173, 174

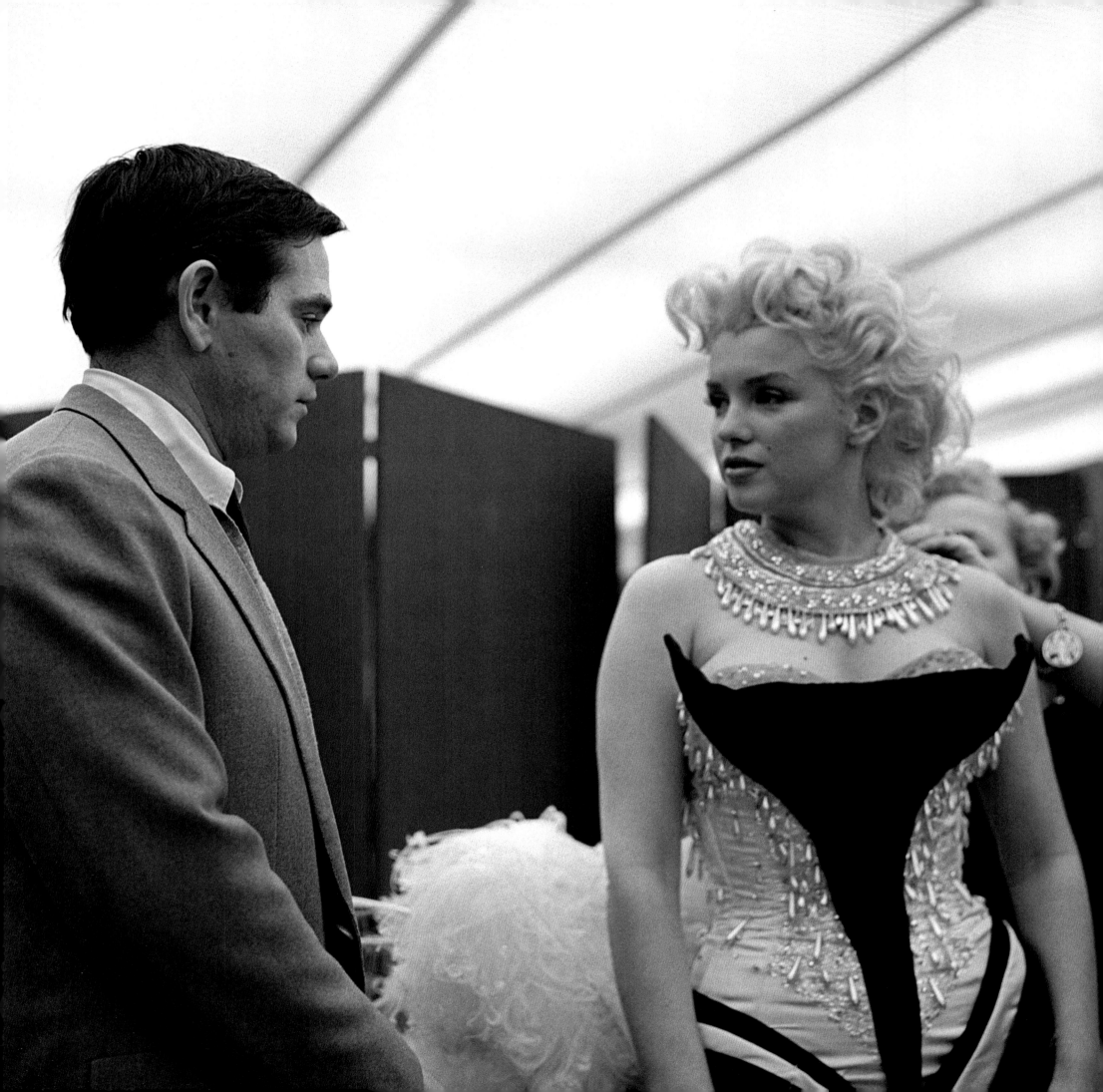

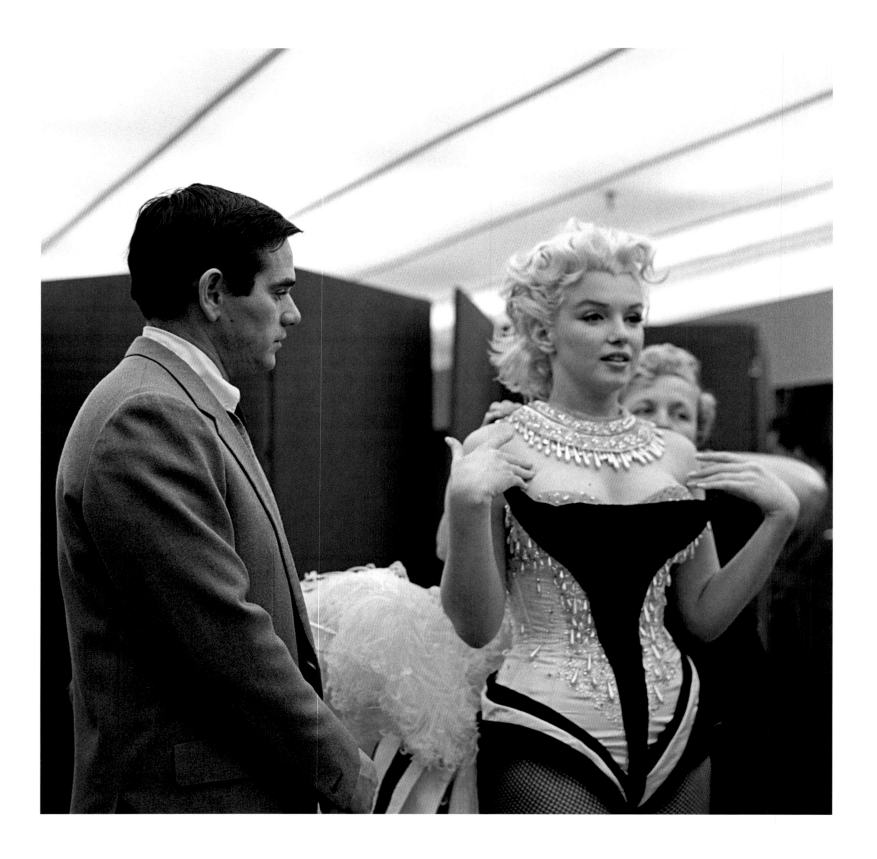

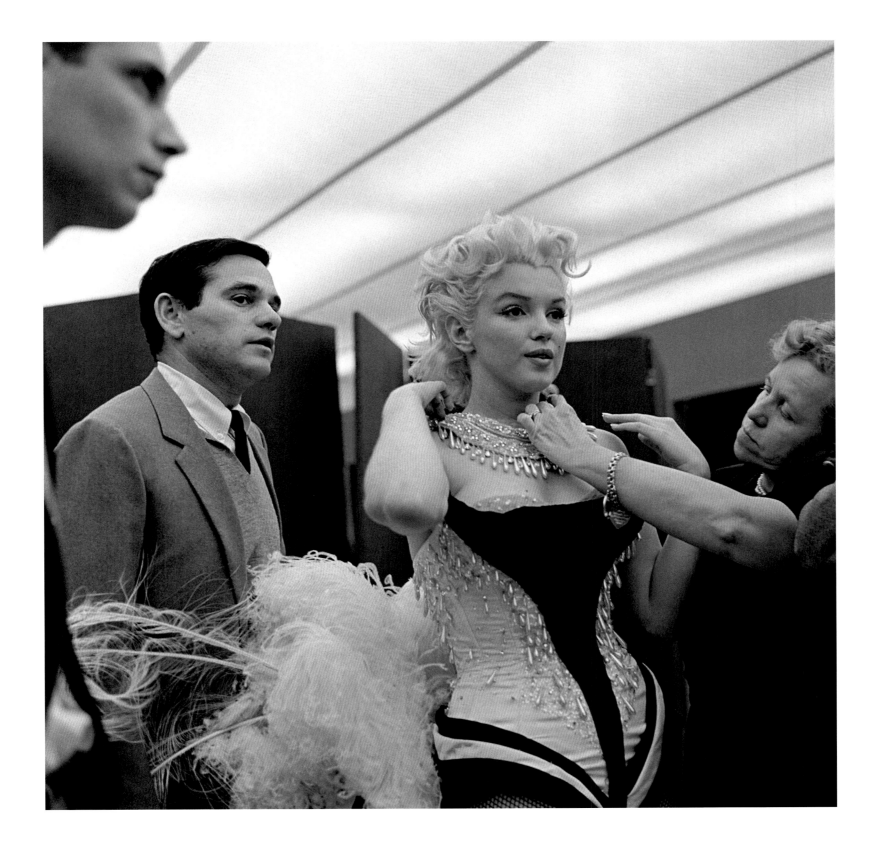

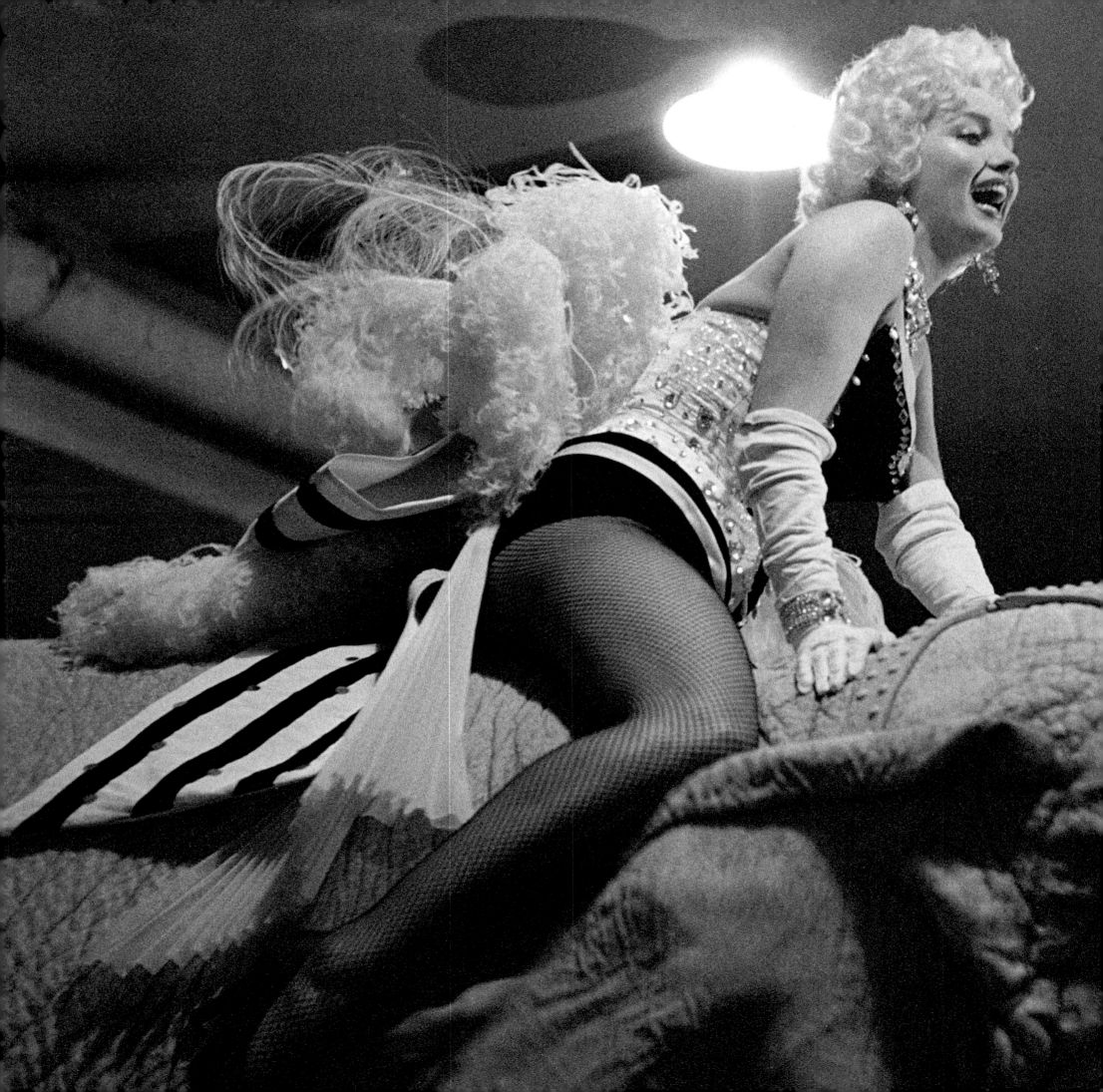

MONROE & MURROW

April 1955 – These images were taken when Marilyn and Milton first got together with Edward R. Murrow to discuss the forthcoming interview on Murrow's show, *Person to Person*. The pre-meetings were held April 1, 1955 at the Ambassador Hotel in New York City, where they discussed questions, substance and a brief outline. They were also introduced to the logistics and technology needed for the live, televised event. The interview itself was done as a live feed from Milton and Amy's home in Weston, Connecticut. The week before, a CBS crew erected a 200-foot transmitting tower and wired the house for sound so that Murrow's voice could be heard in the studio, kitchen and den. Those are the three rooms seen during the live broadcast. Amy remembers that during the week leading to the interview, Murrow would speak to her through the audio system, so she became accustomed and comfortable with the technology. Only days before, the formation of Marilyn Monroe Productions had been announced and the two shareholders were ready to move forward.

Unpublished image:
Page 178

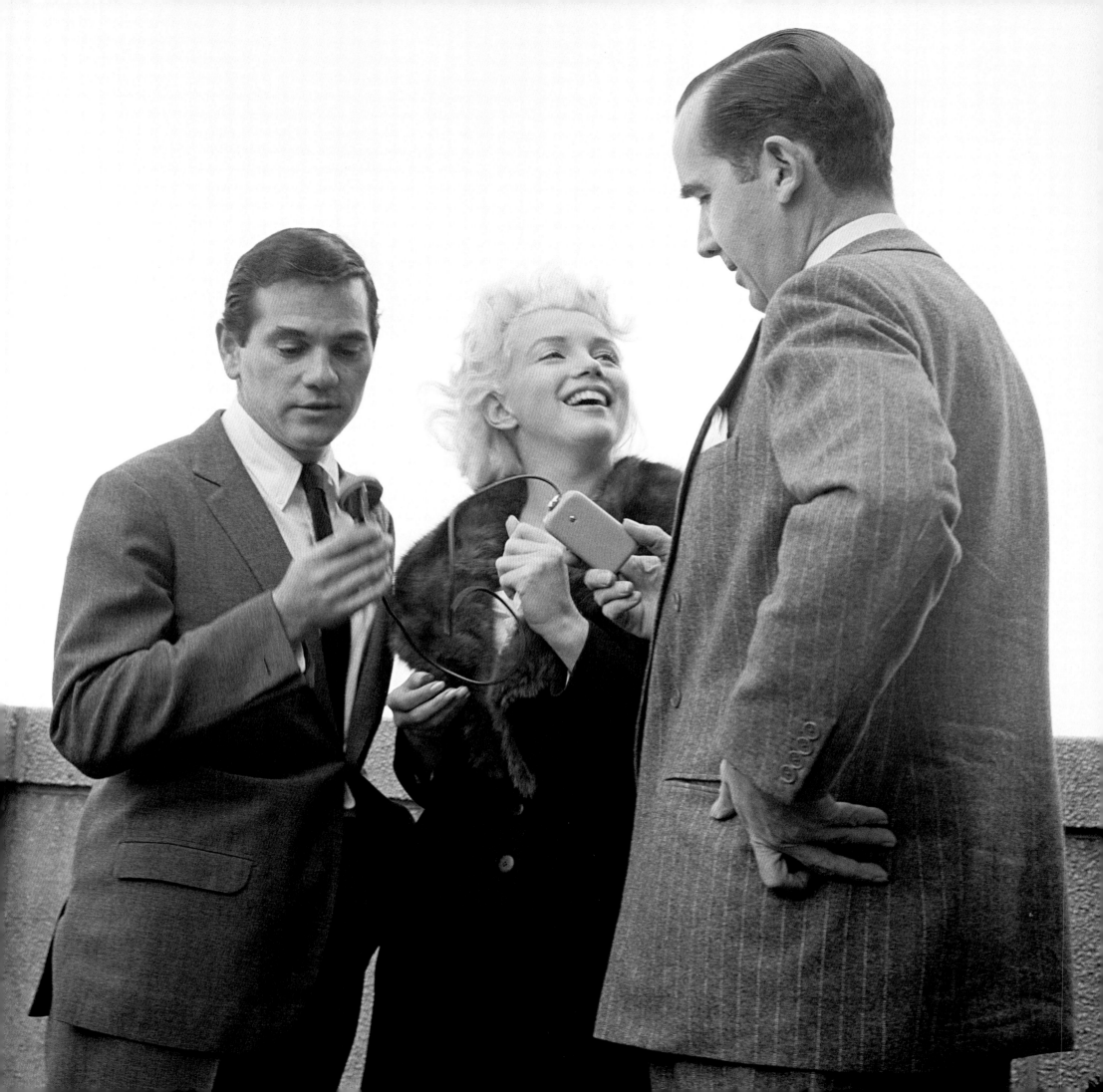

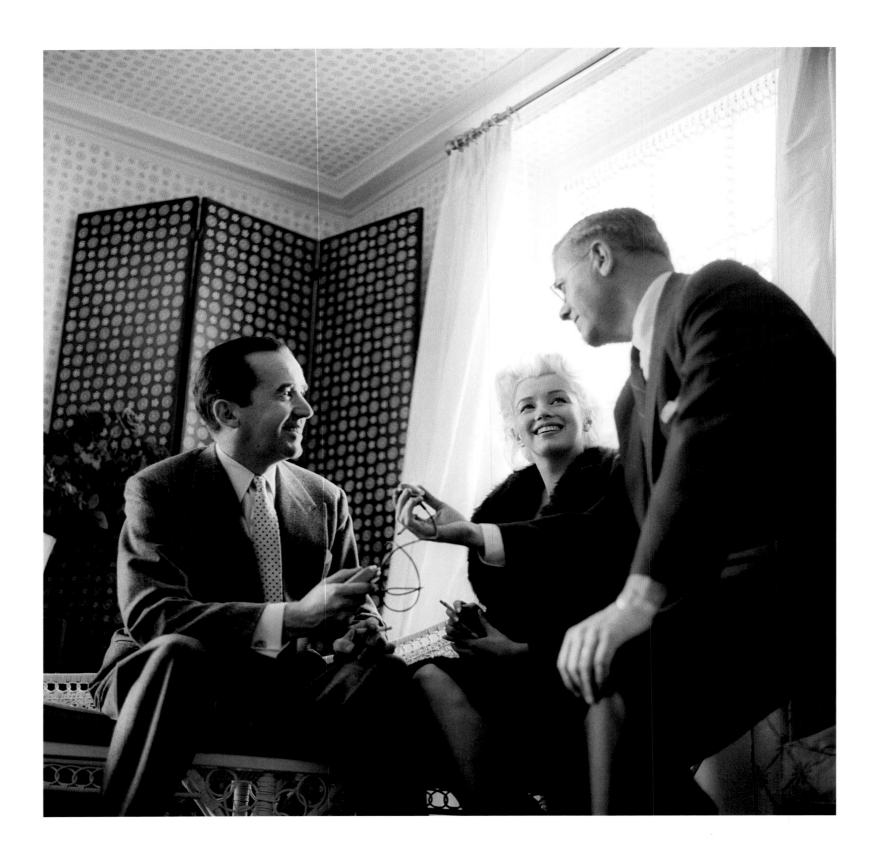

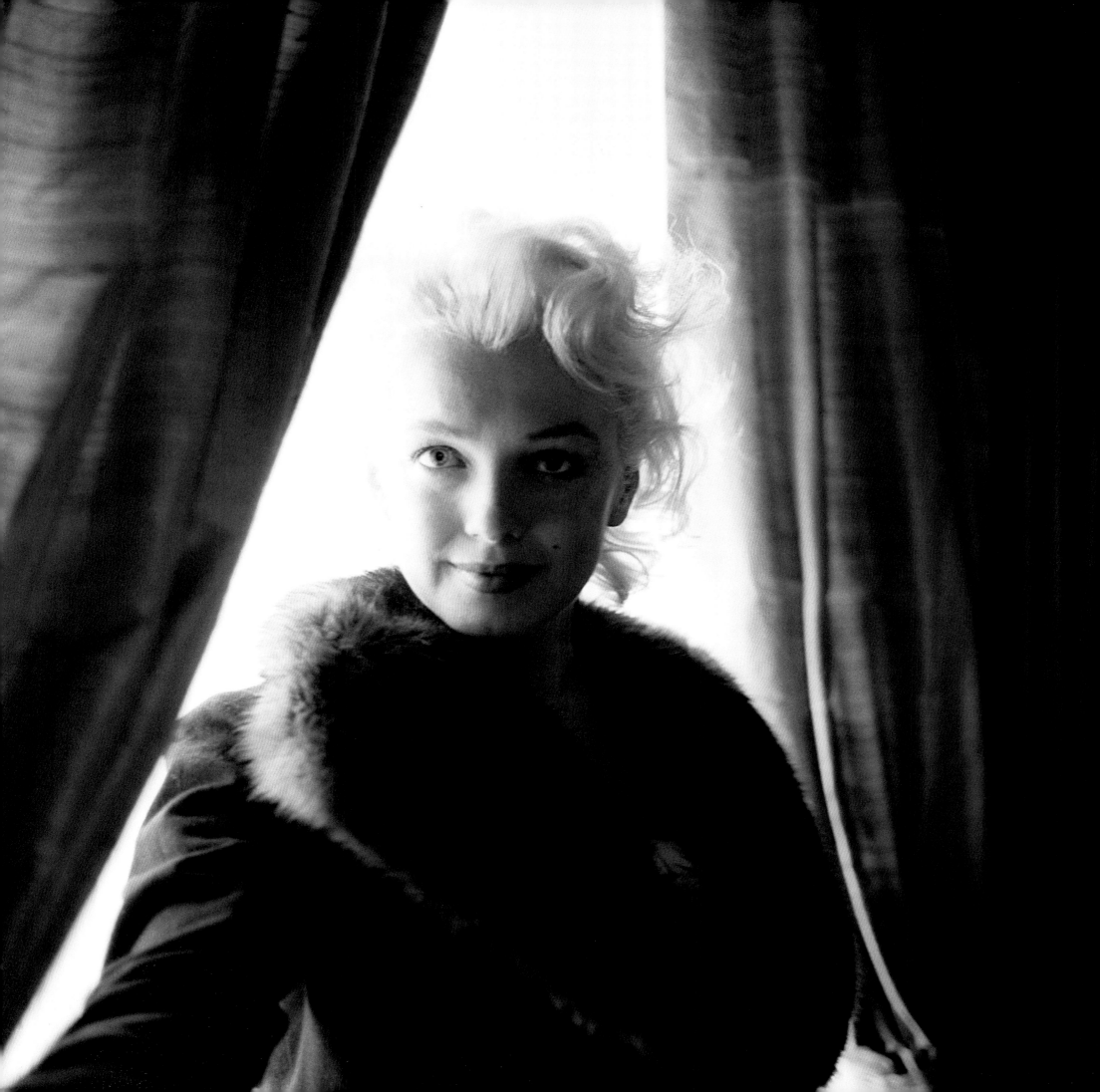

SWIMMING
POOL

June 1955 – On a hot summer's day, Gene Kelly, Amy, Milton and Marilyn drove to the home of Richard and Dorothy Rodgers, who lived just a few miles away from the Greenes' Connecticut home, to cool off with friends. These photos show a side of Marilyn rarely seen by the public: the young freckle-faced star sans makeup.

Unpublished image:
Page 182

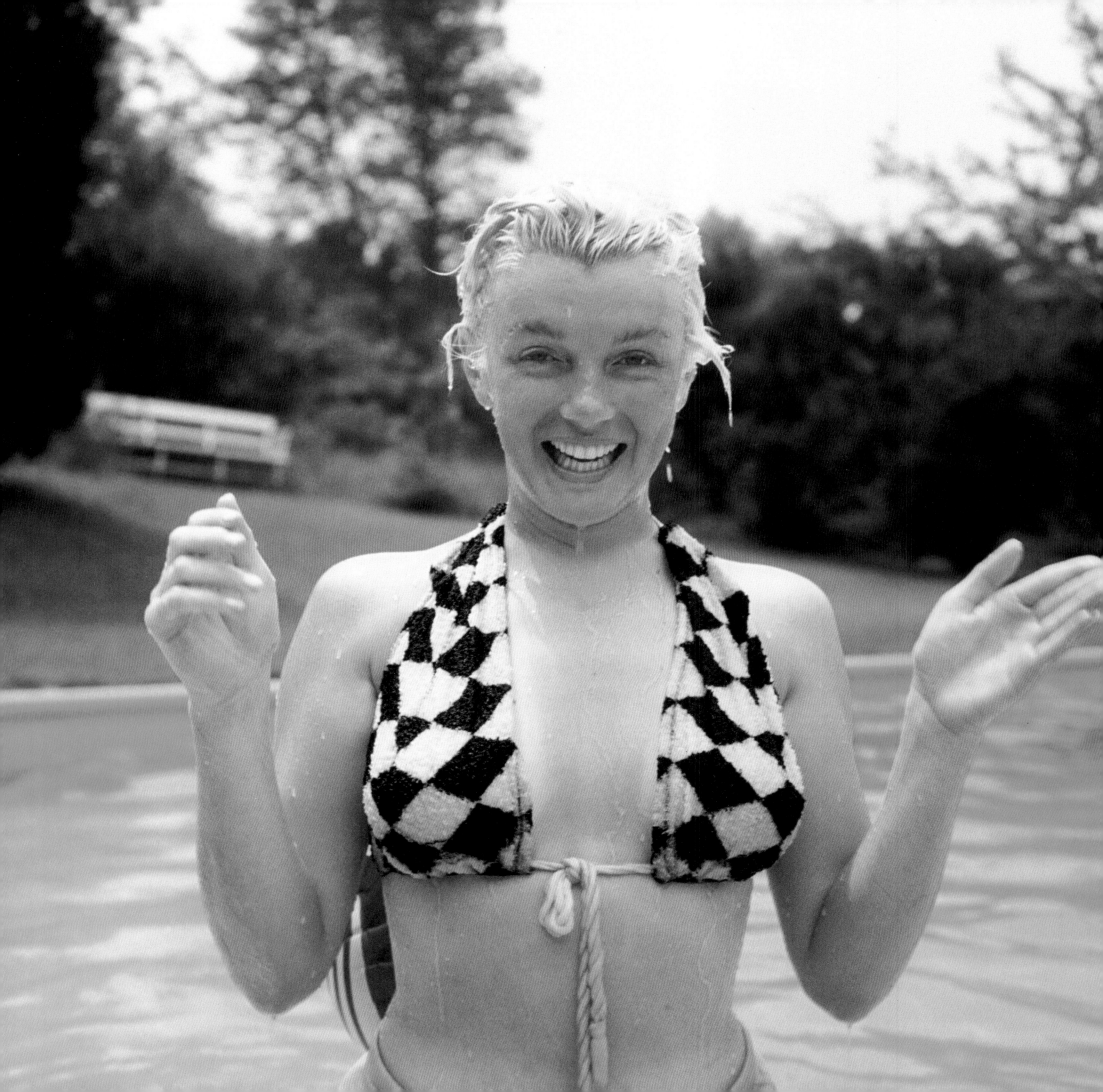

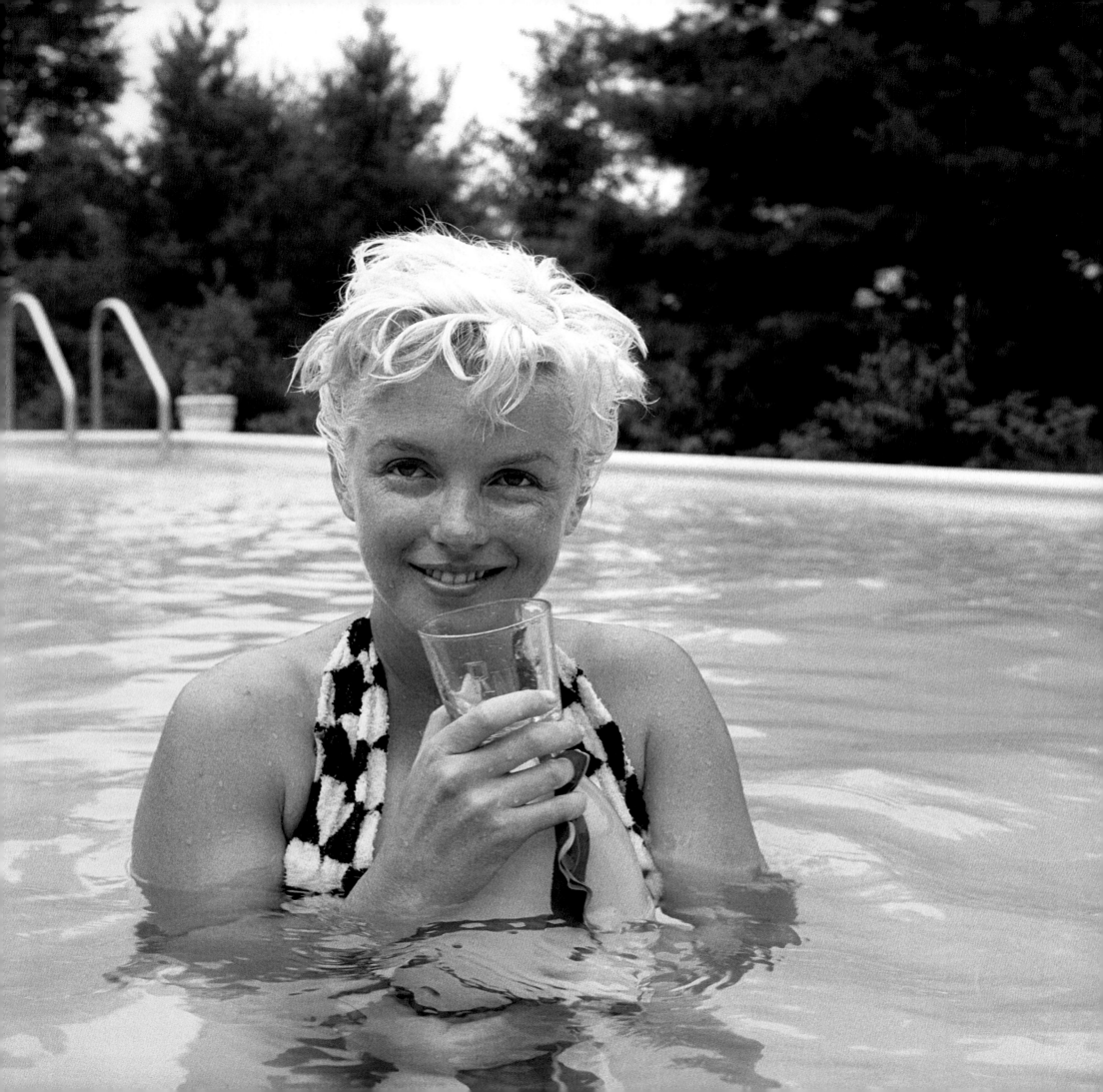

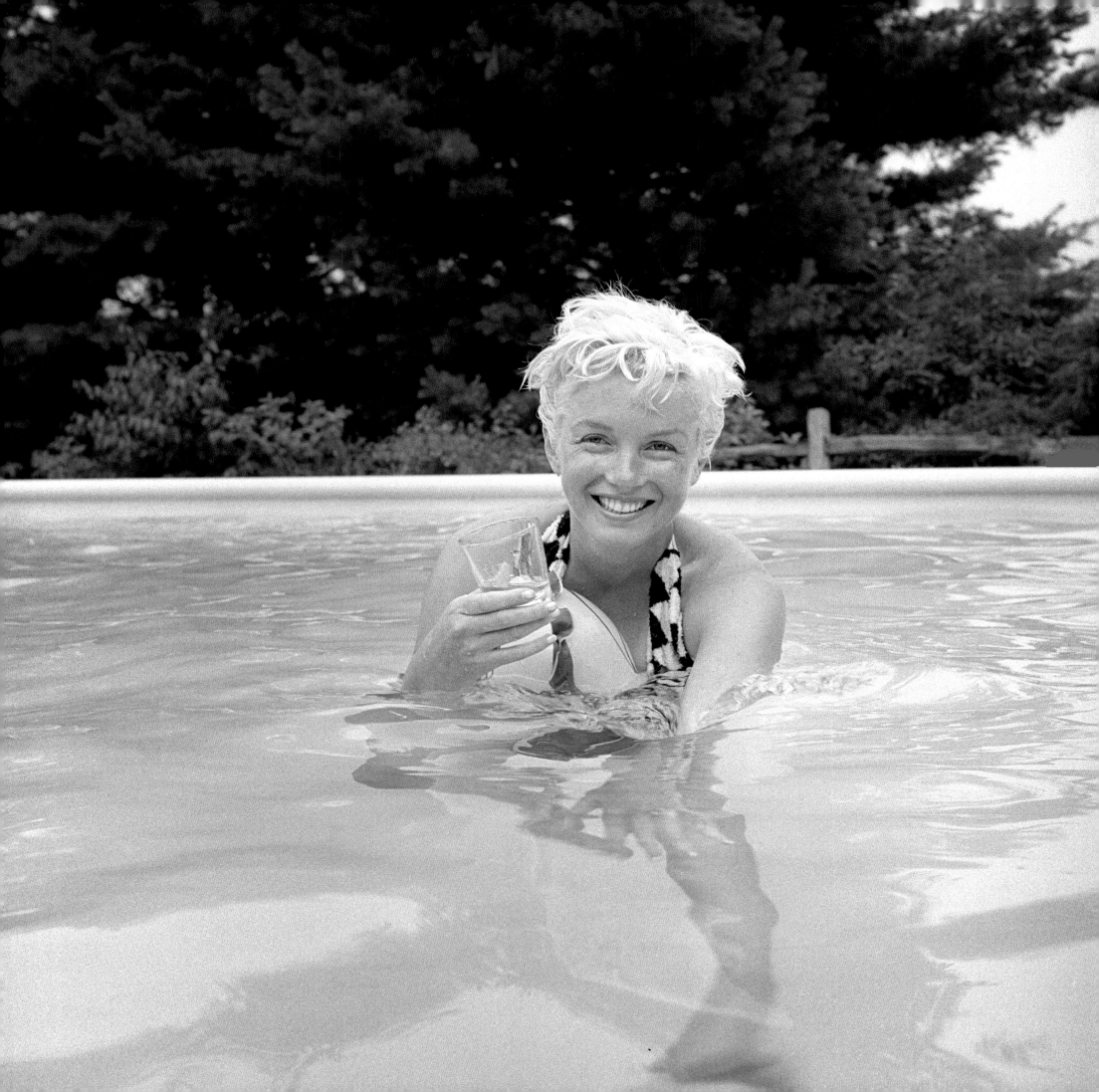

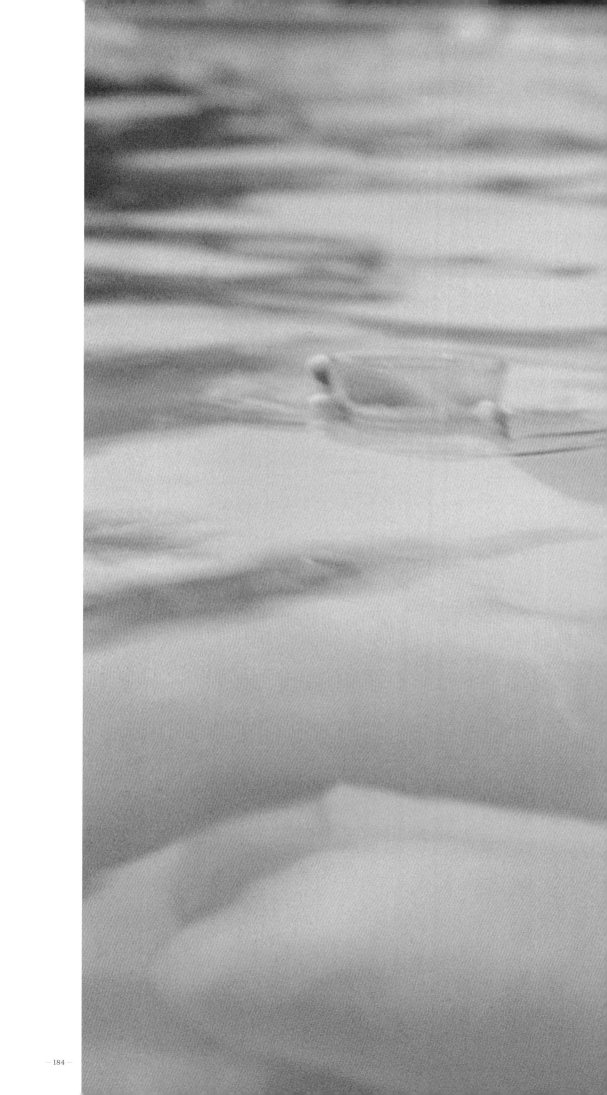

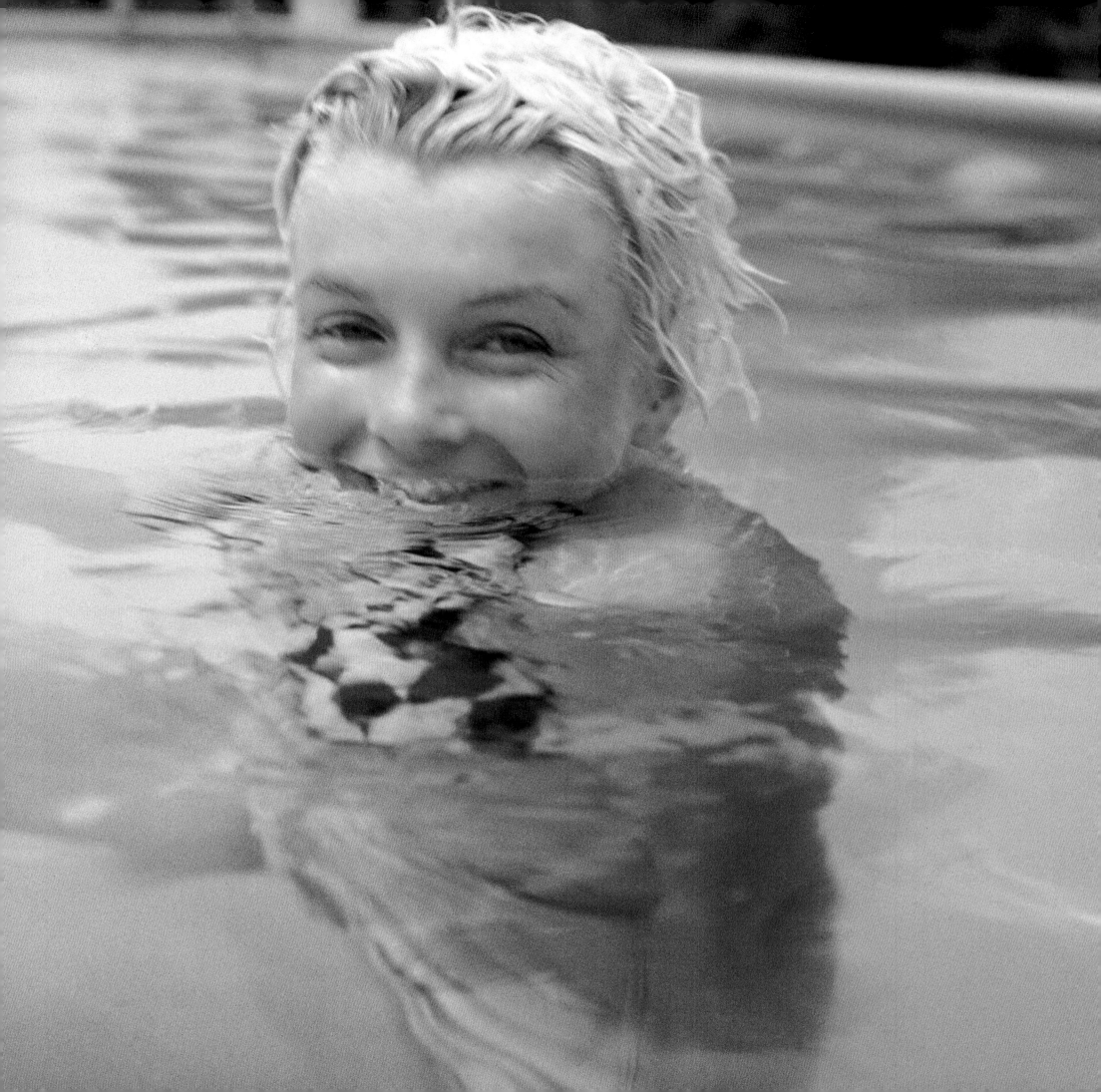

TRESTLE

July 1955 – The Greenes' home in Weston, Connecticut was
originally a barn and a residence. Milton converted the
barn by putting in large ten-foot by four-foot windowpanes
in the ceiling as skylights and similar windows on the north
wall. The light in the studio was soft and glowed. It was more
like a painter or sculptor's studio than a photographer's.
It was designed by the artist Joe Eula, a close family friend.
The next three sittings were not under assignment; they were
just done simply for their enjoyment.

Unpublished images:
Pages 187, 188, 189, 190, 191, 192, 193

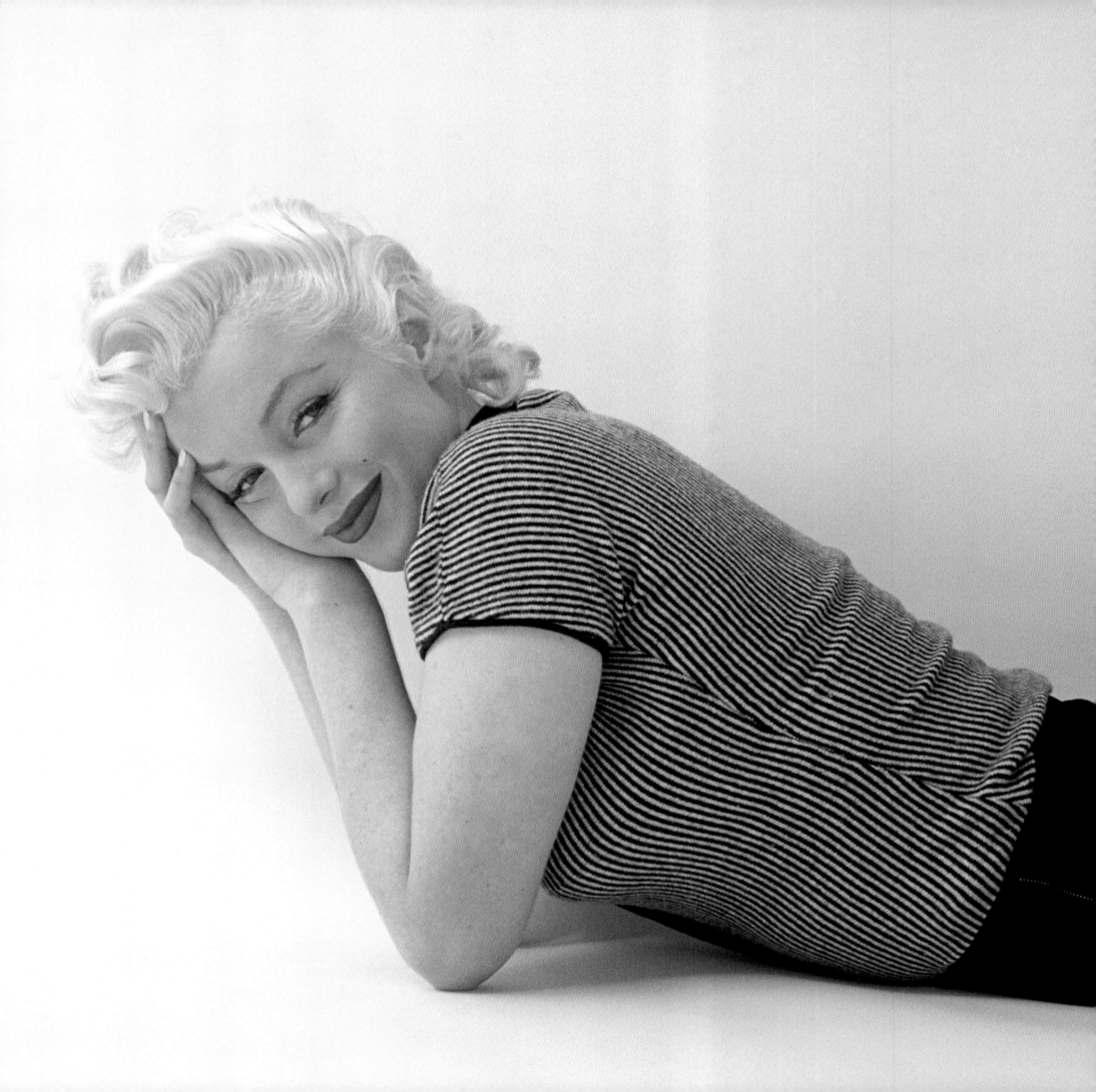

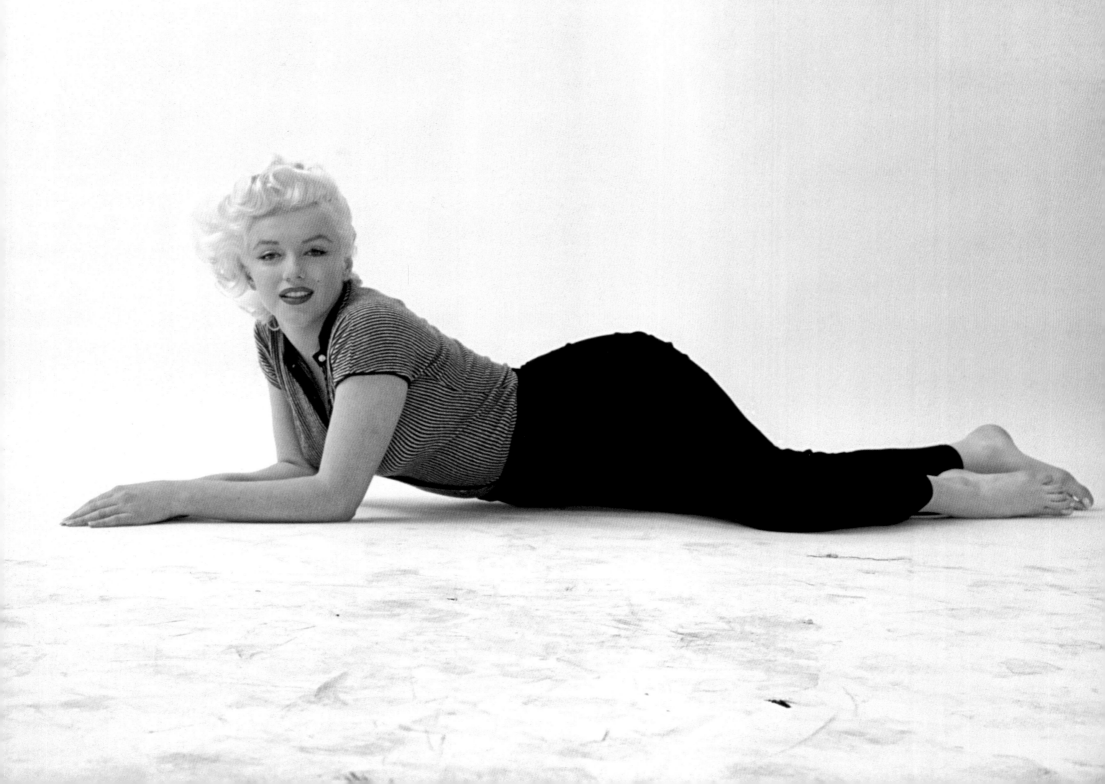

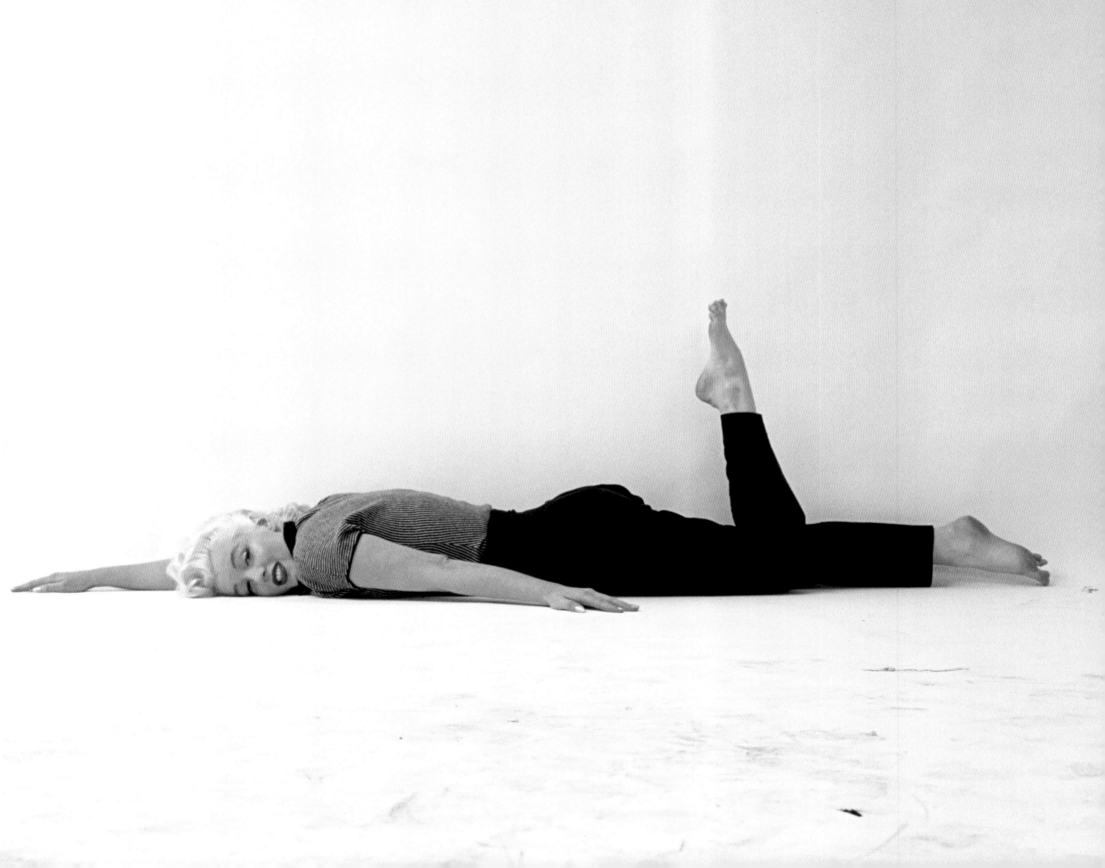

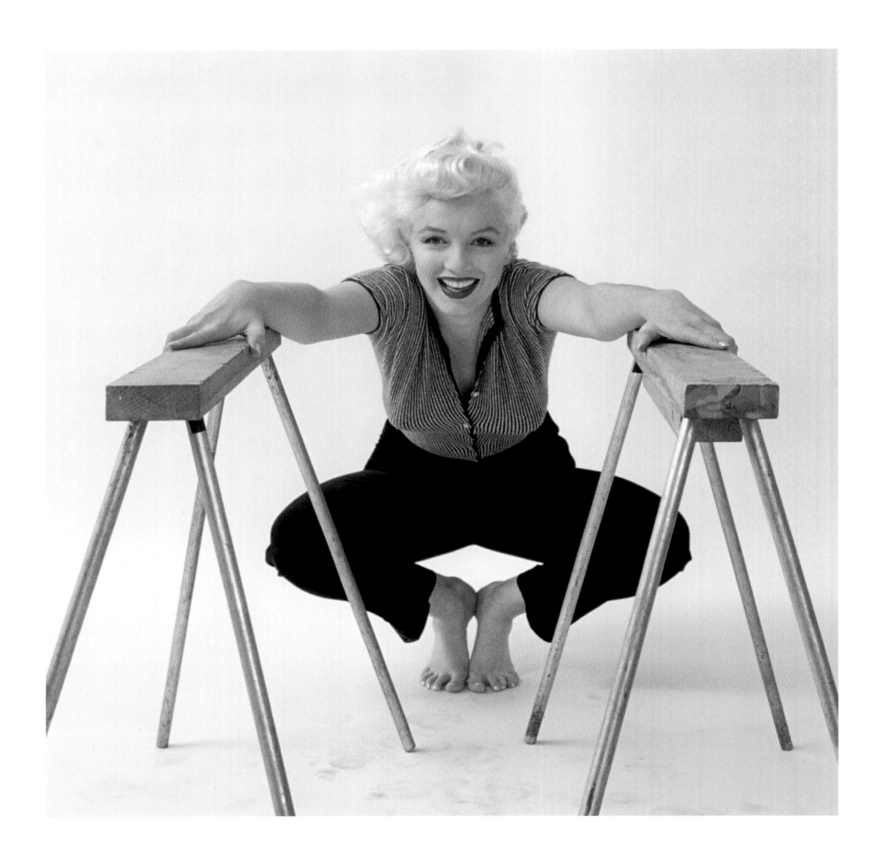

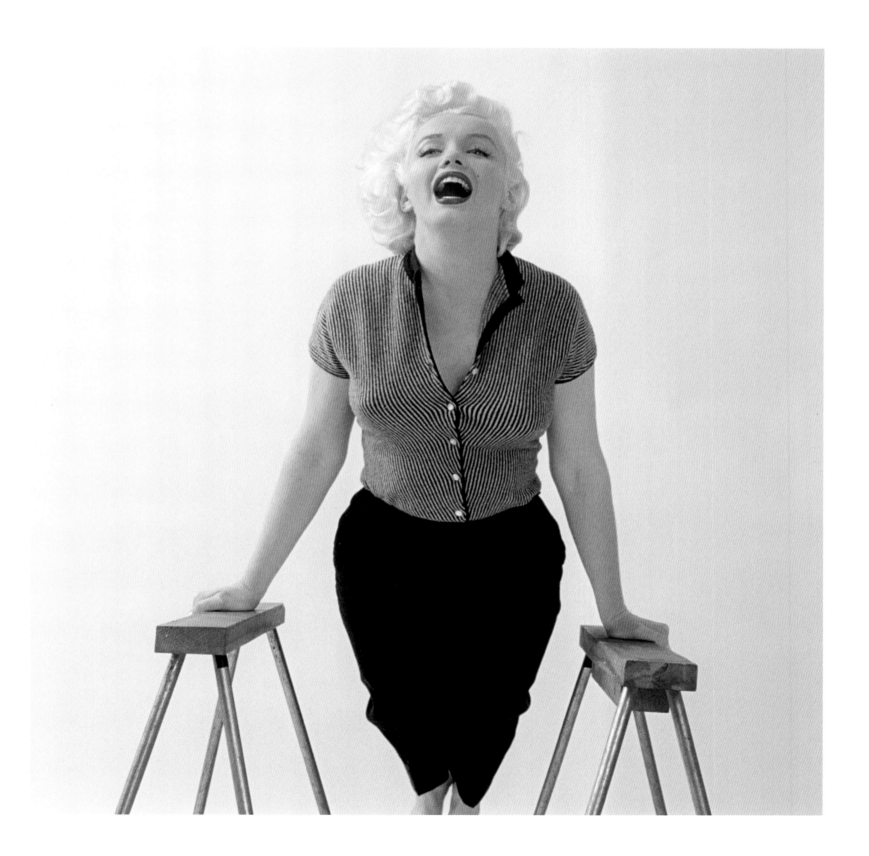

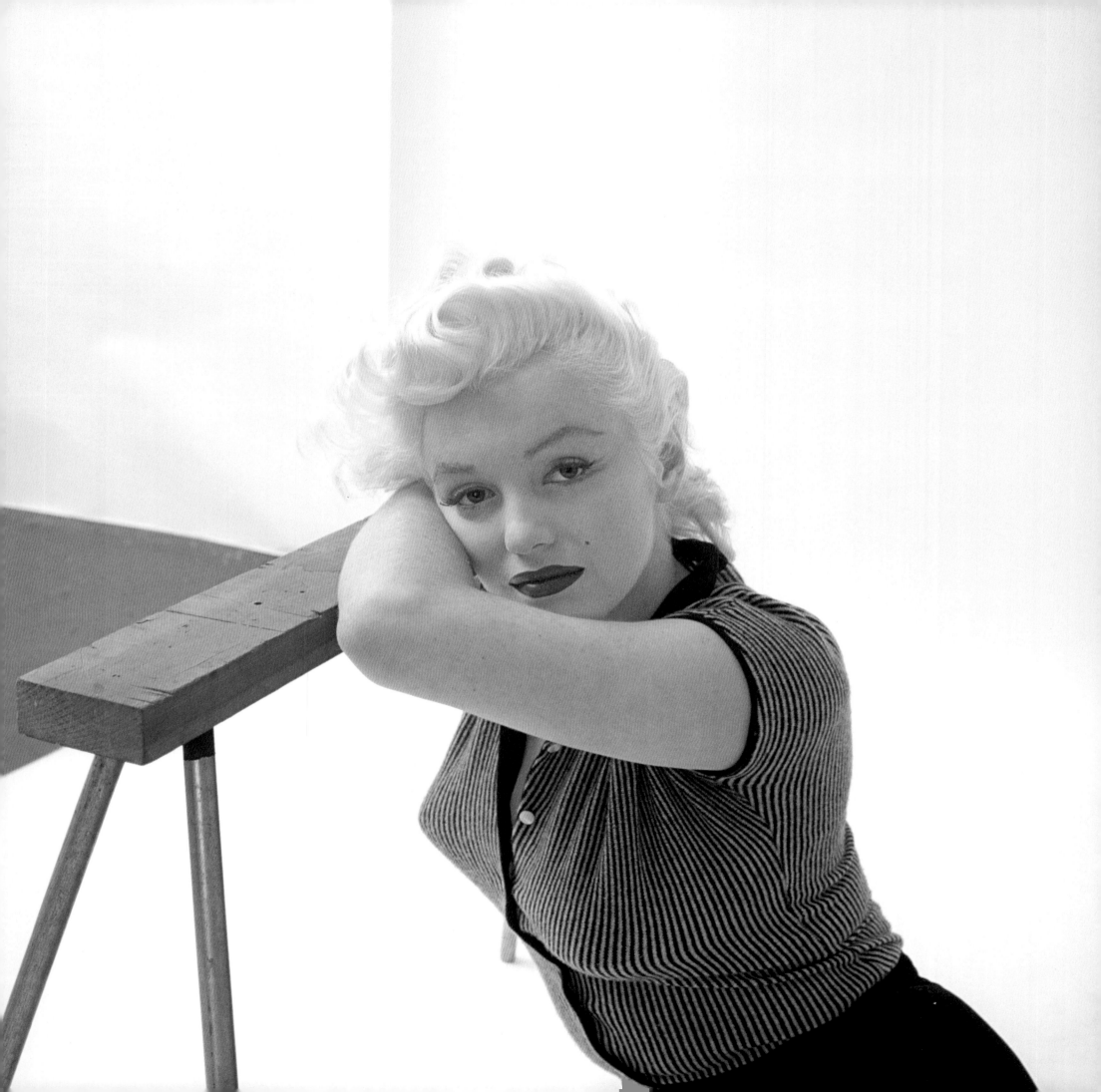

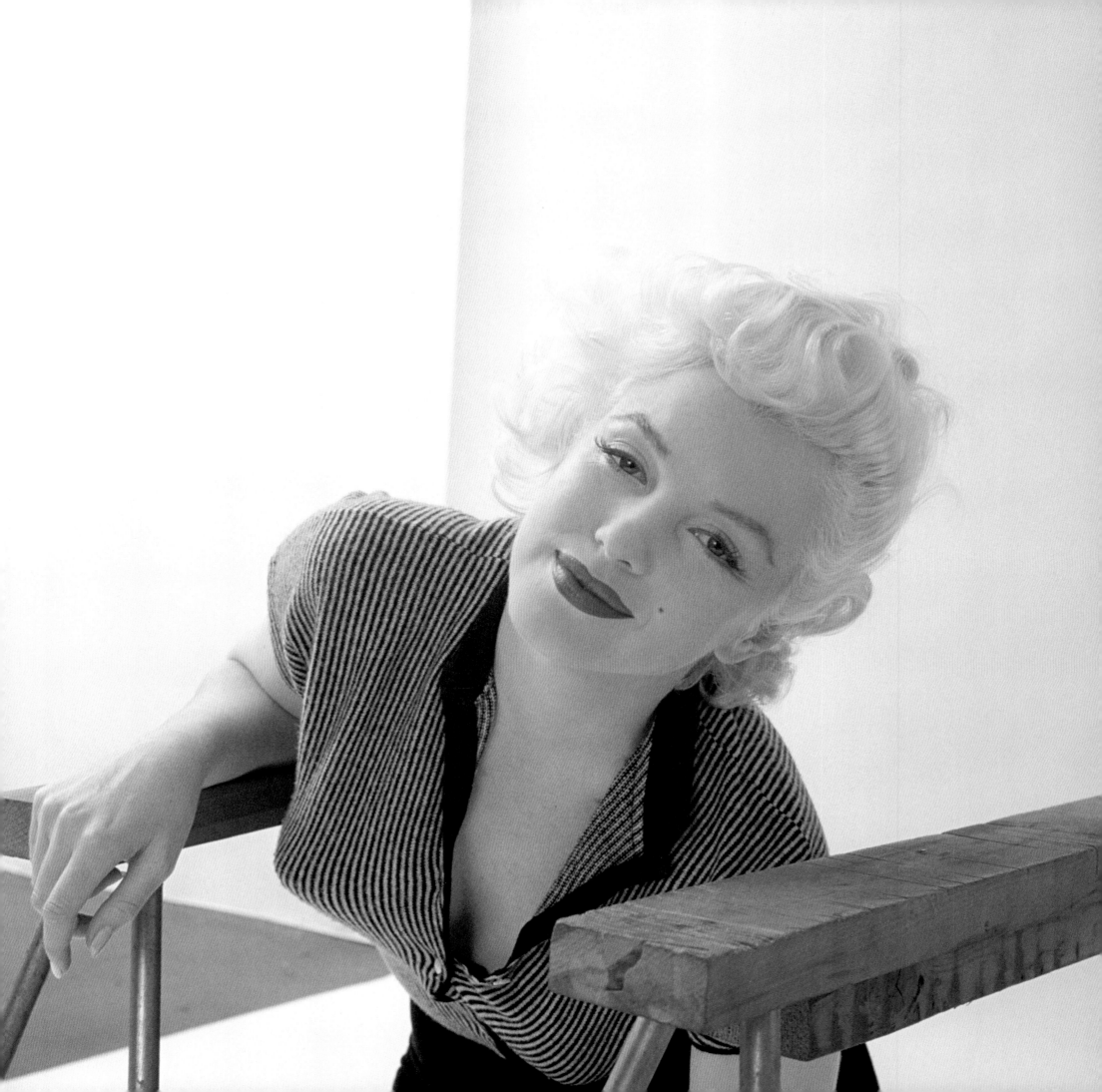

RED SWEATER

July 1955 – Donning one of Milton's props, Marilyn is shape shifting in his cashmere red sweater. Innocent, charming and funny, Marilyn was always the consummate actress.

Unpublished images:
Pages 195, 196, 198, 199

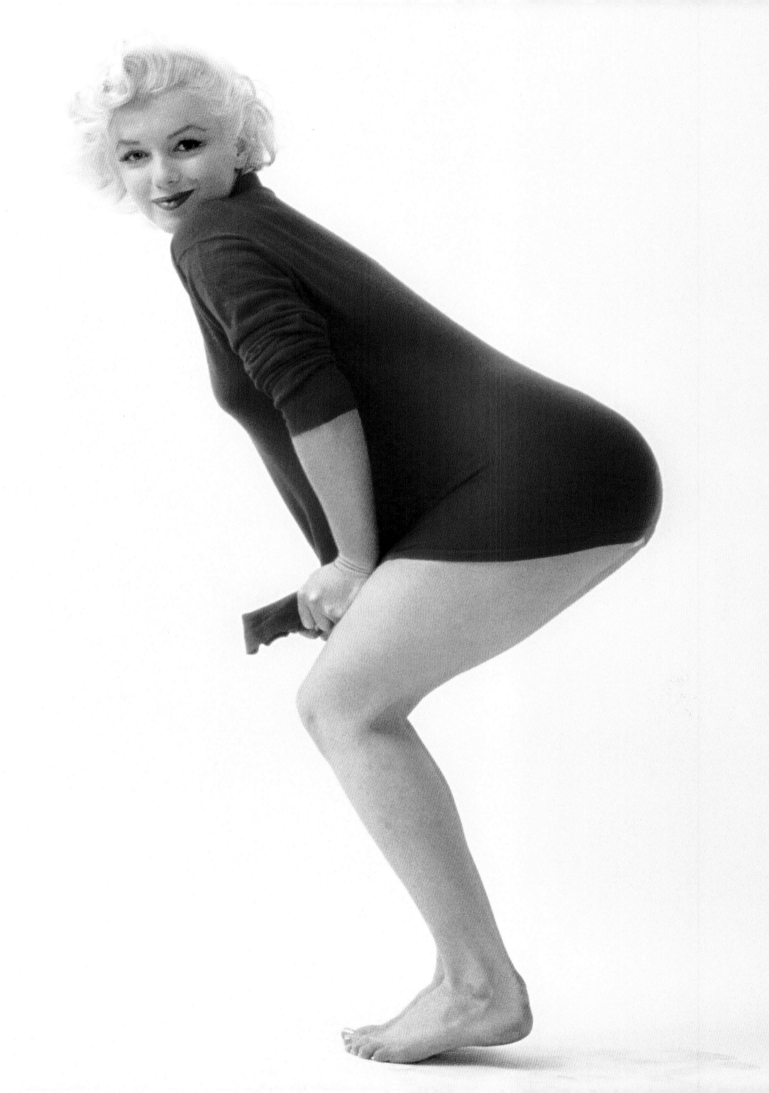

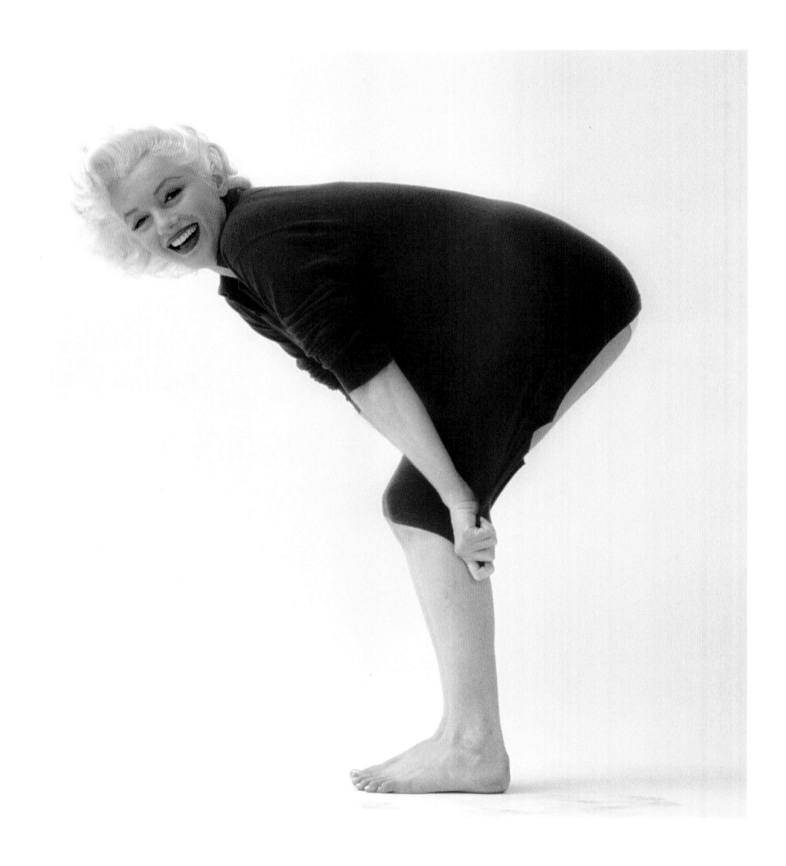

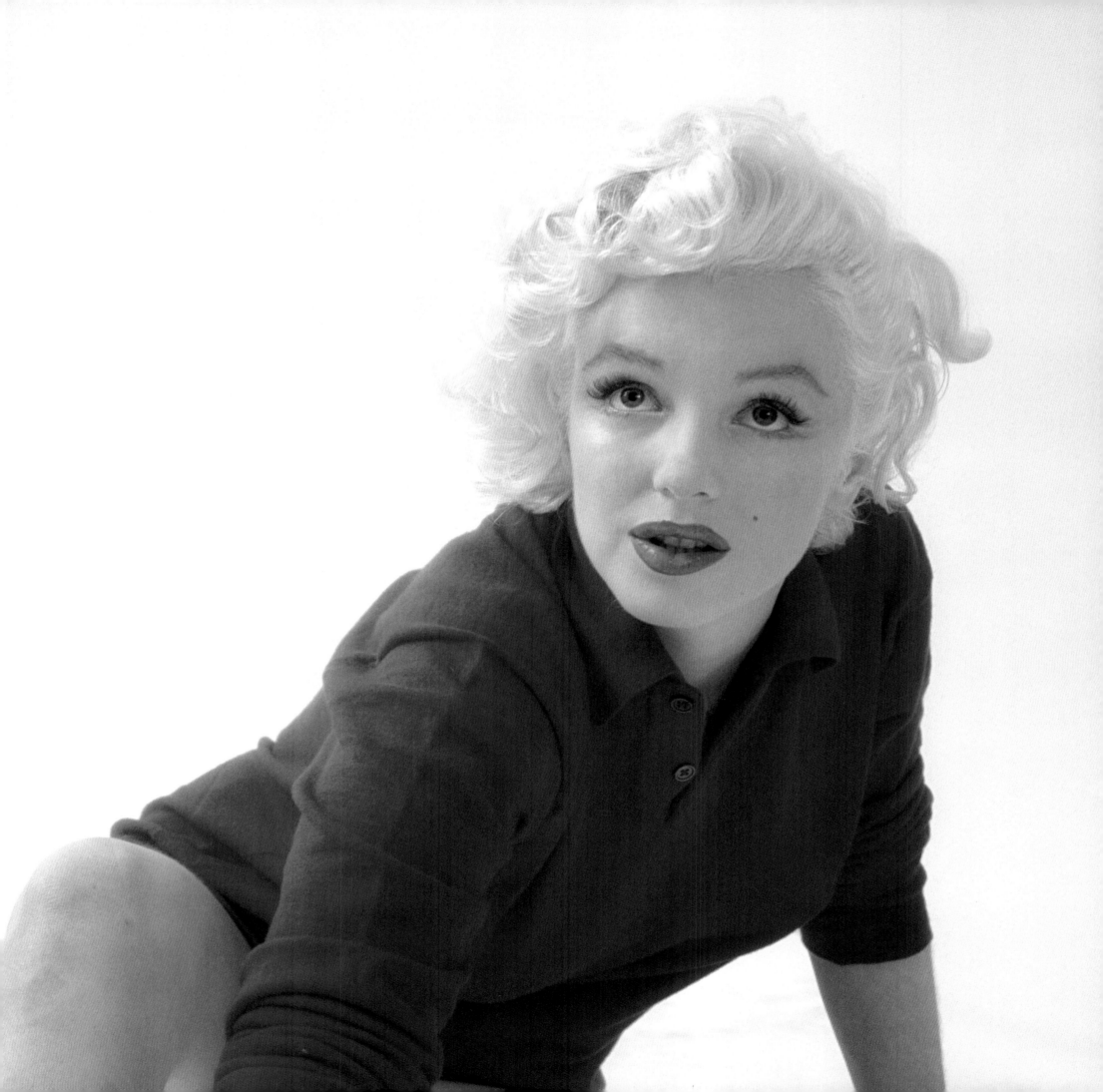

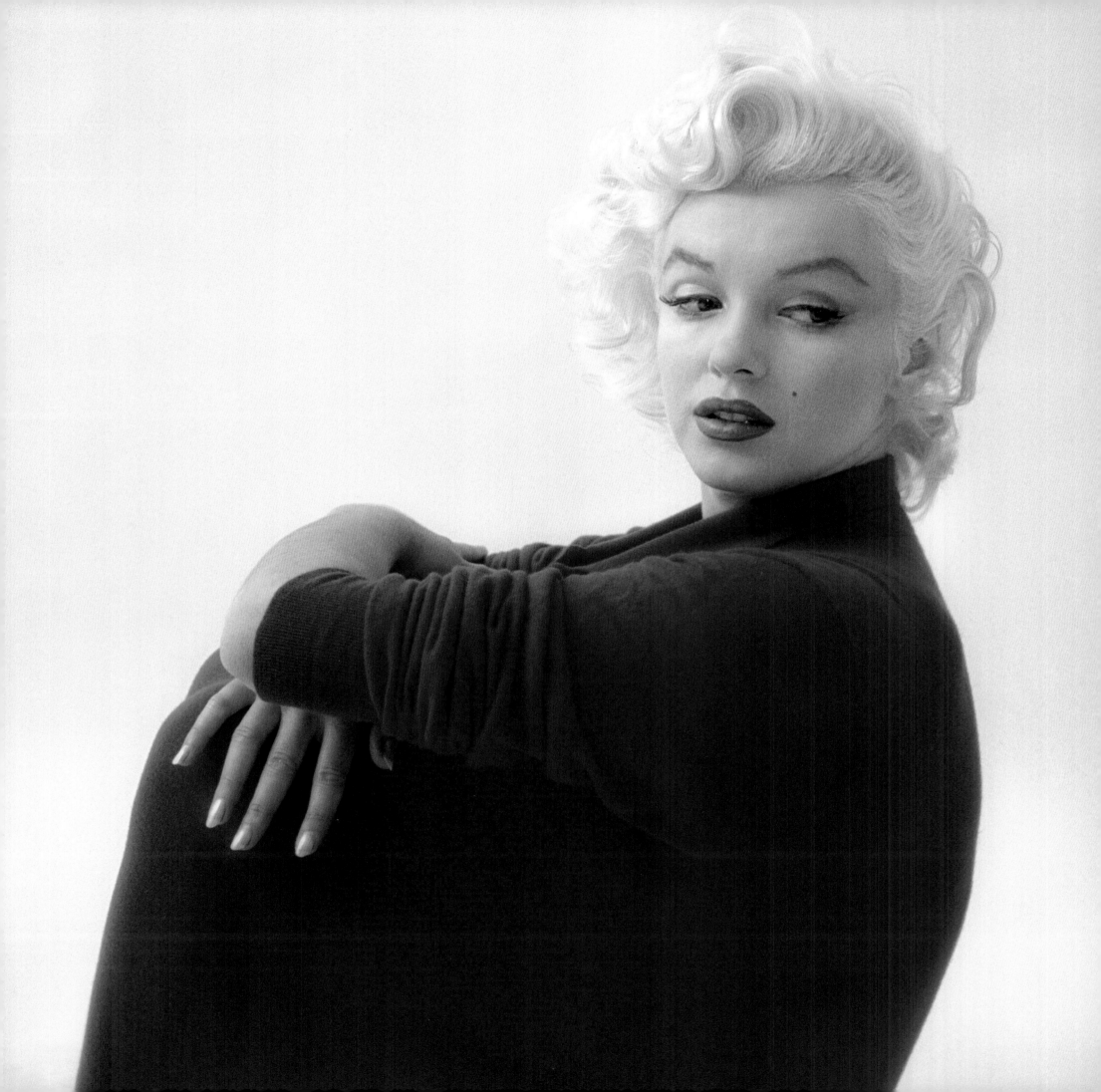

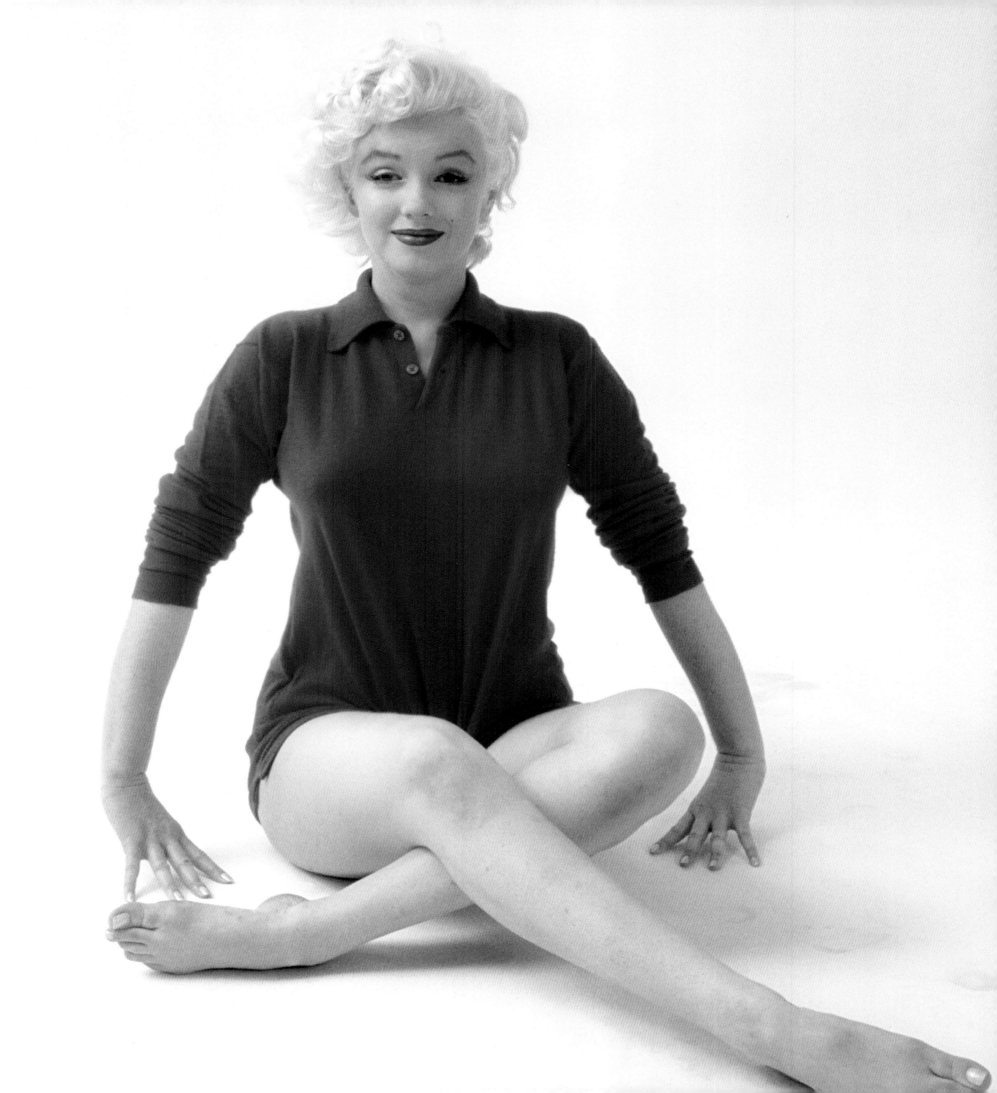

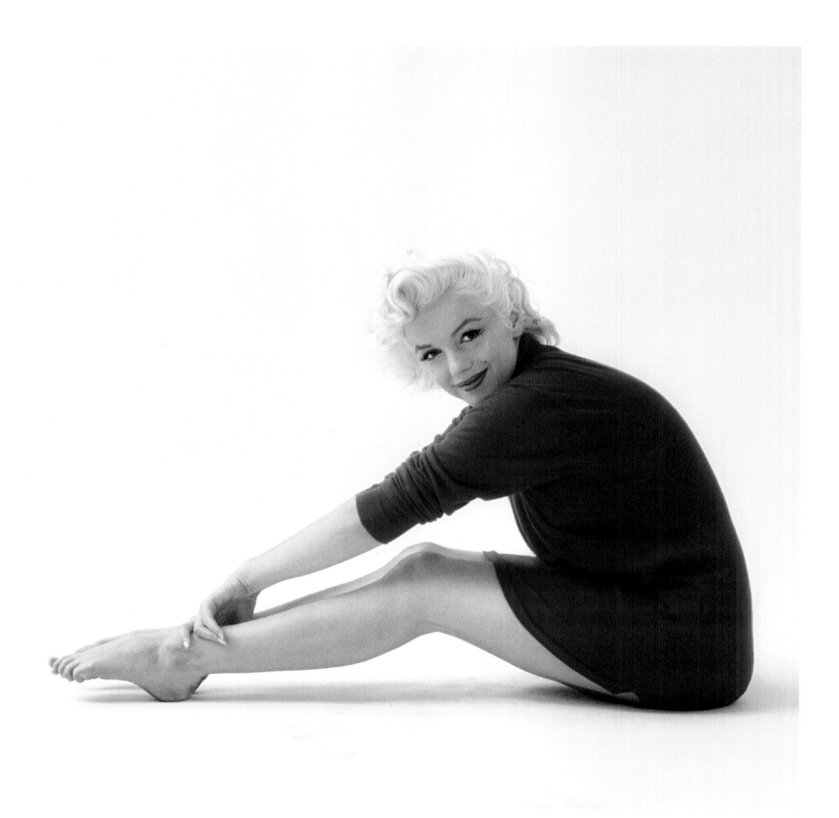

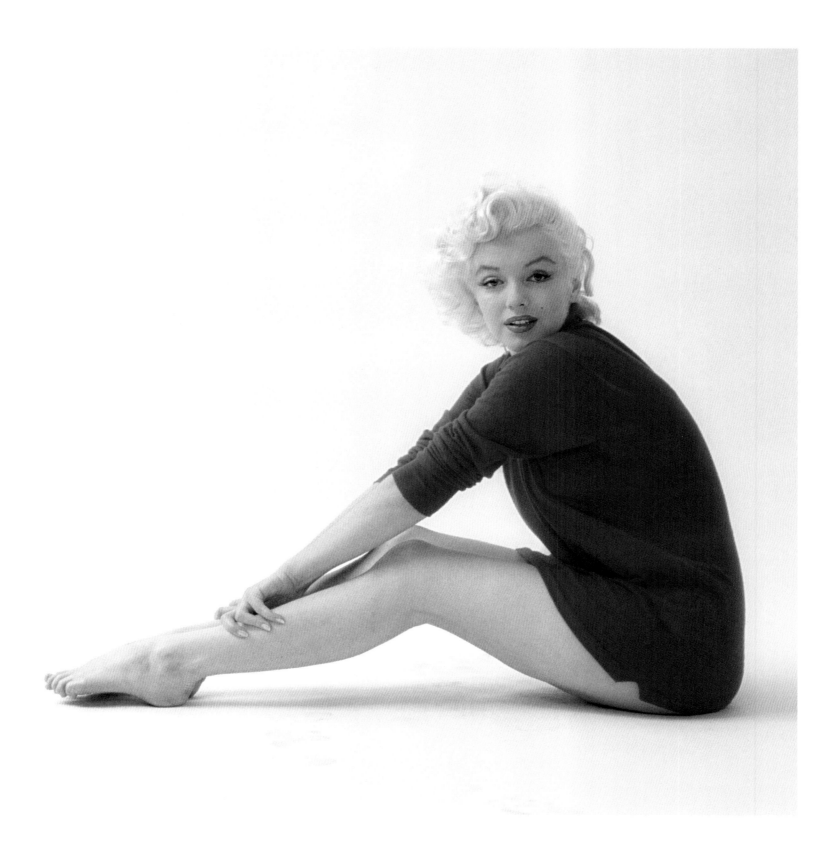

V-NECK
SWEATER

August 1955 – After a family breakfast, and with Marilyn wearing a tennis sweater left behind from a previous fashion sitting, she and Milton went to the playpen once again.

Unpublished images:
Pages 203, 204, 205, 206, 207

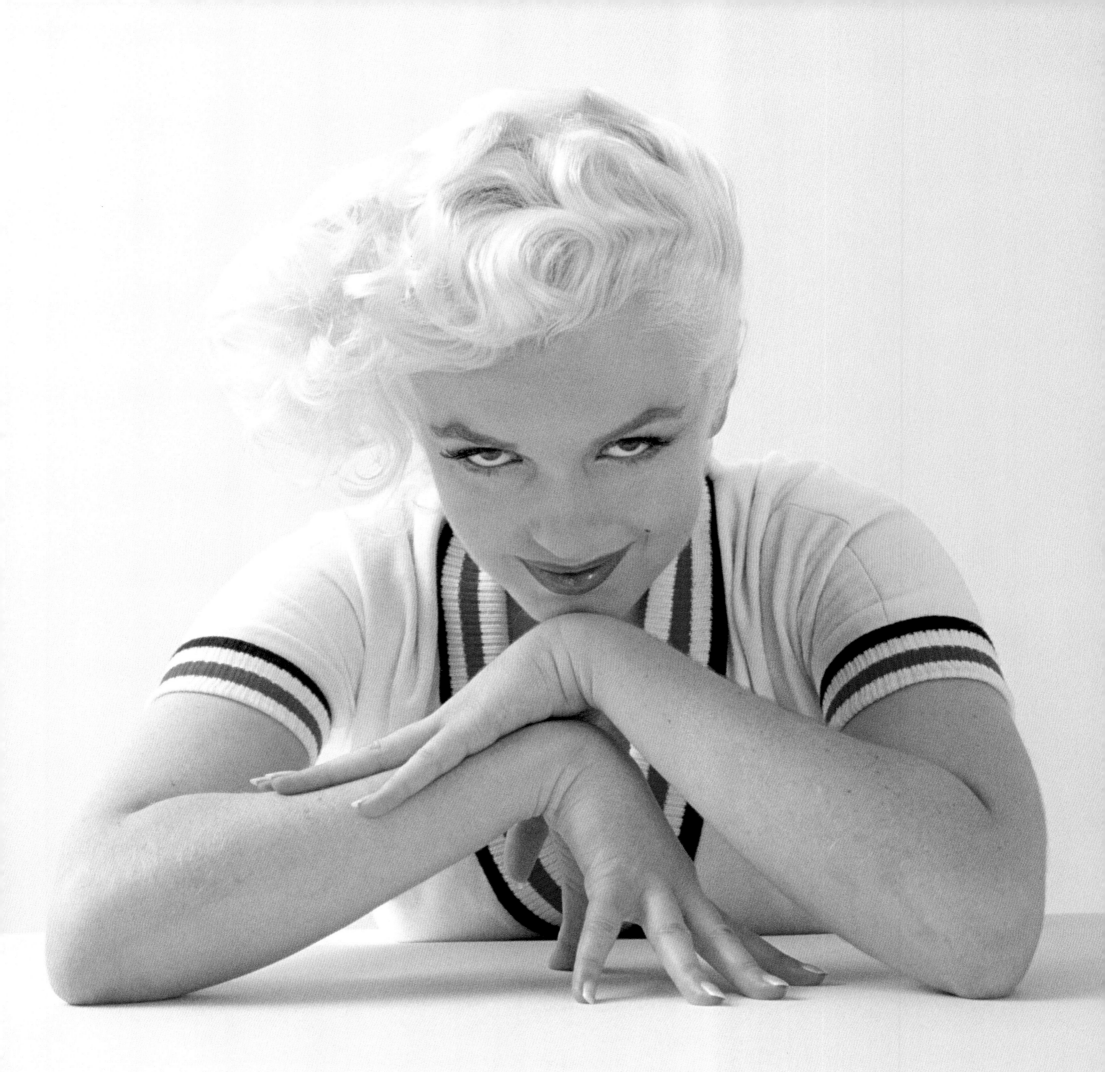

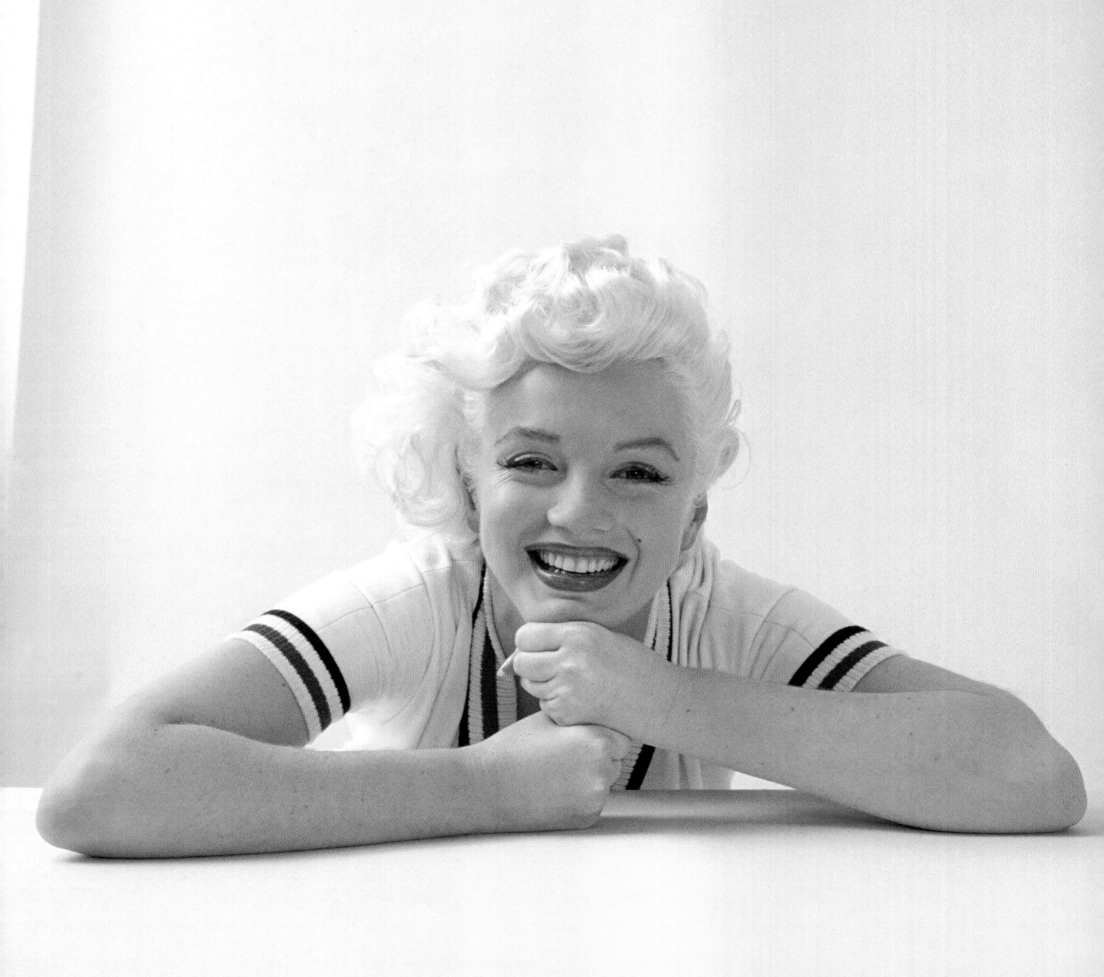

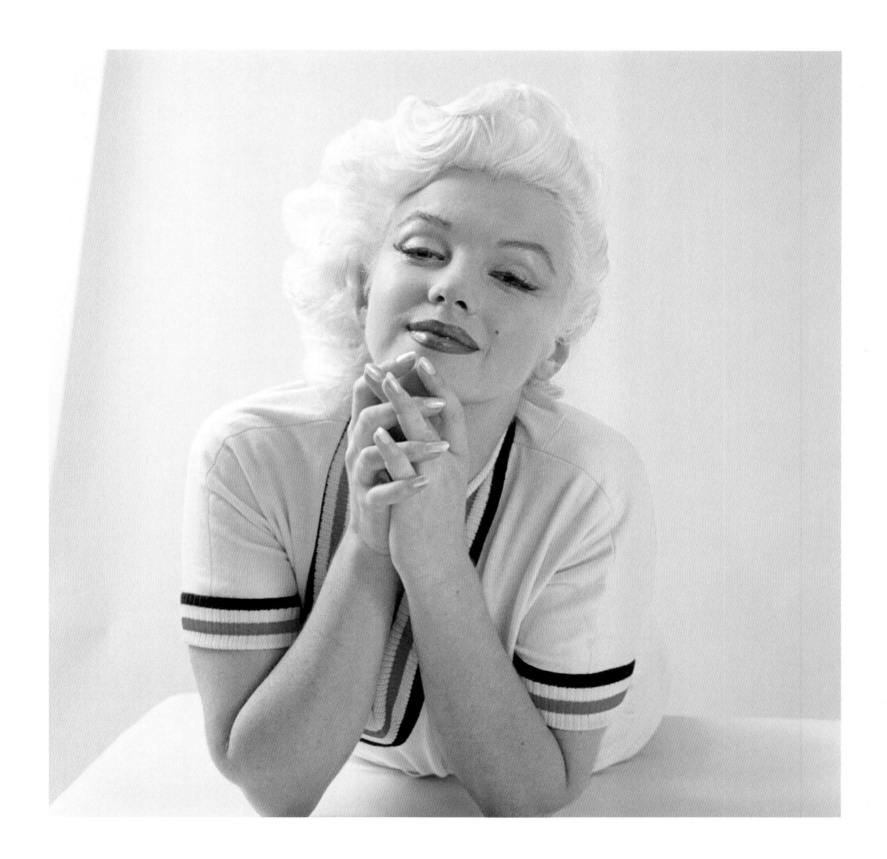

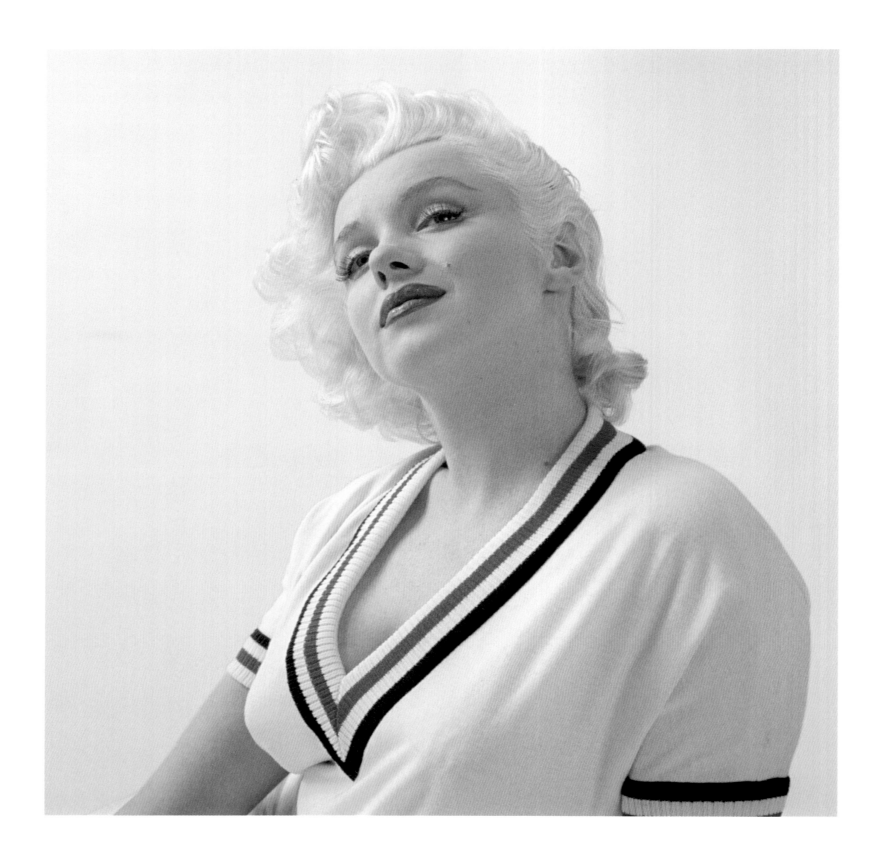

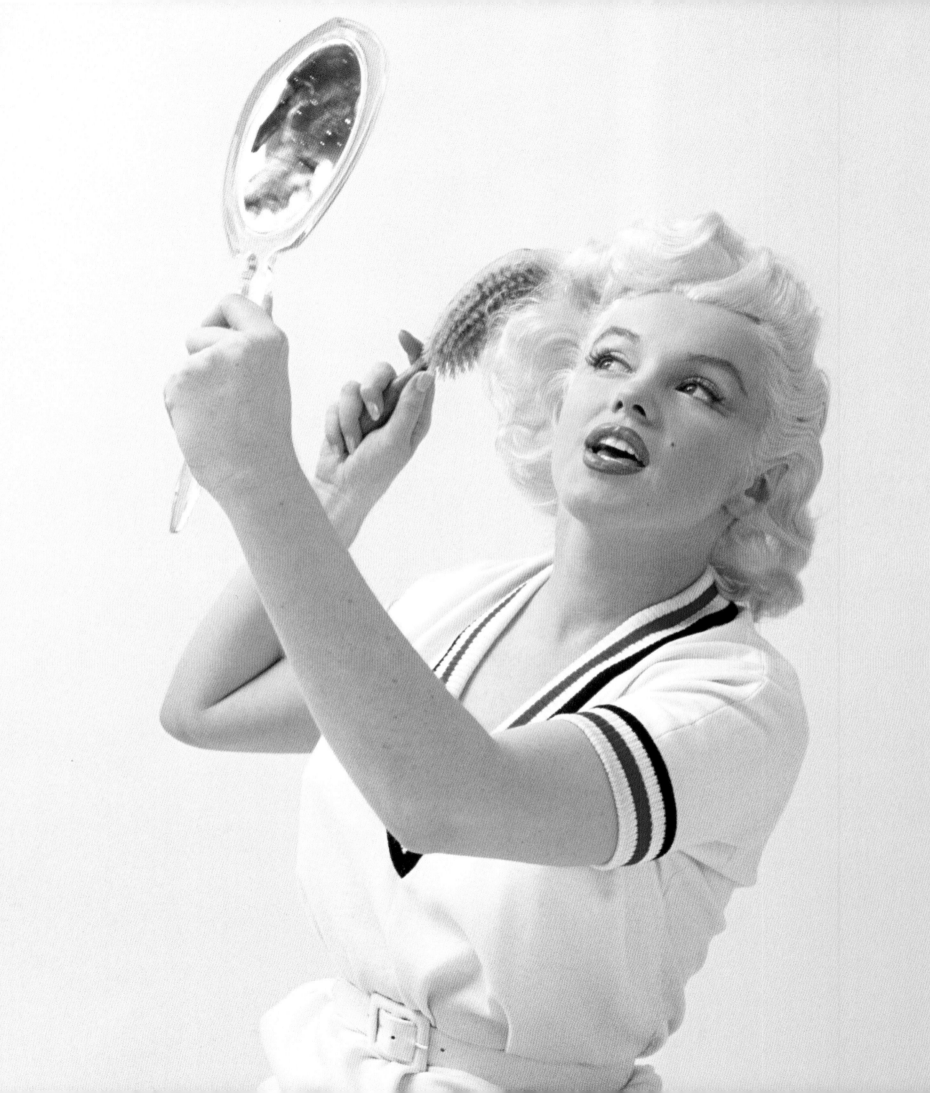

MONROE & CHEVALIER

September 1955 – Milton spent a lovely afternoon with Marilyn and entertainer Maurice Chevalier in his New York studio while on an assignment for *Look* magazine. Using two of his three favorite props (a hat and some soft fabric, which in this case is the boa and the ostrich fan Marilyn is holding), Milton posed them around an upright piano as Chevalier's accompanist played mood music. Chevalier serenaded Marilyn with song after song as his accompanist kept reminding him of more favorites. Marilyn, dressed in gold with matching nail polish and jewelry, thoroughly enjoyed the attention.

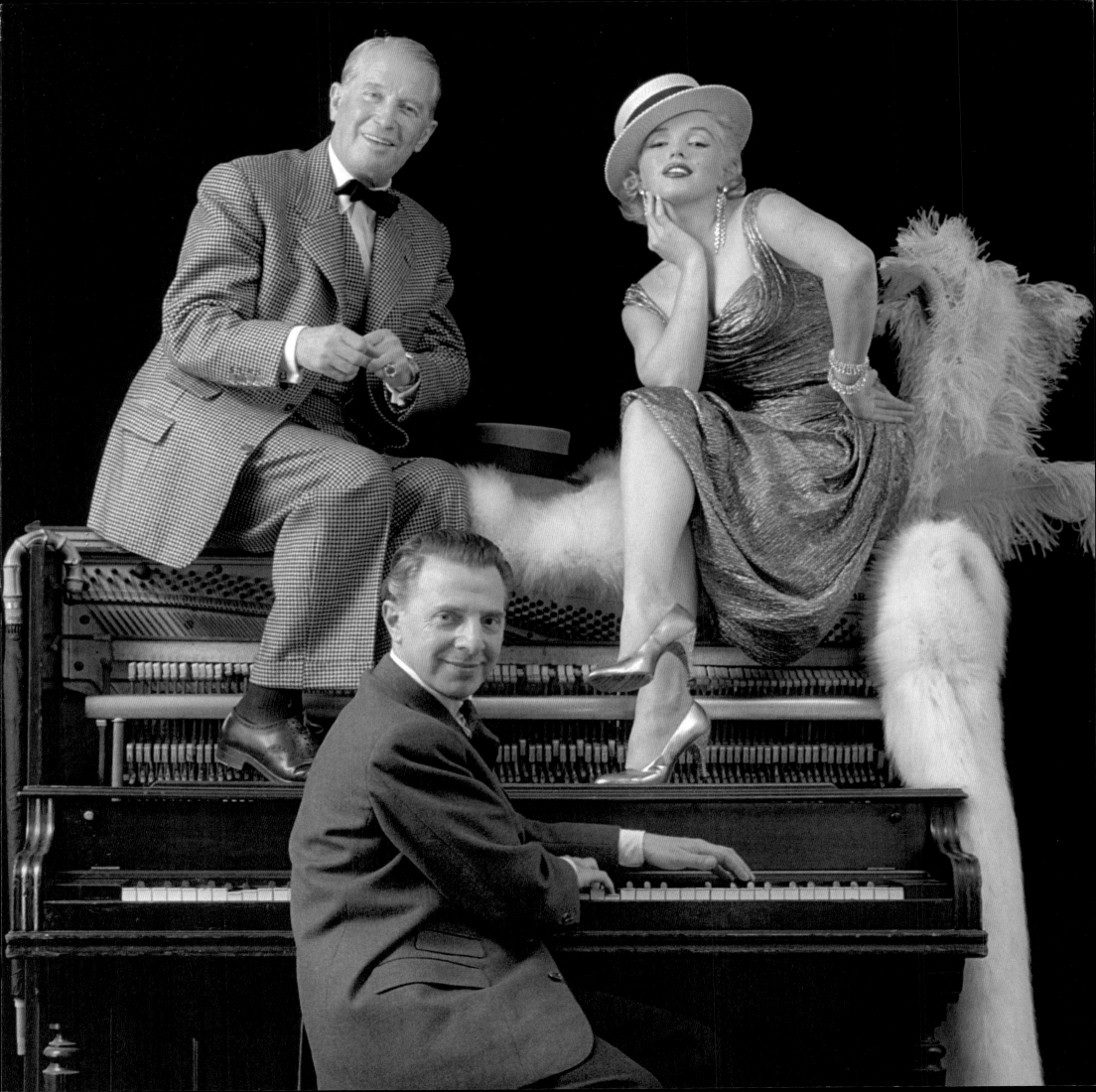

BLACK CAPE

October 1955 – Milton selected two outfits from a rack of
clothes left over from a fashion shoot and used Marilyn as a
model while setting up lights for two shooting environments to
be used the following day. Milton and Marilyn had heard that
the lawsuit filed against 20th Century Fox would soon be
settled and were in festive mood. "She wasn't a victim.
I hate when people describe her as a victim," recalled Amy.
"She was a young woman that was a sponge who wanted life to
come in and show her what she had to do. She was ready
for anything. That's why she had such a great sense of humor.
And she lived every day in the present."

*Unpublished images:
Pages 211, 212, 213, 214, 215*

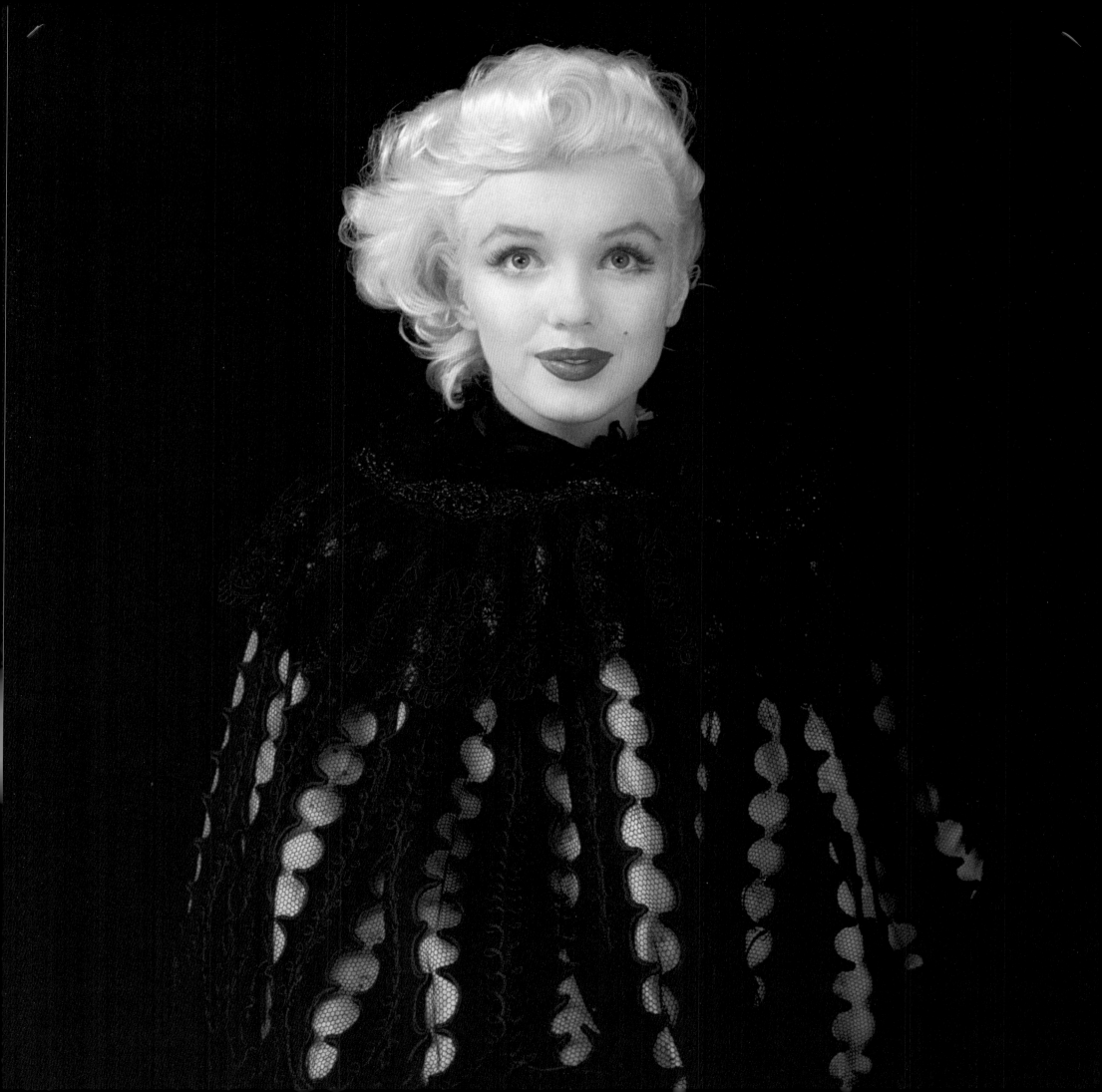

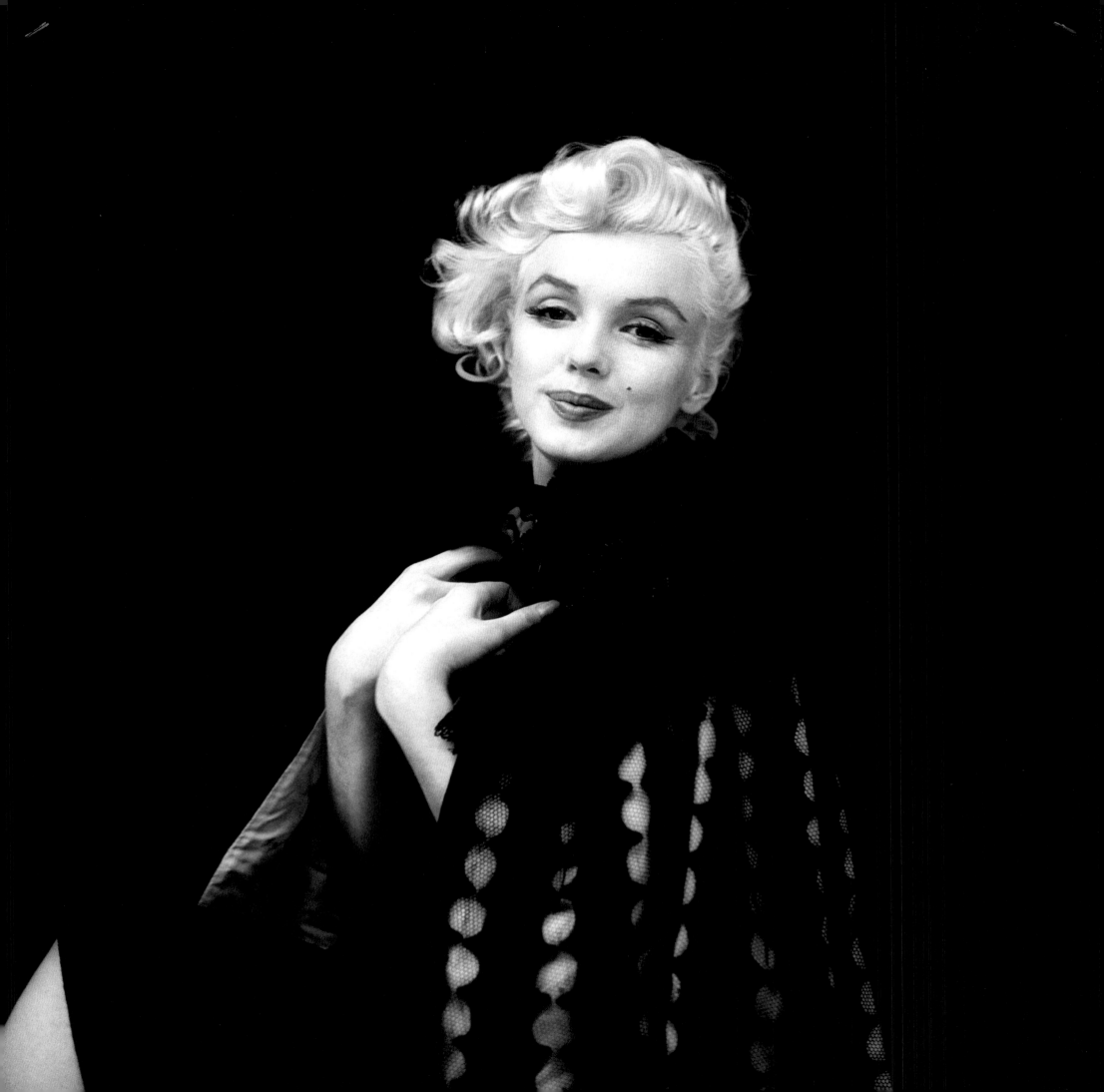

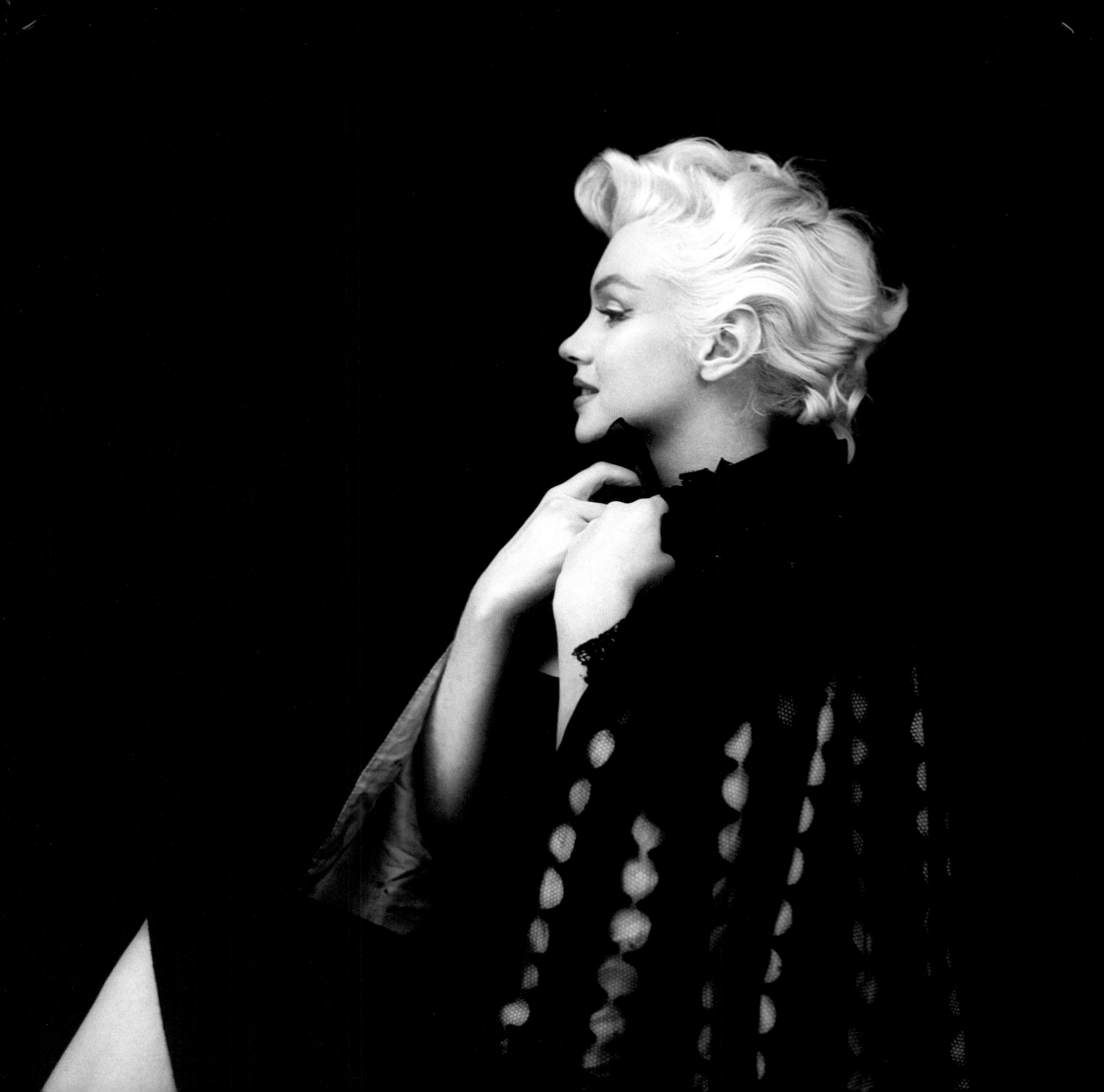

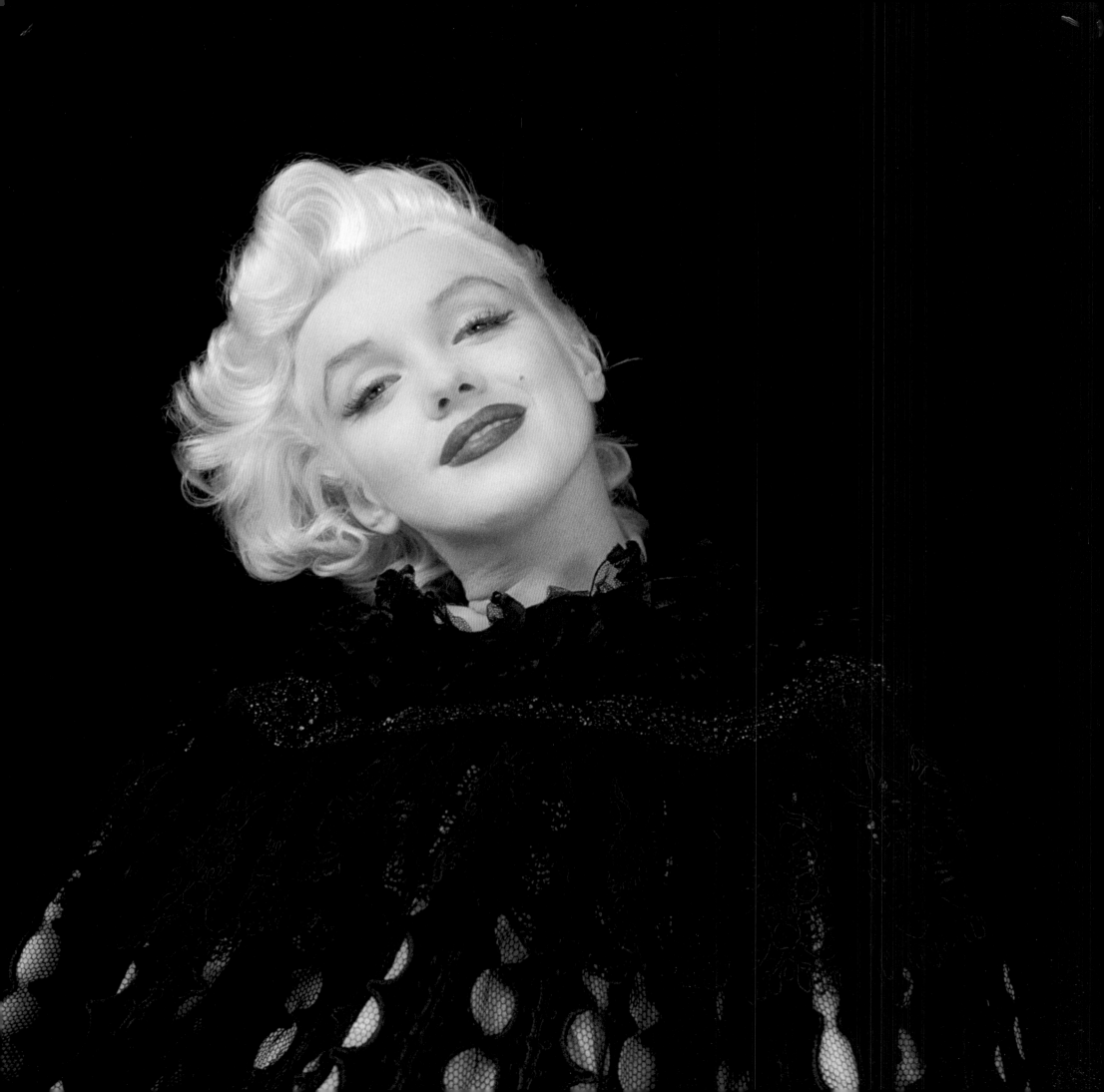

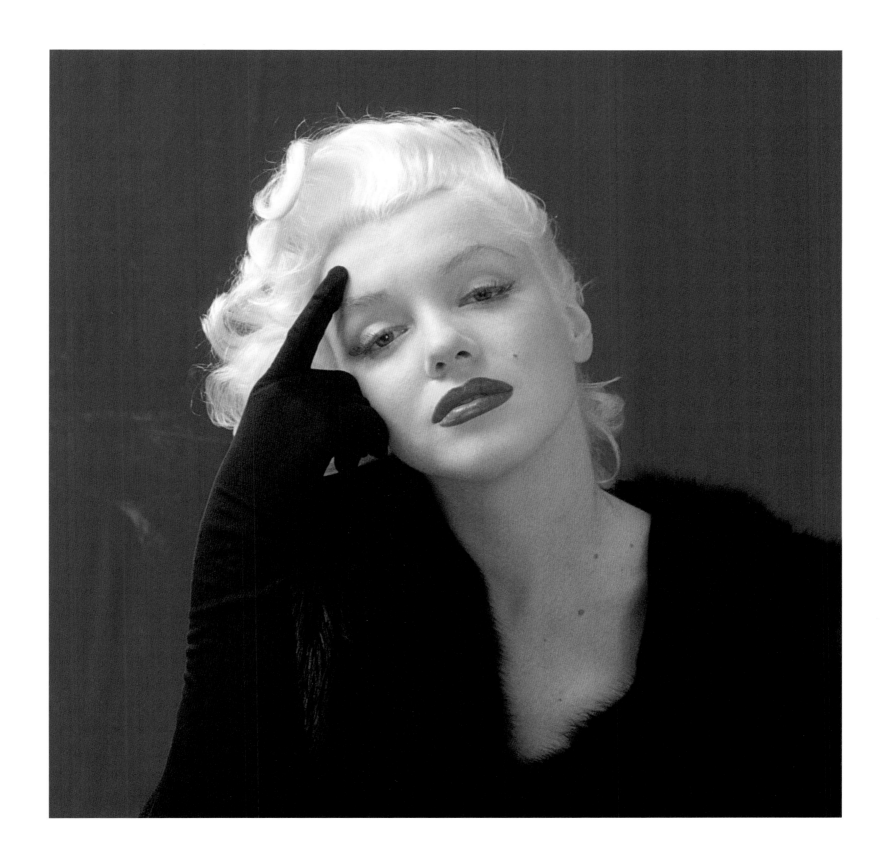

MARILYN &
MARLON

November 1955 – In order to raise money for the Actors Studio, a performance of *The Rose Tattoo* was planned as a benefit gala. Amy was tasked with promoting and selling tickets, which up to that point had been slow going. To help spur sales, Milton called Jay Kanter, Marlon Brando's closest friend and agent, telling him to bring Marilyn and Marlon to the studio for some publicity images to promote the gala. The two were having an affair at the time, which is obvious in the photos by how exuberant Marlon was, which was out of character for the intense and serious method actor.

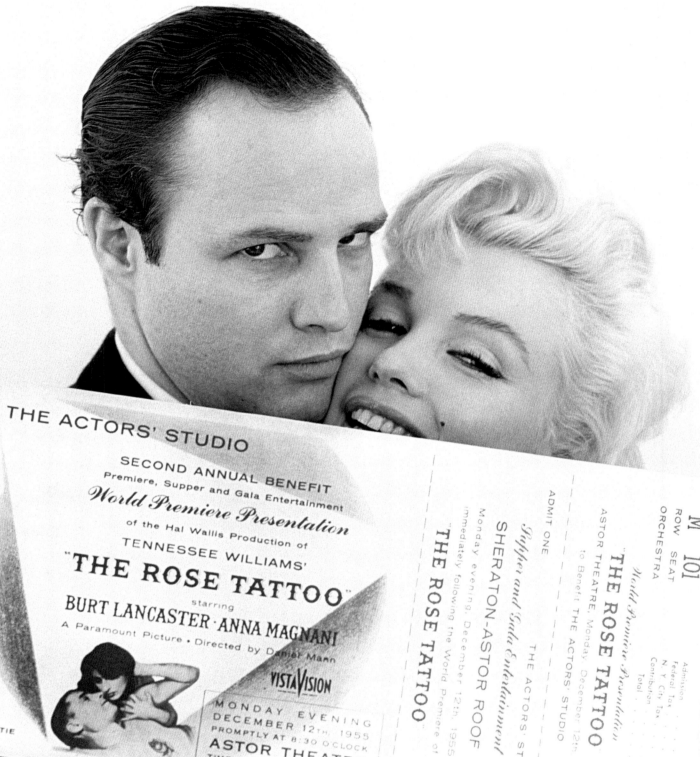

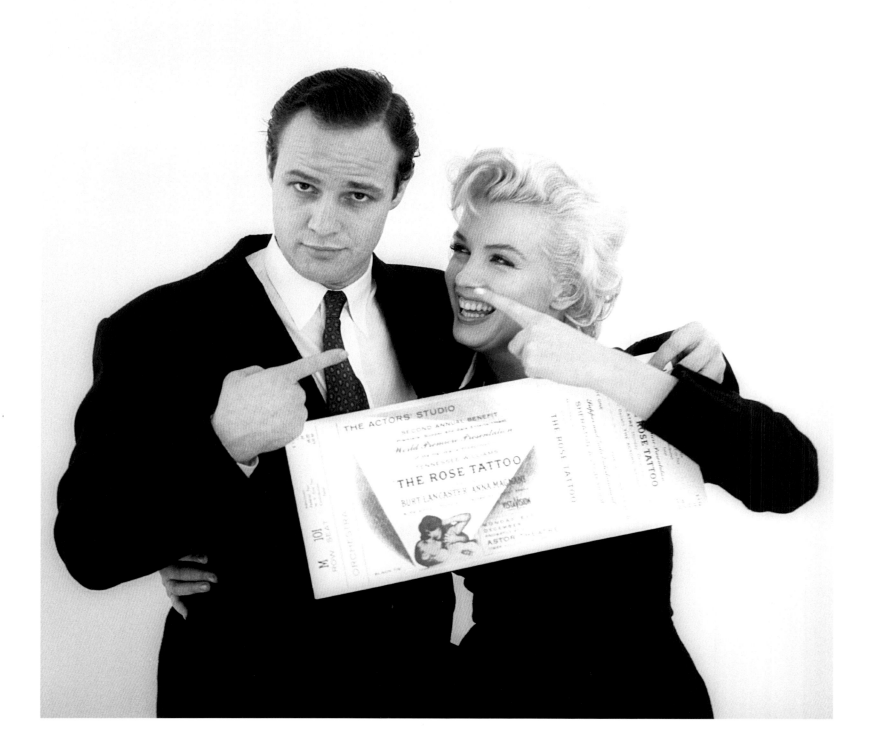

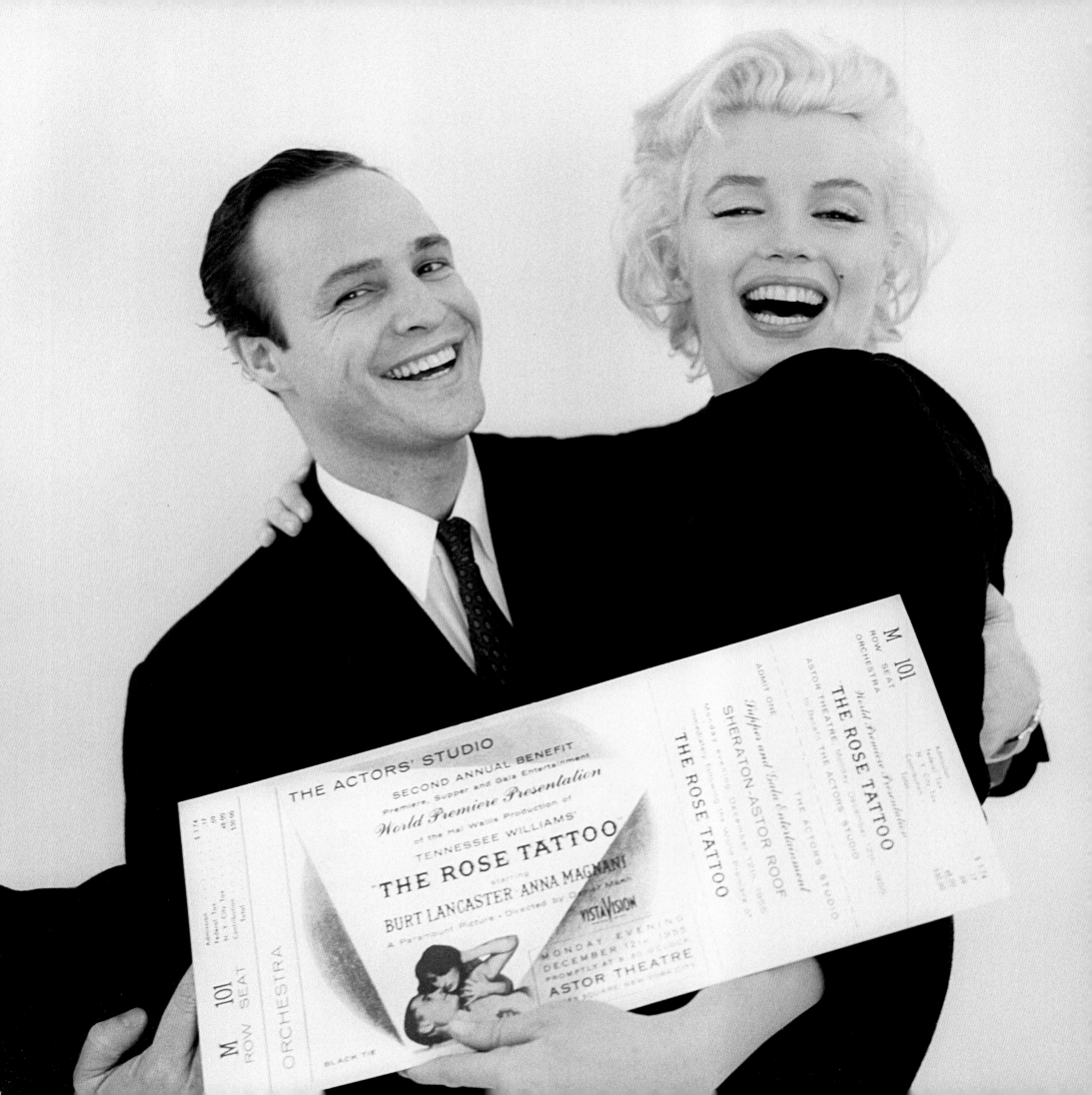

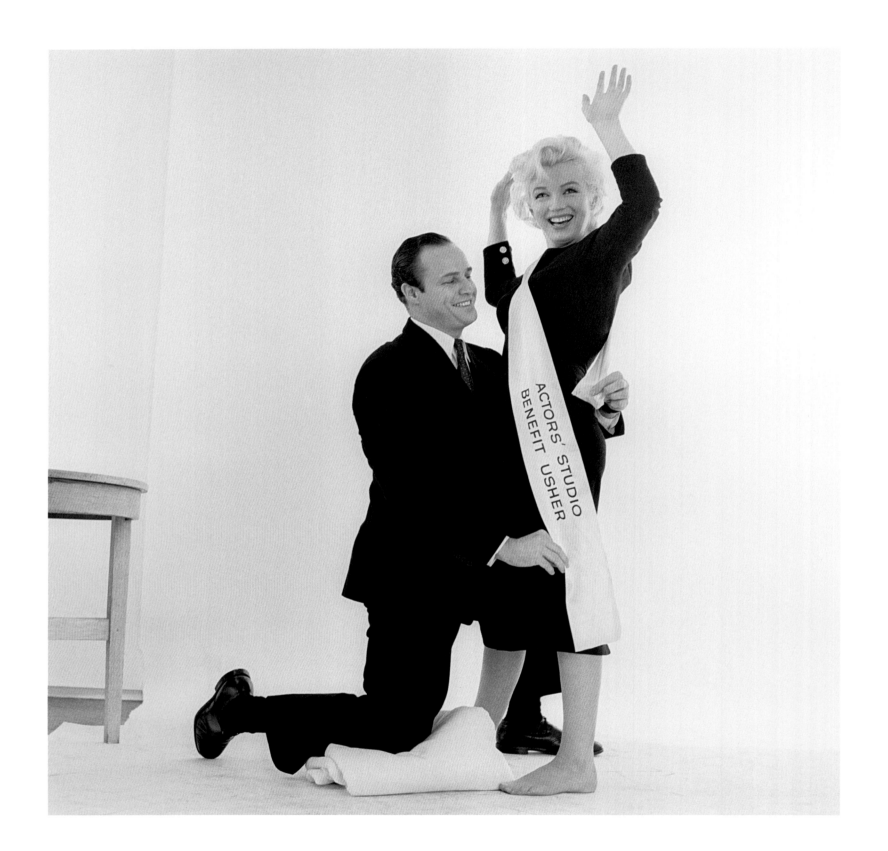

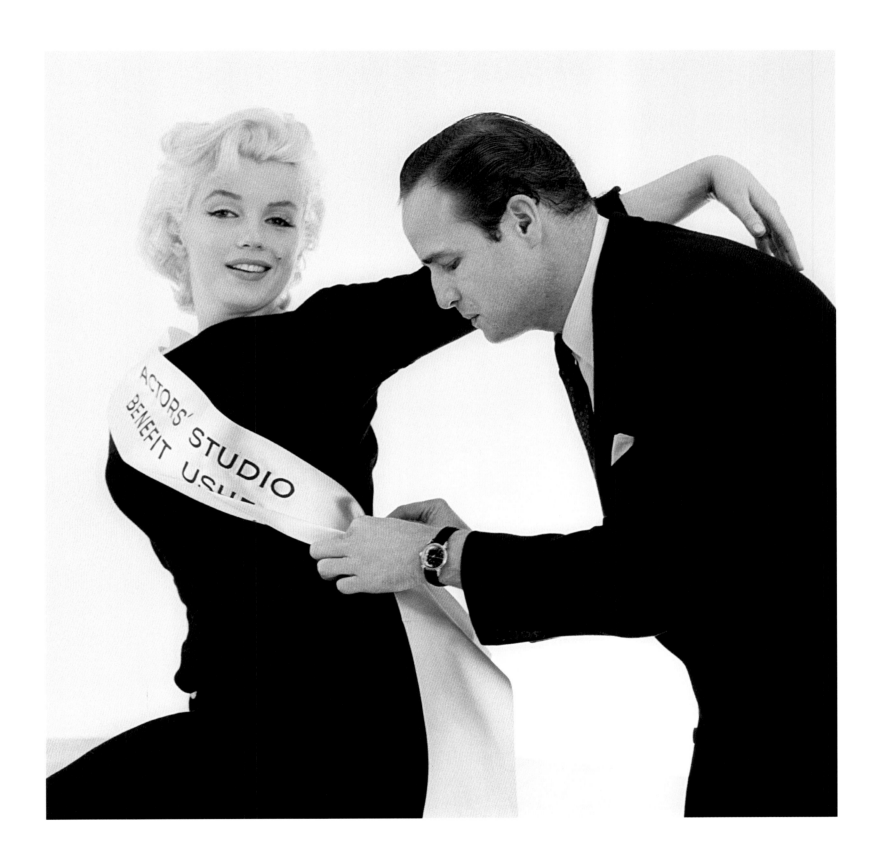

ACTORS STUDIO

December 1955 – Although known as the world's premiere sex symbol, Marilyn was serious about developing her skills as an actor. To truly hone her craft, she came under the tutelage of the controversial Lee Strasberg and The Actors Studio. After 18 months of watching, studying and practicing in private, Marilyn eventually performed in front of the entire class using the Method. Choosing a scene from Clifford Odets's *Golden Boy*, Marilyn stunned those in attendance, many of whom were skeptical of her acting abilities and wary of the sex kitten persona that had helped make her a worldwide superstar. Marilyn became a devoted student of Strasberg, to the dismay of many of those close to her.

Unpublished images:
Pages 223, 224

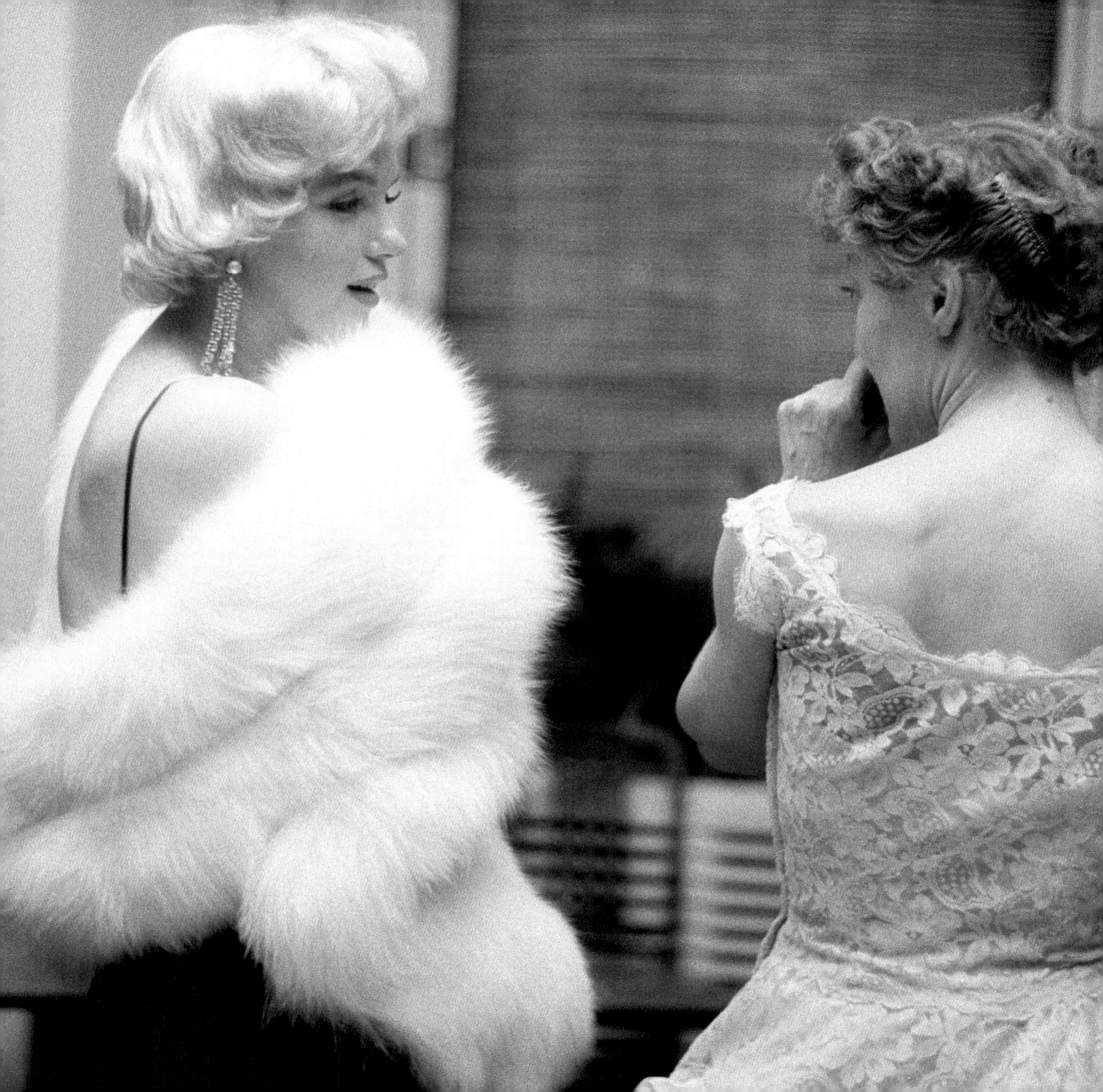

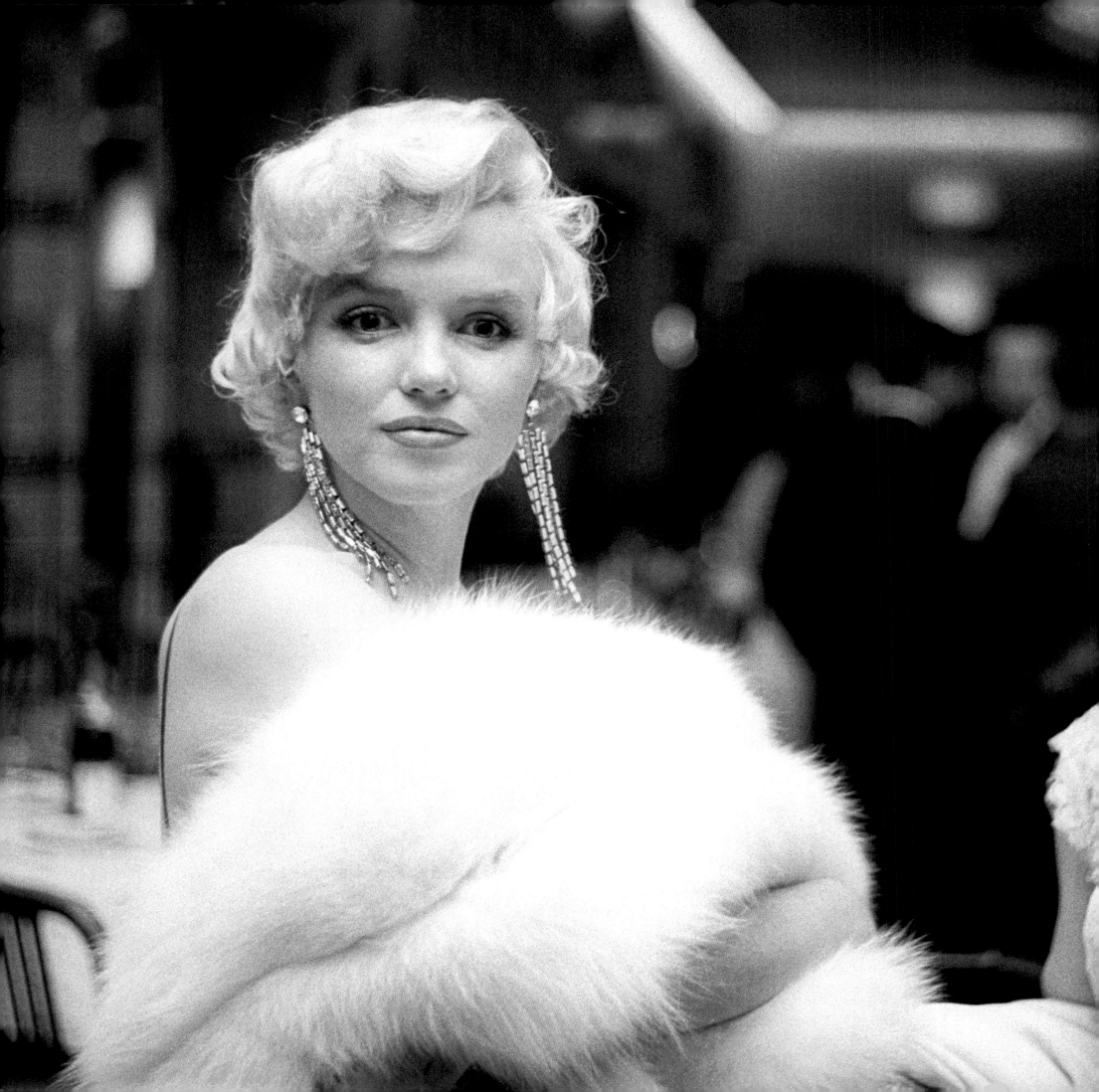

WHITE FUR

December 1955 – 1955 had been a pivotal year that would change both Milton and Marilyn's lives forever. The lawsuit with 20th Century Fox was now behind them and they were ready for what would become a momentous 1956. Here, Marilyn is wearing a white mink, a gift from her business partner, Milton.

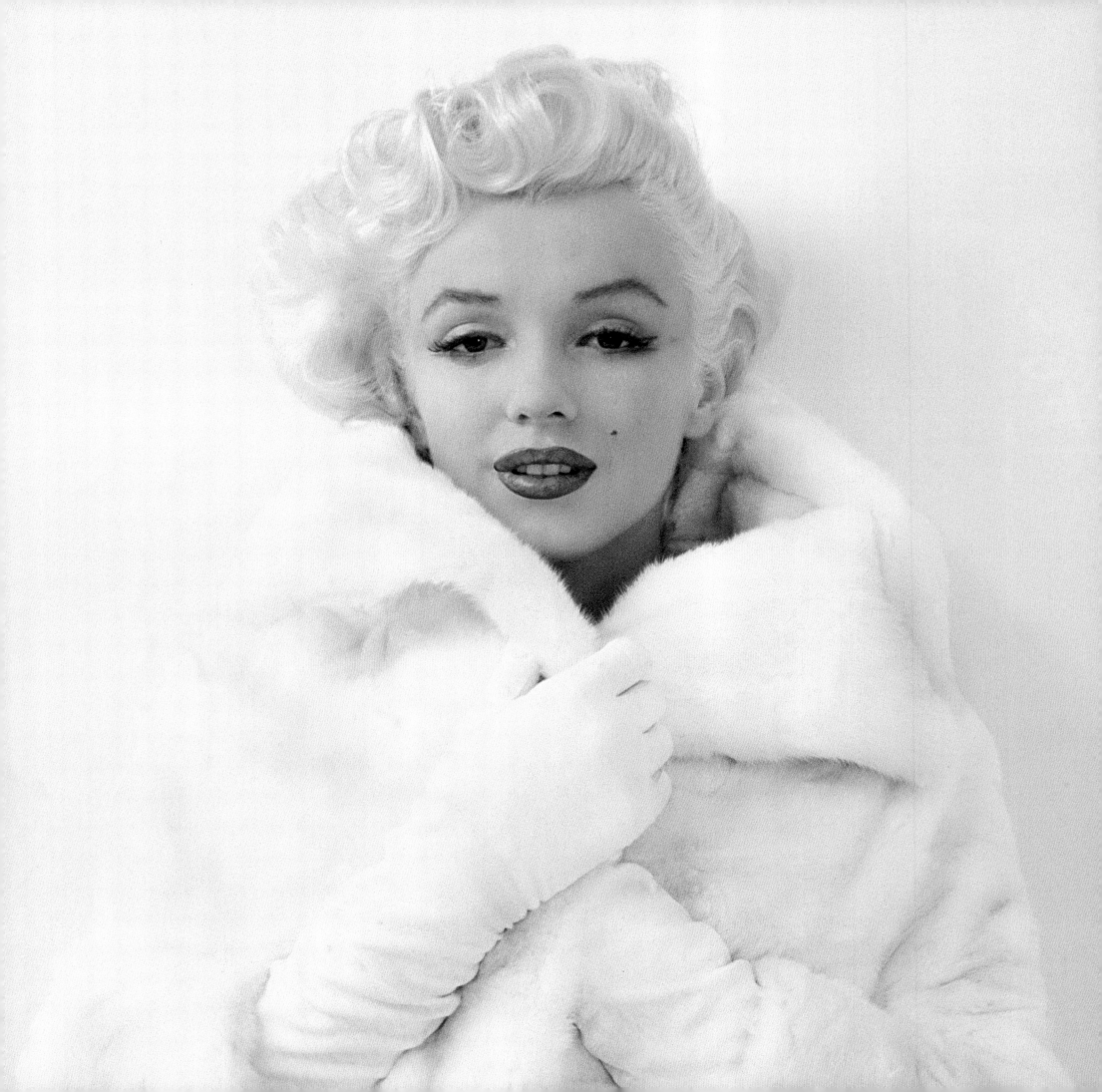

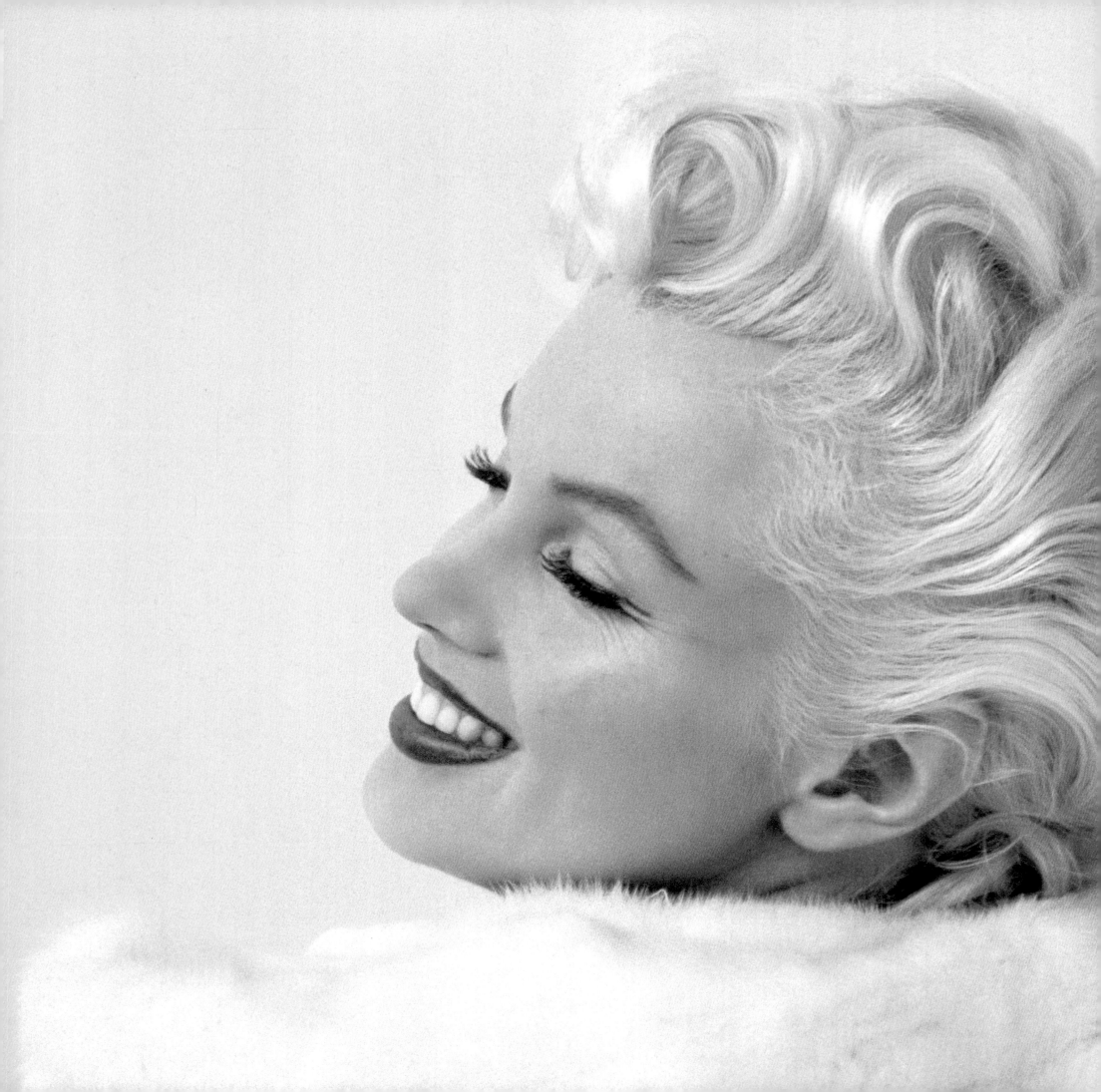

BLACK SITTING

February 1956 – The ultimate Monroe-Greene achievement.
Many Monroe fans revere The Black Sitting as the finest
pictures of Marilyn available. Although sexy and provocative,
the images retain the innocence of youth. With the red wine
flowing, over the course of four hours, Milton and stylist
Joe Eula had Marilyn posing with hats, bustier and fishnet
stockings. Near the end, they went a step further, with
Marilyn going topless and wrapped in black velvet. Other than
the private portfolio that Milton gave Marilyn, the pictures
were never seen by the public during her lifetime.
They appeared for the first time in Norman Mailer's 1976 book
Marilyn. Photographed in Milton's New York studio before
leaving for California to make *Bus Stop*, the use of the bustier
and fishnet stockings sparked the design for the costume
worn by Cherie, the character she played in the film.

*Unpublished images:
Pages 234, 242, 243*

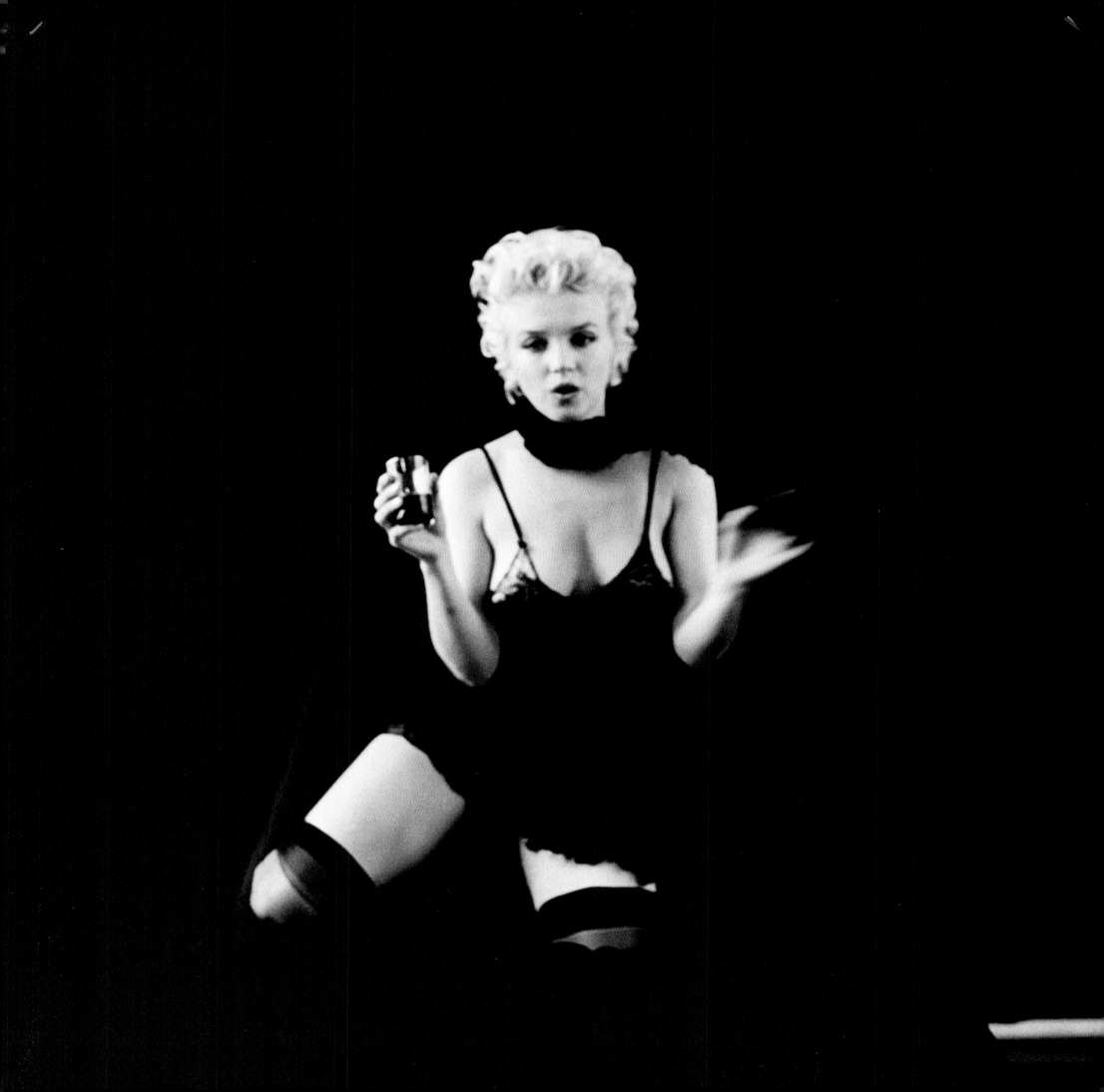

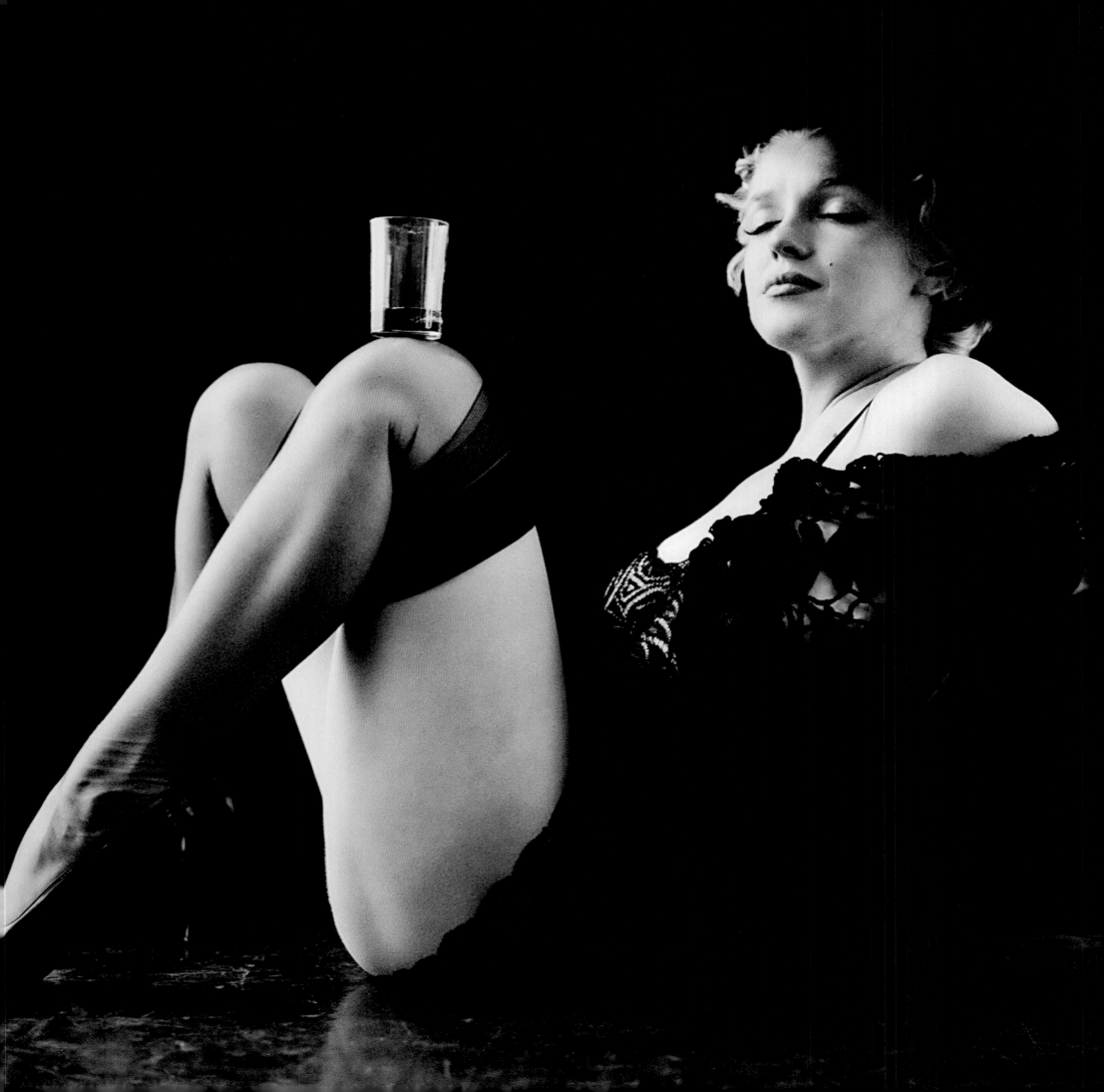

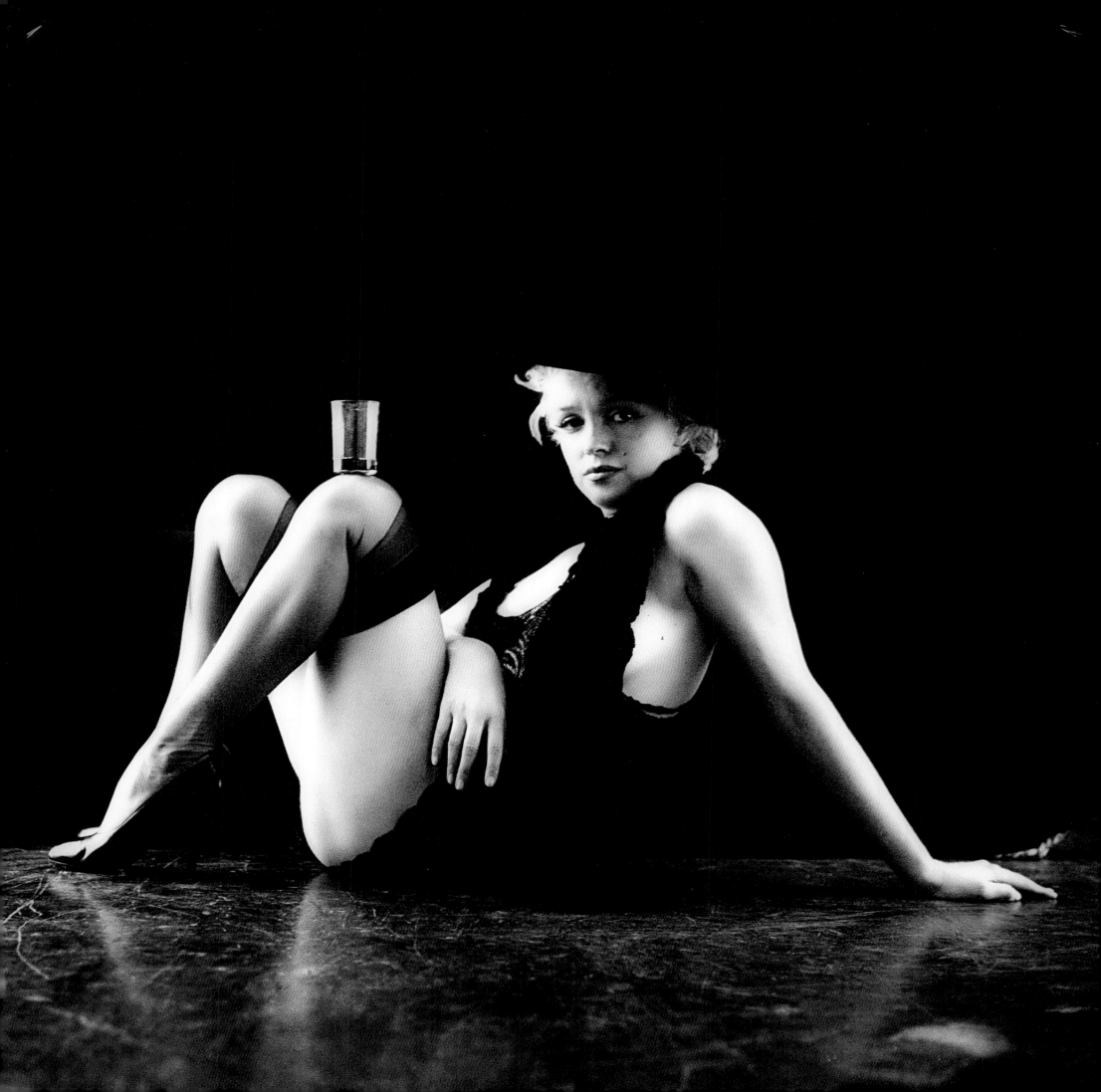

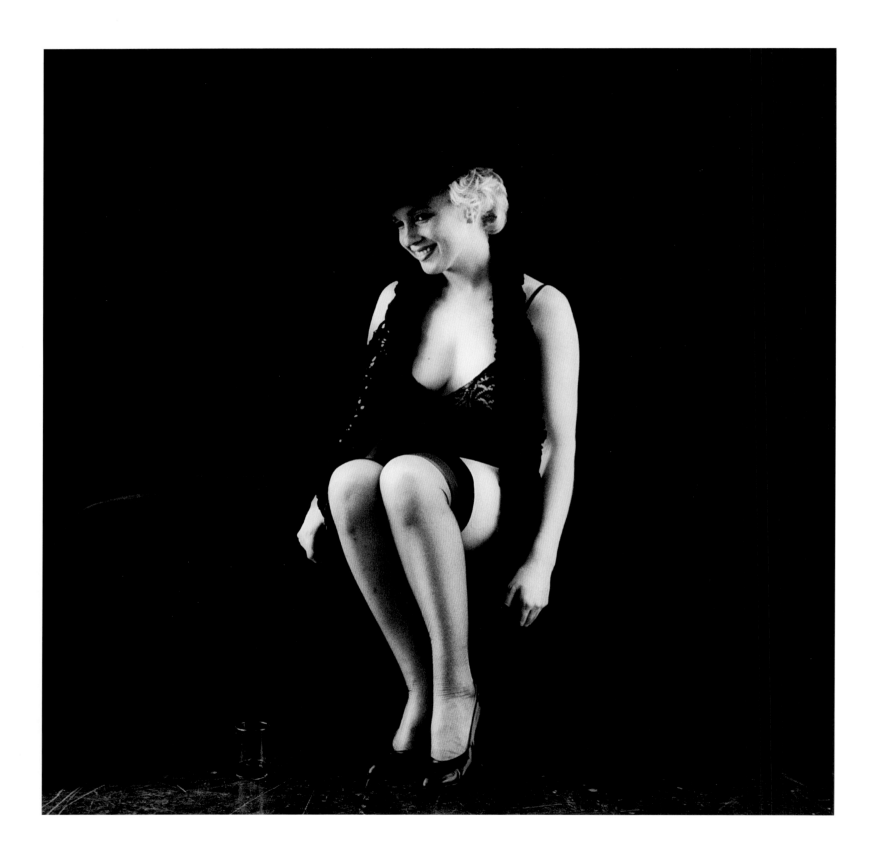

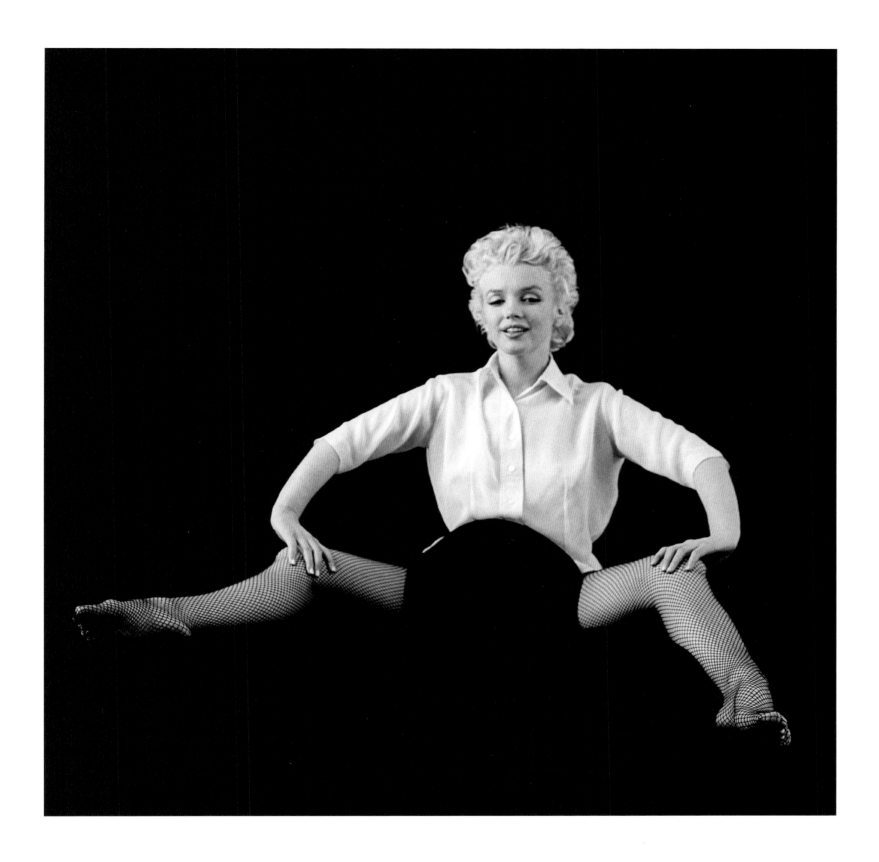

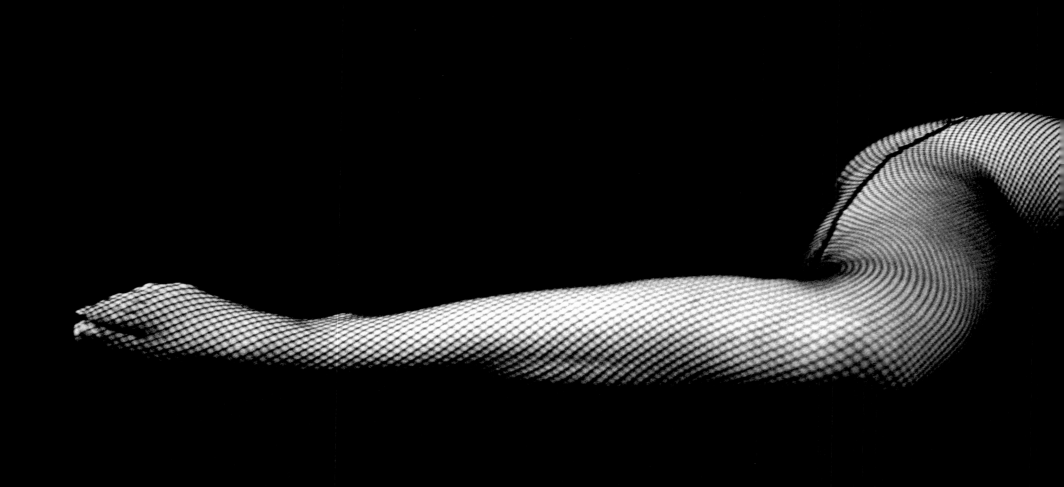

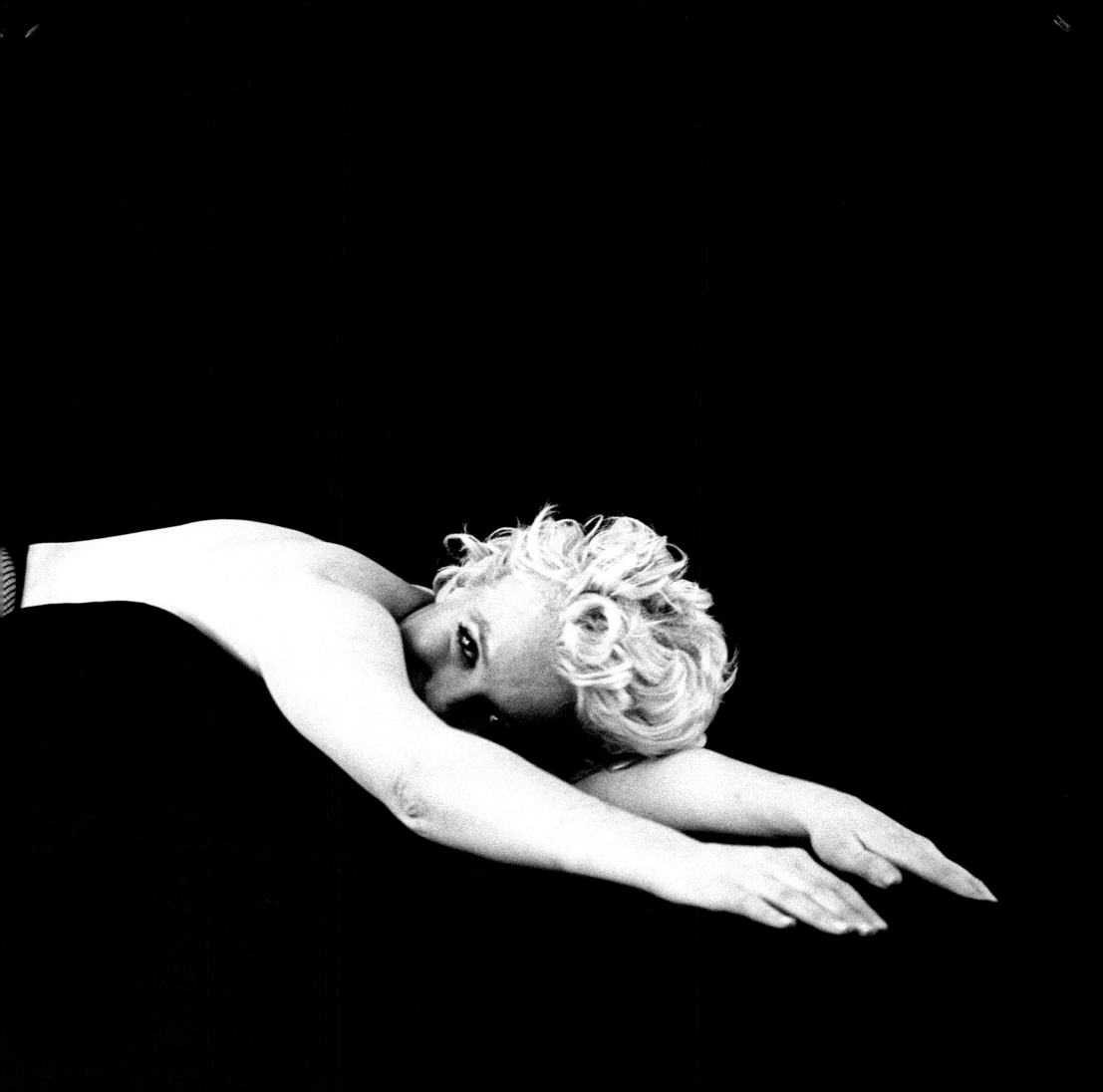

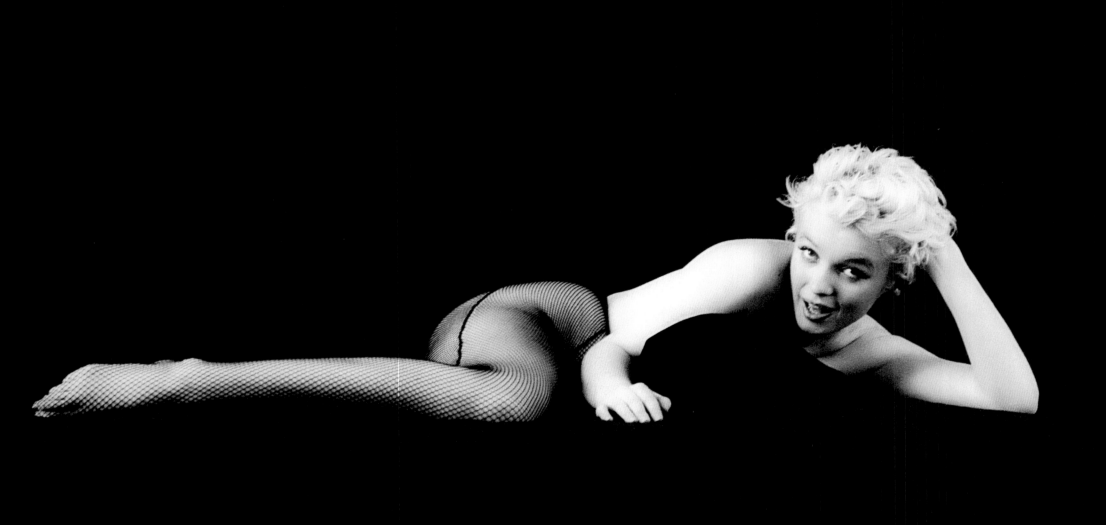

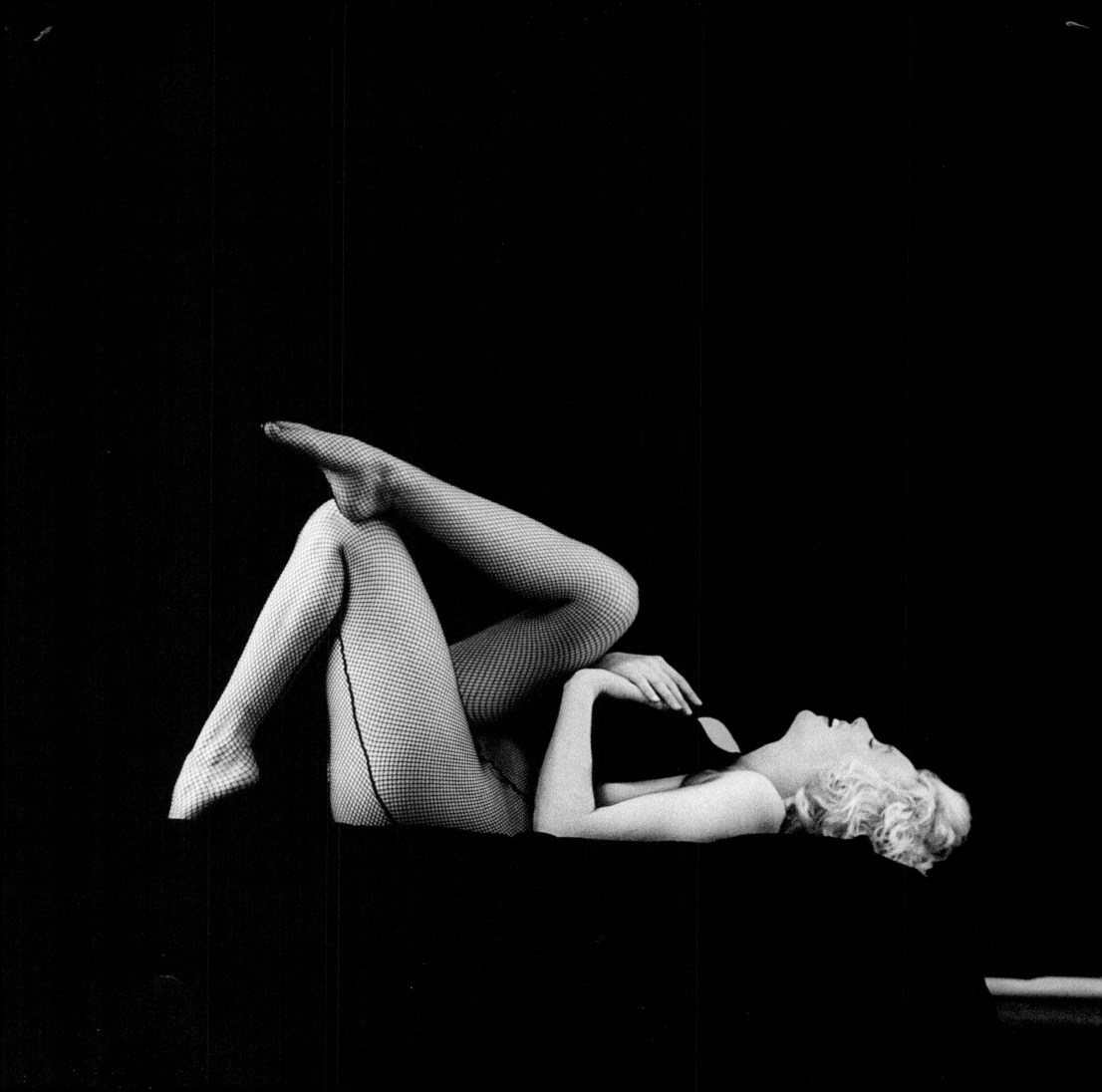

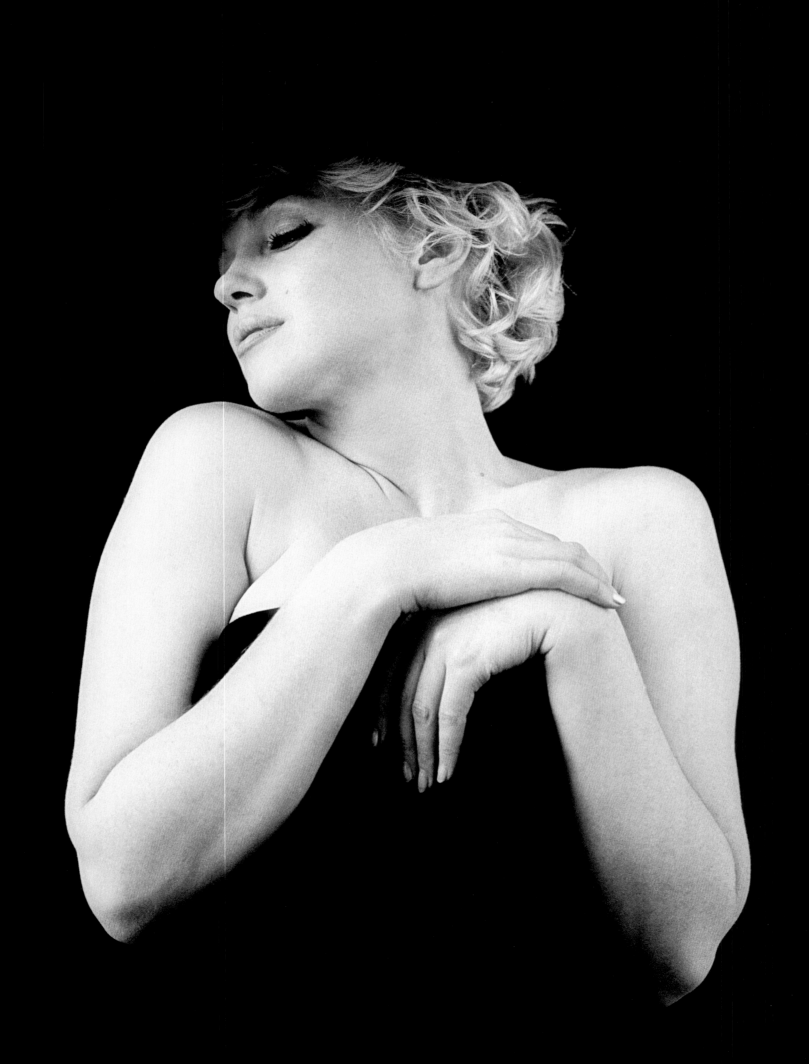

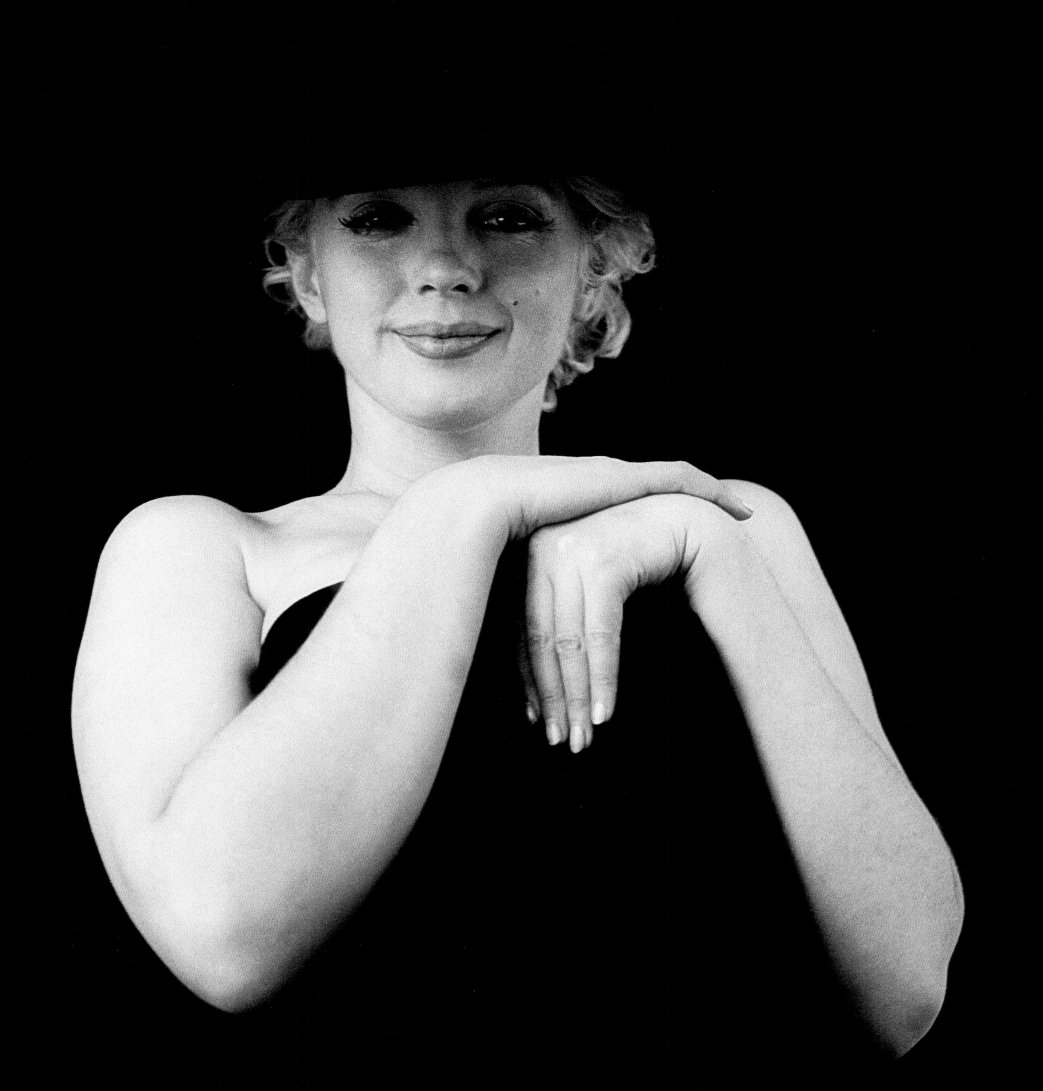

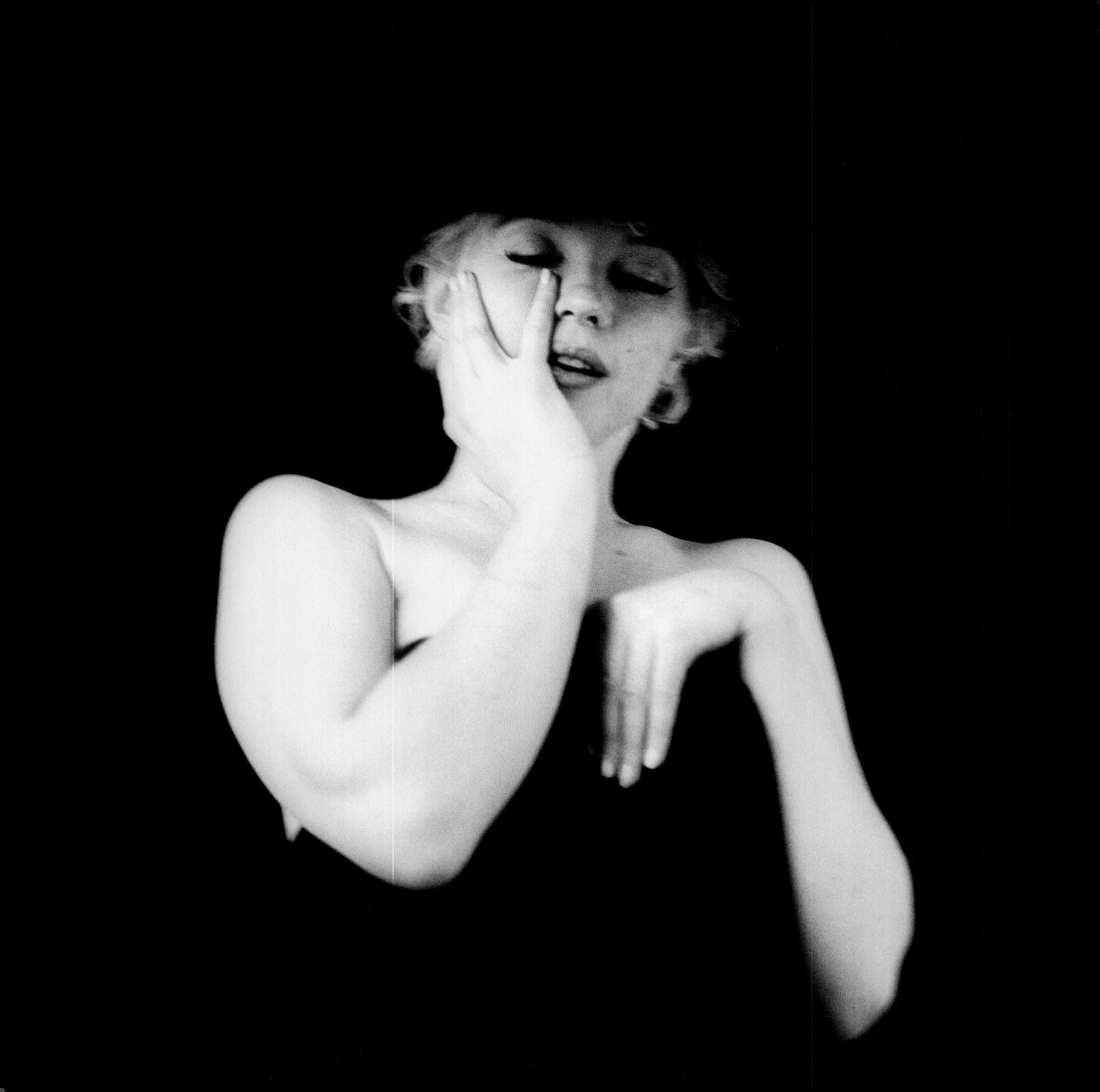

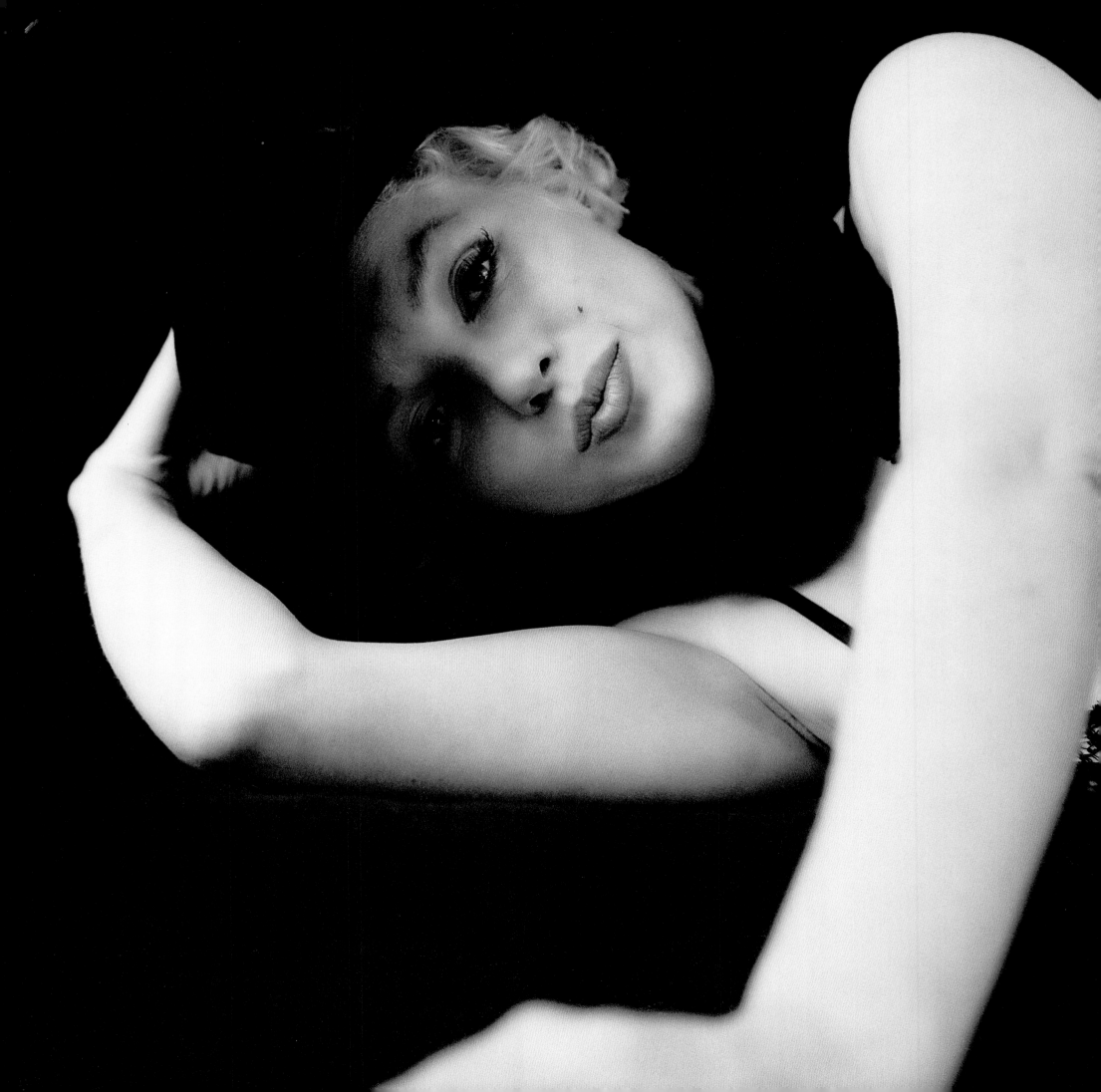

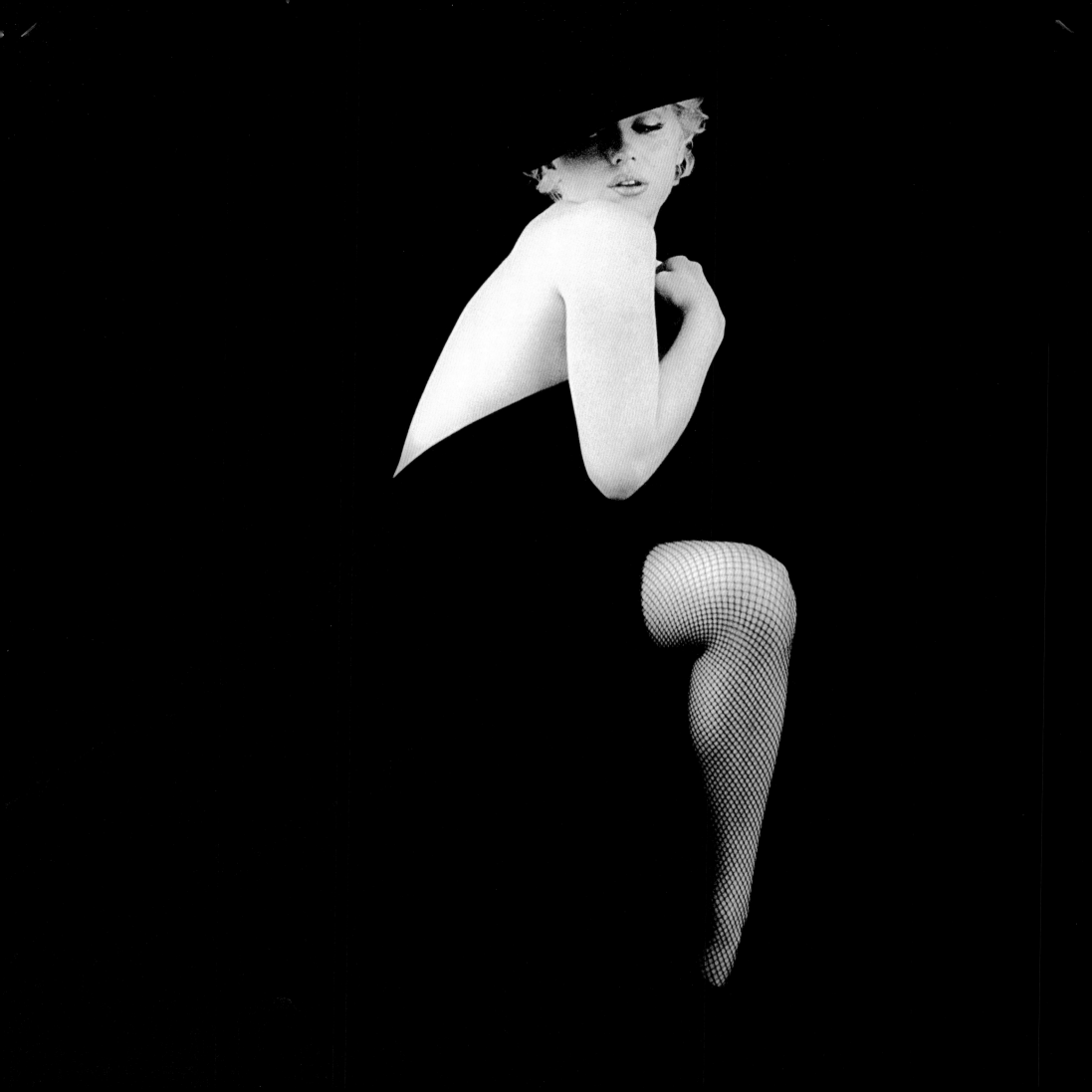

PRINCE PRESS
RECEPTION

February 1956 – Marilyn Monroe Productions held a press
conference at the Plaza Hotel to announce the upcoming
production of *The Prince and the Showgirl*. The ballroom area
was filled with photographers and reporters. Marilyn and
Sir Laurence Olivier entered from a balcony, came down the
stairs and sat at a large round table, proceeding to hold
court with the gathered press. At some point during the
evening, Marilyn leaned forward with laughter and the right
spaghetti strap of her dress snapped, creating the first
documented "wardrobe malfunction." As always, Marilyn
was unfazed; using her coat as a cape, she carried on.

Unpublished image:
Page 247

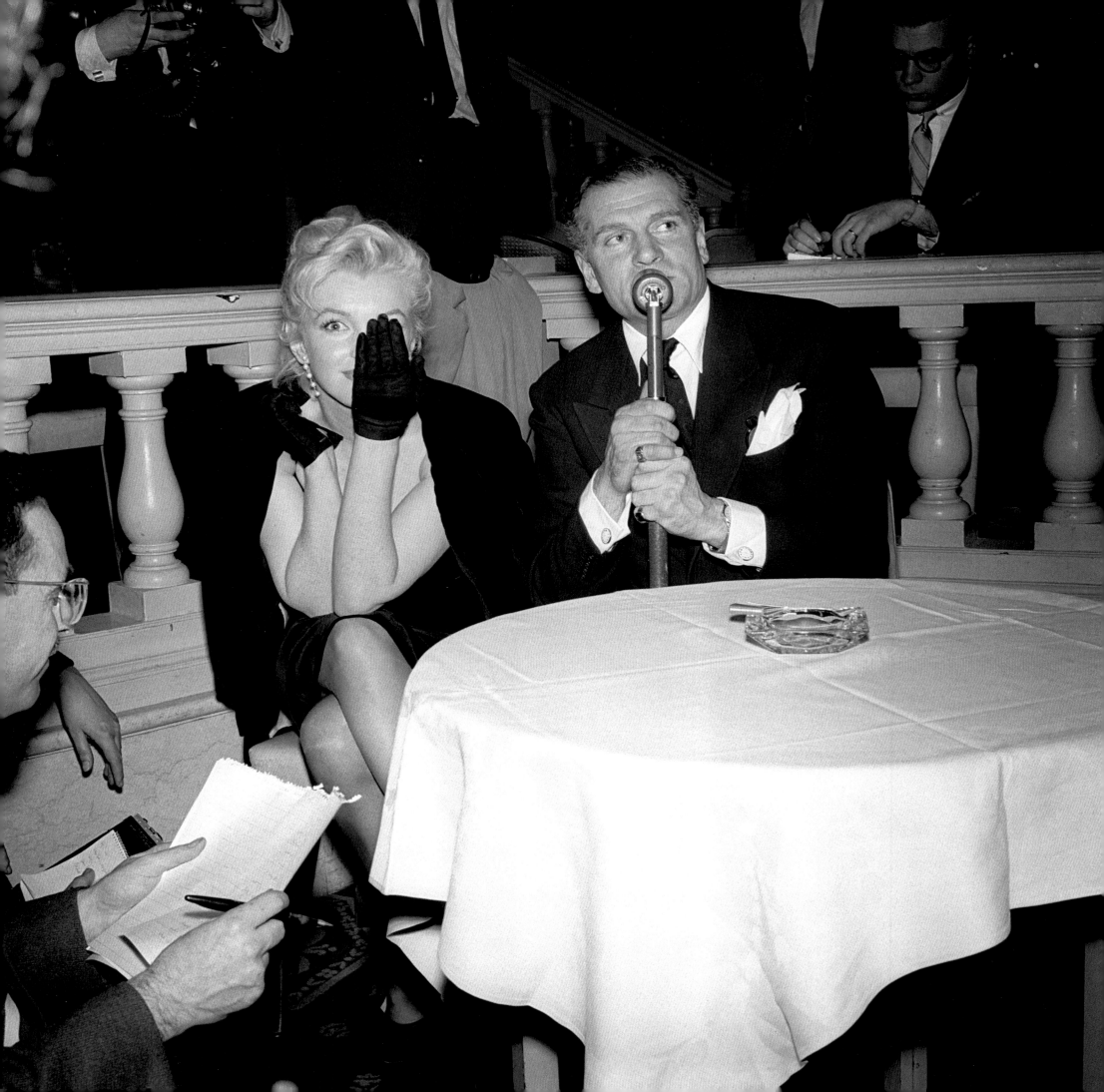

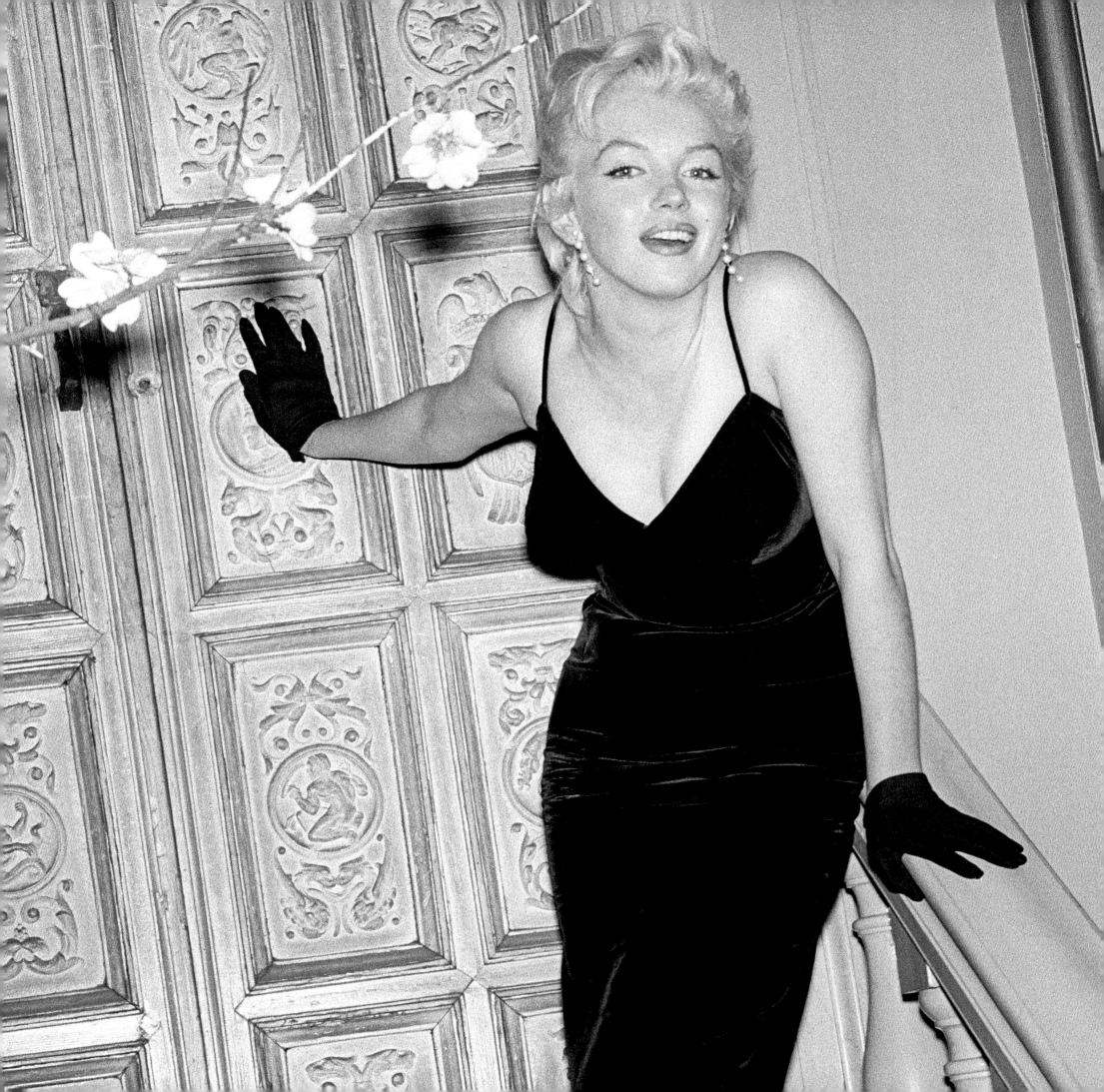

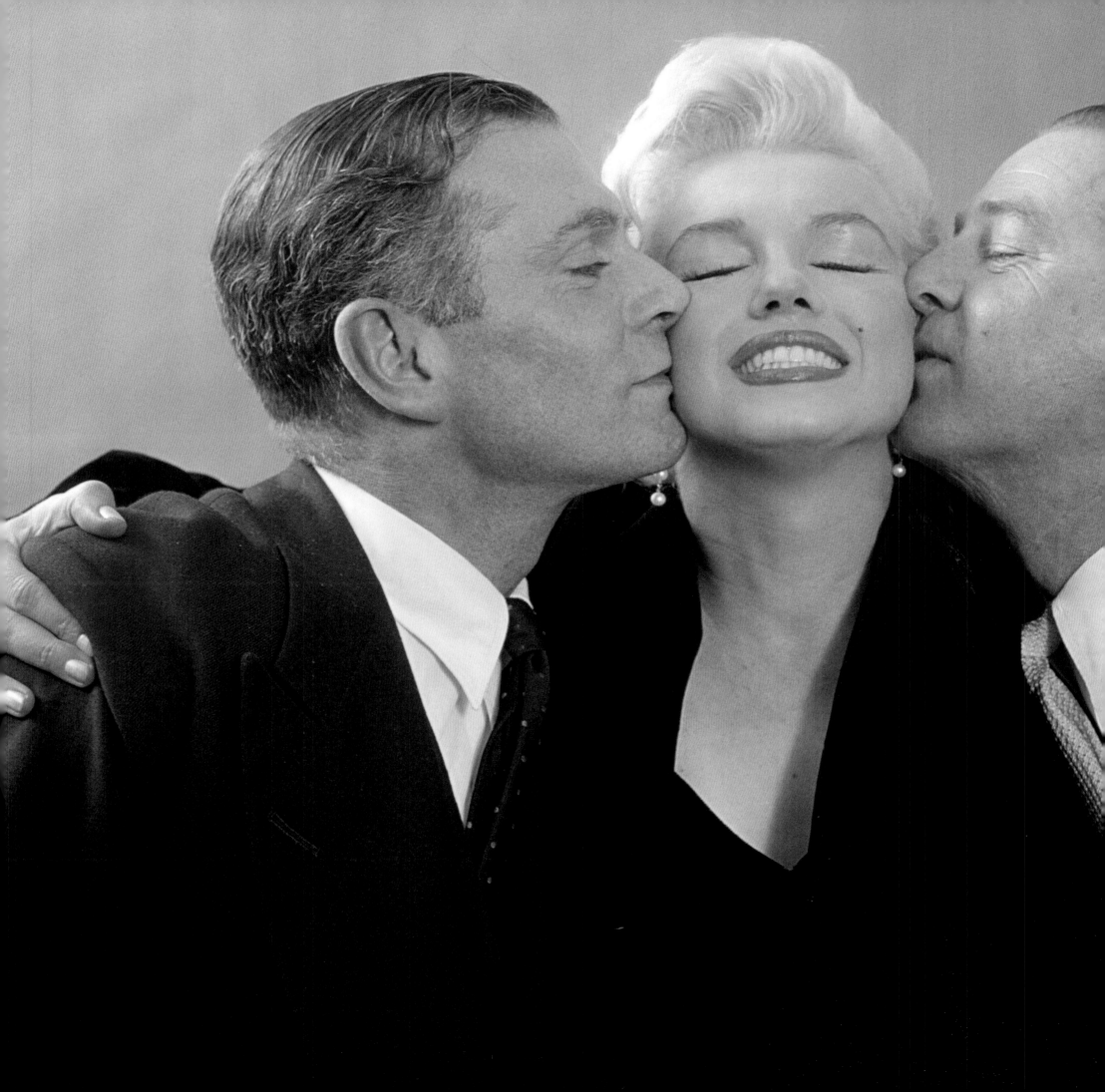

MONROE,
OLIVIER &
RATTIGAN

February 1956 – Marilyn Monroe Productions bought the
rights to Terence Rattigan's stage play, *The Sleeping Prince*.
Rattigan would pen the screenplay for what would
become *The Prince and the Showgirl* starring Monroe
and Olivier, who would also direct the romantic comedy.
Rattigan himself would eventually be knighted by
Queen Elizabeth II in 1971.

*Unpublished images:
Pages 250, 252*

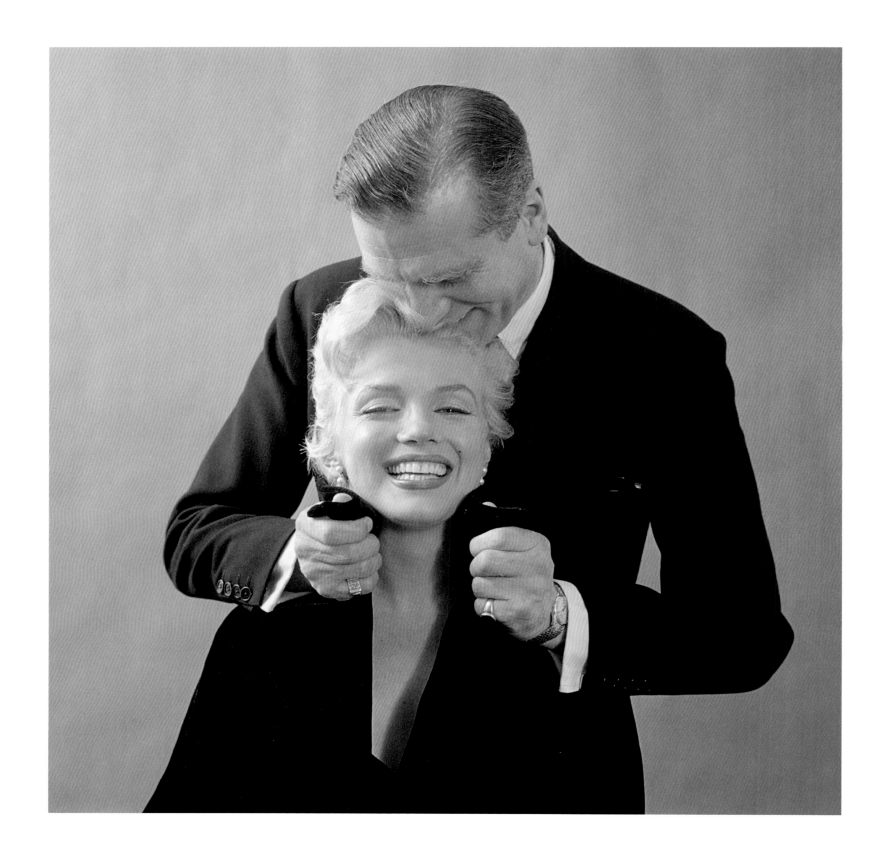

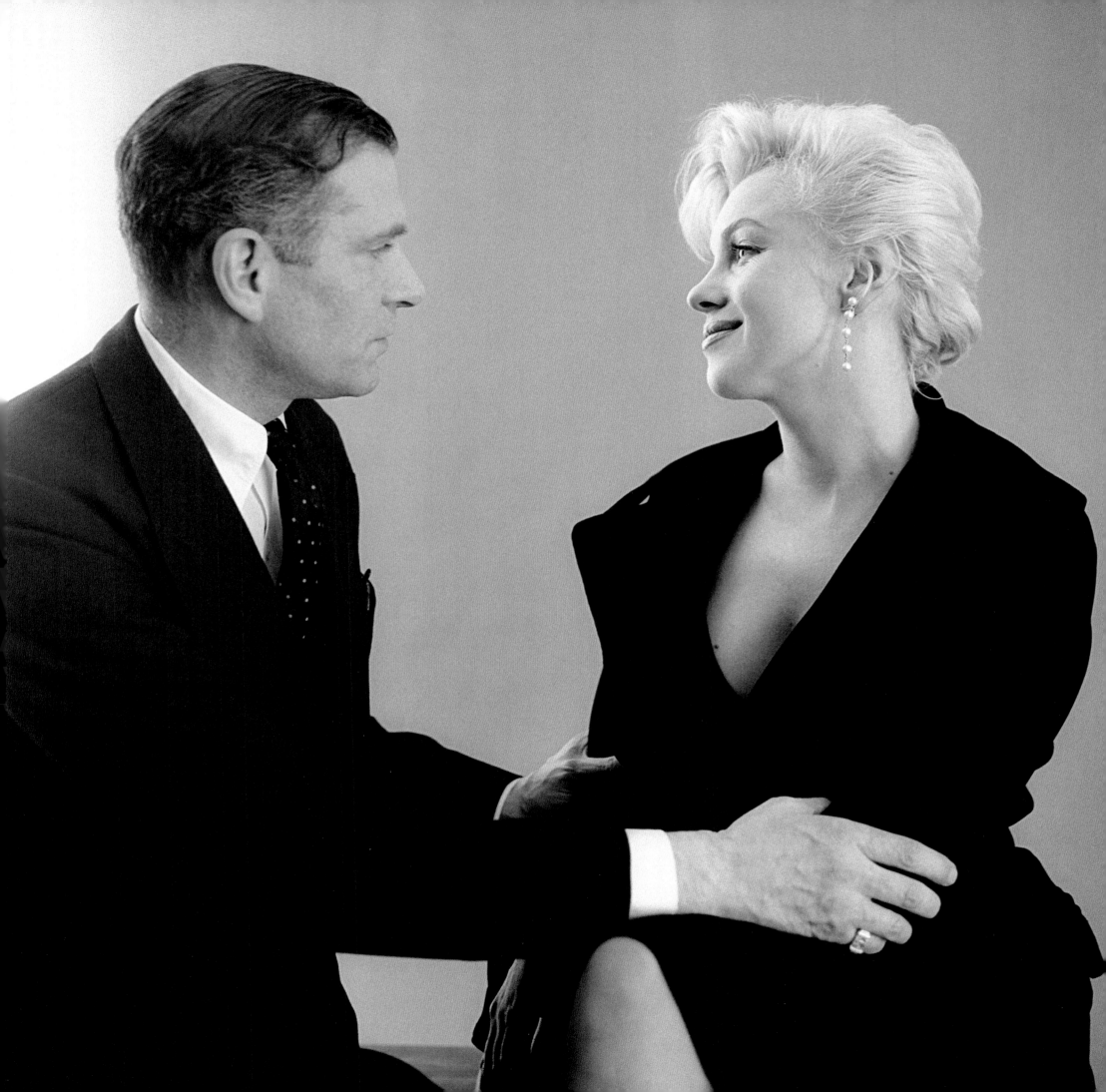

AMERICAN
AIRLINES

February 27, 1956 – One of Milton's many unique skills was that he always brought an editorial viewpoint to commercial accounts – because of that, advertising agencies loved him. The highest paid editorial photographer in the world at that time, Milton came up with the concept of celebrities flying American Airlines. The agents to the era's biggest stars were asked if they thought their clients would be willing to participate in the campaign, and the telephones rang off the wall. Everybody who was anybody wanted to be part of the campaign, not to mention the fact that for five years, first-class accommodation would be provided for participating celebrities and their families. A phenomenal campaign ensued with a superior cast, including, of course, Marilyn Monroe.

Unpublished image:
Page 256

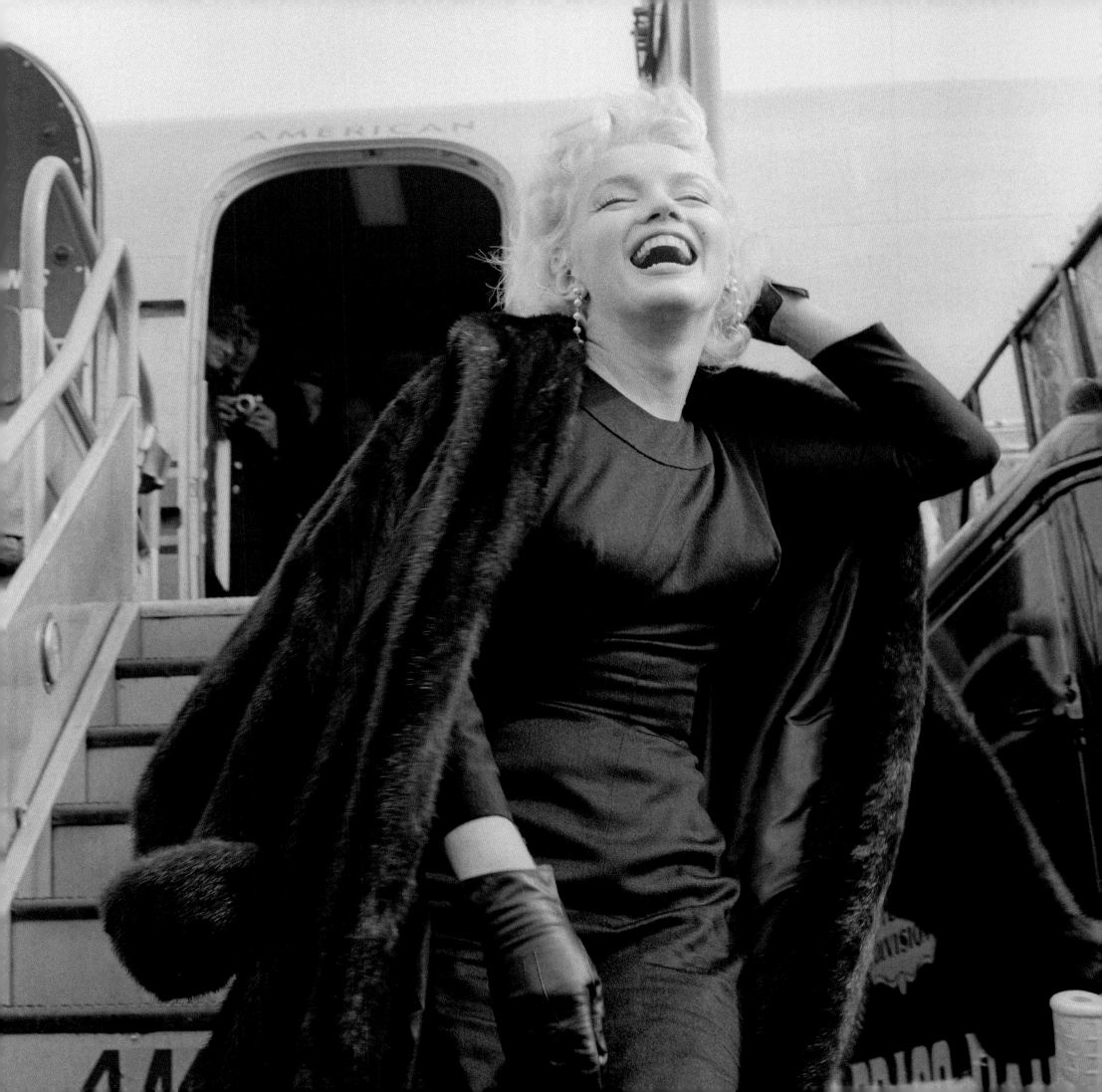

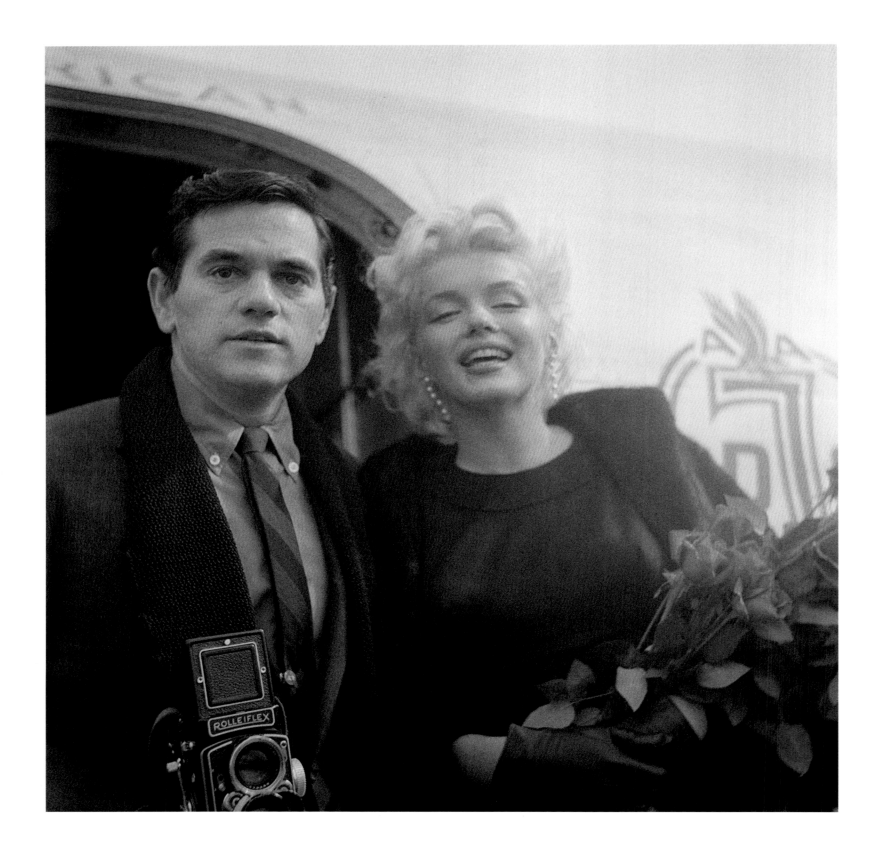

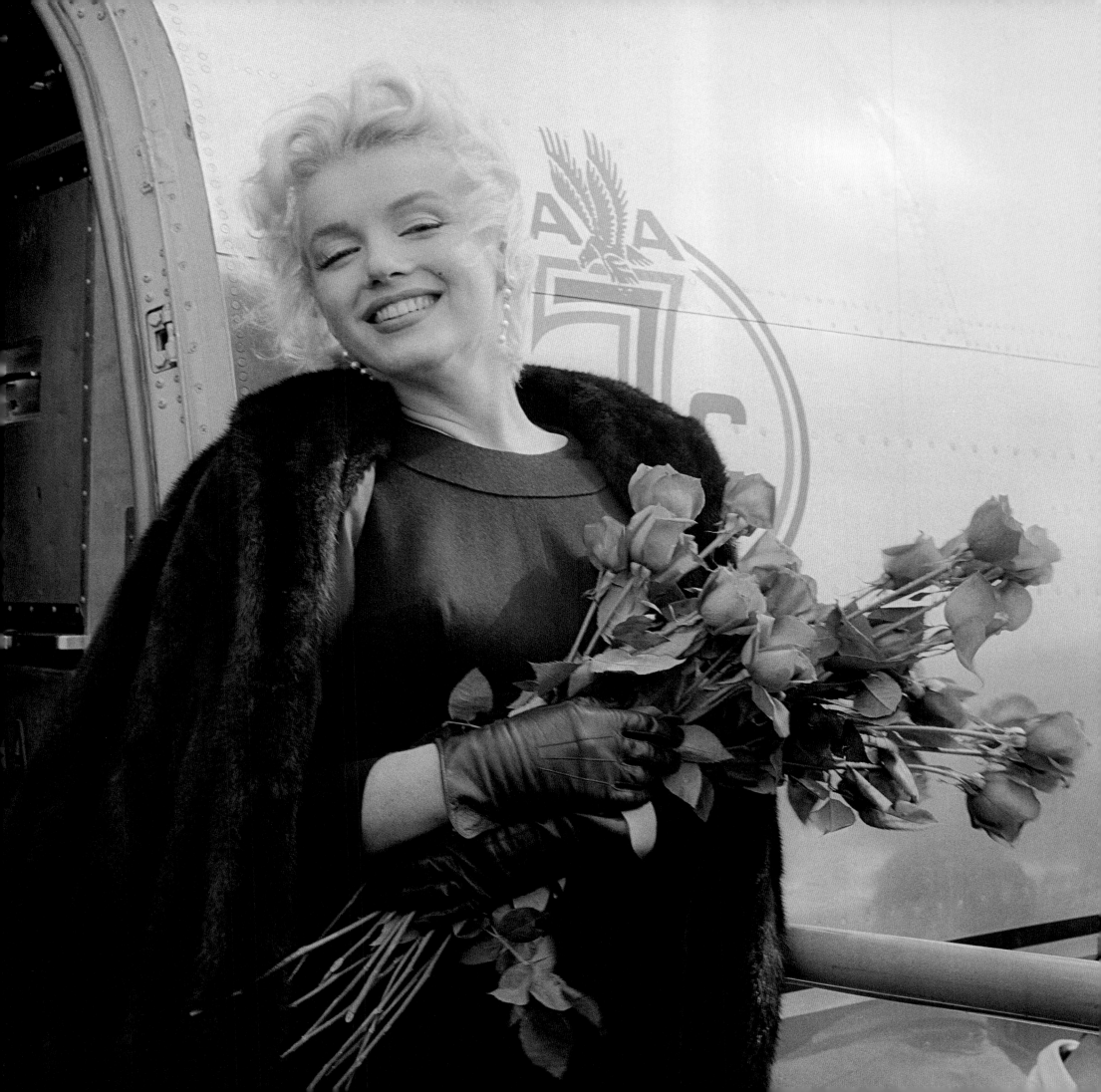

LINCOLN

April 1956 – Marilyn and Milton flew back to Los Angeles to pick up her Cadillac, given to her by Jack Benny for appearing on his show the previous year. This tongue-in-cheek series of photos was taken holding a portrait of "Honest Abe". Marilyn had always looked up to the President and read any book she could find about him.

Unpublished image:
Page 259

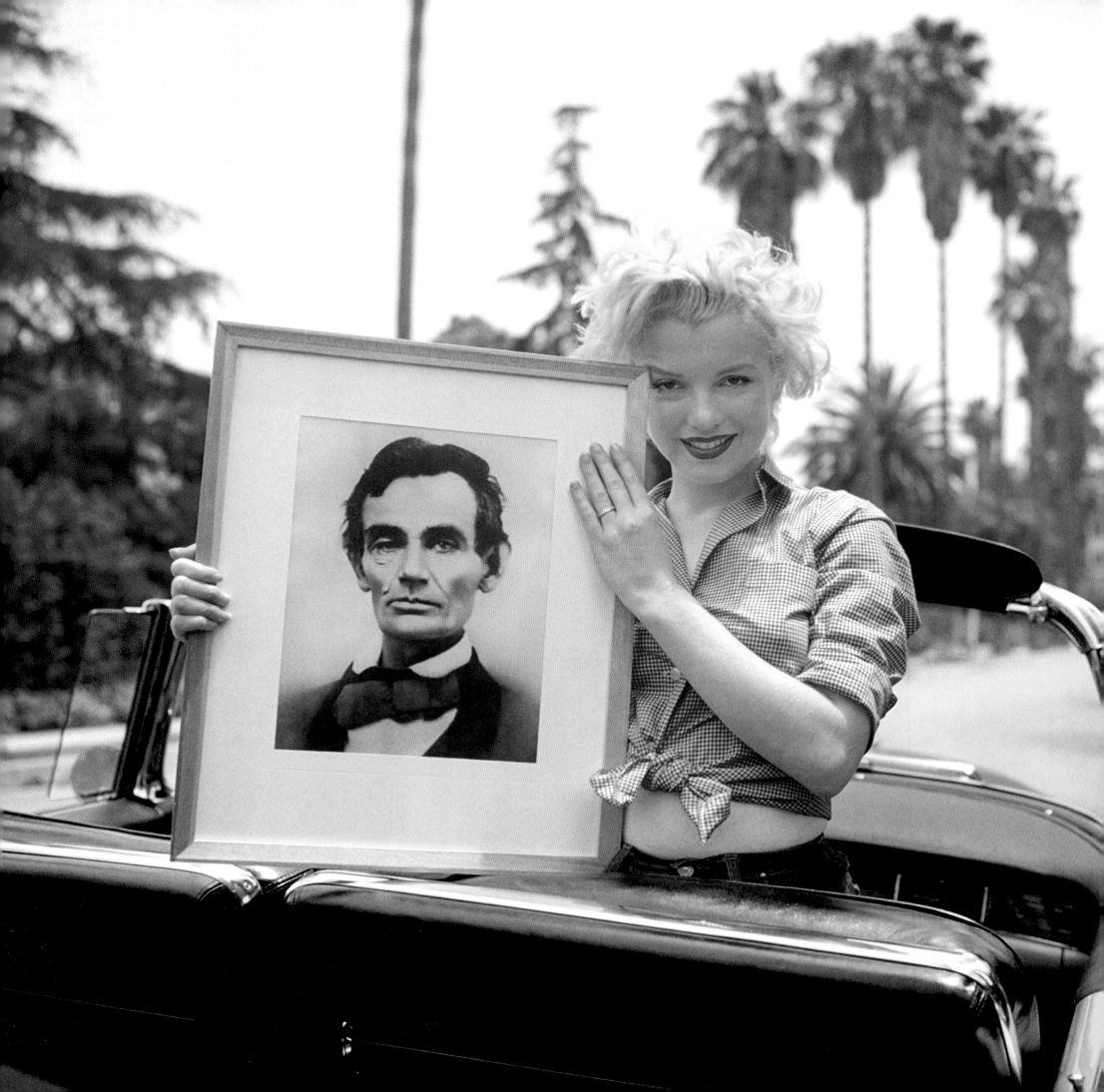

BLACK COAT

April 1956 – During the four weeks of shooting *Bus Stop* in Los Angeles, on their Sundays off, the two cohorts would go to the back lots of Fox and look for locations. With these in mind, they would find costumes and outfits to create fantasy characters. As non-descript as the black coat and hat are, they speak of the simplicity of Milton and his props, with Marilyn as his muse.

Unpublished images:
Pages 261, 262, 263, 264, 265

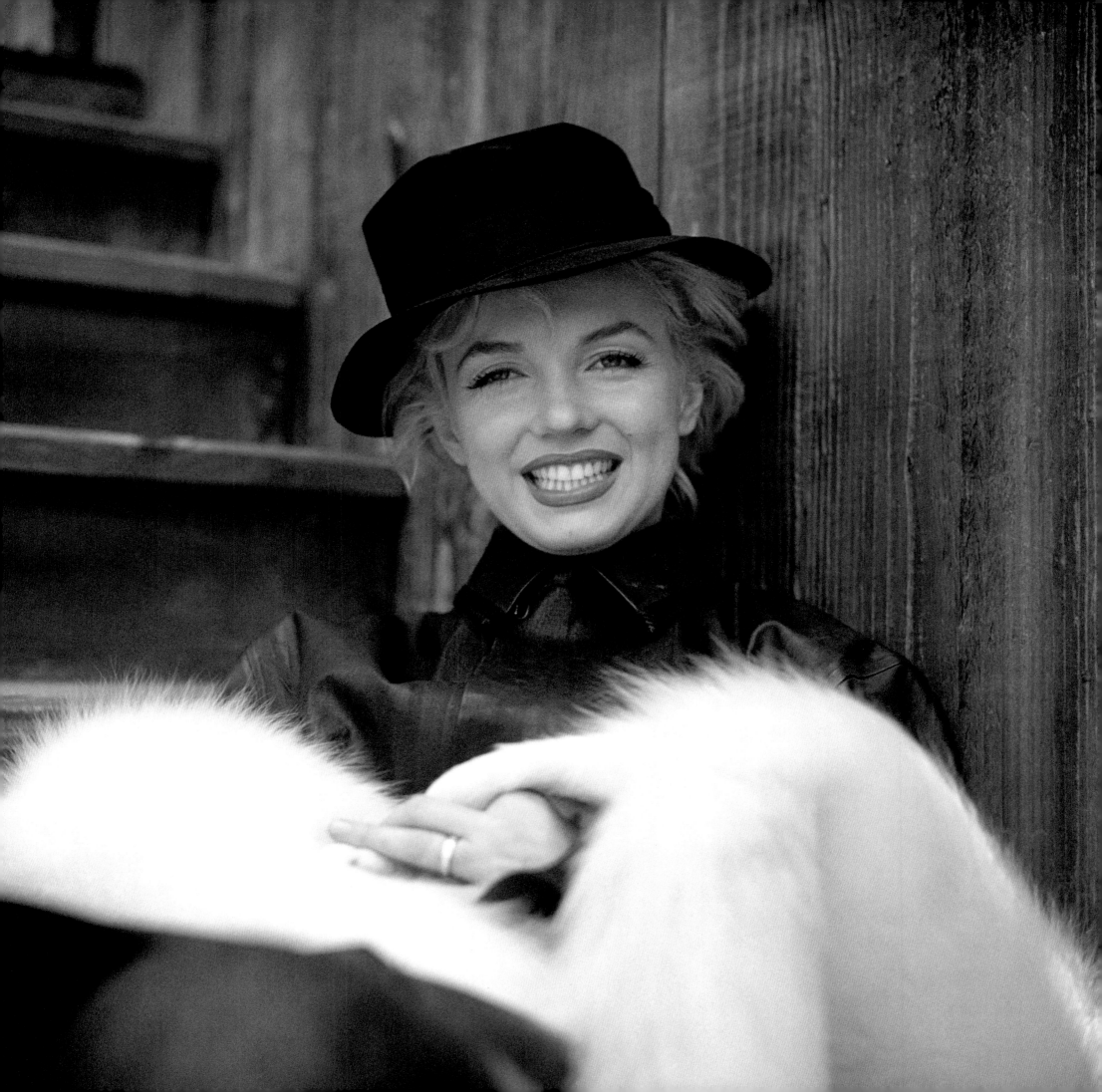

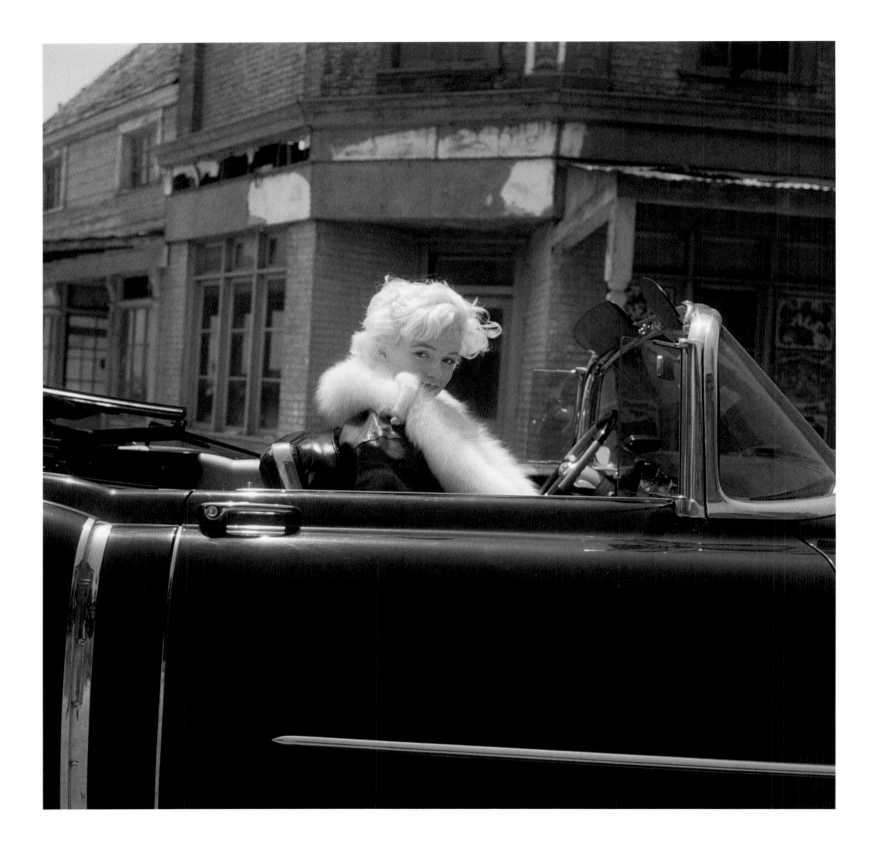

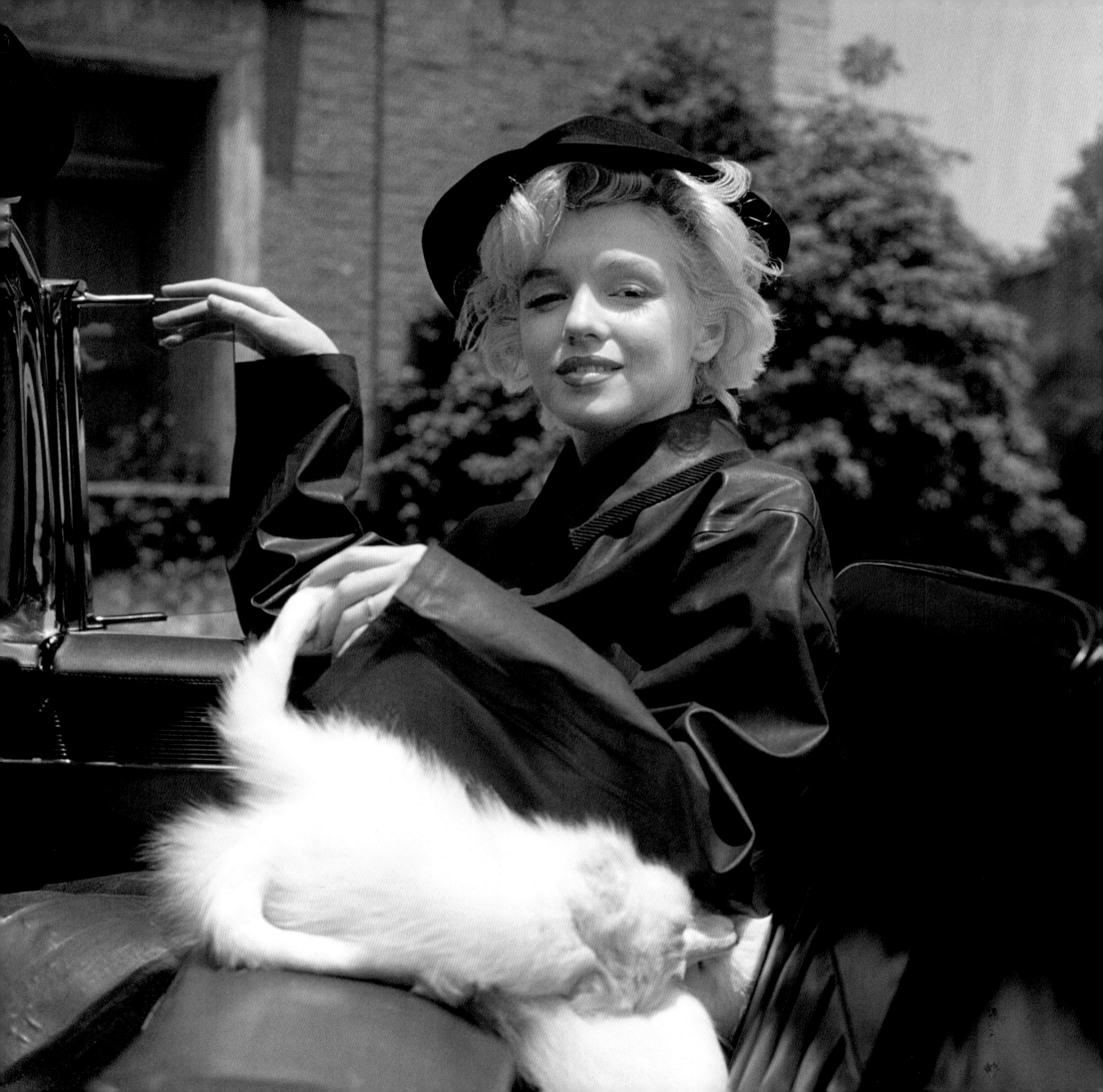

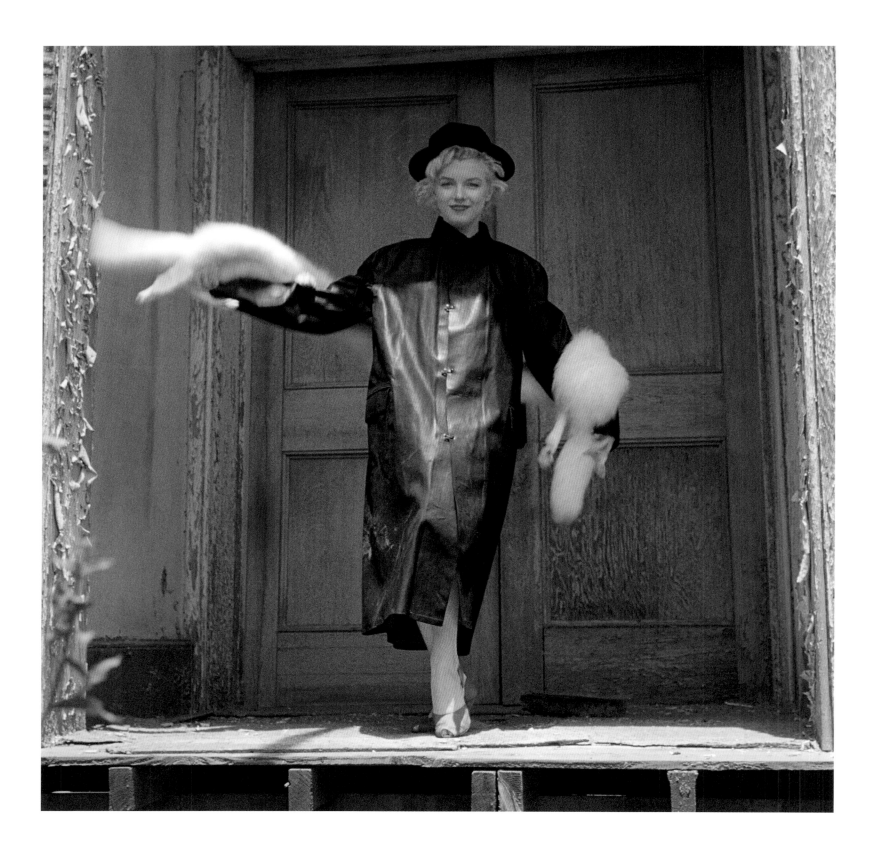

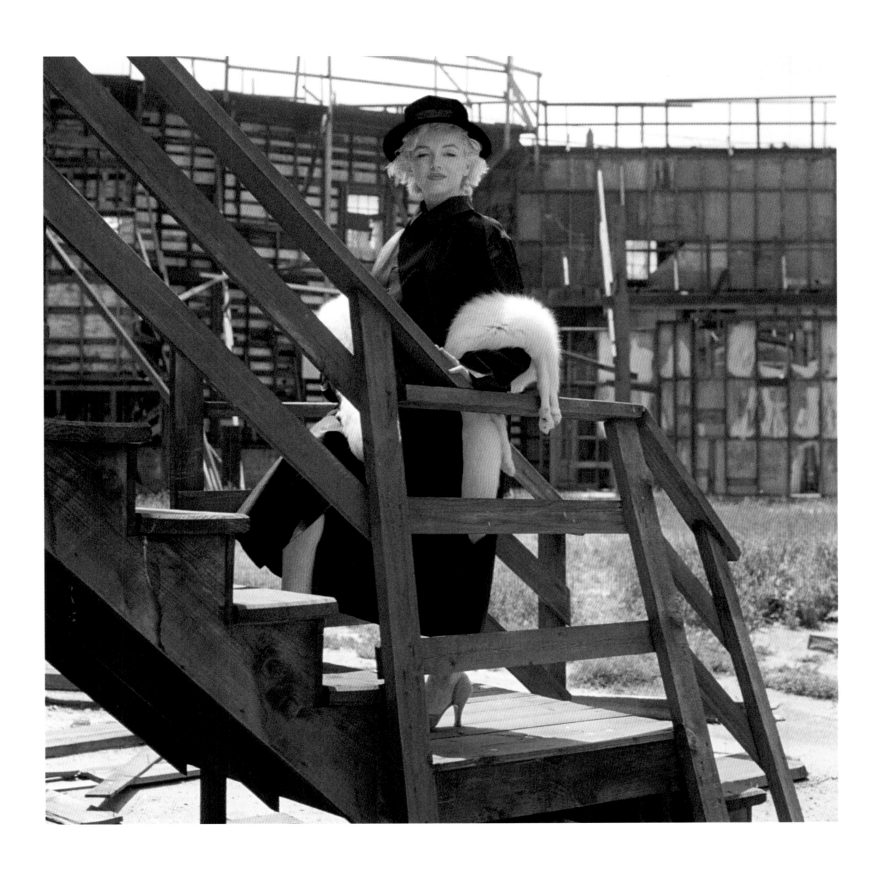

GRAY FUR

April 1956 – Milton captured Marilyn in a fabulous gray fur on the back lot of Fox. These publicity shots for Marilyn Monroe Productions reveal the depth of Marilyn's character, something Milton believed in and nurtured.

Unpublished image:
Page 267

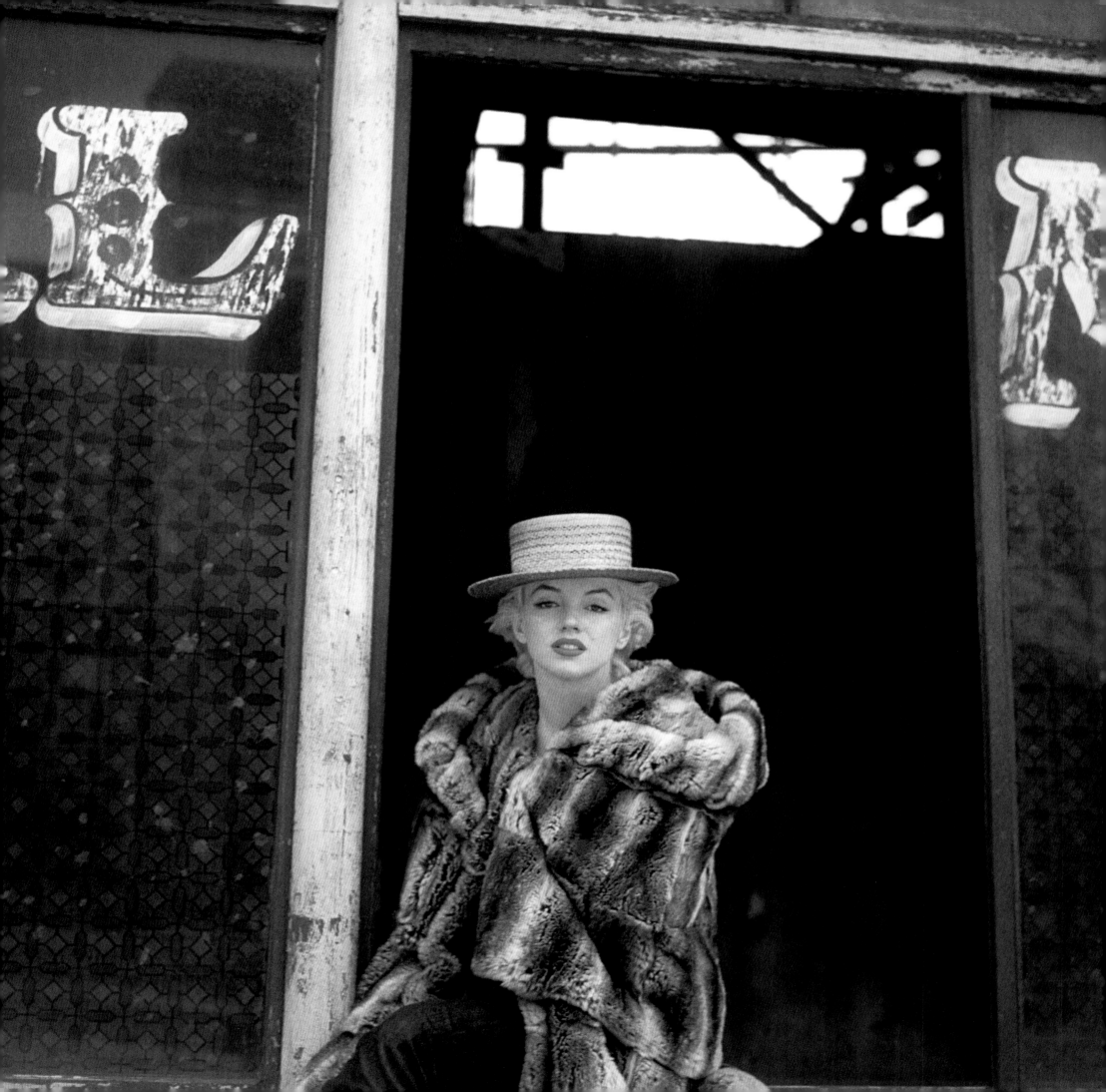

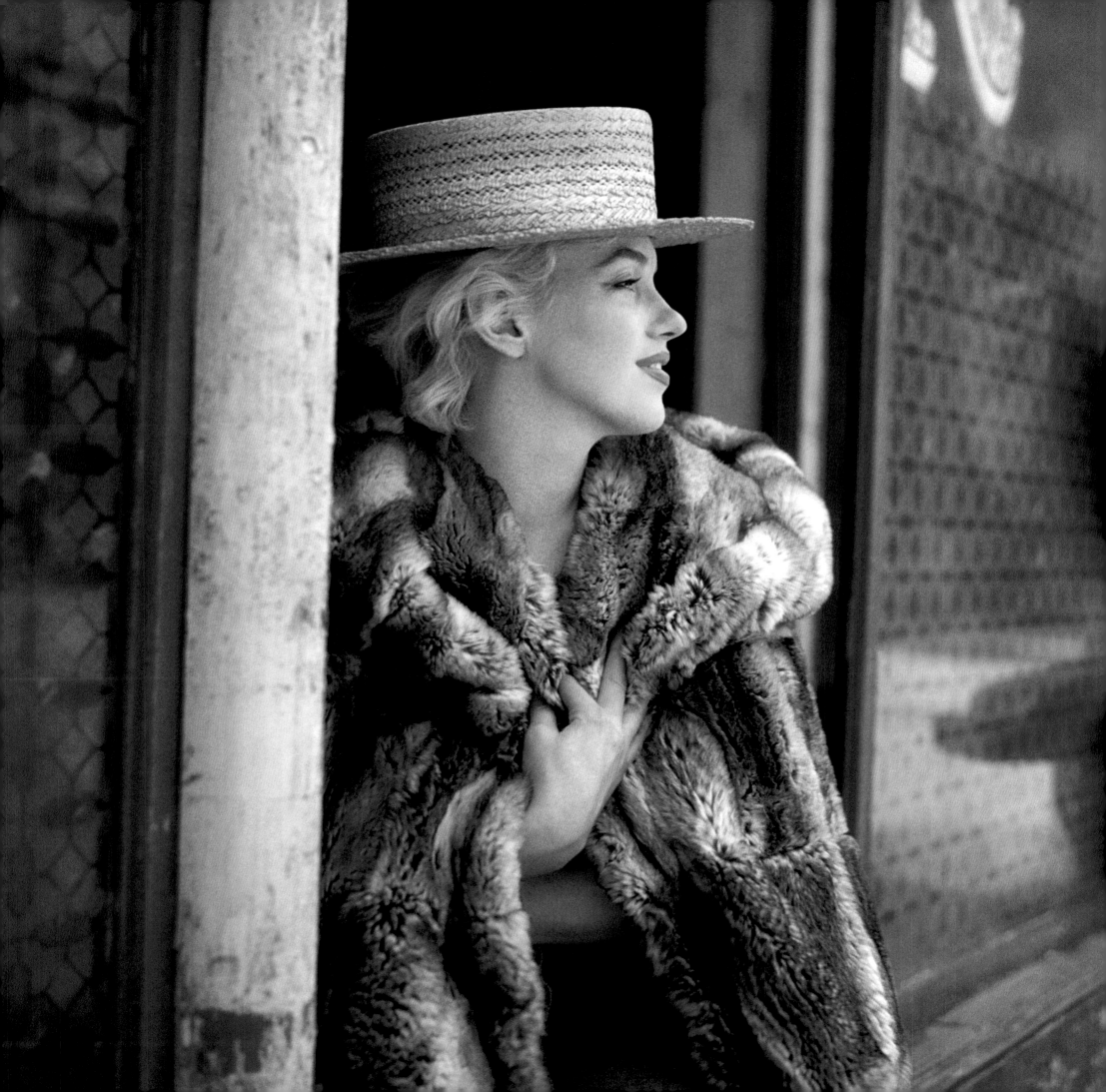

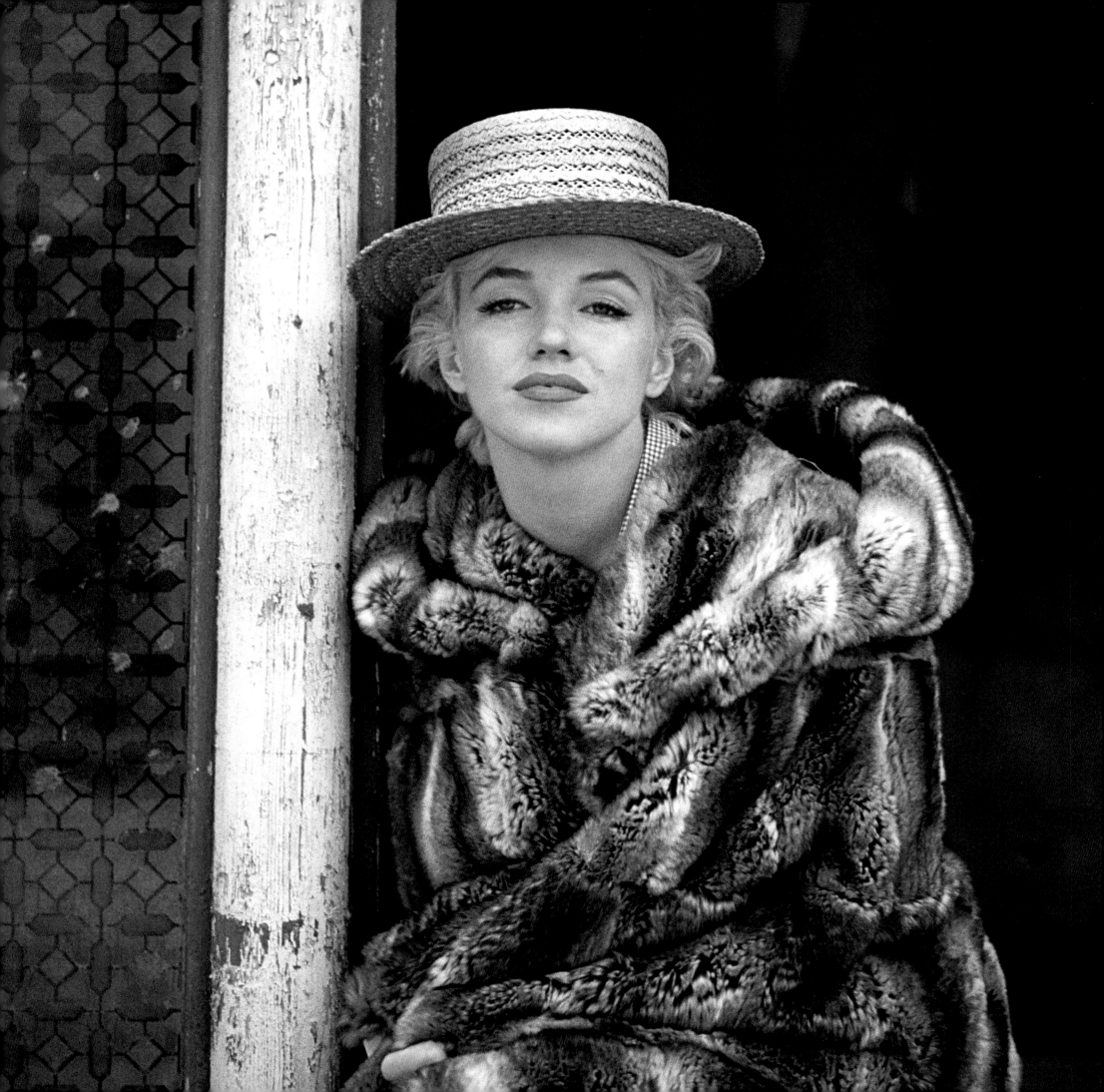

HOOKER

April 1956 – More images from Milton and Marilyn's 20th Century Fox back lot sessions. This time Marilyn vamps it up as a streetwalker. Milton believed in Marilyn's range as an actress and on this Sunday, the two took on a number of characters to portray her diversity. Note the fishnet stockings, introduced first in the Black Sitting, and the blouse, which became the performing costume when she sang "That Ol' Black Magic" in *Bus Stop*. Later, Madonna would copy this series for her *Like a Virgin* promotion.

Unpublished images:
Pages 271, 272, 273, 274, 275, 276, 277

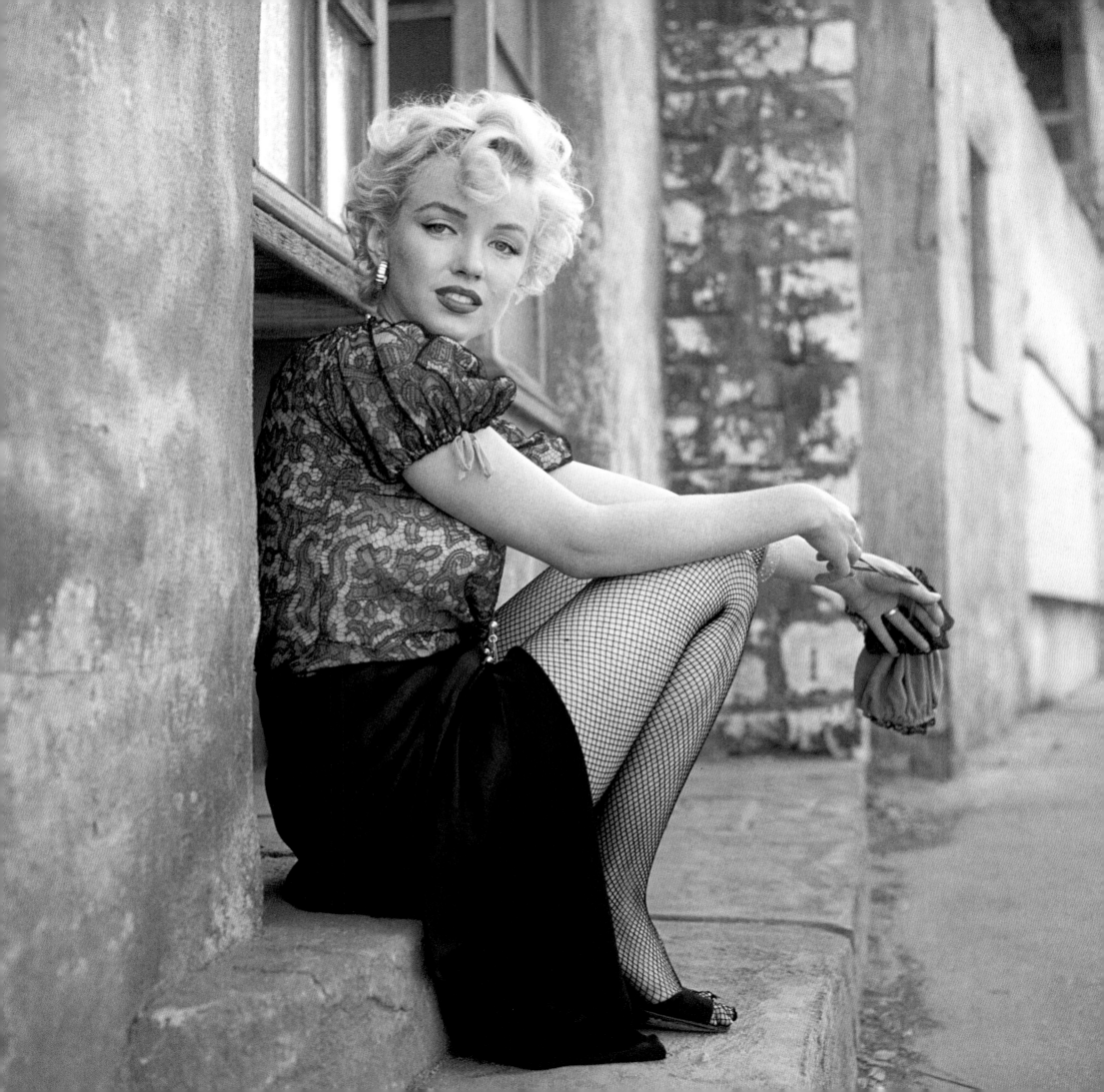

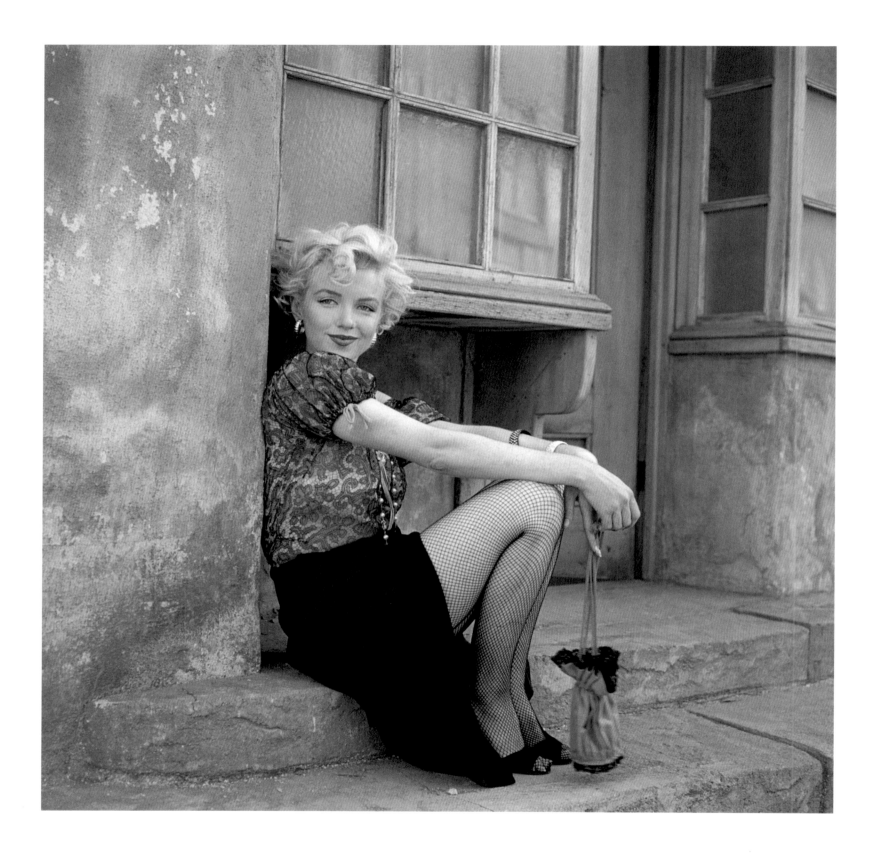

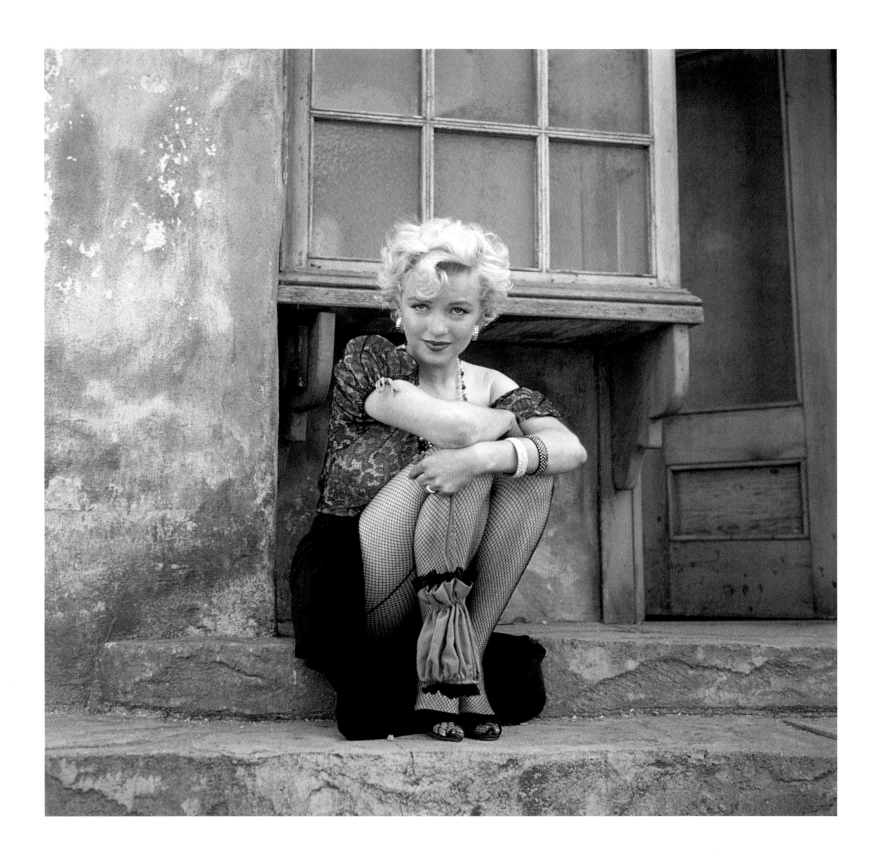

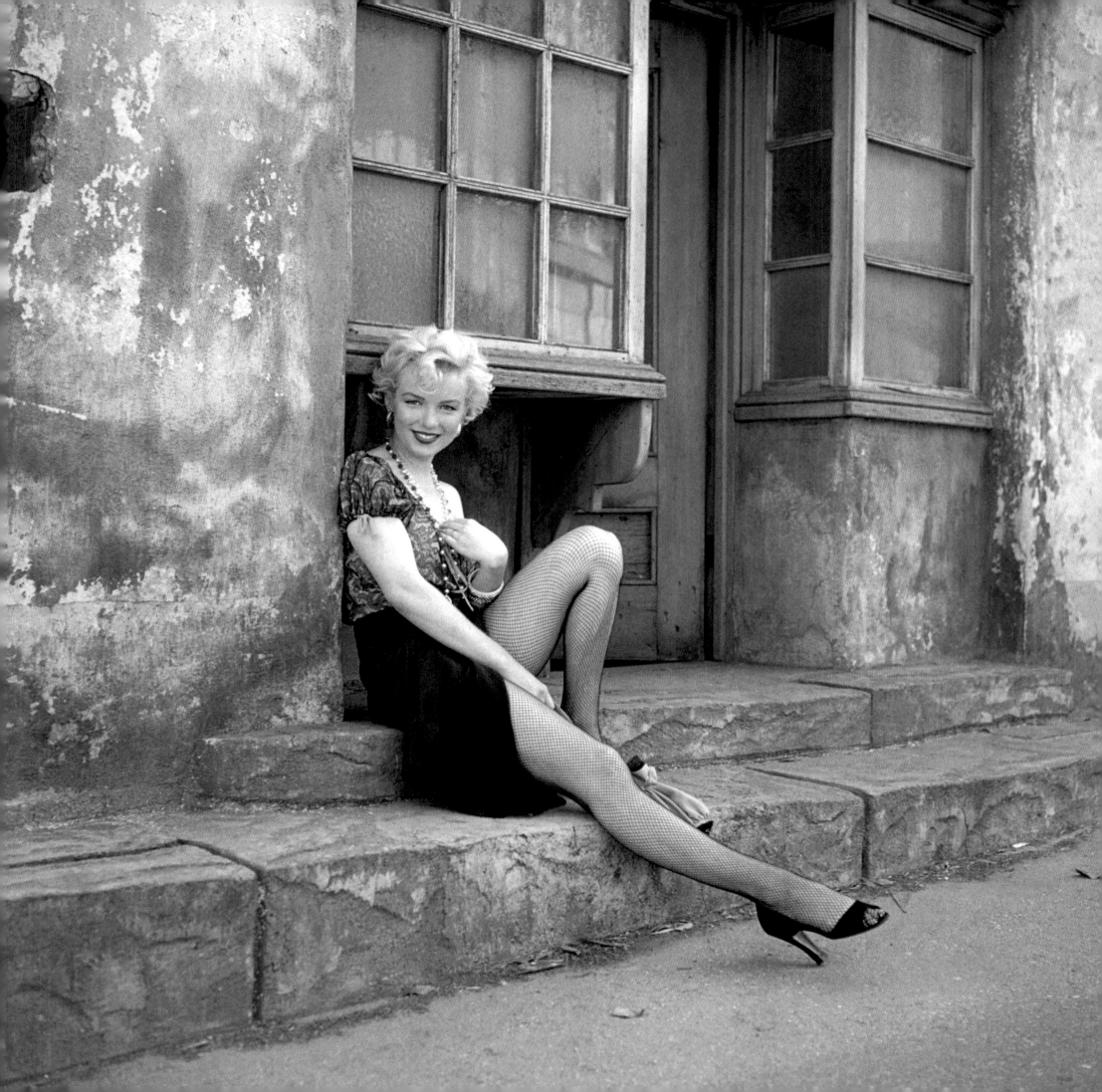

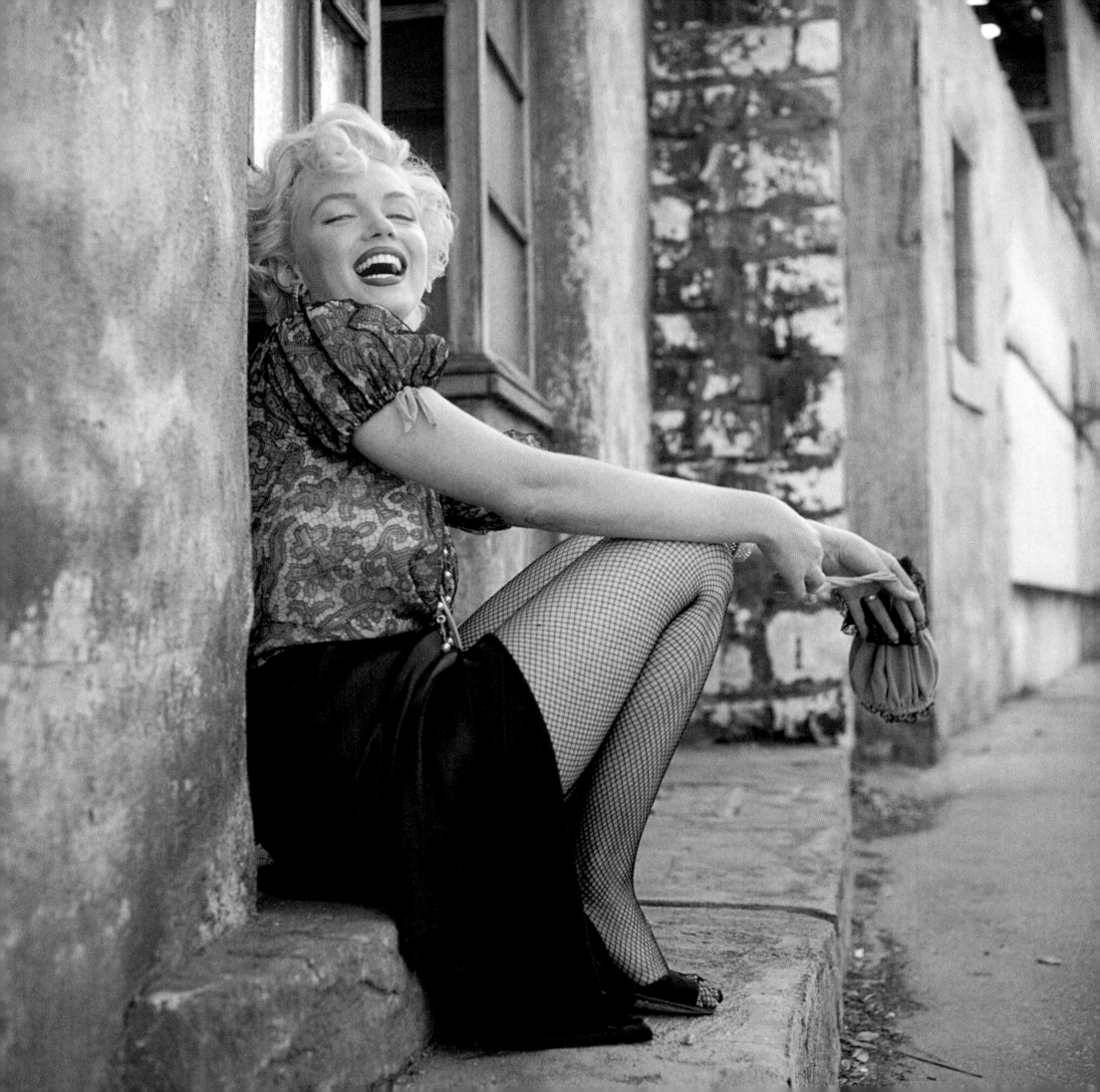

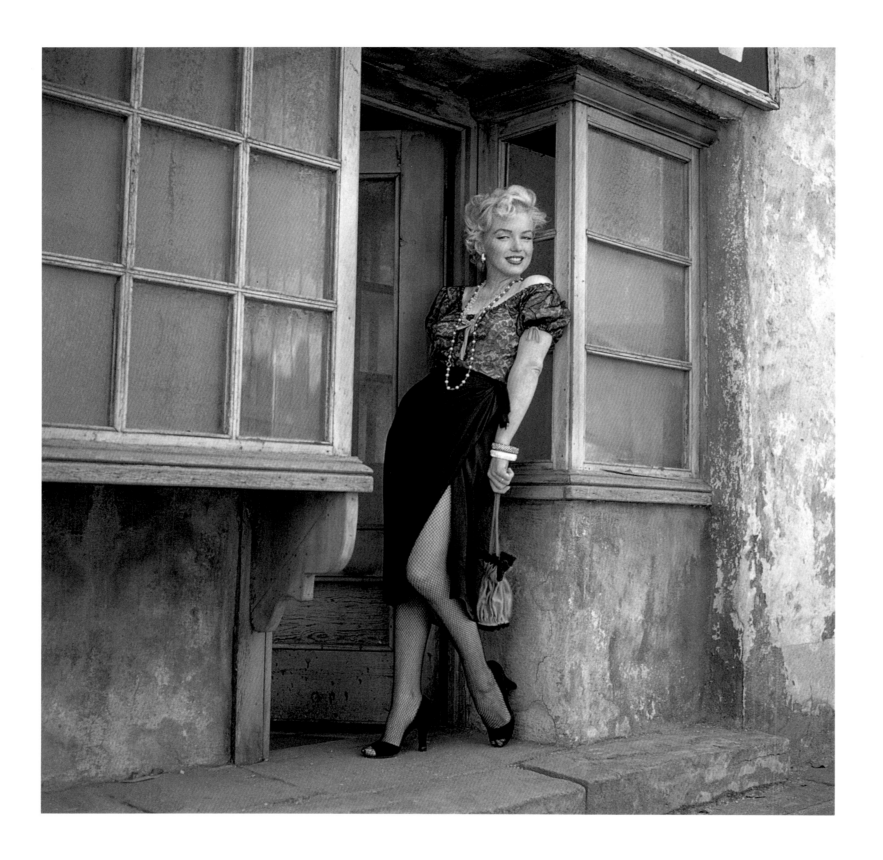

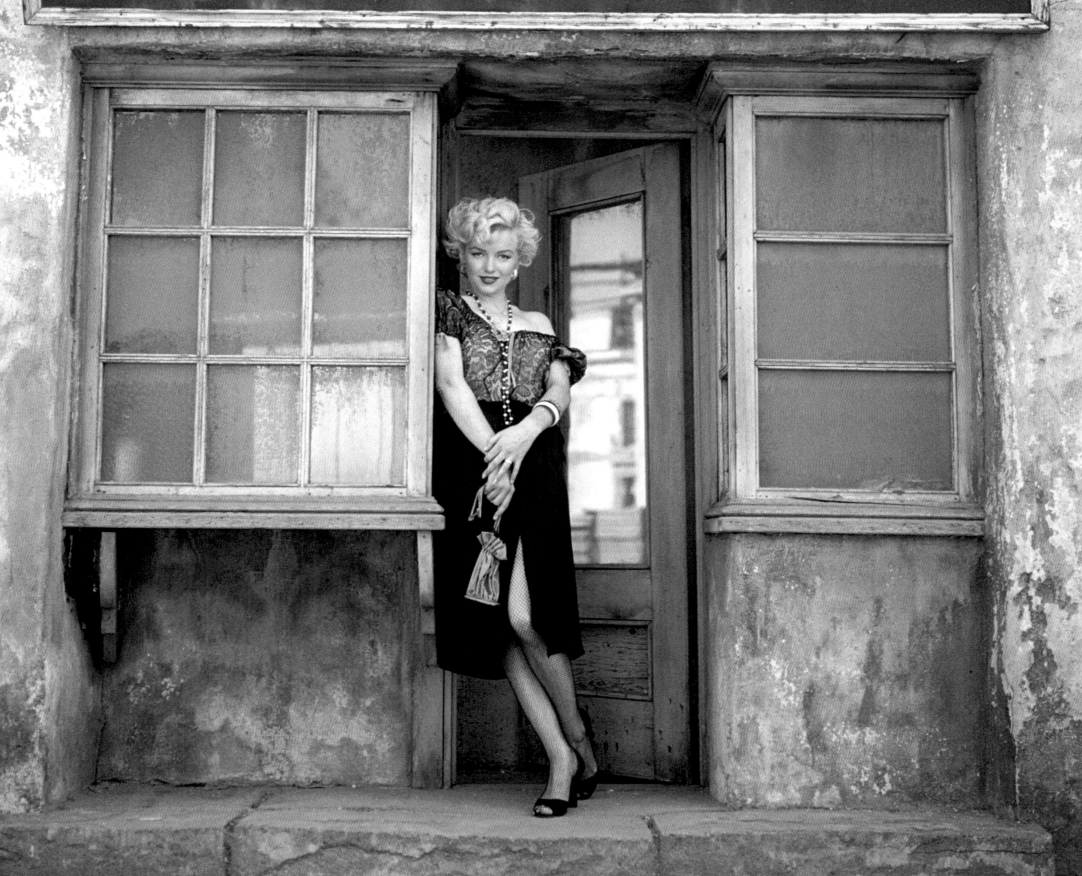

GYPSY

April 1956 – Here Marilyn is dressed as a gypsy palm reader, one of the many outfits she would dress up in while ransacking the 20th Century Fox costume department with Milton on Sunday afternoons. Milton's intuition led him to photograph Marilyn in three different environments: on the stairwell inside the shop; on the windowsill from the inside looking out; and from the street looking in through the window. He also got a wide exterior as well. That's the sign of a photographer exploring options.

Unpublished images:
Pages 279, 280, 281, 282, 283, 284

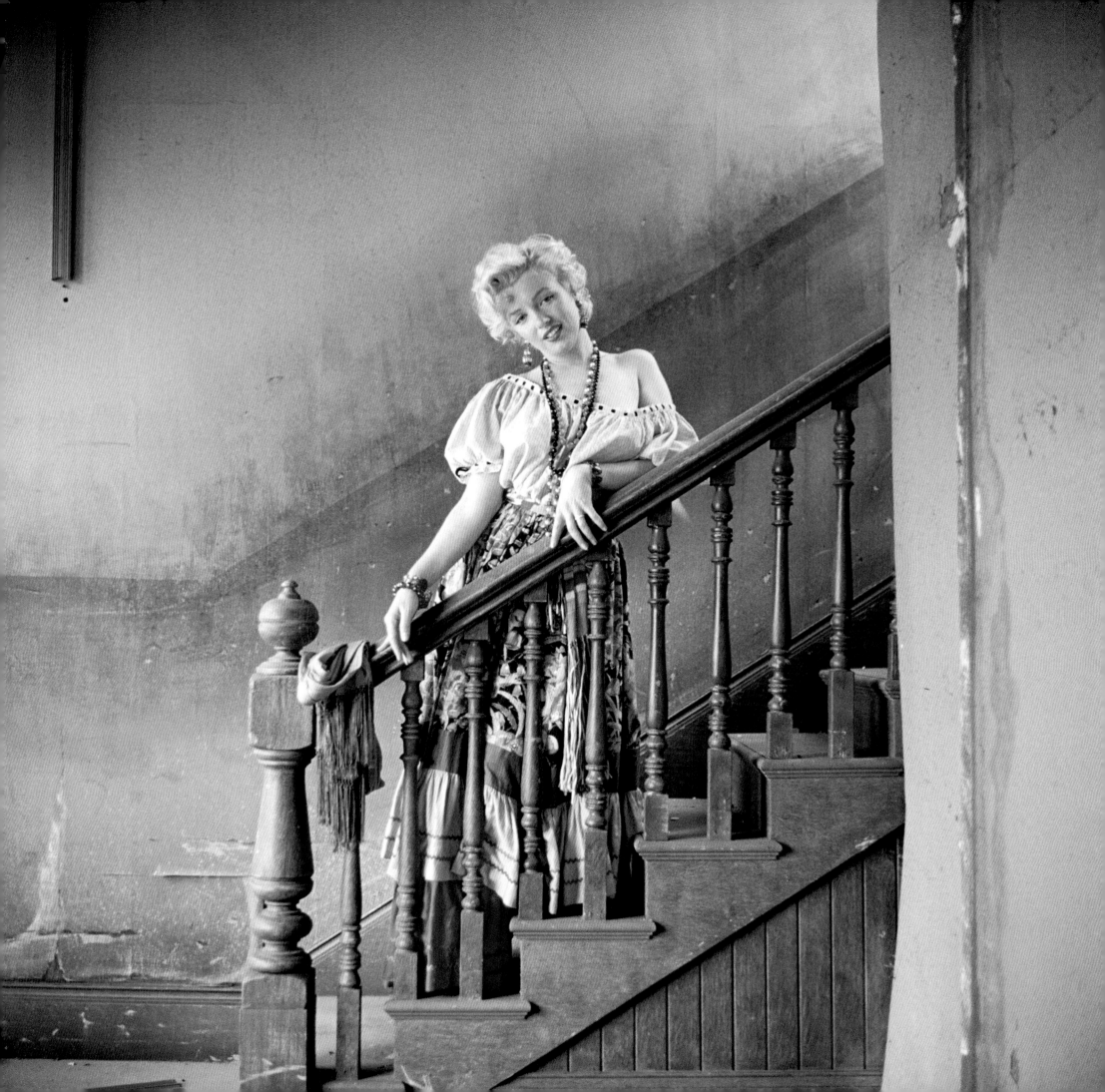

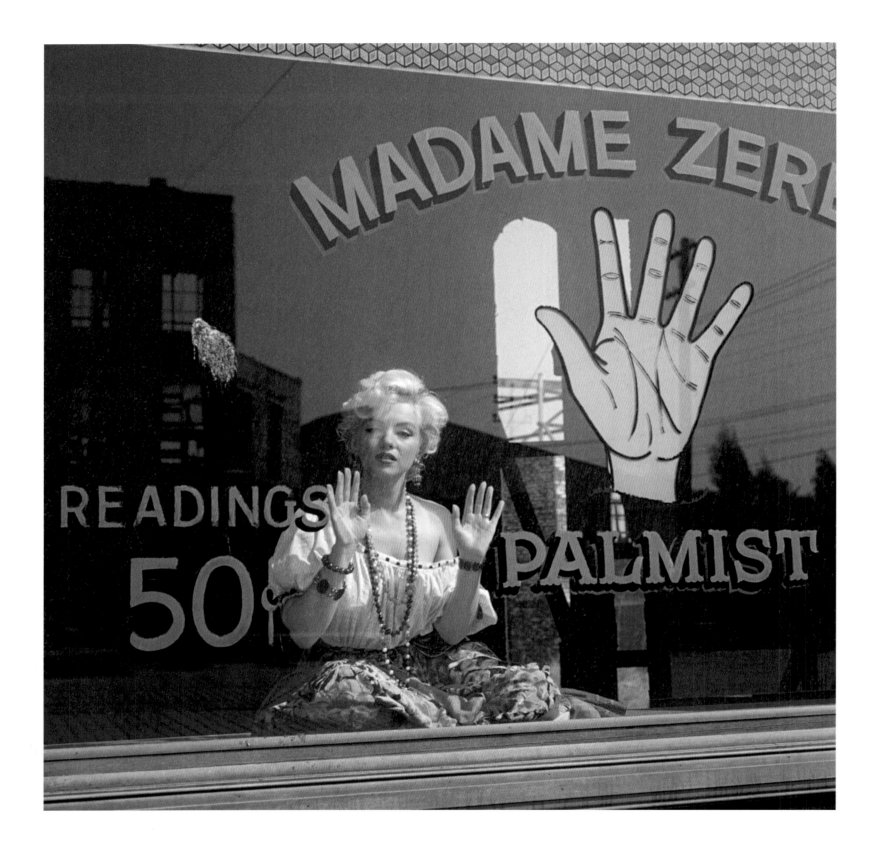

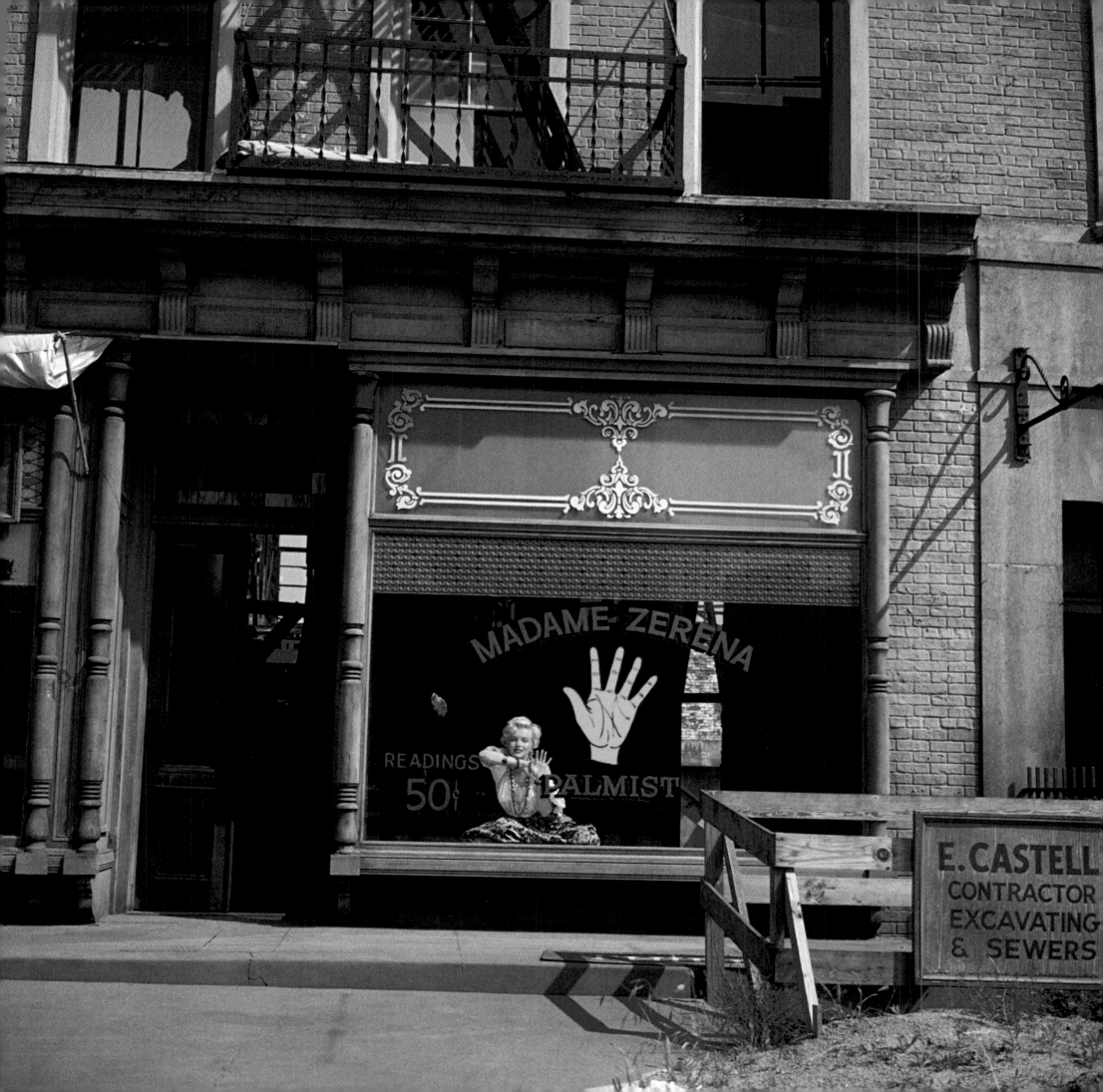

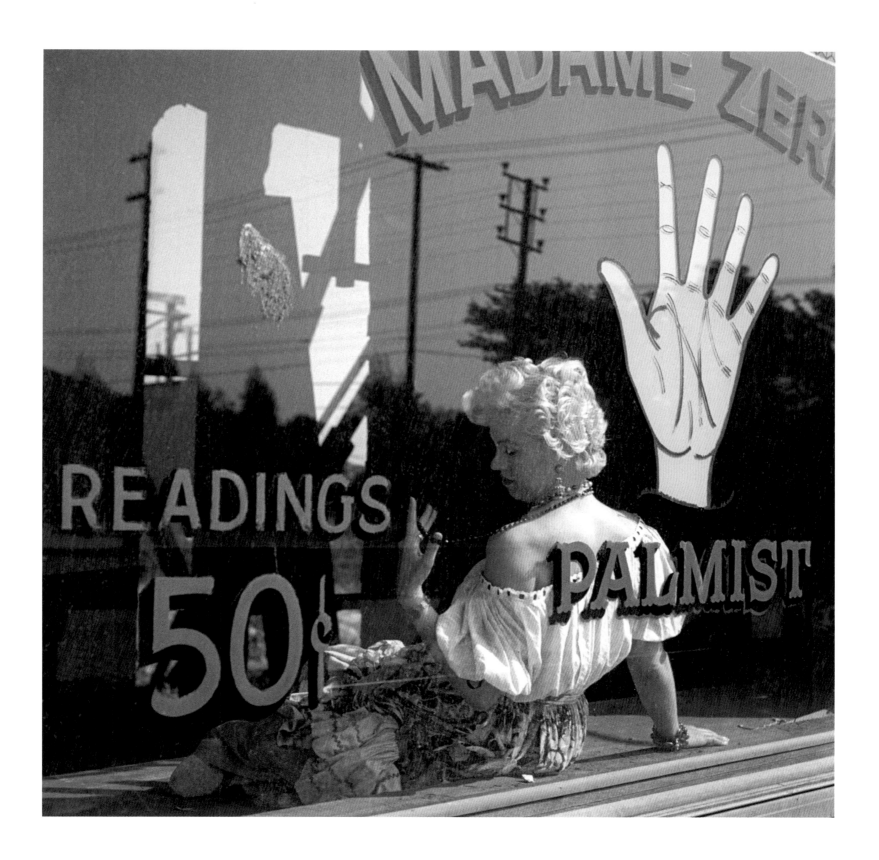

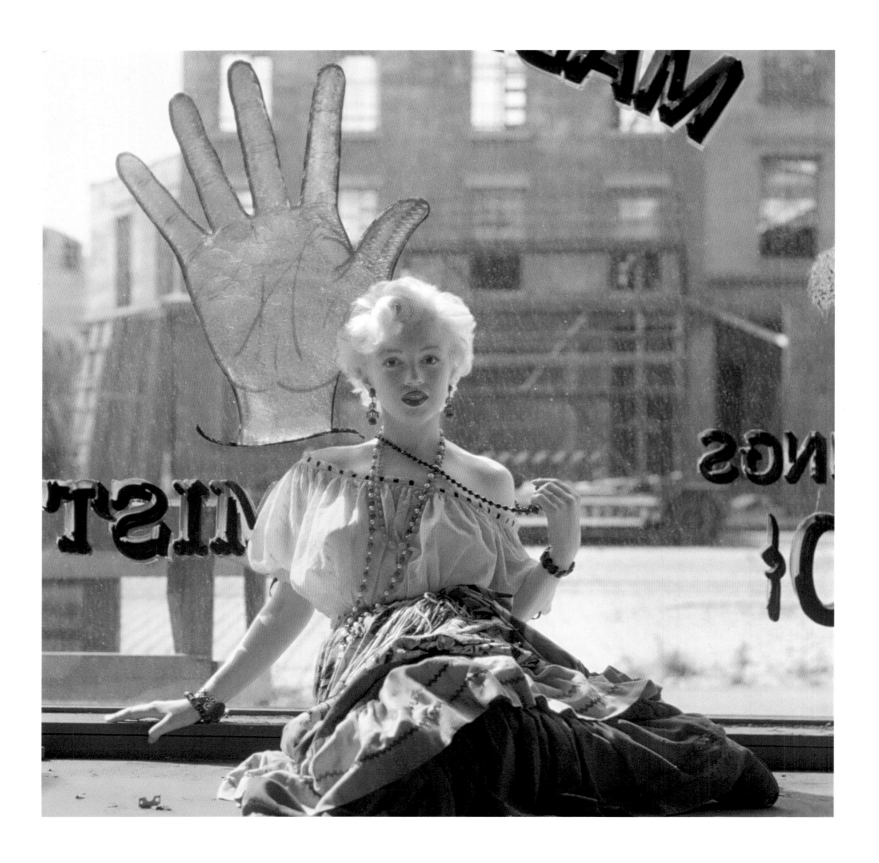

BUS STOP

March-May 1956 – Marilyn Monroe Productions began filming
Bus Stop in March 1956. Although excited, Milton and Marilyn
were also apprehensive heading into the project. Having won
their battle with the studio and negotiated new terms, everything
was riding on their first film together. Marilyn had one job:
focusing on delivering the best performance of her life. Milton
concentrated on all the other details, particularly aesthetics and
how his collaborator was captured on film.

In those days, movie stars used Max Factor pan-cake makeup.
They would apply a base like a primer and then paint the face.
Milton, after seeing the first rushes, said to producer Buddy Adler
and director Joshua Logan, "She's got too much makeup on.
This is a woman who never stepped outside. She should be white
like a ghost." From then on, any exposed skin was patted down
with talcum powder to make her look smooth and white. No detail
was overlooked; Milton coordinated with director of photography
Milton Krasner to change the lighting in the saloon where Marilyn
sang "That Old Black Magic," perfectly off-key. They refocused the
spotlights, making the beam narrower, in addition to adding a
diffuser to remove any harsh shadows and giving the face and skin
a soft glow. Milton also put holes in her fishnet stockings and
played down designer William Travilla's colorful bodice, adding a
level of realism to her character, Chérie, a down-on-her-luck
saloon singer trying to get to Los Angeles to be discovered.
Another aesthetic element Milton introduced to the character
was the green scarf she waved in the air while performing.

Though there were delays and moments of frustration, particularly
between Logan and Paula Strasberg, who helped coach Marilyn
through *Bus Stop*, Marilyn delivered a pivotal performance,
demonstrating to the world she was a serious character actress.

Unpublished images:
Pages 287, 288, 289, 290, 291, 292, 293, 294, 295, 296, 297, 298, 301, 303, 304

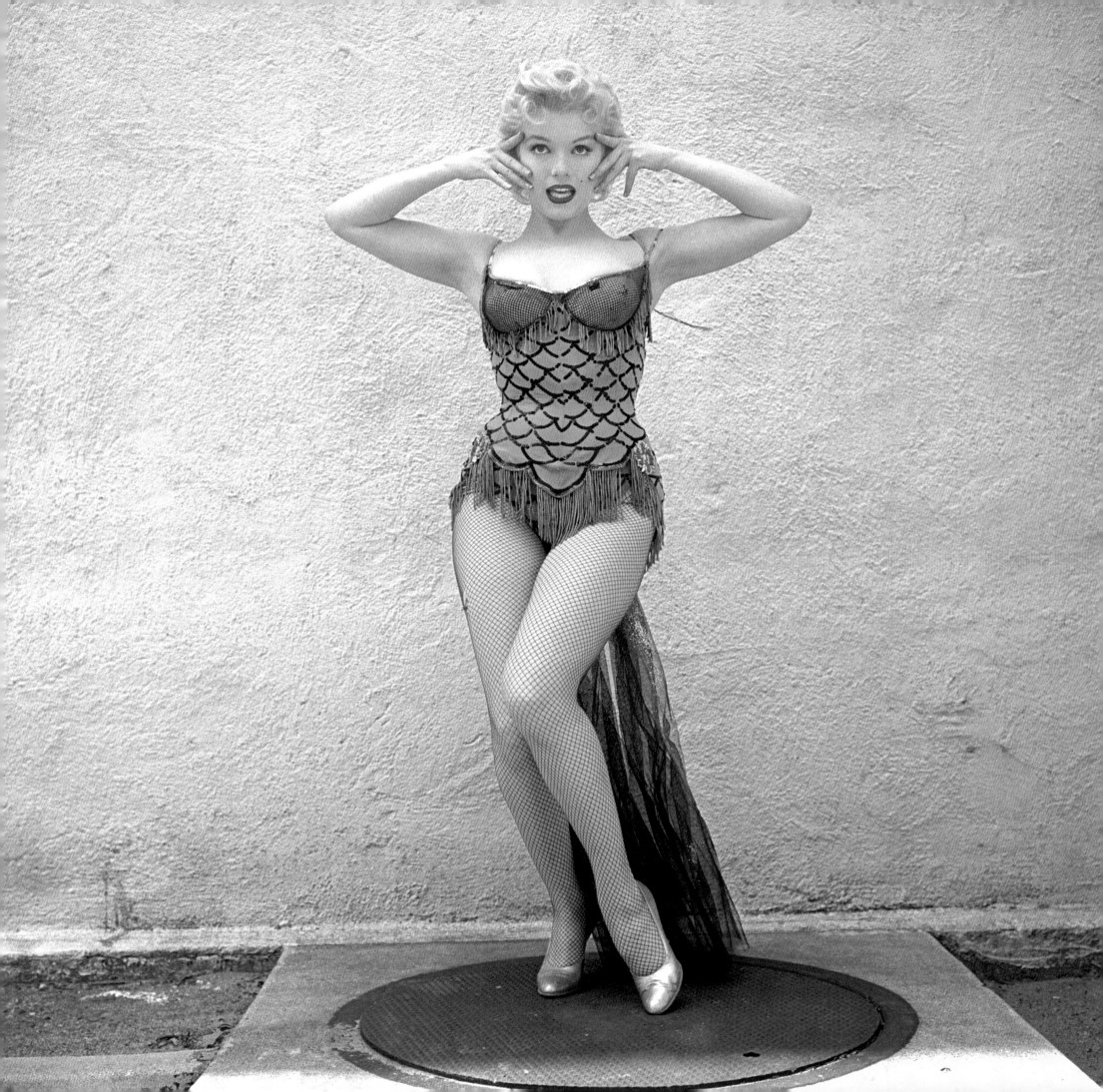

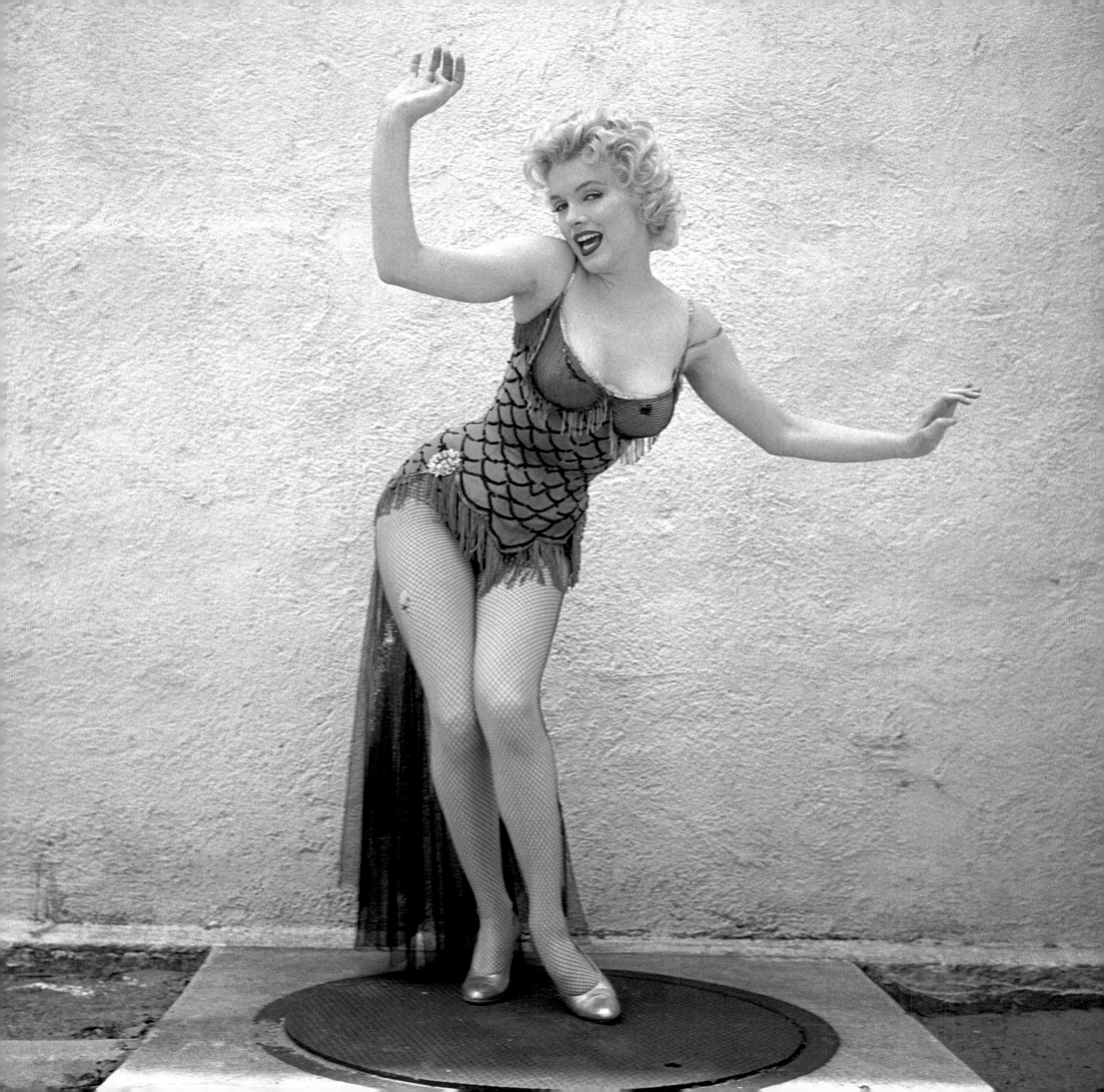

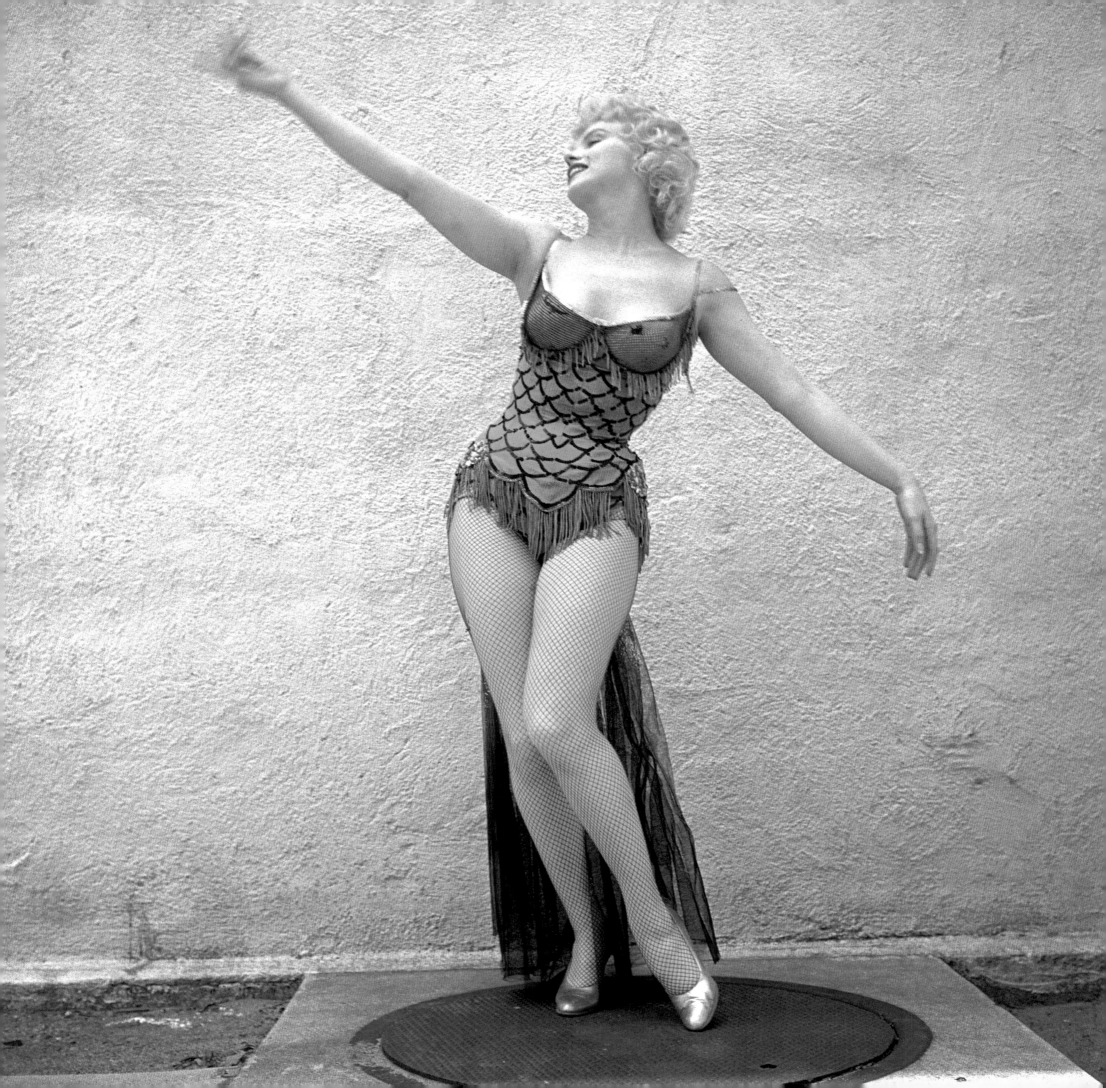

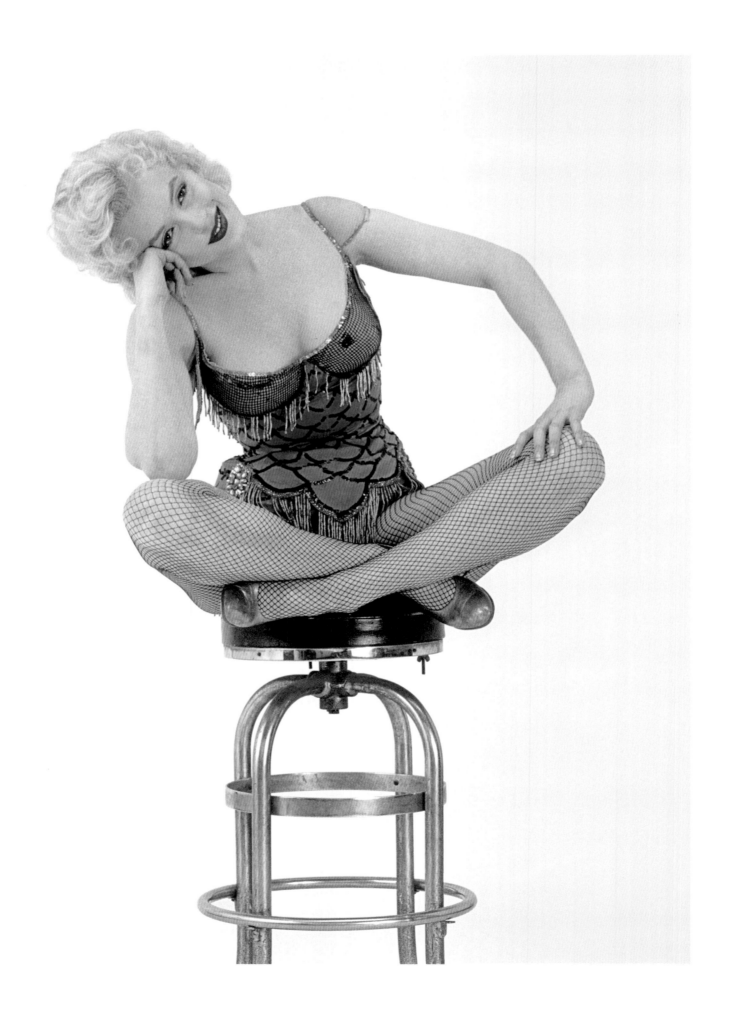

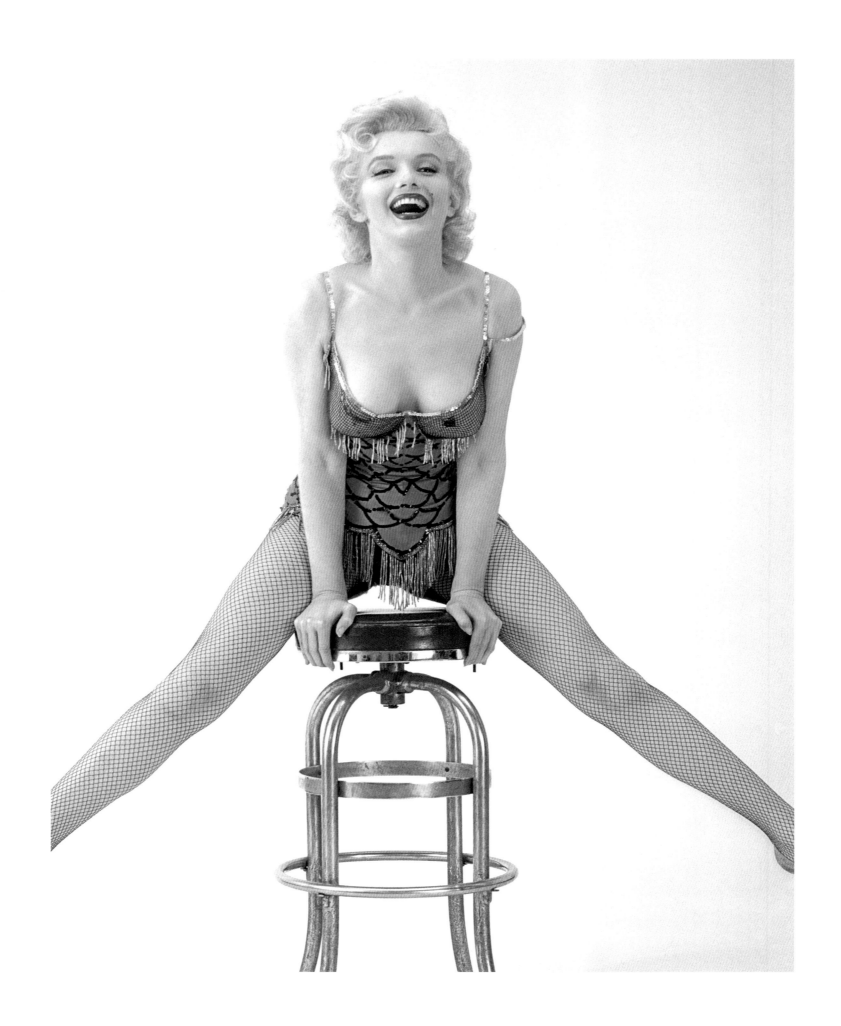

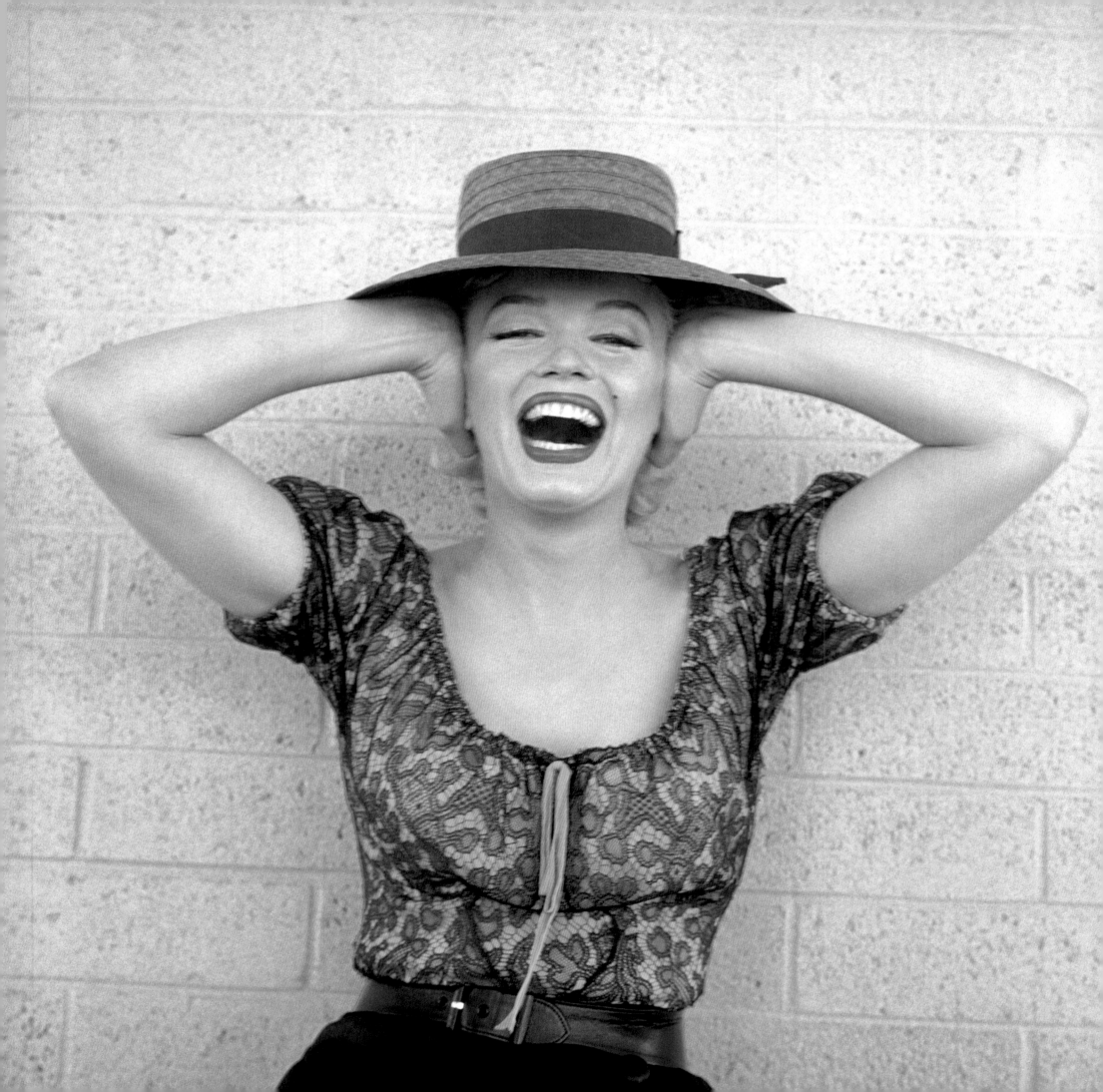

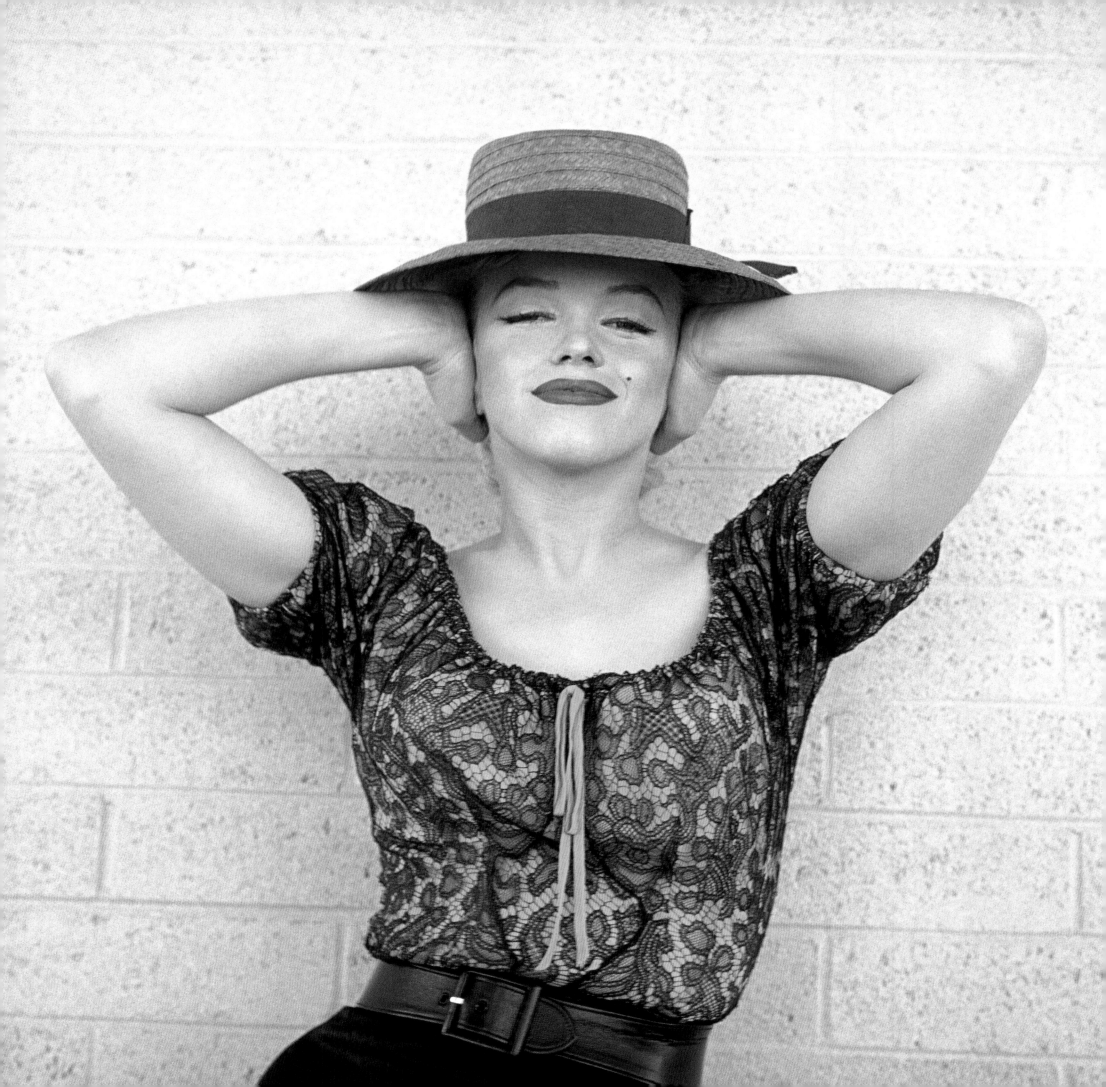

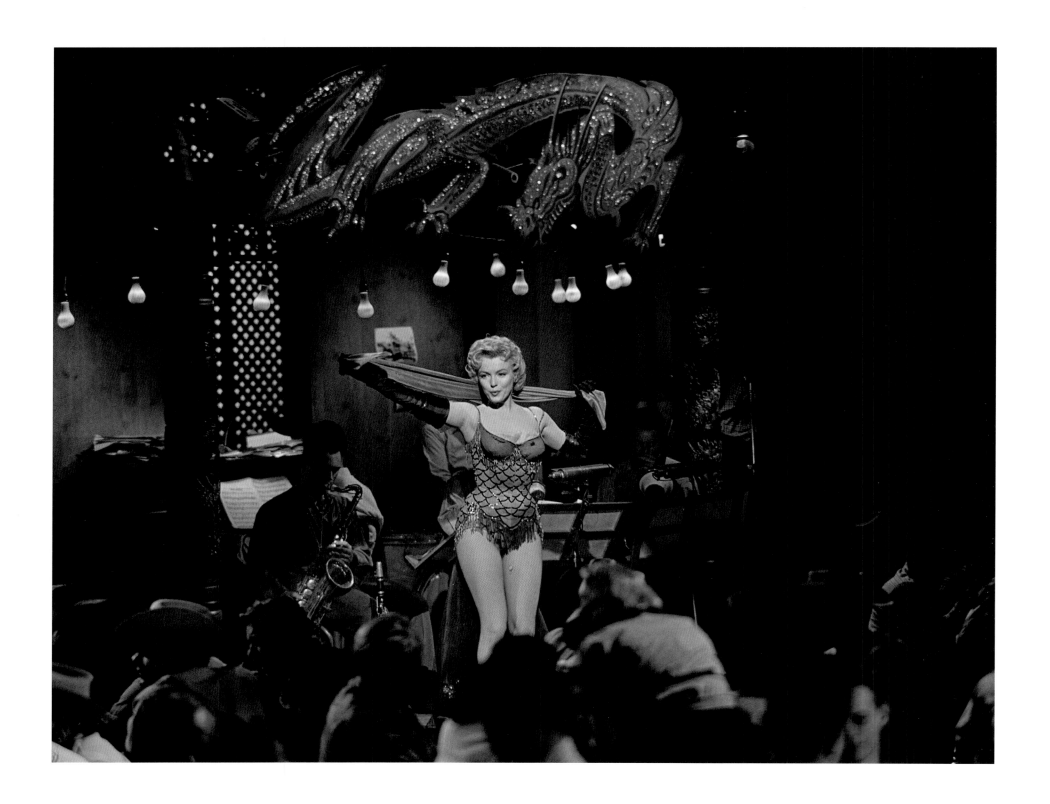

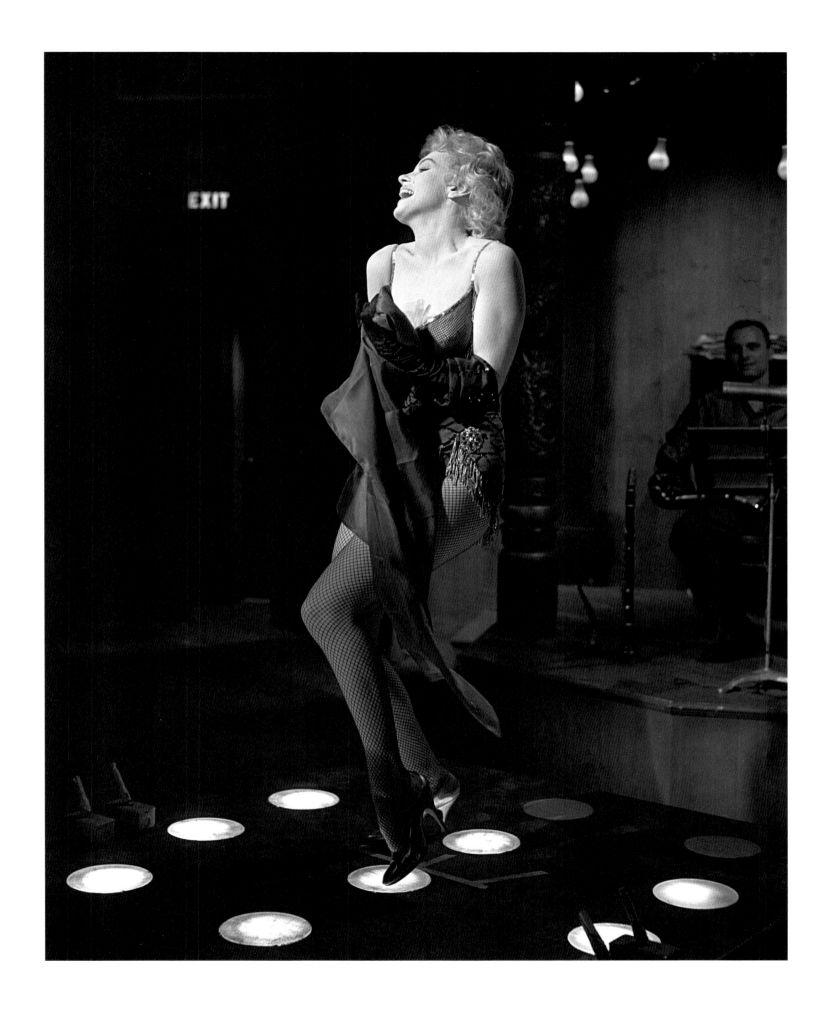

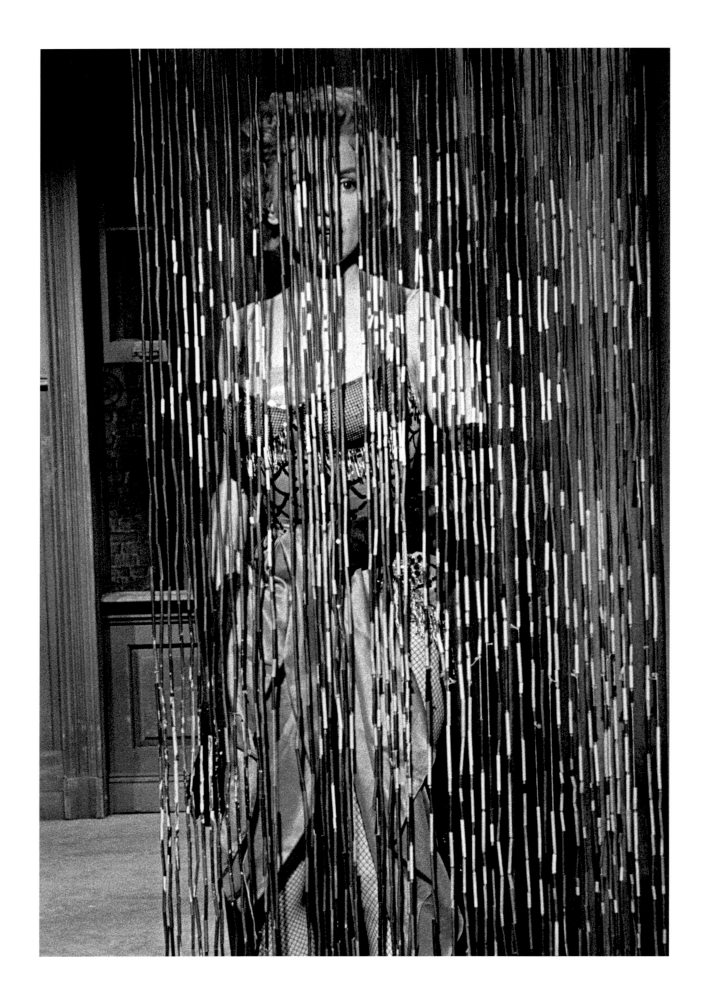

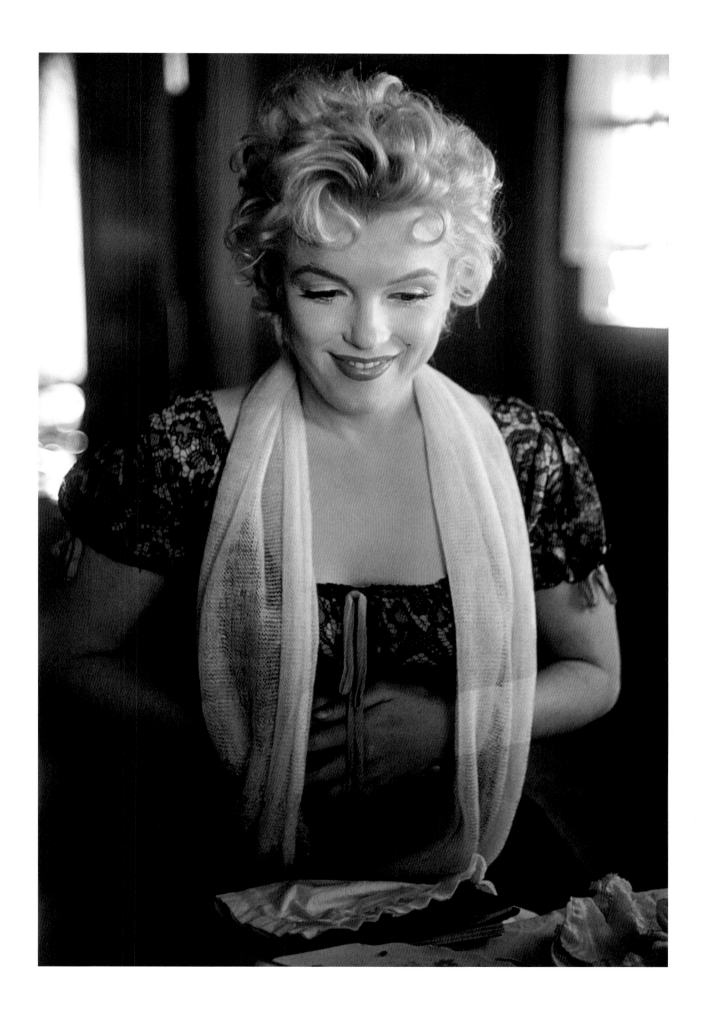

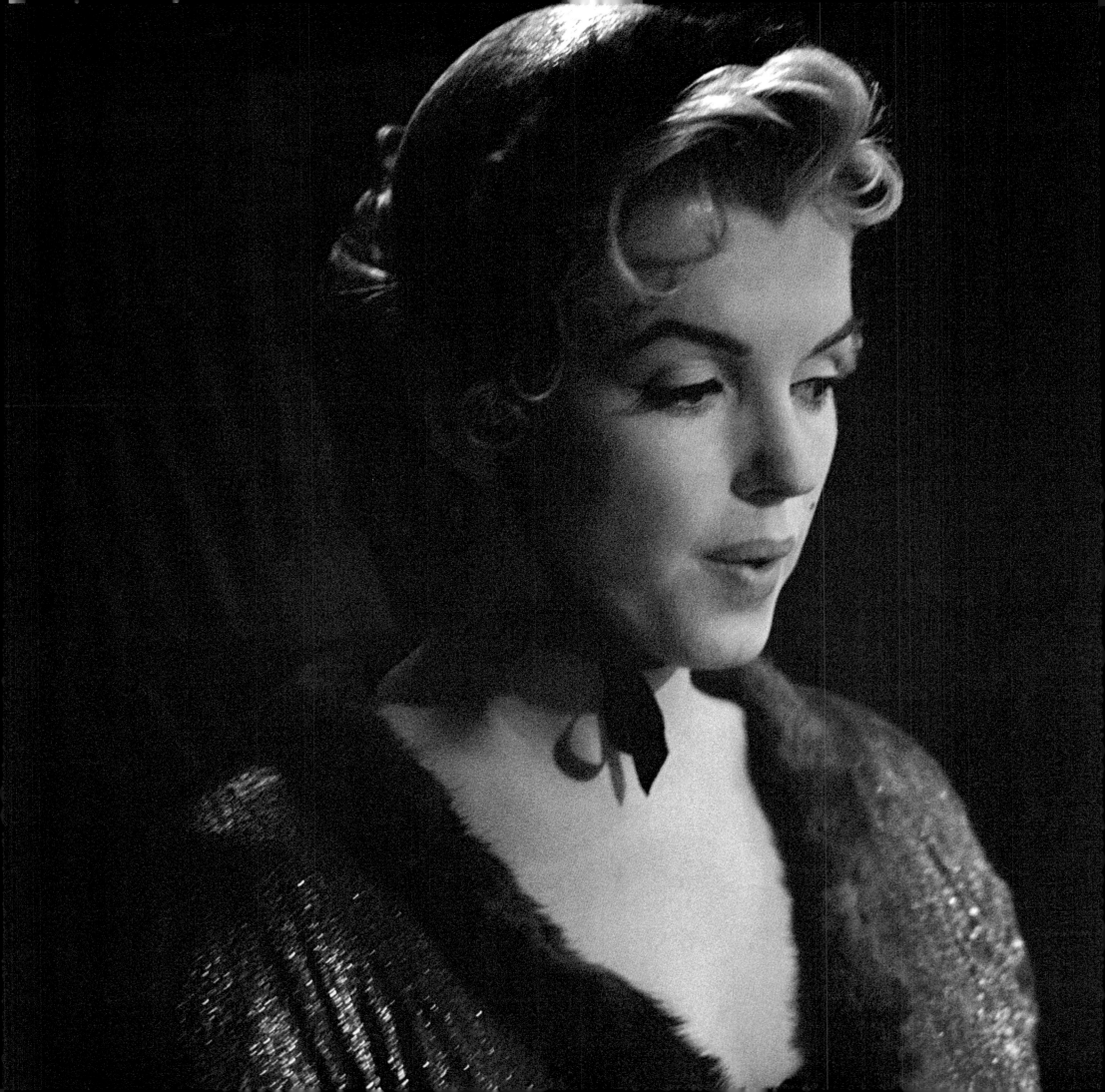

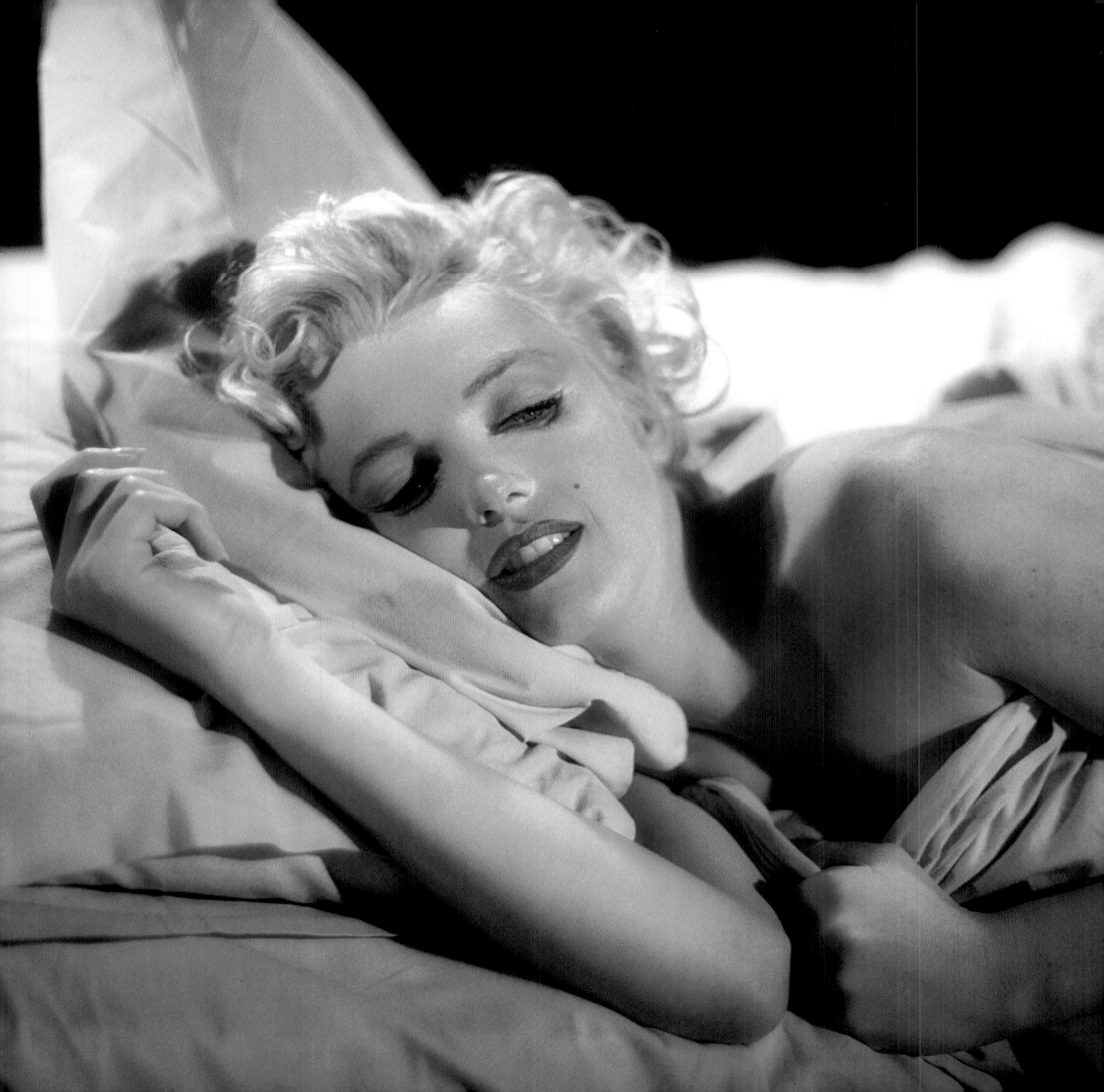

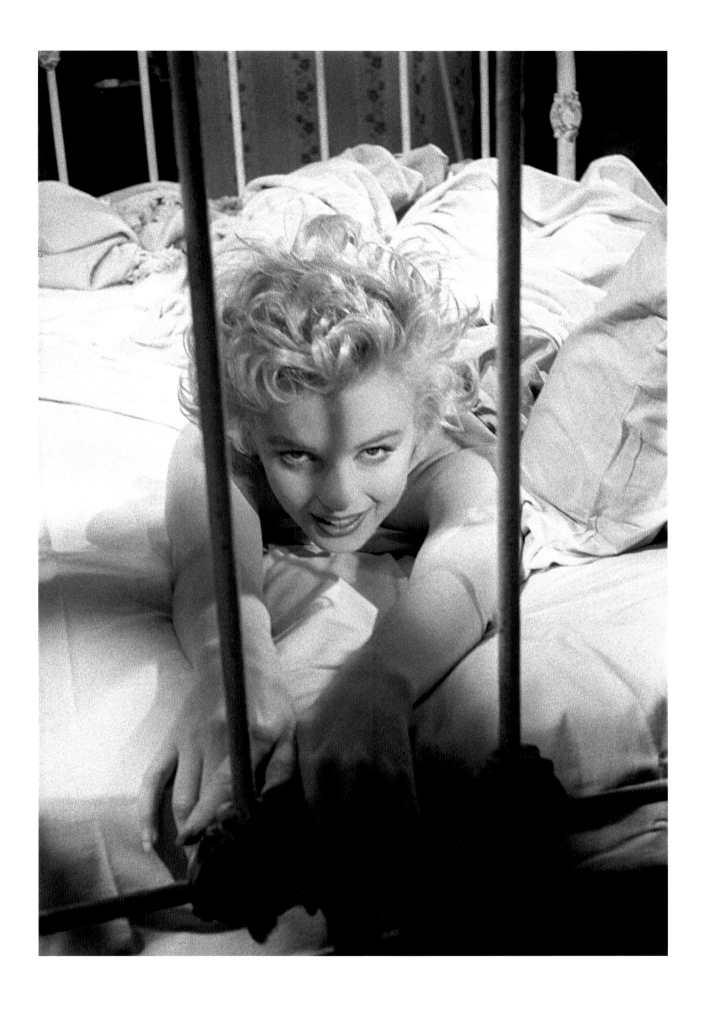

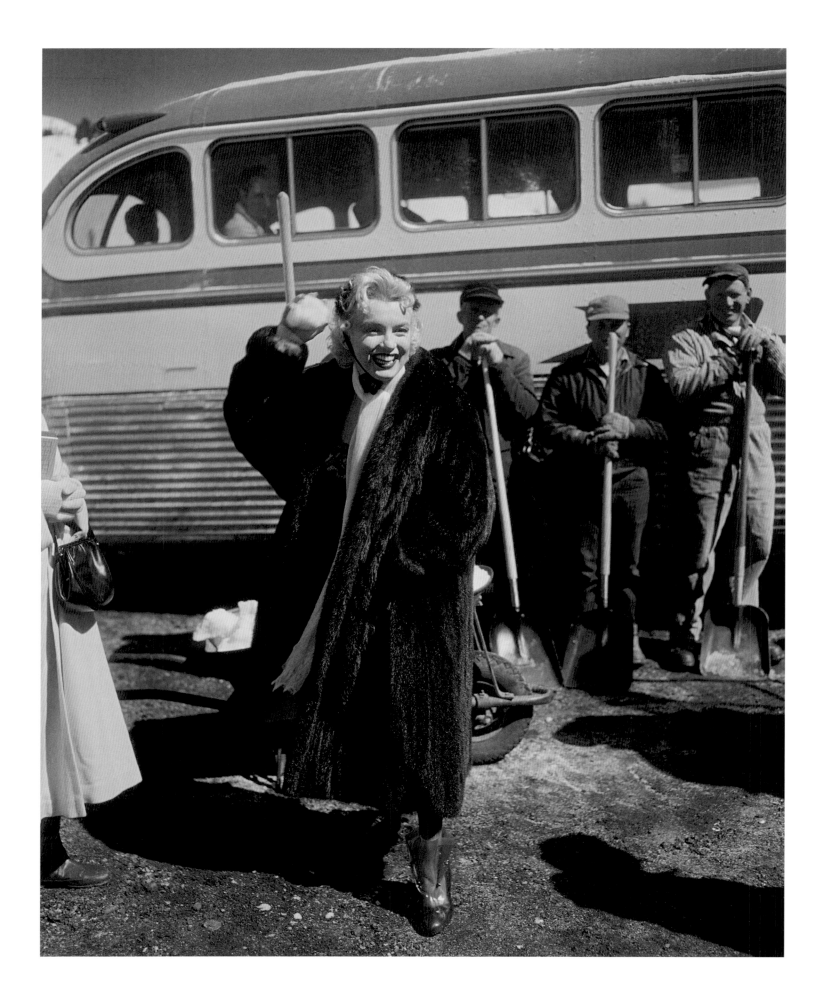

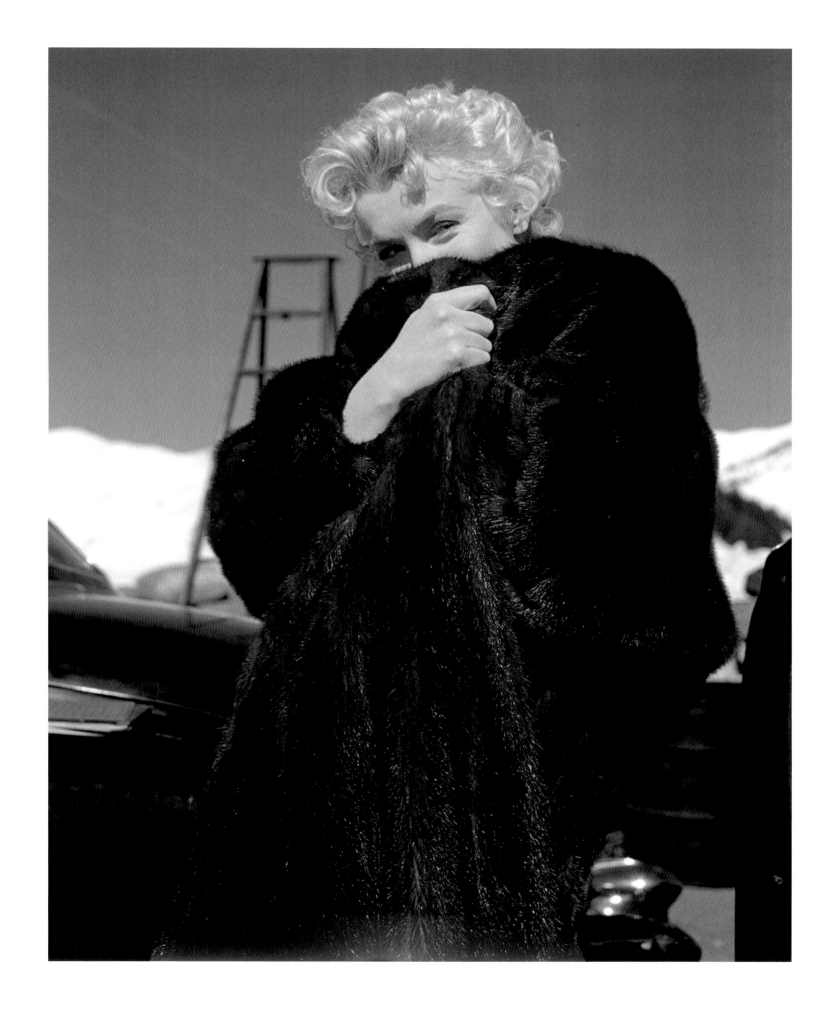

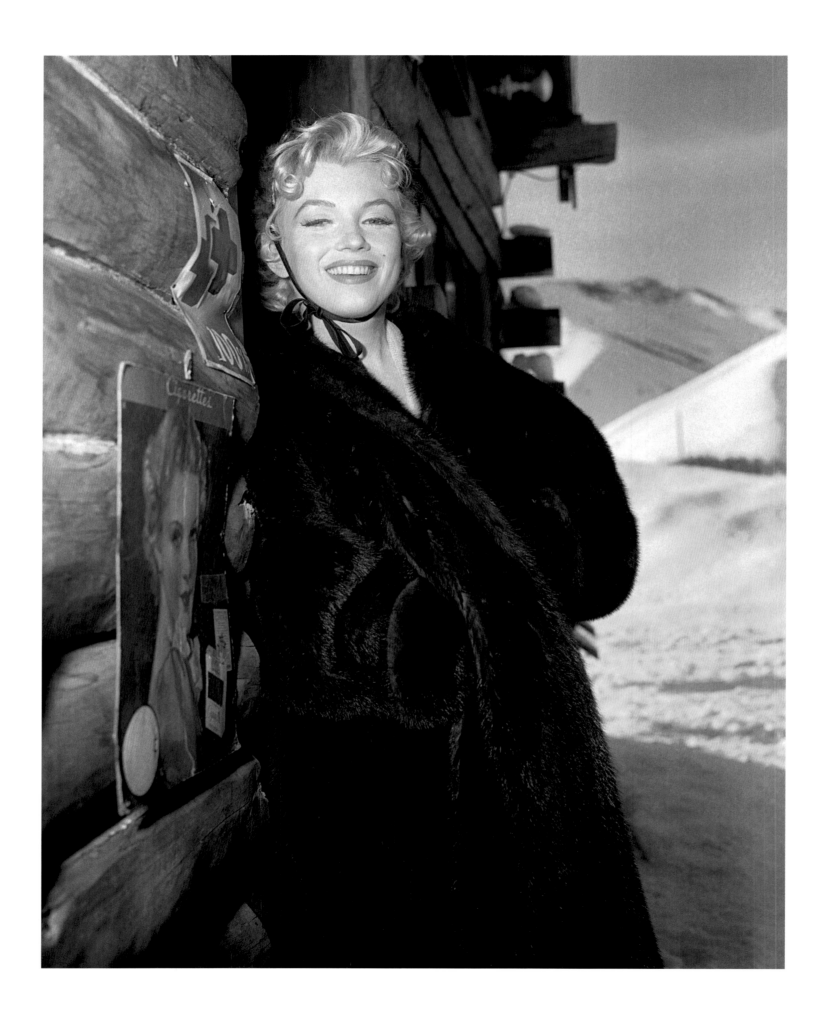

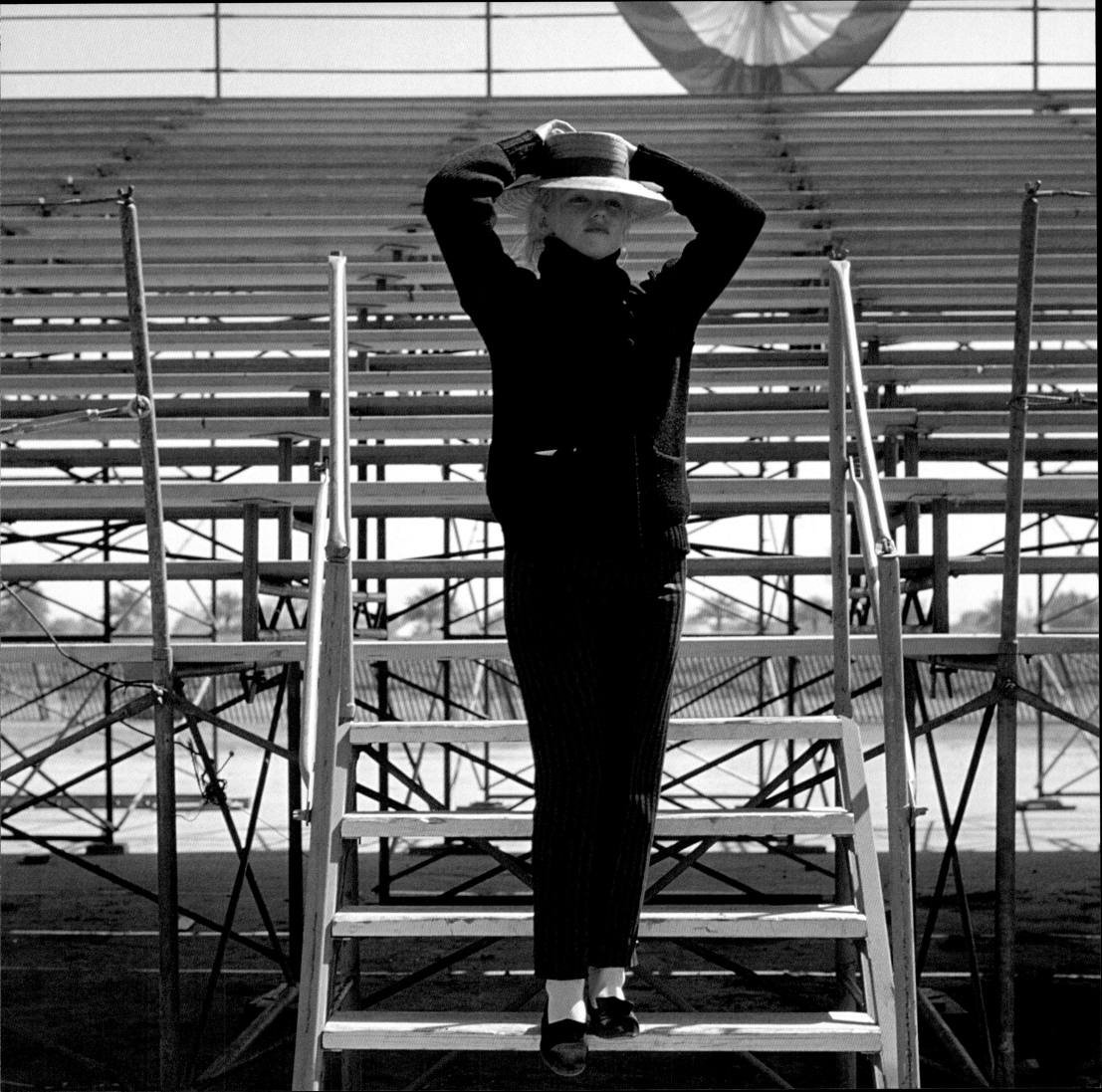

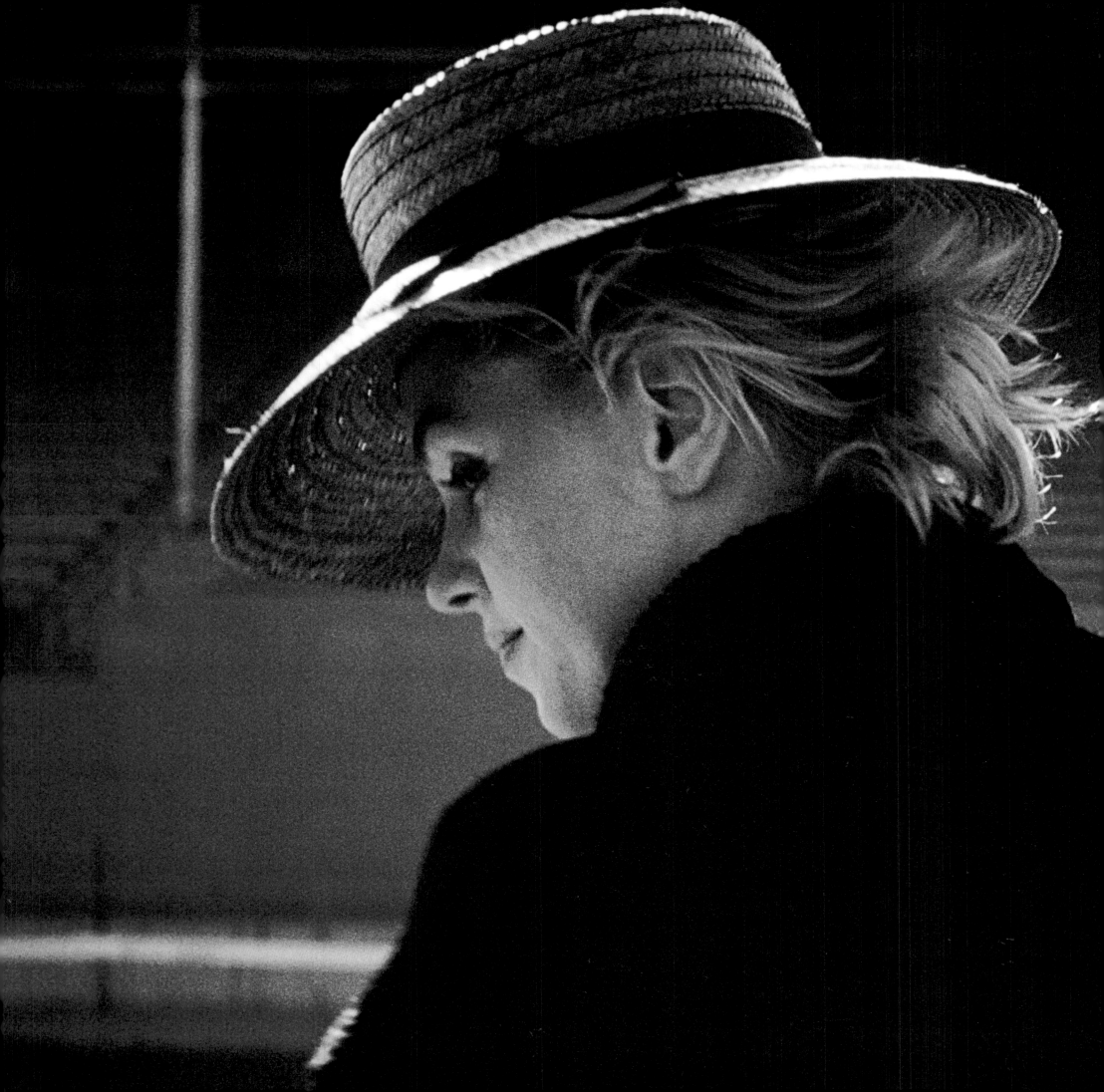

BEVERLY GLEN
PARTY

May 1956 – The Greene family, Marilyn and Inez "Kitty" Owens – who cooked and kept house for the Greenes in addition to taking care of Joshua – lived in a house at 595 North Beverly Glen Blvd., a four bedroom home in Los Angeles that Milton rented while making *Bus Stop*. One night, they allowed reporters and press to come in for a cocktail party. Marilyn was wearing the infamous black spaghetti-strap dress, from the *Prince* press reception. Notice the fashion and gestures of the press gathered around her.

Unpublished image:
Page 310

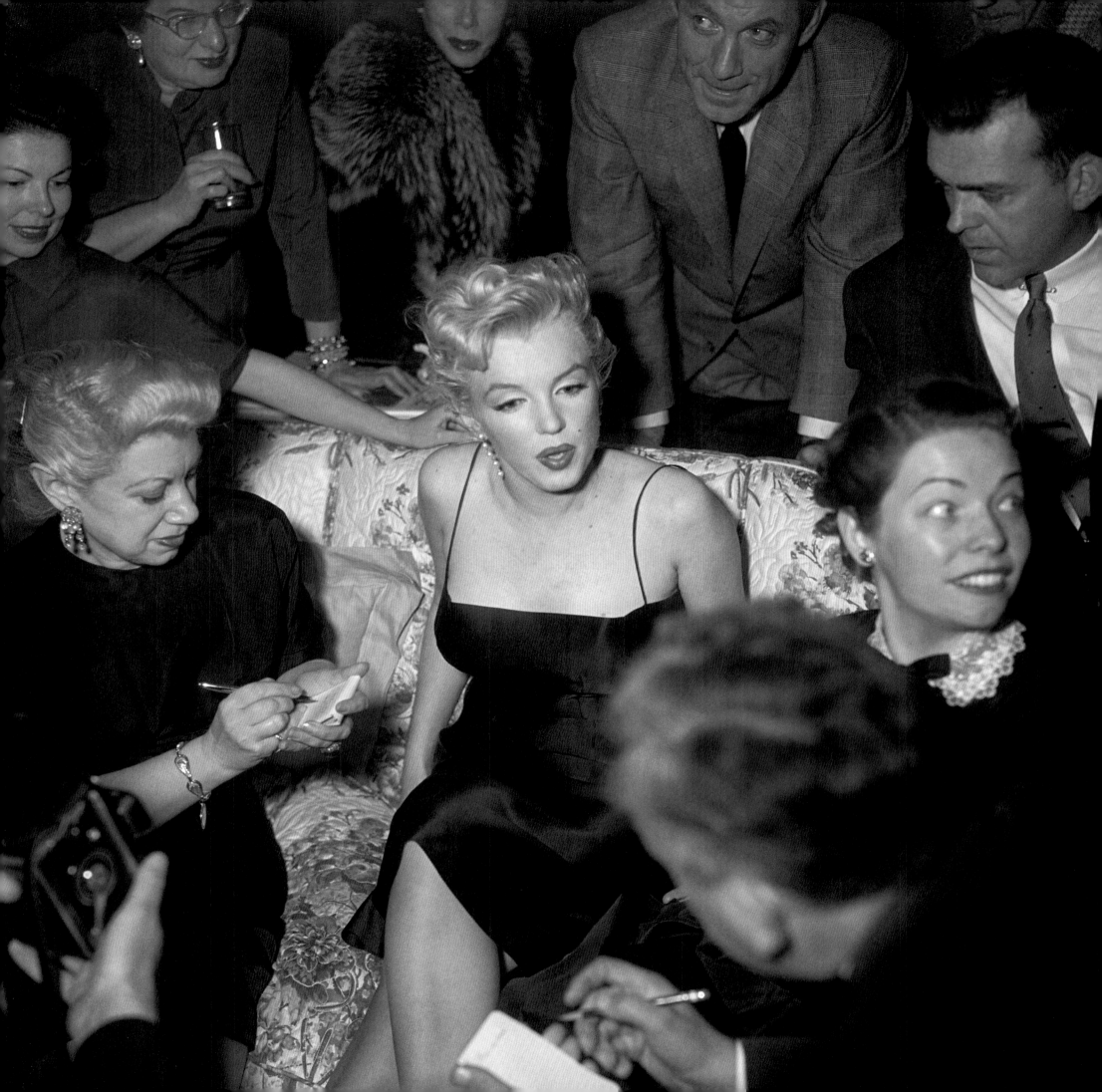

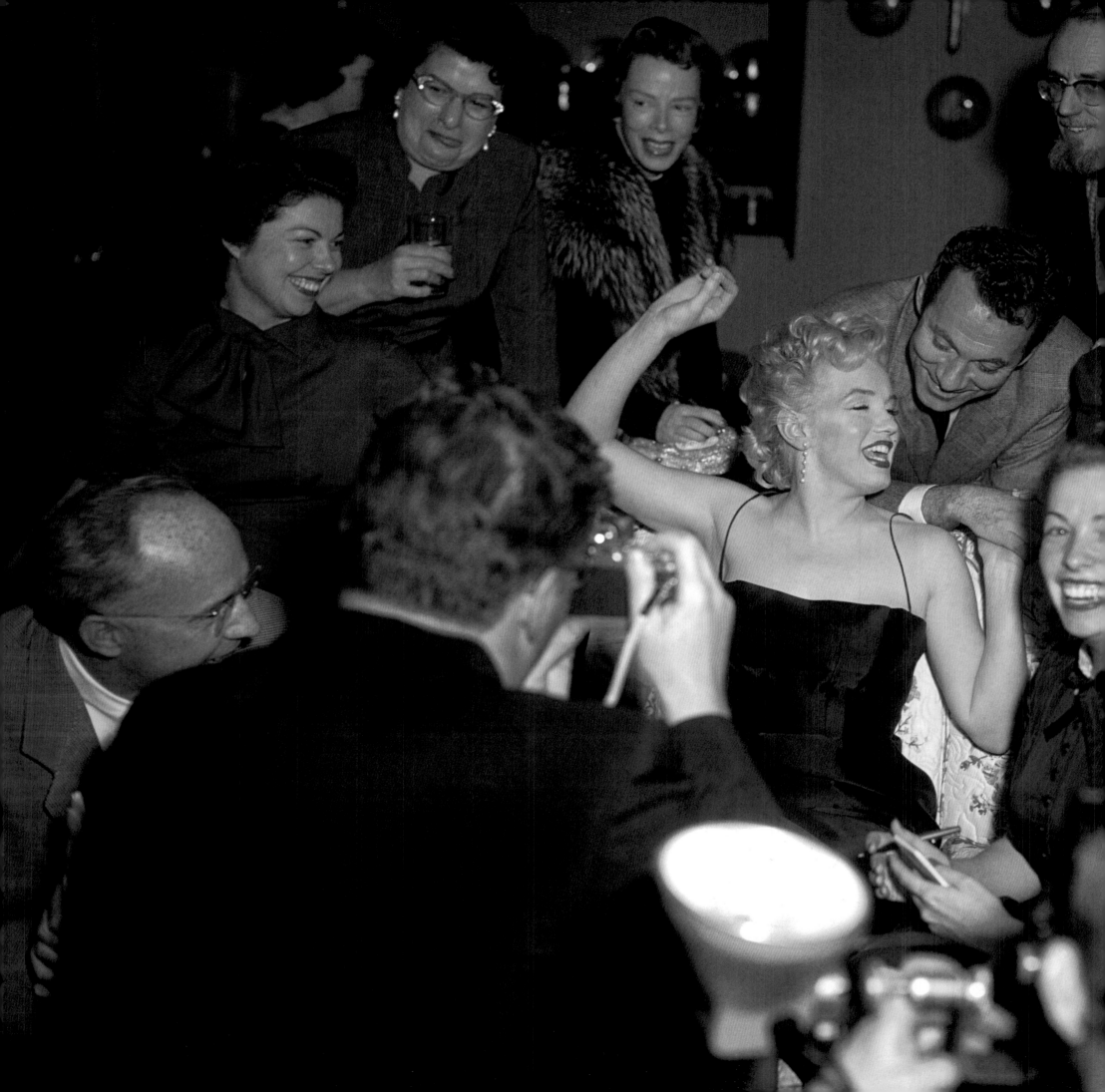

GRADUATION

May 1956 – Marilyn, Milton and Amy went over to Sydney
Guilaroff's mansion. He was the preeminent hairdresser at
MGM and there wasn't a star who didn't go through Sydney's
hands. Although still working on *Bus Stop*, they were beginning
preproduction for *The Prince and the Showgirl*, which
commenced filming months later in London. That day's
work was to try different hairstyles. This series got its
name because Milton printed one of the pictures from this
sitting as a 6x8 oval vignette, which looked like an
old-fashioned graduation picture. Marilyn dubbed it the
high school picture she never had.

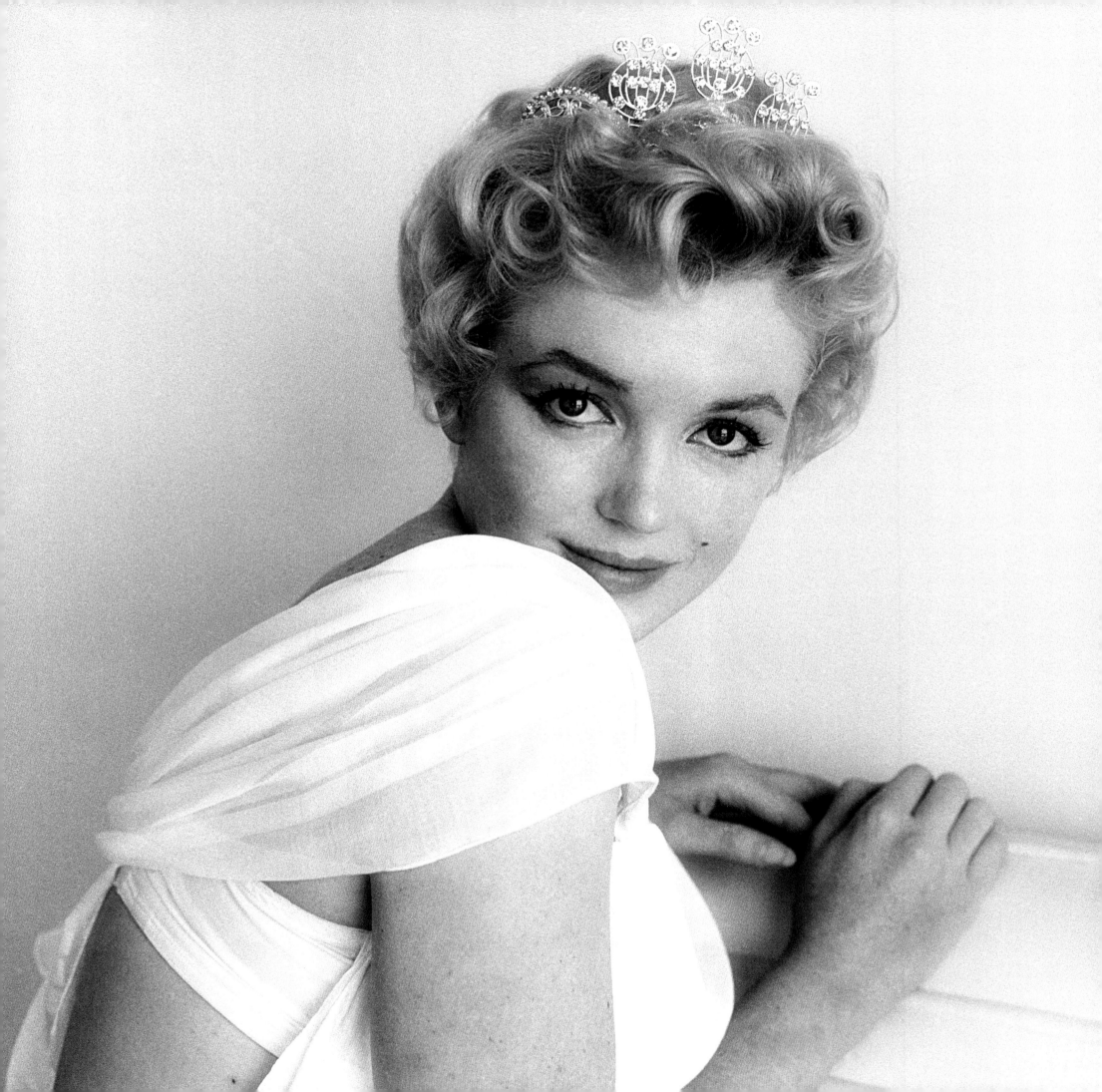

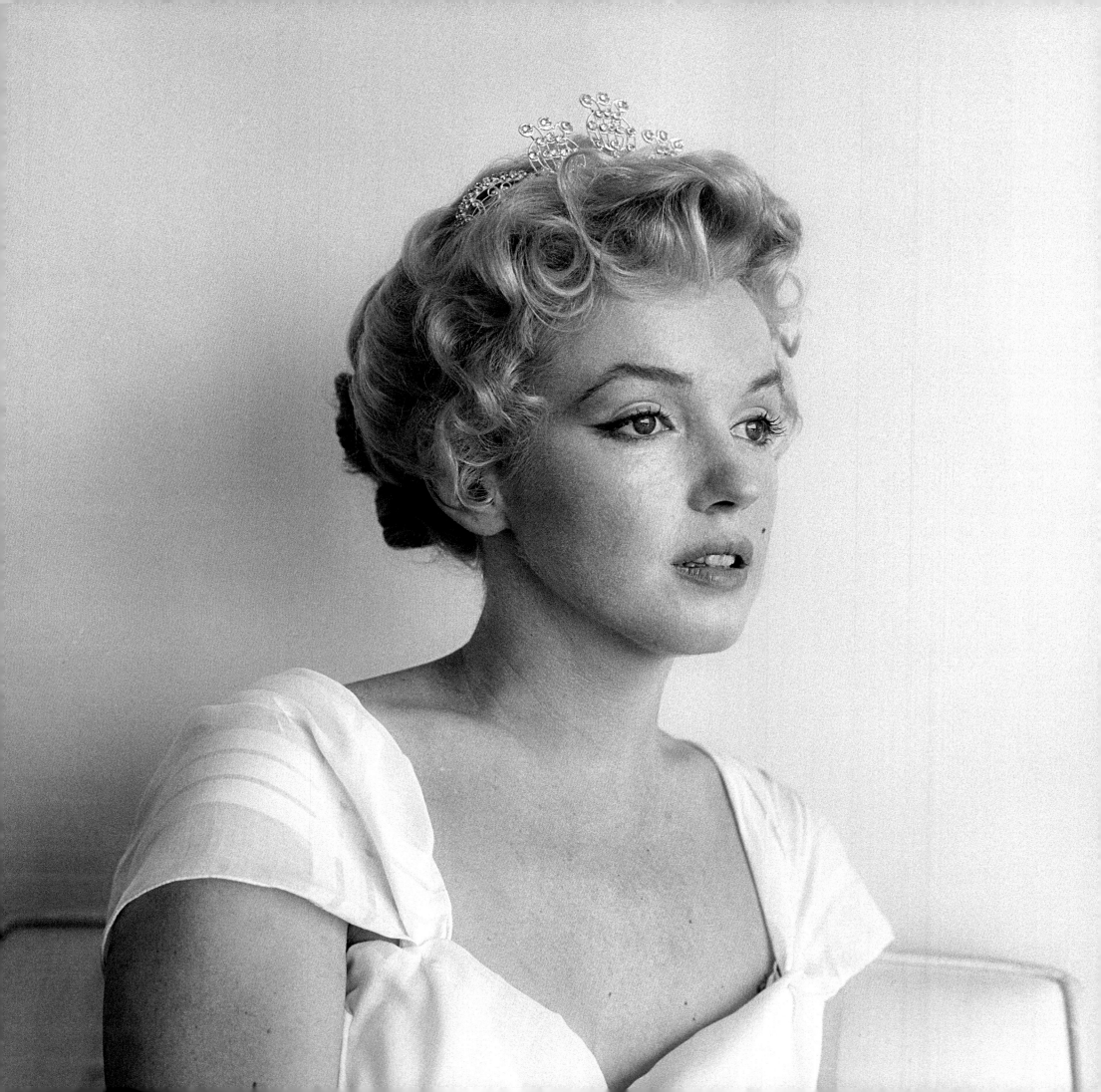

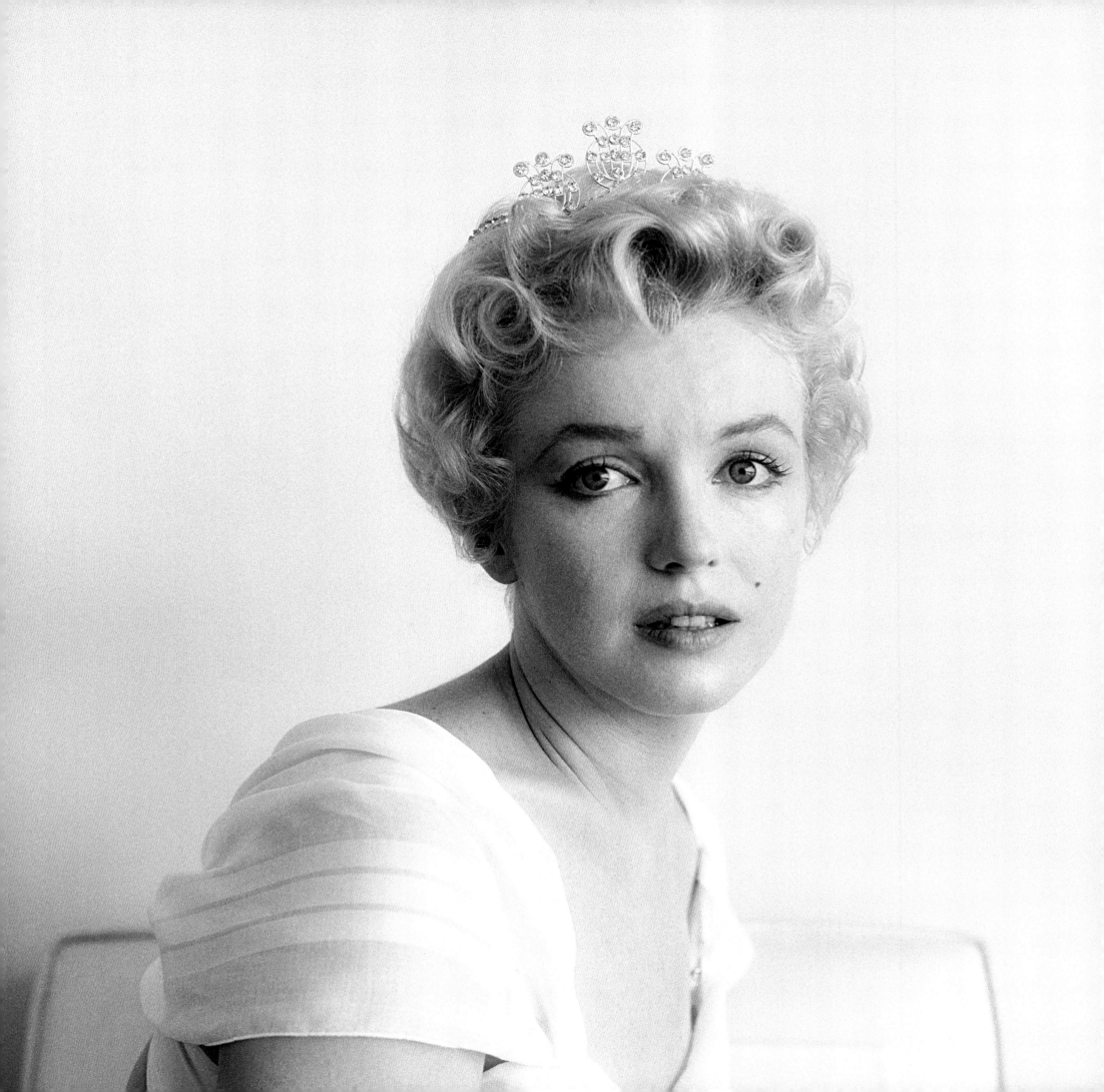

STATUE

May 1956 – Taken at Guilaroff's mansion the same day as the
Graduation pictures, Marilyn posed with his statue of the
discus thrower, which Guilaroff had near the windows of his
living room. The other task of the day's work was for Milton
to visualize a neckline that would be appropriate for her
upcoming character in *The Prince and the Showgirl*.
Milton draped fabrics on Marilyn and secured them with
safety pins, discovering a neckline that would be used in the
costume she wore in the film. Marilyn had a gift for exuding
emotion, even when hugging an inanimate object.

Unpublished image:
Page 317

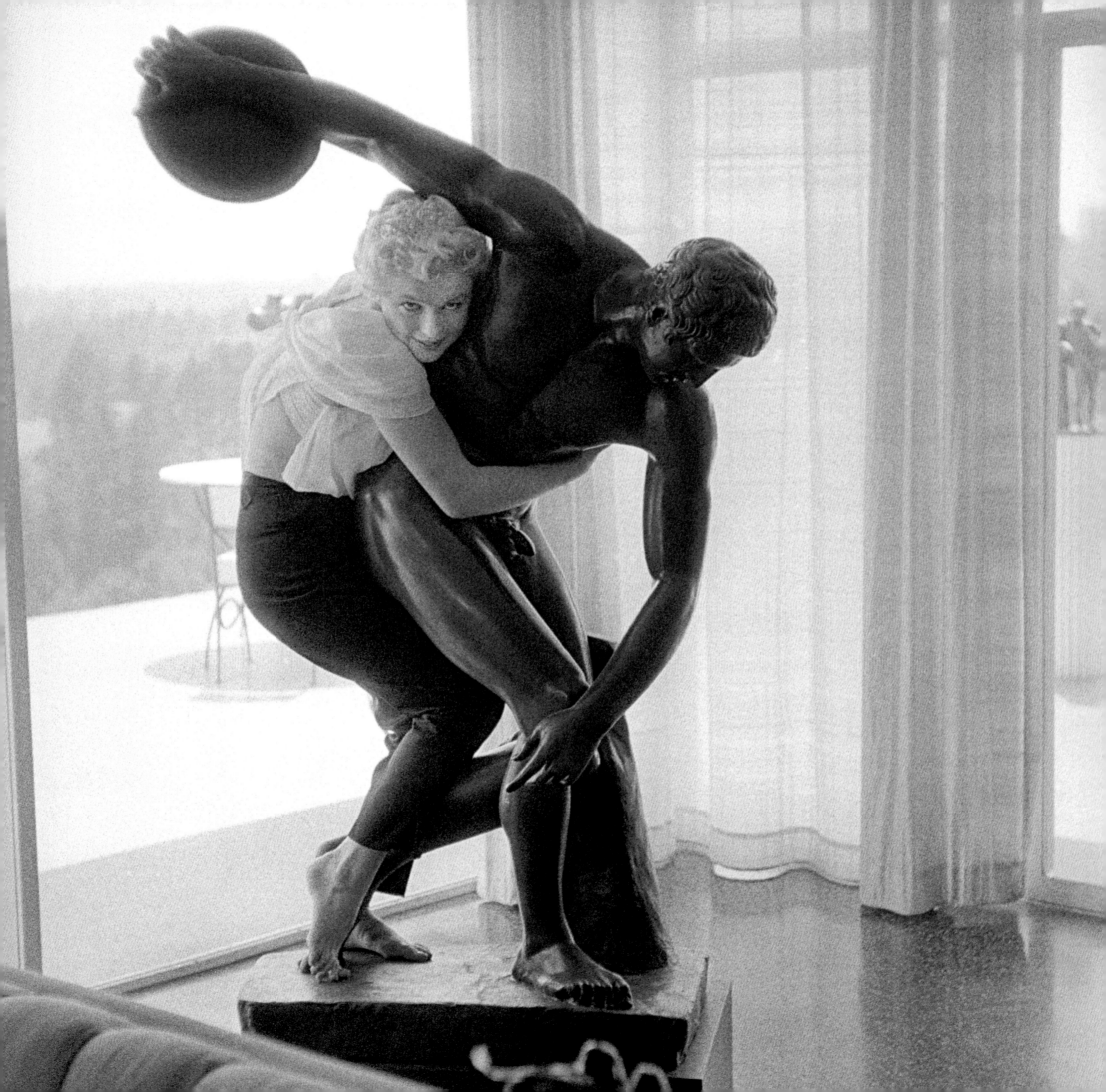

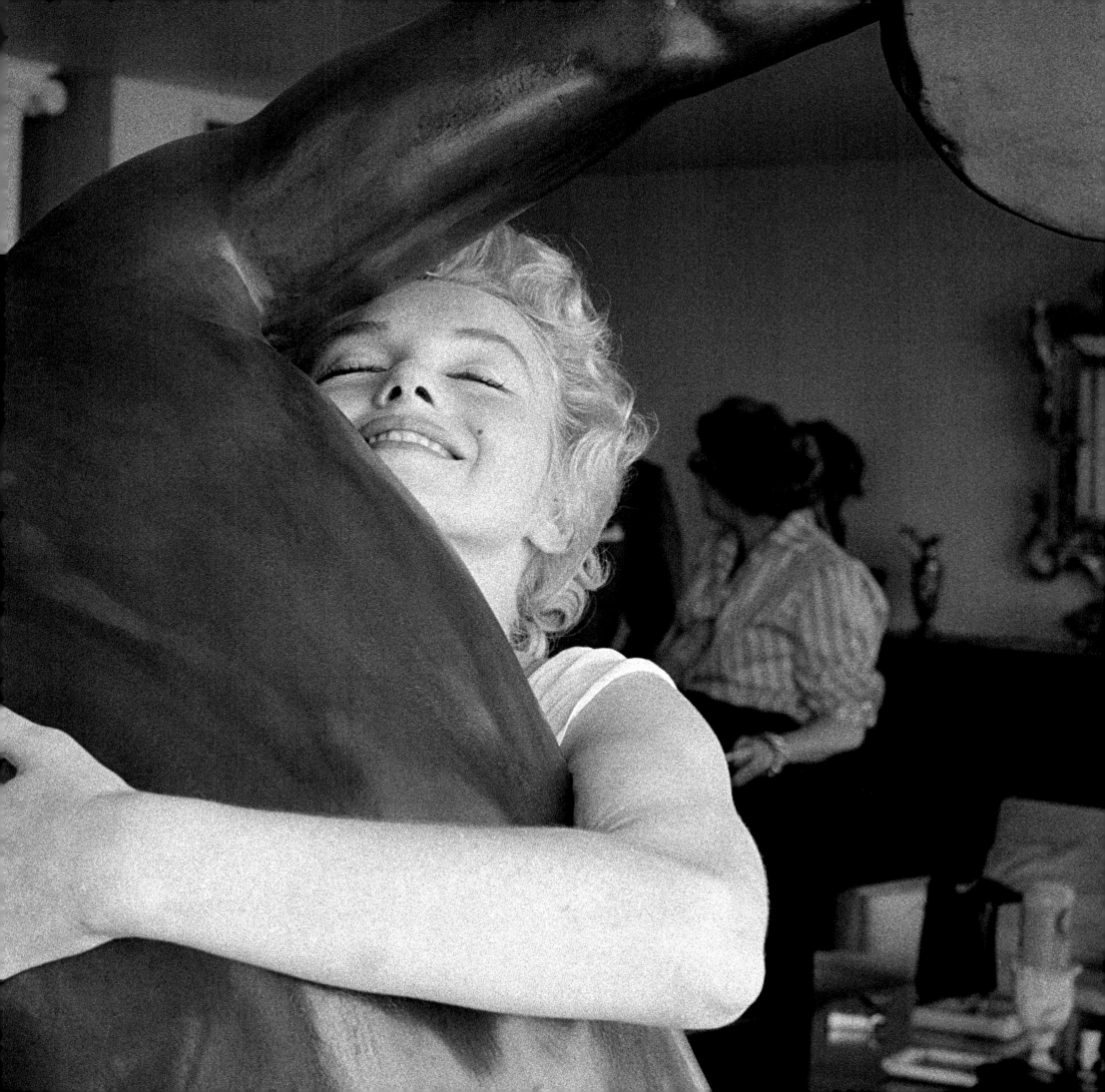

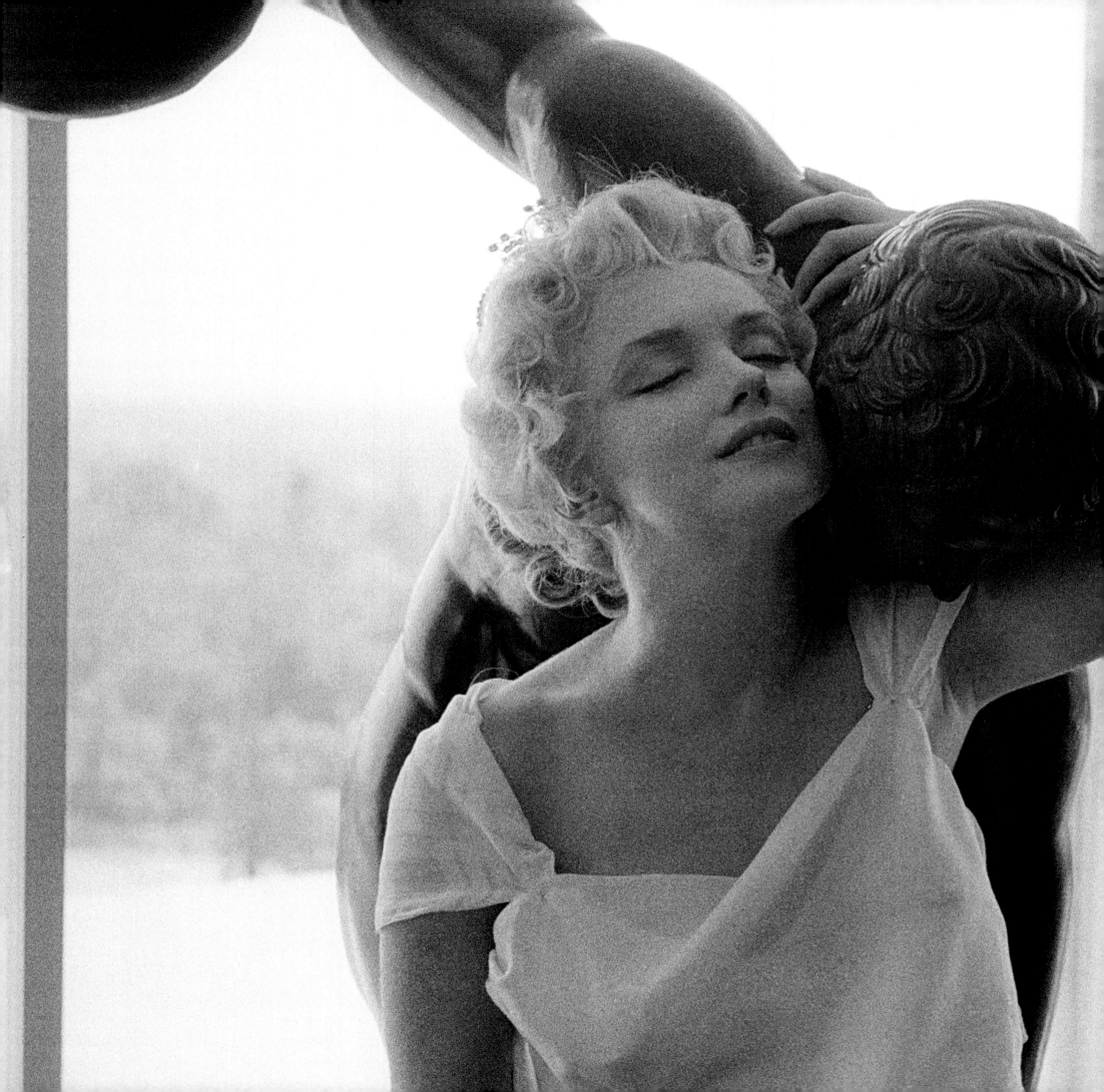

MILLER
WEDDING

June 1956 – On July 1, 1956, a hot summer's day in Katonah,
New York, a select group of family and friends gathered at the
home of playwright Arthur Miller's agent Kay Brown, to
celebrate a traditional Jewish wedding. In attendance were
Milton, Arthur's family, Marilyn Monroe Production's agent
Jay Kanter and his wife Kit, the Strasbergs, the Rostens,
scriptwriter George Axelrod and fashion designer John Moore.
The ceremony took place in an internal room that was fairly
crowded with other guests looking on through doorways and
windows. Marilyn requested that Kitty prepare the meal,
because she knew all of Marilyn's favorite dishes: Corn Flake
Chicken, Southern-style, some sides and a beautiful wedding
cake. It was served alfresco, on two wooden tables.
 The informal gathering shows a happy time for the
newlyweds. An optimistic Marilyn is known to have written
a personal note that day stating, "Hope, Hope, Hope."

Unpublished images:
Pages 323, 330L, 330R, 331, 332, 333, 335

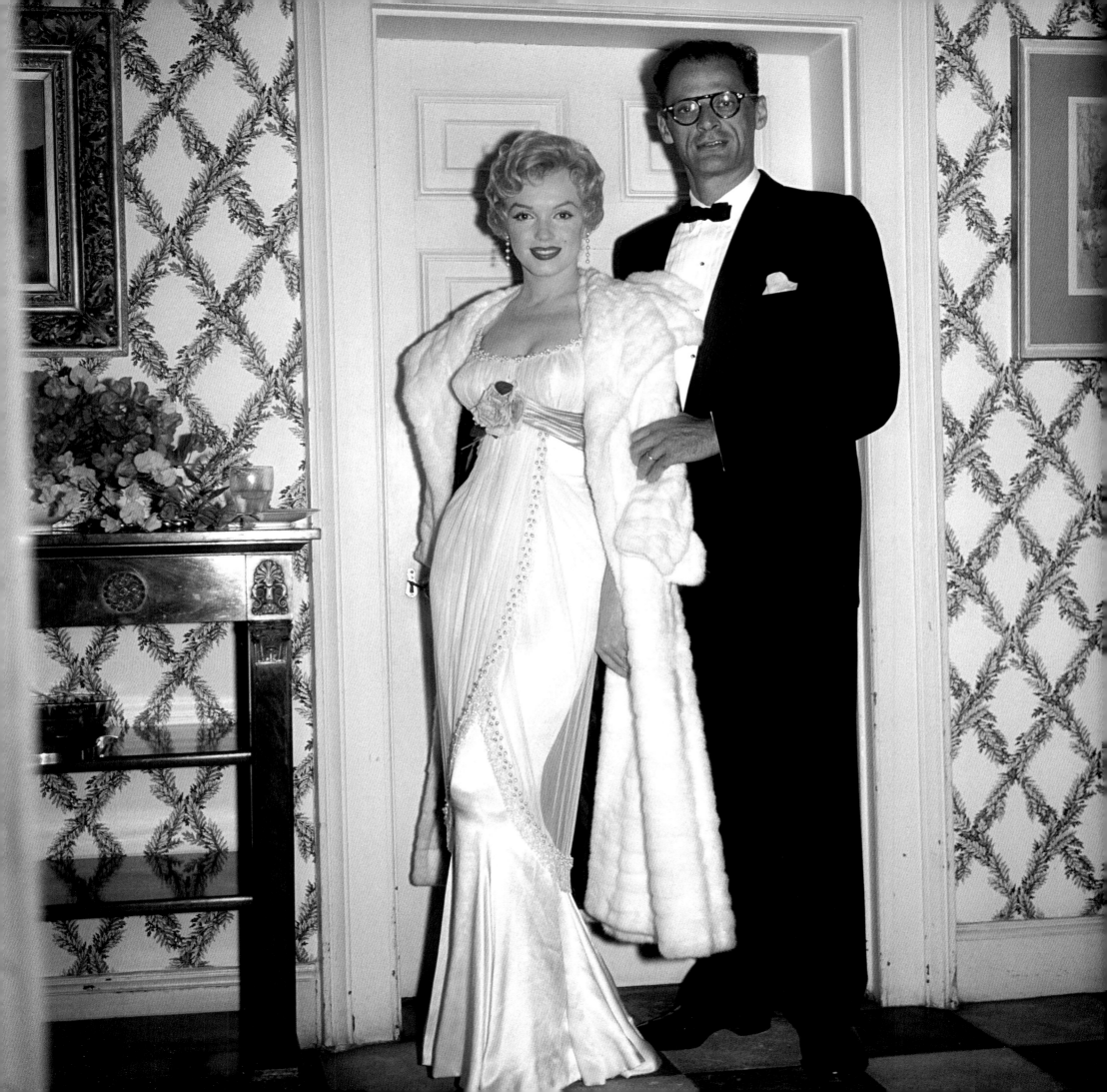

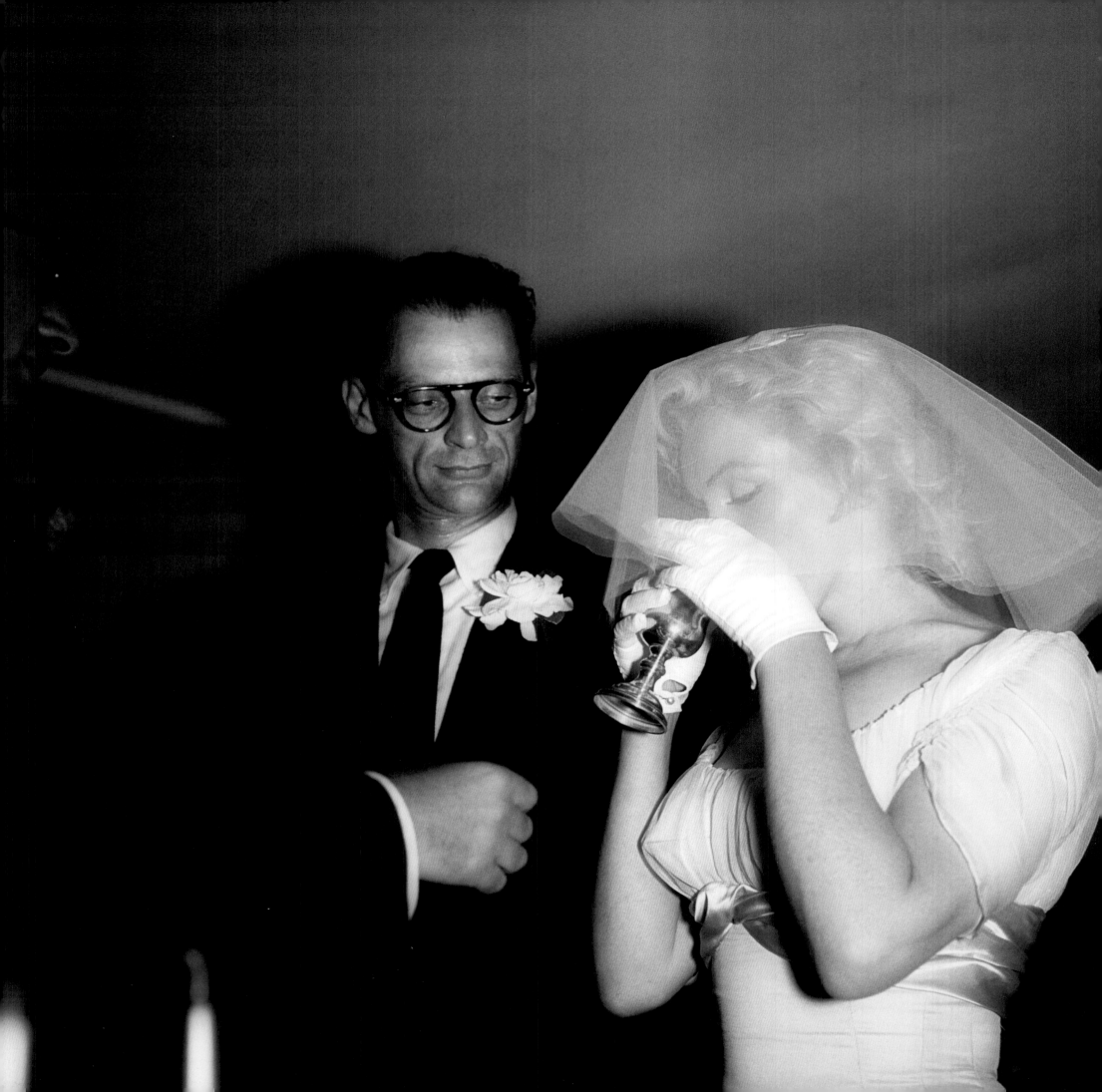

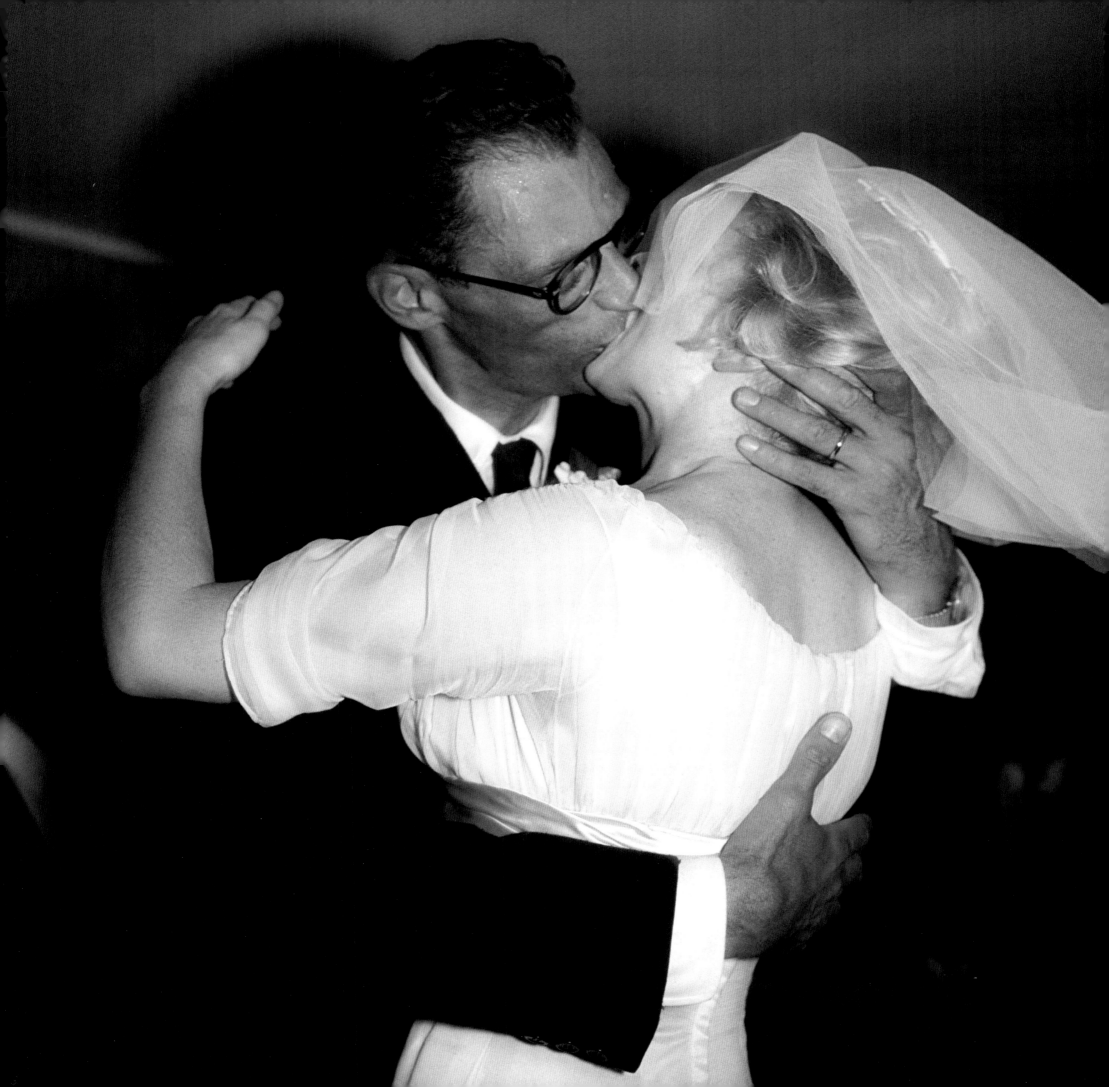

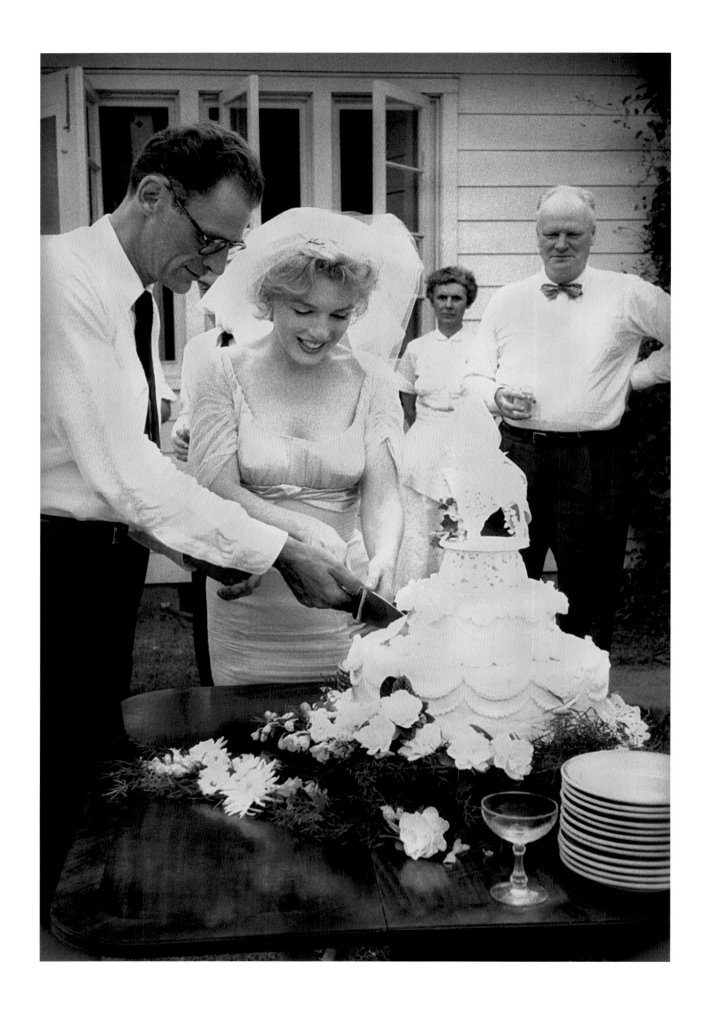

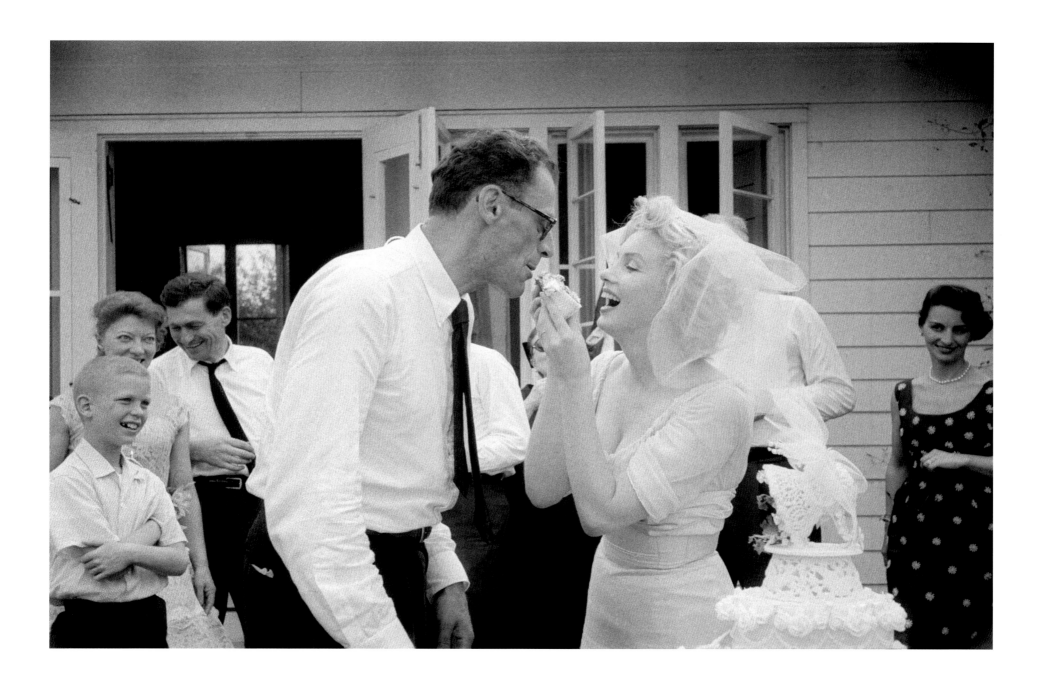

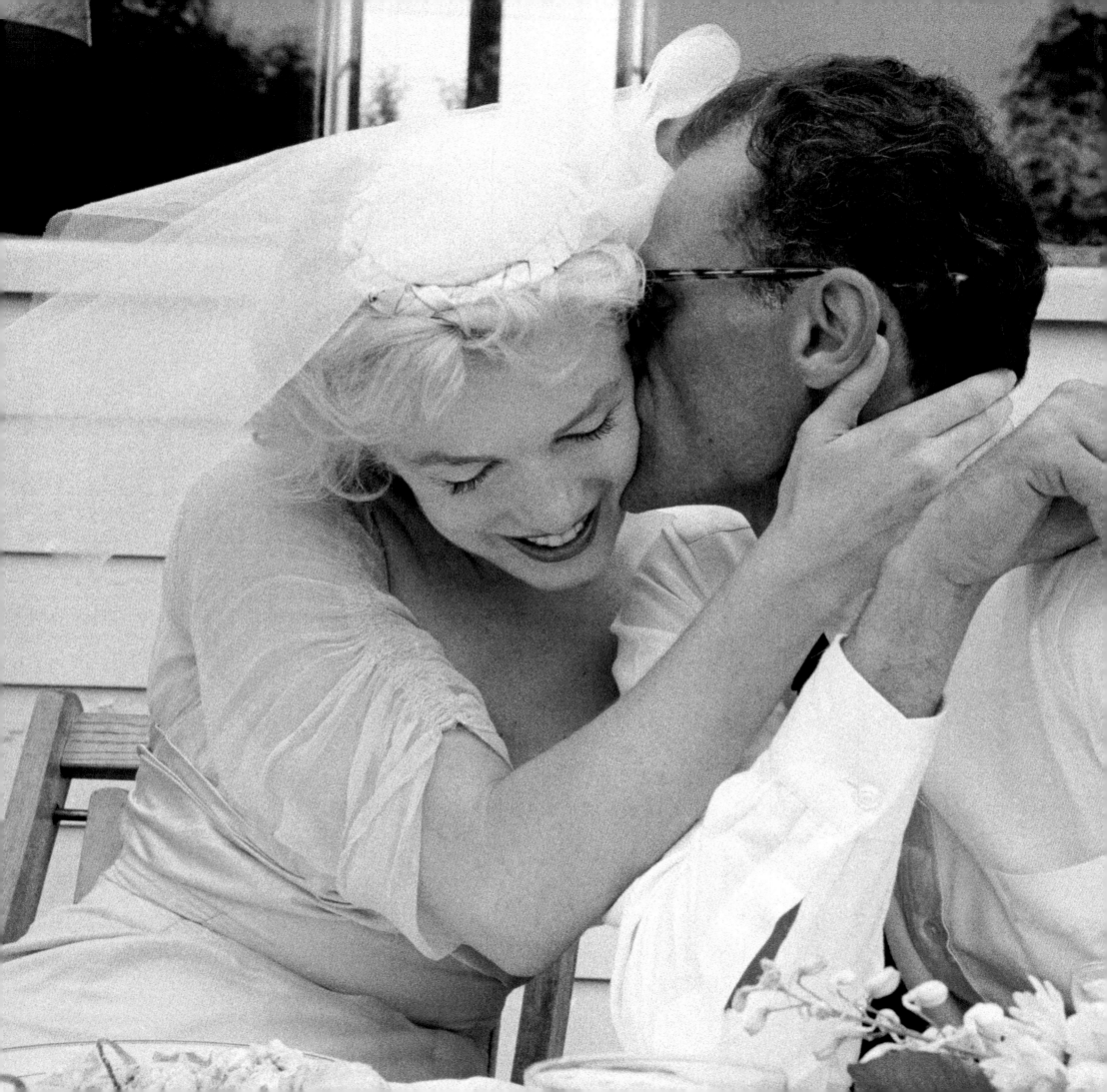

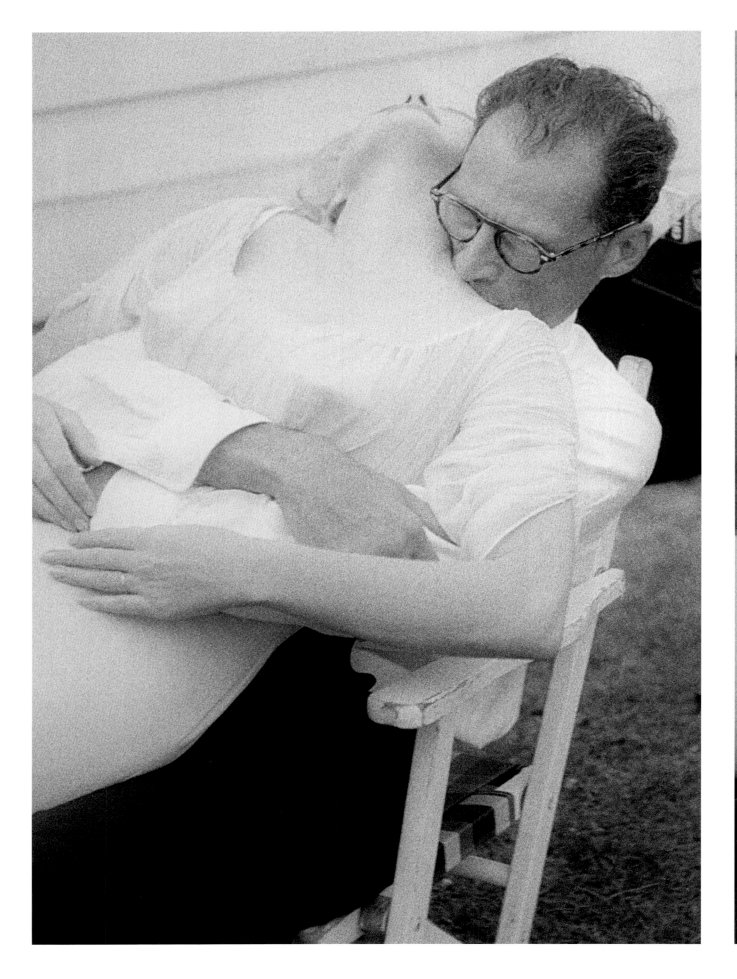

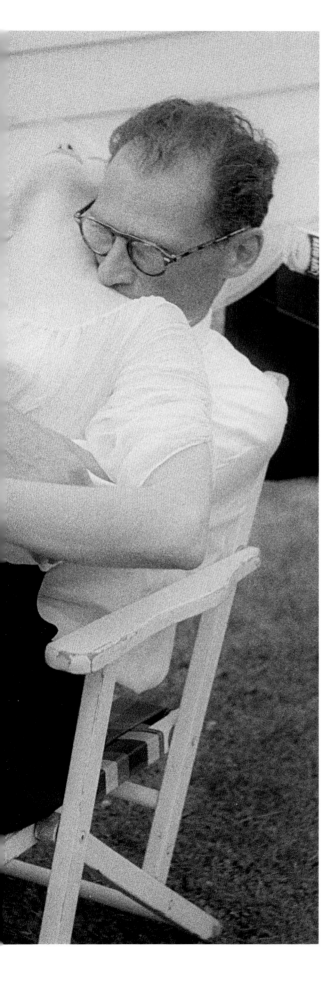
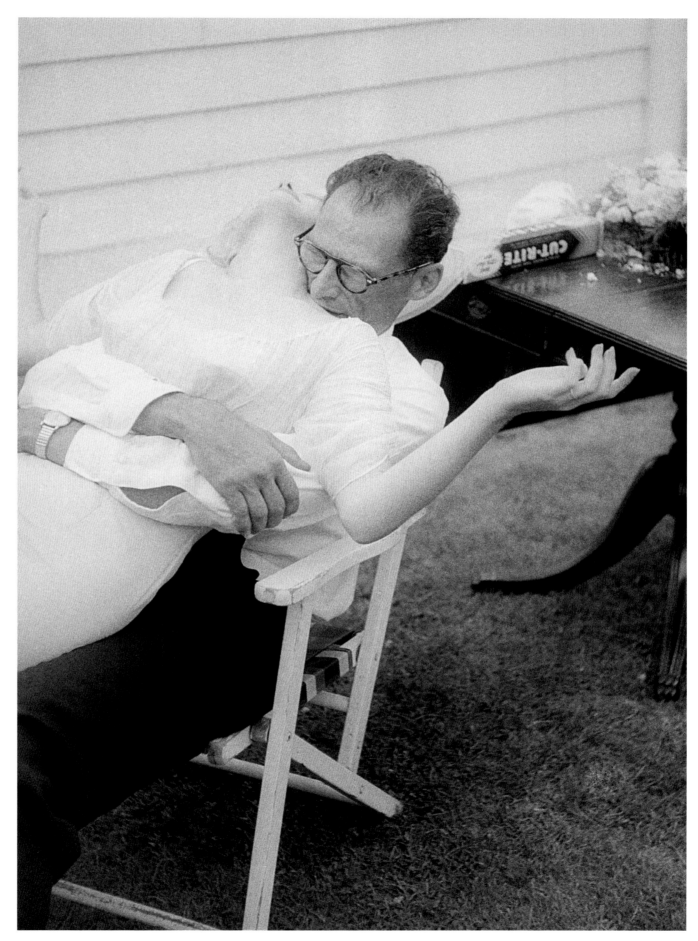

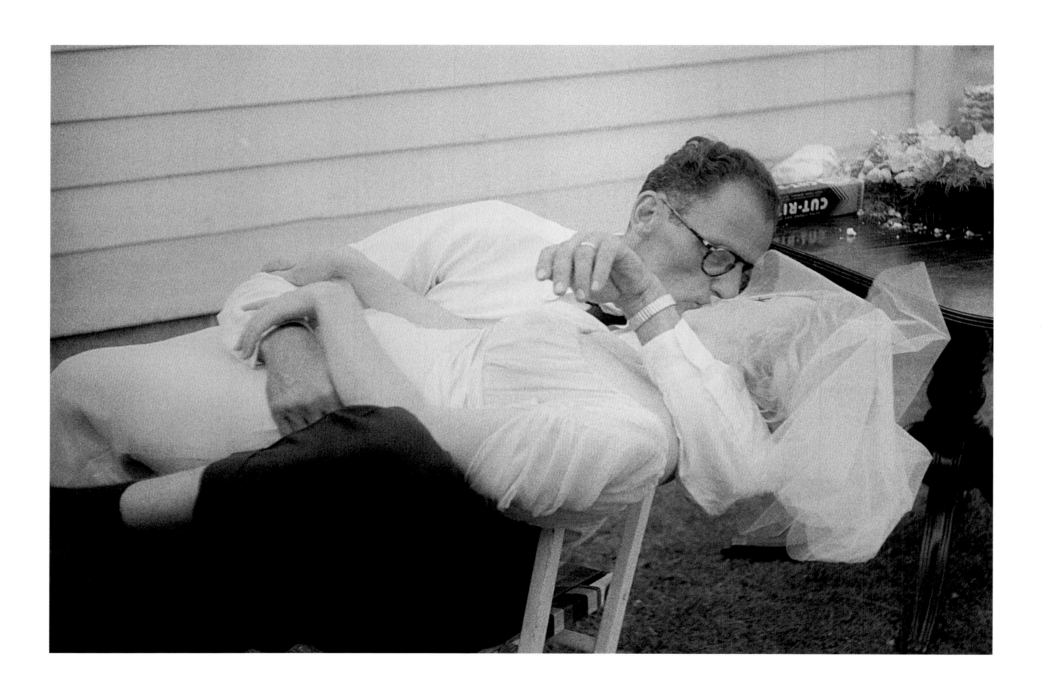

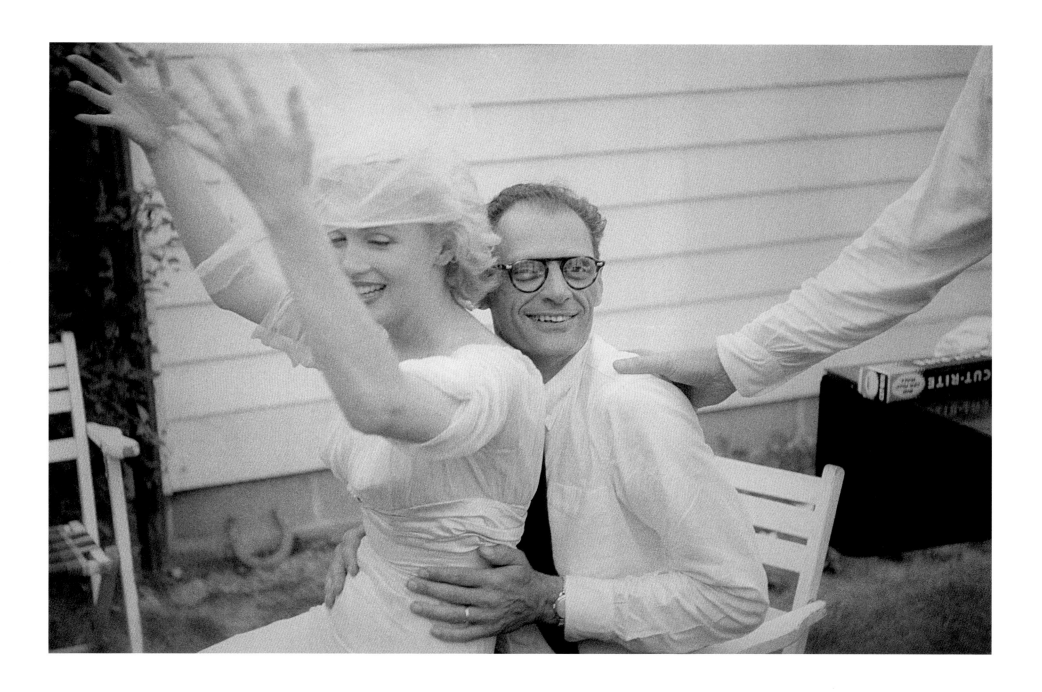

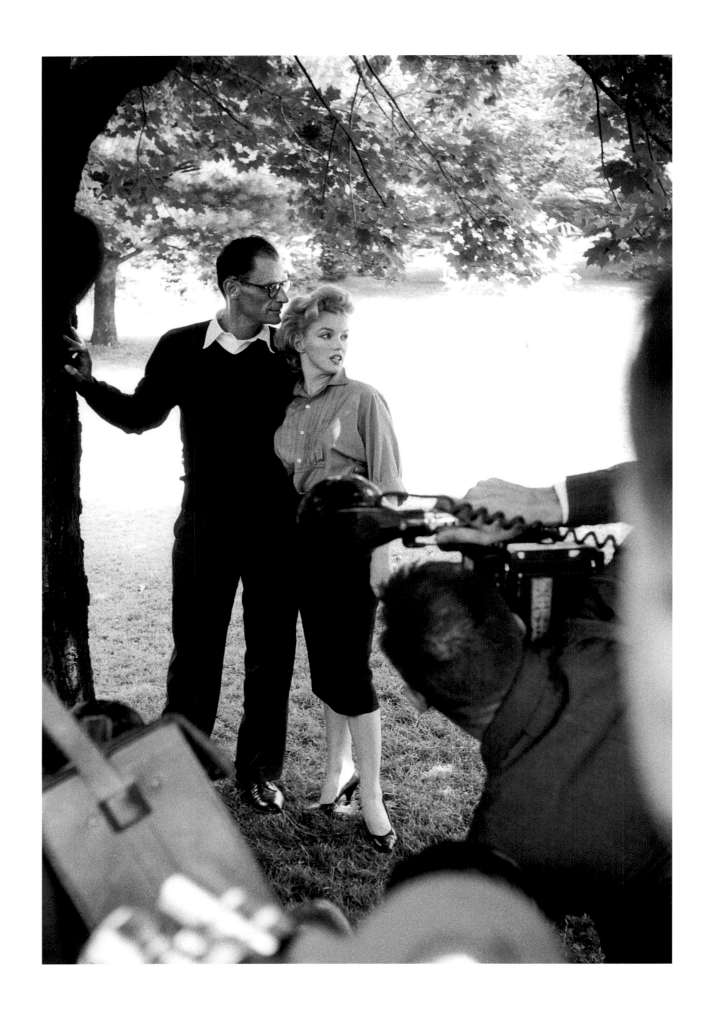

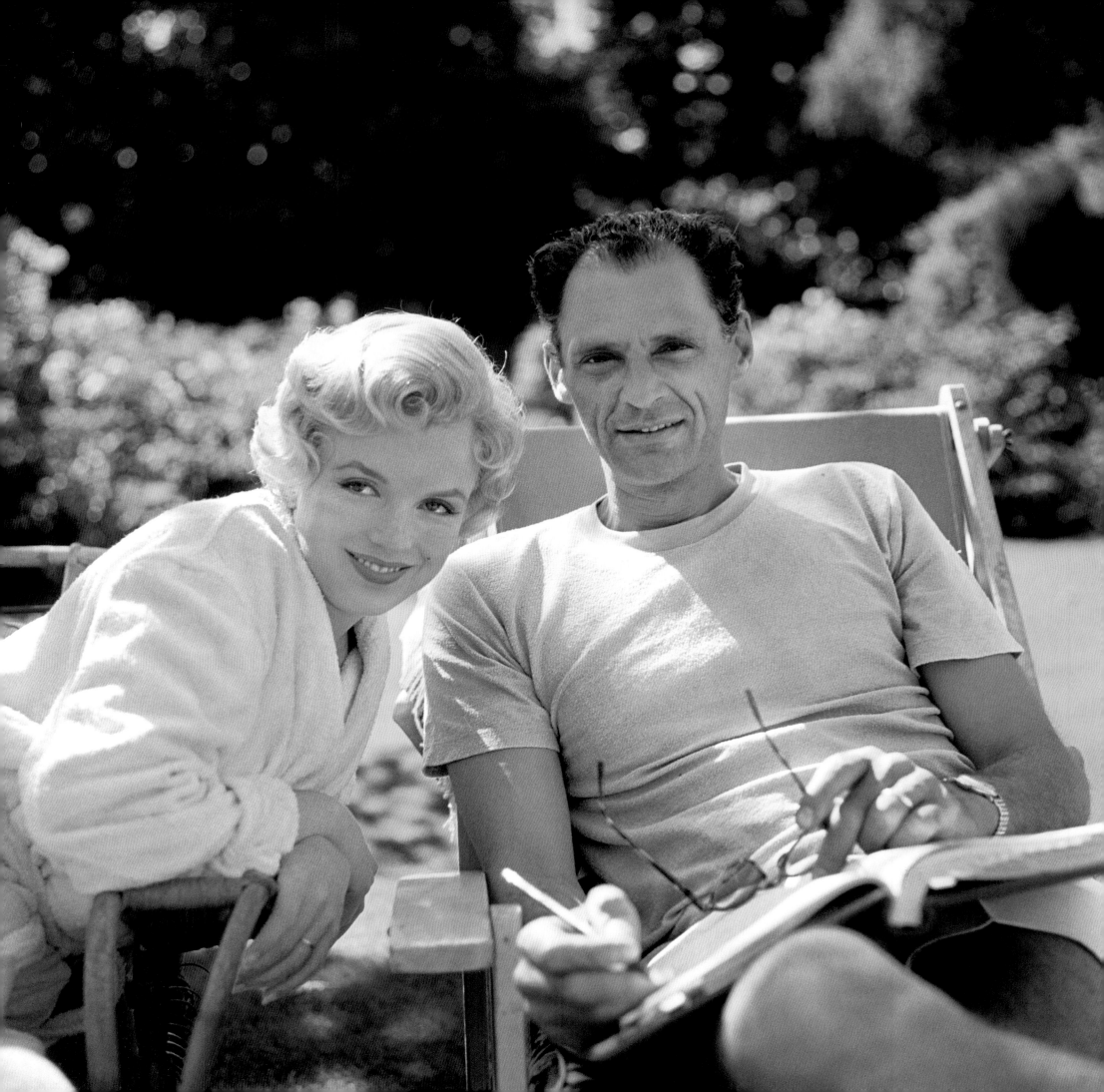

HAIR TEST

July 1956 – The Greenes and the newlyweds arrived in London the week before filming on *The Prince and the Showgirl* commenced. The Greenes stayed at Tibbs Farm in Ascott, while the Millers resided at Parkside House. These pictures were part of a series showing the new hairstyle for her character in the film. They were taken in the grand private gardens in the backyard of their temporary residence.

Unpublished images:
Pages 337, 338

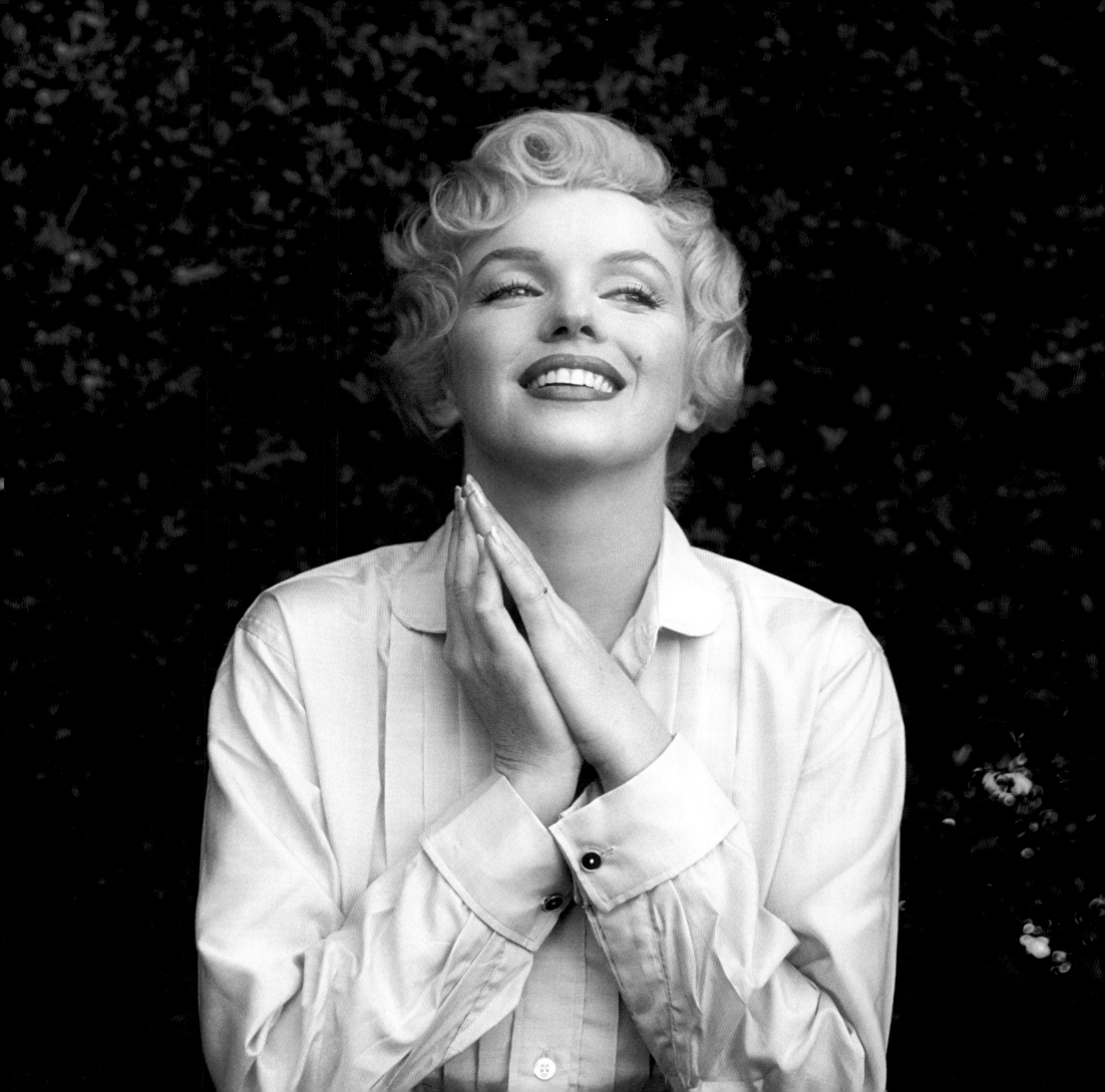

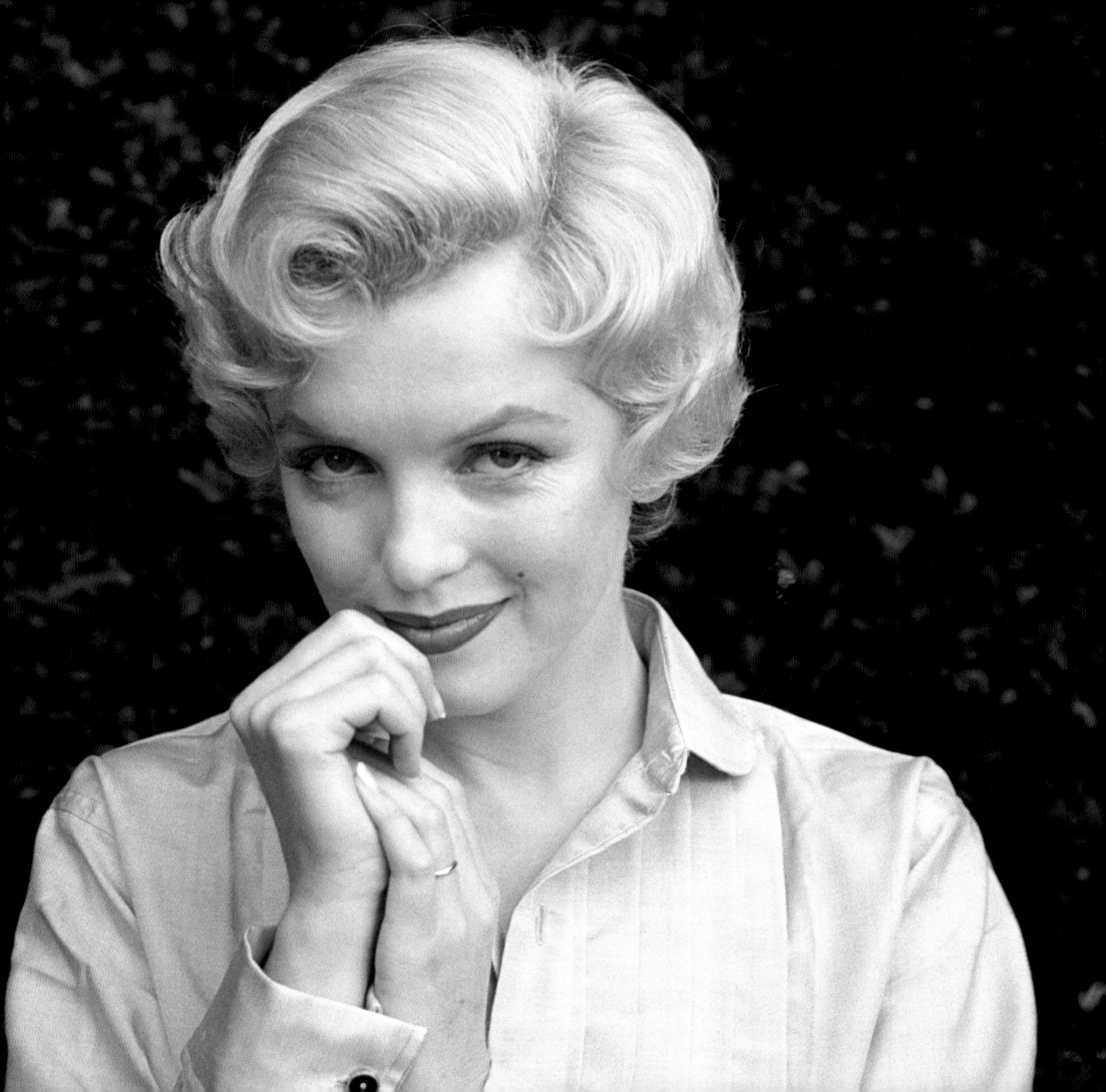

THE PRINCE AND THE SHOWGIRL

July/August 1956 – The 30-year-old Marilyn Monroe and 34-year-old Milton H. Greene embarked on their second film collaboration together. Marilyn Monroe Productions was the executive producer of record and the two of them were in control of all aspects of the production, including allowing Laurence Olivier to direct, and Milton hiring the great photographer/cinematographer Jack Cardiff. Milton and Jack shared an appreciation of aesthetics that guided them through costume design, lighting and camera angles. Newlyweds Marilyn and Arthur arrived in London on July 14, to the eagerly waiting British press. Filming took place at Pinewood studios, but when you look at the sets, the costumes and the lighting, you see the grand, old dramatic Hollywood style of the 1930s. The difficulties encountered during the four months of filming are well documented. However, when you see Marilyn's performance of Elsie on the screen, all those troubles fade away.

Unpublished images:
Pages 343, 344, 346, 347, 349, 350, 352, 353, 354

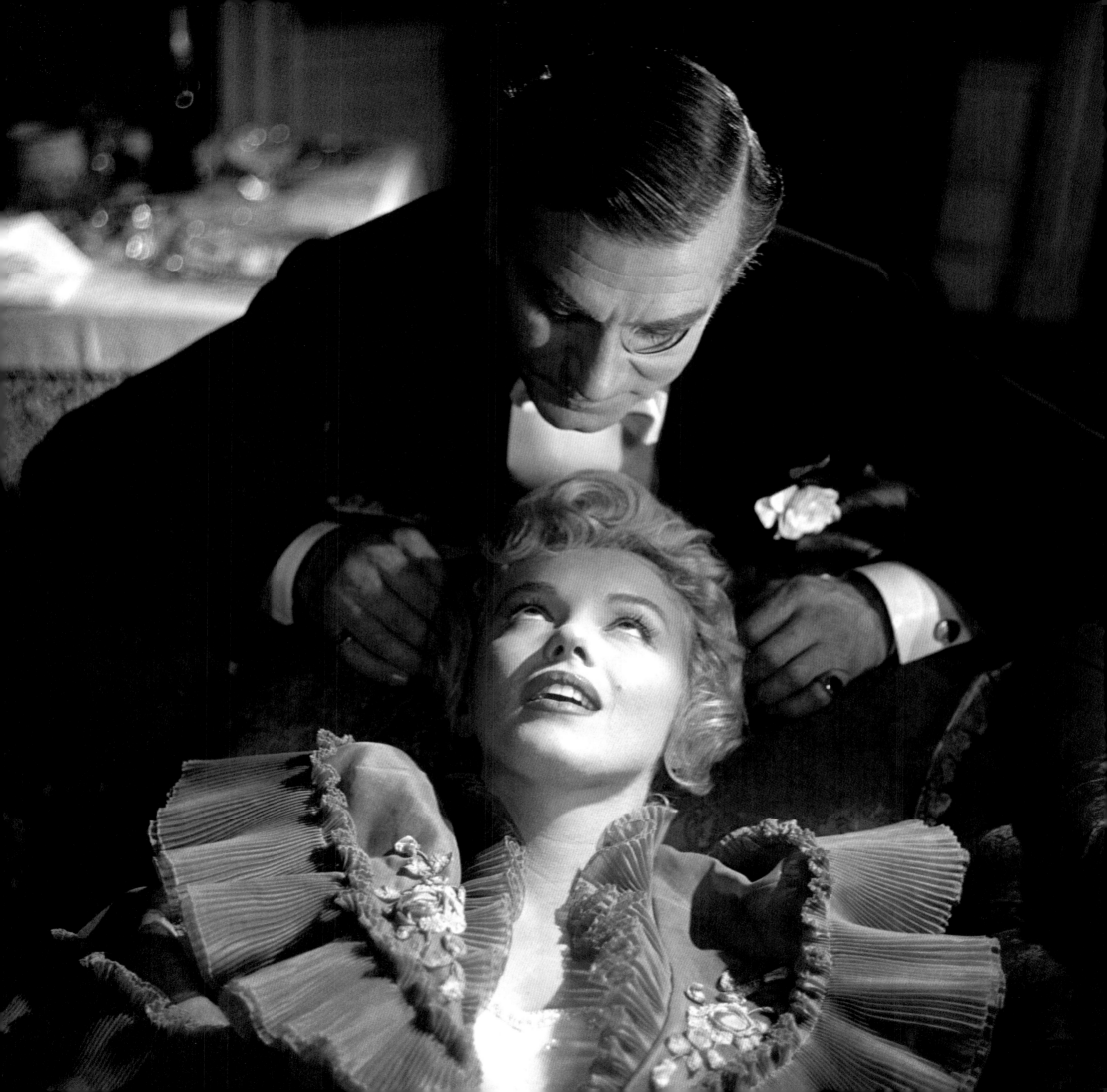

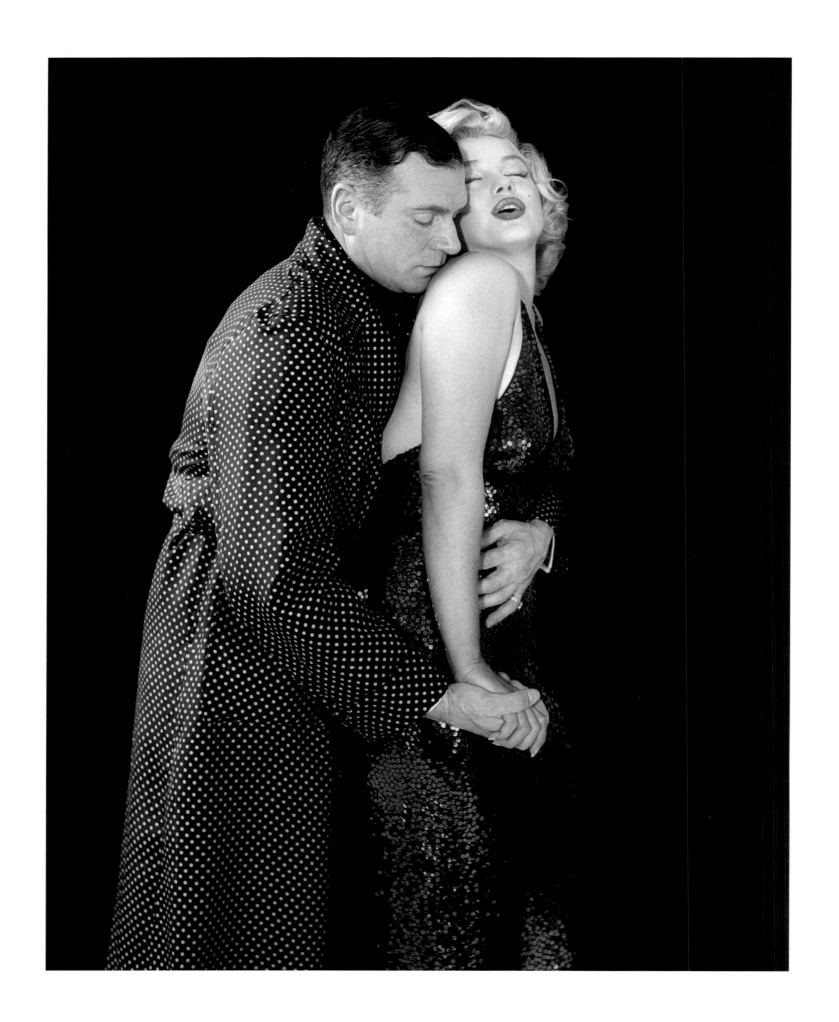

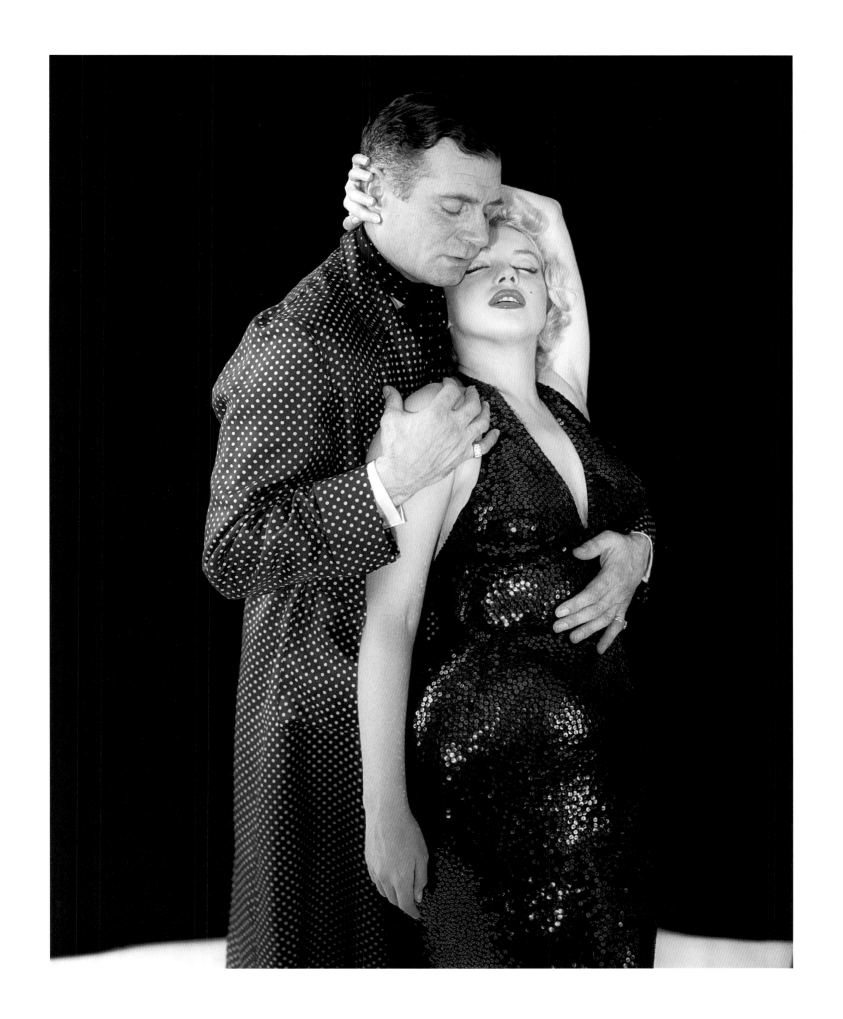

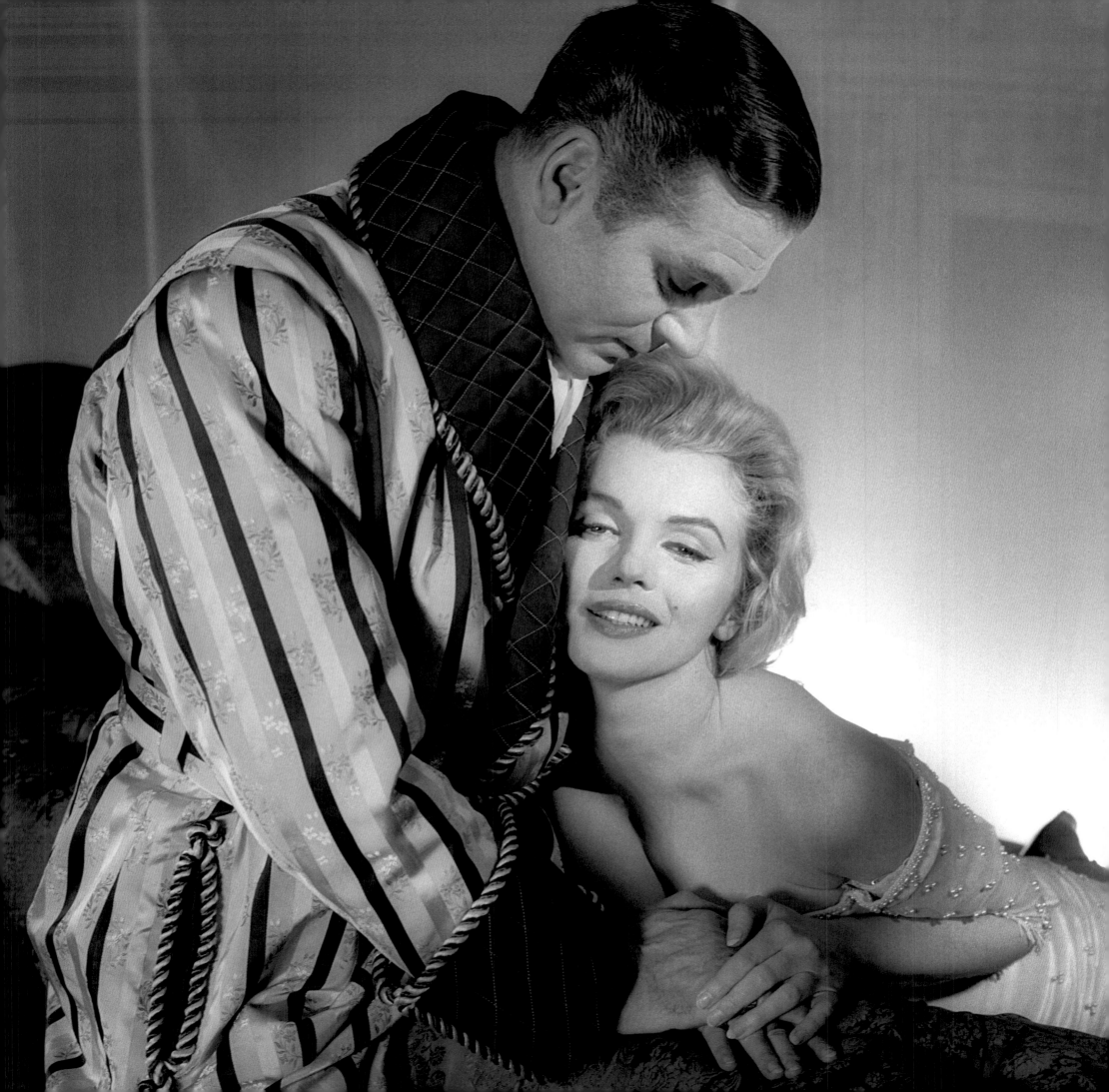

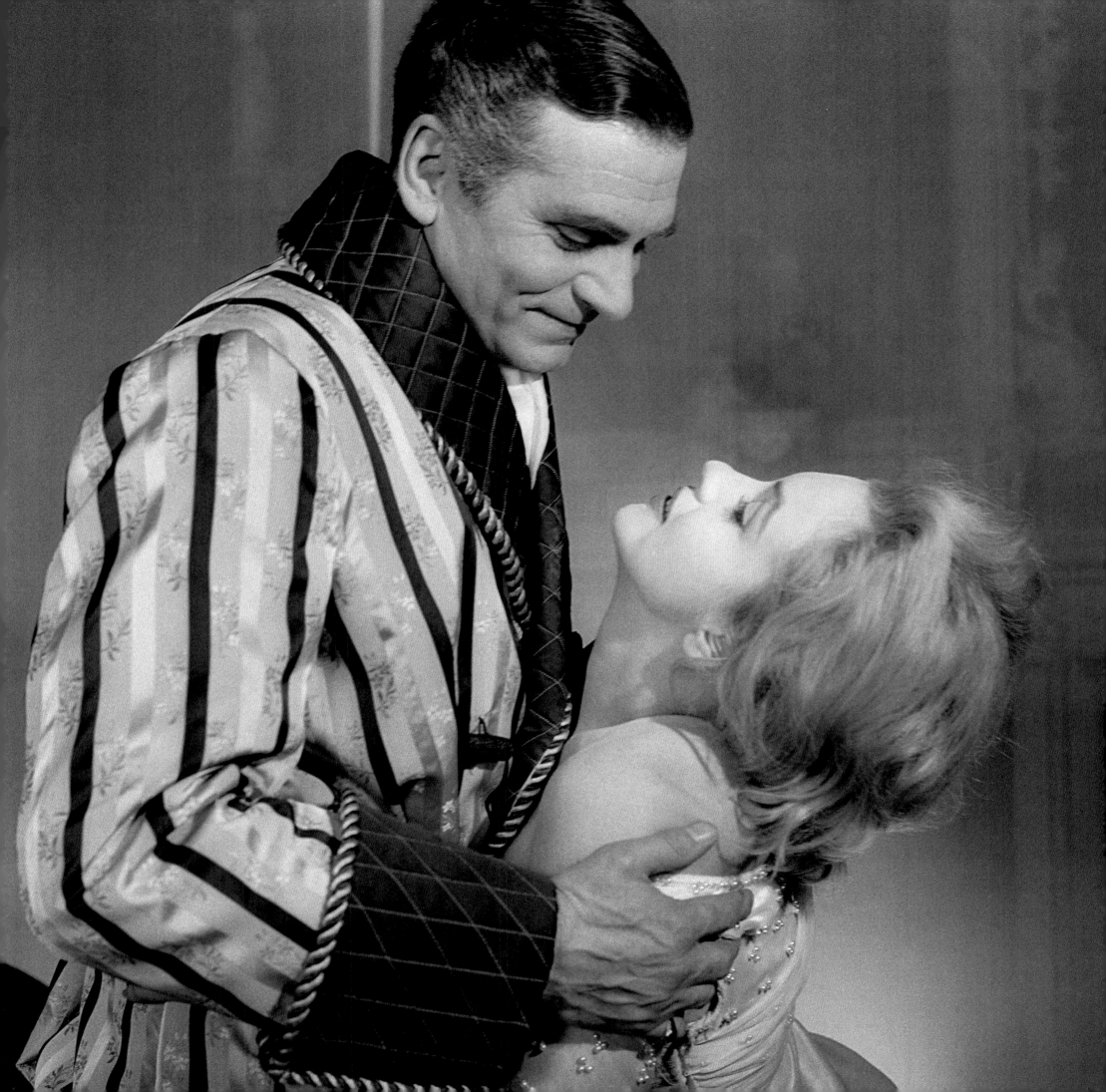

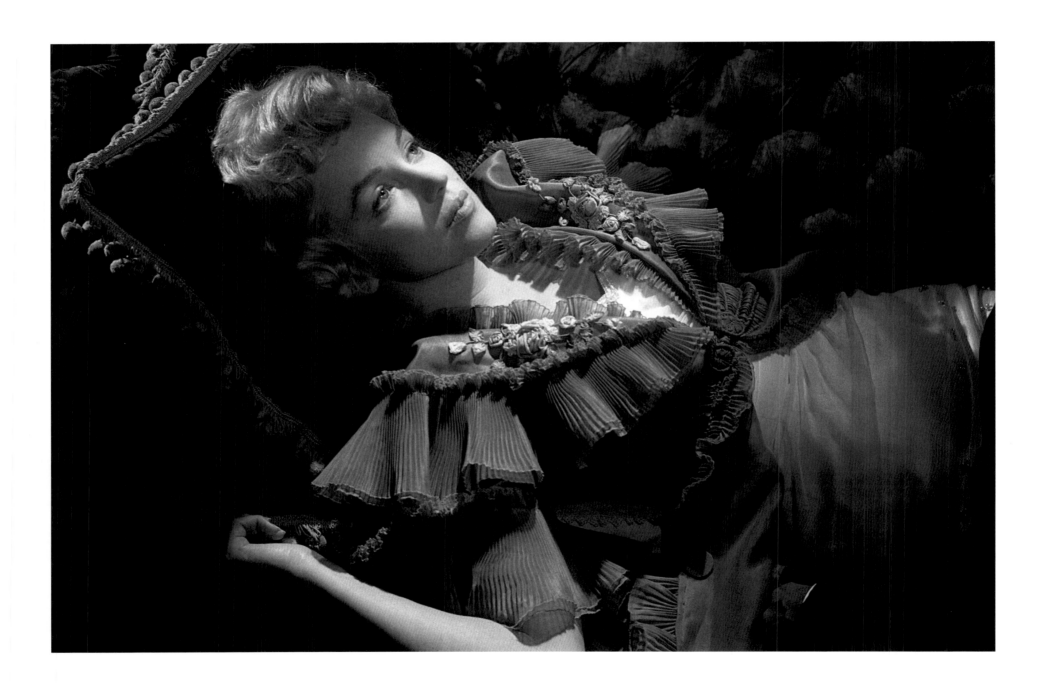

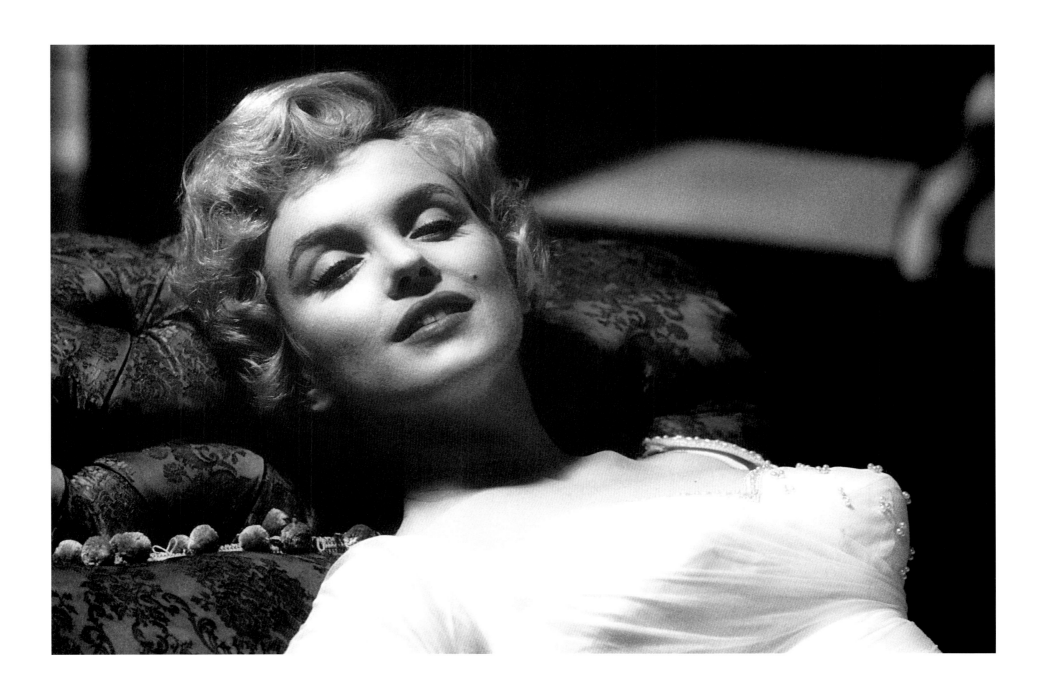

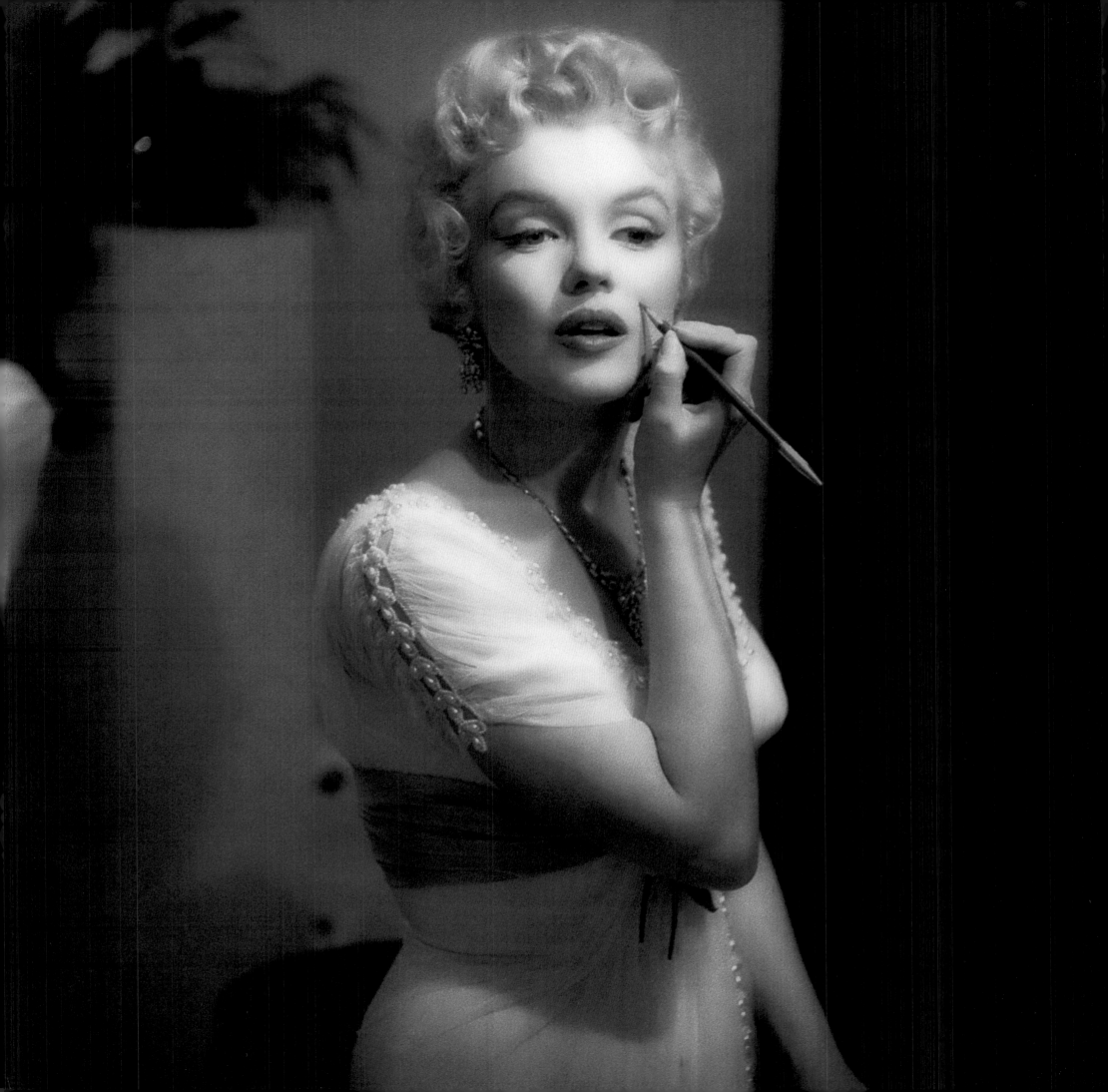

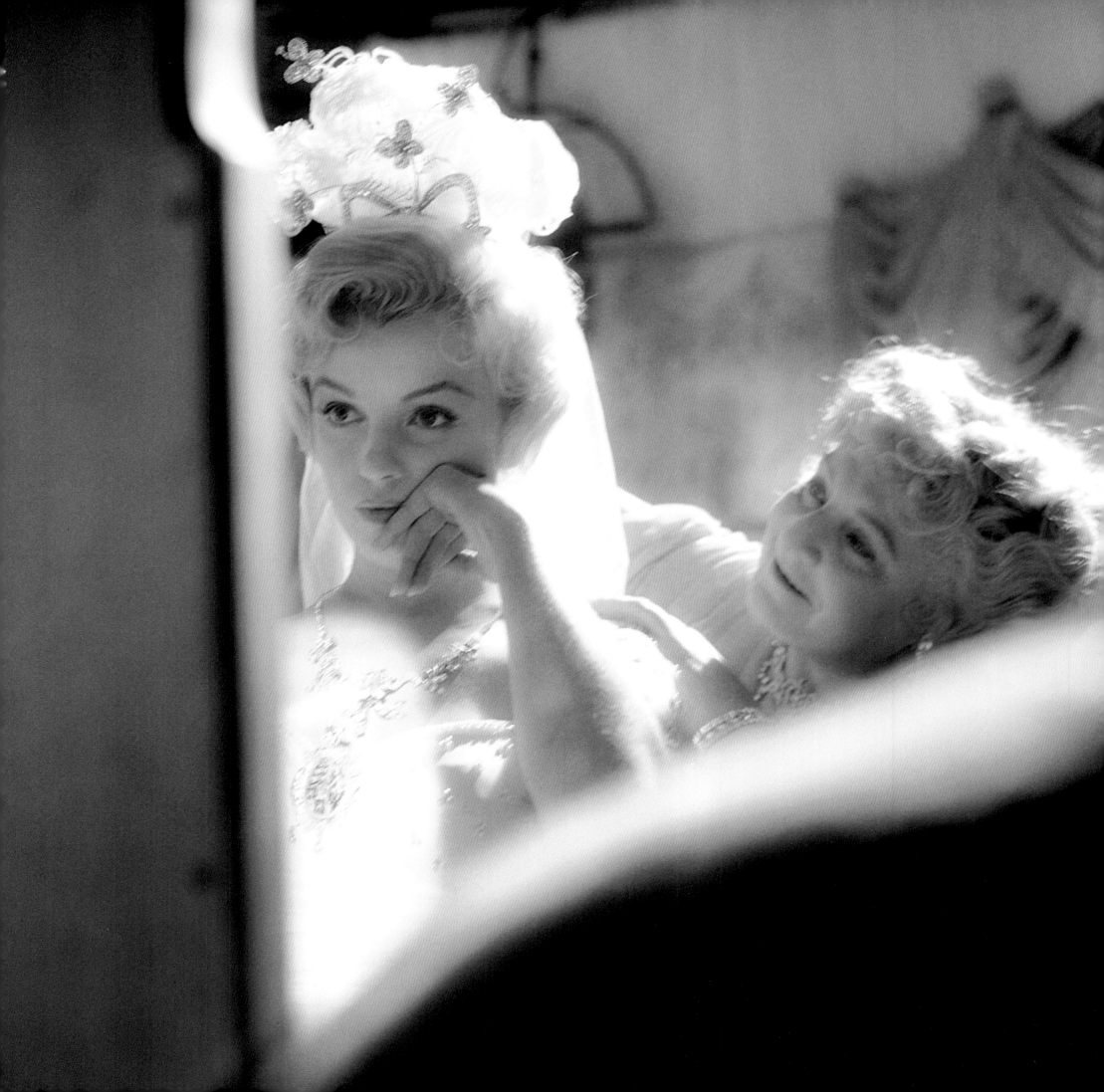

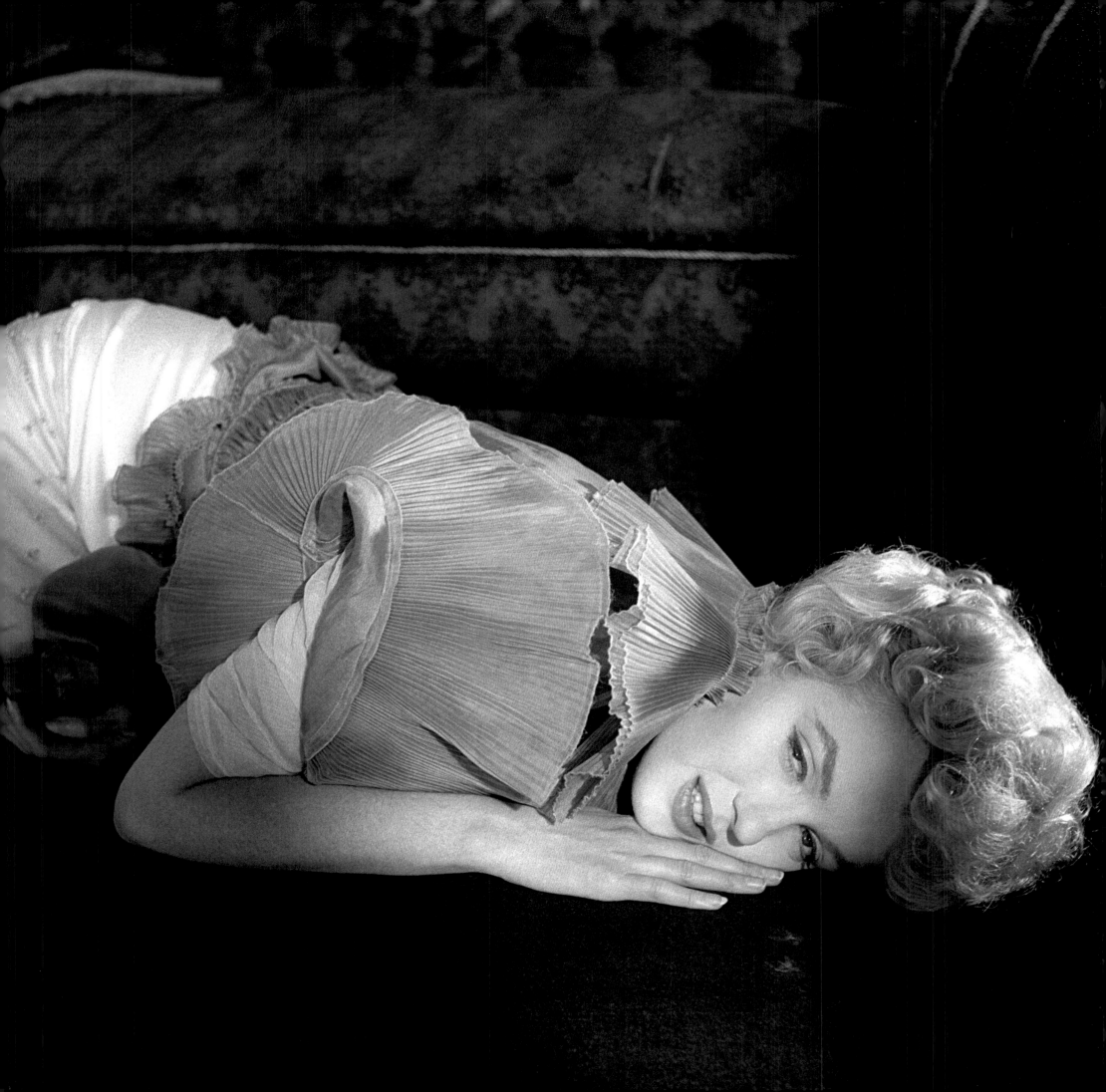

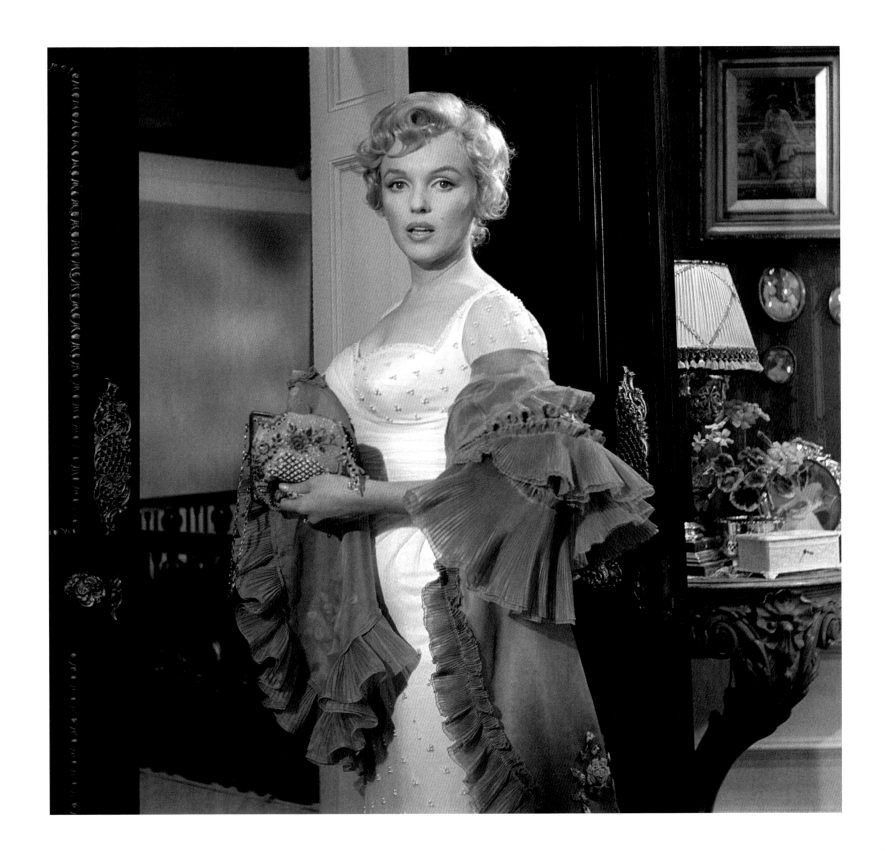

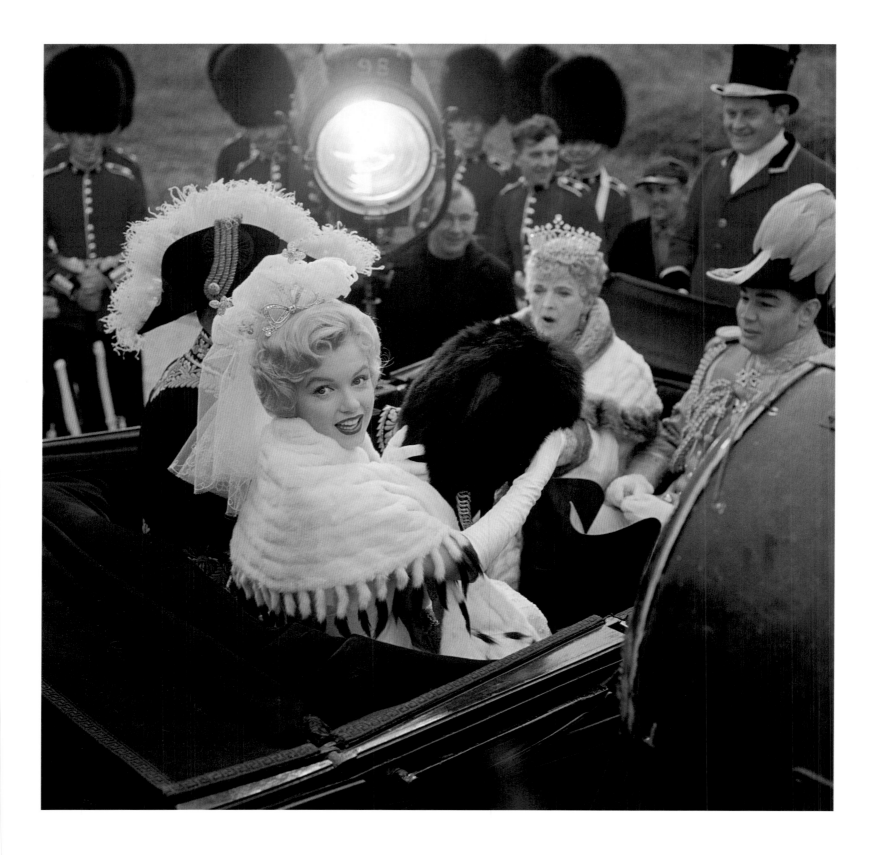

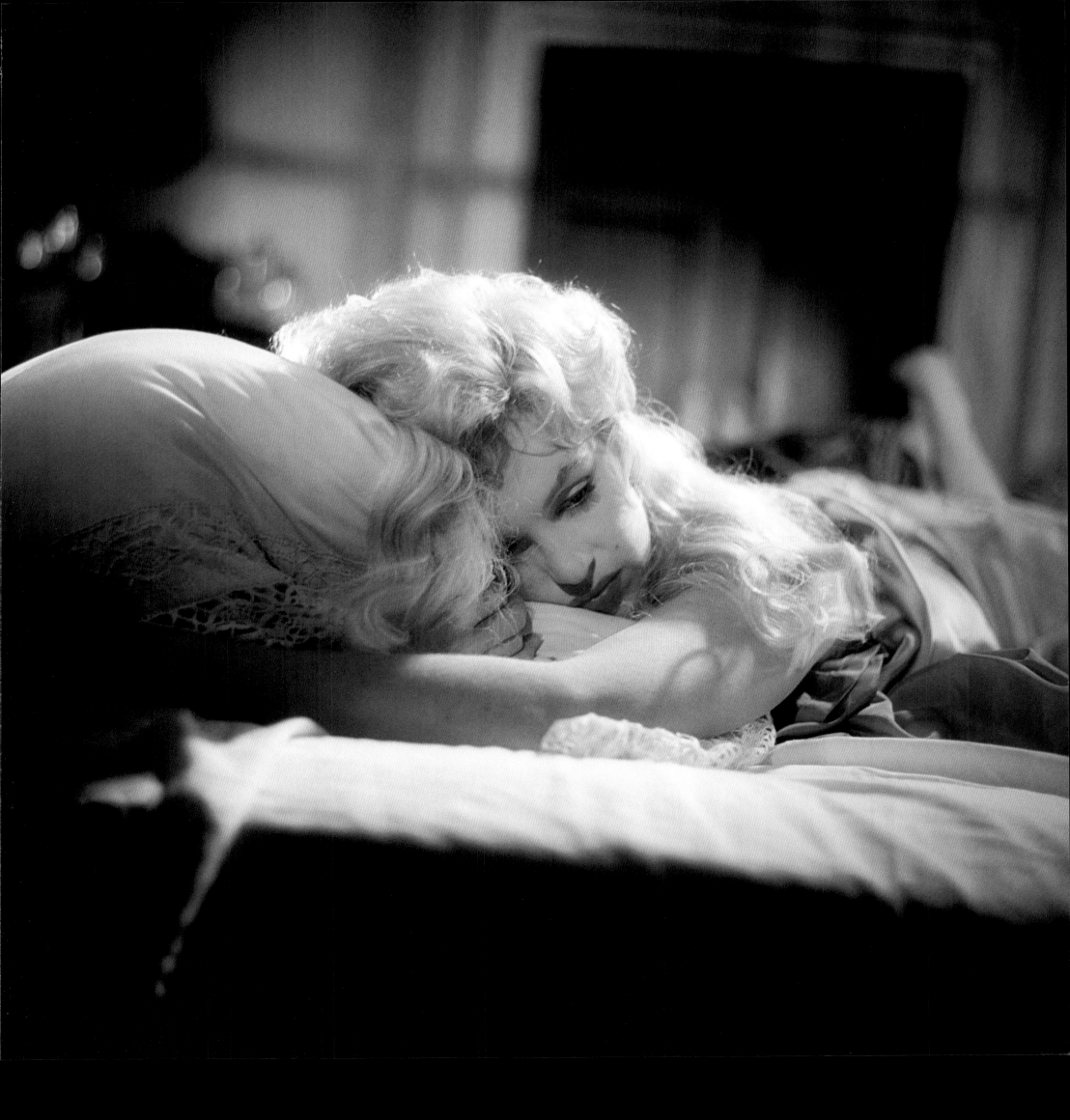

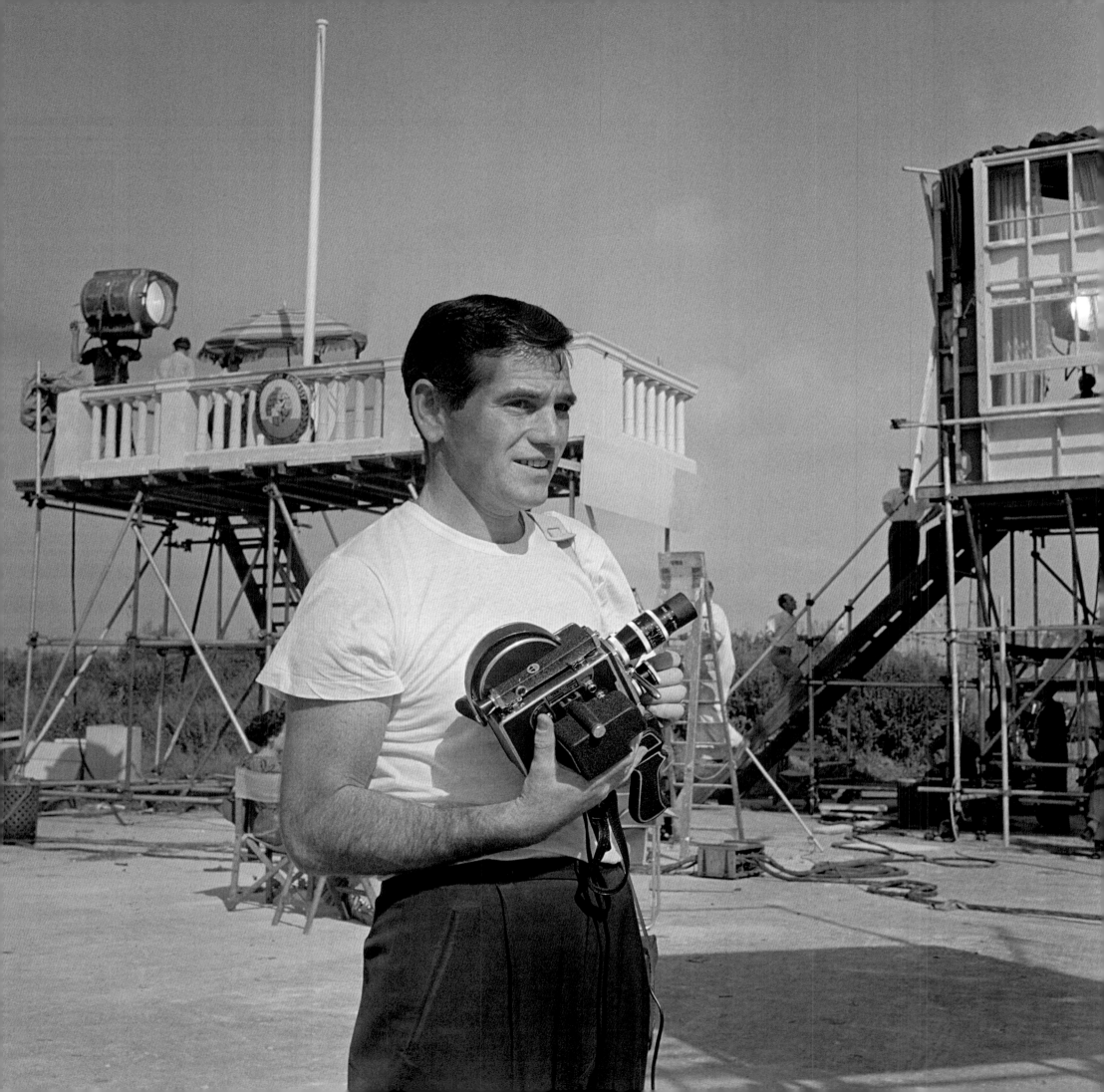

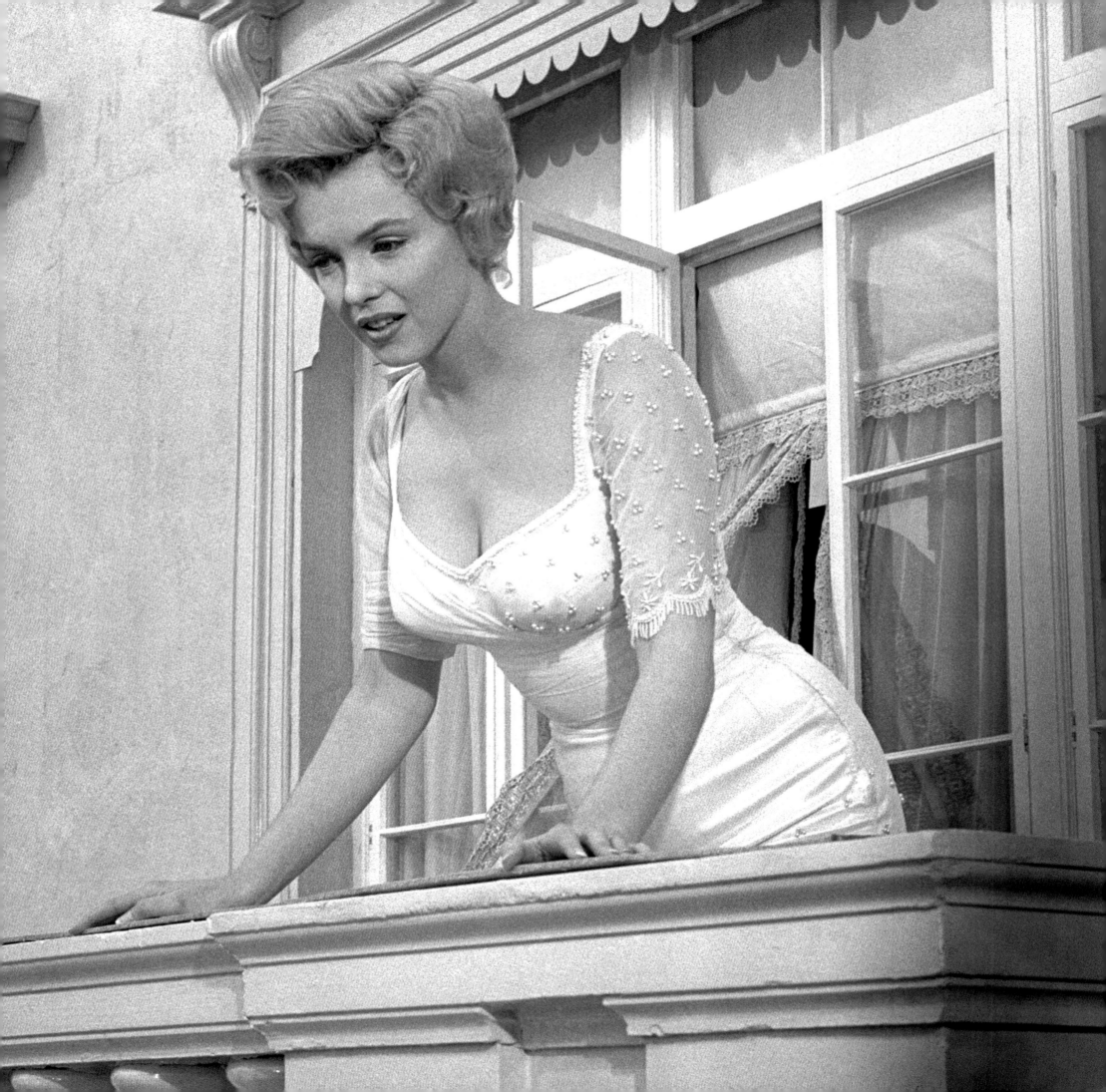

RED SITTING

January 1957 – Photographed for *Life* magazine, this series produced several memorable images. Appropriately entitled the Red Sitting, these photos display the playful eroticism that was apparent in all their work together. Milton did something during this shoot he rarely did, setting up his strobe bank light and adding a 10K tungsten spotlight, which bathed her in a golden yellow glow.

The January 1957 sitting in that simple red dress would be their last assignment together.

Unpublished image:
Page 357

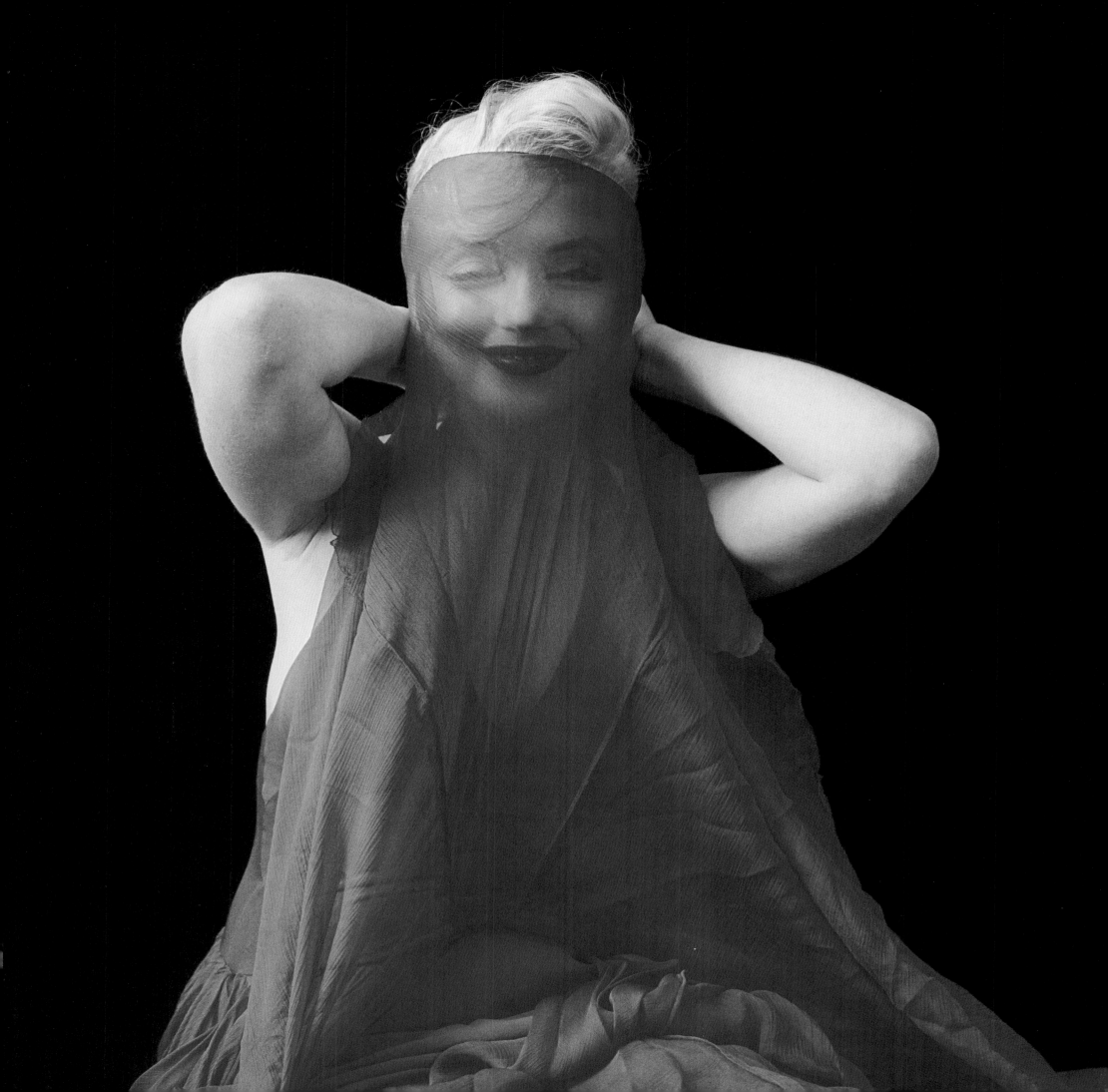

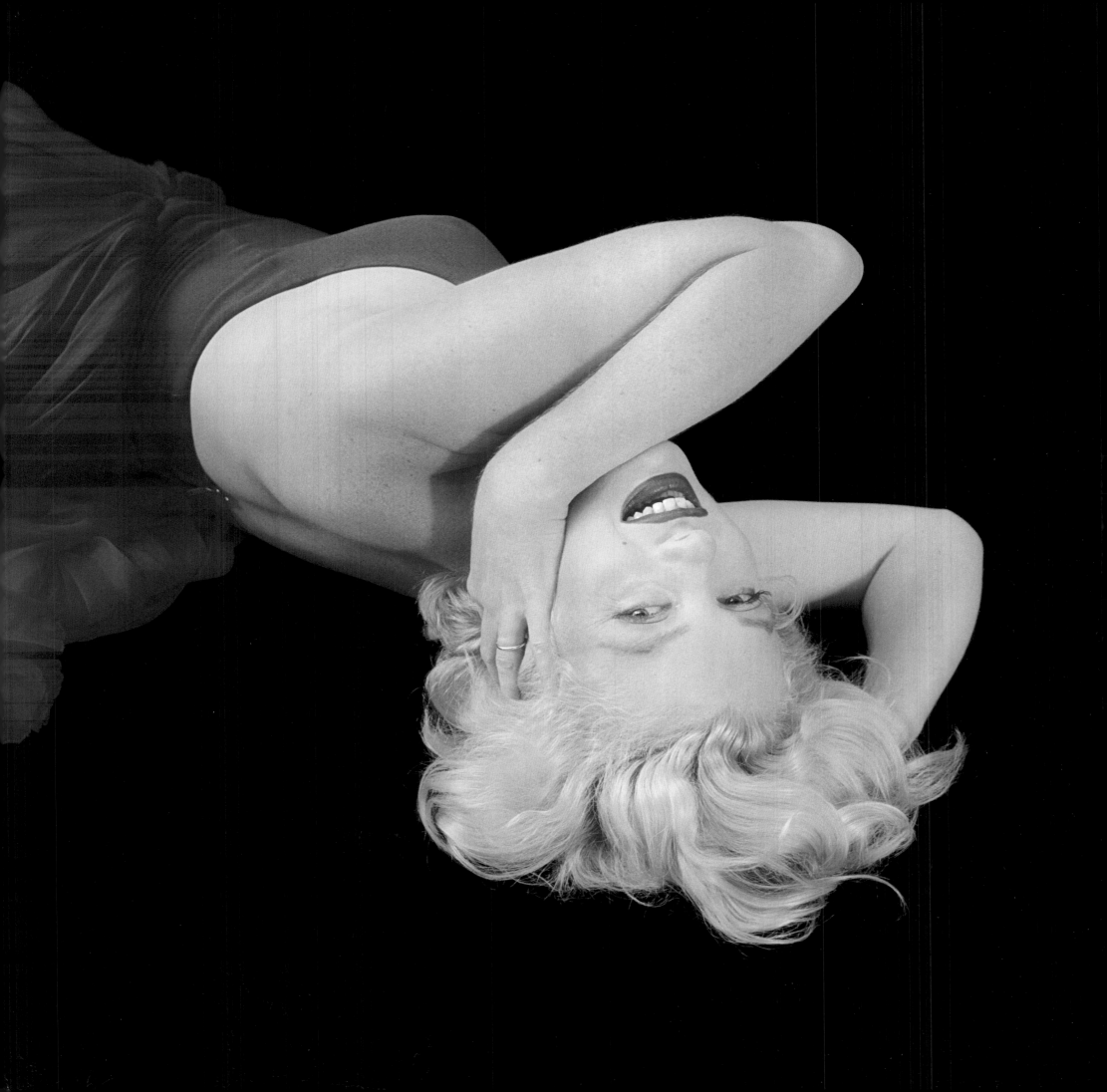

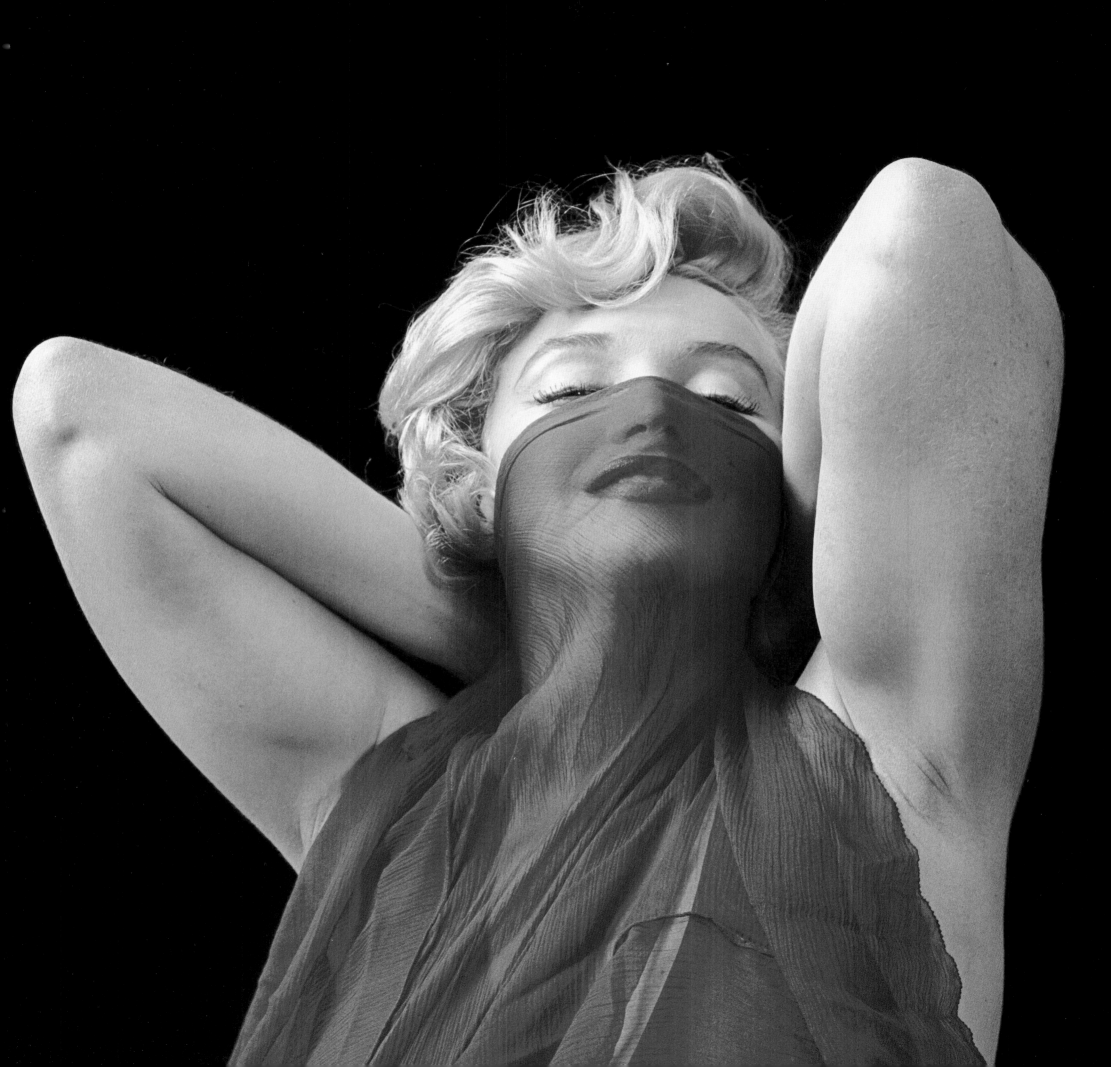

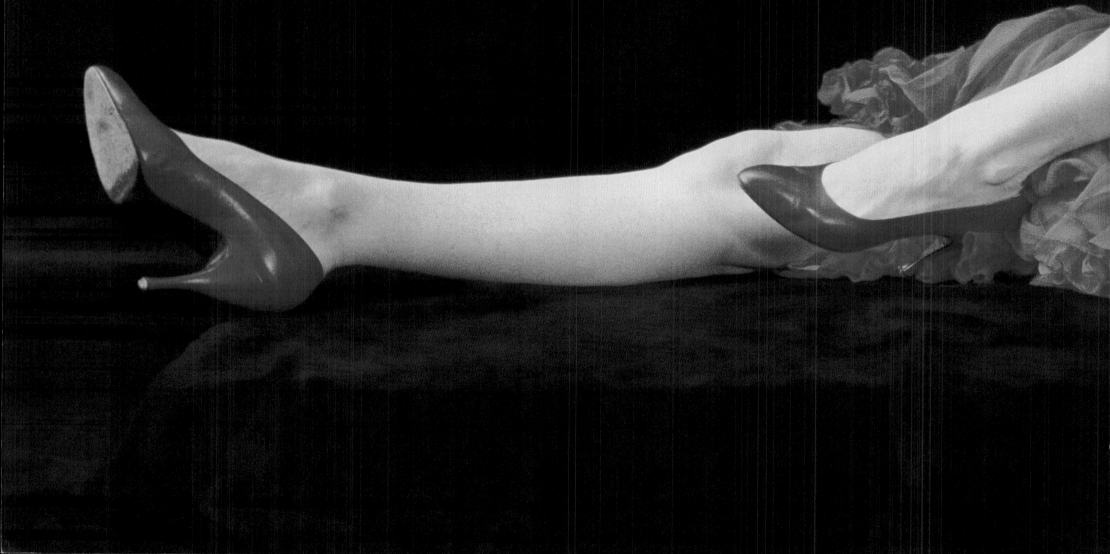

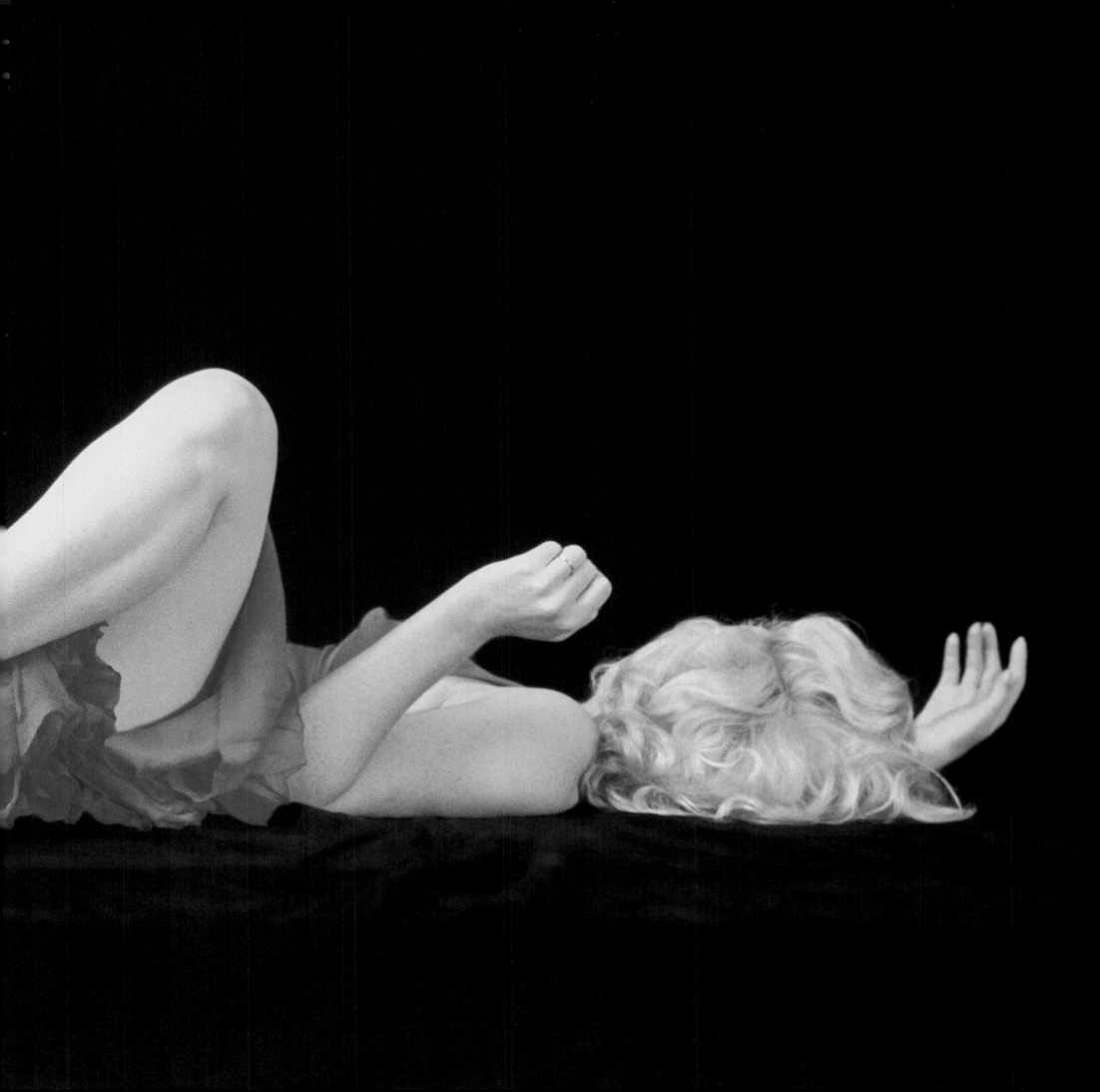

ACKNOWLEDGMENTS

First and foremost, I need to thank Patricia Newcomb. Nobody alive today knew Marilyn the way that Ms. Newcomb did. To have her contribute to this book means a lot to me. I also would like to thank Douglas and Francoise Kirkland, who were instrumental in my transition from the darkroom to digital. Jay Kanter, who has remained a dear family friend throughout my life. Extra special thanks to my dear friend Suzie Kennedy, who, over the past ten years, has continually whispered in my ear that I needed to do this book. Nancy and Tina Sinatra as well as Nancy's daughter, Amanda Erlinger, who, under the direction of Robert Finkelstein, has masterfully maintained an awareness to keep the Sinatra brand current. Through those efforts, they worked with Robin Morgan at Iconic Images on the Frank Sinatra 100th Anniversary book and exhibition. Since my father died, Finkelstein has always been my consigliere and he was the first to make me aware of Robin and Iconic. Robin Morgan for leading the charge at Iconic Images and helping bring all the partners together, making my dream a reality. Carrie Kania has acted as editor and supported and guided us through preparing all the data, text and the concepts on how to bring both versions of this book forward. Stephen Reid, for being flexible and forever patient with the multiple changes and versions of the design of this book. Andrew Whittaker, Susannah Hecht and Stephen Farrow, who helped guide us through wordsmithing, translating and print file management. They continually beat the drum and stayed on top of us, making sure everybody met their deadlines...most of the time anyways. James Smith for truly taking charge of the printing and publishing as well as assisting Iconic Images with the marketing and distribution. A special thanks to Scott Fortner, whom I have leaned on over the years to help separate Monroe fact from fiction. I also am eternally grateful to my Archives team: James Penrod, Rob Welles and Tippy, Stephen Jones and Shawn Penrod. James's constant support and assistance in keeping the images organized made it possible for all the pictures and image information to get where they were needed in an orderly fashion. Rob stepped up and worked long hours preparing these 284 images for publication. His focus and eye for detail are greatly appreciated. Stephen is new to the team, but he let us throw him into the "deep end of the pool" right away, doing a magnificent job in a short amount of time. Shawn has been a loyal friend to me, my family and the Archives. Without his willingness to keep plowing through, I would never have been able to complete this daunting task. I'm always grateful for the commitment of my team. Last but certainly not least, I want to thank my mother, Amy Greene. In addition to her valuable contributions to this book, as the Greene family matriarch, she has been my biggest cheerleader and supporter. I would not be where I am today without her.

Joshua Greene

THE ESSENTIAL MARILYN MONROE
MILTON H. GREENE
50 SESSIONS

© 2017 Joshua Greene
World copyright reserved

ISBN 978-1-85149-867-3

British Library Cataloguing-in-Publication Data
A catalogue record for this book is available from the British Library

Printed in Belgium for ACC Editions, an imprint of ACC Art Books Ltd., Woodbridge, Suffolk IP12 4SD, UK

FSC
www.fsc.org
MIX
From responsible sources
FSC® C014767

ACC EDITIONS

ICONIC IMAGES
FINE ART ARCHIVES PUBLISHING CREATIVE

THE ESSENTIAL MARILYN MONROE
MILTON H. GREENE
50 SESSIONS

THE ESSENTIAL MARILYN MONROE
MILTON H. GREENE
50 SESSIONS